P9-DVB-188

*Applied
Photographic Theory*

WILEY SERIES ON PHOTOGRAPHIC SCIENCE AND TECHNOLOGY AND THE GRAPHIC ARTS

WALTER CLARK, EDITOR

Applied
Photographic Theory

PAUL KOWALISKI
Kodak-Pathé, Vincennes, France

JOHN WILEY & SONS
London · New York · Sydney · Toronto

Printed by J. W. Arrowsmith Ltd., Bristol BS3 2NT

Preface

All human activities are at present deeply pervaded by photography, not only in its intrinsic nature of conveyer of information which allows the precise observation and the faithful recording of events, even remote, or of inaccessible or normally invisible phenomena, but also in its use as an integrated auxiliary element of non-photographic processes and systems. As involved as most other techniques of the present world, photography can play its fundamental part only when all physical conditions required for its correct working are assembled. In amateur photography it is customary to conceal this requirement by incorporating all intricacies into the mechanisms of the camera and of the processing operation while limiting the action of the actual user of the photographic medium to the choice of the viewing angle, the layout and the proverbial clicking of the shutter. In technical and scientific applications of photography however, or in industrial operations such as large-scale photographic or motion-picture film processing, and particularly in the sophisticated complexities of professional, technical and scientific photography, knowledge in depth of the intrinsic principles of photography is indispensible. It is vital therefore not only to know but also to carefully apply the theoretical foundations. They are presented here to this purpose.

Photography, by its nature, has a highly diversified theory which involves chemistry as much as physics and enters fields at first sight foreign to it such as thermodynamics, hydromechanics, the theory of communication and others. To prepare complete, pertinent and up-to-date information on such a vast domain requires careful consideration of the whole available literature ;* this has been made accessible to the reader by detailed reference lists at the end of each section. The search for literature was considerably assisted by

* For practical reasons of ease of access the references were limited to the occidental literature.

the competent and liberal help of Miss José Boichard, Miss Suzanne Bertucat, Mrs. Odette Wartelle and Mrs. Jeanine Karp. Furthermore each chapter has had the invaluable benefit of criticism and suggestions from specialists of the Kodak Research Laboratories in Rochester, U.S.A. and Vincennes, France, particularly C. N. Nelson (Chapters 1 and 4); D. L. MacAdam (Chapters 2 and 3), R. W. Burnham (Chapter 3), J. F. Hamilton (Chapters 5 and 6), J. R. Thirtle and W. E. Lee (Chapter 7), and R. Desprez (Chapter 2). Most of the experimental work of the author's investigations mentioned in several chapters was carefully carried out by Mrs. Nicole Havé who also performed all programming, computing and data processing. The author is much indebted to his secretaries, Mrs. Monique Chambre, Mrs. Jacqueline Boisserie and Mrs. Yolande Kauffmann who successively helped in translating and editing the text; the final drawings of the figures and of the structural formulas were skilfully made by Mrs. Marie-Claire Préteseille.

94300-Vincennes, France P. KOWALISKI
January 1972

Contents

PART TWO
THE MECHANISMS OF THE CLASSICAL
PHOTOGRAPHIC PROCESS

Part One

The Physical Properties
of the Photographic Record

INTRODUCTION

Like most modern techniques the photographic processes are highly evolved and therefore require the use of a steadily increasing number of specially developed chemical compounds and numerous optical, mechanical and electronic devices. It would thus seem justified to discuss first, as is customary, the structure and the preparation of the light-sensitive surfaces, their elements and the most typical equipment.

For the professional, technical or scientific user it is much more important, however, to acquire a good knowledge of what can be accomplished with the photographic materials than to know how the films and papers have been manufactured and how the equipment has been designed. The knowledge of the structure of the light-sensitive materials is useful only occasionally when a working hypothesis is necessary for the correct solution of involved problems. It is more advantageous to attribute a primary importance to the characteristics of the image in the widest sense, i.e. to those of the finished photographic record, and to consider the structure of the sensitive materials and the mechanisms intervening in their use only in a second step.

An image may be judged from many aspects. As the primary purpose of an image or a photographic record is, if not true, at least objective reproduction, it is obvious that a technical knowledge of its physical properties is paramount for its correct evaluation, leaving aside of course that of its esthetic aspects.

The physical characteristics of a photographic record, while very closely interrelated, may be considered under the three separate headings of the reproduction of tones, of colours and of details.

1

Tone and colour reproduction concern mainly the appearance of comparatively large areas, but both also have an influence on detail reproduction. Their domains overlap a good deal, as brightness is one of the inherent attributes of colour as well as a photometric concept.

Detail reproduction also has various aspects: an image can be sharp or blurred, it can look grainy or otherwise non-uniform, and fine details may or may not be visible under the conditions of observation corresponding to the particular use of the record.

To disentangle this maze of criterions it is fundamental to establish between them quantitative relationships; fortunately the knowledge of the physical properties of the photographic record is now not only highly developed and covers a wide ground, but recent studies have contributed much to clarify the notions in this domain, as for instance the application to detail reproduction of techniques until recently almost only employed in the field of telecommunications. The rather explosive generalization of colour photography and colour printing have, besides this, favoured the development of a better knowledge of colour and tone reproduction. Only when relying entirely on these solid bases is it possible to take full advantage of the exceptional possibilities of the photographic process.

1

Tone Reproduction

As any photographic record or reproduction is made to yield an image in the widest sense, it is necessary first to obtain an understanding of the phenomenon which allows us to see an image. The word 'image' describes everything that makes forms and lines appear on an initially uniform area through luminance differences, which can either be small and continuous, or on the contrary, harsh and rather large. The artists call these various luminances 'tones' or 'values'; what really counts is the nature of their progression—continuous or erratic, slow or fast—so that the first item to be discussed is that of 'tone scales' and of their behaviour within the different steps of the photographic process.

The reproduction of tone scales can be studied in two different ways. Either (i) observer reaction is not taken into account, and only the physical aspects of the reproduction process are considered: this is the *objective phase* of tone reproduction; or (ii) a comparison is carried out between the appearances, for an average observer, of the original scene or subject and the reproduction: this is the *subjective phase* which includes the psychophysical properties of vision as well as the conditions prevailing during the observation of the record.

1.1 DEFINITIONS

1.1.1 Objective Tone Reproduction

The relationship between the characteristics of the original scene and that of the reproduction is obtained by comparing their tone scales, expressed in measurable units. All that is thus needed for plotting their functional relationship in a graph are the tone scales of the scene and of its reproduction, calibrated for instance in foot lamberts (Figure 1.1); for various

3

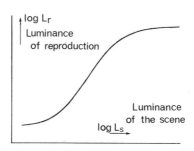

Figure 1.1. Diagram of objective tone reproduction.

reasons, which will be discussed later, logarithmic scales are employed. This functional relationship allows us to judge the degree of exactitude with which the values have been reproduced. It can be seen in the example of this graph, which is representative of the most common case of pictorial photography, that a certain number of well separated steps of low luminance are either reproduced at only one value of luminance, or by steps so closely spaced that even a measuring device as sensitive as the eye does not separate them; at the highest levels of illuminance, the tone scale is also compressed, while the relative values of the steps are either well reproduced or slightly increased in the middle of the tone scale.

Up to this point the information contained in the reproduction has been determined, as already stated, only by measurements concerning its physical characteristics; a detail, for instance, of the original scene, whose luminance differences disappear in the reproduction, is effectively lost; other details with well separated luminance levels may be only slightly differentiated in the reproduction, while for others these differences may be exaggerated.

Merely objective consideration of tone reproduction, however, is not sufficient to yield all the required information, as too many subtle factors influence the judgment by an observer. In all those cases therefore where the reproduction is to be examined visually—i.e. nearly always—it is indispensable to also take into account the subjective phase of the reproduction process.

1.1.2 Subjective Tone Reproduction

The investigation of the subjective aspects of tone reproduction is similar to that of the objective phase: considered from an exclusively technical viewpoint this study reduces to the comparison of the tone scales of the original scene and of its reproduction, as perceived by human observers.

This psychophysical investigation is of course much more involved than the determination of the objective characteristics of the reproduction

process, which depend only on the correct choice and use of the measuring devices. The reactions of different observers, on the contrary, are quite variable and yield dispersed judgments as well as scattered numerical results of the quality of reproduction, so that not only involved experimental methods are required for their evaluation, but also statistical methods for the processing of the results. Leaving aside esthetical considerations and attempting only to establish a visual correspondence between the appearance of the reproduction and that of the original scene, or even the probable appearance of an unknown scene which the observer mentally compares in his memory with what he remembers of a similar situation, the rather particular properties of human vision must be taken into account. These depend on the one hand on the conditions of observation, i.e. on the levels of scene and reproduction illuminance, and on the other hand, on the size and luminance level of the surround, because visual judgment depends not only on the general adaptation of the observer, but also on local adaptation and simultaneous contrast (see p. 43).

Thanks to general adaptation, we see distinctly at very low as well as at very high levels of illumination; indeed our vision covers a very large domain which extends from a fraction of a metre candle in scotopic vision to illuminances a hundred million times greater in bright sunlight. The functional relationship between visual brightness and photometric luminance is therefore rather involved and cannot be represented by one single curve. While the subjective appreciation, in any fixed state of adaptation, of a scale extending from 'black' to 'white' and covering only an overall luminance ratio of the order of a few hundreds has a well determined character which allows us to define a unique relationship, this latter is sensibly modified by the variation of the general level of illuminance. These changes not only lead

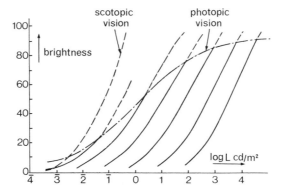

Figure 1.2. The relationship between brightness and luminance depends on the level of general observer adaptation.

to the deformation of the visual sensitivity curve, but also shift it along the luminance axis.[1] The relationship between brightness and luminance must therefore be represented by a family of curves such as those shown in Figure 1.2; this parametric representation, whose particular properties are described in detail below, p. 51, yields the only valid means of comparison of the appearances of the original 'scene' and of its reproduction, in general observed at quite different levels of illuminance and therefore of general adaptation and visual sensitivity.

Starting from the characteristics of objective reproduction and taking into account the different illuminance levels of the 'scene' and of its reproduction, the function of subjective tone reproduction can be determined in each particular case by the choice of the appropriate visual sensitivity curve and by application of Jones' graphical method, described below, p. 76.[2] Figure 1.3 shows as an example of such a result the comparison of an excellent reflection print and the projected image of a transparency of the same image, observed on the screen in a darkened room.[1] As both images were chosen

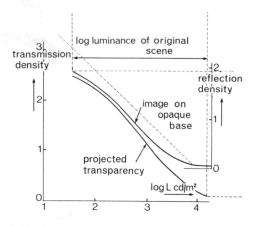

Figure 1.3. Subjective tone reproduction by reflection and by transmission.

as excellent by several observers, their subjective tone reproduction characteristics differ only slightly from the ideal reproduction function represented by the straight line at 45°, except for the highlights of the reflection print whose scale is reduced, as will be shown further, by the conditions of observation.

1.1.3 The Importance of the Tone Scale

The luminance progression, or tone scale, is the basic element of any image or monochrome record intended for visual inspection. Two neigh-

bouring areas, belonging to two different elements in the field of vision, and therefore supposed to make a limit appear, can only be differentiated if their luminance difference is sufficient under the specific conditions of observation. If, on the contrary, their difference is exaggerated, it can happen that the whole gamut of intermediate luminance values disappears between the two areas, thus modifying the appearance of what should have been reproduced.

It is evident that the tone scale is just as important in ordinary photography for the obtention of current pictures as it is in any pictorial expression. It even has more importance in photography than in painting, where artistic transposition allows entire freedom in the choice of hues and values; in photography, where the exact perspective of the object outlines compels documentary realism, artistic expression centres around the choice of lighting and the creation of the appearance of texture and matter. A skilful photographer or cameraman translates the tone scales of reality into images not by physically exact reproduction, but by the choice of an appropriate progression of values which in fact is his essential means of expression. It can thus be just as important to make use of all the steps of a scale as to make some of them disappear. Only a perfect knowledge of the entire process of tone reproduction allows us to attain this aim.

In a wider sense similar considerations apply to other fields where a record in the form of an 'image' is the final purpose, as for instance in documentary photography, in photomicrography, in radiography, in instrumentation recording, etc. In these technical applications of photography a satisfactory tone scale is still more important and the requirements of true reproduction still greater. The image of a pictorial scene is a reminder of a known situation and therefore does not need to be complete. A technical or scientific illustration, however, must be true even in its smallest details, especially when it does not remind us of anything previously known, and it must therefore exactly show the subject or phenomenon to be represented. Often this 'fidelity' of reproduction is so much more difficult to obtain as the luminance level of the original differs from that prevailing during the inspection of the image.

1.1.4 The Effect of Tone Contrast on Detail Reproduction

The effect of the luminance difference of two neighbouring patches on the perception of their line of separation has just been discussed. This appearance of contour sharpness is more closely related to tone reproduction than might at first appear. Let us consider two types of transition between neighbouring patches, one typical of a sharp edge, the other one of a rounded one (Figure 1.4). For the former it is the relative importance of the peaks in the transition curve which has a strong influence on the apparent sharpness of the edge.

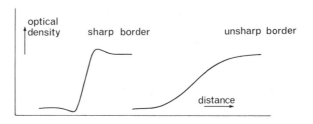

Figure 1.4. Density transitions across edge images.

For the latter it is rather the overall shape of this curve which influences the appearance: the edge can either look convex or concave and in both cases either flat or steep. This illustrates why the correct interpretation of an image is only possible with a satisfactorily distributed tone scale: high or low slope of this scale, or its distortion across the edge, have a big influence on the appearance of the latter. This aspect of detail reproduction is fuller discussed in the next chapter, p. 141.

On a smaller scale, the effect of tone reproduction on picture sharpness makes itself felt in a similar way in all periodic arrays such as patterns of fabric, or dot or line screens. In pictorial photography, this aspect is most important when it is desired to show the surface texture typical of a given material. This holds particularly for enlargements of high magnitude— as for instance in super-8 amateur motion pictures—where tone reproduction, as well as that of detail, are both functions of microscopic tone scales. In scientific photography all the information required can also only be obtained by the choice of that kind of photographic recording which yields best detail through an optimum tone scale. A far-away star, a weak nuclear trace, or the radiography of a clinically important but almost invisible detail are typical examples.

Finally, tone contrast also influences the graininess of an image, a fact well known for prints from negatives taken with miniature cameras, where the grain shows up so much more as the contrast of the paper is higher. A similar correlation exists in radiography between the quantum mottle and the contrast of the film-process combination.

As will be shown below (p. 160), the combined influence on detail reproduction of all effects is at present treated by the use of the modulation transfer function, which describes the amplitude loss of a sinusoidal signal in the course of the reproduction process as a function of spatial frequency; it allows us to treat in the most general manner the three aspects of detail reproduction, sharpness, resolving power and granularity. It is evident that exact reproduction of a sinusoidal density distribution, which is made use of for the obtention

of the modulation transfer function, is closely related to macroscopic as well as microscopic tone reproduction.

1.2 ELEMENTS OF THE QUANTITATIVE INVESTIGATION OF TONE REPRODUCTION

The study of tone reproduction relies on some basic concepts, *photometric*, *photographic* and *sensitometric*, the understanding of which is paramount for the detailed investigation into all specific aspects of the various applications of photography.

All photographic materials, sensitive to light or, more generally speaking, to various kinds of radiation, have a certain sensitivity which must be expressed in numerical values. The whole of the techniques employed for the measurement of this sensitivity form what is called *sensitometry*. These techniques serve to establish the relationship between the quantity of radiation incident on the sensitive material and the resulting photographic effect. The sensitometric units therefore are on the one hand the same as those employed for the measurement of light, i.e. *photometric*, and, on the other hand, those more specific of photography, and thus *sensitometric*.

Photometry, a complex science, is fully described in specialized treatises[3,4]. As only some fundamental aspects are necessary here, only the basic notions of *intensity* of a light source, of *luminous flux*, *illuminance* and *luminance* will be treated here.

Any source of radiation emits, per unit time, a given number of photons which define its *intensity*. The whole of the radiation emitted in unit time constitutes the *flux*, in the case of visible radiation the *luminous flux*. Upon reaching a surface of any kind, the amount of incident flux defines the *illuminance*, and the fraction of luminous flux reflected by this surface determines its *luminance*, as seen either by an observer or a camera. It is obvious that similar concepts could apply also to non-visible radiations.

Various non-metric photometric units are in current use but metric units are becoming more and more frequent. Conversion factors of some of the most employed units are:

Illuminance

$$1 \text{ foot candle} = 10{\cdot}76 \text{ metre candles (lux).}$$

Luminance

$$1 \text{ foot lambert (lumen/ft}^2) = 10{\cdot}76 \text{ cd/m}^2 \text{ (candelas per square metre).}$$

$$1 \text{ millilambert } (10/\pi \text{ cd/m}^2) = 3{\cdot}183 \text{ cd/m}^2$$

$$1 \text{ apostilb (lumen/m}^2 \text{ or } 1/\pi \text{ cd/m}^2) = 0{\cdot}3183 \text{ cd/m}^2.$$

In *sensitometry* it is common practice to place a filter between the source of radiation and the sensitive layer. Its absorption characteristics are either given in values of *transmittance* or of *optical density*. The total amount of radiation acting on the sensitive layer depends on the illuminance in its plane as well as on the exposure time, and is called *exposure*. The properties of the image, which is the result of the photographic recording, are then described, just as in the case of a filter, by its absorption characteristics. Measurement of the image is therefore carried out as for any absorber or filter, and the properties of the exposed and processed photographic layer are expressed either as transmittances or reflectances, or as optical densities, measured either by transmission or by reflection. The quantitative relationship between exposure and the resulting density is in general represented by a curve, characteristic of the light-sensitive material itself and of its processing: the *characteristic curve*. Several parameters: *speed or sensitivity*, *contrast*, *fog*, or others, typical of the whole of the process under study, can be determined from this curve.

1.2.1 Objective Photometry

1.2.1a *Luminous Flux*

A point source emits radiations in all directions. The luminous flux is the amount of luminous energy flowing through a given surface in unit time. If the source has an intensity of *one candela*, it emits in a unit solid angle (steradian) one *lumen* of flux, and therefore in all directions a total flux of 4π lumens (Figure 1.5). The candela is the luminous intensity, in a given direction, of an aperture normal to this direction, having an area of $\frac{1}{60}$ square centimetre and radiating as a complete radiator (black body) at the temperature of solidification of platinum.[4]

The luminous intensity I and the flux Φ are interdependent, so that one or the other of these two concepts can be chosen for the definition of the basic

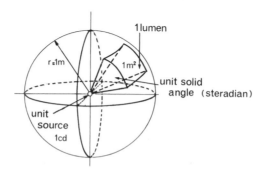

Figure 1.5. Geometric elements of photometry.

unit. In current photometry it is customary to start from the candela. As the radiation emitted by an actual source is never uniform in all directions, the flux within the solid angle Ω must be computed by the integral

$$\Phi = \int_\Omega I \, d\Omega. \tag{1.1}$$

The luminous intensity therefore is

$$I = \frac{d\Phi}{d\Omega}. \tag{1.2}$$

As it is obvious that a real source is never a point source, the luminous flux it emits varies according to its direction. This distribution of flux is usually represented by its indicatrixes which are plane sections of a curved surface laid through the outer ends of all vectors whose origin is in the centre of the source and whose length is proportional to the amount of flux in their direction (Figure 1.6).

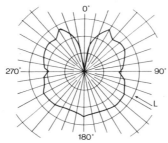

Figure 1.6. Example of an indicatrix of luminous distribution.

1.2.1b *Illuminance*

Any surface placed in front of the source is illuminated by the incident flux. The unit of illuminance, the *foot candle*, is defined as the illumination of a surface of one square foot of area by one lumen of flux at normal incidence.

For the computation of illuminance, let us consider the point source A illuminating a surface element dS of random orientation (Figure 1.7).

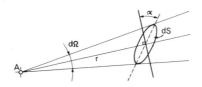

Figure 1.7. Illumination of a surface element dS.

As seen from A, dS intercepts the solid angle

$$d\Omega = \frac{dS \cos \alpha}{r^2},\tag{1.3}$$

and the illuminance E,† equal to the product of the flux by unit surface, is

$$E = \frac{d\Phi}{dS} = \frac{I\,d\Omega}{dS} = \frac{I}{r^2} \cos \alpha.\tag{1.4}$$

This equation expresses the well known inverse square law of illuminance as a function of distance, and also its proportionality to the cosine of the angle between the direction of the incident ray and the normal to the surface.

As will be shown later, illuminance is, jointly with exposure time, the photometric concept employed in sensitometry for the computation of the exposure conditions (see also p. 27).

1.2.1c *Luminance*

A uniform light source of a given size, or a reflecting or transparent surface illuminated by an external source, appears to an observer more or less bright; the corresponding attribute is the *luminance*. By definition luminance is the luminous intensity per unit surface of a primary or secondary (reflecting) surface of a light source. When looking at a scene or an array of objects, even a still-life of abstract ones such as those recorded in certain technical or scientific illustrations, the observer distinguishes the various forms, as mentioned before, by the luminance differences of the areas composing the scene, whether the object surfaces are illuminated by an outside source, or whether the scene contains one or several light sources. Substitution of a photographic camera for the observer leaves the problem unchanged; instead of the retina, it now applies to a light-sensitive layer. Luminance is therefore, among the sensitometric concepts, one of the most important for application in photography, especially for picture taking, or, in general, recording with a camera.

The unit of luminance is the *foot lambert*, which is defined as $1/\pi$ the luminance of a source of an intensity of one candela and an area of one square foot. It is equal to the luminance of a perfectly reflecting surface illuminated by one foot candle.

As just explained, the concept of luminance not only concerns light sources, but all illuminated surfaces. For a perfectly diffusing surface, luminance is thus equivalent to the light reflected by that surface into a hemisphere.

† In most photographic treatises, and especially in sensitometry, illuminance is described by the letter i or I corresponding to the word illuminance, or light intensity. The use of the letter E is made here as recommended by the Commission Internationale de l'Eclairage (CIE).

Let us consider a perfectly uniform light source or a perfectly matt reflector which obeys Lambert's law. By definition such a surface has in all directions the same luminance. Its area, as seen by an observer, varies as the cosine of the angle θ between the direction of observation and the normal to the surface: $da = dS \cos \theta$, so that its magnitude apparently also varies like cosine θ. Its indicatrix therefore is a sphere tangent to the uniform source or reflecting surface (Figure 1.8). The luminance L,† defined as the luminous intensity per unit surface, is thus equal to

$$L = \frac{I}{da} = \frac{I}{dS \cos \theta}. \tag{1.5}$$

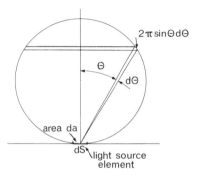

Figure 1.8. Spherical indicatrix of the luminance of a perfect reflector.

A surface element of the source dS emits into the solid angle $d\Omega = 2\pi \sin \theta \, d\theta$ a flux of $d\Phi = I \, d\Omega$. Substituting equation (1.5) yields

$$d\Phi = L \, dS \cos \theta \, 2\pi \sin \theta \, d\theta$$

$$= L \, dS \, \pi \sin 2\theta \, d\theta.$$

The total flux of radiation from the entire source emitted only into one half of space is therefore

$$\Phi = LS\pi \int_0^{\pi/2} \sin 2\theta \, d\theta = LS\pi.$$

This yields, for a perfectly reflecting surface, the relationship between illuminance and luminance

$$E = \frac{\Phi}{S} = \pi L, \quad \text{or} \quad L = \frac{E}{\pi}. \tag{1.6}$$

† Previously the letter B was often employed, derived from the denomination 'brightness', or 'brillance' (in French).

As there is no surface which reflects all of the incident flux, it is further necessary to take the reflection coefficient into account,

$$r = \frac{\text{reflected flux}}{\text{incident flux}};$$

$$L = \frac{1}{\pi} r E. \tag{1.7}$$

1.2.1d *Transmittance, Reflectance and Optical Density*

The amount of flux in a light ray diminishes while crossing an absorbing medium. By definition the transmittance of the medium is the ratio of the transmitted to the incident flux

$$T = \frac{\Phi_t}{\Phi_0}. \tag{1.8}$$

Similarly in the case of surface reflection, the reflected ray is weaker than the incident one, which, by analogy, yields for the reflectance

$$R = \frac{\Phi_r}{\Phi_0}. \tag{1.9}$$

The concept of reflectance is inherently more complex than that of transmittance, because reflectance is a function of the angle of incidence as well as of the surface properties of the reflecting layer. The simple formula given above is in fact only valid for perfect diffusers.

In photographic practice the simple concepts of transmittance and reflectance, with their values given in decimal units and fractions, are made use of in certain specific cases only. Absorption or reflection of radiation by an absorbing layer or filter is in general expressed as *optical density*. This latter is the logarithm of the inverse of transmittance or of reflectance,

$$d_t = \log\frac{1}{T} = -\log T, \tag{1.10}$$

for transmitted light,

$$d_r = \log\frac{1}{R} = -\log R, \tag{1.11}$$

for reflected light. The above mentioned complexity of the concept of reflectance of course also affects reflection density.

The use of logarithmic units is indispensable for several reasons. In the first instance *absorption* of radiation by an absorbing layer as a function of its thickness obeys the well known Bouguer–Lambert law

$$\Phi_\lambda = \Phi_{\lambda 0}\, e^{-kx}, \tag{1.12}$$

where $\Phi_{\lambda 0}$ is the incident flux of radiation (supposed to be monochromatic

of wavelength λ), Φ_λ the transmitted flux of this radiation, k a constant characteristic of the absorbing medium, and x the distance the ray has travelled within the medium. If it is the concentration of the absorbing compound in the layer that is varied rather than its thickness, then Beer's law applies:

$$\Phi = \Phi_{\lambda 0}\, e^{-k'cx}, \tag{1.13}$$

where c is the concentration of the absorber either dissolved or dispersed in an otherwise transparent medium.

The use of logarithmic units is further related historically to the intrinsic properties of human vision. A scale of transmittance or reflectance, varying in geometrical progression, yields in fact an approximately uniform visual tone scale. While the visual uniformity of a luminance scale is more satisfactory when its steps are spaced according to an exponential function (see p. 51), their geometrical progression obeying the psychophysical Weber–Fechner relationship yields an approximation entirely valid within the limits of a given state of observer adaptation when the luminance ratio of the lightest to the darkest steps of the scale is less than a few hundreds. Optical density, logarithmic by definition, therefore expresses sufficiently well the visual impression of the brightness progression of a scale of patches of increasing absorption to grant its general use.

There is, finally, a practical reason for the use of logarithmic units. It is in fact impossible to make use of a linear scale when small fractions are to be distinguished from each other just as clearly as large ones. Current practice however requires the plotting on the same graph of transmittances of almost unit value together with others corresponding to 1/10,000 of the incident flux. This fact is of course a consequence of the two intrinsic phenomena just described, the exponential nature of absorption, and the psychophysical relationship which describes the behaviour of human vision.

1.2.2 Sensitometry

The totality of all those techniques which are made use of for the measurement of the sensitivity of photographic layers, and which allow us to determine the various parameters characteristic of their properties, as well as to measure the absorptions in the finished recordings, is called sensitometry.

In sensitometry, besides processing equipment, two types of instruments are employed: *sensitometers* and *densitometers*. The former are not really measuring devices, but are intended for the exposure of sensitometric samples under perfectly well known and reproducible conditions.† Densitometers on

† The origin of the word sensitometer is historical. In the early days of photography, investigation into the properties of the various processes led to the use of devices comprising a print-out sample which allowed an estimate, upon exposure to a given radiation, of the relative sensitivity of the layer.

the contrary allow us to measure the optical density of absorbing layers and are in fact photometers adapted to this specific purpose.

1.2.2a *Sensitometric Exposure and Development*

A sensitometer includes the following elements: a source of radiation, filters, a device for the setting of exposure time (shutter, switch, etc.), an exposure modulator, a frame defining exactly the position of the sensitive layer in relation to the source.

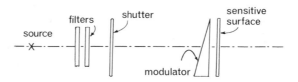

Figure 1.9. Schematic sensitometer diagram.

The basic design of a sensitometer is schematically shown in Figure 1.9. In practice sensitometers differ among themselves by the type of source and its intensity, the type of modulation (time or intensity variation) and by the geometry of the lay-out so chosen as to insure uniform illumination (in absence of the modulator) over the whole surface of the sample which is to be exposed to a given radiation.

The *sources of radiation* are, according to the specific purpose, either incandescent lamps operating under perfectly constant voltage and intensity, or infrared, ultraviolet and X-ray sources.

The modulators for most photographic applications are *intensity scale modulators* (neutral gray step wedges) employed in conjunction with very precise shutters yielding exact exposure. *Exposure time modulation* of each successive step is only applied in certain specific cases, as for instance with direct X-rays as employed in industrial radiography.

After exposure in the sensitometer, the samples are processed under perfectly known conditions resembling as far as possible those of the practical use of the tested material. The factors to be kept under control in a *sensitometric process* are, for a classical photographic material: the *chemical parameters*, i.e. the analytical values of the concentrations of the various compounds dissolved in the processing solutions, and the *physical parameters*, such as the time of immersion, the temperature of the solutions, and the degree of agitation. A corresponding amount of care is indispensable to ensure the perfect sensitometric rigor of processing for other processes also, like those employing photosensitive polymers, electrophotography, etc.

1.2.2b *The Measurement of Density*

A *densitometer* contains a light source and a radiation receptor, a sensitive element allowing us to measure the residual illuminance by a ray of light transmitted or reflected by the sample. In *visual densitometers* the radiation receptor is the eye, employed as a null instrument. Measurements are carried out by photometric matches between a field illuminated by light transmitted or reflected by the sample, and a reference field (Figure 1.10). *Physical* or

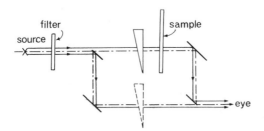

Figure 1.10. Visual densitometer.

photoelectric densitometers, on the contrary, yield in general the measured density value by direct reading of the amplified current of a photoelectric cell (Figure 1.11). Most modern densitometers are built so that their diffusion characteristics correspond for the density measurements with good approximation to those encountered in practical use of the photographic material tested.

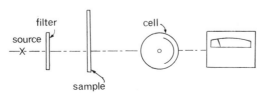

Figure 1.11. Photoelectric densitometer.

Transmittance and reflectance, and the corresponding logarithmic values, are in fact not independent of the *geometry of the light rays* incident on, as well as transmitted or reflected by, the absorbing layer. The many possible lay-outs for the various elements, the source of radiation, the absorbing or reflecting layer to be measured and the radiation receptor (eye, photoelectric cell, etc.), have a great influence on the degree of loss of flux by a layer of given constitution. The relative positions and sizes of the different

elements must therefore be known exactly not only in the measuring devices, but also for the conditions of practical use of the exposed and processed material. This is particularly important for the photographic layers, non-homogeneous and containing several elements of different optical properties†.

According to the geometry of the rays there are four extreme cases: the light of the incident beam can either be entirely specular or entirely diffuse, and of that emerging after transmission through the absorbing layer, either a specular fraction only, or the whole of the diffused amount, may be received, for both conditions of incidence, by the radiation receptor. Combined two by two, there are thus four combinations, represented in Figure 1.12, for

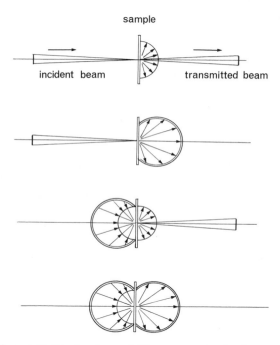

Figure 1.12. The four types of diffuse or specular densitometry.

the measurement of transmission density. These limiting cases are however seldom met with in practice, where photographic images or records are employed or observed under intermediate conditions of diffusion. This fact explains why numerical values of density obtained for a given sample on

† The effect of this structure on detail reproduction is treated in all its ramifications in Chapter 2, p.119.

different instruments can be different. They also vary according to the conditions of use: the same negative, either printed by projection in a specular enlarger, or with diffused light in a printing frame, yields in the two cases quite different light distributions on the printing material. It is necessary that the densitometer approximates the geometry of the light rays during actual use of the material of which a sample is to be measured.

As it is impossible in practice to use several instruments, the manufacturers of modern densitometers choose in general a lay-out yielding average diffusion. The sample to be measured is applied against a small circular diffusing area whose diameter can be varied at will in most instruments,† and the transmitted ray is taken up by the cell at a short distance.

This densitometer lay-out, corresponding well in fact to the practical conditions most frequently encountered, is that recommended in the USA Standard for 'American Standard Diffuse Density' which defines the experimental conditions for a satisfactory approximation of the measurement of density in diffuse light. Either the incident beam is rather specular and normal to the sample plane, and the whole transmitted flux is taken into account for the measurement of density, or the optical path is reversed so that the incident flux is entirely diffuse and only the specular normal fraction of the emerging light is measured. As small differences of instrument lay-out have a rather strong influence on this type of measurement, the standard describes diffuse density by definite techniques, including an integrating sphere, an opal glass diffuser and also a contact printing method. Densitometer manufacturers are thus able to design their instruments such that they correspond well to the conditions of practical use of photographic materials.

The optical conditions are particularly complex for reflecting layers, which makes still more difficult the definition of *reflection density*[6,7]. Homogeneousness of the reflecting layer, the respective refractive indexes of its elements on which the internal reflections depend, and its surface texture, which determines the first surface reflection, lead, according to the angles of incidence and reflection of the rays, for a given layer to different results. The ratio between the absorption density of a layer carried by a transparent base, and the reflection density of the same layer on a white reflecting base, has the following characteristic (Figure 1.13). At low values reflection density increases faster than the corresponding transmission densities, further to numerous internal reflections (section a of the curve in Figure 1.13). The contribution of internal reflections diminishes however with the increase of absorption, so that at somewhat higher values reflection density becomes proportional to transmission density within a comparatively wide

† This variation of measuring aperture is obtained very simply by placing one among a series of discs of varying aperture between the illuminated light diffusing window and the sample.

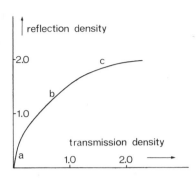

Figure 1.13. Relationship between reflection and transmission density.

interval (b, Figure 1.13). At still higher levels the constant contribution of light directly reflected by the surface gains more and more importance, and finally limits reflection density at a maximum value which then remains independent of any further increase of absorption within the layer (c, Figure 1.13).

Reflection density is therefore always measured with a fixed lay-out of light-ray geometry such as to eliminate the undesirable effect of surface texture with varying angles of incidence and reflection: either the incident ray is perpendicular and the reflected ray taken at an angle of 45° to the normal of the sample surface, or it is the incident ray which is inclined by 45° and the reflected ray is at right angles to the surface (Figure 1.14). The values measured are thus specific of the tested layer and correspond satisfactorily to the result of visual inspection under optimum conditions of observation.

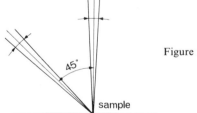

Figure 1.14. Geometry of reflection density.

For *colour densitometry*,[8,9,10] the basic definitions remain unchanged of course, but it is necessary to take into account the spectral composition of the light source employed for the measurements. All colour processes are trichromatic† and the colour photographic materials therefore have either

† The principles of colour reproduction are described in Chapter 3, p. 211.

three layers, each of which carries one of the elementary images, or else three dyes or three pigments in one single layer. This constitution leads to two types of colour densities: those resulting from only one of the three trichromatic elements, called *analytical densities*, and those corresponding to the total effect of the whole trichromatic recording, called *integral densities*.

Usually, analytical densities are measured in the spectral band of maximum absorption of the dye (Figure 1.15) either within a very narrow band, i.e.

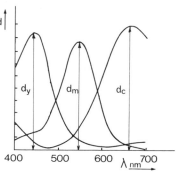

Figure 1.15. Analytical densities of dyes employed in three-colour photography.

in monochromatic light (analytical spectral density) or with a coloured filter of known absorption characteristics. The direct measurement of analytical densities can only be carried out on a separate elementary image of a trichromatic record.

In a complete colour record composed of three elementary images, either in superposition or mixed in one layer, the direct measurement with a filter of known spectral transmittance yields an integral density value. Let d_c, d_m and d_y be the analytical densities of three elementary images measured with filters or with given monochromatic lights, and d_r, d_g and d_b the three integral densities measured with the same filters whose transmission bands correspond to the three absorption maxima of the dyes or pigments (Figure 1.16). As each integral density results from the addition

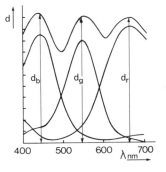

Figure 1.16. Integral densities of a three-colour photograph.

of three individual densities measured in one transmission band, this yields

$$d_r = a_{11}d_c + a_{12}d_m + a_{13}d_y,$$
$$d_g = a_{21}d_c + a_{22}d_m + a_{23}d_y,$$ (1.14)
$$d_b = a_{31}d_c + a_{32}d_m + a_{33}d_y.$$

The validity of Beer's law is generally assumed (p. 15).

Within the limits of concentration or layer thickness where Beer's law is valid, the ratios between the coefficients a_{ij} of each dye remain constant: a_{21}/a_{11} and a_{31}/a_{11} for the *cyan*, a_{12}/a_{22} and a_{32}/a_{22} for the *magenta*, and a_{13}/a_{33} and a_{23}/a_{33} for the *yellow*, which are the three elementary colours in a trichrome colour reproduction (see page 249). The analytical densities therefore result by solving equations (1.14):

$$d_c = k_{11}d_r + k_{12}d_g + k_{13}d_b,$$
$$d_m = k_{21}d_r + k_{22}d_g + k_{23}d_b,$$ (1.15)
$$d_y = k_{31}d_r + k_{32}d_g + k_{33}d_b.$$

The coefficients of equations (1.14) are obtained by a graphical method: after measuring the densities in red, green and blue light of the three concentration scales of the elementary cyan, magenta and yellow dyes or pigments, the secondary densities of each dye are plotted as a function of the principal densities (Figure 1.17). The average gradients of these curves yield the coefficients a_{21}, a_{31}; a_{12}, a_{32}; and a_{13}, a_{23}, for $a_{11} = a_{22} = a_{33} = 1\cdot0$.

The measurement of *reflection colour density*[11] involves not only the factors already described for white light reflection densities (p. 19), but is

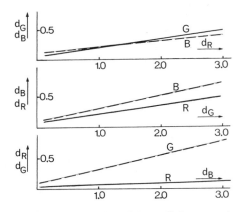

Figure 1.17. Graphical determination of the coefficients $a_{i,j}$ of equation (1.14).

still more involved because of the trivariance of colour. As a result of the non-linear relationship between transmission and reflection densities, it is in fact not possible to employ linear transformation equations for the computation of analytical reflection densities. In the method proposed by Pinney and Voglesong[11] to avoid this difficulty, the measured integral reflection densities are first transformed into integral transmission densities by the use of three curves like the one in Figure 1.13, empirically determined for each of the elementary colours of the process. By using linear equations, it is then possible to compute the analytical transmission densities, which can then again be transformed into analytical reflection densities by using for each of the three colours the same empirical relationship between transmission and reflection densities.

Increase of the concentration of one or several of the dyes of a colour photographic system does not only increase the saturation of the colour obtained, but also diminishes its equivalent luminance (see p. 91). This property of colours makes itself most felt when they are observed or measured by reflection.

Practical colour densitometry, by transmission as well as by reflection, intrinsically complex, has to be carried out under particularly well defined conditions. Colour density is in fact the result of the spectral characteristics of the densitometer light source as well as of the filters, and of the photoreceptor. In a typical instrument, for instance, the light source is an incandescent lamp of a colour temperature of 3000 K, whose infrared emission has been filtered out carefully (Figure 1.18). Neither the light source nor the cell, in most instruments of comparatively uniform spectral characteristics, have the greatest influence on the recorded values; these depend rather on the spectral transmittance bands of the red, green and blue filters. Figure 1.19 shows an example of the red, green and blue responses of an instrument

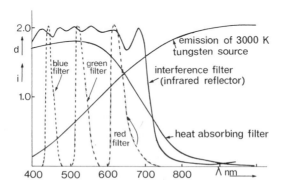

Figure 1.18. Spectral characteristics of a system of colour densitometry.

having the spectral characteristics of Figure 1.18. The spectral density curve of a high density area on a typical reversal colour film is shown in Figure 1.19; its three responses d_r, d_g and d_b are represented in full lines. It is obvious that another filter set would yield different values on account of the non-uniform spectral absorption of the sample.

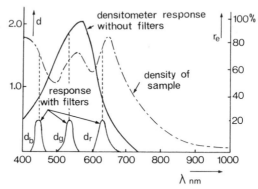

Figure 1.19. Densitometer response with and without filters.

For a given film-process combination, i.e. for a particular dye set, it can reasonably be assumed that the densities obtained with two different sets of filters 1 and 2 will be proportional:

$$d_{r_1} = k_1 d_{r_2},$$
$$d_{g_1} = k_2 d_{g_2}, \qquad\qquad (1.16)$$
$$d_{b_1} = k_3 d_{b_2}.$$

There thus exists a simple homothetic relationship between the sensitometric curves obtained from these measurements (Figure 1.20).

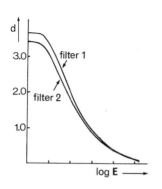

Figure 1.20. Homothetic relationship between densities measured with two different filters.

Densitometric measurements serve in general to determine the printing conditions for the reproduction of a trichrome original or intermediate. This makes it necessary to know the relationship between the response of the sensitive material, to be exposed through the original, and that of the densitometer.[12] For each of the elementary receptors the former is

$$R_{0,s} = \int_{400\,nm}^{700\,nm} E(\lambda)T_i(\lambda)S_i(\lambda)\,d\lambda, \qquad (1.17)$$

where $E(\lambda)$ is the spectral distribution of the exposing light, $T_i(\lambda)$ the transmittance of the red, green and blue filters, and $S_i(\lambda)$ the spectral sensitivity of each of the three sensitive layers. The densitometer response can be expressed in a similar way by

$$R_{0,d} = \int_{400\,nm}^{700\,nm} E'(\lambda)T_i'(\lambda).S'(\lambda)\,d\lambda, \qquad (1.18)$$

where $E'(\lambda)$ is the spectral distribution of the densitometer light source, $T_i'(\lambda)$ the transmittance of the red, green and blue filters, and $S'(\lambda)$ the spectral sensitivity of the photoreceptor of the densitometer. Equations (1.17) and (1.18) do not include the spectral absorption $N(\lambda)$ of the sample which is to be measured prior to the printing operation. Introduction of the sample into the beam yields for the sensitive layer

$$R_{N,s} = \int_{400\,nm}^{700\,nm} E(\lambda)T_i(\lambda)N(\lambda)S_i(\lambda)\,d\lambda \qquad (1.19)$$

and for the densitometer

$$R_{N,d} = \int_{400\,nm}^{700\,nm} E'(\lambda)T_i'(\lambda)N(\lambda)S'(\lambda)\,d\lambda. \qquad (1.20)$$

According to the definition of transmission density by equations (1.10), the following two sets of three equations define the densities for the sample N in red, green and blue lights, on the one hand for the sensitive material, and on the other hand for the densitometer:

light-sensitive printing material
$$\begin{cases} d_{s,r} = -\log\dfrac{\int ET_rNS_r\,d\lambda}{\int ET_rS_r\,d\lambda}, \\[2mm] d_{s,g} = -\log\dfrac{\int ET_gNS_g\,d\lambda}{\int ET_gS_g\,d\lambda}, \\[2mm] d_{s,b} = -\log\dfrac{\int ET_bNS_b\,d\lambda}{\int ET_bS_b\,d\lambda}, \end{cases} \qquad (1.21)$$

$$\text{densitometer}\begin{cases} d_{d,r} = -\log\dfrac{\int E' T_r' N S_r'\, d\lambda}{\int E' T_r' S_r'\, d\lambda}, \\[2ex] d_{d,g} = -\log\dfrac{\int E' T_g' N S_g'\, d\lambda}{\int E' T_g' S_g'\, d\lambda}, \\[2ex] d_{d,b} = -\log\dfrac{\int E' T_b' N S_b'\, d}{\int E' T_b' S_b'\, d\lambda}. \end{cases} \tag{1.22}$$

The densities $d_{s,r}$, $d_{s,g}$ and $d_{s,b}$ of the samples as 'seen' by the light-sensitive layers of the printing material are called 'printing densities' so as to distinguish them from those measured by the densitometer. According to the light sources employed for the printing operation and in the densitometer, the spectral responses of the sensitive layers and the photoreceptor, and the set of red, green and blue filters, the printing densities will be different from those measured in the densitometer. It can be assumed however, just as in the case of densitometry with two sets of filters, that these two sets of density values are proportional for a given set of dyes, i.e. for a given type of trichrome original or intermediate. This can be written

$$d_{s,r} = k_r'\, d_{d,r},$$
$$d_{s,g} = k_g'\, d_{d,g}, \tag{1.23}$$
$$d_{s,b} = k_b'\, d_{d,b}.$$

Assuming the validity of this linear relationship, coefficients can be determined by a series of sensitometric exposures for a given trichrome taking material, for the corresponding printing film, the densitometer and its filters, and for the processes employed. Once determined, these coefficients allow computation of printing densities for the given working conditions from those measured.

The correspondence between the *spectral composition of the light employed in the densitometer* and that effectively employed for the printing through the material measured is necessary not only for colour, but also in black-and-white. Transmission density in the ultraviolet region, for instance, of a black-and-white negative is considerably lower than that measured in visible light and shows a definite minimum at a wavelength of 320 nm. For a given negative film for example, a patch with a density of 1·32 at 400 nm can thus at 320 nm have a density of only 0·76; another one, of density 3·3 at 400 nm would have a density of only 2·46 at 320 nm, etc.

1.2.2c *Exposure*

A fundamental characteristic of the photographic systems is the additivity of radiations. Contrary to other light-sensitive systems, such as photo-

luminescent, photoconductive or photoresistant and photoemissive cells and layers, the photographic systems, i.e. those which yield, in accordance with the amount of radiation received, a lasting record, add radiation received during a given time. Not only the classical silver halide layers show this property, but also all other photographic systems including polymers and electrophotographic and thermographic layers. The final photographic effect is only very approximately proportional to the sum of radiations received by the sensitive layer in a given time, as many complex phenomena take part in the formation of photographic images (p. 422). The assumption of additivity is most often valid, however, within the limits of the practical use of photographic systems, so that currently the radiation incident during a given time is quantitatively described by the *exposure* of the sensitive layer, equal to the product of the illuminance of this layer by the exposure time:

$$\text{Exposure } \mathbf{E} = E.t \text{ metre candle seconds.} \tag{1.24}$$

The letter \mathbf{E} chosen to describe exposure is employed here to conform with the current use in all domains of photographic technique. The bold letter \mathbf{E} is however employed in this chapter to avoid confusion with the standardized designation E of illuminance.

As already mentioned, the photographic result is only rather approximately proportional to the total exposure. It depends on each of the individual values of both factors in equation (1.24), illuminance and exposure time. For most uses at least the order of magnitude of these two parameters must therefore be known, or else one of them must be kept constant at a value which corresponds to the actual purpose of the tested material. In practical photography of current scenes by amateurs, professional or portrait photographers, reporters and motion-picture cameramen, only luminance variations are met with while the exposure time remains constant for each picture or frame. In other techniques, on the contrary, it can be the exposure time that varies, while the luminance or irradiation remains constant. The spectral composition of the illuminant also strongly influences the results; for all precise work, in monochrome as well as in colour photography, it is therefore usual to indicate the type of light source employed and its spectral characteristics.

1.2.2d *The Characteristic Curve*

In the classical photographic process exposure to light of the sensitive material results, after processing, in blackening of the layer. In other processes the result of exposure to actinic radiation may be quite different, as for instance in colour photography or in those processes which make use of light-sensitive polymers. Quite independently of these differences it is usual, however, to describe the behaviour of a light-sensitive material by the

quantitative relationship between *the exposure* (sum of radiation incident during exposure) and the *resulting absorption* (density) of the completely processed layer. It is not practical to express this functional relationship by an equation as too many quite variable parameters intervene in photographic processes. The function

$$d = f(\log \mathbf{E}) \tag{1.25}$$

is therefore determined by experiment and traditionally represented in a graph by the '*characteristic curve*' (d is optical density, **E** exposure) (Figure 1.21). This curve, typical for a given light-sensitive material and its processing

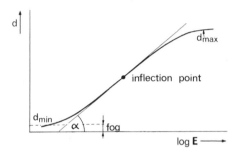

Figure 1.21. Graph of the function $d = f(\log \mathbf{E})$.

conditions, allows us to define several parameters which describe the practical behaviour of the whole process. The most important of these are *speed* (sensitivity), *contrast* and *fog*; their definitions depend not only on the nature of the light-sensitive material, but rather on what is required from the photographic recording. Other parameters, such as minimum and maximum densities, etc., can also be found from the characteristic curve.

1.2.2e *Photographic Speed or Sensitivity*

Speed, or *sensitivity*, of a light-sensitive system is in general defined by a parameter derived from the minimum exposure yielding a record satisfactory or just useful for the chosen purpose. This parameter, characteristic of the material and its process, is therefore defined by the magnitude of exposure corresponding to an appropriate density value on the characteristic curve. This density level must be chosen according to the practical purpose, and therefore varies with the material and the process; the importance of a correct choice is well demonstrated by the comparison of the characteristics of two different materials (Figure 1.22): at a net density of 0·6, for instance, above fog and base density (see p. 35) and at the density level where the two

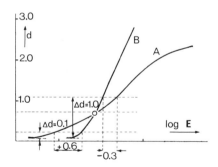

Figure 1.22. Example of two widely differing materials of identical sensitometric sensitivity.

curves intersect, the speeds are equal for both materials. At a net density of 0·1, it is however material A which is four times as fast as material B, whereas at a density of 1·0 the speed of material B is twice that of material A.

In practice the speed of a photographic material is determined according to standards or other prevailing official recommendations.[13] As speed increases when less exposure is required to yield a given density, it is in general described by an equation of the form

$$S = \frac{k}{E},$$ (1.26)

where S is the sensitivity of the system, E the exposure corresponding to a given density value and k a constant of appropriate magnitude. In this definition sensitivity depends on the chosen density and it is therefore called

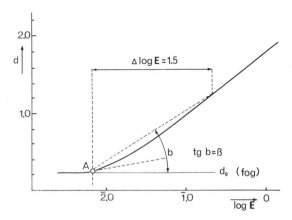

Figure 1.23. Graphical definition of the fractional gradient sensitivity criterion.

the 'fixed density method' to distinguish it from the older 'fractional gradient method' of determination of a speed criterion.[14] This latter is based on the exposure value which yields on the characteristic curve the point for which the slope of the tangent to the curve is 0·3 that of the average slope over a 1·5 log **E** interval starting at that point (Figure 1.23). The standards of many countries (United States of America, Great Britain, Western Germany etc.) are now based on the fixed density criterion shown in Figure 1.24.[13] Similar standards exist for other than black-and-white negative film, as for instance for negative and reversal colour films, for aerial photography, etc. (see p. 38).

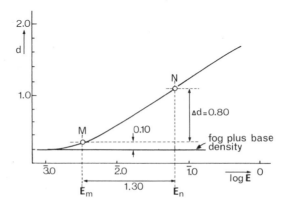

Figure 1.24. Fixed density sensitivity criterion.

This type of definition of speed takes into account only the presence of a deposit of just perceptible or sufficient density in the processed layer. For specific applications other criterions may be of equal importance, such as a certain image structure or amount of information obtained with a minimum of exposure, as for instance a given number of usable lines per millimetre, or a given degree of sharpness. These definitions of sensitivity are however much less employed than those based on density.

In pictorial photography, professional as well as for amateurs, the sensitometric criterion of sensitivity must fit the practical results and lead to perfectly exposed images. It is therefore necessary that the sensitometrically determined speed values are checked by practical trials; it is even possible to define speed criterions based only on pictorial tests. Grover and Grimes[15] investigated the rationalization of such practical speed determinations, expecially for reversal colour films, and found that the six fundamental parameters acting on photographic sensitivity are: calibration of shutter and

diaphragm; type of subject (composition) and geometry of lighting; solar angle or altitude; projection conditions (see also p. 39); method of presentation to the observers and evaluation technique; conversion of the results to numerical speed values.

Taking into account each of these six criterions Grover and Grimes derived for the particular case of colour transparencies the following thumb rule: at f/16 the exposure time for a sunlit and front-lighted scene is inversely proportional, for a reversal colour film, to its ASA speed.

1.2.2f *Spectral Sensitivity*

The measurement of sensitivity by sensitometric exposure to 'white' light, which is a mixture of all monochromatic radiations emitted by the source, yields a total figure depending on the spectral distribution of the flux radiated by the source as well as on the spectral sensitivity of the layer. In many technical applications, and especially in colour photography, it is necessary however to know the contribution of each of these two parameters.

Daylight, for instance, contains in clear weather much blue radiation, whereas tungsten sources emit more red than blue light. Figure 1.25 shows the spectral distribution of radiation emitted by several sources currently employed in photographic work.

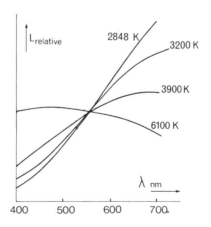

Figure 1.25. Spectral distribution of various radiations: 2848 K, incandescent lamp; 3200 K, professional studio tungsten lamp; 3900 K, flash bulb; 6100 K, average daylight.

The spectral sensitivity of a photographic material is determined through exposure of several sensitometric strips, each to one monochromatic radiation. This results in a series of sensitometric curves corresponding to given wavelengths, from which the sensitivity of the material under test for each

of the monochromatic lights is determined just as the total sensitivity from a 'white' light exposure. Plotted in a graph as a function of wavelength these sensitivity values yield the spectral sensitivity curve. For current photographic materials the sensitivity to monochromatic radiation is defined as the energy (ergs per unit surface of the sensitive layer) necessary for the obtension, with a given process, of a density of 1·0.

The practical effect of the spectral distribution of emission by the source as well as of the spectral sensitivity of the layer is very important. An ordinary photographic layer, as for instance one containing silver bromide, is by itself sensitive only to blue light (Figure 1.26, curve A). It must therefore be sensitized by dyes (see p. 370) also to green light (Figure 1.26, curve B), which makes it orthochromatic, or to almost all radiation contained in visible light, to make it panchromatic (Figure 1.26, curve C). These curves A, B

Figure 1.26. Spectral sensitivities of photographic layers.

and C correspond to the energetic definition given above, i.e. to exposure of the layers of different spectral sensitivity to a hypothetical light source of uniform spectral energy distribution. When exposed to customary real sources, their responses are of course quite different: the first layer, non-sensitized to green and red radiation, is relatively more sensitive to daylight than to incandescent tungsten light, whereas the panchromatic layer is more sensitive to the latter (Figure 1.27).

In colour photography spectral sensitivity of each of the layers is of prime importance, as it defines the nature and the relative amounts of the radiation recorded during exposure by each layer (see p. 249).

1.2.2g *Photographic Contrast*

Photographic contrast is a measure of the rate of density increase with exposure. The simplest definition of contrast is therefore given by the differen-

Figure 1.27. Action of the spectral emission of light sources on the sensitivity of photographic layers.

tial of the function $d = f(\log \mathbf{E})$,

$$\gamma = \frac{df(\log \mathbf{E})}{d \log \mathbf{E}}.$$ (1.27)

Thus the slope of the tangent to the characteristic curve at its point of inflection is in general chosen as a typical parameter (Figure 1.21),

$$\gamma = \tan \alpha.$$ (1.28)

This simple definition of contrast is not always sufficient in practice as it does not take into account the slope of the curve in a density scale between definite density values, useful for a given application. The slope of a secant between two given points of the characteristic curve is therefore often preferred. The contrast thus obtained is really characteristic of a well defined part of the corresponding image.

Two black-and-white negatives obtained on two different materials and having the same gamma (Figure 1.28) may serve well to illustrate this problem.

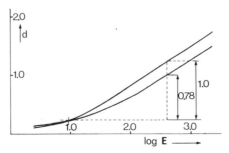

Figure 1.28. Differing characteristics of two materials of identical gamma.

The luminance scale of a given scene yields not only different density scales on each of these two materials, but besides this the local luminance differences are differently reproduced. In spite of having the same gamma, these two negatives are not alike and yield different prints; this follows from the definition of the parameter 'gamma', which depends only on the slope of the straight part of the characteristic curve near the inflection point.

To avoid this difficulty, another parameter, the *contrast index*, which expresses the average slope of the most frequently employed part of the characteristic curve, has been proposed (Figure 1.29).[16] The lower limit of this

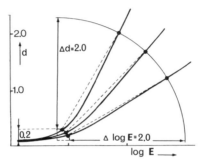

Figure 1.29. Graphical definition of contrast index.

segment of the characteristic curve is its point of intersection with a circle having a radius of 0·2 density units and its centre on a horizontal line through the total fog value (density of the base + fog of the layer). The upper limit of the segment is the intersection of the characteristic curve with a circle having the same centre and a radius of 2·2 density units. The contrast index has the advantage of compensating for the difference in shape of the characteristic curves of various materials, especially in their lower part called the 'toe' region.

Many parameters derived from average slopes taken between specific points on the characteristic curves are currently employed in colour sensitometry. Typical examples are parameters such as the toe contrast TC, and the upper scale contrast USC shown in Figure 1.30.

For monochromatic exposures, such as those employed for the measurement of spectral sensitivity, contrast varies with wavelength. When determining spectral sensitivity this property should in principle be respected by developing all samples to yield the same contrast, i.e. with different development times. In practice it is safer, however, to develop all strips for the same time.

Contrast variation as a function of wavelength has a practical effect mainly in the case of exposures with narrow band filters such as those em-

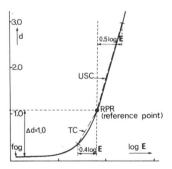

Figure 1.30. Examples of sensitometric parameters adapted to a specific material.

ployed for trichrome separations (see p. 267). Contrast differences which would be obtained with one single time of development are therefore compensated for by varying this time accordingly.

1.2.2h *Fog*

Every sensitive material, even when not exposed to actinic radiation, has after processing a minimum density, called fog. Fog does not contribute to the modulation of light by the photographic image, but uniformly increases absorption over the whole image area. It partly results from absorption of light by the base, and partly from that of the photosensitive layer itself. In the sensitive layer of a black-and-white film, for instance, a small fraction of the unexposed crystals is spontaneously reduced during development. On the characteristic curve minimum density represents the magnitude of the amount of fog (Figure 1.21). Similarly an unexposed but normally processed colour film contains in each of its layers small amounts of dyes whose added absorptions form the fog.

1.2.2i *Numerical Computations*

For a very long time photography was either a craft or considered as a hobby for amateurs, which together with the very great tolerance of the black-and-white materials towards exposure errors is the origin of a traditionally empirical approach to photographic techniques, even when employed for professional or scientific purposes. The appearance of colour photography however, with its much more precise requirements of exposure, as well as the progress in the domain of photoreceptors, has contributed to the widespread use of quantitative methods. Besides this the precise conditions of the various photographic operations are now so well known that most numerical values can be estimated with good approximation.

The following examples of numerical computations show the application of some of the above mentioned basic notions to various frequently

encountered situations. They further give, in the form of practical exercises, some simple useful formulas.

Computation of exposure time. For normal *camera exposures* the *exposure time* is directly proportional to the area of the lens stop, and inversely proportional to the scene luminance and to the speed of the light-sensitive material

$$t = \frac{kf^2}{L_s S},$$ (1.29)

where t is the exposure time in seconds, f the stop or the relative aperture (ratio between the diameter of the effective pupil and the focal distance), L_s the subject luminance and S the sensitivity expressed as ASA speed. For L_s in foot lamberts, the coefficient k has a value of 3·33.

This formula is now to be applied to the camera exposure of an outdoor scene. The maximum illuminance within the temperate regions of the earth, due to direct radiation from the sun, amounts to about 10,000 foot candles, to which the illuminance from sky light adds on a clear day without clouds about another 1500 foot candles. The resulting total illuminance is therefore 11,500 foot candles. This maximum value only occurs rarely however, so that the recommendations of the manufacturers of photosensitive materials for exposures in fair weather correspond to an average illumination lying between $\frac{1}{2}$ and $\frac{1}{3}$ of this maximum. The value to be chosen for the computation is therefore 4500 foot candles which yields, for an average subject of 18% reflectance, a subject-luminance $L_s = 0·18 \times 4500 = 810$ foot lamberts. This yields, for a reversal colour film of exposure index 25 and an $f/11$ stop, an exposure time

$$t_1 = \frac{3·33 \times 121}{810 \times 25} = \frac{1}{50}\,\text{s}.$$

A negative colour film having an ASA exposure index of 64 requires, for the same conditions, an exposure time of

$$t_2 = \frac{3·33 \times 121}{810 \times 64} = \frac{1}{125}\,\text{s}.$$

For the example of an indoor exposure with artificial light of an average subject, illuminated by two lamps of 1800 candles, each at 12 feet from the subject, the illuminance is $E = 3600/144 = 25·0$ foot candles, and the subject luminance $L_s = 0·18 \times 25·0 = 4·5$ foot lamberts. When exposing this scene with a sensitive black-and-white material of ASA speed 400 and a lens-stop of $f/8$, the exposure time is

$$t_3 = \frac{3·33 \times 64}{4·5 \times 400} = 0·1185\,\text{s},$$

or about $\frac{1}{8}$ of a second.

Computation of the exposure time for projection printing of black-and-white negatives onto paper is carried out in a way similar to that given above for camera exposure:

$$t = \frac{k}{S_p (E_{min} E_{max})^{\frac{1}{2}}} \, s,$$ (1.30)

where S_p is the sensitivity of the paper, k a constant equal 1000, and E_{min} and E_{max} the minimum and the maximum illuminance in metre candles in the paper plane. The sensitivity S_p is defined as

$$S_p = \frac{k}{\mathbf{E}_p}$$ (1.31)

where $k = 10{,}000$, and \mathbf{E}_p is the exposure in metre candle seconds necessary to yield, with normal processing, a reflection density of 0·6. Formula (1.30), which takes minimum as well as maximum illuminance, E_{min} and E_{max}, into account has the advantage over other definitions, including only minimum illuminance of the paper in the highlights, that it applies for a given negative to all contrast grades of a type of paper. In this respect it is equivalent to the type of exposure determination employed in automatic photofinishing printers (see p. 73), carried out by integration through a photoelectric cell and expressed by

$$t = \frac{k}{S_p E_{average}}.$$ (1.32)

For a negative of density scale $\Delta d = 1\cdot3$ (ratio of minimum to maximum density equal 20) and a maximum illuminance in the paper plane of 0·70 metre candles, the exposure time is thus for a white glossy bromide paper of grade 2 (see p. 68), of a sensitivity $S_p = 320$,

$$t = \frac{1000}{320\,(0\cdot035 \times 0\cdot70)^{\frac{1}{2}}} = 20 \text{ seconds.}$$

Illumination of the sensitive layer. For the sensitometric interpretation of experimental results it is often useful to know the photometric value of the illuminance of a given area of the light-sensitive layer during its exposure.[17] This exposure illuminance in a photographic camera can be computed, taking into account all parameters, from the equation

$$E_i = L_0 \left(\frac{u - F}{2uf} \right)^2 T_v H \cos 4\theta,$$ (1.33)

where E_i is the illuminance in the image plane in foot candles (lumen/ft^2), L_0 the object luminance in foot lamberts, and where the meaning of the other

symbols is: f, relative aperture; F, focal length of the lens; T_v, lens transmittance factor; u, lens–subject distance; H, vignetting factor; θ, angle of the incident ray with the optical axis.

Substitution of some numerical values corresponding to frequently encountered situations reduces this formula to a simpler expression. For $u = 40F$, $T_v = 0.90$, $H = 1.0$ and $\theta = 13°$ (cos $4\theta \cong 0.90$), equation (1.33) simplifies to

$$E_i = 0.64\frac{L}{f^2}. \tag{1.34}$$

Applied to the above examples, this formula yields for the exterior scenes taken on reversal colour film with a relative aperture of $f/11$, an illuminance $E_i = 0.64(2750/121) = 14.5$ metre candles. The metric unit is employed here, as usual in sensitometry, rather than the foot candle. With the computed exposure time of $\frac{1}{25}$ second, the exposure is then 0.29 metre candle seconds (log $E_1 = \overline{1}.462$). Similarly for the colour negative film the exposure is $E_2 = 0.116$ metre candle seconds (log $E_2 = \overline{1}.065$). For the interior scene the illuminance of the film plane, $E_3 = 0.1418$ metre candles, is of course much lower and requires an exposure of $E_3 = 0.018$ metre candle seconds (log $E_3 = \overline{2}.248$).

The computed illuminance of the sensitive layer allows a determination of the numerical values required for the automatic exposure determination by photoemissive cells or photoresistors built into cameras. This automatic exposure setting, corresponding to the average of the most frequently encountered scenes, is made difficult by the great variability of the scene luminance distributions, particularly for reversal colour films whose exposure latitude is by definition more restricted than that of negative films. Scudder, Nelson and Stimson[18] re-evaluated all factors acting in this particular case on automatic exposure determination by taking into account not only the ratios of the optical and spectral responses of the sensitive layer and the cell, but also of the illuminance distribution within the scene.

According to USA Standard PH2.21-1961,[19] the sensitivity of a reversal colour film is

$$S_x = \frac{8}{(E_h E_s)^{\frac{1}{2}}} = \frac{8}{E_m}, \tag{1.35}$$

where E_h is the exposure required to yield in the neutral scale a density of 0.20 above fog, E_s the exposure yielding either a neutral density of 2.0 above fog, or, if smaller, that which corresponds to the point of contact of the tangent to the sensitometric curve passing through the point of the curve of abscissa E_h and E_s. The exposure determined by the cell is

$$E_0 = E_i t, \tag{1.36}$$

where the film plane illuminance E_i is expressed in metre candles and the effective shutter opening exposure time t in seconds; taking the ratio E_0/E_m as constant, substitution yields

$$E_0 = \frac{K_1}{S_x}. \tag{1.37}$$

Scudder, Nelson and Stimson determined on the one hand K_1 by the psychometric selection of the 'preferred exposures' of customary scenes, and on the other hand quantitatively the influence of all other intervening parameters. K_1 was expressed in relation to the lens transmittance factor and to the spectral response of the cell, and by taking into account the analysis of the luminance measurements within the scene to be photographed. For image sizes of 16 mm film and those above, the resulting 'exposure constant' can be computed from the equation

$$K_1 \,(16\ \text{mm}) = \frac{3 \cdot 3r}{T_v R}, \tag{1.38}$$

and for the Super-8 size from the equation

$$K_1 \,(\text{Super-8}) = \frac{4 \cdot 15r}{T_v R}, \tag{1.39}$$

where r is the ratio of the luminance of a uniform calibrating light source to that of the scene yielding the same value through the cell circuit, T_v is the transmittance factor of the lens, and R a parameter, qualifying the luminance distribution of a particular scene relative to that of an 'average' scene. Based on subjective evaluation of optimum results by 'preferred exposures', the automatic exposure settings according to equations (1.38) yield on the average the best practical results, equivalent for instance to those resulting from speed determinations by pictorial tests,[15] (see p. 30).

1.2.3 Subjective Photometry

As mentioned before, photometry can be considered either from an objective or from a subjective viewpoint. This characteristic is inherent not only to the measurement of light but to its actual nature. The flux emitted by a light source carries radiant energy which can of course be measured with instruments, but the intrinsic and fundamental nature of light is to make the material world visible. It is thus a natural reaction to judge the effect produced by light through visual comparisons or matches. Visual evaluations of monochromatic luminances, whose energies are known in measurable units, are in fact indispensable in establishing the fundamental connection between the two methods of measurement, objective and subjective, i.e. for the obtention of the spectral luminosity curve. This curve

shows, as a function of wavelength, the reciprocal values of the energies which yield equal visual responses at each wavelength (Figure 1.31). It allows us to compare the relative brightnesses of any two monochromatic energies of given wavelengths, and therefore to establish the quantitative relationship between visible light and energetic flux. It has its maximum at 555 nm; at this wavelength one lumen is equivalent to 0.001471 watts of monochromatic radiation.[20,21,22,23]

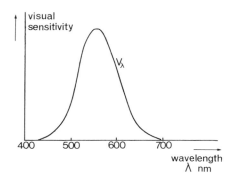

Figure 1.31. The spectral visibility function V_λ.

1.2.3a *Visual Comparisons and Matches*

Visual comparisons are carried out with photometers, the oldest and the simplest of which is the Bunsen grease spot photometer: a translucent greasy area on a sheet of paper, illuminated from both sides, appears to an observer lighter or darker than the dry surround according to the ratio of the illuminances on both sides.[24] By making the spot disappear through adjustment of this ratio, for instance by varying the distances between the two light sources and the plane of the paper carrying the spot, it is possible to compare the brightnesses of the two sources by applying the inverse square law of distance, equation (1.4). The illumination of the comparison field is obtained in modern visual photometers through prisms or mirrors, such as the Lummer cube (Figure 1.32). In many instruments the levels of illumination of the comparison fields are adjusted by the above mentioned variation of distance, in others various devices are employed to modify the incident flux, such as absorbing wedges (disks or rulers whose optical density varies continuously with the angle of rotation or linear distance), or pairs of polarizing prisms or filters whose relative rotation changes the level of illuminance.

The most current photometric field appears to the observer as two adjacent halves of a circular area, surrounded by a uniform field whose illuminance

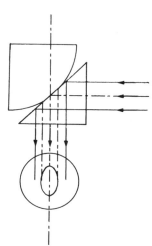

Figure 1.32. Photometric 'cube'.

can also be adjusted (Figure 1.33). More complex fields are also employed which resemble, more than the circular field, arrays to be judged by the observers in normal practice. Various complex photometric fields have thus been designed for investigations of the luminance distribution in photographic images[26] (see p. 44).

Figure 1.33. Photometric matching field.

The simplest and most reliable method is that of the visual matching of the two halves of the field, i.e. that where the observer's eyes serve only as a null device.[27] One half of the sensitometric field is illuminated by a standard source which has, for the observer, an exactly known luminance value. He then adjusts the appearance of the other half with one of the above mentioned devices controlling the amount of flux until obtention of a visual match. This allows one to determine either the ratio or the difference between the illuminances of the two halves of the photometric fields, resulting for instance from illumination by two different sources. In this case, the known source is measured in visual values against the standard source.

Among the methods not relying on visual matches the most important are those of *interval section* and of the determination of *just noticeable differences*

(J.N.D.s).[28,29,30,31] In the first method the observer is required to set the illuminance of the comparison field such that its brightness appears to be a given fraction, for instance one half, of that of the standard field. Repeated intersection leads to very small steps which allow us to build the scale required for the definition of a functional relationship between (energetic) luminance and (visual) brightness. For the determination of just noticeable differences almost matched photometric fields are presented to the observers who are required to define by trial and error the smallest luminance difference which just allows a distinction between the brightnesses of the two halves of the field.

1.2.3b *Effects of the Conditions of Observation*

The purpose of visual measurements being the establishment of quantitative relationships between the physical stimulus, the luminance and the corresponding sensation, the brightness, the matches must be carried out under conditions of observation closely resembling those which prevail in the customary evaluation of images; they have indeed a considerable influence on the results.

The photometric field must above all cover a sufficiently wide area or viewing angle. To make it correspond approximately to the dimension of the fovea, so that the results agree with the sensitivity of the cones of the retina and therefore apply to photopic (daylight) vision, most older researches were carried out with viewing angles smaller or equal to 2°. Experience showing however that the customary visual field, even when the attention of the observer is fixed on a given subject, is slightly larger than the fovea and also includes peripheral rod action, the photometric fields presently employed are wider and always cover a viewing angle of 10°.[32]

The principal parameters acting on the results of visual measurements are the general illuminance level, which defines the state of general observer adaptation, and the geometry of the test field with its surround. The evaluation of brightness depends indeed on general adaptation, but local adaptation and the effects of simultaneous contrast related to the structure of the visual field also have considerable influence on the results, especially in complex arrays such as those of 'images'.

General adaptation allows human vision to cover a very wide domain of illuminance levels, extending from a small fraction of a foot candle for scotopic vision to the dazzling illumination of bright sunlight, about one million times greater. Once adapted to any given level of illuminance, however, the observer cannot perceive more between 'black' and 'white' than luminances whose maximum ratio does not exceed a few hundreds. General adaptation is characterized by the sluggishness of its reaction:

after any important change of the overall illuminance level the re-establish-ment of perfect perception of all visible luminance steps can last several minutes, particularly when the transition occurs from very bright illumination to a very dark ambiance.

Local adaptation and simultaneous contrast effect, due to the immediate environment of the point observed in a given state of general adaptation, are much faster. Local adaptation which varies ceaselessly further to the uninterrupted movements of our eyes, especially when the field of vision includes very light and very dark areas, only requires a few seconds, and simultaneous contrast, resulting from the juxtaposition of areas of greatly differing luminances is instantaneous. This latter effect, which makes areas of low luminance appear still darker when they are near very light ones, contributes to an increase of their brightness difference and therefore im-proves the visibility of image detail. This increase of the brightness differences only occurs in daylight vision, i.e. at comparatively high illuminance levels; it gradually diminishes with decreasing illuminance and disappears in mesopic vision. In the dark, with scotopic vision after full dark-adaptation, the darkening of the 'whites' becomes very apparent in absolute values and the 'blacks' seem to gain in brightness: the simultaneous contrast effect then disappears altogether.

In visual photometry the effects of general adaptation are taken into account by an appropriate choice of the matching sequences, allowing the precise definition of the adaptation state of the observers, and also by the use of adequate surrounds. The investigation of subjective black, chosen by Lowry and Jarvis as a criterion of general adaptation,[33] as well as many other researches,[17,34] demonstrate in fact that the area immediately sur-rounding the point fixed by the observer has a predominating effect on his state of adaptation and therefore on his visual sensitivity; the immediate contact of the surround with the photometric field further adds to the general adaptation the effects of local adaptation and inhibition. The influence of the surround, due on the one hand to its luminance level and on the other to the size of the photometric field proper, relative to that of the surround, has been represented by Nelson[1] on visual sensitivity curves such as those shown in Figure 1.2. Each of the steps of a neutral grey scale, successively chosen as the photometric field, determines together with its surround a mean luminance and therefore a definite state of adaptation described by the corresponding visual sensitivity curve. In a first case, shown at the top of Figure 1.34, with a surround of lower luminance than the white step of the photometric (grey) scale, the sensitivity curves are rather widely spaced and the apparent contrast of the grey scale remains low. With a lighter surround, of luminance identical to that of the white step of the scale, the corresponding

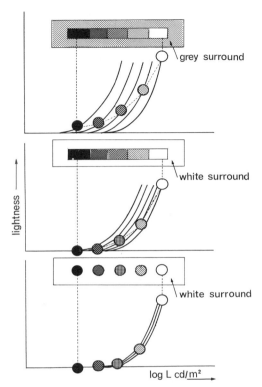

Figure 1.34. Influence of surround luminance and field size on observer adaptation.

visual sensitivity curves are much less separated and the appearance of the grey scale is changed: the darkest steps cannot be distinguished any more and the contrast in the lighter part of the scale is increased, in spite of the apparently lower brightness of the first or 'white' step. A reduction of the size of the grey patches still further enhances these effects of a light surround (see lower part of Figure 1.34): the points representing the brightnesses of the grey scale steps then all lie almost on one single curve of visual sensitivity which corresponds to a luminance level slightly lower than that of the white background.

These observations apply directly to the evaluation of photographic images, seen either by transmission or by reflection, and also to the effect of light or dark surrounds. The quantitative determination of these effects by Breneman is an excellent example of subjective photometry. A complex reference field, so designed as to appear to the observer like a photographic image, carries on a uniform transparent background of a density of 1·3

irregularly distributed standard patches formed of small rectangular areas of various densities, ranging from complete transparency (white) to complete absorption (black). The observer compares their visual brightness to that of typical patches in the photographic images to be measured, adjacent to the reference field. To imitate the appearance of the various kinds of images— reflection prints with or without white borders, or transparencies—either diffuse light is added to, or carefully kept away from, the image and a uniform surround of varying illuminance is introduced.

With this experimental set up it can be shown that considerable variation of the general level of image illuminance, from about 10 to 100 foot candles, has practically no influence on the relative luminances of the image itself. The effect of the white border (illuminated surround), on the contrary, is considerable: when the surround illuminance equals approximately that of the highlights, the entire image area appears darker, by an effect of lateral adaptation, in spite of remaining, in fact, unchanged. This gives rise to an apparent contrast increase in the highlights and middletones, and it flattens the shadows which approach the level of subjective black faster than without a white border (Figure 1.35). A transparency can thus appear as a paper print by the simple addition of a border lighter than the image area.

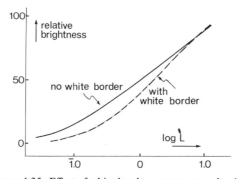

Figure 1.35. Effect of white border on tone reproduction.

These results and those of similar studies could also be applied to images projected on screens such as in motion picture theatres, and further to television images.[35,36,37] A screen without any flare light, surrounded by a uniform field of a luminance well adapted to that of the average level in the image area would yield ideal conditions of observation and of visual comfort. The actual use of such a surround, for instance in a theatre, leads to practical problems however, so that the best solution is offered by high screen illuminance which diminishes the influence of the surround.

1.2.3c *Heterochromatic Matches*

Another factor which intervenes in visual measurements is the colour difference of both halves of the photometric field. The measurement of the luminous intensity of light sources, for instance, illustrates this problem. The standard source (chosen internationally for the definition of the candela) is a black body at the melting temperature of platinum (see p. 10). This standard, of a colour temperature of 2042 K, appears however yellow–orange when compared to the white of the slightly bluish light sources now currently in use, so that all matches are heterochromatic and not simply photometric. This difficulty has been mentioned repeatedly in the literature and many methods have been proposed to overcome it: photometric fields more complex than that composed of two half-circular areas, flicker photometry, measurements making use of the limit of visual acuity, etc.[3] The difference in colour of the two halves of the photometric field leads to high dispersion of the results obtained by different observers and thus obliges us, as mentioned above, to carry out several matches as well as to apply statistical methods.

The colour difference between the photometric half-fields leads, besides this, to important visual effects, described in detail below, p. 244. The brightness or the equivalent luminance of colour patches is in fact not related in a simple manner to their luminance. For any given constant (energetic) luminance level the (visual) brightness or equivalent luminance increases with saturation for all colours, except for the yellows.

1.2.3d *Uniformly Spaced Tone Scales*

Visual photometry is not only employed for the evaluation of light sources. It is widely applied to the study of the intrinsic properties of vision and also to the construction of uniformly spaced tone scales. These latter are important in the investigations of photographic tone reproduction. Various progressions have been proposed for uniformly spaced scales, mainly for those to be viewed by reflection, such as the gray scales in colour order systems. These include in their geometrical representation, as described below, p. 228, a neutral axis joining the points representative of subjective black and subjective white which must be divided in visually equal steps.

A simple and frequently encountered progression, which yields in practice a comparatively uniform scale, is the simple geometrical progression where the luminance of each step is twice that of the preceding one. Closer spaced geometrical progressions are those with a factor of square root of two, and even $\sqrt[3]{2}$ and $\sqrt[6]{2}$. Within the limits of the currently encountered luminance levels of photographic images, these progressions yield reasonably uniform visual scales. They also have the advantage of yielding simple arithmetic progressions for optical densities, with constant differences between successive

steps, which are for the above mentioned scales respectively 0·3, 0·15, 0·10, and 0·05 density units. As mentioned before, these scales are employed in sensitometry.

In the various colour order systems other uniform achromatic scales have also been proposed. Figure 1.36 shows the comparison of the progressions of several of these scales, those of the Munsell, Ostwald and DIN systems (p. 228).[38,39] (See also Reference 30 of chapter 3.) The simple logarithmic scale $n = k \log R$ of the Ostwald system has the drawback, like the geometrical progressions, of attributing to the subjective black the value of 1·0

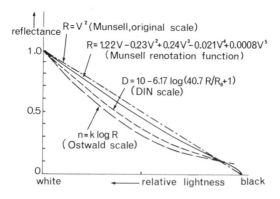

Figure 1.36. Uniformly spaced tone scales.

of reflectance R instead of zero. Besides this the magnitude of its steps, when compared to the original exponential Munsell value scale $V = R^{\frac{1}{2}}$, is too great in the highlights and too small in the shadows. The Munsell renotation value scale, however, worked out very carefully by a working committee of the Optical Society of America from 1940 to 1943,[40] as well as the most recent of the uniform neutral scales, that of the German standard system DIN, are not only comparatively close to each other, but intermediate between the original Ostwald and Munsell scales. Both have been established by statistical methods from a great number of observations and are thus quite representative of a uniform division of the tone scale.

The Munsell renotation scale is defined by the relatively complicated empirical relationship between the reflectance R and the renotation value V

$$R = 1 \cdot 2219V - 0 \cdot 23111V^2 + 0 \cdot 2395V^3 - 0 \cdot 021009V^4 + 0 \cdot 0008404V^5.$$

$$(1.40)$$

So as to simplify the computations, Ladd and Pinney[41] proposed the use of simpler functions of the form $V = a + b \cdot f(R)$, and determined the empirical

constants of each equation by the method of least squares. Among these equations those yielding the most satisfactory approximation of the Munsell renotation scale are

$$V = -1.324 + 2.217\,R^{0.3520} \tag{1.41}$$

and

$$V = -1.636 + 2.468\,R^{\frac{1}{3}}. \tag{1.42}$$

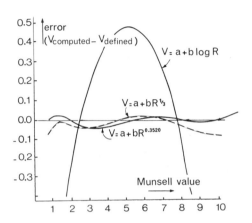

Figure 1.37. Magnitude of errors through approximations of Munsell renotation function.

Figure 1.37 shows the very small errors introduced through the use of fractional exponents of R, but also the important difference between the uniform scale and that obeying the logarithmic law with adjusted coefficients.

$$V = 0.388 + 4.505\,\log R. \tag{1.43}$$

Another advantage of the $R^{\frac{1}{3}}$ function as proposed by Ladd and Pinney, equation (1.42), is that it allows an easy computation either of V or R, not possible with the Munsell renotation value function, equation (1.40).

1.2.3e *Psychophysics of Vision*

The uniformity of tone scales raises the question of the relationship between luminance, a physical entity, and the corresponding sensation, brightness, now also called equivalent luminance. A simple trial shows in fact that the smallest luminance difference of two neighbouring patches, visible to an attentive observer, depends on the level of luminance.

In the dark a sheet of white paper, illuminated by one candle only, will in fact look much lighter when another candle is added to illuminate it.

When the initial illumination is not that of a candle, but on the contrary full summer sunlight, the luminance increase resulting from the addition of the light of one candle will pass unnoticed. To double the lightness as had been done in the first case by a second candle, another sun would then be necessary. Similarly the just noticeable difference of luminance sufficient to increase the lightness of white paper when illuminated by a candle would remain unnoticed in sunlight; to obtain an identical just noticeable difference of lightness would require a much greater increase of luminance. In other terms, what remains constant is the ratio of the just noticeable luminance difference to the overall luminance level

$$\frac{\Delta L}{L} = \text{const.} \tag{1.44}$$

This relationship is well known as Weber's law.[42] Weber, who was physiologist, showed in fact, further to trials carried out around 1830 on the subjective evaluation of weights as well as the apparent length of straight rods, that the ratio between the intensity of the initial stimulus and the smallest variation appreciated by the observers was constant for the sensations studied. The constancy of this ratio for sensation of brightness had been found much earlier by Bouguer.[43]

Weber's law was later generalized by Fechner who applied it directly to measurements of sensations.[28] He postulated that the just noticeable difference of sensation ΔS is constant and proportional to the value of Weber's ratio

$$\Delta S = k_1 \frac{\Delta L}{L}. \tag{1.45}$$

Integration of the corresponding differential equation yields the logarithmic relationship

$$S = k_2 \log L + k_3, \tag{1.46}$$

well known as Weber–Fechner's law or psychophysical relationship.

While having often been subject to discussion because of its attempt to establish a connection between an objective physical phenomenon and the reaction of organic sensitivity, which the consciousness of sensation however interpretes according to prevailing circumstances, the Weber–Fechner concept yields within the limits of specific and well defined experimental conditions satisfactory approximation. It therefore describes—over the very wide gamut of illuminance levels which the visual phenomena are able to cover—in each particular case only a minute fraction of the relationship between brightness and luminance. The entire aspect of this relationship can be covered adequately only by a parametric representation

which also includes the effects of observer adaptation, such as in the example shown in Figure 1.2.

The results of early checks of the Weber–Fechner psychophysical relationship, carried out by Aubert, Koenig and Brodhun, Nutting, and Blanchard, and assembled and compared by Abribat,[44] demonstrate the limits of its validity: the $\Delta L/L$ ratio only remains constant within the rather narrow limits of the domain extending from a few to about 150 foot lamberts (Figure 1.38). More recently Lowry confirmed the constancy of this ratio

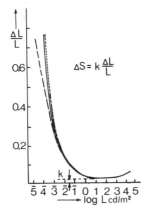

Figure 1.38. Experimental determination of the Weber–Fechner relationship.

also at much higher luminance levels, for experiments carried out under favourable conditions.[45] The Weber–Fechner law therefore only holds within a rather restricted domain of general adaptation and for photopic vision. Within the limits of this adaptation it allows, according to Nutting,[46] the definition of a visual sensitivity function. Considering that the smaller the Weber ratio the higher this sensitivity, it is obtained from $\Delta L/L = f(\log L)$ by taking its reciprocal; the integration of $L/\Delta L = f(\log L)$ then yields the function S of visual sensitivity in the chosen luminance domain (Figure 1.39).

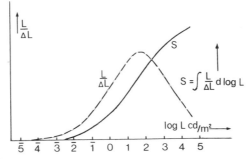

Figure 1.39. Visual sensitivity for one state of observer adaptation.

As mentioned before, visual sensitivity cannot be described by this single function over the entire gamut of illuminances accessible to human vision; according to Nelson[1] it can be represented in the parametric form of Figure 1.2 over an extended scale of luminances ranging from a small fraction of one to several thousands of foot lamberts. Grosskopf[35,47] also employed this kind of parametric representation for the presentation of the results of brightness evaluations of a circular uniform area of small size (field angle 1°), placed in a wide illuminated surround (Figure 1.40); these curves

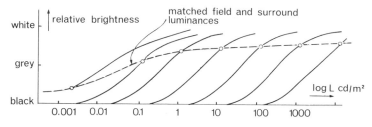

Figure 1.40. Parametric representation of visual sensitivity.

resemble, further to the conditions of observation in Grosskopf's experiments, those of Nutting, Figure 1.37, but are rather different from Nelson's curves: indeed all relationships of subjective photometry depend closely on the experimental conditions (see also hereafter).

The failure of the Weber–Fechner relationship to define visual sensitivity is not only due to its limitation to a restricted domain of luminance. Recent investigations, particularly those by Stevens[31,48], and by Stevens and Stevens[49], demonstrate that the basis of Fechner's concept, the constancy of the just noticeable difference step, is not in agreement with experimental evidence. The logarithmic relationship[46] has therefore at present been replaced by an exponential function of the form

$$S = k_4 L^n, \tag{1.47}$$

already proposed by Plateau almost one hundred years ago,[29] and recently confirmed by Hopkinson,[50] Hunt,[51] Warren and Warren,[52] Jameson and Hurvich[53] and Marimont,[54] but essentially by the researches of Stevens, and Stevens and Stevens, mentioned above.

The values of the constant k_4 and of the exponent n of equation (1.47) depend on the conditions of observation; the exponent n varies widely with adaptation, especially when the surround, seen simultaneously with the photometric field, gives rise to the simultaneous contrast effect. Without this effect, however, n remains relatively independent of adaptation and

reaches for the dark adapted eye a minimum value of 0·33. This value, proposed by Hopkinson and by Hunt, was confirmed by Stevens and Stevens; in their experiments they avoided the effect of simultaneous contrast by allowing the observer first to adapt during three minutes by fixation of a uniform field, and by requiring them to evaluate immediately afterwards, prior to any modification of their state of adaptation, the brightness of a photometric field of 5·7° presented to them in a dark surround. The results of these measurements are expressed by the equation

$$S = k_5(L - L_0)^n,$$ (1.48)

in which L_0 is the luminance corresponding to the absolute threshold of the sensation of light. For adaptation levels ranging from total darkness to 1000 millilamberts, the numerical values of k_5, L_0 and n are given in Table 1.1. In the presence of the simultaneous contrast effect, however, when the

TABLE 1.1

Adaptation level (millilamberts)	k_5	L_0 (millilamberts)	n
dark	10	0 (approx)	0·333
0·01	8·6	0·0004	0·335
0·1	7·2	0·0016	0·342
1·0	5·5	0·0079	0·355
10	3·7	0·032	0·38
100	2·2	0·16	0·41
1000	1·0	1·58	0·44

observer evaluates the brightness of a grey area of varying luminance within a white background as surround, the exponent n increases rapidly with the adaptation level. Some values given by Nelson[55] are set out in Table 1.2. k_5 and L_0 are variable according to the geometry of the photometric field.

TABLE 1.2

Luminance of surround in foot lamberts	n
0·01	0·54
1·0	1·6
1000	2·9

For complex fields, such as those of images either projected onto a screen or seen by reflection, the perception of brightness was investigated by

Bartleson and Breneman.[56] The results of their determinations are expressed in logarithmic coordinates by a non-linear relationship between perceived brightness and luminance, given by the equation

$$B = 10^{\alpha} \frac{L^{\beta}}{\text{antilog } \gamma \ e^{\delta \log L}}, \qquad (1.49)$$

where α, β, γ and δ are parametric constants. The differences between this relationship and the simple exponential equations (1.47) and (1.48) mainly depend on γ and δ, which are functions of the luminance of the image field as well as those of its surround. Equation (1.49) perfectly describes the perception of brightness in photographic images: the computed effect of a white border is identical to the empirically determined result represented by the curves of Figure 1.35 (see p. 45).

The knowledge of the subjective aspects of the photographic image has the intrinsic value of allowing us to define its most favourable objective characteristics. Giving access to conclusions—even incomplete or approximate ones—which are based on the visual evaluation average of many observers, the investigation of the subjective aspects yields the facts indispensable for the creation of images or photographic reproductions without any loss of their informational content. It is only in this sense that the knowledge of subjective photometry is applied to the technique of photography. The actual use of photography in the widest sense, based on quantitative measurements, remains, however, connected to the objective phase of tone reproduction.

1.3 SPECIFIC ASPECTS OF TONE REPRODUCTION

1.3.1 Monochrome Photography (Black-and-White)

Monochrome photography is, by definition, the typical field of study of tone reproduction. From a technical viewpoint it allows us to record and to transmit information only by luminance variations; artistic expression is besides this also a function of tone reproduction alone. All these aspects have therefore been widely studied since the beginnings of photography, and it is sure that the inventors like Niepce, Daguerre, Fox Talbot and others were attracted by these fundamental aspects of their new techniques much earlier than the publication of the researches by Hurter and Driffield as well as later those by Jones on the quantitative relationships between the luminance scales of the photographed subject and those of its reproduction. Investigation into this problem requires the knowledge of the influence of all parameters intervening in the camera and the printing exposures. There are first the optical conditions during exposure of the negative and the effects of its sensitometric curve shape and spectral sensitivity, then the optical conditions

of printing by contact or by projection, further the photographic charac-
teristics of the printing material, and finally the physical properties of the
final print.

Knowledge of all these parameters is necessary for the application of
Jones' graphical method, which, as already mentioned, takes separately the
objective and the subjective phases of tone reproduction into account.

1.3.1a *Effects of Flare Light*

In the various operations where exposure of the sensitive material is
carried out in a photographic camera, as during picture taking, or during
projection printing in a copying camera or in an enlarger, it is necessary to
know the relationship between the distribution of luminance in the scene to
be taken, or in the original image or negative to be copied, and that in the
plane of exposure of the light sensitive layer. Similarly, to study the effect
of the projection on tone reproduction by a transparency requires the
definition of the relationship between its scale of transmittances (or densities)
and that of the luminances of the projected image.

In the case of a camera exposure the two luminance scales differ above
all by their relative levels: the original scene is generally much lighter than
the image in the camera, but this difference, while sometimes quite important,
is not essential. What really modifies the luminance distribution in the image
plane is the flare light, superimposed on the optical image of the scene. The
total illuminance E_t of the sensitive layer is equal in fact to the sum of the
image illumination E_i by the optical system and the uniform illumination
E_f by the flare light

$$E_t = E_i + E_f. \tag{1.50}$$

Uniform illumination of the focal plane by flare light acts on the tone scale
mainly at low levels of illuminance: being comparatively weak, the flare
light can double, or increase even more illuminance in the lower scale, but
remains without any influence in the areas of high illuminance of the sensitive
layer.

The uniform illuminance of the focal plane by flare light is partly due to
unwanted reflections in the optical system. Each interface between elements
of different refractive indices reflects a fraction of light which should only
serve to form the optical image. Dust particles and moisture, or minute
greasy traces, on the exterior faces of the lens or on filters increase this
diffusion of light, while the generally applied anti-reflecting treatment of the
optical surfaces diminishes flare light.

Another much more important fraction of flare light has its origin in the
multiple reflections within the 'darkroom' of the photographic camera.
The light-sensitive layer, highly illuminated at certain points by the

image of the scene, reflects light into the camera and thus illuminates all asperities inside this 'darkroom'. The resulting multiple reflections yield a general illumination, and thus an undesirable uniform contribution to the desired optical image illumination of the sensitive layer, which can be of the same order of magnitude as, or even higher than, the illuminance which would correspond to the darkest parts of the original scene in the absence of flare light. These conditions of illumination in the interior of a photographic camera are similar to those which can be observed during the projection of a motion picture in a theatre: varying with each scene, the screen reflects more or less light in the theatre and thus illuminates the spectators and the walls which, in turn, reflect flare light onto the screen.

Jones and Condit's method[17] applied to the study of the luminance scale of exterior scenes allows us to introduce the effect of flare light into the sensitometry of the negative. Each scene has a maximum and a minimum luminance, $L_{s\,max}$ and $L_{s\,min}$ respectively, which can be measured in the field with a telescopic photometer; the ratio of these extreme values yields the luminance scale of the scene

$$\Delta L_s = \frac{L_{s\,max}}{L_{s\,min}}. \tag{1.51}$$

In the areas corresponding to these two limits of the luminance scale the processed negative image has the densities $d_{i\,max}$ and $d_{i\,min}$ respectively. These define on the d–log E curve of the film in its specific process two extreme values of illuminance of the sensitive layer during its exposure, $E_{i\,max}$ and $E_{i\,min}$ (Figure 1.41), yielding the illuminance scale in the image plane

$$\Delta E_i = \frac{E_{i\,max}}{E_{i\,min}}. \tag{1.52}$$

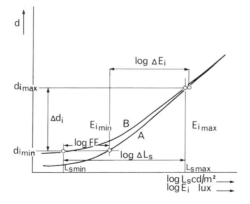

Figure 1.41. Effect of camera flare on sensitometric response of the negative.

According to Jones and Condit the ratio of the luminance scale of the scene to the luminance scale of the image is the 'flare factor'

$$FF = \frac{\Delta L_s}{\Delta E_i}. \tag{1.53}$$

For all of the 126 scenes of their investigation the illuminance scale of the image plane ΔE_i was shorter than the luminance scale of the scene ΔL_s. This difference is obviously due to flare light inside the camera which adds over the whole image plane a uniform amount of illuminance. An equivalent effect would result from the addition of a constant value of luminance ΔL to all scene luminances if the scene would be photographed without any flare light. On the d-log E diagram of Figure 1.41, further to its logarithmic scale of abscissae, this constant value ΔL corresponds at the level of minimum density $d_{i\,min}$ to a much longer line segment than at the level of maximum density $d_{i\,max}$. It corresponds at this latter level to a very small fraction of the scene illuminance and can therefore be neglected without introducing any error. Comparison of the segments ΔL_s and ΔE_i in Figure 1.41 yields further
$\log E_{i\,max} - \log E_{i\,min} = \log(L_{s\,max} + \Delta L) - \log(L_{s\,min} + \Delta L)$,
so that

$$\Delta L = \frac{E_{i\,min}L_{s\,max} - E_{i\,max}L_{s\,min}}{E_{i\,max} - E_{i\,min}}. \tag{1.54}$$

On the average ΔL is of the same order of magnitude as the minimum scene luminance, but it can sometimes be many times as large, for instance in a contrasty back-lighted scene. For the 126 scenes taken by Jones and Condit with a high-quality professional camera, the flare factor FF varied from 1·15 to 9·50, with an average value of 2·35. In modern miniature cameras its average value is higher, ranging from 3·0 to 5·0 according to the light distribution in the scene.

Consideration of the effect of flare during the image exposure thus leads to two separate sensitometric relationships, that corresponding to the exposure of a film sample in the sensitometer, practically without flare light (curve A, Figure 1.41), and that corresponding to the negative exposed in the camera in presence of flare light (curve B, Figure 1.41). The first is that of the *negative material*, and the second that of the *negative image*, or the *negative*. It is important to distinguish these two functions in the discussion of negative curve shape.

1.3.1b *The Curve Shape of the Negative*

In the modern conception of monochrome photography the only parameter adapting tone reproduction to each application should be the curve shape of the finished negative image. It is obvious that tone reproduction is

also much influenced by the choice of the positive material, for instance of the photographic paper, and by the way it is exposed. It is more convenient, however, to maintain all processing operations rigidly standardized and to solve the problem of tone reproduction in the picture exposure step by an appropriate choice of subject lighting and of negative curve shape. This allows processing of the negative either in a machine or in deep tanks under well known and fixed conditions for all chemical and physical parameters of the process (see p. 501), and further standardized printing. It is thus possible to define the sensitometric curves of the negatives so as to adapt them to the current applications of pictorial photography for an optimum shape in all density regions, which are the 'toe' in the lower part of the curve corresponding to the shadows, the central part which corresponds to the middle tones, and the 'shoulder' which reproduces the high-lights.[57]

A negative that is to yield satisfactory tone reproduction in the *shadows* must have a comparatively long toe (Figure 1.42). According to the amount

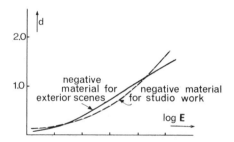

Figure 1.42. Sensitometric characteristics of negative materials designed to cope with customary flare levels.

of flare light, the sensitive material should thus have either a shorter or a longer toe: in the studio, where high-quality professional cameras are employed, and where the picture area is never surrounded by large areas of high luminance, i.e. where during exposure only little flare light is present, the sensitive material must have the long toe. For exterior scenes, on the contrary, where a great amount of skylight is strongly diffused within the camera, the light sensitive material should have a short toe which will be extended through the flare light. This applies particularly to amateur miniature cameras which have in general, further to their compact design, a high flare factor.

The final form of the negative toe, i.e. that due to the contribution of the camera as well as of the subject and the negative material, has on the other hand also a strong influence on exposure latitude. In the studio, for example,

a short-toe film can only yield satisfactory tone reproduction with a just sufficient amount of exposure, whereas a long-toe film yields a constant high level of quality in a much wider exposure range (Figure 1.43).

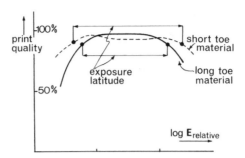

Figure 1.43. Effect of toe shape on photographic quality.

In the *middle tones* the negative has either a linear response with a long straight-line portion, or the d–log E curve is concave over its whole length. Figure 1.44 shows the three types of curve shapes most frequently encountered: negative A, with an upwards bent curve, yields in the studio, and especially for portraiture, the best quality; negative B, with its long straight line, is that of a negative with the greatest latitude for exterior scenes, and therefore useful for amateur or news photography; and negative C, intermediate between these two, allows one to obtain excellent average quality under the highly variable conditions encountered in the professional photography of exterior scenes, and also in industrial and documentary photography.

Tone reproduction in the *highlights* depends on the upper part of the negative curve. In portraiture work brilliant highlights result from a negative curve with steadily increasing slope, as film having this response accepts

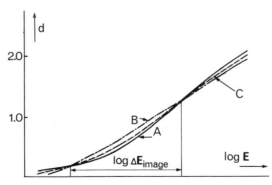

Figure 1.44. Sensitometric responses according to specific uses of negative materials.

very high exposure values in the highlights. On the contrary, film intended for a more general application must rather have a straight-line characteristic (Figure 1.44, curve C), so that the highlight contrast is still sufficient without leading to high density, resulting in long exposures during printing.

It is obvious that these considerations on the curve shape of the negative are only valid with correct exposure and development. These two parameters have in fact a strong influence on the final results; the final quality of the print will be at its optimum only with a just sufficiently exposed, but not under exposed, negative; its development should aim at a contrast index of 0·6, or for negatives with a long straight-line characteristic, a gamma of 0·7. Such negatives can then be printed onto grade 2 paper on a diffused light enlarger (see p. 68), when their minimum densities range from 0·25 to 0·37, and their maximum densities from 1·05 to 1·15. These figures apply to all black-and-white nagatives, not only to those of pictorial photographs, but also to scientific or technical records (photomicrographs, etc.).

1.3.1c *Spectral Sensitivity and Tone Reproduction*

The density-distribution within the image, on which depends the reproduction of the original tone scale, depends of course on the spectral sensitivity of the sensitive material. The exposure of the sensitive layer is in fact

$$E = \int I(\lambda)s(\lambda)t(\lambda)R(\lambda)d(\lambda), \qquad (1.55)$$

where $I(\lambda)$ is the spectral distribution of the luminous intensity of the light source, $s(\lambda)$ the spectral sensitivity of the layer, $t(\lambda)$ the spectral transmittance of the optical system, including an eventual filtration, and $R(\lambda)$ the spectral reflectance of the subject. The achromatic image is thus, for the physicist, a unidimensional representation of a multidimensional universe, because it transposes the monochromatic scales of all wavelengths into only one spectrally neutral scale. When at least one of the parameters of the integral (1.55) has definite spectral limits, the integral becomes finite; as its parameters are empirical functions, its value is then determined by graphical integration (Figure 1.45). This method of determination of the recorded energy not only applies to photography in visible light, but also to the recording of all other radiations (infrared, ultraviolet, etc.).

Considered as a visual phenomenon the achromatic representation of a scene in full colour is much simpler: the reproduction transposes three scales, those of the hues, the saturations and the equivalent luminances of the colours, into one single scale of brightnesses. It is thus only necessary to transform two parameters of the information contained in the scene so that they fit into the achromatic tone scale, because the third parameter, the

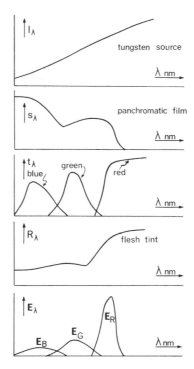

Figure 1.45. Determination of effective spectral sensitivity by graphical integration.

brightness, remains unchanged in the reproduction. The two parameters to be translated into tones, hue and saturation, define the coloured aspect of an area called its chromaticity (see p. 224). The problem thus finally reduces to the satisfactory representation of the chromaticities, simultaneously with the brightnesses, by the tone scale alone of the monochromatic reproduction.

The discussion of the effect of the achromatic representation of all colours and of all brightnesses is simplified by considering only the three principal regions of the visible spectrum. Exposure of sensitometric strips with red, green and blue filters yields three d–log \mathbf{E} curves (Figure 1.46) whose relative position, together with the exposure values obtained by graphical integration of the corresponding spectrophotometric data (Figure 1.45) determine the densities of the negative, exposed separately with each of the three filters. The sum of these three densities is in fact equivalent to the density obtained by exposure to 'white' light, i.e. without filters. This separation according to the three principal regions of the visible spectrum shows the effect of the

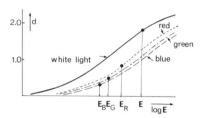

Figure 1.46. Estimation of relative spectral sensitivity levels by exposures with red, green and blue filters.

relative importance of the sensitivities in these regions. It is thus possible, for instance, to determine to what extent oversensitization in the red region acts on the reproduction of a flesh tint relatively to that of foliage green or sky blue.

Each colour, even when highly saturated, has an inherent brightness, called equivalent luminance (see also p. 91), which can be determined by heterochromatic photometry by comparing it to one of the steps of a neutral grey luminance scale. As this match relies on the spectral sensitivity of the eye (Figure 1.31), it might appear that the best spectral sensitization of a photographic layer for satisfactory tone reproduction should be identical to that of the spectral visual sensitivity of the average observer. The customary spectral sensitization of normal negative films is however very different (Figure 1.47). Mouchel[58] has shown that this difference is necessary for the

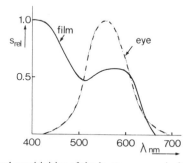

Figure 1.47. Spectral sensitivities of the human eye and of a panchromatic film.

separation of tone values of frequently reproduced object colours, and especially for a conventional rather than photometrically exact reproduction of the tone ratios. A sky must in fact look lighter than the green of a foliage and it is very important to reproduce flesh tints in such a way that they are

advantageous to the people represented. In his conclusions Mouchel shows however that a slight modification of the customary blue-to-green sensitivity ratio would be desirable, by lowering slightly the blue and by increasing accordingly the green sensitivity.

1.3.1d *The Photometric Properties of the Positive*

In black-and-white photography, or simply in 'photography', the positive is the final result of the process of recording and reproducing any given scene and must therefore yield optimum objective and subjective tone reproduction. It might thus seem that a positive image should have fixed and predetermined photometric properties, independently of the way it will be employed by the user. Positive images are obtained however, according to their purpose, either on paper base for viewing by reflection, or on a transparent support for projection on a screen; this latter type of observation is now practically limited however to professional motion-picture films. If the final result is to be identical under these two very different conditions of observation, the positive prints must have such properties that all sensitometric, optical and psychophysical factors which intervene during their preparation, as well as during their observation, are entirely compensated. The sensitometric characteristics of the positive materials are therefore chosen consequently, taking into account the effects of diffuse light during the printing operation and that of the level of illumination of the positive and its surround during its observation. These factors are discussed in detail in the chapter on subjective photometry (p. 42).

Practical experience and numerous investigations[26,59] have shown that the objective tone reproduction curve, desirable in black-and-white photography, differs slightly from the 45° straight-line characteristic which would correspond to the exact reproduction of the original luminance scale, and further that the overall contrast of a transparent positive, intended for motion-picture projection in a darkened room at a comparatively high level of screen illuminance, must be much higher than that of a reflection print. Figure 1.48 shows the two corresponding curves for first-choice prints of exterior scenes, selected by several observers among slightly different positives of the same scene. The optimum curve for a non-enlarged transparency, intended for direct viewing on an illuminator in a normally lighted room, is intermediate and situated between the two other curves, so that it approaches quite closely the 45° straight-line characteristic.

The sensitometric characteristic which yields for a motion-picture positive film optimum tone reproduction from the currently employed negatives is that shown in Figure 1.49. Its concave shape in the lower density range and its contrast of about 2·2 in the straight-line region of the higher densities is now common to all films employed for theatre projection.[60,61]

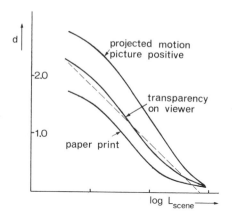

Figure 1.48. Optimum tone scales of black-and-white images viewed by transmission, by projection, or by reflection.

As in professional black-and-white motion-picture work the camera exposures are carried out under well controlled conditions of illumination and of lighting contrast, and, as the development of the negative is entirely constant, this single grade of positive film allows us to print all negatives correctly. The only variable parameter is the exposure of the positive, obtained by the correct choice of the appropriate printing 'step' which defines, according to its density level and according to the desired effects, the illumination of the negative in the printer.

The problem of optimum curve shape of a photographic paper is more involved, as it is more closely related to the inherent photometric properties of an image on an opaque base, intended to be seen by reflection amidst well illuminated surrounds. Even under excellent lighting conditions, and

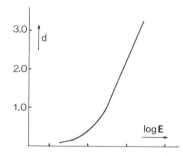

Figure 1.49. Sensitometric characteristics of a black-and-white motion-picture positive film.

almost without any flare light, the ratio between the extreme luminances of a reflection print is limited. According to its surface structure it reflects a certain amount of light, further reducing this ratio by lightening the shadows and the areas which should be black. This ratio, customarily given as density difference, is called 'Density Scale': it can exceptionally reach the value of 2·0, but the figures generally accepted are for a white and glossy paper 1·70, for a semimatt paper 1·50, and for an entirely matt paper 1·30. For inspection in full daylight, rich in ultraviolet radiation, the corresponding values are slightly higher, as most papers now contain brightening agents which fluoresce when exposed to ultraviolet light.

In black-and-white amateur photography, and to a certain extent in professional photography, especially for news pictures, the density scales of the negatives are extremely variable, so that not only the exposure but also the overall contrast of the paper must be adapted to each negative. The various methods currently employed for the obtention of the best prints will be described in the next section, and only a general description of the optimum characteristic curve of a black-and-white photographic paper, as well as its characteristic parameters, will be given here.

If a paper is to yield the objective tone reproduction characteristic shown in Figure 1.48, its highlight contrast must be much lower than its shadow contrast, and it must be capable of accepting the whole density scale of the negative to cover its entire luminance scale. The fraction of the characteristic curve which corresponds to these conditions is shown in full line in Figure 1.50. Between the points h and s, its gradient, very low in the highlights,

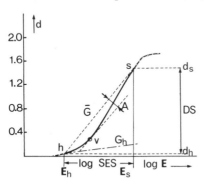

Figure 1.50. Sensitometric characteristic and parameters of a photographic black-and-white paper.

increases continuously and reaches its highest value not far from the maximum density; this is the concave curve shape typical of a good photographic paper. This continuous contrast increase with density corresponds well, besides this, to the most satisfactory psychophysical conditions for the differentiation of small luminance differences, as described in the chapter on subjective photometry.

Numerous investigations served the purpose of defining this curve shape by parameters such that their comparatively simple relationships describe unambiguously the various characteristics of a photographic paper. Thus according to Jones and Nelson[62,63] there is a constant ratio between the highlight gradient G_h and the average gradient \bar{G}, this latter being that of a straight line drawn through the point h and tangent to the curve at its shoulder, at the point s: $G_h = 0\cdot 1\, \bar{G}$. Defined in this way the points h and s determine the limits, on the one hand, of the exposure scale or scale index $\log SES = \log E_s - \log E_h$, and on the other hand of the density scale $DS = d_s - d_h$. Morrison[64] further proposed a method allowing a description of the rounded shape of the characteristic curve. The tangent to the curve, parallel to the line joining points h and s, allows us to define the degree of this incurvation by the magnitude of the distance between the two straight lines, called arcuance by Morrison. The position on the curve of the point of contact v of the tangent defines besides this the shape of the incurvation; its position is given by the vertex ratio $V = 100\ [(d_v - d_h)DS]$. Careful checks of these parameters by application to the curves of many papers, carried out by Jones and Nelson, confirm that the points h, v and s define curve shape unambiguously.

This framing of the characteristic curve has been included in USA standard PH2.2.1966,[65] which names the gradient \bar{G} 'bar gamma' and also defines several other parameters necessary for the evaluation of the speed and contrast of photographic papers (Figure 1.51). The position of the two tangents to the curve which determine the bar gamma is given by their distance (A

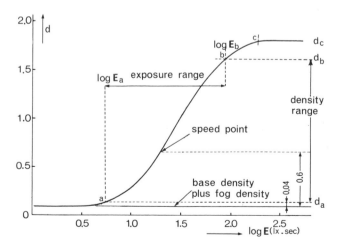

Figure 1.51. Sensitometric parameters of USA standard PH2.2.1966.

of Figure 1.50), equal to 0·1 log E unit; the log exposure range and the density range cover the domain situated between points a and b of Figure 1.51 and thus allow a satisfactory correlation between the density scales of the negatives and those of the papers to be established, point a being placed on the curve at a density higher by 0·04 than that of unexposed, developed, fixed, washed and dried paper, and point b at 0·9 of the maximum density d_c. Paper speed is given by the equation

$$S_{paper} = \frac{10^3}{E_{0·6}},\qquad(1.56)$$

in which $E_{0·6}$ is the exposure in metre candle seconds yielding a density of 0·6 above minimum density.

Flare light present during the printing operation modifies the exposure scale modulated by the negative and therefore the characteristic curve of the paper. Printing conditions vary considerably, in fact, according to the various applications: in certain extreme cases the illumination of the negative during printing onto the positive material is entirely specular; in other extreme cases it is entirely diffuse. Between these two limiting illuminations all degrees of diffusion of the printing light can be encountered; it is therefore possible to set up a scale between total absence of flare, i.e. fully specular printing illumination, and total diffusion of the printing light. The amount of diffuse light which reaches the sensitive layer of the positive material depends, besides this, to a large extent on the negative itself. When an important area of a negative, containing small important details of comparatively high density, is entirely transparent, the effect of flare is very important in projection printing. With contact printing the degree of diffusion changes less from one negative to another.

In optical professional motion-picture printers, where a small and powerful light source is placed comparatively far from the negative and where the printing light is further directed onto the positive by mirrors and lenses, printing illumination is highly specular and diffusion very slight. Another current use of specular printing light occurs in certain photofinishing printers (see p. 73). This type of illumination has the advantage of high luminous efficiency and further improves the sharpness of the prints. Its drawback is that it makes visible all non-uniformities or scratches on the back of the base or on the surface of the emulsion layer (Figure 1.52).

In most photographic enlargers, and in many other optical printers, the system of illumination is such that the printing light is semi-diffuse. The optical system is still that which would yield specular light with a very small light source, but the incandescent lamp has a large bulb of opal glass so that the negative is illuminated by quite diffuse light. Other means of introducing

Figure 1.52. Optical effect of a surface defect in specular illumination.

diffusion in the light beam are ground or embossed plastic sheets, the latter having numerous small lenticules which define the ratio between the relative amounts of specular and diffuse light.

Full diffusion of the printing light is only encountered in contact printing, when the negative is directly applied against a diffusing surface, such as a uniformly illuminated opal or ground glass.

1.3.1e *Methods of Printing on Paper*

The sensitometric response of a photographic paper must correspond, as has been shown before, to the characteristics of the negative. If the whole density scale of the paper is to be employed in the image, its scale index *SES* must in fact be equal to the density scale of the negative to be printed.

(a) (b)

Figure 1.53. Characteristics of photographic papers yielding satisfactory, but different prints from the same negative.

Figure 1.53 depicts two cases of different papers which yield correct prints because they satisfy this condition.[64] The two papers whose curves are shown in Figure 1.53a, one glossy and the other matt, have quite different density scales, but both print the same negative successfully because their scale index *SES* is identical. The two papers of Figure 1.53b also both allow the correct printing of a given negative for this same reason, but, just as in the first case, tone reproduction by each will be very different.

Other papers on the contrary have all the same sensitometric contrast in a rather important part of their H. and D. curve without having the same scale indexes. The curves of two such papers are represented in Figure 1.54; Figure 1.54a shows the curves of a glossy and a matt paper having the same gamma, but different scale indexes, and Figure 1.54b a similar situation for two glossy papers which differ in their sensitometric response mainly in the lower density range. These two papers yield the same tone reproduction in a part of their scale, but the whole range of information contained in a negative with a density scale corresponding to the paper with the higher scale index cannot be printed correctly on both.

(a) (b)

Figure 1.54. Photographic papers of identical gamma yielding different prints.

Various methods can be employed to adapt the scale index of the papers to the density scales of various negatives. The first and the oldest one is that of the use of several grades with scale indexes increasing in steps, so that all negatives can be printed correctly by choosing for each the most appropriate grade. This method is mainly useful for the individual printing of relatively small numbers of prints, as for instance in certain types of professional, technical or scientific work. The other and more recent methods have been developed for the continuous printing, at an industrial scale, of very great numbers of prints, as for instance in industrial photofinishing of amateur prints; only one paper is then employed, in general in a continuous web, and its scale index is modified for each print by various methods which will be described below.

Papers of different grades. Figure 1.55 shows very schematically a series of sensitometric curves typical of the various contrast grades of white glossy papers for projection printing. These curves are not those of any specific paper, as too many slightly different types are available on the market. They show however certain rather characteristic properties of these and similar papers for contact printing: all curves have the typical shape with

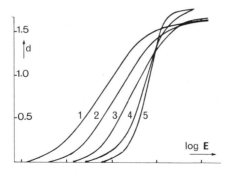

Figure 1.55. Typical example of a set of contrast grades.

a rounded toe, a relatively steep gradient towards the shoulder and a rather sharp bend when reaching the maximum density. The shoulder density varies for the different grades. It has its highest value on papers of high contrast and is slightly lower than the average for the softest grades, so that the tone scale of negatives either very low in contrast, or with a very long density scale, is reproduced at its best.

USA Standard PH2.2.1966[65] contains in its appendix a table which gives an approximate relationship between the log exposure ranges (or scale indexes) and adjectives descriptive of the contrast of the corresponding papers. This correlation, defined so that the scale index is equal to the density range of the negative that best fits the paper, is given in Table 1.3. The majority of negatives normally exposed and developed correspond to grades 2 and 3.

TABLE 1.3

Grade (not contained in the standard)	Contrast	Log exposure range or Scale index
0	very soft	1·40–1·70
1	soft	1·15–1·40
2	medium	0·95–1·15
3	hard	0·80–0·95
4	very hard	0·65–0·80
5	extra hard	0·50–0·65

The curves of Figure 1.55 have all been obtained with only one optimum time of development. The variation of the development time of a paper, however, is a factor which has a great influence on tone reproduction. This is

Figure 1.56. Speed variation with development of a chloride paper.

illustrated by the families of curves in Figures 1.56 and 1.57. The first shows
the progression obtained on a glossy paper intended for contact printing.
During development this type of emulsion reaches its final characteristic
very rapidly so that an increase of the development time only yields a horizon-
tal shift of the curve, i.e. a speed gain without any change of contrast: for
this paper the increase in development time is thus equivalent to an ex-
posure increase.

Figure 1.57. Simultaneous contrast *and* speed variation with development time of a chloro-
bromide paper.

Figure 1.57 on the contrary shows the curves representative of various
development times for a paper with a chlorobromide emulsion, intended for
projection printing. The rate of development of this emulsion is slower,
so that an increase of development time rather increases the contrast whose
maximum value is thus only reached with the longest development times.
This type of paper therefore allows us to adapt the characteristics of the
paper to that of each negative still better than by the simple choice of the
appropriate grade.

Papers for industrial printing operations. The use of various paper grades in large scale industrial print production has several practical disadvantages. Storage and handling of several paper grades, exposure of individual sheets and their separate development, are all factors unfavourable to the rapid printing of large quantities of prints. Several methods now exist, however, which allow one either to vary the contrast and the scale index of one single paper, or else to adapt the luminance scale of the negative to the characteristics of a single grade by making use of certain optical properties of the printer.

The *polycontrast papers* have two emulsions of different spectral sensitivity: one of high contrast, sensitive to blue light, and the other of lower contrast, mainly sensitive to green light. A series of filters whose spectral region of transmission varies progressively from blue to green, allows variation of the ratio between the exposures of the two emulsions in such a way that the overall contrast of the paper varies exactly like that of the various grades. Figure 1.58 shows the example of such a paper exposed on the one hand with Wratten filter No. 34, of magenta colour, which transmits blue light and absorbs green radiation, thus yielding the highest contrast, and on the other hand, for obtention of the lowest contrast, exposed with a yellow CC 50Y filter which absorbs some of the blue radiation. Filters with intermediate spectral transmittances yield contrasts and scale indexes intermediate between those of these two limiting curves. The polycontrast paper thus allows variation of the scale index by a simple change of the exposure by the choice of an appropriate printing filter. It can thus be exposed in a continuous web and automatically developed in continuous processing machines. Being sensitive to blue and green, it requires however a rather dark red safelight and is therefore better adapted to the large scale printing of professional and industrial photographs than to photofinishing operations, where traditionally a light yellow safelight is employed.

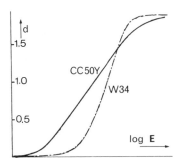

Figure 1.58. Contrast variation of a polycontrast paper with changes of spectral distribution of the exposing radiation.

Systems employing an additional uniform flash are based on a different principle: the modification of curve shape is obtained by a uniform exposure, too weak to fog the emulsion.[66,67,68] These systems make intentional use of the otherwise unwanted effect of flare light, described on p. 66. The initial contrast of the photographic paper is chosen rather high so as to yield, without an additional flash, the curve shape of the grade of highest contrast, but according to the level of the additional uniform exposure increasing scale indexes corresponding to the softer grades. The principle of this contrast modification for one single paper is shown in Figure 1.59.

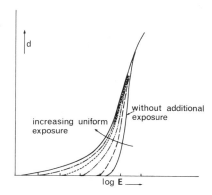

Figure 1.59. Contrast variation of a photographic paper by uniform flashing.

This type of paper is employed in printers which allow a choice of a given contrast, corresponding to the negative to be printed, by pushing a button carrying the grade number and controlling the additional uniform exposure, made either just prior to or just after the principal exposure through the negative.

The unicontrast system. As has been mentioned before, the optical conditions of projection printing have a considerable influence on the effective curve shape of the positive. This is not only due to flare in the optical system, but also to diffusion of light by the silver deposit forming the negative image. This nonhomogeneous deposit yields different density values according to the amount of diffused light in the light beam. This property, together with the effect of flare light in the optical system, is employed in the unicontrast system, in which only one paper of medium contrast is employed for the printing of amateur prints on an industrial scale.

Without the effect of flare light the logarithmic luminance scale in the projection plane, i.e. that of the paper, would have a progression of opposite sense, but otherwise identical to that of the negative densities, a relationship which, in a graph, would appear as a straight line under 45°. Further to the

non-homogeneity of the silver deposit a fraction of the light incident on the negative is diffused and thus lost for image formation, therefore increasing the apparent contrast of the negative in the domain of low and medium densities. In the higher density range, however, the uniform contribution of flare light originating in the optical system gradually diminishes the apparent contrast of the negative image. The curve U in Figure 1.60 shows this relationship between the progression of the negative densities and that of the logarithmic luminance in the paper plane compared to the simple 45° straight-line relationship.

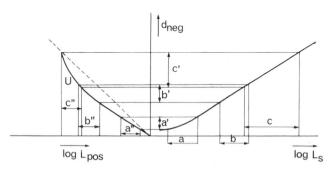

Figure 1.60. Matching of log exposure ranges in the unicontrast printing system.

The unicontrast system takes advantage, in an ingenious manner, of this optical modification of contrast, by also taking into account the statistical frequency of the different types of negatives encountered in amateur printing. Further to the remarkable exposure latitude of amateur negative films, most of these negatives have very similar density scales of average magnitude (b, Figure 1.60) simply because the most often encountered subjects—groups, children, beach or snow scenes—are relatively few. Several typical subject matters taken in full sunlight, and therefore yielding negatives of rather high density, have however a longer density scale than the average (c, Figure 1.60) whereas others, such as scenes taken under dark cloudy skies, whose negatives are of rather low density level, have only a short density scale (a, Figure 1.60). The values of the three resulting, and quite different, density scales a', b' and c' are made uniform by the effect of light diffusion in the projection system, so that the three quite different negatives can be printed on one single paper of medium grade, adapting its exposure by the correct choice of exposure time.

On the high-efficiency production printers employed with this system for the exposure of amateur prints, this adjustment of exposure time is done automatically by a photoelectric cell; it integrates the total flux transmitted by the negative and controls the exposure time through an electronic circuit.

The exposure of the paper is thus a function of the average integrated density of each negative. For an important fraction of the currently encountered negatives this criterion of integrated average density defines an exposure time which gives the highest yield of satisfactory prints; it also simplifies the evaluation of the negatives by the cell, which must be instantaneous and simple (see also p. 37). A certain number of negatives, however, less frequent, have principal subjects of densities quite different from those of the remainder of the image; moreover, when the principal subject only covers a very small area in the negative, the exposure time determined by the cell will not yield a good print. A sunburnt person in front of the uniform background of a beach, or the portrait of a person of rather pale complexion on a dark background, are typical examples; in the first case the high average density of the negative would result in an overexposure of the main subject, which therefore would appear almost black on the print, but in the second case the high amount of luminous flux reaching the cell leads to an exposure time so short that the portrait would be pale and lack detail. To avoid this difficulty the printers include a row of push buttons allowing modification of the exposure time according to the type of negative to be printed. Figure 1.61 shows typical negatives and the corresponding print exposures. As the majority of the negatives can be exposed without corrections, the normal exposure time is obtained by pushing the central button 'N'. According to the magnitude of the entirely transparent fraction of the negative area the exposure time can either be increased (buttons $N+$ and $+$), or it can be shortened (buttons $N-$ and $-$). An identical system of semi-automatic exposure time setting is also employed on the preflash-type printers, but these have a further set of buttons controlling the additional uniform flash, and thus corresponding to the choice of the most appropriate paper grade. The advantage of the unicontrast system lies in its simplicity: as exposure with button N, i.e. with the normal exposure time, yields good prints in the majority of cases, the errors of negative judgment by the operator are almost entirely avoided. Experience shows in fact that these errors—mostly due to human factors—compensate in industrial printing for the apparent advantages of sensitometrically precise corrections. Further to its simplicity the unicontrast system yields in practice, with less skilled operators, a higher yield of good prints than the use of various grades or the uniform preflashing technique.

Tone reproduction in prints obtained from the two less frequent types of negatives—either of low density and short density scale (*a*, Figure 1.60), or over-exposed and of high density level (*b*, Figure 1.60)—is not identical in the unicontrast system. The contrast decreases gradually towards the shadows for the first type of negatives, but increases for the latter type. This compromise is however very acceptable, so much more as it only concerns a minority of prints.

The centre of interest is by far the densest part and covers not more than one quarter of the total image area : a considerable exposure increase above the automatically determined value is required ; + (plus) button.

The main subject and other dense parts of the negative cover from one quarter to one half of the total image area : a slight exposure increase improves detail rendition in the faces ; + N button.

Normal negative. The light and dense areas of both the main subject and the background are evenly distributed : no exposure correction ; normal exposure button on the printer.

The main subject and other light parts of the negative cover from one quarter to one half of the total image area : slight exposure reduction is required to avoid dark faces ; − N button.

The centre of interest is the thinnest part of the negative and covers less than one quarter of the total image area : the automatically determined printing exposure must be considerably reduced ; − (minus) button.

Figure 1.61. Model negatives for the choice of printer correction level in the unicontrast system.

1.3.1f *Jones' Diagrams*

The graphical method invented by Jones, already mentioned in several instances, allows a determination of objective and subjective tone reproduction with full consideration of all the empirical relationships between the various parameters described in the preceding chapters[2] (see also p. 3). These relationships depend so much on the influence of different factors that they cannot be expressed analytically, and apparently minor variations in curve shape correspond in the visual evaluation of the final result to quite important differences. Thanks to Jones' simple graphical method it is possible to obtain complete information on the reproduction of tones by a given system. The basic idea underlying this method is to employ the axis of ordinates of a first graph—in which for instance the luminance scale of the original subject has been transformed by the first parameter of the system, the flare light in the camera—as the axis of abscissae of a second graph which gives the transformation due to a second parameter, for instance the sensitometric characteristic of the negative, etc. Taking into account all operations intervening during the process of photographic reproduction, it is possible to construct the tone reproduction curve with precision, so that not only any given system can be evaluated, but also all parameters, and especially the exposure and processing conditions can be chosen for optimum results.

For the determination of the objective phase of tone reproduction in monochrome photography, Jones' diagram is to be constructed as follows (Figure 1.62): the logarithmic luminance scale of the original scene is first plotted on the horizontal axis *a* of abscissae. The next step is to obtain, with the help of the flare curve of the camera (Figure 1.41, see p. 54), on the axis *b* of ordinates the logarithmic luminance scale in the plane of the light-sensitive negative layer, which corresponds to that of the sensitometric exposure of

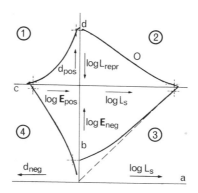

Figure 1.62. Basic principle of Jones' diagram of objective tone reproduction.

the same material. The sensitometric curve of the negative film and its process, typical of the practical conditions of use, can now be plotted above this scale and yields the densities of the negative on axis c. This density scale, taken in the opposite sense, is during the printing operation the logarithmic luminance scale for the positive material. It is thus further employed, again as axis of abscissae, for the sensitometric curve of the positive material. The density scale thus obtained on axis d shows the final result of the photographic recording: comparing it to the log-luminance scale log L_s of the original scene yields curve O of objective tone reproduction.

This curve represents only the physical characteristics of the photometric reproduction of the tone scale. To make it apply also to the effective conditions of visual observation it is necessary to relate it, as shown above, to subjective photometry and particularly to the visual response as a function of the luminance level. Starting from curve O in a second graph according to Jones' original method, similar to the first dealing with objective tone reproduction, curve S of subjective tone reproduction results; this is the diagram of Figure 1.63.

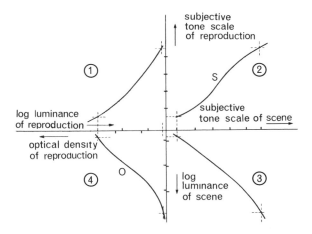

Figure 1.63. Jones' diagram of subjective tone reproduction.

In a later publication[69] Jones extended his method of successive junction of graphs and thus succeeded finally in including all factors, objective as well as subjective ones, in one single diagram.

A modern form of the diagram of subjective tone reproduction is that devised by Bartleson and Breneman.[70] Based on brightness evaluations of areas perceived in arrays of complex fields, their method allows us to determine the function of subjective tone reproduction from the curves giving the

response to the viewing condition of the original scene and to those of the viewing of the reproduction, and from the curve of objective tone reproduction (Figure 1.64). To eliminate the effect of the generally quite important luminance level difference of the scene and its image, the reproduction cycle is represented and evaluated in relative values: for the scene in relative brightness ranging from zero for the absence of light to 100 for 'white', taken as reference, and above 100 for specular reflections of higher luminance than that of white; and for the reproduction also as brightness relative to its 'white'. By projection of the scene luminances over the curve of objective tone reproduction (lower right quadrant) onto the relative brightness function of the image (lower left quadrant), and by comparison of these values with the relative brightness of the scene (upper right quadrant), the function of subjective tone reproduction results in the upper left quadrant. The example of Figure 1.64 shows this function for an image projected onto a screen in a darkened room, i.e. without a surround. The corresponding

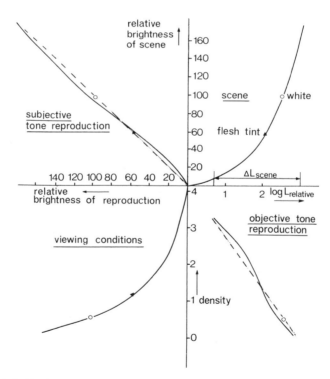

Figure 1.64. Subjective tone reproduction diagram by Bartleson and Breneman of an image projected in a darkened room.

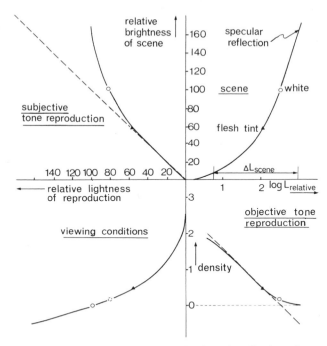

Figure 1.65. Subjective tone reproduction of a reflection print.

diagram, determined for a reflection print which is observed with an illu-
minated surround, yields in the shadows almost the same proportionality
between the scene and the reproduction as that obtained in the projected
image, but differs from this latter for the highlights (Figure 1.65). In the print
the specular reflections cannot be reproduced lighter than 'white'.

To take into account the dependence of the subjective response to lumin-
ance on its general level, Nelson[1] proposed to include into Jones' diagram
parametric families of curves such as those of Figures 1.2 and 1.38. A similar
technique was also employed by Clark[71] for the extension of Bartleson's
and Breneman's results to various luminance levels of print observation
(Figure 1.66). At low illuminance the luminance scale is considerably com-
pressed; its contrast grows however with increasing luminance level and
reaches an optimum when the maximum luminance of the image equals 209
foot lamberts.

1.3.2 Second Generation Reproduction and Edition

There are many applications of photography where the final record is not
printed directly from an original, but from an intermediate second-generation

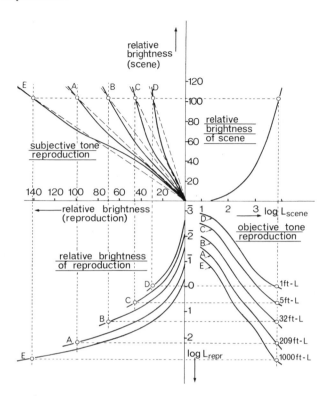

Figure 1.66. Parametric representation of subjective tone reproduction as a function of general adaptation level.

negative, supposed to resemble exactly the initial one. Typical examples are the photographic edition of post cards, professional motion pictures, and printed illustration. On the other hand there exist several photographic or cinematographic reversal processes, mainly in colour, yielding direct positives; a copy from these originals is also a second-generation print. It is finally often necessary to obtain a reproduction, as exact as possible, of an existing positive print, sometimes of historical value.

The principal problem encountered in all these cases is that of *correct* tone reproduction. The problems of subjective judgment are here less important; the duplicating step must yield, in fact, either a negative or a positive both objectively correct, such that each density step be reproduced in the second-generation print as a step of identical density. Determination of the characteristics of intermediate films for copying thus obviously takes advantage again of the graphical method by Jones, whose principle is des-

cribed in the preceding section, and which is particularly advantageous in this application.

Starting from the log luminance scale of the original scene, plotted on the axis a of abscissae, one obtains through the curve of the negative (see also p. 76), and Figure 1.62, fourth quadrant) on axis b its density scale, and further, by the use of the positive curve, on axis c the first-generation reproduction scale (Figure 1.67). It must be mentioned that the negative is only visible in the negative–positive process, but disappears in the course of the reversal process (see p. 473). In this case the diagram reduces to the positive curve and scale c.

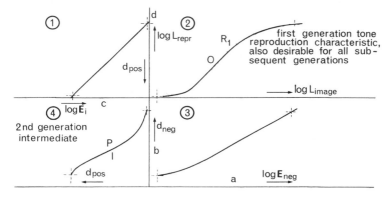

Figure 1.67. Objective tone reproduction in a second-generation print.

The density scale of the positive is now plotted in the opposite sense on axis d: it corresponds to the log luminance scale of the reproduction and allows one to establish curve R_1 of the objective tone reproduction, in the first generation, which must be reproduced exactly. It is thus necessary to have either an intermediate negative or an intermediate positive–negative combination so that the second-generation tone scale R_2 is identical to scale R_1 of a normal first-generation positive. For large-scale edition, such as that of post cards, motion-picture prints, or printed matter, the second technique is currently made use of, i.e. that employing an interpositive-internegative film couple of specially matched sensitometric characteristics. The duplicating of positive originals, on the contrary, requires a negative-intermediate film having such a response that the initial tone scale is satisfactorily reproduced.

1.3.2a *Negative-Positive Second Generation Edition*

In large-scale photographic and cinematographic edition it is necessary, for various reasons, to prepare an intermediate from which the large number

of required prints is to be copied. The intrinsic value of the original is in most cases too great to run the risk of spoiling it during repeated rapid printing; it is, further, often necessary to introduce modifications, corrections, special effects, or captions, according to the requirements of the edition, the script, etc. All these reasons make a second generation print indispensable. In the case of negative-positive processes, the original negative is available, but only employed for the preparation of an intermediate negative. As the films employed for this first negative and for the final positive prints have normal sensitometric characteristics, intended to yield satisfactory tone reproduction in a first-generation reproduction, the density scale of the intermediate negative must be identical, step for step, to that of the original negative. It is obvious that this is only possible if the overall photographic characteristic of the interpositive-internegative combination corresponds to the 45° straight line of the first quadrant in Figure 1.67. Otherwise stated, these two intermediate films must have linear responses within a long density interval, and the product of their gammas must further be equal to 1·0:

$$\gamma_{\text{interpos}} \cdot \gamma_{\text{interneg}} = 1 \cdot 0. \tag{1.57}$$

Their common response must in fact obey the Goldberg condition.[72]

Black-and-white professional motion pictures. Camera exposure is done on a negative film adapted on the one hand to the usual studio lighting conditions, and on the other hand to those of an average exterior scene. In the studio the lighting ratio between the shadows and the highlights is on the average 1:3 (Δ log luminance-studio $= 2 \cdot 0$), with only a small amount of flare light (flare factor $FF = 2 \cdot 5$), which yields an exposure scale of 1·60. Exterior scenes, on the contrary, show higher luminance differences (Δ log luminance-exterior $= 2 \cdot 2$), but there is also more flare light ($FF = 4 \cdot 0$), which reduces this scale, so that the same logarithmic exposure scale of 1·60 approximately results again. The negative film with a medium toe and a long straight section of the curve, resembling film C of Figure 1.44 is developed to a gamma of 0·63 which yields, for log $\mathbf{E} = 1 \cdot 60$, a density scale $\Delta d = 1 \cdot 12$. This density scale must now be plotted correctly on the log \mathbf{E} scale of the interpositive film so as to coincide with the straight-line portion of the sensitometric curve of this film. Figure 1.68 shows such a curve and also that of an internegative film, placed correctly one with regard to the other so as to yield a second generation negative satisfying the above mentioned condition. The new negative has in fact a density scale practically identical to that of the original negative. This figure also makes apparent the importance of sufficient exposure of the two intermediate films, and especially of the interpositives. Correct reproduction of the whole tone scale of the original is only possible when the useful density scale falls into the straight-line portions of

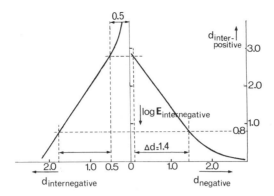

Figure 1.68. Sensitometric relationship between interpositive and internegative of black-and-white motion-picture photography.

the two sensitometric curves. The minimum density of the interpositive must thus be at least 0·80 and that of the internegative about 0·50.

Professional colour motion pictures. While it is obvious that obtention of a good quality second-generation print in a trichromatic system is much more involved than in black-and-white, the condition to be obeyed for satisfactory tone reproduction remains unchanged: the overall response of the inter-positive-internegative couple must approximate the 45° straight line for each of the three elementary images of the trichrome combination. It might thus seem that a certain freedom would remain as to the choice of contrasts for the intermediate films, just as in black-and-white, observing of course the condition of equation (1.57). For the purpose of easy handling, however, and also for correct colour reproduction, which is discussed in detail for this particular case on page 267, it is desirable to employ the same film for the interpositive as well as for the internegative; such a unique intermediate film must then have the straight-line 45° characteristic, i.e. a gamma of one in all three layers, because it is to be copied on itself.

Figure 1.69 shows the sensitometric characteristic of such a film as employed for full feature motion-picture productions in colour.[73] When its three layers are all correctly exposed such that the whole density intervals of each elementary image of the original negative fall within the straight-line portions of its characteristic curves, tone reproduction remains unchanged. This also holds for the internegative which is exposed from the interpositive on the same film. As both intermediates, the positive as well as the negative, then have gammas equal to 1·0 in all three layers, the second-generation negative satisfies the Goldberg condition and yields, with correct exposure, the same tone scale as the original negative.

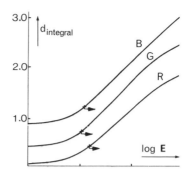

Figure 1.69. Sensitometric characteristic of an intermediate film (serving as well for the inter-
positive step as for the internegative) for colour motion pictures.

The same result can be obtained in one single operation on a reversal
film.[74] This simplification not only has the advantage of the omission of a
printing and the corresponding processing step, but it also improves the
sharpness of the final positive prints as well as the quality of colour reproduc-
tion. The sharpness improvement is due to the formation of the three
interpositive dye images directly within the layers carrying, after the first
development, the three black-and-white internegative images; this dis-
position avoids all loss of definition by the omission, between the negative
and the positive phase, of the printing step which cannot be avoided in the
interpositive-internegative system. The satisfactory colour reproduction
by a reversal intermediate film, on the other hand, results first from the sup-
pression of one dye image generation—that of the three internegative
images—and further from the greater ease of incorporation of the required
corrections (see p. 269). Figure 1.70 shows the sensitometric characteristics

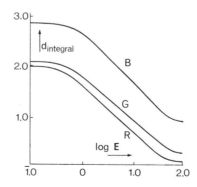

Figure 1.70. Sensitometric response of a reversal intermediate film for colour motion pictures.

of a reversal intermediate film described by Beckett, Morris, Schafer and Seemann.[74]

Edition of black-and-white postcards. From the viewpoint of tone reproduction the problem is practically the same as that of the printing of motion-picture theatre prints. The camera negative is taken on a film whose curve shape suits either exterior scenes, or interiors and other various subjects taken in the studio. According to the subject matter a film having one of the three characteristics represented on Figure 1.44 is employed, so that the recording of the original scene yields excellent tone reproduction on a first-generation print. For reasons such as those mentioned earlier, the photographic edition of postcards also requires an internegative: just as in black-and-white motion-picture work, intermediate films with long straight-line responses and complementary slopes allow us to maintain satisfactory tone reproduction in this duplicating step. Rather varied slopes are employed however in this domain; the gamma values range for the interpositive from 1·50 to 1·0, and for the internegative from 0·65 to 1·0, the latter values corresponding to the use of one film for both intermediates.

1.3.2b *Reversal Processes*

Amateur colour photography. Amateur colour photography makes use of two types of processes: negative-positive systems, yielding paper prints just as in black-and-white, and reversal systems mainly employed for the obtention of transparencies intended for projection; these can however also be printed onto reversal paper, the requirement being to obtain the same tone reproduction as on prints from negatives.[75]

For the purpose of comparing the results of these two systems, let there be first a negative-positive process typical of a colour negative film and a colour print paper, and further for the reversal process the combination of a typical colour reversal film with a colour reversal paper.† The objective tone reproduction curve of a grey scale reproduced by the first system can then be considered as a standard and thus as a basis for comparison. Just as in monochrome reproduction, this curve is found through a Jones's diagram (Figure 1.71).

The choice of the neutral scale is justified by experience. In fact it appears statistically in large-scale photofinishing operations that satisfactory tone reproduction is much more important for the judgment of colour prints than exact colour reproduction (see p. 274). Besides this, tone reproduction varies in colour scales according to the hue, as will be discussed later, in

† In the investigation by Kowaliski and Mouchel[75] the materials employed were, for the negative-positive system Kodacolor film and Ektaprint C paper, and for the reversal system Kodachrome II film and Ektaprint R paper.

section 1.3.3. The neutral scale therefore yields a satisfactory indication of average tone reproduction and thus correlates well with the subjective judgment of the prints.

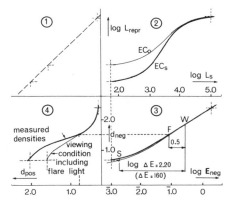

Figure 1.71. Objective tone reproduction by a photographic negative–positive colour process.

For the construction of the diagram of Figure 1.71 optimum exposure is supposed for a subject having a luminance ratio of $1:160$, or a log exposure scale $\Delta \log \mathbf{E} = 2{\cdot}20$. This scale, when plotted in the graph by placing point S at a density typical of correct shadow exposure, yields point W corresponding to a white subject. The reflectance of an average flesh tint, point F, is less than that of a white subject by $0{\cdot}50 \log \mathbf{E}$, and must be reproduced on the print with a white light density of $0{\cdot}70$. This value defines the position of the sensitometric curve of the positive in the 4th quadrant. The density scale of the positive, transferred into the second quadrant, yields by comparison with the log luminance scale of the original scene curve EC_s of the objective tone reproduction under sensitometric conditions, i.e. without flare light. A certain amount of flare light is always reflected from the print, however,[76] which, when taken into account, leads finally to curve EC_e of the objective tone reproduction by this negative-positive process under normal conditions of observation. This curve, considered as a standard, must now be compared to that of the print obtained from a transparency.

To this purpose the sensitometric curve of a positive grey scale, obtained on the chosen reversal colour film and measured in white light, is plotted in another diagram (Figure 1.72, fourth quadrant). Just as in the case of the negative, it must be transformed by taking into account the flare light in the camera. Corrections for flare light in the printing step are neglected for the sake of simplicity, just as in the positive-negative printing step, because of the use of a well designed professional printer with little flare

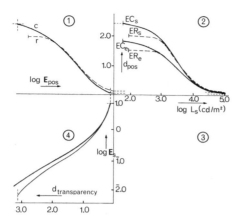

Figure 1.72. Objective tone reproduction by a reversal reflection print from a colour transparency.

light. The density scale of the transparency, corrected in this way, is now employed in the opposite sense as log exposure scale for the reversal colour paper. The sensitometric curve of the paper, plotted in the first quadrant, thus yields the density scale of the positive paper print obtained by double reversal. Comparison of this log luminance scale of the print with that of the original, in the second quadrant, then yields the sensitometric curve ER_s of tone reproduction. After having again been corrected for the effect of flare light (curve ER_e) this result can now be compared with curve EC_e of the negative-positive system.

Inspection shows that the correspondence between the two curves is satisfactory in the middle tone region, but that there is some difference in the shadows as well as in the highlights. The former is slightly exaggerated in the graph, mainly as a result of the densitometer characteristics which emphasize the differences between the two papers in the higher densities. In the highlight region, however, the difference is more significant and typical of a second-generation reproduction. The comparatively long toe of the reversal print would be undesirable, in fact, if all print exposures were optimum. In a large-scale print production, however, this condition is never ideally observed; fortunately the longer toe increases exposure latitude and contributes to a high yield of good prints, thus fully compensating for the theoretically not entirely satisfactory curve shape.

The diagram of Figure 1.72 also allows a definition of the characteristics of an ideal reversal colour paper, which, from a transparency, would yield a positive print identical in tone reproduction to that of a print obtained from a negative. This characteristic is shown in the first quadrant (curve c)

and is obtained by comparison of the tone reproduction curve of the negative-positive system (curve EC_s) and the corrected density scale of the transparency.

Motion-picture processes. By tradition the professional motion-picture industry employs, in black-and-white as well as in colour, the second-generation negative-positive system. In some of its domains, however, which are not the least important, such as television newsreels, audiovisual and teaching pictures, and technical and advertising reels, the camera exposure is done on reversal film, either for economic reasons or to make a first projection within the shortest time possible. For just the same reasons as in the negative-positive system, second-generation prints are then also required. These can be obtained either on a reversal-print film or on the standard positive-print film through the intermediate step of an internegative film. Still more than in amateur printing the problem of tone reproduction is here very important; further problems are those of image structure, such as acutance and graininess. These latter, however, are fully treated in Chapter 2, so that only tone reproduction will be considered here.

The camera taking reversal film is thus only an intermediate which does not need to have projection characteristics. These are only necessary for the print film which is to be copied from the original, and are the same as those of an original film intended for projection.[75] Investigation of second-generation tone reproduction by a reversal system thus starts from one of the widely used amateur reversal films, intended for direct projection, taken as a standard for the evaluation of the professional system, which employs for the edition reversal films for the original as well as for the prints.† The comparison of tone reproduction by these two processes is again carried out by using the reproduction curves of grey scales, obtained with the two camera films; these curves, including the effect of flare light, are represented in quadrants 2 and 3 respectively of the diagram in Figure 1.73. The density scale of the second film, that intended for the obtention of prints, taken in the opposite sense, constitutes the log exposure scale for the reversal-print film. The sensitometric curve of this latter film, plotted in quadrant 4, yields the density scale of the final projection print. Projected onto the axis of ordinates of quadrant 2 this scale allows the comparison of second-generation tone reproduction with that of first-generation reproduction by the original film.

Inspection of the curves shows that the differences between the two systems are not the same as those encountered in amateur prints on paper: in the

† In the paper by Kowaliski and Mouchel[75] these films were Kodachrome II film for direct projection, and Kodachrome Commercial film and Eastman Color Reversal Print Film for second generation prints.

second-generation print it is the middle-tone contrast which is now higher, whereas the lower parts of the curves, representing the highlights, are almost identical and the density differences in the shadows are minor and not visible on the screen. If the second-generation print is to have tone-reproduction characteristics identical to those of the camera film intended for direct projection, the reversal-print film should have a curve shape such as in-dicated by the dotted line in the fourth quadrant of Figure 1.73: this curve results from the comparison of the density scale of the original projection film (ordinates of the second quadrant) with that of a camera film designed for print edition (ordinates of the third quadrant).

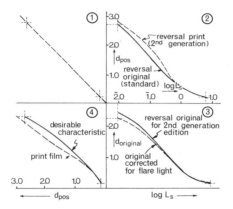

Figure 1.73. Tone reproduction in reversal printing of a reversal colour camera film.

Printed illustration in colour. The majority of professional reversal still transparencies in colour are used for printed illustration. These images, which are the result of highly skilful and involved professional work, and obtained with very careful lighting, are in fact also only intermediates employed by photoengravers and printers as second-generation originals. It might thus seem that they could have any characteristics, even such as to be unsatisfactory for visual inspection, as for instance inverted elementary colours (false colour process) or visually unpleasant tone reproduction, if this would be an advantage for the final result, the printed reproduction. In fact these originals must have excellent visual characteristics, on the contrary, and are obtained on films which yield in one process directly positive transparencies; this is obviously indispensable to an editor for the rapid judgement of pictures, for his choice of the subject matter, and his decisions about the lay-out.

Not being specially adapted to photographic second-generation reproduction, these originals make necessary the use of techniques which are specific to the graphic arts printed colour reproduction.

1.3.2c *Reproduction of Positive Originals*

It frequently happens that the only original available is a positive print on paper. This is always the case with black-and-white news illustrations for daily papers and other periodic publications, and also very frequently with all originals employed in historical documentation. Photographic reproduction of this type of document evidently requires an intermediate negative.

If the photographic quality of the original print is to be maintained, this copying operation must not affect tone reproduction. As the paper ultimately employed for the printing of the second-generation prints is normal, i.e. having the same sensitometric characteristics as that which had been employed for the printing of the original positive print, the intermediate negative should also have a density scale identical to that of the original negative. In other words it is necessary to follow the steps represented in Figure 1.67 in the opposite sense: starting from the density scale *c* of the 'original' positive, the density scale *b* of the negative must be produced. This is only possible if the film material employed for this new negative has a characteristic curve which results from a 90° rotation of curve *P* of the initial positive material. It is not necessary to really carry out this rotation; it is in fact sufficient to simply change the designation of the coordinate axes of the 4th quadrant, such as indicated in Figure 1.67. By this method the optimal curve *I* of a film for an intermediate copying negative is found: it has a long toe of low contrast and a shoulder of rather high and progressively increasing slope. Figure 1.74 shows the characteristic curve at three development times of a film designed for this use: the original positive prints being very varied and

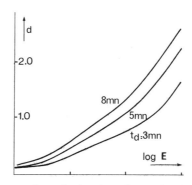

Figure 1.74. Characteristics, at three development times, of a duplicating film for positive originals.

having not always an ideal density scale, these curves constitute a compromise which in practice yields the highest number of satisfactory reproductions.

The sensitometric characteristics of curve I in Figure 1.67 and those of the curves in Figure 1.74 are specially suitable for photographic second-generation reproduction on paper. Reproduction of an original positive print by the graphic printing processes is more complicated: most of these require either a screened or a continuous tone interpositive transparency. The printed image thus becomes a third or even a fourth generation reproduction, and its tone reproduction a function of the printing process, the paper, the inks, i.e. of all intermediate steps intervening in the process.

1.3.3 Colour Scales

Black-and-white tone-reproduction studies are based, as has been shown, on the graphical method by Jones. Its application to the various colour photographic processes has intentionally been limited in the preceding chapter to neutral scales because of the high importance of satisfactory neutrality as well as good tone reproduction of the grey scale in a good colour photograph. The intrinsic properties of the various hues, and especially their equivalent luminance† or brightness, have however a deep influence on their respective tone scales[77] and thus merit a rather detailed study.

1.3.3a *Equivalent Luminance*

It is well known that different colours look more or less light. Their apparent brightness or equivalent luminance depends on two phenomena: on the one hand the total transmittance or reflectance of dyes or pigments varies considerably with their hue; on the other hand, their visual brightness depends on the correspondence between their spectral transmittance or reflectance, and the spectral distribution of visual sensitivity. The first factor—an objective one—intervenes together with the spectral sensitivity of the film during photographic recording; the second—a subjective one—acts on the visual judgment of the images. Photographic tone reproduction of colour scales is thus only one of the specific aspects of the systematic classification of colours, discussed below in the chapter on colour reproduction, page 228.

In those classifications mainly concerned with reflecting surface colours, the scales of each hue are considered from two viewpoints: that of *saturation*, where the progression results from a mixture of a saturated colour with white, and that of *brightness* where the successive addition of increasing quantities of black to a saturated colour of given hue yields a scale of decreasing

† Term recommended by Committee E-1.3.1 (Colorimetry) of the CIE at Basel in 1965.

brightness. It is evident, as can be seen by simple inspection of the three-dimensional models of these classifications, that colours vary also in brightness in the so-called saturation scales, and that they also vary in saturation in the so-called luminosity scales. In spite of this duality in their progression, the apparent change in saturation varies in the former and that of luminosity varies in the latter, so that they are currently called according to their visually predominant property.

The apparent luminance of reflecting surfaces, or lightness, has been defined by Judd as the attribute permitting the perception to be classified as equivalent to some member of a series of achromatic object colour perceptions ranging for light-diffusing objects from black to white.[78] For the evaluation of tone reproduction in colour prints on paper, it is thus necessary to compare uniform patches in colour scales of the process under consideration with those of a grey scale, and to ascribe to each step, as a measure of equivalent luminance, the reflection density of the neutral grey step obtained by the heterochromatic match. Figure 1.75 shows these tone scales for the two series of three colours cyan, magenta, yellow, and red, green, blue, of a photographic paper.

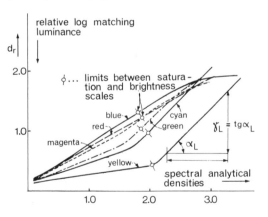

Figure 1.75. Colour tone scales. The slope of the lightness curves defines in each point the lightness contrast γ_L.

The successive exposure increase for a single layer of photographic colour paper yields, after development, first a succession of increasing concentration of either cyan, magenta or yellow dye, corresponding to saturation scales. From the maximum densities of these scales on, the colours are then modulated in lightness by the dyes of the two other layers, until they reach the black of the process. In the same manner, simultaneously increasing exposures of two layers yield saturation scales of red, green and blue colours, until they reach their respective maximum density. From here on, increasing exposure of the third layer yields for each of these hues the corresponding lightness scale.

The axis of abscissa of Figure 1.75 thus shows, for each colour, two concentration scales: one starting from the origin and corresponding to the progressions of saturation, and farther on that of those dyes which act on the lightness scales. As to the characteristics of their progressions, the curves of Figure 1.75 show that the six principal colours form two groups: yellow, cyan and green, on the one hand, with a very pronounced change in slope between the saturation and lightness domains, and magenta, red and blue on the other hand, with lightness decreasing continuously over the whole length of the scale. The first group is formed by the intrinsically luminous colours whose dominant wavelengths fall in the center of the visible spectrum, where the eye is most sensitive. The second group comprises the intrinsically dark colours from red through magenta to blue, which correspond to a lower spectral sensitivity of the eye. The yellow step of maximum concentration is in fact not darker than a neutral grey density of about 0·4, whereas the most saturated blue is equivalent in lightness to a neutral grey of density 1·4, i.e. it appears about ten times darker. The figure also shows the high lightness of cyan whose step of high saturation is only about two times darker than the maximum yellow patch.

The curves of Figure 1.75, characteristic of the progression of equivalent luminance in colour scales, have been called 'lightness (or brightness) curves' and their slope, in analogy with photographic contrast, the lightness (or brightness) contrast γ_L (or γ_B).

1.3.3b The Photographic Effect of the Transmittance or Reflectance of Colours

Among the dyes and pigments yielding the various hues, the yellow ones transmit or reflect most light and the blue ones the least. This is an objective fact resulting from their spectral absorptions. The example of two parallelepipeds, one yellow and the other blue, of spectral reflectance distributions Y_0 and B_0 (Figure 1.76) allows us to study the resulting photographic effect.[77]

Figure 1.76. Spectral reflectance of
yellow and blue objects.

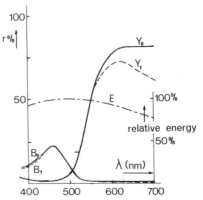

Illuminated by daylight of a colour temperature of 6100 K (curve E) their spectral reflectances are Y_1 and B_1; the areas under these curves are proportional to the respective amounts of reflected light: the yellow parallelepiped reflects about 38 % of the incident light, and the blue one only about 6 %. With a lighting ratio of 4 to 1 between the highlights and the shadows, the light part of the blue object reflects only about two thirds of the amount of light reflected by the shadows of the yellow subject (Figure 1.77). During exposure in the camera, this great luminance difference situates each of the objects in a very different domain of the sensitometric curves, so that they are reproduced with quite different density scales, in spite of their identical lighting and shape.

Figure 1.77. Light reflected by yellow and blue parallelepipeds (in metre candles).

The magnitude of this difference is determined by the spectral distribution of the photographic effect, resulting jointly from the lighting, the reflectance of the subject, the absorption of the lens and the spectral sensitivity of each layer (Figure 1.78) (see also p. 60). The curves of the figure show the sensitivities of a widely used reversal colour film designed for the projection of amateur transparencies and movies. The areas under these curves are proportional to the exposures E_R, E_G and E_B of the three layers by the two

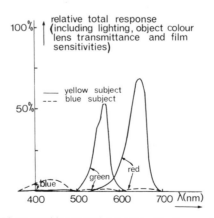

Figure 1.78. Photographic spectral responses of yellow and blue objects.

colours of the object under investigation. Expressed as percentages and standardized again the exposures E_0 of an ideal white subject, which reflects the whole of the incident light, these exposures are given in Table 1.4.

TABLE 1.4

	E_R	E_G	E_B
Yellow subject	76·2	43·5	1·2
Blue subject	1·0	2·0	13·8

The ratios between these exposures and those of the luminances of the various faces of the parallelepipeds (Figure 1.77) allow us to plot on the sensitometric curves the exposures corresponding to the highlights and the shadows (Figure 1.79). This yields the photometric characteristics of the reproduction, expressed in integral densities.

The saturation scales result from those densities which correspond mainly to the subject colour: the blue integral density for the yellow subject, and the green and red integral densities for the blue subject. These scales fall in the upper part of the curve and do not differ much from each other; the saturations of both subject hues are thus well modulated. The modulation of their lightness is, however, very different. It is provided by the green and red integral densities for the yellow subject, and by the blue integral density for the blue subject. This modulation of lightness thus falls for the yellow subject in the lower parts of the curves, but for the blue subject it is situated at a much higher level of density. The reproduction of the blue subject therefore not only reflects a comparatively low amount of light, like the original, but it is made still darker by the high density of the yellow dye which modulates its lightness scale. This latter modulation is, besides this, however more

Figure 1.79. Density scales of yellow and blue objects as reproduced on a reversal colour film.

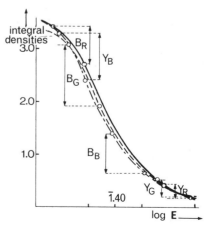

satisfactory than that of the yellow subject, as shown by the comparison of the density scales of Figure 1.79 (see Table 1.5).

TABLE 1.5

	d_R	d_V	d_B
Yellow subject	*0·33*	*0·40*	0·97
Blue subject	0·72	1·17	*0·75*

These computed results apparently allow a much higher exposure latitude for the yellow subject than for the blue one. A practical trial confirms this as far as the density differences between the highlights and the shadows are concerned. Figure 1.80 (see Plate 1) shows some yellow subjects on a yellow background, normally exposed as well as overexposed and underexposed by one stop respectively. The underexposed picture does not look much denser than the overexposed one, and its shadows do not really look dark as they are far from tending towards black.

The density differences, however, describe only one part of the problem. Closer examination of the three images reveals unsatisfactory tone reproduction in the overexposed image, and a definite gain in detail visibility with underexposure.

For the blue subjects, the result is very different (Figure 1.81 [see Plate 1]). The difference between the overexposed and the underexposed images is more visible and reaches the limits of the exposure latitude of the film. On the overexposed image the highlights of the light blue wool ball are almost white, and on the underexposed image the shadows of the dark blue one are black. Just as on the reproductions of the yellow subjects, there is again a difference between the latitude related to the density differences as normally taken into account, and that which concerns tone reproduction. All details of the light as well as of the dark blue balls can in fact be well distinguished on both the overexposed and the underexposed images.

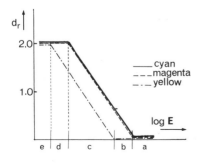

Figure 1.82. Density variations resulting from changes of illumination of a coloured object.

1.3.3c *The Reproduction of Tones in Colour Scales*

The behaviour of density scales resulting from variations in the illumination of a subject to be reproduced have been studied by Mouchel.[79] For a simple colour acting either only on one or identically on two layers of the picture-taking film, five different regions can be distinguished in function of decreasing exposure. For a blue patch, for instance, a simplified schematic representation with a straight-line characteristic curve yields the following domains (Figure 1.82):

(a) The three dyes are at their minimum level of density—the reproduction corresponding to total overexposure yields the white of the process.

(b) Only the two dyes corresponding to the subject hue (cyan and magenta) are modulated—the reproduction varies along a 'saturation' scale.

(c) All three dyes are modulated—in the schematic case of straight-line response the colorimetric chromaticity of the reproduction remains constant for varying exposure.

(d) The two dyes corresponding to the subject hue reach their maximum density and only the third, the yellow, is modulated—successive reductions of exposure yield the 'brightness' scale of the reproduction.

(e) All three dyes reach their maximum density: the reproduction yields the black of the process.

In practice, where the characteristic curves have almost no straight-line portion, scale *c* of this progression is limited to one single value of exposure. In this case the reproduction contains, besides white *a* and black *e*, both achromatic, only the 'saturation' scale *b* and the 'brightness' scale *d* which meet in point *c* corresponding to the most saturated colour attainable by the process for this hue.

These density scales, which depend on the dye concentrations, define the objective aspect of the photographic reproduction. To judge the subjective reproduction of tones for each hue, it is necessary to consider another aspect, that of the brightness curves of Figure 1.75, which introduces the subjective concept of equivalent luminance.[77] The effect of density variation on tone reproduction depends in fact very much on the hue. The brightness contrast being low in the 'saturation' scales of yellows, cyans and greens, tone reproduction of these hues is influenced more by overexposure than that for magentas, reds and blues, whose brightness contrast γ_B remains practically constant over the whole available scale. Generally speaking, the effect of exposure variation is different according to the hue of the colour to be reproduced. This fact explains the difference between the two aspects of exposure latitude, either related to density scale or to tone reproduction. The subjective phase of tone reproduction is in fact at least as important in colour reproduction, or even more so, than in black-and-white, because the

trivariance of colour allows us to distinguish a much greater number of just noticeable difference steps, equal in fact to the third power of their number in a neutral grey scale.

It is thus apparent, in a quite general manner, that the intrinsically bright colours, yellow, green and cyan, whose dominant wavelengths fall in the centre of the visible spectrum, are more sensitive to overexposure, when considered from the viewpoint of tone reproduction, than the intrinsically dark colours, such as red, blue and magenta. In the region of underexposure, the opposite holds. Here the brighter colours have the advantage. These conclusions are valid for colour prints to be seen by reflection as well as for colour films to be projected on a screen or seen on a transparency viewer. The brightness curves have in fact been obtained with photographic colour paper, but are entirely valid for the results obtained on a reversal colour film.

The example of the parallelepipeds, as well as that of yellow subjects on a yellow background and blue subjects on a blue background, correspond to extreme conditions chosen on purpose to show clearly the phenomena involved. In practice such particular cases are of course only very scarcely met with. The presence of colour hides in fact the importance of tone rendition in a reproduction, whereas it is the only apparent variable in a monochrome image. It is further hidden for currently seen subject matters among other aspects such as the latitude of the density scales, or simultaneous colour contrast resulting from the neighbourhood of opposing hues. This explains the very satisfactory practical exposure latitude of colour photographic processes.

1.3.4 Distorted Tone Scales

In certain particular cases, mainly in documentary, scientific or technical photography, the total luminance scale of the subject is so large that it cannot fit within the tone-reproduction capability of the process. A subject composed only of patches of very high and very low luminances without any intermediate tones, and not allowing any use of auxiliary lighting, compels us to improve the tone scale of the reproduction by making use of corrective methods. It is necessary in this case, for instance, to approach the tone scales of the highlights and the shadows until they almost form only one single scale, compatible with the photographic and photometric characteristics of the process: the case of astronomy or space flight, where some details of the subject matter are exposed to intensive radiation and others practically not illuminated, is a typical example.

A second case where correction of tones is necessary is the second- or third-generation reproduction of photographs or printed images. The general aspect of this type of duplication of positive pictures is described in section

1.3.2. As mentioned there, multiple repetition of the negative–positive or reversal cycle of the normal photographic processes successively distorts the tone scale, mainly by an increase of the middle-tone contrast. This can either be avoided by the use of materials with an accordingly distorted sensitometric response (p. 90), or by corrective masking methods, which both lower the contrast in the middle-tone scales.

On the other hand the reverse may also be true, and it may be necessary to increase the contrast in a part of the density scale for better separation of recorded but not sufficiently differentiated details.

Finally, distortion of the tone scale is also employed for special purposes such as the elimination of all intermediate tone steps, except the lightest and darkest ones, for the obtention of contour line reproductions, or, on the contrary, retention of only a few steps of the tone scale, which yields 'posterized' unmodulated uniform areas in the image.

A common disadvantage of all processes conceived for a distortion of the tone scale is to reduce exposure latitude considerably. A photographic material whose sensitometric curve varies strongly in slope in some places makes it necessary to place the exposure scale on a precisely chosen section of this curve. The least exposure error leads to the loss of a significant useful part of the curve and thus to erratic results. This lack of exposure latitude, which limits the current use of materials and processes with a distorted tone scale, is often compensated, however, by the improvement of the photographic quality obtained through a well employed corrective process. The possibilities presented further by the systems yielding either photographic line images, or flat colour area or step scale reproductions as for instance in advertising applications, also justify the use of such processes.

It is important to underline, however, that the materials and processes described are strictly limited to their particular purposes. The progress in the manufacture of sensitive layers, lenses and cameras, as well as the extended knowledge of the various aspects of tone reproduction, allow us at present to obtain satisfactory results in pictorial photography even under apparently inappropriate conditions of subject lighting, partly because of the general use of colour photography and also through the simplification of flash photography, and by incorporation of the flash in the camera. For this reason only two methods are employed when a tone scale is to be distorted or corrected: either that of a film with a particular sensitometric response, or the various forms of masking systems including the methods derived from them.

1.3.4a *Films with a Distorted Sensitometric Curve*

Films whose sensitometric response is represented by a curve with two different gradients like that of Figure 1.74 are not only useful for the copying of positive prints, but also for the obtention of various effects. The same

principle has also been employed for the correct printing of colour transparencies onto paper (see p. 85).

Employed as a negative, a black-and-white film with two gradients, known as gravure copy film, increases the highlight contrast, but emphasizes the contrast in the shadows when serving as a positive. Successively employed, first as a negative and then as a positive, it therefore yields a curve with a flattened middle-tone gradient (Figure 1.83). This low-contrast section of the curve can be placed in any part of the tone scale, simply by careful adjustment of the two exposures. Correctly employed as a negative only, a gravure copy film allows on the other hand the correct copying of composite originals, containing typed matter and line copy, i.e. details without intermediate values, as well as continuous tone illustration whose tone scale covers the whole range from black to white.

Figure 1.83. Duplicating film with distorted sensitometric response.

In colour work a two-gradient film can serve on the one hand as an internegative material, to be copied from reversal transparencies for the printing onto colour print paper made to be employed normally with colour negatives. On the other hand, it is employed just as in black-and-white, for the copying of positive colour prints. The use of such a film in colour is somewhat more delicate, however, than in black-and-white, because of the necessity to superimpose the three integral density curves exactly (Figure 1.84).

In printed monochrome reproduction, exceptionally good quality can be obtained through the use of two images superimposed by successive printing. The result of this technique is equivalent, from the sensitometric standpoint, to that of a positive two-gradient film. One single printing step of black ink on a good paper yields in fact a maximum reflection density of only 1·40,

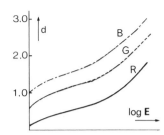

Figure 1.84. Double gradient colour internegative film
for printing from transparencies.

while a good photographic glossy print reaches the value of 1·70 to 1·80.
If the impression is to have the same maximum density as the original photo-
graph, two successive printing steps must therefore be superimposed. The
first image, the principal one, is obtained from a normal negative which
covers the whole luminance scale of the original, and a second one from a
negative about nine times overexposed ($\Delta \log E \cong 0.95$). The superposition
through successive printing of these two positive images yields the result
shown in the mixed line in Figure 1.85.

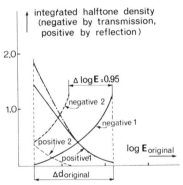

Figure 1.85. Sensitometry of graphic arts
monochrome reproduction with two partial
images printed in register.

Wide latitude photography. When the density scale recorded on a normally
processed black-and-white negative film is larger than 1·5 density units, it is
not possible to avoid a compression of the tone scale in the highlights and
in the shadows. Certain particular subjects, however, as for instance those
encountered in aerial or space photography and in astronomy, reach
luminance scales of 1 to 1,000,000 and cannot therefore be reproduced
by the customary methods. To allow satisfactory recordings of such items
Levy[80] proposed the use of a system of very low negative contrast, using
conventional films processed to low gamma; Figures 1.86 and 1.87 show
the very low contrast obtained on the one hand with a negative film of
high sensitivity, and on the other hand with a high resolution film designed
for microfiling. The special developer, containing only phenidone and sodium

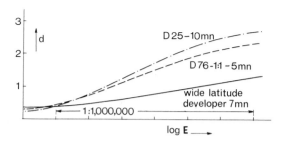

Figure 1.86. Negatives processed in a wide-latitude developer and in conventional low-contrast developers.

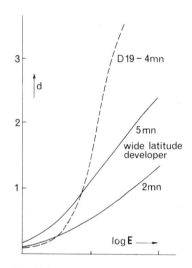

Figure. 1.87. Wide-latitude processing of microfile film.

sulphite (see p. 426) not only lowers the contrast but also increases toe speed slightly and yields a straighter response. Negatives processed that way allow well distinct detail to be obtained even in the case of strong overexposure, which cannot be avoided in the highlights when the luminance ratio reaches the values given above; the resolving power of negatives considerably overexposed, for instance by an exposure one thousand times above normal, indeed remains excellent with this low contrast process.

1.3.4b *Masking and Allied Processes*

A mask is a photographic image, to be superimposed in register with another photographic image of identical outlines, made with the purpose

Plate 1

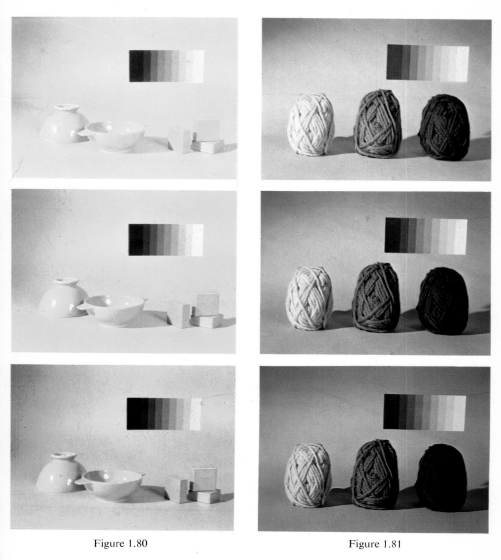

Figure 1.80 Figure 1.81

Effect of both underexposure and overexposure on exposure latitude and tone reproduction of yellow
and blue objects.

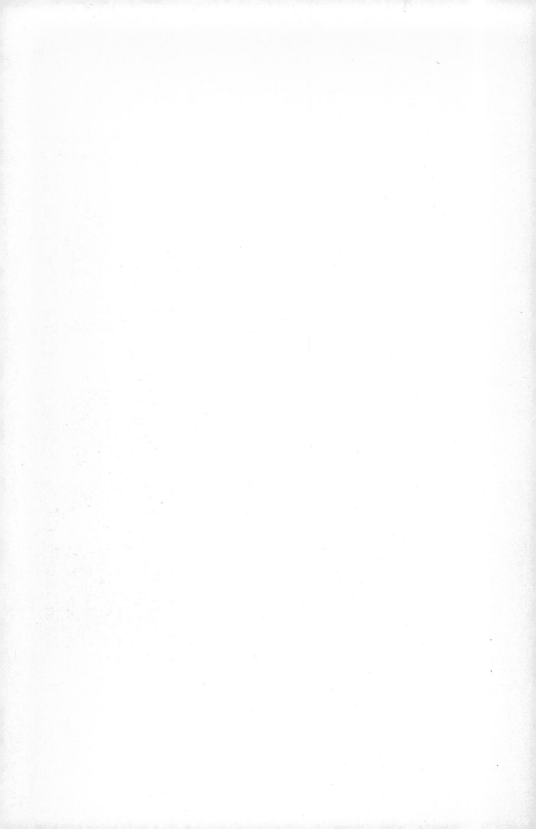

of modifying the latter's reproduction characteristics. The mask can be a negative or a positive and it can be used with a negative as well as with a positive.

Highlight mask. As mentioned earlier (p. 89), printed edition in colour is in general carried out from a colour transparency which serves as an intermediate original. To correct for the unwanted absorptions, those of the dyes in the transparency as well as those of the printing inks employed for the final synthesis of the image (see p. 255), corrective masks must be employed. While improving colour reproduction, these masks also act on tone reproduction. Curve *a* of Figure 1.88 shows the sensitometric characteristic of a neutral grey scale recorded on the transparency, and curve *b* that of the corresponding negative mask. Curve *c*, resulting from the combination of

Figure 1.88. Effect of colour correcting mask on tone reproduction.

both scales—that of the original and that of the mask, whose average contrast corresponds to the correction of the unwanted spectral absorption of the dyes—has, however, too low a contrast in the highlights. This tone compression in the lighter parts of the image can be corrected by a highlight mask (Speck[81]). This mask is obtained, prior to the exposure of the principal colour correction mask, by copying the original colour transparency onto a high-contrast film with an exposure just sufficient to make the highlights appear (curve *b*, Figure 1.89). Superimposing this mask in register with the original transparency yields a tone scale whose minimum density is not at its end, as in the original, but in an intermediate position; this transparency–mask combination thus yields an original whose density increases not only towards the shadows, but also, to a smaller degree, towards the highlights. Thus a principal colour correcting mask, printed from this combination transparency, has the maximum of its density scale in the lighter middle-tone

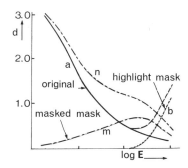

Figure 1.89. Correction of tone reproduction through highlight masking.

region (curve *m*, Figure 1.89). The highlight mask is discarded after exposure of the principal mask, and the superposition of this colour correcting mask with the original transparency yields the final desired density scale with a high gradient in the highlights (curve *n*, Figure 1.89). Very satisfactory tone reproduction is thus obtained in the highlights of the final printed reproduction.

Suppression of tones. Derivations. Instead of attempting to make the tone scale as perfect as possible, it can also be useful, for particular purposes, to make it disappear. Elimination of the luminance modulation can be employed in black-and-white for 'tone-line' reproduction, showing essentially the contours of the subjects, and in colour for images composed only of uniform unmodulated patches. This elimination of the middle tones is obtained by the use of a mask having the same contrast as the original record. In a negative-positive process this mask is therefore a positive of the same gamma as that of the camera negative, and in a two-generation reversal process the mask is a negative, complementary to the original positive transparency (Figure 1.90).

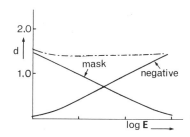

Figure 1.90. Suppression of tone scale by a mask of slope identical to that of the original.

Transformation of a monochrome continuous-tone photograph, i.e. one that is well modulated in its whole tone scale, into a line image, requires a somewhat peculiar technique for the exposure through the masked negative. Immediate contact between the negative and its complementary mask would in fact make all luminance modulation, and therefore the image, disappear. For the obtention of the contour outlines the two films are therefore spaced slightly apart, and a rather small light source, nearly a point source, is placed laterally relative to the centre of the image. Rotation of the films during the exposure of the line positive around this centre allows the oblique light rays to pass along the outlines of all image areas limited by a sharp density variation. The result is a line picture, whose line width depends on the geometry of the exposure arrangement, i.e. on the width of the spacing between the negative and its mask and on the lateral displacement of the light source with respect to the image centre.

In a colour image the presence of chromaticity differences allows us to take advantage of the suppression of the tone scale without making use of this somewhat involved exposure technique. The elimination of the modulation of luminance, one of the three psychophysical attributes of a colour (see p. 212) gives a predominance to its other two attributes, hue and saturation, i.e. to its chromaticity. After the complete compensation of the tone scale there remain in the image only uniform areas of differing chromaticities, so that the subject outlines appear by simultaneous contrast. Evans and Klute[82] employed the combination of both of these techniques, the formation of contour outlines and of uniform colour patches, with that of the highlight mask, for the creation of a particular type of photographic reproductions, called 'derivations'.

Isohely. Instead of eliminating the luminance modulation in the whole tone scale, it is also possible to suppress it only in more or less important fractions of that scale. Each non-modulated part is then necessarily situated at a different luminance level, so that a stepped reproduction curve results (Figure 1.91). Several techniques yielding this distortion of the tone scale

Figure 1.91. Stepped tone scale of isohelic reproduction.

have been described, among which those by Person[83] and Romer[84] are the best known. In the classical method of Isohely a positive transparency is first obtained from a given negative with identical contrast, and then employed for the printing of several high-contrast intermediate negatives with successively increasing exposures. Each of these new negatives then serves for a small fraction of the total exposure of the final positive, which is thus composed of distinct steps of increasing density.

1.3.5 Extension of the Concept of Tone Reproduction

The preceding discussions concern the reproduction of luminance scales which make subject matter visible. As already stressed in several instances, the precise meaning of the term 'reproduction' in this context is the transformation, by the photographic process, of the scale of the original scene into an objective image of reality. Viewing this image, the observer establishes in his conscience a subjective link between what the scene has probably been and what he perceives on the reproduction. In most cases, however, he has never had occasion to see the original scene, and even if he has, the record in his memory is only fractional.

In numerous applications of photography, mainly technical and scientific, the problem is still more complex. It is in fact often impossible to see the causes of the image, either because they are not accessible even with the help of optical or other instruments, or because they are not simultaneously present in the ultimately recorded array. It is the purpose of the record, however, to well distinguish all details, which is only possible, as has been shown many times during this whole chapter, by an excellent differentiation of tones. During observation of such a picture of the invisible the observer is tempted, by custom as well as by a quite natural reaction, to judge it as if it was a straightforward reproduction of visible reality. The obvious existence of such extrapolation compels us to extend the concept of tone reproduction so that the luminance scale of an image, which is not a 'reproduction' in the proper meaning, could be treated as if it was.

This extended interpretation applies to two different cases. In the first one it is possible, by using more or less involved methods, to measure various parameters, sometimes even photometric ones, of the subject to be recorded. The problem is then comparatively simple: all that is required is to establish the functional relationship between the results of these measurements and the tone scale of the photographic reproduction. This knowledge then allows us to check whether the recorded tone scale really makes the phenomenon under investigation appear. In the other case the 'original subject' cannot be observed otherwise than by the photographic process. If the final result must be improved, this can then only be done by trial and error by starting from the 'image' and working up in the opposite way to its origin. The first

case allows a rational sensitometric solution of the problem; it remains however entirely empirical in the second case.

Typical examples of the first type of problems are photomicrography in visible light, especially phase contrast and interferential microphotography, spectral analysis of invisible radiations, and medical as well as industrial radiography. The second case is well represented by electronic photomicrography, high-speed motion pictures, and by Schlieren photographs, especially ballistical ones.

1.3.5a *Tone Scales in Medical Radiography*

One example of the photographic recording of an invisible but measurable phenomenon, which may serve as an illustration, is that of medical radiography.[85]

The anatomical details modulate the X-ray beam according to their absorption and their thickness, and thus form on the intensifying screen those shadows which compose the radiographic image (Figure 1.92). It is

Figure 1.92. Exposure of a radiograph.

thus necessary to determine the correlation between these absorptions of X-rays, which modify the fluorescence of the screen, and the resulting density differences on the radiograph. As it is very difficult, if not impossible, to measure the absorptions of tissues, blood vessels, muscles, bones, shortly of all parts of a living body, they are compared by photographic photometry to those of a stepped wedge made of a homogeneous material of absorption characteristics similar to those of living tissues, i.e. methyl polymethacrylate

(plexiglass). The substitution of a measurable and accessible element for the studied subject is the key to the solution of this type of problem.

Figure 1.93 shows the structure of such a wedge, focalized towards the source and so stepped in plexiglass thicknesses that the recorded densities are approximately spaced uniformly on the sensitometric curves. The steps

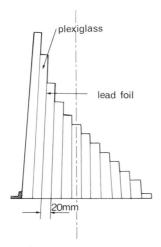

Figure 1.93. Sensitometric step wedge for X-ray exposures.

of the wedge are further separated by thin sheets of lead foil so as to avoid the unwanted action of diffused radiation. The comparison of the photographic effect of this step wedge, and that of the anatomic details is made possible by first establishing the photometric correlation between the luminance scale of the screen, exposed to the X-ray beam through the wedge, and the corresponding scale in the sensitometer, whose lamp–filter combination emits luminous radiation spectrally only resembling that of the screen fluorescence. For the normal case of a calcium tungstate screen, for instance, the incandescent sensitometer lamp has a colour temperature of 2660 K and is employed with a Kodak Wratten filter No. 39 (Figure 1.94). The film is first exposed for a given time in contact with the intensifying screen exposed through the plexiglass wedge, and then another strip of the same film in the sensitometer for the same time.† Identical density values, obtained on both film samples after processing, necessarily result from

† In practical radiography the film is exposed on each of its sides by one of the two intensifying screens contained in the cassette. To imitate this geometry, the sensitometric exposure is carried out by exposing successively each side of the film held against the step wedge: the sensitometric exposure thus becomes equivalent to that in practical use, including the unwanted exposure of each side by the opposite screen (punch-through).

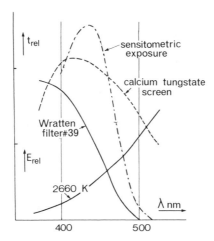

Figure 1.94. Spectral distribution of sensitometric and fluorescent screen exposures.

equivalent exposure illuminations. Those of the sensitometer being known, the illumination of the film through each plexiglass thickness is thus found by use of the sensitometric curve (Figure 1.95).

The spectral distributions of the sensitometric exposure and that by the intensifying screen are, as mentioned before, not identical, but only similar.

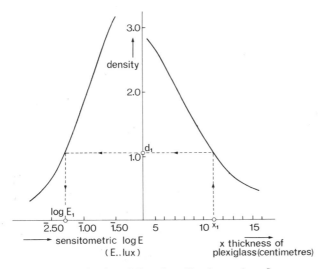

Figure 1.95. Graphical determination of film plane illuminance by a fluorescent screen and a plexiglass step wedge.

The calibration of the plexiglass wedge by photographic photometry therefore requires the validity of the additivity law.[86] As in every photographic exposure, the total effect results from the addition of the effects due to the elementary monochromatic radiations, and replacement of one of these by another is only allowed when the additivity law holds. According to the spectral sensitivity of the emulsion the individual contributions of these elementary monochromatic lights have in fact fixed ratios, and they are additive if—and only if—the replacement of any one of these radiations in the ratio of the corresponding sensitivities by another one leaves the photographic result unchanged at all density levels. A practical check of the validity of this law, carried out in the present case with monochromatic lights of wavelengths of 420 and 460 nm, shows that a normal medical X-ray film adds exposures correctly, so that the described method of calibration of the plexiglass step wedge is entirely satisfactory. This allows us to add scales of plexiglass thicknesses on the axis of abscissae of the standard sensitometric diagram, for each given condition of radiographic exposure (tube voltage and current, exposure time), and thus to correlate density differences

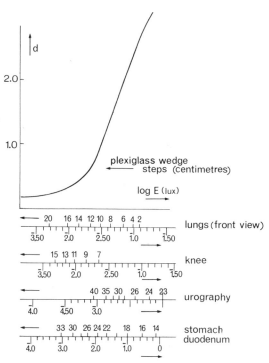

Figure 1.96. Plexiglass step wedge progressions for various radiological examinations.

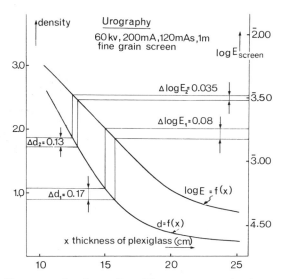

Figure 1.97. Non-proportional recording of fluorescent screen luminance differences.

between diagnostically interesting details with the corresponding log exposure values (Figure 1.96).

Figures 1.97 and 1.98 show the result of such a comparison for two typical cases of medical radiography. In the cases illustrated the urography (Figure

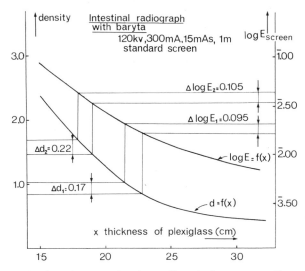

Figure 1.98. Approximately proportional recording of a fluorescent radiographic image.

1.97) does not translate all absorption differences by proportional density differences, but proportionality is observed in the major part of the domain of the recorded luminances in the stomach radiography (Figure 1.98). Considering the density difference of two areas in a radiograph it is thus possible to check whether a specific anatomical detail is correctly 'reproduced', as compared to others, as the same 'equivalent plexiglass thickness' should in the photographic record yield identical or at least very similar density differences.

The knowledge of the correspondence between the absorptions of anatomical parts and those of plexiglass further allows to plot the Jones' diagrams for medical radiography, just as for the reproduction of luminance scales.

In the *objective phase* the energy distribution of the X-ray beam, transformed into a luminance distribution by the intensifying screen, is directly compared to that of the luminance scale of the radiograph on the illuminator. The direct contribution of X-rays to the image on the film need not be taken into account as it is sufficiently small to be omitted. The radiograph being a negative, the objective tone-reproduction curve is identical with the sensitometric curve, calibrated for the exposure by the intensifying screens by the above described method, and oriented the correct way, as the log luminance scale of the radiograph is identical to the density scale taken in the opposite sense (Figure 1.99).

Visual evaluation of the quality of a radiograph by an observer further requires the search of an analogy with the *subjective phase* of tone reproduc-

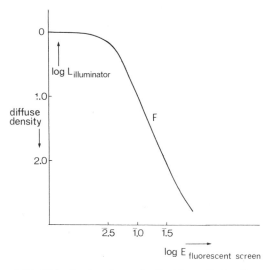

Figure 1.99. Objective tone 'reproduction' in medical radiography.

tion in the visible domain. The modulated X-ray beam being composed of invisible radiation, it is necessary to take as a starting point the information contained in the shadows of the fluorescent image on the intensifying screen. As the problem of the objective phase for this screen has been solved by photographic photometry and the use of a plexiglass wedge, it is now possible to construct a diagram similar to that of the subjective reproduction of a visible subject, in spite of the practical impossibility of seeing the screen under the normal conditions of radiographic practice. Figure 1.100 shows this diagram which gives the relationship between what could be seen on the intensifying screen and what is really visible on the radiograph illuminated by the viewer.

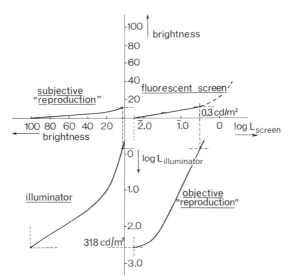

Figure 1.100. Subjective tone 'reproduction' by an X-ray system with fluorescent screens.

1.3.5b *Representation of the Invisible World*

In the above example of medical radiography, which, as already mentioned, is one of the comparatively simple ones, the problem has been reduced to that of the reproduction of the visible world by carrying out a few additional measurements and experiments. It was thus possible to substitute a homogeneous and measurable material for the unaccessible and invisible living parts, and thus to connect the final image to the first instance of the process where visible radiation appears. Similar methods could be imagined for other cases where the initially invisible phenomenon is first transformed, with the purpose of being recorded, into an 'image' of visible radiations, as

for instance in photomicrography or in spectrography, or in the recording of complex phenomena on cathode-ray screens.

In most cases it is not necessary however to resort to such involved investigations as that described above. In visible-light photomicrography for instance, visual adjustment is almost always possible. With some experience it is thus possible to obtain a maximum of details in the photographic record. Without any attempt to describe the detail of other adjustments, it might be sufficient to mention as an example the considerable effect on tone reproduction of the setting of the substage condensor: with too large an aperture the excess of flare light impairs tone reproduction and the image is less sharp than it should be. With too small an aperture the substage condensor reduces the numerical aperture of the microscope lens and not only yields an unsharp image, but also forms unwanted interference fringes which destroy satisfactory tone reproduction across all contours, thus optically creating unrealistic detail. Similarly, in electron microscopy or in Schlieren photography, appropriate adjustment of the instruments can improve tone 'reproduction' so that details which otherwise would be lost, can be made apparent.

In quantitative spectroscopy tone reproduction is of primary importance. Density measurement of spectral lines can only yield correct results when a sensitometric scale of fully known characteristics is also exposed on each film or plate exposed in the spectroscope, so that exact photometry of each spectral line can be carried out by comparing its density with those on the sensitogram. This simple measure is not sufficient, however, when an important fraction of the lines is recorded in the lower part of the sensitometric curve, where the contrast gradient is low: the density differences between certain lines, sometimes rather small, can then be of the same order of magnitude as the experimental error due to the spectroscope as well as to all parameters of the photographic process. It is then also important to obtain a satisfactory tone scale in the domain of interest, important for the spectroscopic investigation considered.

Further examples which could be mentioned are numerous. Their common purpose is to make invisible phenomena appear as images; being photographic, these can only be satisfactory when having an appropriate tone scale. This condition implies correct use of the photographic means, almost always possible with little difficulty by the simple observation of quite elementary rules, such as the correct choice of the sensitive surface, of the time and the other conditions of exposure, and of adequate processing.

What remains fundamental is that an almost invisible detail of an image is inefficient in the transmission of the required information; the concept of tone 'reproduction', taken in a wider sense, is thus just as fundamental for the representation of the invisible as it is in the reproduction of the visible world.

REFERENCES

1 Nelson, C. N., The theory of tone reproduction. In C. E. K. Mees and T. H. James (Eds.), *The Theory of the Photographic Process*, 3rd Ed. Macmillan, New York: Collier-Macmillan, London, 1966, pp. 473 and 476.
2 Jones, L. A., Photographic reproduction of tone. *Jl. O.S.A.*, **5** (1921), 232.
3 Walsh, W. T., *Photometry*, Dover Publications, New York, 1965.
4 Fabry, Ch., *Introduction générale à la photométrie*, Ed. de la Revue d'Optique, Paris, 1927.
5 American Standard PH2-19-1959, *American Standard Diffuse Transmission Density*.
6 McFarlane, J. W., A reflection densitometer. *Jl. O.S.A.*, **24** (1934), 19.
7 Nicodemus, F. E., Directional reflectance and emissivity of an opaque surface. *Jl. of Applied Optics*, **4** (1965), 767.
8 Williams, F. C., Current problems in the sensitometry of color materials and processes. *Jl. S.M.P.T.E.*, **56** (1951), 1.
9 Evans, R. M., Hanson, W. T. Jr, and Brewer, W. L., *Principles of Color Photography*, Wiley, New York, 1953, p. 404.
10 Powers, S. A., and Miller, O. E., Pitfalls in color densitometry. *Phot. Sc. Eng.*, **7** (1963), 59.
11 Pinney, J. E., and Voglesong, W. F., Analytical densitometry of reflection color print materials. *Phot. Sc. Eng.*, **6** (1962), 367.
12 Anderson, C. R., Osborne, C. E., Richey, F. A., and Swift, W. L., Sensitometry of the color internegative process. *Jl. S.M.P.T.E.*, **63** (1954), 143.
13 USA Standard PH 25-1960, *American Standard Method for Determining Speed of Photographic Negative Materials* (*Monochrome, Continuous-tone*).
 British Standard BS 1380, *Method for Determining the Speed of Sensitized Photographic Materials. Part 1—Negative Monochrome Material for Use in Daylight*.
 Norme Française S 20-001, *Photographie. Détermination de la sensibilité et de l'indice de pose des émulsions négatives à haute sensibilité*, September 1954 and modification of June 1963.
 Deutsche Norm DIN 4512, *Photographische Sensitometrie. Bestimmung der Lichtempfindlichkeit von Schwarzweisz-Negativmaterial für bildmässige Aufnahmen*, October 1961.
 U.S.S.R. National Standard GOST 10691-63. *Photographic Materials on Transparent Base. Sensitometry of Photographic and Cinematographic Black-and-White Materials for Various Uses*.
14 Jones, L. A., The evaluation of negative film speeds in terms of print quality. *Jl. Franklin Inst.*, **227** (1939), 297, 497.
15 Grover, W. S., and Grimes, R. L., Improved method for determining the speeds of photographic films by pictorial tests. *Phot. Sc. Eng.*, **11** (1967), 283.
16 Niederpruem, C. J., Nelson, C. N., and Yule, J. A. C., Contrast index. *Phot. Sc. Eng.*, **10** (1966), 35.
17 Jones, L. A., and Condit, H. R., The brightness scale of exterior scenes and the computation of correct photographic exposure. *Jl. O.S.A.*, **31** (1941), 651.
18 Scudder, J. F., Nelson, C. N., and Stimson, A., Re-evaluation of factors affecting manual or automatic control of camera exposure. *Jl. S.M.P.T.E.*, **77** (1968), 24.
19 USA Standard PH2-21-1961, *Speed of Reversal Color Films for Still Photography*.
20 Gibson, K. S., and Tyndall, E. P. T., Visibility of radiant energy. *Sc. Papers U.S. Bureau of Standards*, **19** (1923–24), 131.

21 *Minutes of the 6th Session of the CIE*, (Geneva 1924), p. 67.
22 Wright, W. D., *Researches on Normal and Defective Colour Vision*, London 1946, p. 71.
23 Committee on Colorimetry, Optical Society of America, *The Science of Color*, Washington 1963, p. 223.
24 BUNSEN'S verbesserte Kohlenbatterie und einige Versuche mit derselben. *Ann. d. Phys.*, **60** (1843), 402. See also reference 3 (Walsh), p. 152.
25 Lummer, O., and Brodhun, E., Ersatz des Photometerfettflecks durch eine rein optische Vorrichtung; Ueber ein neues Photometer; and Die Photometrischen Apparate der Reichsanstalt für den technischen Gebrauch. *Zeitschrift f. Instrumentenkunde*, **9** (1889), 23 and 41, and **12** (1892), 41.
26 Breneman, E. J., The effect of level of illuminance and relative surround luminance on the appearance of black-and-white photographs. *P.S.A. Jl.*, **6** (1962), 172.
27 References 3, p. 189, and 4, p. 31.
28 Fechner, G. Th., Uber ein psychophysisches Grundgesetz und dessen Beziehungen zur Schätzung der Sterngrössen. *Abh. der math. -phys. Kl. der Königl. Sächsischen Ges. der Wiss*, **4** (1859), 457.
29 Plateau, M. H., Sur la mesure des sensations physiques, et sur la loi qui lie l'intensité de ces sensations à l'intensité de la cause existante. *Bull. de l'Acad. Roy. de Belgique*, **33** (1872), 376.
30 Munsell, A. E. O., Sloan, L. L., and Godlove, I. H., Neutral value scales. *Jl. O.S.A.*, **23** (1933), 294.
31 Stevens, S. S., On the psychophysical law. *Psychol. Rev.*, **64** (1957), 153.
32 Reference 3, p. 259, and Commission Internationale de l'Eclairage, *Minutes 14th Session*, Vol. A, p. 95, Paris, 1960.
33 Lowry, E. M., and Jarvis, J. G., The luminance of subjective black. *Jl. S.M.P.T.E.*, **65** (1956), 411.
34 Reference 23, p. 230.
35 Grosskopf, H., Der Einfluss der Helligkeitsempfindung auf die Bildwiedergabe. *Kinotechnik*, **17** (1963), 243.
36 Guth, H., Surround brightness: Keyfactor in viewing projected pictures. *Jl. S.M.P.T.E.*, **57** (1951), 214.
37 Knopp, L., Nixon, K. O., and Henderson, S. T., Symposium for screen viewing. *Trans. Illum. Eng. Soc.*, **21** (1956), 199.
38 Ostwald, W., *Mathematische Farbenlehre*; and *Physikalische Farbenlehre*, Leipzig 1923.
39 Richter, M., Das System der DIN-Farbenkarte. *Die Farbe*, **1** (1953), 85.
40 Newhall, S. M., Nickerson, D., and Judd, D. B., Final report of the O.S.A. subcommittee on the spacing of the Munsell colors. *Jl. O.S.A.*, **33** (1943), 385.
41 Ladd, J. H., and Pinney, J. E., Empirical relationships with the Munsell value scale. *Proc. Inst. Rad. Eng.*, **43** (1955), 1137.
42 Weber, E. H., De pulsu, Resorptione, Auditu and Tactu I. In *Annotationes Anatomicae and Physiologicae*, C. F. Koehler, (Ed.), Leipzig 1834.
43 Bouguer, P., *Essai d'optique sur la gradation de la lumière*, Paris, 1729. (Re-edited in *Les maîtres de la pensée scientifique*, Paris, 1921).
44 Abribat, M., Sur le rendu photographique des luminosités. *Comptes rendus des réunions à l'Institut d'Optique*, **6** (1935), 3.
45 Lowry, E. M., The luminance discrimination of the human eye. *Jl. S.M.P.T.E.*, **57** (1951), 187.

46 Nutting, P. G., Effects of brightness and contrast in vision. *Trans. Illum. Eng. Soc.*, **11** (1916), 939.
47 Grosskopf, H., Der Einfluss der Helligkeitsempfindung auf die Bildübertragung im Fernsehen. *Rundfunktechn. Mitt.*, **7** (1963), 205.
48 Stevens, S. S., Measurement and man. *Science*, **127** (1958), 383.
49 Stevens, J. C., and Stevens, S. S., Brightness function: Effects of adaptation. *Jl. Opt. Soc. Am.*, **53** (1963), 375.
50 Hopkinson, R. G., Light energy and brightness sensation. *Nature*, **178** (1957), 1065.
51 Hunt, R. W. G., Light energy and brightness sensation. *Nature*, **179** (1957), 1026.
52 Warren, R. M., and Warren, R. P., Basis for judgments of relative brightness. *Jl. Opt. S.A.*, **48** (1958), 445.
53 Hurvich, L. M., and Jameson, D., The perception of brightness and darkness. In J. Deese and L. J. Postman (Eds.), *Contemporary Topics in Experimental Psychology*, Boston, 1966, p. 6.
54 Marimont, R. B., Model for visual response to contrast. *J. Opt. Soc. Am.*, **52** (1962), 800.
55 Reference 1, p. 475.
56 Bartleson, C. J., and Breneman, E. J., Brightness perception in complex fields. *Jl. Opt. Soc. Am.*, **57** (1967), 953.
57 Simonds, J. L., Factors affecting the quality of black-and-white reflection prints. *Jl. Phot. Sc.*, **11** (1963), 27.
58 Mouchel, P., L'interprétation des couleurs par la photographie noir-et-blanc. *Actes VIIèmes Journèes Int. Couleur*, (1963). The translation of colours into black-and-white photographs. *Jl. Phot. Sci.*, **11** (1963), 291.
59 Reference 1, p. 469.
60 Jones, L. A., and Sandvik, O., Photographic characteristics of sound recording film. *Jl. S.M.P.T.E.*, **14** (1930), 180.
61 Clark, L. D., Picture quality of motion pictures as a function of screen luminance. *Jl. S.M.P.T.E.*, **61** (1953), 241.
62 Jones, L. A., and Nelson, C. N., A study of various sensitometric criteria of negative film speeds. *Jl. O.S.A.*, **30** (1940), 93.
63 Jones, L. A., and Nelson, C. N., Control of photographic printing. *Jl. O.S.A.*, **38** (1948), 897.
64 Morrison, C. A., An objective method of specification for sensitometric curves of photographic papers. *Jl. Franklin Inst.*, **243** (1947), 55.
65 USA Standard PH2-2-1966, *American Standard, Sensitometry of Photographic Papers.*
66 Berghaus, H., Wandlung der Papiergradation durch Zuzatzbelichtung. *Agfa, Mitteilungen aus den Forschungslaboratorien*, Berlin 1958, Vol. 2, p. 198.
67 Eggers, J., Veränderung der Gradation von handelsüblichem Photomaterial durch Kombination von Kurzzeit-und Langzeitbelichtung. *Agfa, Mitteilungen aus den Forschungslaboratorien*, Berlin 1958, Vol. 2, p. 205.
68 French Patent of June 16, 1936, Nr. 815.985.
69 Jones, L. A., Recent developments in the theory and practice of tone reproduction. *Phot. Jl.*, **89B** (1949), 126.
70 Bartleson, C. J., and Breneman, E. J., Brightness reproduction in the photographic process. *Phot. Sci. Eng.*, **11** (1967), 254.

71 Clark, L. D., Mathematical prediction of photographic picture quality from tone-reproduction data. *Phot. Sci. Eng.*, **11** (1967), 306.
72 Goldberg, E., *Der Aufbau des photographischen Bildes.* Halle a.d. Saale, 1926 (2nd ed.).
73 Bello Jr., H. J., Groet, N. H., Hanson, W. T., Osborne, C. E., and Zwick, D. M., A new color intermediate positive-intermediate negative film system for motion picture photography. *Jl. S.M.P.T.E.*, **66** (1957), 205.
74 Beckett, C., Morris, R. A., Schafer, R. K., and Seemann, J. M., Preparation of duplicate negatives using Eastman Color Reversal Intermediate Film. *Jl. S.M.P.T.E.*, **77** (1968), 1053.
75 Kowaliski, P., and Mouchel, P., Negative-positive versus reversal systems. *Jl. Phot. Sc.*, **13** (1965), 125.
76 Hunt, R. W. G., Luminance levels in colour transparencies and reflection prints. *Jl. Phot. Sc.*, **13** (1965), 108.
77 Kowaliski, P., Le rendu des valeurs dans les échelles de couleurs. *Actes des VIIèmes Journées Internationales de la Couleur*, Florence 1963. Tone reproduction in colour scales. *Jl. Phot. Sc.*, **11** (1963), 169.
78 Judd, D. B., *Color in Business, Science and Industry.* New York, 1952, p. 281.
79 Mouchel, P., La reproduction des saturations des couleurs par les procédés photographiques usuels. *3èmes Journées Internationales de la Couleur*, Bruxelles, 1959.
80 Levy, M., Wide latitude photography. *Phot. Sci., Eng.*, **11** (1967), 46.
81 Speck, R. P., An improved masking method for color transparencies. *Jl. P.S.A.*, **11**, (1945), 461.
82 Evans, R. M., Klute, J., and Petersen, D., 'Derivations from color photographs,' in R. M. Evans, *Eye, Film and Camera in Colour Photography.* New York and London, 1959, p. 350.
83 Person, A., *Bildmässige Leica-Photos durch Tontrennung*, Frankfurt a.M., 1935.
84 Romer, W., Isohelie, eine neue Technik der bildmässigen Photographie. *Camera*, **10** (1932), 291.
85 Kowaliski, P., Tone reproduction in medical radiography. *Jl. Phot. Sc.*, **14** (1966), 311.
86 Van Kreveld A., Ein Gesetz für die Schwärzungskurven bei Mischfarben. *Z. wiss Phot.*, **32** (1934), 222.

2

Detail Reproduction

An image which at first appears satisfactorily uniform in sufficiently large areas and whose outlines look sharp, reveals after closer examination a rather non-homogeneous structure, more and more apparent with increasing magnification.

The research of a detail in a portrait (Figure 2.1) may serve as an example. At normal magnification the specular reflections of the spotlights in the eyes of the subject look sharp on the positive print as well as in the original negative. Closer inspection of this detail through a magnifying glass however makes its non-homogeneous structure appear, resulting in a certain graininess as well as in some lack of sharpness. The reflected light spot itself, further magnified, as for instance with a microscope, looks still less homogeneous and compounded of small clumps of silver grains. The filamentary structure of a single grain can finally be seen at the extreme magnification of the electron-microscope. This simple experiment not only allows to discover the discontinuous nature of the image, but also the inadequate definition of its outlines. It further shows to what degrees the evaluation of the various aspects of an image depends on the magnification, i.e. on its purpose.

This example of the image structure resulting from the use of the classical silver halide process reveals several phenomena, the most important being at first sight graininess and sharpness. Had the image also contained some periodic structure, such as the pattern of a fabric or an array of lines, resolving power could have also been judged. The apparently obvious interactions between these phenomena make their study quite difficult; modern methods of investigation however not only allow us to evaluate each aspect quantitatively, but also to study image structure as a whole by one single homogeneous treatment.

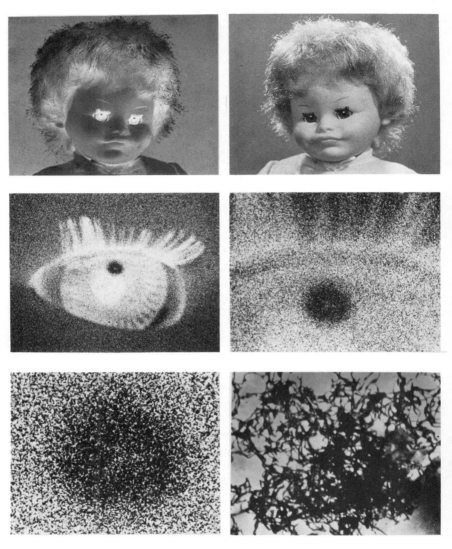

Figure 2.1. The influence of the structure of a photographic image on detail reproduction becomes increasingly apparent with magnification. *Top row:* At normal viewing magnification both the negative and the positive appear sharp and of uniform structure. *Centre row:* At low magnification (left) or when viewed through the microscope (right) granularity as well as lack of sharpness of the image become apparent. *Bottom row:* The structure of the developed image can be studied more completely at still higher magnifications, with the visual (left) or the electron microscope (right).

In the classical photographic system these modern methods have contributed to improve the properties of the materials and thus to adapt them entirely to the various uses. Certain problems, discussed in detail in the older literature, have therefore lost much of their interest, while other problems, such as the relationship between the structure of an image and the information it transfers gain steadily in importance. The results of numerous investigations, carried out mostly for the black-and-white silver halide processes because of their predominance in a not too distant past, apply in many cases also to colour photographic processes, to silver halide systems processed by diffusion transfer, and to a certain extent also to non-silver processes like electrophotography or even those making use of photosensitive polymers. Independently of the differences between the processes the principal aim remains in fact the same: obtention of sharp images or recordings without any apparent grain at the magnification corresponding to the proposed use, and optimum recording of information.

2.1 DEFINITIONS

2.1.1 Granularity and Graininess

Just as in the case of tone reproduction, the evaluation of image structure makes objective and subjective aspects appear simultaneously. The quantitative evaluation of the lack of homogeneity of an image informs us about its objective characteristic, called *granularity*. The appearance of non-uniformity, at sufficiently high magnification, of an area supposed to look uniform, however, is the subjective aspect, called *graininess*. In the customary use of photography it is mainly this subjective aspect which makes itself felt; the knowledge of its relationship to the objective data allows us to solve difficult problems, mainly at the higher limits of magnification or sensitivity.

2.1.2 Resolving Power

In many cases periodic arrays of line or dot patterns are encountered, such as in fabrics, whose structure disappears in the reproduction when the size of their elements decreases below a certain level. The *resolving power* of a reproduction process is defined as the number of lines per unit length which can just be distinguished in the image, supposing that they were perfectly sharp and black or grey on a white background. This definition is obviously that of a subjective criterion, because the choice of the limit of resolution depends on the judgment by an observer; the inherent difficulty of this choice is further increased by the graininess of the image which obscures the appearance of fine lines only slightly different from the background.

2.1.3 Sharpness

The example of the successively more and more enlarged image shows the very relative significance of the subjective concept of sharpness. An image which, at low magnification, looks perfectly sharp, can have unsharp borders at high magnification. As shown in the first chapter (p. 8), this transition of density across an outline is closely related to tone reproduction; it is in fact a function of border and fringe effects which can have various origins. A border for instance between a light and a dark area whose microdensitometric trace has a rather wide zone of transition, and which would thus be judged as being unsharp, can however be sharp through the presence of a border effect of appropriate width. The objective evaluation of the transition between two density levels and its relationship to the subjective aspect of sharpness thus leads to the use of a quantitative criterion, *acutance*, computed from the microdensitometric trace across the border.

2.1.4 Definition of an Image

The definition of an image is a practical concept which encompasses its graininess as well as its sharpness and its resolving power. According to the purpose of a reproduction, any one of these three parameters can be predominant. At very high magnification, for instance, it may happen that sharpness is still satisfactory while graininess has already become excessive. On the other hand it might at first appear that the sharpness of an image should improve with increasing resolving power. These two properties are quite independent, however, so that materials yielding very sharp images have sometimes poor resolving power, while others which allow to separate the lines of a very fine pattern can yield not too well defined images.

2.1.5 The Origins of Image Structure

Independently of the process employed, all problems of image structure have their origin either in the non-homogeneous structure of the sensitive layers, leading to diffusion of the exposing radiation, or in the spreading, within the layer, of the processing solutions or of other image-forming elements, as for instance the dyes in a colour photograph. Image structure is sometimes also influenced by local distortions or lateral contractions of the layer, for instance by imagewise hardening. The diffusion of the exposing light is defined by the point or line spread function; this is the basic element of its quantitative study. The mathematical treatment of the consequences of diffusion of processing solutions is more involved.

2.1.6 The Coherent Treatment of Image Structure Phenomena

Taken separately as in this short enumeration, the various phenomena of image structure, while having common origins, do not seem to lend them-

selves to a coherent treatment. They contribute in common, however, to the transfer of information, i.e. to the recording of signals; it is therefore possible to apply to their study methods initially developed for the solution of problems occurring in telecommunication. In this domain the variable is time; so as to make use of similar methods for the evaluation of images it is thus only necessary to replace time by a conveniently chosen spatial variable. The basic idea of this treatment of the problems is that every function—as for instance the light distribution across a sharp border, or that across the lines of a periodic dark-and-light line pattern—can be represented by an infinite sum of sinusoidal functions. Their amplitudes plotted as a function of spatial frequency (number of oscillations per unit length) yield the *frequency spectrum*. Knowing that a sinusoidal function is invariant to transfer operations, it is therefore only necessary, for the obtention of the *modulation transfer function (MTF)* to measure the transmitted spectrum which yields the response of the system under study. This method can be extended further by making direct use, for the description of the image structure of a material or a process, of the aleatory phenomenon of granularity.

2.2 THE THREE FUNDAMENTAL ASPECTS

2.2.1 Granularity and Graininess

2.2.1a *The Measurement of Granularity*

In the classical photographic process, in black-and-white as well as in colour, the elements of an image or a recording have a granular structure which becomes apparent as soon as the magnification of observation or any other use reaches a certain degree. The perception of this non-uniform structure is of course undesirable because it impairs the quality of the reproduction and therefore limits the usefulness of the recording, intended for the communication or the conservation of information.

The objective evaluation of the degree of non-homogeneity requires the exploration, in a microdensitometer, of a uniformly exposed and normally processed sample. Scanning the sample with a very small luminous spot leads to the appearance of transmittance fluctuations around a mean value from which a measure of the granularity of the light-absorbing deposit may be derived. Figure 2.2 shows a typical recording; inspection reveals that it depends on two parameters: the frequency of the density fluctuations per unit length, and the magnitude of the density variations around the mean. To find a measure of granularity a parameter is required which gives a unique description of these typical characteristics of a material, and which further correlates satisfactorily with the subjective appearance of the resulting graininess.

Figure 2.2. Microdensitometer trace of a uniformly flashed and developed area.

In modern microdensitometers designed for the measurement of granularity, scanning is obtained by rotation of the sample. Figure 2.3 shows the optical system of the instrument described by Jones, Higgins, Stultz and Hoesterey;[1] similar set-ups have been employed by Debot[2] and Frieser.[3] The fluctuations of luminous flux reaching the photomultiplier

Figure 2.3. Granularometer.

tube resulting from the rotation of the sample are directly recorded by an rms voltmeter which measures the standard deviation of the density variations.[4]

A photoelectric method of granularity measurement has been developed

by Frieser.[5] It is based on the variation of the response of photoresistors according to the geometry of the incident radiation. The greater the granularity of the uniformly exposed developed photographic layer exposed onto the cadmium sulphide photoresistor, the more it differs from that due to its exposure to uniform illumination. This change of resistance can serve for the definition of a granularity value.

Many authors have studied the distribution of such density differences relative to the mean; in the older researches the principal problem was to find a measure of these fluctuations which would be independent of the dimensions of the scanning area. A scanning spot whose diameter is of the same order of magnitude as the apparent elements of the granular structure gives rise, in fact, to a maximum of transmittance oscillations; these decrease gradually, however, with increasing scanning spot size and thus follow the pattern of the subjective judgment of graininess which depends on magnification.

A measure of granularity, characteristic of the material and independent of scanning spot size, has been developed by Selwyn.[6] Starting from model structures, Selwyn shows that the distribution of transmittance fluctuations is normal (Gaussian) only when the scanning spot area is much larger than the projection of the individual grains, and when they are distributed by chance and their number per unit volume of the layer is sufficiently large; Selwyn further demonstrates that the corresponding *density* distribution is also Gaussian as long as the density fluctuations remain sufficiently small. Now a normal distribution is entirely defined by the value of its standard deviation σ, expressed in units of the variable, i.e. in our case the standard deviation of density σ_d. The measure of granularity proposed by Selwyn is therefore

$$\mathscr{G} = \sigma_d\sqrt{2a}. \tag{2.1}$$

Measurements carried out with precise modern microdensitometers on very carefully prepared, uniformly fogged and developed samples, confirm this normal distribution of density fluctuations. The validity of Selwyn's relationship[1] has been checked by Higgins and Stultz[7] for several black-and-white negative films; Figure 2.4 shows this experimental relationship at several density levels for a typical fine grain film. For a circular scanning spot of diameter δ equation (2.1) can in fact be written

$$\log \sigma_d = \log \mathscr{G} - \log \delta. \tag{2.2}$$

Selwyn's relationship is thus represented by a straight line of slope -1 in a $\log \sigma_d = f(\log \delta)$ plot.

The parameter σ_d, the standard deviation of density fluctuation distribution, also called root mean square of deviation (rms), further to the validity

Figure 2.4. Plot of Selwyn's granularity function in logarithmic coordinates.

of Selwyn's relationship yields a satisfactory measure of granularity. RMS granularity is the objective criterion which allows classification of negative black-and-white photographic materials according to their graininess aspect, and has further the advantage, due to its analogy with noise in electronic systems, of making it possible to apply to the photographic system the methods of investigation of telecommunication systems.

2.2.1b *Graininess*

Graininess, a subjective measure of the sensation of non-homogeneity of an image, can be evaluated by the method of blending magnification. Varying the magnification, the observer is requested to choose that ratio which corresponds to his judgment of the limit between the appearance of uniformity and of non-homogeneity, with magnification defined as the ratio of the angles subtended when viewing the sample either at a given magnification or with the unaided eye at a distance of ten inches. Graininess is then, by definition, 1000 times the reciprocal of the blending magnification M. Figure 2.5 shows typical results of graininess as a function of density, determined by this method. The maximum values, corresponding to a density level of about 0·3, result from a maximum number of oppositions, at this density level, of micro-areas either entirely transparent or entirely opaque. At higher densities graininess decreases as the image area is more and more covered by agglomerations of grains.

Other methods of graininess measurements have also been proposed, such as that of Romer,[8] carried out by comparisons at high magnification.

Jones' and Higgins' method,[9] based on the structure of the retina, attempts to establish a unique relationship between subjectively determined values

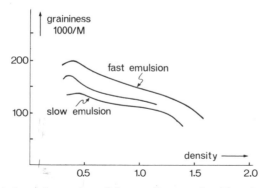

Figure 2.5. Typical graininess values of slow, medium speed and fast photographic layers.

of graininess and those obtained by an objective method. Graininess measurements by the blending magnification method, carried out by Jones and Higgins on a very elaborate set-up,[10] yield the subjective values for the definition of this ratio.

Investigation of the mechanism of retinal vision by Hartline[11] and Granit and Davis[12] shows that the eye responds to the *luminance differences* of neighbouring areas, and that the blending limit is related at each luminance level to a fixed difference of illuminance of two neighbouring cones of the retina. With the purpose of obtaining an objective measure corresponding to these differences the scanning aperture of Jones' and Higgins' microdensitometer is composed of two adjacent circular areas. It thus yields the average density difference for a great number of pairs of adjacent spots in the sample. Jones and Higgins call these density differences *syzygetic density differences*, $S\Delta d$, a term derived from the Greek syzygia, conjugation, to indicate the close contact between the adjacent circular scanning areas. Knowing the blending magnification from the measurement of graininess, it is possible to find *the critical diameter* of these two apertures, characteristic of the difference of illumination of two adjacent cones of the retina, and thus a well defined and objectively measurable value, $\overline{S\Delta d}$, the average *syzygetic density difference*.

A similar experimental method, also based on transmittance differences of adjacent areas, had previously been employed independently by Van Kreveld[13] in his attempt at deriving a quantitative evaluation of graininess by objective measurements.

For uniformly fogged black-and-white photographic silver halide layers, Jones' and Higgins' method yields very satisfactory correlation between graininess determination, as subjectively determined by measuring blending magnification, and the objectively measured values of average syzygetic

density difference $\overline{S\Delta d}$. In this case the agglomerations and overlappings of individual grains are in fact due entirely to a chance distribution. In most applications of photography, however, agglomeration of grains is more accentuated than in the case of a distribution only due to chance, so that various degrees of graininess can be observed, from the finest grain to large-scale mottle resulting from the interaction of several effects, as for instance in one of the simplest cases that of the graininess of the negative and of the positive. To separate each factor in such complex systems, a mathematical generalization is made use of which is based on the fluctuation of the density difference between neighbouring areas, separated by variable distances. This is the autocorrelation function, discussed in detail on page 182.

2.2.1c *Practical Aspects of the Graininess Problem*

Due to the high degree of perfection of modern photographic materials and processes, graininess becomes apparent only in those applications where the original recording must be considerably magnified: extreme enlargement of details in news pictures, in aerial reconnoissance, photogrammetry, space exploration and in microfile recordings. In colour photography graininess makes itself felt only at the highest magnifications in professional and amateur motion pictures. In medical radiography, where the records are examined without any magnification, it is, as will be shown later, rather the mottle resulting from the use of fluorescent screens that is visible; in industrial radiography, on the contrary, graininess is apparent because of inspection under low-power magnification.

When studying the ratio between graininess and granularity of *black-and-white silver halide materials*, Stultz and Zweig[14] found that the appearance of graininess correlates well with the standard deviation of the density fluctuations of a microdensitometer record (rms granularity) when the projection of the scanning area on the retina, at the chosen ratio of magnification, corresponds to a diffusion spot diameter at 50 microns. As already mentioned, graininess depends in fact, for the normally encountered complex granularities, on the magnification of the most current use, so that the scanning area should in principle have an appropriate diameter for each specific use of a given material. In the case of the print of a black-and-white negative film onto a positive film (Figure 2.6), the graininess of the print is at high magnification (small scanning area) that of the positive material, but tends with decreasing magnification (increasing scanning area) towards that of the negative material.[14]

Practical experience shows however that it is easier to class the various materials according to their granularity when all measurements are carried out with a scanning spot of fixed diameter. Such a standardized method, for instance, is employed for the granularity classification of all Kodak products:

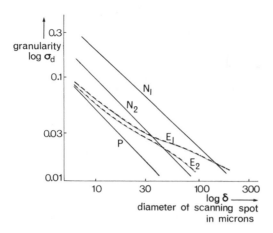

Figure 2.6. Influence of scanning spot size on granularity. Negatives N_1 and N_2, printed on positive material P yield respectively granularities E_1 and E_2.

the scanning area has a diameter of 48 μ, corresponding to 12 × magnification, and the measurements are carried out with an optical system of aperture f/2·0 on samples of an overall density of 1·0. The numerical value of rms granularity is then equal to $1000\sigma_d$, standard deviation of the density fluctuations corresponding to these experimental conditions. It yields the granularity scale of Table 2.1.

TABLE 2.1

Grain	Standard deviation σ_d (rms granularity)
Coarse	$\geqslant 44$
Moderately coarse	35–44
Medium	27–34
Fine	22–26
Very fine	16–21
Extremely fine	6–15
Micro-fine	$\leqslant 6$

It is important to stress that the perception of graininess, while correlating with these granularity values, of course depends on the effective magnification. The above scale applies to 12 × magnification, which is approximately that of the projection of a 16 mm motion picture; when varying the magnification the subjective appearance of graininess of black-and-white images is

approximately proportional to it; it is also proportional, in this case, to the contrast of the positive material.

The standard deviation of the density fluctuations allows us also to define the smallest visible graininess difference. This just noticeable difference of graininess, J.N.D., is approximately equal to a 6 % difference between the rms granularities of two samples, on condition that the graininess is easily visible, i.e. the observation has to be carried out at a magnification definitely above that of blending.

For *colour images* the proportionality between graininess and magnification is less well observed than with black-and-white materials. Dye formation is in fact a secondary process resulting from the primary process of the development of silver halide crystals: oxidized colour developer diffuses a certain distance before reacting with the coupler to form a dye (see p. 457). Zwick[15] has shown that the distribution of dye around each silver grain yields a long slope of diminishing density (Figure 2.7), and further that this

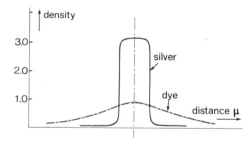

Figure 2.7. Schematic distribution of dye around a silver 'grain' in a colour image.

deposit of dye differs from that forming a black-and-white silver image in being transparent. The resulting relationship between the magnification and rms granularity is therefore very different from that obtained in black-and-white (Figure 2.8). Just as in black-and-white the visible graininess is due to the agglomeration of grains, of a period of about 50 μ, whereas the individual dye clouds have only a diameter of 1 to 3 μ. The principal contribution to graininess is due to the luminance differences of the coloured elements, so that their chromaticity only intervenes through its effect on luminance.[15,16] Zwick and Osborne[17] have further shown that graininess mainly depends on the image structure of the magenta component which absorbs light in the spectral domain where the eye is most sensitive.

Another contribution to graininess of colour films has its origin in an effect of the dyes on the hardening of gelatin.[18] This can give rise to formation

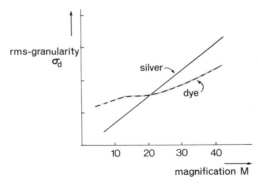

Figure 2.8. Granularity of a dye image as a function of magnification.

of a rough surface, made up of very small monticules above each dye cloud of the upper layer of a colour film. During optical printing in specular light these surface irregularities lead for each 'grain' to a local loss of light which increases the granularity of the print. This effect is similar to that described for scratches or other surface accidents, on page 67 (Figure 1.52).

In *medical radiography* graininess is due to an interaction of the fluorescent screen and the film. Uniform exposure to X-rays yields on the processed film a graininess which, according to Rossmann[19] can be considered to be built up of three components: two of these are due to the screen: *quantum mottle*, by far the most important, results from the spatial fluctuations of the X-ray quanta absorbed by the screen. The second is *structure mottle*, much less important, resulting from eventual non-homogeneities of the screen. These two granularities, of rather great period, are superimposed on the much finer *film granularity*. Neglecting the structure mottle, the standard deviation of the total density fluctuations is therefore

$$\sigma_{d_{total}} = [\sigma^2_{d_{film}} + \sigma^2_{d_{screen}}]^{\frac{1}{2}}. \tag{2.3}$$

It has further been shown that the fluctuations of the number n_X of X-ray quanta around their mean value $\overline{n_X}$, absorbed by unit surface of the screen, vary according to a Poisson distribution. Taking into account this distribution and the photographic gamma of the radiographic film, Rossmann shows that the standard deviation is

$$\sigma_{d_{total}} = \left[\sigma^2_{d_{film}} + (0.43\gamma)^2 \frac{1}{\overline{n_X}}\right]^{\frac{1}{2}}. \tag{2.4}$$

The total graininess of the film–screen system should thus increase with a decreasing number of quanta, i.e. with increasing sensitivity of the film.

On the other hand, Rossmann also shows that the statistical fluctuations and the granularity of the film are not the only factors which act on graininess in medical radiography; it also depends on the image-forming properties of the system, and mainly on its sharpness. To consider the problem as a whole, it is thus necessary to make use of the modulation transfer function (see p. 160).

In black-and-white silver halide systems processed by *diffusion transfer* (see p. 476), the distribution of silver between the negative and the positive, and therefore the resulting granularity, vary considerably from one process to another. These factors have been studied by Tregillus[20] for a process in which the customary ratio of magnification makes graininess an important factor. The film on which the positive image is to be formed carries on a polyester base a hydrophilic layer containing nuclei of physical development. After having been soaked with the processing solution, it is applied against an exposed negative film; the exposed part of the silver halide contained in this latter then forms a negative image, while another fraction migrates into the receiving film, where it forms the positive. The morphology of the silver deposit in the negative as well as in the positive image depends on the one hand on the negative emulsion and the nuclei of the receiving layer, and on the other hand on the composition of the processing solution. This latter resembles a monobath (see p. 444), but it differs from it by the relative kinetics of the development of the exposed silver halide and the temporary solubility of the non-exposed halides, which precipitate by physical development either on the just developed negative silver or on the nuclei of the receiving layer, where they form the positive. Comparing the mass of silver fixed in each of the two layers with their optical density, i.e. by determining the covering power of the deposits (optical density/grams of Ag per dm^3) and by determining on electron micrographs the structure of the silver as a function of density. Tregillus shows in two examples how much the graininess of diffusion transfer systems can vary. In one negative film-receiving film pair yielding high contrast, the rms granularity of the negative is higher than that of the same film processed in the conventional way by immersion, whereas

TABLE 2.2. RMS Granularities of Films Processed Either by Diffusion-Transfer or by Immersion

	Negative processed by diffusion-transfer	Negative processed by immersion	Positive on the receiving layer
High-contrast system	40	29	20
Low-contrast system	20	21	13

another system of low contrast has an rms granularity value of magnitude similar to that obtained in the conventional process. Table 2.2 shows the numerical values of these examples.

2.2.2 Resolving Power

Just as graininess is increasingly apparent with magnification, the quality of reproduction of very fine detail decreases with magnification, which makes it finally entirely disappear in an image. The resolving power of a photographic or optical system is by definition the limit of its reproduction capacity of very fine detail. In optics the objective criterion of this capacity is the separation of two adjacent points in the image plane by a distance equal to the diameter of the first dark ring of the Airy disk; this is the Rayleigh criterion which gives the dependance of the angular separation θ of two points on the radius r of the entrance pupil of the lens and on the wavelength λ of the monochromatic radiation:

$$\theta = \frac{1 \cdot 22\lambda}{2r}. \tag{2.5}$$

The resolving power of photographic systems is, however, rather a subjective concept because it defines the limit of magnification at which very fine detail is still visible in the reproduction. It is expressed by the number of lines (periods) per millimetre which at this limit can still be distinguished, and therefore implies the choice of a limiting value by an observer. Photographic resolving power thus depends on the type of test object, on the characteristics of the apparatus and optics employed to form the reduced image of the test pattern on the sensitive layer, and finally on the conditions of observation.

2.2.2a *The Measurement of Resolving Power*

To judge the recording of very fine detail of various structures, neither necessarily periodic or of geometrical regularity, it is customary to use as traditional test object a crenelate line pattern, also known as Foucault pattern.[21] It is composed of lines of uniform density separated by entirely transparent intervals, and therefore yields a crenelate luminance distribution of only two luminance values L_0 and L_1 (Figure 2.9). In modern test objects of this pattern the widths of the lines and the intervals are equal; this 1:1 ratio is now in general use because it allows comparison of the various results. Sandvik has shown in fact that the numerical value of resolving power is proportional to the logarithm of this space-to-line width ratio.[22] The unwanted effect of flare during exposure of the samples is avoided by the use of transparent lines on a dark background.

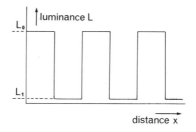

Figure 2.9. Luminance distribution in a Foucault bar pattern.

The density of the background and of the dark lines has a considerable influence on the resolving power; two ratios $\rho = L_0/L_1$ frequently employed, because they correspond to situations often encountered in practice, are 1000 and 1·6, i.e. the lines as well as the background have densities of 3·0 and 0·20 above base and fog density respectively. The latter value has been found particularly advantageous for the evaluation of the quality of photographic systems (Carman and Charman).[23]

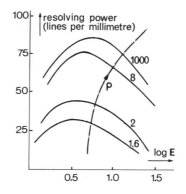

Figure 2.10. Influence of test-object contrast on resolving power.

Figure 2.10 shows an example of the increase of resolving power as a function of test-object contrast.[24] This relationship has been expressed by Sandvik[25] by the equation

$$R = R_\infty(1 - e^{-\alpha D}), \tag{2.6}$$

where R is the resolving power, R_∞ that for infinite object contrast ρ, α a constant and $D = \log \rho$, the density difference between the background and the clear lines; according to this relationship the resolving power is pro-

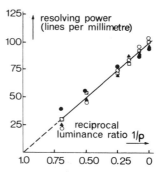

Figure 2.11. Sandvik's resolving-power relationship.

portional to the inverse $1/\rho$ of the luminance ratio (Figure 2.11). Perrin and Altman[24] have shown that this simple relationship is not very often encountered and that it varies rather considerably for different materials, but also that it approaches, on the average, the exponential function of equation 2.6.

The geometry and the general lay-out of the test objects also have a great influence on resolving power. Among the many patterns employed and described in the literature, that of three parallel lines inscribed in a square yields the highest values of resolving power and is therefore now the most employed. Resolving power is in fact approximately proportional to the

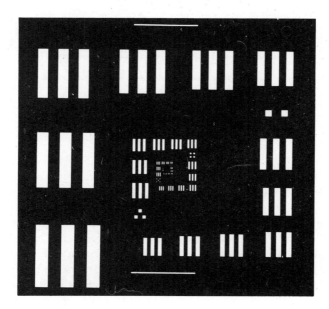

Figure 2.12. Proposed USA-standard resolving-power test object.

logarithm of the length-to-width ratio of the lines for ratios between 3 and 30, and tends towards a limit for higher values.[25] The 1:5 ratio of the three parallel lines within a square thus situates this test object in the advantageous part of that scale. This basic design is recommended for a proposed American Standard (Figure 2.12) whose general layout is derived from one having been thoroughly tested by the U.S. Air Force. In this proposed test object the ratio between the sizes of successive squares of three lines is 20/10 and the squares of decreasing size successively approach the centre, so that those corresponding to the highest resolving power are nearest to the optical axis where the quality of the optical images is at its highest.

Other similar test objects adapted to particular uses of the photographic materials have been recommended for the standardization of microfile film. The National Bureau of Standard of the U.S. recommend a crenelate five-bar test object with equal bars and space widths. A test object with wider spaced bars has been described by Carlu and Ducrocq[27] (Figure 2.13); it corresponds

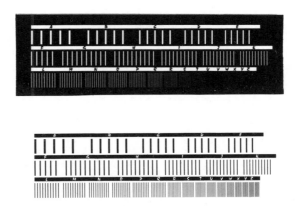

Figure 2.13. Test object with wide bar spacing for evaluation of microfile films.

to patterns most frequently encountered in practice, such as lines or letters, i.e. either dense detail on a clear background or light detail on a dark background. To best reproduce these patterns the width of the bars in the test object is only one fifth of its total period; besides black and grey bars on a white background ($\rho = 16\cdot0$ and $1\cdot6$) it also carries white bars on a black background ($\rho = 16\cdot0$). With the aid of a graph like that of Figure 2.14 these three test-object scales allow a determination, for any given reduction ratio, of the optimum exposure for the simultaneous reproduction of dark and light detail of high contrast ($\mathbf{E_0}$) and they also define an exposure domain yielding satisfactory reduced scale reproduction of lines of a given width in

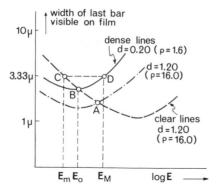

Figure 2.14. Graph for determination of optimum exposure for simultaneous reproduction of dark and light detail.

the original, such as for instance 0·1 millimetre (interval CD between the minimum exposure E_m and the maximum exposure E_M).

Customarily the test object is exposed onto the sensitive layer to be judged by projection in a reduction camera. A simple arrangement employing a reversed microscope has been described by Altman.[28] The transparent original test object is projected by the microscope onto the film to be tested, which is rigidly held in the focal plane by a vacuum back. Focussing is checked with a microcomparator.

Resolving power varies considerably with exposure, but it is practically independent of the processing conditions.[29,30] The exposure which yields maximum resolving power is best described by the corresponding average density. For films employed in aerial photography Levy[31] found the highest values for a diffuse density of 0·85; this density level agrees with the average of values found in other investigations.

The exposed and processed samples are read in a microscope for evaluation. The magnification to be employed is, according to Selwyn,[32] approximately equal to the numerical value of the resolving power (Figure 2.15). A slightly

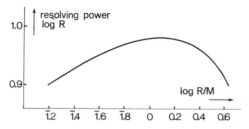

Figure 2.15. Magnification for resolving power determination as defined by Selwyn.

lower magnification however yields higher values, because it makes graininess diminish slightly and thus facilitates the detection of the test-object image. A series of magnification ratios employed in routine measurements have been published by Perrin and Altman.[33] A × 10 occular is permanently used on the microscope but the objectives are chosen according to the resolving power so as to be in agreement with Selwyn's rule (see Table 2.3).

TABLE 2.3

Resolving power (lines/millimetre)	Microscope objective
< 100	× 40
100–300	× 100
300–1000	× 200
> 1000 ('high resolution' plates and films)	× 450

2.2.2b *Interpretation of Resolving-Power Measurements*

The subjective nature of resolving power, very apparent in practice, results from its definition. To a primary luminance distribution of the form of a crenelate function of amplitude E_p (Figure 2.16), corresponds in the

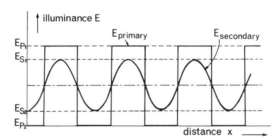

Figure 2.16. Primary bar pattern illuminance and secondary reduced size reproduction luminance distribution.

reduced size reproduction a secondary distribution which is approximately sinusoidal and has limiting ordinates E_{S_1} and E_{S_2}. According to Gretener[34] the ratio of these ordinates is

$$\frac{E_{S_2}}{E_{S_1}} = \left(\frac{1}{2} - \frac{2}{\pi}\sum_{n=1}^{\infty}\frac{1}{n}\exp\left(-\frac{1}{4}n^2\omega^{*2}\right)\right) \bigg/ \left(\frac{1}{2} + \frac{2}{\pi}\sum_{n=1}^{\infty}\frac{n}{n}\exp\left(-\frac{1}{4}n^2\omega^{*2}\right)\right)$$

$$= \left(\frac{1}{2} - A\right) \bigg/ \left(\frac{1}{2} + A\right), \tag{2.7}$$

where n is the rank of the harmonic frequencies of a Fourier series, ω^* a function of the inverse of the test-object period, i.e. of its frequency as well as of the light diffusion in the sensitive layer (see p. 137 and p. 146). The ratio E_{S_2}/E_{S_1} thus tends monotonically towards the limit 1, which it only reaches for $\omega^* = \infty$, i.e. when the frequency of the test object becomes infinite. The crenelate line pattern therefore does not allow us to derive a mathematically defined criterion of the resolution limit. This depends in an empirical manner on the limit of contrast perception by the observer, and on the level of the disturbing graininess.

This fact is well illustrated in a comparison of resolving power with the detection and identification of fine detail on photographic recordings by Carman and Charman,[23] not only for the parallel-line test object, but also for other objects with sharp outlines. In spite of the repetition of the readings up to six times by several well trained observers, and in spite of an agreement among them on precise criterions of measurement, a considerable dispersion of low-contrast resolving-power values was found.

Only a statistical interpretation allows us to avoid this lack of certitude in the determination of resolving power (Brock[35]). Indication of one single figure can in fact only show a central tendency of the results obtained from tests carried out otherwise under identical conditions. Thus the value of 316 lines/millimetre of the example in Figure 2.17 only means that in this case,

Figure 2.17. Example of the statistical distribution of resolving power determinations.

for unit standard deviation σ, $66\cdot7\%$ of the tests yield values between $316 - 20 = 296$ and $316 + 20 = 336$ lines per millimetre, and still more dispersed values according to the statistical distribution within the limits of $\pm2\sigma$ and $\pm3\sigma$, etc.

A method of resolving-power evaluation which not only takes into account this dispersion of measurements, but also the ratio ρ of the test-object luminances, is that described by Perrin and Altman.[33] Average values of several tests are obtained for a series of increasing exposure and plotted above a log ρ axis of abscissae, which also serves for the plotting of the sensitometric characteristic, thus allowing us to judge the corresponding density level (Figure 12.18). In the same graph the resulting resolving-power

Figure 2.18. Determination of resolving power as a function of test-object luminance ratio ρ and of exposure.

maxima are then also plotted as a function of the logarithm of the test-object luminance ratio log ρ; resolving-power values for other test-object luminance ratios can thus be found.

Figures obtained by this method are sufficiently reliable to allow a classification of various materials according to their resolving power. Table 2.4, employed for Kodak films, is typical of such a classification.

TABLE 2.4

Resolving power (lines/millimetre)	Classification	
<55	low	L
56–68	moderately low	ML
69–95	medium	M
96–135	high	H
136–225	very high	VH
>225	extremely high	EH

Independently of such a classification, which only applies to the sensitive layers, various other parameters present during actual exposure can have a more or less pronounced effect on practical resolving power: the influence

of the lens is obvious (see p. 144), just as that of the structure of the elements of the scene to be reproduced; this latter is taken into account, as has been shown, by the use of various test-object luminance ratios, but there are still other parameters, such as the disturbance of the optical image by the atmosphere, or image motion during exposure, which can considerably reduce the measured values. These additional influences are particularly felt in *aerial photography* which remains the most important field of use of resolving power as a quality criterion of detail reproduction. Linear motion of the optical image during exposure, for instance by insufficient compensation of the motion of the aircraft, can have a considerable effect. Figure 2.19

Figure 2.19. Influence of motion during exposure on effective resolving power R relative to static resolving power R_0 (d is displacement).

shows the resulting loss of resolving power, as well as the losses due to periodic vibrations or to random motion (Paris[36]). The curve of this latter type of movement is theoretical and has been computed by Paris supposing a normally distributed disturbance, but it shows the importance of resolving-power degradation by random motion relative to those due to linear motion and to vibrations.

The importance of resolving power in aerial and spatial photography is not only a matter of tradition, but has several reasons:[35] it not only allows us to judge in a simple manner the possibilities of the recording of fine detail by a system or a sensitive surface, but also to form an overall judgment on the combined effects of all parameters transmitting or degrading the information required.

2.2.3 Sharpness, Acutance, Definition

2.2.3a *Sharpness*

The sharpness of an image is a subjective concept related to the evaluation by an observer of the limit of two neighbouring patches which differ either in

luminance or in colour. For the straight boundary in a photographic image sharpness has in fact been defined by Ross[37] as the rate of change of the visual sensation of its luminance in the direction perpendicular to the edge.

2.2.3b *Acutance*

The research of an objective concept allowing a description of this important property of an image is again based, just as for graininess[11,12] (see p. 127), on the visual response mechanism to local luminance differences. The response of the eye to just noticeable luminance differences results in fact, at each luminance level, from a fixed difference in illumination of adjacent cones in the retina. Jones and Higgins[38] derived from this type of response the objective correlate of sharpness, *acutance*, by making use of the concept of luminance gradient sensitivity. Knowledge of the rate of luminance variation across the border serves to determine the elementary gradients of small luminance increments from which acutance is derived.

As in the case of the measurement of resolving power, the acutance test object is very critical as well as very simple: a sharp straight edge pressed against the sensitive layer. After exposure to a specular light beam and development, a more or less well defined limit is obtained, which is then scanned on a microdensitometer (Figure 2.20). As the response of the eye to luminance differences is approximately logarithmic, i.e. according to density difference (see p. 15), the *average density gradient* $\overline{G_d}$ is taken as a measure of the stimulus of sharpness sensation. It is measured over the distance $x_B - x_A$, and the limit between two adjacent areas looks so much sharper as the boundary is narrow. Jones and Higgins[38] therefore proposed to express acutance by the relationship

$$\text{acutance } A = \frac{\overline{G_d}}{(x_B - x_A)}. \tag{2.8}$$

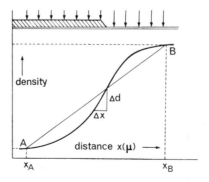

Figure 2.20. Determination of actuance.

As the determination of equal density increments Δd for the direct measurement of the density gradient $\overline{G_d}$ is unwieldy, it is rather the average gradient for equal distance increments Δx which is determined, and acutance is then expressed by the mean square of this gradient, $\overline{G_x^2}$. It can be shown in fact that

$$\frac{\overline{G_x^2}}{d_B - d_A} = \frac{\overline{G_x^2}}{DS} = \frac{\overline{G_d}}{x_B - x_A} \tag{2.9}$$

where DS is the total density difference between the two areas whose delimitation is to be judged for sharpness.[9,38]†

The density interval DS is measured over the whole width within which density variation is perceptible. The limits x_A and x_B are therefore defined by the smallest visible density gradient, which has been found by Jones and Higgins to be 0·005 density unit per micron. In practice the acutance of a given material and process is measured at several density levels by a series of increasing exposures under the straight edge. After recording of the edge traces in the microdensitometer and computation of acutance for each exposure, it can be plotted as a function of density scale (Figure 2.21). These curves confirm that only one quite well defined exposure level yields optimum sharpness, a fact well known from practical experience.

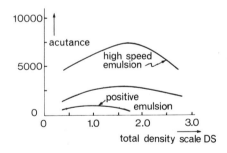

Figure 2.21. Acutance as a function of density scale.

2.2.3c *Definition*

Acutance and sharpness are only partial attributes of a more general concept of image quality. Encompassing the whole of detail reproduction, it is obviously subjective because it is based on human judgment of the appearance of detail. It includes sharpness as well as resolving power,

† In their first paper Jones and Higgins proposed a different definition of acutance: $\overline{G_x^2}$ was to be multiplied by DS and not divided by this value. The formula given here is that published later and confirmed by experience.

graininess and tone scale, and is called *definition*. Due to this complexity and its subjective nature there is no analytical expression which describes definition in terms of all of its parameters. Higgins and Wolfe derived an expression which allows us to take into account the simultaneous influence of acutance and of resolving power for given graininess and tone reproduction characteristics.[40] When all details can be well distinguished under the chosen conditions of observation because resolving power is satisfactory, definition correlates well with acutance alone; low resolving power, on the contrary, acts on definition. The figures obtained by combining both parameters in the equation

$$D = A(1 - e^{-0.007R^2}), \qquad (2.10)$$

where D is definition, A acutance and R resolving power, correlate well with the judgments of definition made by observers of Jones' and Wolfe's investigation (Figure 2.22). Stultz and Zweig[41] demonstrated this possibility of combination of the effects of several parameters in one single psychometric progression for the variables sharpness and graininess. Their results show that the relative influence of each parameter depends on the conditions of the experiment: graininess appears more important to the observers when they judge the total quality than when they specifically evaluate definition.

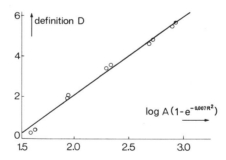

Figure 2.22. Dependence of definition on acutance and resolving power.

Finally, definition not only depends on the characteristics of the sensitive layer and on the quality of the image-forming optical system, but also on the physical and material conditions of exposure and processing: Higgins and Wolfe[40] have shown that the precision of focusing, the depth of field and the angular distance from the optical axis are all factors which act on definition. The relative aperture of the lens during exposure also plays an important part. In most cases an opening one or two stops smaller than the full aperture of the lens yields the highest sharpness. Very small lens openings lead to

diffraction phenomena and thus affect definition, even if they seem at first sight to improve it by an increase of depth of field.

2.3 THE PHYSICAL STRUCTURE OF THE PROCESSED IMAGE

All aspects of detail reproduction or detail rendition—graininess, resolving power, sharpness and definition—which affect the quality of an image or of a photographic recording, have their origins either in the optical behaviour of the sensitive layer during its exposure, or in adjacency effects occurring during processing. Because of the predominance of the classical silver halide process, in black-and-white as well as in colour, these phenomena are best known as they appear in these processes. The origins of image structure in other processes are however sufficiently similar for the descriptions specific to the silver halide systems to remain generally valid, especially when they concern the optical behaviour of the layers during their exposure.

2.3.1 External and Internal Exposure

A photographic layer composed of silver halide embedded in gelatin is opalescent and besides this lightly coloured. Observed in transmitted light, it is not opaque, but milky, because the silver halide crystals, whose refractive index is much greater than that of the gelatin which surrounds them, give rise to multiple refractions and reflections in the layer (Figure 2.23). The resulting

Figure 2.23. Reflection and diffraction in a silver halide crystal of a photographic layer.

diffusion modifies the distribution of the exposing light (or radiation), and thus leads to the distinction between the external exposure, imposed on the layer, from the internal exposure which acts within it to form the latent

image.† In the sensitive layers of films and papers for colour photography, the distribution of internal exposure is due to the same phenomenon, but additional light diffusion occurs through the presence in the layers of couplers and their solvents. Similarly the optical properties of electrophotographic layers, especially those containing zinc oxide or organic photoconductors, are quite similar to those of the silver halide layers. Only the light-sensitive polymers, which form entirely homogeneous layers and do not diffuse the radiations to which they are sensitive, have quite different optical properties and can therefore yield reproductions of microscopic size.

2.3.1a *Light Diffusion in a Heterogeneous Medium*

The dispersion of light by the crystals of a silver halide layer impairs its straight-line propagation. The resulting light diffusion can be made visible by illuminating a rather thick emulsion layer with a very narrow pencil of light, and by observing or photographing the layer, at right angles to the beam, on a high-contrast material (Zeitler[12]). An exposure series thus yields a set of cross-sections of equiluminous surfaces (Figure 12.24).

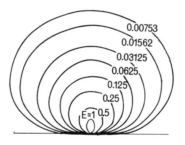

Figure 2.24. Diffusion of visible light in a photographic layer.

The theoretical treatment of this light diffusion must rely on approximations, because Mie's exact theory[43] only applies to one single diffusion by a spherical particle. In this case the angular distribution of the diffused beam, the characteristic (or indicatrix) q_θ, only depends on the ratio a of the radius r of the particle to the wavelength λ of the exposing light, $a = 2\pi r/\lambda$. For very small values of a the forward and backward scattering of light is symmetrical (Rayleigh diffusion). With increasing values of a, however, the amount of light diffused in the direction of incidence increases until the beam finally

† It is important to distinguish these two exposures, taken in relation to the whole layer, from the external or internal latent image which appears in a single silver halide crystal, either on its surface or in its interior.

tends towards the straight pencil fulfilling the conditions of geometrical optics.

Repeated scattering by the large number of crystals encountered by the beam in an emulsion layer rapidly modifies this diffusion characteristic or indicatrix, according to the number of successive light diffusions. Figure 2.25

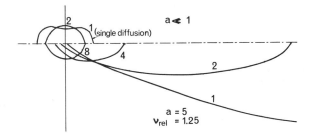

Figure 2.25. Light distribution in the vicinity of a particle as a function of the number of diffusions and the ratio *a* of particle radius to wavelength of light.

shows how the light distribution around a particle becomes almost spherical after only two diffusions for $a \leqslant 1$ (Rayleigh diffusion), but that eight diffusions are necessary for the obtention of a similar characteristic with $a = 5$ and a relative refractive index between the particles and the surrounding medium of $v_{rel} = 1.25$ (Theissing[44]). Total scattering, i.e. a spherical characteristic, results in the general case after a number of diffusions which depends on the ratio *a*. The amount of scatter can be expressed, according to Theissing, by the amount of light diffused at right angles to the incident beam (Figure 2.26).

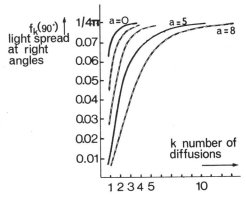

Figure 2.26. Estimation of the ratio *a* of particle radius to light wavelength through the fraction of radiation diffused at right angles to the direction of incidence.

Light scatter within the photosensitive layer modifies the distribution of illuminance imposed by the exposure; as mentioned before, the internal exposure depending on the *spread function* of the layer, therefore differs from the external exposure. The spread function describes the light distribution within the layers of an infinitesimally narrow exposure which, in the uni-dimensional case, is that of an infinitely long line materialized by a long and narrow slit, and in the two-dimensional case, that of a point, obtained in practice by a very small circular aperture. Figure 2.27 shows the general

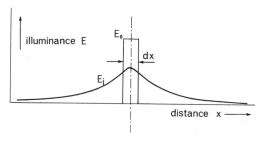

Figure 2.27. General pattern of a line-spread function.

shape of this function in the unidimensional case; various expressions have been proposed to describe it approximately. Among these the Gaussian error function, proposed by Gretener,[34] has a physical meaning. Calling $x-y$ the plane of the coordinate system parallel to the sensitive layer, and z the direction of the incident beam, perpendicular to the layer, this spread function is:

$$A(x, y, z) = \exp -\omega_0^2(x^2 + y^2) - \omega_{0z}^2 z^2 = \exp -\omega_0^2 r^2 - \omega_{0z}^2 z^2 \qquad (2.11)$$

in which ω_0 and ω_{0z} are constants depending on the degree of light scatter in the layer. This function yields prolate spheroids about the axis z (ellipsoids of rotation) as surfaces of constant illuminance; these can be made to approach the shape of computed and observed distributions by introducing two different constants ω_{+0z} and ω_{-0z} for forward and backward scattering. They thus describe very satisfactorily the effective light distribution in the layer (Figure 2.28). Other approximations have also been proposed such as that by Sayanagi[45]

$$A(x, y) = \frac{1}{2\pi\sigma^2} \exp (x^2 + y^2)^{\frac{1}{2}}/\sigma \qquad (2.12)$$

in which σ is also a constant characteristic of the diffusion. Simpler approximations with linear exponents of the form $A(x) = e^{-\omega_0 x}$ are less satisfactory as they lead in the two-dimensional case to the expression $A(x, y) = e^{-\omega_0(x+y)}$, introducing a non-realistic asymmetrical distribution about the axis;

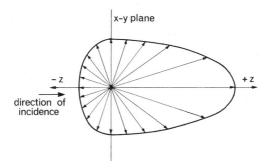

Figure 2.28. Light distribution within the photographic layer.

$A(x, y)$ = constant implies in fact $(x + y)$ = constant, i.e. a diffusion which would vary around the axis of the beam.

2.3.1b *The Distribution of Internal Exposure*

An element of external exposure $E_0\,dx$ at x_1, further to the symmetry of the spread function $A(x)$, yields at $x_0 = 0$ an internal exposure E_i identical to that which results at x_1 from an internal element $E_0\,dx$ at x_0 (Figure 2.29).

Figure 2.29. Determination of internal exposure.

For the case of uniform exposure, E_0 = constant, the effect of all elements $E_0\,dx$ at $x_0 = 0$ is obtained by integration of $A(x)$ over the whole exposed area (Gretener[34]); with

$$dE_i(x) = K A(x) E_0\,dx \qquad (2.13)$$

the internal exposure is

$$E_i(x_0) = 2 \int_0^\infty dE_i(x) = 2KE_0 \int_0^\infty A(x)\,dx \equiv E_0. \qquad (2.14)$$

This yields for the constant K

$$K = \frac{1}{2 \int_0^\infty A(x)\,dx} = \frac{1}{2F(\infty)} \qquad \left(\int_0^x A(x)\,dx = F(x) \right) \qquad (2.15)$$

and

$$dE_i(x) = E_0\,dx\frac{A(x)}{2F(\infty)}. \qquad (2.16)$$

Figure 2.30. Distribution of internal exposure for an arbitrary distribution of external exposure.

In the general case of an arbitrary distribution of external exposure, the internal exposure can be found in a similar way by convoluting the external exposure $E_0(x)$ with the spread function $A(x)$. This gives (by omitting the constant factor $1/2F(\infty)$)

$$E_i(x) = \int_{-\infty}^{\infty} E_0(x - \xi)A(\xi)\,d\xi. \qquad (2.17)$$

An important special case is that of the sharp border, chosen as a criterion of sharpness evaluation for the computation of acutance and materialized by a sharp straight edge applied against or projected onto the sensitive layer (p. 142). In this case the internal exposure is equal to the integral of the spread function

$$E_i(x) = \int_{x_0}^{\infty} A(x)\,dx, \qquad (2.18)$$

represented graphically by the transition curve (Figure 2.31). This makes it possible to determine $A(x)$ by exposing with a straight edge and by scanning the image, after processing, in the microdensitometer across the border. As the resulting edge trace represents the integral of the spread function, this latter is the differential of the edge trace.

$$A(x) = \frac{dE_i(x)}{dx} \qquad (2.19)$$

and thus yields its slope. This method has been applied in practice.[46]

Figure 2.31. Internal exposure resulting from straight-edge luminance distribution.

Another very important external exposure is the sinusoidal light distribution (Figure 2.32) of amplitude E_a and spatial frequency v, oscillating around the mean value E_m

$$E_0(x) = E_m + E_a \cos 2\pi v x. \qquad (2.20)$$

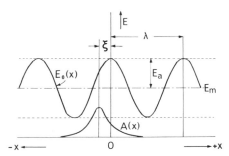

Figure 2.32. Sinusoidal exposure distribution $E_0(x)$ and spread function $A(x)$.

Substitution in equation (2.17) yields, for the corresponding internal exposure

$$E_i(x) = E_m \int_{-\infty}^{\infty} A(\xi)\, d\xi + E_a \int_{-\infty}^{\infty} A(\xi) \cos 2\pi v(x - \xi)\, d\xi. \qquad (2.21)$$

The sinusoidal light distribution is interesting because of its mathematical simplicity; during the process of photographic reproduction it remains in fact sinusoidal in all linear transformations and varies only in amplitude. It is therefore basic for the treatment of image-structure problems by Fourier analysis, discussed in detail at the end of this chapter (see p. 160).

For a periodic light distribution the modulation of the internal exposure diminishes with increasing frequency of the external exposure, whether

sinusoidal or crenelate (Pinoir[47]). The modulation of the external exposure being

$$M_0 = \frac{E_{0\,max} - E_{0\,min}}{E_{0\,max} + E_{0\,min}},$$

and that of the internal exposure

$$M_i = \frac{E_{i\,max} - E_{i\,min}}{E_{i\,max} + E_{i\,min}},$$

the reduction factor of the modulation is $\alpha = E_i/E_0$. Frieser computed this factor, choosing the spread function with linear exponents

$$A(x) = \frac{2 \cdot 3}{k_1} \rho 10^{-2(x)/k_1} + \frac{2 \cdot 3}{k_2}(1 - \rho)10^{-2(x)/k_2}, \tag{2.22}$$

in which the first term represents the light scatter in the layer, and the second, further to the very low magnitude of k_2, the practically non-scattered fraction of the incident light which contributes to the internal image.[48] In many cases light diffusion in the layer is sufficient to make this second contribution to the internal image negligible, and the spread function then reduces to the simpler form initially employed by Frieser:[49]

$$A(x) = \frac{2 \cdot 3}{k} 10^{-2(x)/k}. \tag{2.23}$$

For $k = 20$ the variation of α as a function of the periodicity r of the test object is shown by the curve in Figure 2.33.

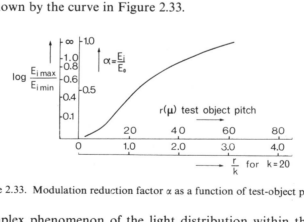

Figure 2.33. Modulation reduction factor α as a function of test-object pitch r.

The complex phenomenon of the light distribution within the diffusing layer has been treated by Metz[50] and also by Pitts[51] by considering the problem of the internal exposure as in application of radiation transfer;[52,53] this method makes it possible to compute the internal illuminance $E(z)$

within the depth z of a layer of thickness h from its transmittance $T(h)$ and its reflectance $R(h)$ prior to exposure, by taking in account the statistically distributed multiple reflections. Separating the loss of incident flux into its two fractions, eliminated either by diffusion or lost by absorption, Metz determines the total extinction coefficient $K_e = K_s + K_a$, where K_s is the diffusion coefficient and K_a the absorption coefficient, and then shows that two constants only, K_a and $K_p = K_e - (K_e - K_a)\overline{\cos \gamma}$ are sufficient to yield a closely approximating description of the diffusing medium, $\cos \gamma$ being the average cosine of the angle of diffusion.[54] Applying further the Monte-Carlo equations to this problem, which allows us to follow a great number of statistically independent photon trajectories, Metz devised a method for the computation of the line spread function and obtained results closely resembling exponential functions, in accordance with Frieser's equations (2.22) and (2.23). This method also allows the computation of the coefficient k of equation (2.23) from the reflectance and transmittance factors of the layer; as these vary with wavelength it follows that k is not a constant but also dependent on wavelength.

The practical effects of light scatter within the layer are numerous and will be discussed for each particular application in the last part of this chapter. Variation of the internal exposure according to the size of the pattern or object to be recorded modifies the density relationship in the image, so that the density difference of a detail and the background decreases with its size. Figure 2.34 shows the example of a microdensitometer trace of dark lines on a clear background and of transparent lines on a dark background.

Figure 2.34. Influence of line width on detail reproduction.

Due to the lateral spread of internal exposure by the sideward diffusion of the exposing radiation, the width of a detail of given dimensions, as for instance of a line of exactly known width, also varies with exposure. The ratio of the recorded dimension to that of the external exposure is involved however, because the edge traces of the borders influence the result. Figure 2.35 shows the result of an exposure series of a slit of fixed width. The limits

as seen by an observer under appropriate magnification, are shown by small circles.[55]

actual width

Figure 2.35. Widening of a line with exposure.

A method for the evaluation of the quality of microphotographic reproductions based on this change of apparent size has been developed by Carlu.[56] It applies to all reproduction systems yielding 'all or nothing', i.e. all those

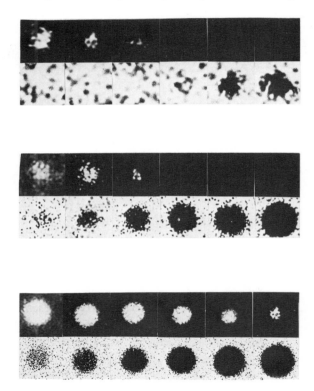

Figure 2.36. Exposure scale test object for the evaluation of detail reproduction in microphotography. *Top:* Object diameter 5 microns, magnification × 1250. *Middle:* Object diameter 11 microns, magnification × 550. *Bottom:* Object diameter 31 microns, magnification × 200.

which have only two luminance levels such as phototypesetting, the repro-
duction of halftone images or of fine line copy, trace photography in bubble
chambers and the preparation of masks for microelectronics. The test object
for the determination of the quality of the photographic systems employed
in these domains comprises two series of six circular patches, one light on a

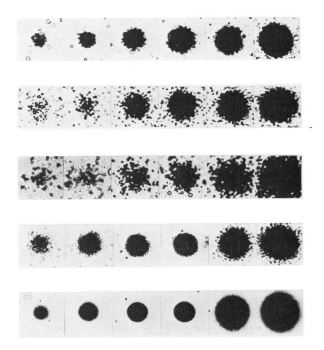

Figure 2.37. Evaluation of microphotographic reproduction quality with the exposure scale test
object. *Top row:* Halftone duplicating film. *2nd row:* Phototypesetting film. *3rd row:* Rapid
cathode-ray tube recording film. *4th row:* Microfile film. *5th row:* High-resolution film for
microelectronics and scientific photography.

dark background and the other dark on a light background, exposed by
exposure steps of 0·05, 0·10 or 0·20 log E. The size of the patches is chosen
according to the proposed use of the photographic material; Figure 2.36
shows a result obtained with patches of diameters of 5, 11 and 31 microns, and
Figure 2.37 shows the comparison of several films evaluated with patches of a
diameter of 11 microns; the widely varying effects of the exposure level on
various photographic materials is very striking.

By its non-uniform distribution within the depth of the layer, the developed
image can be considered as a tridimensional recording medium; the total

thickness of the layer can indeed be subdivised into 'elementary layers' each of which carries a different image. Berg[57] has shown that the internal exposure first increases upon penetration under the surface and then decreases rapidly. The modulation transfer functions (see p. 160) of the elementary layers vary in consequence. The global effect of light diffusion on this function and its relationship to the initial structure of the layer have been studied by Frieser and Kramer.[58]

2.3.2 Adjacency Effects

The second principal reason for the geometrical difference between the light distribution applied to the sensitive layer during its exposure and the image recorded after its processing, is, as has been shown before, the diffusion of the active species of the developer. The exchange of developer which has reacted with the exposed parts of the layer, and fresh solution, not only takes place depthwise but also within the sensitive layer parallel to its surface. During development fresh developer diffuses from non-exposed areas into strongly exposed ones, which furnish in exchange reaction products, mainly oxidized developing agents, retarding anions, and hydrogen ions which decrease the pH (see p. 434). These exchanges influence the kinetics of direct development, and to a certain extent also those of solution physical development.

2.3.2a *Border and Fringe Effects*

The principal migrations of developer components, as well as the micro-densitometer trace of the reproduction of a sharp border in the presence of adjacency effects, are schematically shown in Figure 2.38. Two effects can be observed: in the high-density region the density increase near the limit

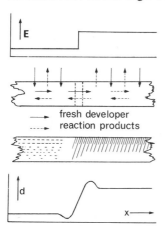

fresh developer
reaction products

Figure 2.38. Action of the migration of active and inhibiting species in the developer.

yields the *border effect*, whereas the density decrease along the limit of the less dense area gives the *fringe effect*. Both effects, when not exaggerated, contribute to an increase of acutance, and therefore of sharpness.

A typical result of this migration of reaction products is the Eberhard effect.[59] Discovered in 1912 in astronomical photography, it was studied by the exposure of circular areas whose diameters varied from 0·3 to 30 milli-metres, and which were as much denser as they were smaller (Figure 2.39).

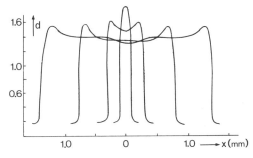

Figure 2.39. Eberhard effect.

A further decrease in size below a certain limit, however, diminishes the density again, further to the lowering of the internal exposure by the light diffusion in the layer. The Eberhard effect, not only of historical interest in astronomy, has a great practical importance for the evaluation of the intensities of spectrum lines by photographic photometry (see p. 114), because it acts on the recorded densities.

Another effect due to the inhibition of development by reaction products is the exaggerated separation of two very close lines of minute areas. The developer, more exhausted within these lines or areas than in their environ-ment, reduces the density by diffusion into the interval. This effect, discovered by the Polish astronomer Kostinsky carries his name.[60]

Gelatin hardening effects can also lead to displacement of small details. In certain developers the oxidized developing agent hardens the gelatin (see p. 468); this tanning action contracts the layer in areas of high exposure laterally as well as in its thickness, according to the internal exposure. The resulting distortion of the layer modifies the location of small details. This effect, formerly also very important in astronomy, was discovered and studied by Ross.[61] It has now lost its importance due to the forehardening in manufacture of the layers of modern products, and further also due to the presence in most developers of a sulphite content sufficient to inhibit the formation of developer oxidation products which would have a hardening action.

2.3.2b *The Quantitative Effect of Adjacency Phenomena*

The complexity of the simultaneous exchange of several chemical species by diffusion, strongly influenced by the type and degree of agitation during development, proves that the quantitative treatment of adjacency effects is involved. It requires a non-linear mathematical model taking into account many factors, including also covering power, i.e. the ratio between the density and the mass of developed silver. For the solution of this problem Nelson[62] introduced a supplementary spread function, to be added to that describing the light diffusion in the layer (Figure 2.40). The ratio of the areas under each of these two curves is an indication of the importance of the adjacency effect.

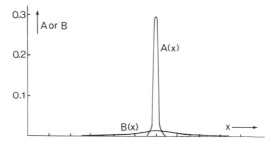

Figure 2.40. Light spread function $A(x)$ and developer spread function $B(x)$.

Without such an effect the area a_B under curve $B(x)$ is zero, but can attain, with a quite pronounced effect, about 0·2 to 0·3 of the area under curve $A(x)$, the light-spread function of the layer. This separation of the two diffusions, that of the light during exposure, and that of the developer solution during development, allows the computation of the density distribution resulting from a given external exposure $E_0(x)$. Equation (2.17) yields the internal exposure $E_i(x)$ from which it is possible to determine, together with the large area sensitometric characteristic $d = f(\log E)$, the density values which would result without any adjacency effect. Introducing the chemical spread function $B(x)$ Nelson determines the approximate density distribution in the presence of such an effect from the equation

$$d'(x) = \frac{d(x)}{1 - a_B} - \int_{-\infty}^{\infty} B(\xi)\frac{d(x - \xi)}{1 - a_B}\,d\xi, \qquad (2.24)$$

in which $d(x)$ is the density which would have been obtained without an adjacency effect. As shown in the example of Figure 2.41, this formula, which only takes into account the non-linearity of the sensitometric relationship $d = f(\log E)$, already yields a good approximation to the Eberhard effect.

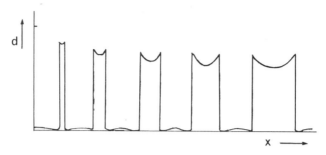

Figure 2.41. Eberhard effect computed from equation (2.24).

To include also those non-linearities which are either due to the covering power or to the difference between the magnitude of the border and fringe effects—the former being almost always more important than the latter—Nelson developed the more precise relationship

$$d'(x) = d(x)\left[1 + \frac{a_B d(x)}{1 - a_B}\right] - \frac{d(x)}{1 - a_B}\int_{-\infty}^{+\infty} B(\xi)\, d(x - \xi)\, d\xi. \quad (2.25)$$

2.3.2c *The Practical Importance of Adjacency Effects*

Adjacency effects have a strong influence on the quality of photographic recordings, mainly because of the resulting sharpness improvement. Sharpness being a subjective concept, the widths of the fringes due to these effects must be small enough to not become objectionable, but just sufficient to increase the acutance enough for a sensation of crispness. In modern processes this condition is adhered to by the precise adjustment of emulsion-process interaction, essentially by the exchanges of the active species of the developer, due to its chemical formula as well as to the physical parameters of development, agitation and temperature (see p. 446). To obtain optimum results it is therefore very important to carefully observe the working instructions concerning these parameters.

The lateral diffusion of the developer reaction products, or of an excess of fresh developer, can also have detrimental consequences. If, for instance, the film is held vertically in the developer without any agitation, gravitation effects can lead to the underdevelopment of zones situated just below highly exposed areas or, on the contrary, to overdevelopment in the opposite case. Directional effects of this kind are also encountered in continuous-processing machines, for example in the proximity of the perforations of motion-picture films.

A particular form of diffusion phenomena, infectious development, plays an important part in graphic reproduction. Developers with a very low

content of free sulphite serve for the obtention of the highest sharpness of halftone dots. The developer oxidation products locally accelerate development and thus yield extreme microcontrast. The mechanism of this reaction, discovered by Yule[63] is described in detail on page 433.

2.4 HARMONIC ANALYSIS OF DETAIL REPRODUCTION

The various aspects of image structure, graininess, resolving power and sharpness, have until now been discussed separately, such as they appear at first sight to an observer. The independent treatment of each of these three phenomena is not only justified by their intrinsic nature—and therefore for historical reasons—but it also results from the methods of investigation employed in each specific case. The use of the apparently most severe experimental method—microdensitometry for the evaluation of granularity, a high-contrast crenelate test object for the measurement of resolving power, and a straight edge applied against the sensitive layer for the evaluation of sharpness—clearly differentiates these three aspects and prevents consideration of their mutual interactions. However, as has been mentioned a number of times, application to image structure of methods developed for telecommunication and, in a more general way, for the transfer of information, allows a more coherent treatment. This makes it possible to judge the behaviour of a reproduction process by taking into account all factors, comprising the optical system as well as all other parameters which act on the final result.

2.4.1 The Modulation Transfer Function

The most general treatment of image-structure problems is based on the application of harmonic or Fourier analysis; a small number of functions only are invariant, in fact, to transformations resulting from the transfer of information-carrying signals. Among these the sinusoidal functions are the only ones which have for the photographic case a practical significance, and it is very convenient, therefore, to transpose the form of a straight edge, for instance, or of a crenelate test object, mathematically difficult to handle, by its Fourier transform.†

2.4.1a *The Invariance of a Sinusoidal Exposure*

A ray of normal incidence yields in the sensitive layer, further to the homogeneous dispersion and the aleatory position of the sensitive crystals, an internal exposure distribution which is perfectly symmetrical around its axis. Based on this symmetry of the spread function $A(\xi)$ Gretener[34] has

† Other functions which would remain unchanged are $f(x) = a \cdot e^{-bx}$ for $0 < x < \infty$, and in a more general manner $f(x) = a \cdot e^{-bx^2}$; therefore also the function $f(x) = \sin h(b \cdot x)$.[32,64]

developed a straightforward demonstration of the invariance, during its
recording, of a sinusoidal distribution of illumination. Relative to the point
of incidence $P(0)$ the external exposure to the right of P (Figure 2.42) is in
image space

$$E_0(\xi_1) = E_m + E_a \cos (2\pi\nu\xi_1 - x), \tag{2.26}$$

and that to the left of P is

$$E_0(\xi_2) = E_m + E_a \cos (2\pi\nu\xi_2 + x). \tag{2.26a}$$

Figure 2.42. Invariance of a sinusoidal light distribution during photographic recording.

Because of the symmetry $A(\xi_1) = A(\xi_2)$ the two external exposures can be
overlaid by pivoting $E_0(\xi_2)$ around $P(0)$ onto $E_0(\xi_1)$, as in the treatment of the
internal exposure distribution on p. 149. This yields

$$\begin{aligned}
2E_0(x) &= E_0(\xi_1) + E_0(\xi_2) \\
&= 2E_m + E_a[\cos (2\pi\nu\xi_1 - x) + \cos (2\pi\nu\xi_2 + x)] \\
&= 2[E_m + E_a \cos x \cos 2\pi\nu\xi]. \tag{2.27}
\end{aligned}$$

Equation (2.27) represents an external sinusoidal distribution in ξ whose
amplitude is a function of x. The internal exposure being, according to (2.17)

$$E_i(\xi) = K \int_0^\infty E_0(x)A(\xi) \, d\xi, \tag{2.28}$$

substitution of equation (2.27) yields

$$E_i(\xi) = 2K\left[E_m \int_0^\infty A(\xi) \, d\xi + E_a \cos x \int_0^\infty A(\xi) \cos 2\pi\nu\xi \, d\xi, \right. \tag{2.29}$$

and further substitution of the value of the constant K from (2.15), $K = \frac{1}{2}\int_0^\infty A(\xi)\, d\xi$,

$$E_i(\xi) = E_m + E_a \cos x \frac{\int_0^\infty A(\xi) \cos 2\pi v\xi \, d\xi}{\int_0^\infty A(\xi)\, d\xi}$$

$$= E_m + E_a \rho(v) \cos x. \tag{2.30}$$

The internal exposure is therefore sinusoidal like the external exposure, but its amplitude is reduced by the factor ρ which is a function of the spatial frequency v,

$$\rho(v) = \frac{\int_0^\infty A(\xi) \cos 2\pi v\xi \, d\xi}{\int_0^\infty A(\xi)\, d\xi}. \tag{2.31}$$

The function $\rho(v)$ which, for a given photographic system, describes the change of modulation of a sinusoidal distribution of illumination, is the *modulation transfer function*, currently abbreviated as *MTF*.

Other demonstrations of the invariance of the sinusoidal function in the course of an information transfer have been given by Frieser and Pistor,[65] Selwyn[32] and Lamberts.[66] Lamberts' demonstration is more rigorous than that presented here, as it also includes the variation of the phase angle Φ. Because of the symmetry of the spread function $A(\xi)$, however, there does not occur any phase shift in a photographic system, but it must be taken into account in an optical system for the computation of the light distribution by a lens in the case of oblique incidence.

The physical significance of the modulation transfer function is schematically shown in Figure 2.43 through its connection to the relationship between the internal and external exposures.[73] If $A(\xi)$ is the spread function of a photographic system, and the $E_0(x)$ functions the light distributions applied to the layer by a sinusoidal test object of increasing spatial frequencies, then the $E_i(x)$ functions represent the corresponding internal exposures. Their reduced amplitudes, plotted in the lower graph as a function of spatial frequency v yield the modulation transfer function of the system.

2.4.1b *Image Structure and Modulation Transfer Function*

The physical meaning of a *modulation transfer function*, as for instance that represented in Figure 2.43, is exactly the same as that of an optical absorption spectrum or of the response function of a pass-band filter in electronics. It describes in fact, just as these other functions, the amplitudes loss of sinusoidal signals (sinusoidal light distributions) as a function of frequency through the transmission by the reproduction system.

Figure 2.43. Graph showing the physical meaning of the modulation-transfer function.

The function $E_0(x)$, which represents the exposure distribution of illumination, can be expressed by a trigonometric polynomial[67,68,34] of the form

$$S_n(x) = \tfrac{1}{2}a_0 + \sum_1^n (a_n \cos nx + b_n \sin nx), \qquad (2.32)$$

where a_n and b_n, the amplitudes of the harmonics, are given by the equations

$$\left. \begin{aligned} a_n &= \frac{1}{\pi} \int_{-\pi}^{\pi} E_0(x) \cos nx \, dx \ (n = 0, 1, 2, \ldots, n), \\[4pt] &\text{and} \\[4pt] b_n &= \frac{1}{\pi} \int_{-\pi}^{\pi} E_0(x) \sin nx \, dx \ (n = 0, 1, 2, \ldots, n). \end{aligned} \right\} \qquad (2.33)$$

It is often convenient to use the complex form for the polynomial as well as for the amplitudes of its harmonics:

$$S_n(x) = \sum_{-\infty}^{\infty} C_n e^{inx}, \qquad (2.34)$$

$$C_n = \frac{1}{2\pi} \int_{-\pi}^{+\pi} E_0(x) e^{-inx} \, dx. \qquad (2.35)$$

Each term of the sums in the right-hand members of (2.32) and (2.34) being periodic, $S_n(x)$ is also periodic, and the polynomials can therefore be an approximation only for periodic light distributions $E_0(x)$ of period 2π. This makes it necessary to limit the approximate function $S_n(x)$ to the interval $(-\pi, \pi)$ and to consider $E_0(x)$ to be periodic outside of this interval and therefore defined by the equation $E_0(x + 2\pi) = E_0(x)$.

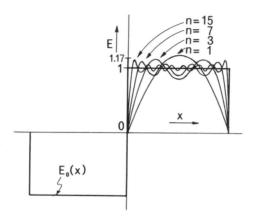

Figure 2.44. Restitution by Fourier series of a periodic crenelate bar pattern light distribution.

Figure 2.44 shows the example of the light distribution corresponding either to a straight edge or to a periodic crenelate pattern, i.e. the function $E_0(x) = -1$ in the interval $-\pi < x < 0$ and $E_0(x) = +1$ for $0 < x < \pi$. In this case the series is

$$S_n(x) = \frac{4}{\pi}\left(\frac{\sin x}{1} + \frac{\sin 3x}{3} + \cdots + \frac{\sin (2n - 1)x}{2n - 1}\right). \tag{2.36}$$

The successive approximations of the straight-edge distribution by this series for $n = 1, 3, 7, 15$ and ∞ are shown in Figure 2.44.

This example of decomposition of the external light distribution $E_0(x)$ into a finite number of harmonics allows us to show the principle of the computation of the internal exposure $E_i(x)$ in a given photosensitive layer by the use of the modulation transfer function $\rho(v)$. All that is necessary is to multiply the amplitudes a_n and b_n of the harmonics with the corresponding distinct values $\rho(nv)$. This yields

$$E_i(x) = E_m + \sum_1^n [a_n\rho(nv) \cos nx + b_n\rho(nv) \sin nx]. \tag{2.37}$$

This comparatively simple solution is however not of enough general validity to be satisfactory for the study of the more important cases of image structure. The example of Figure 2.44 not only shows that the convergence of $S_n(x)$ towards $E_0(x)$ with the increase of the number of terms is slow, but it also shows the effect of a discontinuity of the initial function $E_0(x)$ on the increase of the amplitude of the oscillations in its neighbourhood. Even with an infinite number of terms there remains for the ordinate of the discontinuity $E_0(0)$ a non-negligible difference, $S_n(0)$ being ± 1.17 in that case.[68] This is the Gibbs phenomenon whose effect can be attenuated by several methods, such as those of the arithmetic mean or of the sigma factors,[69] both applied in the examples at the end of this chapter (p. 194).

To avoid this difficulty, and also to allow a very general treatment of image structure, it is the Fourier transform which is employed, the Fourier series being its approximation with a discontinuous frequency spectrum. Let the interval, where $S_n(x)$ approaches $E_0(x)$, be extended from the interval $(-\pi, \pi)$ to a much larger, but finite domain $(-l, l)$. By the change of scale $\xi = \pi x/l$ this latter is made equivalent to the normal interval $\pm \pi$ so that the Fourier series has now the arbitrary limits $\pm l$:

$$S_n(x) = \sum_{-\infty}^{+\infty} C_n e^{in\pi x/l} \qquad (2.38)$$

and

$$C_n = \frac{1}{2l} \int_{-l}^{+l} E_0(x) e^{-in\pi x/l} \, dx. \qquad (2.39)$$

The interval can be further extended by taking for instance wider limits $\pm L$ and defining that the approximation to the original function is to remain identical as in the interval $\pm l$, but that $S_n(x)$ be 0 outside the original domain up to $\pm L$. Further to this change of interval the anlysis of the function $E_0(x)$ is now of course entirely different, in frequency as well as in amplitude. For $\lambda = 2l$ the angular frequency is $\omega = 2\pi/\lambda = 2\pi v$, where v is the spatial frequency, as before. The spatial frequencies of the harmonics are then in the first case

$$v_1 = \frac{1}{2l}, v_2 = \frac{2}{2l}, \ldots, v_n = \frac{n}{2l}, \ldots,$$

and in the second case, for the larger interval $\pm L$:

$$v_1 = \frac{1}{2L}, v_2 = \frac{2}{2L}, \ldots, v_n = \frac{n}{2L}, \ldots.$$

If, for instance, L is twice as wide as l, the fundamental frequency will be half that of the initial one. This doubles the order of the harmonics and the

sum then contains twice as many frequencies as before. Increasing the
interval further obviously leads finally to an infinite number of harmonics,
i.e. to a continuous frequency spectrum of the original function $E_0(x)$.
This response is defined by the function

$$A^{\#}(v) = \int_{-\infty}^{+\infty} E_0(x)\, e^{-2\pi i v x}\, dx, \tag{2.40}$$

which is the Fourier transform of the function $E_0(x)$. By extending the
interval further, from $\pm L$ to $\pm \infty$, the sum of the Fourier series (2.34) tends
towards the Fourier integral

$$E_0(x) = \int_{-\infty}^{+\infty} A^{\#}(v)\, e^{2\pi i x v}\, dv. \tag{2.41}$$

From what precedes, the physical significance of equations (2.40) and (2.41)
is obvious: for a given function $E_0(x)$ the Fourier transform (2.40) yields its
complete harmonic analysis, i.e. its continuous frequency spectrum, whereas
the Fourier integral (2.41) restitutes the original function by the synthesis of
its harmonic components. $E_0(x)$, because of the perfect reciprocity of equa-
tions (2.40) and (2.41), is also the Fourier transform of the function $A^{\#}(v)$.
The transform $A^{\#}(v)$ can also be expressed by trigonometric functions:

$$A^{\#}(v) = \int_{-\infty}^{+\infty} E_0(x) \cos 2\pi v x \, dx - i \int_{-\infty}^{+\infty} E_0(x) \sin 2\pi v x \, dx$$

$$= A^{\#\cos(v)} - iA^{\#\sin(v)}. \tag{2.42}$$

Normalizing the real part of $A^{\#}(v)$ by dividing through the area under $E_0(x)$,

$$A_{\mathrm{norm}}^{\#\cos}(v) = \frac{\int_{-\infty}^{+\infty} E_0(x) \cos 2\pi v x \, dx}{\int_{-\infty}^{+\infty} E_0(x) \, dx}, \tag{2.43}$$

an expression results which is similar to that of the modulation transfer
function $\rho(v)$ in equation (2.31). To compute the internal exposure it is
therefore only necessary to compute the convolution integral of $E_0(x)$
and $\rho(v)$:

$$E_i(x) = E_0(x) * \rho(v) = \int_{-\infty}^{+\infty} \rho(v) A^{\#}(v)\, e^{2\pi i x v}\, dv. \tag{2.44}$$

2.4.1c *The Interpretation of the Fourier Transform*

The relationship between a spatial luminance distribution $E_0(x)$ and its
frequency response $A^{\#}(v)$, at first sight not very obvious, can easily be
explained graphically by choosing several typical examples and by displaying
in each case the corresponding functions opposite to one another.[70,71]

Let us choose, to this purpose, distributions important in photography:
a uniform exposure (Figure 2.45), a slit of finite width (Figure 2.46), a straight
edge (Figure 2.47); the crenelate periodic pattern (Figure 2.48) and the
sinusoidal exposure distribution (Figure 2.49).

Figure 2.45. Uniform exposure.

Figure 2.46. Exposure through slit of finite width.

Figure 2.47. Straight-edge exposure.

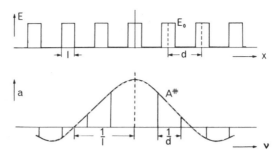

Figure 2.48. Crenelate bar pattern.

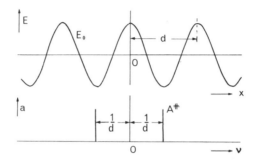

Figure 2.49. Sinusoidal pattern.

The spectrum of the *uniform exposure* $E_0(x) = 1·0$ has only one unit frequency amplitude $A^\#(0) = 1·0$. This results from the reciprocity of the two functions, because the illumination by an infinitely narrow slit, mathematically equivalent to an instantaneous impulse (Dirac's 'delta' function), yields a constant and continuous spectrum extending from $-\infty$ to $+\infty$. The frequency response for illumination by a *slit of finite width*, on the contrary, is given by the function $A^\#(v) = \sin v / v$.

The *straight edge* can either be represented by the 'signum x' function, equal to $+1$ or to -1 according to the sign of x, as shown in Figure 2.47, or by Heaviside's unit step function, nul for $-\infty < x < 0$, and equal to one for $0 < x < \infty$. These two functions, not very different, have similar frequency responses; containing the factor i they must be represented in the imaginary plane.

The *crenelate periodic pattern* has a composite frequency response. It only contains harmonics of distinct frequencies whose amplitudes are limited by the $\sin v / v$ spectrum of the single slit. A wavelength increase of this pattern without modification of the width of its elements increases the number of

harmonics and at the limit yields for the single slit the continuous spectrum of Figure 2.48.

Contrarily to this complex structure, the spectrum of a *sinusoidal input* is very simple: for the function cos πx, symmetrical with respect to the origin, it only contains two harmonics which correspond, in absolute values, to the inherent frequency of the function.

These few examples underline the essential property of the relationship between a light distribution $E_0(x)$ and its frequency response $A^\#(v)$: a small object in wide open space corresponds to a signal with a very wide spectrum; contrarily to what it would seem when considered in object space, it is not a high-frequency input signal. A very wide object, on the contrary, whose spectrum is the narrower the wider the object, is recorded by the sensitive layer as an input signal with a very narrow frequency band.

Application by Kelly[72] of this line of thought to the three-bar crenelate pattern of the resolving power standard test object, Figure 2.12, puts further emphasis on the utility of the investigation of frequency spectra. As mentioned before, resolution of fine detail by the sensitive layer is judged with its help by the smallest of its elements whose three bars can just be distinguished in the image. Figure 2.50 shows how the three bars of finite width can be considered as the convolution of one narrow slit with a three-impulse

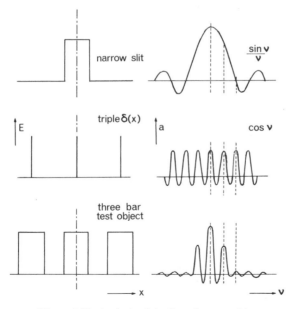

Figure 2.50. Analysis of the three-bar test object.

'delta' function; the same operation, applied to the spectra of both elements yields the corresponding frequency response. Represented in more detail in Figure 2.51, the significant part of the spectrum is compared to that of the image of the three-bar object, obtained with a diffraction-limited optical

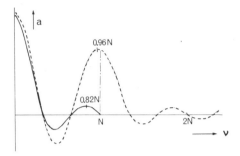

Figure 2.51. Spectrum of three-bar test object (broken line) compared to that of its image through a diffraction limited optical system with cut-off at N cycles (full line).

system of rectangular aperture and a cut-off at N, where $1/N$ is the wavelength of the three-bar test object. As shown in Figure 2.52, this test object, reproduced by such an optical system is just at the limit of resolution. The reproduction by an optical system with a circular aperture leads to a much more involved mathematical treatment, but yields not very different results.

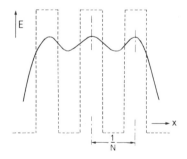

Figure 2.52. Resolution limit of three-bar test object.

This example shows the effect of the suppression of one part of the harmonics on the transmission of information, represented in our case for the input signal by the crenelate three-bar test object, and for the output signal by its image at the limit of resolution.

2.4.1d *Cascading of Linear and Non-Linear Effects*

The transmission of a signal is linear when the output signal is proportional to the input signal. When all elements of a system are linear in this sense its total response can be computed by convoluting their frequency responses, i.e. by multiplying them ordinate by ordinate. Non-linear elements, on the contrary, introduce harmonic distortion and make it necessary to apply a more involved treatment. As in the case of image formation the optical response of a photosensitive layer is linear, it is possible to compute the internal exposure by equation (2.44). This does not imply, however, that the sensitometric response of the negative is linear; it is on the contrary the typical example of a non-linear element.

Let us suppose a photosensitive negative material whose sensitometric d–log \mathbf{E} response is straight in its major part (Perrin[73]). After exposure and development, its transmittance is

$$t = k\,\mathbf{E}^{-\gamma}. \tag{2.45}$$

For $\gamma = 1{\cdot}0$ this relationship between exposure and transmittance is represented by a hyperbola; Figure 2.53 shows the effect of this response on the sinusoidal exposure of an ideal layer, supposed without any light diffusion.

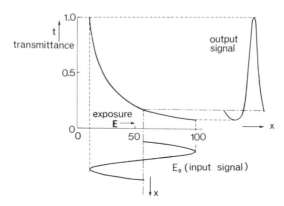

Figure 2.53. Effect of the non-linear response of the photographic process on a sinusoidal input signal.

The distortion of the input signal due to the sensitometric straight-line 45° response of the negative is very obvious. Repetition of the exposure step by the printing onto the positive compensates it, however, and restitutes the sinusoidal transmittance function, on condition that the positive has unit contrast and that there is neither any light diffusion in the layer nor any

modulation loss in the printer, i.e. that the modulation transfer function of the printer–positive layer combination is of constant unit value over the whole frequency range. Lamberts[74] has shown that harmonic distortion resulting from the non-observation of these conditions is only slight as long as the printer insures excellent contact and therefore yields perfect definition. For an actual positive film this distortion only attains 10 % in a small number of cases for a modulation of 70 % and decreases rapidly further with diminishing modulation. This is due to the mutual compensation of the effect on the modulation by either the even or the uneven harmonics; the former increase it and the latter diminish it, so that the effective response resulting from the cascading of both operations does not differ very much from that computed for hypothetical materials without any light diffusion.

This result has been checked experimentally by Lamberts for the currently employed 35 mm professional motion-picture sequence of black-and-white films (Figures 2.54 and 2.55). In this system the camera negative (CN) is first copied onto an intermediate duplicating positive (DP) which is then printed onto an intermediate negative film to yield a duplicating negative (DN). This negative is then employed for the production of the release prints (RP). Figure 2.54 shows the response as experimentally determined with each of these four films, and Figure 2.55 the comparison of these measured values and those of the successive printing steps.

Adjacency effects introduce important non-linearities and therefore forbid the straightforward convolution of several modulation transfer functions. The concentration of developer reaction products is in the customary determination of the sensitometric $d = f(\log \mathbf{E})$ response in direct relation

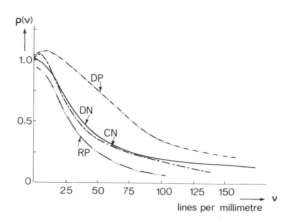

Figure 2.54. Individual responses of the various films employed in the professional motion-picture chain.

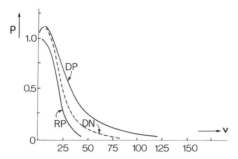

Figure 2.55. Overall responses of intermediate steps and the final release print of the motion-picture chain.

with the density level, owing to the comparatively large area of each step of the sensitometric strip. The same layer, however, when exposed to a sinusoidal light distribution of high spatial frequency, contains during development a concentration of reaction products which is intermediate between that prevailing in a uniformly exposed area for either minimum or maximum density. For low spatial frequencies there results therefore in the presence of an adjacency effect a higher modulation than in its absence.[75] Figure 2.56, which shows the modulation transfer function for three processing conditions, gives an indication of the magnitude of these differences.

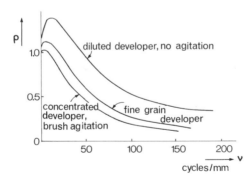

Figure 2.56. Effect of developing conditions on the modulation-transfer function of a film.

The mathematical analysis of non-linear photographic transfers has been carried out by Simonds.[76] A given external exposure is first subdivided into a series of fractional exposures E_n (Figure 2.57), to give the internal exposure at $x = 0$ as a function of the elementary external exposures

$$E_i(0) = f(E_{-n}, E_{-n+1}, \ldots, E_0, \ldots, E_n). \tag{2.46}$$

Figure 2.57. Fractioning of an exposure distribution into its elements E_n.

This function of $2n + 1$ variables is then represented by the multidimensional MacLaurin series

$$E_i(0) = \sum_{k=-n}^{n} a_k E_k + \sum_{k=-n}^{n} \sum_{l=-n}^{n} a_{k,1} E_k E_l + \text{higher order terms}. \qquad (2.47)$$

In the case of linear transfer only the linear terms remain and the internal exposure is

$$E_i(0) = a_{-n} E_{-n} + a_{-n+1} E_{-n+1} + \cdots + a_n E_n, \qquad (2.48)$$

and becomes by substitution of $g_i = a_i/\Delta x$

$$E_i(0) = \Delta x(g_{-n} E_{-n} + g_{-n+1} E_{-n+1} + \cdots + g_n E_n). \qquad (2.49)$$

For a sufficiently small interval Δx this series approaches the convolution integral (2.17)

$$E_i = \int_{-n\Delta x}^{+n\Delta x} g(\xi) E(x - \xi) \, d\xi, \qquad (2.50)$$

where $g(\xi)$ is equivalent to the optical spread function.

In the presence of adjacency effects, however, it is necessary to take into account the higher-order terms. By carrying out an analogous substitution, for instance for the quadratic terms $g_{i,j} = a_{i,j}/(\Delta x)^2$, the sum of these terms tends towards

$$\int_{-n\Delta x}^{n\Delta x} \int_{-n\Delta x}^{n\Delta x} g(\xi_1, \xi_2) E(x - \xi_1) E(x - \xi_2) \, d\xi_1 \, d\xi_2,$$

and the sums of the higher order tend towards similar expressions. In these the functions $g(\xi)$, $g(\xi_1, \xi_2)$, $g(\xi_1, \xi_2, \xi_3), \ldots$ are characteristic of the total response of the non-linear system. Simonds demonstrated that observation of the first- and second-order terms only is sufficient to yield, in the presence

of adjacency effects, a very satisfactory approximation of the exact relation-
ship between exposure (input) and the transmittance of the recording
(output). Equation (2.46) is in this case

$$E_i(0) = (a_{-n}E_{-n} + a_{-n+1}E_{-n+1} + \cdots + a_nE_n) + (b_{-n}E_0E_{-n}$$
$$+ \; b_{-n+1}E_0E_{-n+1} + \cdots + b_0E_0^2 + \cdots + b_nE_0E_n). \qquad (2.51)$$

To determine the coefficients a_i and b_i for a given film-process combination
the film is exposed to a test object, for instance to a straight edge, by varying
successively the luminance difference of the test as well as the average
exposure level. For the computation of the coefficients the microdensito-
metric density recordings, thus obtained after development, are subdivided
into a sufficient number of intervals Δx. If the system is linear all coefficients
b_i of the second-order terms are equal to zero, but they differ significantly
from zero when non-linearities are present; the order of magnitude of these
second-order terms is a measure of the importance of the adjacency effects.

Figure 2.58. Distribution of coefficients a_i of the linear terms of equation (2.51).

For the example of one of the cases studied by Simonds, Figure 2.58 shows
the coefficients a_i of the linear terms as a function of the distance from the
straight edge when the quadratic terms are neglected, and Figure 2.59 shows
both sets of coefficients a_i and b_i when the computation includes the linear
as well as the quadratic terms. The excellent approximation due to the
introduction of the second-order terms, in spite of the omission of those of
higher order, is shown in Figure 2.60, which gives the comparison of the
measured density values with those computed with and without observation
of the second-order terms.

2.4.1e *Evaluation of the Modulation Transfer Function*

The experimental obtention of the modulation transfer function has been
described in detail by Lamberts,[77] and by Lamberts, Straub and Garbe.[78]

Figure 2.59. Values of coefficients a_i of the linear terms and of coefficients b_i of the second-order terms of equation (2.51) as a function of distance from straight edge.

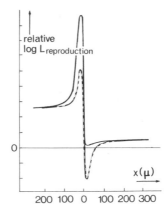

Figure 2.60. Improvement of computed result of adjacency effects through observation of the second-order terms of equation (2.51).

In a reduction camera, in which either a narrow slit or the light-sensitive layer can be placed in the focal plane, a test object of sinusoidally varying transmittance is introduced (Figure 2.61). First the MTF of the lens alone is determined through the slit with the photomultiplier tube, and then the total response of the layer and the lens is determined from the microdensito-meter trace, taking into account the sensitometric characteristic. The MTF

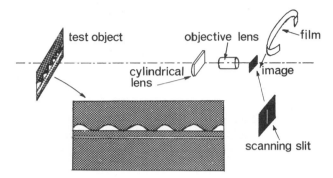

Figure 2.61. Set-up for the experimental determination of modulation-transfer functions of photographic materials.

of the layer alone is then obtained by dividing the total result by the response of the lens alone as first determined. The general validity of this method was demonstrated by Lamberts with a panchromatic negative film, either exposed so as to yield two different density levels (0·35 and 1·70), or developed for quite different times (two and ten minutes) (Figure 2.62). Agitation during development was very rigorous with the purpose of suppressing as far as possible any adjacency effects.

The sinusoidal light distribution for illuminating the sample can be obtained by various means. In the camera described by Lamberts and Straub[78] an optical system, including a cylindrical lens, forms the images of

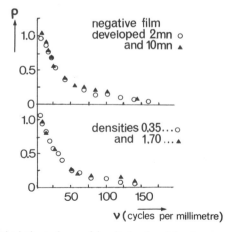

Figure 2.62. Check of the independence of density level and development time of a modulation-transfer function.

a series of drawings of sinusoidal modulation of varying frequencies, in focus only at right angles to the axis of the cylindrical lens. The same optical system also allows us to form a series of uniformly illuminated exposure steps with straight-line slits of various widths. In other set-ups the modulated illumination is obtained optically without the material representation of the sinusoidal function by drawings.

In Hendeberg's system[79] the modulation results from rotation of a polarizing film in the illuminating beam of polarized light, simultaneous to a linear displacement of the sample in front of a slit. Other authors employed the aerial interference image obtained with Lloyd's mirrors.[80,81,82] A set-up of this kind as well as its calibration has been described in detail by Frieser and Kramer.[81] According to Langner and Müller[82] the principal advantage of this method is the ease of obtention of a large number of periods at each spatial frequency, as well as the very high signal-to-noise ratio. Drawbacks mentioned by these authors are the necessity of monochromatic coherent illumination and the aperture variation of the exposing beam with frequency. It is also difficult to obtain low spatial frequencies with Lloyd's mirrors, below 10/mm in red light and 20/mm in blue light, as they would require very long mirrors of exceptional optical quality.

The elimination of the effect on the results of the modulation transfer function of the microdensitometer has been discussed by Lamberts and co-workers,[78] Frieser and Kramer,[81] and Langner and Müller.[82] The microdensitometer records illuminations proportional to the transmittance of the sample, which gives rise, on the one hand, as has been shown, to harmonic distortions (see p. 171), and further modifies the input signal according to the modulation transfer function of the instrument. Langner and Müller studied this aspect of the evaluation of the modulation transfer function of a film; they correct the resulting error by dividing the measured value of modulation at each frequency by the modulation transfer factor of the microdensitometer. This simple method, exactly valid only for sinusoidal signals, allows us to keep the error below 5% in an extended domain of modulations and photographic contrasts.

A simple graphical method for the determination of a density-independent modulation transfer factor for any given film–processing combination has been described by De Belder, Jespers and Verbrugghe.[83] First the maximum and minimum illuminations of the aerial image are measured by scanning it in the microdensitometer at several illumination levels, obtained by introducing a series of neutral grey densities d_i (Figure 2.63a). In a second graph, Figure 2.63(b), the resulting minimum and maximum densities of the sample are plotted and density independent values of the modulation transfer function are then computed from the horizontal distances between the limiting curves, Δd_0 and Δd_{eff}.

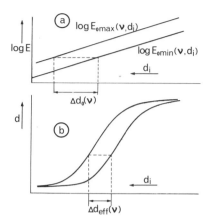

Figure 2.63. Graphical determination of modulation-transfer functions independent of density level.

The modulation of the exposing light is

$$m_0(v) = \frac{E_{0\,max} - E_{0\,min}}{E_{0\,max} + E_{0\,min}} = \frac{1 - 10^{\Delta d_0}}{1 + 10^{\Delta d_0}}, \qquad (2.52)$$

and that of the sample

$$m_{eff}(v) = \frac{T_{max} - T_{min}}{T_{max} + T_{min}} = \frac{1 - 10^{\Delta d_{eff}}}{1 + 10^{\Delta d_{eff}}}, \qquad (2.53)$$

so that the modulation transfer factor ρ_v at any frequency v is obtained independently of the recorded average density level,

$$\rho_v = \frac{m_{eff}(v)}{m_0(v)}. \qquad (2.54)$$

De Belder, Jespers and Verbrugghe demonstrated the validity of their method by obtaining parallel limiting curves when applying it to several film–process combinations; Figure 2.64 shows the curves of one of their examples for several spatial frequencies.

As the routine evaluation of the modulation transfer function of many samples is very time consuming, especially for colour reproduction systems, Gendron and Goddard derived characteristic vectors of this function to make its determination easier.[84] Simond's method for the computation of characteristic vectors[85] can be used to this purpose, because modulation transfer factors taken at neighbouring frequencies are not independent of each other. The first step in the determination of vectors capable of describing

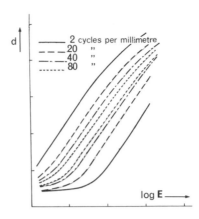

Figure 2.64. Independence of modulation limits of the density level.

the normally observed variations of the modulation transfer functions of film–process systems is to take a sufficiently large sample of such functions and to compute the mean of all measured values. This yields one single mean modulation transfer function, so that the elements of the covariance matrix, from which the characteristic vectors are extracted, can be computed from the differences between each individual function and this mean. In Gendron's and Goddard's investigation three vectors only, obtained in this way, allowed a satisfactory description of 98·6 % of the variance of the original functions. This demonstrates that the representative curves of the modulation transfer functions only vary in three independent ways, so that they can be determined by a restricted number of measurements. Figure 2.65 shows, in logarithmic coordinates,† the effect of each of the three vectors on the mean. The first of the three vectors is representative of the greatest variability of the function which it is possible to express by one single figure. The remaining two are characteristic of additional variabilities of the functions, typical of those appearing in their experimental determination.

Determination of the modulation transfer function without characteristic vectors requires the measurement of the modulation transfer factors $\rho(v)$ at least at eight frequencies to yield a curve representative of the system. Computing such functions from the values determined at $2\frac{1}{2}$, 5, 10, 20, 40, 60, 80 and 100 cycles per millimetre, Gendron and Goddard demonstrated from the resulting regression coefficients that four measurements only are necessary for the obtention of the three vectors which define the modulation

† This logarithmic plot, frequently employed for the graphic representation of routine measurements, is equivalent to a plot in non-logarithmic coordinates, as for instance that of Figure 2.43.

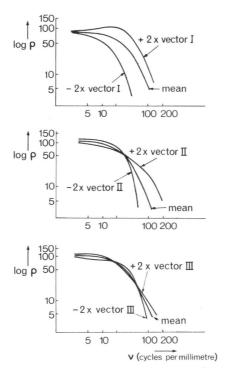

Figure 2.65. Characteristic vectors permitting modulation-transfer function determinations from a reduced number of measurements.

transfer function of a given system. They then chose the frequencies of 10, 20, 60 and 100 cycles per millimetre, and defined the characteristic vectors by the linear combination of the modulation transfer factors M_i

$$Y_i = A_0 + A_1 M_{10} + A_2 M_{20} + A_3 M_{60} + A_4 M_{100}. \qquad (2.55)$$

A technique for the automatic computation of the modulation transfer function of photographic systems has been described by Jones.[86] Starting from exposures of straight edges made either in the laboratory or chosen in negatives exposed under practical exposure conditions, their microdensitometric trace is first fed into the computer. This then determines the spread function while applying corrections for all errors introduced not only by the microdensitometer but also by the non-linear sensitometric conversion, and then only derives from this information directly the modulation transfer function.

2.4.2 Autocorrelation and the Wiener Spectrum

In telecommunication the importance of the signal-to-noise ratio is of prime importance when a very weak signal—a voltage variation in time—is to be detected within a noisy background of chance fluctuations, also of voltage. Methods developed for the solution of this problem also apply to the photographic system. Felgett has shown that granularity can in fact be treated like a noise,[87] and the detail of this application of information transfer to photography has been worked out by Zweig.[88]

2.4.2a *The Autocorrelation Function*

Similarly to variations of current or voltage in time, spatial density fluctuations around their mean are characterized by the degree of correlation between successive values, separated by a distance τ instead of a time interval. This is the autocovariance of a function, applied in this case to the microdensitometric recording $f(x)$ (Figure 2.2), theoretically of infinite length (x varying from $-\infty$ to $+\infty$), and expressed by the equation

$$\varphi(\tau) = \lim_{X \to \infty} \frac{1}{2X} \int_{-X}^{X} f(x)f(x+\tau)\, d\tau. \qquad (2.56)$$

By definition therefore the autocovariance is the average of the product of the density fluctuations at x and at $x + \tau$. For $\tau = 0$

$$\varphi(0) = \lim_{X \to \infty} \frac{1}{2X} \int_{-X}^{X} f^2(x)\, dx = \sigma_d^2, \qquad (2.57)$$

i.e. the autocovariance at zero distance is equal to the statistical variance of density. This latter is also equal to the maximum value of the covariance, because for $\tau = 0$ the correlation between the fluctuations is perfect. To limit the values of the autocovariance between $+1$ and -1, the function is normalized by dividing by $\varphi(0)$,

$$\rho(\tau) = \frac{\varphi(\tau)}{\varphi(0)} = \frac{\varphi(\tau)}{\sigma^2}. \qquad (2.58)$$

The absolute value of $\rho(\tau)$ is in fact less than or equal to 1 because $\varphi(\tau) \leqslant \varphi(0)$. $\rho(\tau)$, plotted as a function of τ, yields a normalized correlogram; in a general sense a correlogram is a plot of an autocorrelation function.

The existence of positive values of $\rho(\tau)$ is an indication of correlation between spatial density fluctuations; for distances τ less than the diameter of the scanning area the correlation is obvious, but for values greater than τ it must either result from an insufficient number of points scanned (as in any statistical problem), or from an approximately periodic phenomenon of a period much larger than that of the granularity itself, as for instance some

kind of mottle. This type of correlation can also be due to the overlapping
of two different effects, such as a graininess resulting from the interaction of
the granularities of a negative and a positive, or else, in a medical radio-
graphic system, that resulting from the quantic fluctuations of emission of
a fluorescent screen as well as of the granularity of the film, to mention only
the most frequently encountered examples. Figure 2.66 shows schematically
the separation by correlograms of two granularities of very different
periodicities.

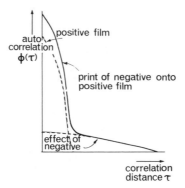

Figure 2.66. Correlogram of a negative–positive system.

The autocorrelation function also allows an explanation of the exact role
of the average syzygetic density difference.[89] As long as the densities corre-
sponding to adjacent positions of the scanning area are entirely independent,
or when their correlation is constant and equal to $\varphi(\delta')/\sigma_d^2$, where δ' is the
distance between the centers of the two apertures, the average syzygetic
density difference $\overline{S\Delta d}$ is proportional to the square root of the difference
between the values of the autocovariance for $\tau = 0$ and $\tau = \delta$. When,
however, the autocovariance tends towards zero for $\tau = \delta$, $\varphi(\tau) = 0$, the
average syzygetic density difference is proportional to the standard deviation
σ_d of the density fluctuations, $\overline{S\Delta d} = k\sigma_d$. This shows that the measurement
of granularity by the determination of $\overline{S\Delta d}$ furnishes only part of the total
information, and depends on the properties of the granular deposit. Zweig
further demonstrated that even a very small variation of the macroscopic
density across the sample modifies the relationship between $\overline{S\Delta d}$ and σ_d and
thus impairs the proportionality between these two variables.[88]

2.4.2b *The Power Spectrum*

The density fluctuations of the microdensitometric recording can also be
studied in a different way. Just as any other function, $f(x)$ has a Fourier

transform,

$$F(v) = \int_{-\infty}^{\infty} f(x)\, e^{-2\pi i v x}\, dx. \tag{2.59}$$

$F(v)$ plotted as a function of v is the spectrum of $f(x)$, giving for each frequency v the amplitude of the corresponding harmonic component. When the density fluctuations $f(x)$ of the granularity are strictly due to chance, the average of $F(x)$ disappears within a finite interval of x extending from $-X$ to $+X$. As this is the case for uniformly fogged and developed samples, it is necessary to avoid this difficulty by taking the square of the transform, called the power or Wiener spectrum of $f(x)$,

$$\Phi(v) = \lim_{X \to \infty} \frac{1}{2X} \left| \int_{-\infty}^{\infty} f(x)\, e^{-2\pi i v x}\, dx \right|^2. \tag{2.60}$$

An important property of this function, $\Phi(v)$, is that it is also the Fourier transform of the autocovariance $\varphi(\tau)$,

$$\Phi(v) = \int_{-\infty}^{\infty} \varphi(\tau)\, e^{-2\pi i v \tau}\, d\tau, \tag{2.61}$$

i.e. it also yields the frequency spectrum of $\varphi(\tau)$ and therefore describes the granularity by the harmonic components of the autocorrelation function. As shown further, on page 197, this allows us to introduce the effect of granularity together with the modulation transfer functions and thus to follow it through all steps of a reproduction process. Doerner[89] underlined this advantage, as well as that of the combination of the successive steps of a reproduction process by simple multiplication (see p. 198) and gave examples of the application of the Wiener spectrum to the printing of one film onto another, as well as to the film–screen system of medical radiography; Figure 2.67 shows the effect of the printing of a very fast negative film onto

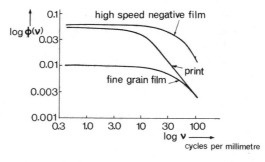

Figure 2.67. Power spectra of a fast negative film and of its print onto a fine-grain material.

a slower negative film of finer grain. For each of these two uniformly exposed films $\Phi(v)$ is constant (with the exception of a small inflection at the higher spatial frequencies, due to the filtering action of the scanning area), but the mottle resulting from the interaction of both granularities makes $\Phi(v)$ decrease with v.

Medical radiographic films, exposed in contact with fluorescent screens, not only record the desired information which is due to the absorption of the X-rays by the anatomic details, but also time fluctuations of X-ray quanta. The result is the overlapping of a 'quantum'-mottle over the grain proper of the film. Starting from the Wiener spectrum, and including the parameters of the film–screen system, Rossmann derived an expression for the standard deviation $\sigma_{d\,mottle}$ of these density fluctuations.[90] He also employed the Wiener spectrum to determine quantitatively the differences between various film–screen systems.;[91] Figure 2.68 for instance shows the increase of screen–film mottle as a function of sharpness for two systems, one with an excellent modulation transfer characteristic (Curves A), and the other with greater absorption of X-rays but forming less sharp images (Curves B). The first system reproduces sharp detail better but yields higher mottle, while the other is more advantageous for larger and less sharp details which are reproduced on a more uniform surround, i.e. with less background noise.

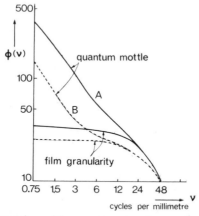

Figure 2.68. Comparison of the power spectra of two radiographic systems.

Other examples of Wiener spectra for various photographic materials were directly determined from micro-densitometric recordings by Klein and Langner;[92] the rather pronounced periodicities of the granularities in their examples make the spectra typical of the investigated materials and of their processes (Figure 2.69).

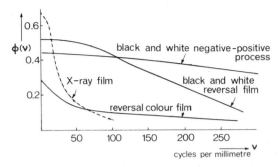

Figure 2.69. Relative granularities of various films.

2.4.3 Harmonic Optical Analysis

The harmonic analysis of a photographic system yielding its modulation transfer function can also be carried out directly with an optical set-up. This method, first employed by Gaultier du Marache[93] for the evaluation of the photographic reproduction quality of photoengraving screens was adapted by Desprez and Pollet[94] to the measurement of the modulation transfer function of photographic systems.

2.4.3a *The Optical Power Spectrum*

The amplitude of a plane wave of monochromatic light, upon transmission through a developed photographic layer, diminishes and also undergoes a phase shift Φ proportional to the optical path within the layer. Let x–y be the plane of the sample; the complex amplitude of the transmitted wave then is

$$f(x, y) = A_0(x, y)\, e^{i\Phi(x,y)}, \tag{2.62}$$

where A_0 is the amplitude and Φ the phase of the incident wave. As the energy transmitted by the wave is proportional to the square of its amplitude, the transmittance of the layer is

$$T = \frac{A^2}{A_0^2}, \tag{2.63}$$

so that the amplitude loss including the phase shift is proportional to $\sqrt{T}\, e^{i\Phi}$. The wave modified by its transmission through the layer can again be expressed by a sum of sinusoidal functions, i.e. by harmonic analysis of the amplitude transmission by the sample.

According to Huygens's principle each sinusoidal component of the transmitted beam generates two plane waves, symmetrical relative to the optical axis of the system, which with a lens can each be made to converge

in its focal plane u–v. The illuminance in each point of this plane then is a measure of the power of one of the elementary wave components.

Figure 2.70 represents schematically the relationship between the light wave incident on the layer and that converging in the focal plane of the lens.

Figure 2.70. Relationships between the parameters of an incident light wave and of that converging at the focal plane.

To each point $M(x, y)$ of the sample of known transmittance correspond sinusoidal components converging in the u–v plane. Each point $L(u, v)$ is thus representative of one of these sinusoidal components whose spatial frequency v, μ is only a function of u and v. The illuminance of a point $L(u, v)$ is therefore proportional to the power $|A(v, \mu)|^2$ of the incident component and the power spectrum of the sample can be obtained directly by scanning the focal plane u–v. This constitutes a simple means for the determination of the modulation transfer function from the image of a test object, on condition that it covers the whole frequency range.

2.4.3b *The Measurement of the FTM by this Method*

The test object chosen by Desprez and Pollet is a uniformly fogged and developed film of high graininess, printed either by contact or by projection on the layer under investigation. The sample then carries besides the reproduction of the test object also its own graininess, equivalent to a noise and independent of the test object. The individual power spectra N of the test object and P of the sample to be measured are therefore determined first by optical harmonic analysis, and then the power spectrum I of the print of the test object onto the sample. If the print has been developed to a contrast γ, and if the modulation transfer functions of the printer and of the sample to be evaluated are ρ_1 and ρ_2 respectively, the power spectra are related by

the equation

$$I = P + \gamma^2(\rho_1, \rho_2)^2 N,$$ (2.64)

from which ρ_2 is obtained as

$$\rho_2 = \frac{1}{\gamma\rho_1}\left(\frac{I - P}{N}\right)^{\frac{1}{2}}.$$ (2.65)

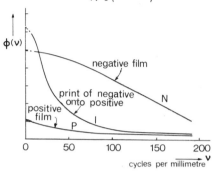

Figure 2.71. Power spectra determined by harmonic optical analysis.

Figure 2.71 shows an example of three power spectra N, P and I as determined by optical harmonic analysis, and Figure 2.72 gives the comparison of a modulation transfer function obtained by this method with one measured by scanning images of sinusoidal patterns in a microdensitometer.

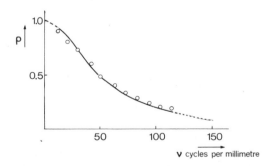

Figure 2.72. Modulation-transfer function from microdensitometric measurements (continuous line) and from harmonic optical analysis (circles).

2.4.4 Applications of the Modulation Transfer Function

The introduction of the concept of harmonic analysis into the evaluation of image structure makes it possible, as shown before, to synthesize its

various aspects. Harmonic analysis is therefore most useful for the study of the relationship between image structure and photographic quality taken in its most general sense. Applied to photographic processes which are designed to yield images it is particularly useful for the evaluation of certain specific results such as those relative to the transfer of low or high spatial frequencies or those related to very high magnification; it is obvious that harmonic analysis is an indispensable tool in those domains where the information transfer is strictly linear, such as in optics or holography.

2.4.4a *Computation of Detail Reproduction with the Use of the MTF*

When the frequency spectrum of the subject to be reproduced is known, such as for instance those shown in Figures 2.45 to 2.49, the image spectrum can be obtained by multiplying the subject spectrum with the modulation transfer function of the reproduction system. Fourier synthesis of the resulting harmonic components then yields the luminance profile of the reproduction. In other words, the image $L'(x_i)$ for any given abscissa x_i in a photographic layer being the convolution of the object luminance distribution $L(x)$ and the line spread function $S(x)$ of the layer, $L'(x_i) = L(x) * S(x)$, one must first determine the transform $[L(x)]^{\#}$ of the object distribution so as to obtain that of the image by multiplying it with the modulation transfer function,

$$[L'(x_i)]^{\#} = [L(x)]^{\#} MTF$$

By the inverse Fourier transform of $[L'(x_i)]$ this then yields the image luminance $L'(x_i)$.

While yielding the correct solution, this rigorous method raises in practice a problem of computation. The Fourier transforms of the customary input luminance distributions are known in general but the final image spectrum obtained empirically by repeated multiplication is only available in tabular form, and not as a simple function of spatial frequency which would allow us to find its Fourier transform by computation or in tables.

This difficulty can be avoided by the use of Fourier series instead of transforms, i.e. Fourier integrals. For any given abscissa x_i of an object luminance distribution $L(x)$ the image luminance $L'(x_i)$ is obtained by multiplying for this abscissa all terms of the input Fourier series by the corresponding modulation transfer factors and by adding these products. The resulting amplitudes of the individual harmonics, expressed by the coefficients of the terms of the final series, then yield by numerical integration distinct values of the function corresponding to the luminance distribution in the reproduction. In an application of this method Simonds, Kelch and Higgins[95] used for the simulation of an exposure through a slit a Fourier series with three terms only; in this example the non-linear transmittance

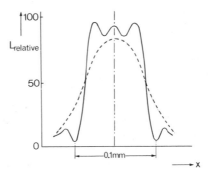

Figure 2.73. Luminance distribution of the original defined by equation (2.66) and of its computed reproduction.

response of the photographic image is taken into account by the introduction of the sensitometric characteristic into the computation. The assumed characteristics of the original and the reproduction process are:

(i) a one-dimensional scene luminance distribution (Figure 2.73),

$$L = 50 + 50 \cos v_1 x - \tfrac{50}{3} \cos 3v_1 x + \tfrac{50}{5} \cos 5v_1 x; \qquad (2.66)$$

(ii) a modulation transfer function of the lens–negative-film optical transfer characteristics as represented by curve 1, Figure 2.74;

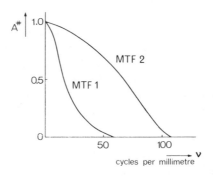

Figure 2.74. Schematic modulation transfer functions of the lens–negative-film and the printer–positive-film combinations.

(iii) a sensitometric characteristic of the negative film $d = \tfrac{1}{2} \log E$, or $T = E^{-\frac{1}{2}}$ (Figure 2.75, curve a);

(iv) a modulation transfer function of the optical characteristics of the printer, as represented by curve 2, Figure 2.74;

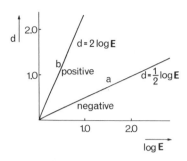

Figure 2.75. Assumed sensitometric characteristics of the negative and the positive materials.

(v) a sensitometric characteristic of the positive material $d = 2 + 2 \log E$, or $T = 1/100E^2$ (Figure 2.75, curve b).

The internal exposure of the negative layer by an object of the form (2.66) with a fundamental spatial frequency of 10 cycles per millimetre, $v_1 = 10/\text{mm}$, is obtained by multiplying its harmonic components with the corresponding modulation transfer factors of the lens–negative-film combination.

$$E_{i \text{ neg}} = 50 + 50(A^{\#}_{10/\text{mm}}) \cos v_1 x - \tfrac{50}{3}(A^{\#}_{30/\text{mm}}) \cos 3v_1 x$$
$$+ \tfrac{50}{5}(A^{\#}_{50/\text{mm}}) \cos 5v_1 x$$
$$= 50 + (50)(0 \cdot 75) \cos v_1 x - \tfrac{50}{3}(0 \cdot 19) \cos 3v_1 x$$
$$+ \tfrac{50}{5}(0 \cdot 03) \cos 5v_1 x. \tag{2.67}$$

Taking into account the non-linear response of the negative $T = E^{-\frac{1}{2}}$, its transmittance then is computed by numerical integration of the Fourier series

$$T_{\text{neg}} = 0 \cdot 1629 - 0 \cdot 0729 \cos v_1 x + 0 \cdot 0201 \cos 2v_1 x - 0 \cdot 00055 \cos 3v_1 x$$
$$- 0 \cdot 0131 \cos 4v_1 x + 0 \cdot 00127 \cos 5v_1 x + \cdots. \tag{2.68}$$

By applying to this negative transmittance the modulation transfer factors of the optical characteristics of the printer

$$E_{i \text{ pos}} = 0 \cdot 1629 - 0 \cdot 0718 \cos v_1 x + 0 \cdot 0191 \cos 2v_1 x - 0 \cdot 0005 \cos 3v_1 x$$
$$+ 0 \cdot 00106 \cos 4v_1 x - 0 \cdot 0009 \cos 5v_1 x + \cdots. \tag{2.69}$$

The reproduction of the original distribution is finally obtained by numerical integration from the non-linear response of the positive $T = 1/100E^2$, and is shown in Figure 2.73 as the dotted line.

Simonds, Kelch and Higgins made use of this method of computation to study the influence on detail reproduction of the sensitometric characteristics as well as of the modulation transfer function. To this purpose they

inverted the sensitometric and the harmonic responses, obtaining the following four combinations (Table 2.5).

TABLE 2.5

	A	B	C	D
Lens–negative-film MTF (Figure 2.74)	1	1	2	2
Sensitometric response of the negative film	$T = \mathbf{E}^{-\frac{1}{2}}$	$T = \mathbf{E}^{-2}$	$T = \mathbf{E}^{-\frac{1}{2}}$	$T = \mathbf{E}^{-2}$
Printing stage MTF (Figure 2.74)	2	2	1	1
Sensitometric response of the positive material	$T = 0{\cdot}01\mathbf{E}^{-2}$	$T = 0.01\mathbf{E}^{-\frac{1}{2}}$	$T = 0{\cdot}01\mathbf{E}^{-2}$	$T = 0{\cdot}01\mathbf{E}^{-\frac{1}{2}}$

The reproduction of the input signal as obtained in these four cases is shown in Figure 2.76; positives C and D are lower in transmittance than are positives A and B, because they have supposedly been printed in poor conditions of modulation transfer. The least satisfactory reproduction is

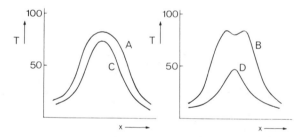

Figure 2.76. Luminance distributions of reproductions of the original given by equation (2.66), according to the choice of negative and positive characteristics.

that of print D; here the inversion of the sensitometric response adds to the poor optical printing condition. A high-contrast negative and a low-contrast positive, while yielding normal tone reproduction, as shown here, impair detail reproduction. This fact is well known in practice where the negatives always have low contrast, and the positives a correspondingly high contrast. An experimental check by Simonds, Kelch and Higgins, including a very slight separation of the negative and the positive by a thin spacer, confirmed the advantage for image structure of the combination of a low-contrast negative with a high-contrast positive (Figure 2.77).

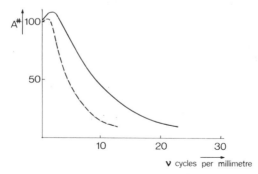

Figure 2.77. Combining a low-contrast negative and a high-contrast positive (continuous line) enhances detail reproduction.

For the investigation of current photographic materials it is not always necessary to include in the computation the non-linearity of transmittance as has been done in this example; it is often possible to simply cascade the individual harmonic responses of the components, supposing the optical and mechanical printing conditions are satisfactory,[74] (see also p. 171).

It is useful, on the other hand, to carry out the computations according to the method outlined by Simonds, Kelch and Higgins with a greater number of terms in the Fourier series, reproducing more closely the luminance profiles of crenelate test objects or straight edges, which are those currently employed in photography for the evaluation of resolving power or acutance. The introduction of a sufficient number of terms is now possible through the use of modern computers; series of a thousand terms have been employed for the evaluation of photographic systems.[96,97,98] While sufficient for yielding satisfactory luminance profiles, this number of terms can still be handled on the computer in a reasonably short time.

For this kind of computation of the reproduction either of a straight edge or a crenelate bar pattern, a useful periodic luminance distribution is that of Figure 2.78; with a sufficiently large period this function represents a straight edge, and with very small periods patterns of parallel lines yielding crenelate luminance distributions. In the Fourier series corresponding to this function all even cosine terms and all sine terms cancel out and the coefficients a_n of the odd cosine terms take alternatively the values $+1/n_i$ and $-1/n_{i+2}$. The length unit employed for defining the frequency of this periodic input signal must be chosen according to the reproduction system under consideration; for a Super-8 movie film, for instance, where the magnification is very high, the number of periods is taken within one millimetre, while a system intended for direct vision without magnification, such as a medical X-ray film–screen combination, requires a length unit of several centimetres for accepting a

sufficient number of harmonics, a thousand in this particular case. The test object is introduced into the computer in the form of a Fourier series corrected by the method of σ-factors; this correction is obtained by multiplying each term of the series by a coefficient depending on its order,

$$\sigma_k = \frac{\sin \pi k/m}{\pi k/m},$$

where k is the order of the term and m that of the total chosen number of harmonics.[69] Comparison of the effect of this corrective method on series of

Figure 2.78. Luminance distribution pattern of straight edge and crenelate bar test object.

ten, a hundred and a thousand terms of the test object of Figure 2.78 shows that the chosen number of one thousand harmonics is just sufficient to make the input representative of the luminance distribution of a straight edge (Figure 2.79). Multiplication of the corrected terms of the Fourier series by

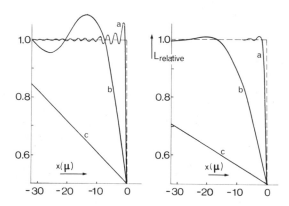

Figure 2.79. Effect of σ-factor correction on series of ten, a hundred, and a thousand harmonics.

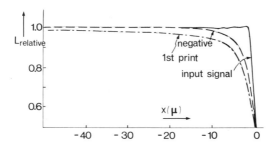

Figure 2.80. Computed reproductions of straight edges by an aerial reconnaissance film and by its print.

the modulation transfer factors of the reproduction system and the subsequent synthesis of the resulting harmonic components then yields the output signal, i.e. the luminance distribution of the reproduction. Figures 2.80 to 2.82 show a few examples of results obtained by this method: the reproduction of a straight edge by a black-and-white film for aerial reconnaissance and by duplication of this original; comparison of the reproductions of a straight edge exposed either directly by X-rays onto a film for medical radiography (Figure 2.81, curve a) or by visible light onto reversal colour films, the first without incorporated couplers (curve b) and the second with couplers in the layers (curve c); and finally the reproductions of straight edges in the

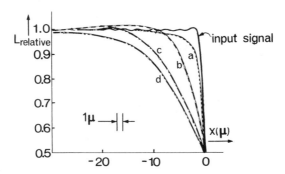

Figure 2.81. Comparison of computed straight-edge reproductions: (a) X-ray film by direct X-ray exposure; (b) reversal colour film without couplers in the layers; (c) reversal colour film with incorporated couplers; (d) reversal print from original record (c).

conditions of medical radiography, on the one-hand with a low-intensity fluorescent screen yielding sharp images (Figure 2.82, curve a) and on the other hand with a fast screen, showing however strong lateral diffusion of visible light, on the same film (curve b).

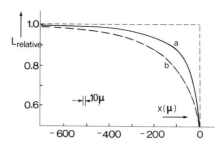

Figure 2.82. Computed straight-edge reproductions in medical radiography. (a) High-definition low-emission fluorescent screen; (b) high-speed screen.

The computation of detail reproduction with Fourier series has also been employed to evaluate the relative importance of the transfer of low and high spatial frequencies.[96,98] Two hypothetical modulation transfer functions, one favouring low and the other high frequencies (Figure 2.83), introduced into the computations, show that a rather important gain of the transfer of high frequencies (curves a) has only a slight influence on the reproduction of a straight edge while a more complete transfer of the low spatial frequencies yields a quite visible improvement of acutance (Figure 2.83, curves b).

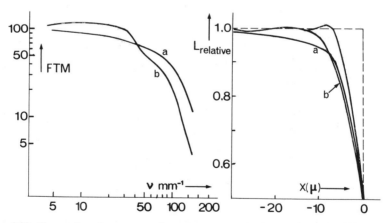

Figure 2.83. Comparison by computation of the action on detail reproduction quality of preferential transfer of either low or high spatial frequencies.

The application of Fourier series to the computation of detail reproduction finally allows us to demonstrate an intrinsic property of resolving power which explains its practical usefulness[97] (see also p. 141). For a periodic bar

pattern the number of useful terms in the series is a function of the spatial frequency of the test object. The successive introduction of the test object of Figure 2.78 with periods diminishing until those of the cut-off frequency, which roughly corresponds to the resolving power limit, therefore reduces by and by the useful number of terms in the series representative of the object luminance. At the limit there remains only one single modulation transfer factor, so that only the one term of this frequency can be employed. The image luminance distribution therefore becomes exactly sinusoidal, in good agreement with the image structure observed in practice at the limit of resolution. Similarly, the use of only one harmonic as input signal makes the 'object' appear sinusoidal even if it initially had a crenelate luminance distribution. At the limit of resolution the reproduction therefore becomes independent of the exact form of the input signal, because the sensitive material can then only transmit one single harmonic. This intrinsic property of modulation transfer explains the great practical value of the resolving power concept for photographic applications, particularly with high reduction or magnification ratios, and also the very satisfactory correspondence between resolving power and spatial cut-off frequency at the high-frequency end of the modulation transfer function.

2.4.4b *Power Spectrum and Modulation Transfer Function*

The description of a photosensitive system by the frequency response of its harmonic components also allows us to take into account its granularity as well as its modulation transfer function. Doerner[89] has given an example of the application of such a combination of power spectra with the modulation transfer functions of the printer and the positive to the transfer of granularity in an optical printing operation; the elements of this transfer are shown schematically in Figure 2.84.

Figure 2.84. Successive transfer of power spectra by the elements of a photographic system.

Due to its granularity the exposed and processed negative has a varying transmittance $T(\xi)$, and therefore makes the initially uniform illuminance E_0 differ from one point to another. The illuminance is further modified by the

optical spread functions $A_0(\xi)$ of the lens and $A_P(x)$ of the positive. By combining these two into one single spread function $A(\xi)$, the luminance distribution in the positive layer is given by the convolution integral (see p. 150)

$$E_i(x) = \int_{-\infty}^{\infty} E_0 T(\xi) A(x - \xi) \, d\xi. \tag{2.70}$$

The power spectrum $\Phi_P(v, E_i)$ of the luminous intensity within the layer then is the product of the square E_i^2 of the illuminance (in energy units) with the power spectrum $\Phi_N(v, T)$, the transmittance fluctuations of the negative, and the square of the optical transfer function $A^{\#}(v)$ of the printer,

$$\Phi_P(v, E_i) = E_i^2 \Phi_N(v, T) |A^{\#}(v)|^2. \tag{2.71}$$

As it is more convenient to express the power spectrum as a function of positive or negative density rather than of printer illuminance, Doerner introduced the following approximations:

(a) a sensitometric straight-line response

$$d(x) = \gamma \log E(x), \tag{2.72}$$

(b) $\quad \Phi[v, \log E(x)] = (0\cdot43)^2 \dfrac{\Phi[v, E(x)]}{[\bar{E}(x)]^2}. \tag{2.73}$

The power spectrum of the density fluctuations in the print then is

$$\Phi_P(v, d) = \gamma^2 (0\cdot43)^2 \frac{\Phi(v, E)}{E^2 \bar{T}^2}, \tag{2.74}$$

which, upon substitution in equation (2.71), yields

$$\Phi_P(v, d) = \gamma^2 \Phi_N(v, d) \cdot |A^{\#}(v)|^2. \tag{2.75}$$

To take into account the granularity of the positive a supplementary term must be added; the total granularity of the final print therefore is

$$\Phi(v, d) = \gamma^2 \Phi_N(v, d) |A^{\#}(v)|^2 + \Phi_P(v, d), \tag{2.76}$$

where $\Phi_P(v, d)$ describes the inherent granularity of the positive. Doerner checked the validity of this relationship for contact and projection printing and obtained an excellent correlation between the computed and measured values (Figure 2.67). This expression is equivalent to equation (2.64) p. 188.

Rossmann[19,91] applied a similar method to the film–screen system of medical radiography. As shown before, on page 131, the conclusions on the image structure of this system from statistical considerations only about quantum mottle and film granularity are not sufficient to explain entirely the observed facts. Interaction between the inherent granularity of the film and radiographic quantum mottle also depends on the definition of the

film–screen combination, i.e. on its modulation transfer function. The power spectrum determined from the density fluctuation of the radiographic system therefore has a total value which includes the two independent components of granularity and mottle,

$$\Phi_{total}(v) = \Phi_{mottle}(v) + \Phi_{grain}(v). \tag{2.77}$$

To obtain the power spectrum $\Phi_{grain}(v)$ of the film granularity alone, it is sufficient to separate the film slightly from the screen by a thin spacer, so that the effect of the quantum fluctuations disappears; $\Phi_{mottle}(v)$ can then be computed from equation (2.77). It can also be expressed, within a limited interval of exposure, according to equations (2.73) and (2.74) by the relationship

$$\Phi_{mottle}(v) = \gamma^2 \frac{\Phi_E(v)}{\bar{E}^2}, \tag{2.78}$$

where γ is the gradient of the sensitometric response of the processed film and E the illuminance in the plane of the sensitive layer by the fluorescence of the screen. The power spectrum $\Phi_E(v)$ of this illuminance is related to that of the quantum fluctuations of the X-ray screen, $\Phi_X(v)$, by the modulation function $A^\#(v)$ of the film–screen system

$$\Phi_E(v) = g^2 |A^\#(v)|^2 \Phi_X(v). \tag{2.79}$$

The amplification factor g of the screen gives the number of light quanta emitted per absorbed X-ray quantum. As the number n_X of X-ray quanta absorbed per screen unit surface fluctuates according to a Poisson distribution, $\Phi_X(v)$ is proportional to \bar{n}_X; the illuminance by the fluorescent light, on the other hand, is proportional to the amplification factor and the mean number of X-ray quanta, $E \sim g\bar{n}_X$. By substituting, and from equations (2.78) and (2.79), a relative value of the modulation transfer function of the film–screen system results,

$$A^\#(v) \sim \frac{[\bar{n}_X \Phi_{mottle}(v)]^{\frac{1}{2}}}{\gamma}. \tag{2.80}$$

This study mainly underlines the great advantage of reasoning in spatial frequency transfer rather than in illuminance distribution in object and image space, and demonstrates quantitatively the importance of a satisfactory modulation transfer through an excellent contact between the emulsion layer and the fluorescent screen surface. The determination of the modulation transfer function proper is easier, however, by the direct measurement of the spread function $A(x)$.

The method for the obtention of the spread function of a radiographic system developed by Rossmann, Lubberts and Cleare[99] consists of the

exposure of the film–screen combination to X-rays through a ten-micron slit, made of platinum jaws two-millimetres thick, and in scanning the profile of the line recorded on the processed film in the microdensitometer. From this record, the sensitometric response of the film, and the modulation transfer function of the microdensitometer, the spread function $A(x)$ of the system is obtained on an electronic computer, and from it the modulation transfer function.[100] These two functions provide complete information on the transfer properties of the system. Studying many film–screen pairs by this method, Rossmann and Lubberts[101] demonstrated that the light spread within the layer is a function of the quantum yield of the screen, so that film–screen systems of given overall sensitivity can yield widely varying image structures. The greatest differences result from the combination of different films with screens whose speed responses differ to a large extent (Figure 2.85).

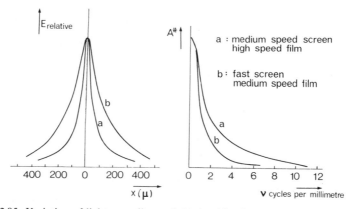

Figure 2.85. Variation of light spreading and the resulting image structure in medical radiography according to the chosen film–screen combination. Spread functions of two systems (left) and corresponding modulation-transfer functions (right).

The intrinsic characteristics of the random noise produced by radiographic fluorescent screens has been studied by Lubberts.[102] Contrary to the simple case of a linear time-invariant electrical network, for which the transfer function can be determined by means of a white-noise input applied to the system, the fluorescent screen generates under the impact of X-ray photons pulsations of visible light within its whole thickness; the response of the screen, i.e. the spectral density of the 'Wiener' fluctuations of visible energy around their mean value in the film plane, can therefore be obtained by integrating the square of the optical transfer function relative to the thickness of the fluorescent layer.

2.4.4c *Other Applications of the MTF*

The extension of the application of harmonic analysis to the overall evaluation of image quality makes it possible to include in this evaluation parameters which are not actually part of the photographic process. A typical example can again be found in medical radiography: the energy of the X-ray beam, which, when reaching the fluorescent screen carries the whole diagnostic information, not only depends on the form and the kind of the anatomic detail to be depicted, but also on the geometry of the focal spot. Each of these elements has its own harmonic frequency spectrum and can therefore be included in the investigation of the image structure of the system.[103,104] The geometrical lack of sharpness resulting from the dimensions of the focal spot, for instance, schematically shown in Figure 2.86, introduces in the screen's fluorescent emission a spectrum such as curve A, Figure 2.87, which, when convoluted with the modulation transfer function B

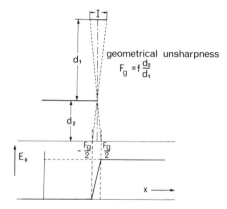

Figure 2.86. Lack of sharpness due to finite size of focal spot.

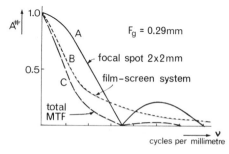

Figure 2.87. Modulation-transfer functions resulting from finite size of focal spot and type of film–screen combination.

of the screen–film combination yields the spectrum C of the image forming emission of actinic radiation.

In a similar way the spectrum of an anatomic detail can be approximated by that of an absorbing cylindrical object; this spectrum is of the form $\sin x/x$ (Figure 2.88, curve C), like that of a slit of finite width (Figure 2.46, p. 167). Its comparison with that of the film–screen system MTF (curve A, Figure 2.88), and with this system's power spectrum (curve B, Figure 2.88) shows the high degree of quantum mottle in this example. Consideration of the object and process spectra allows us to acquire a complete knowledge of the whole system, and to modify it in consequence for optimum detail reproduction.

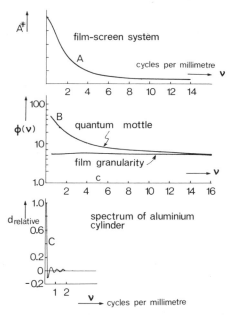

Figure 2.88. Investigation of detail reproduction in medical radiography by simulation of an anatomic detail by a cylindrical absorber.

In xerography Neugebauer[105] employed the modulation transfer function for the computation of the optical density of the image as a function of the fundamental xerographic parameters: thickness of the selenium plate, plate voltage prior to exposure, dimension of the toner particles, distance of the development electrode, and capture and recombination of the charge carriers generated by the incident light. The relative positions of the xerographic elements are shown schematically in Figure 2.89, including a development

Figure 2.89. Elements of an electro-photographic system.

counter electrode as employed in pictorial xerography; the ordinate y denotes the average distance above the plate of the region of capture, by the electronic field, of the toner particles. The shape of the modulation transfer curve varies according to the relative importance of the parameters, which makes it possible to determine the characteristic of a xerographic reproduction. From the computed general shape of the modulation transfer function (Figure 2.90), which resembles that of silver halide photography with a very

Figure 2.90. Modulation transfer function of the xerographic system.

pronounced adjacency effect, Neugebauer derived the following important conclusions:

(i) For line copy a y/L ratio of about 0·01 yields the best compromise between speed and acutance. A higher value of this ratio impairs sharpness, and a lower value reduces speed. Speed and acutance remain very satisfactory, however, over a wide range of the y/L ratio (L, thickness of selenium plate).

(ii) In pictorial xerography thick plates and high plate voltages are advantageous for high speed, and a small distance of the development electrode practically eliminates the adjacency effect. Thick plates make the sensitometric response of the xerographic system resemble that of the customary silver halide process.

Figure 2.91. Elimination by spatial filtering of the moire pattern in a second-generation half-tone print. *Top:* without filtration. *Bottom:* filtration of moire pattern by introduction of noise in the optical path.

Application to the photographic process of harmonic analysis can even allow us to solve problems otherwise insoluble. It is well known, for instance, that the second-generation halftone reproduction of an already screened original gives rise to an objectionable moire pattern. As disclosed by Kazuo Sayanagi this unsharp long-period screen pattern which covers the image can be eliminated almost entirely by appropriate spatial filtration;[106] this correction results from the use of a phase filter which introduces 'noise' in the light beam (Figure 2.91).

The modulation transfer function finally allows us to evaluate the performance of unconventional processes. Figure 2.92 shows as an example the comparison of various reproduction characteristics obtained with the Bimat system of processing (see p. 477) with different contact times between the light-sensitive layer and the nuclei-containing processing layer which forms the positive.[107]

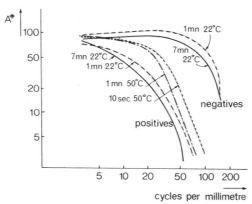

Figure 2.92. Detail reproduction by the Bimat system according to transfer contact time.

REFERENCES

1 Jones, L. A., Higgins, G. C., Stultz, K. F., and Hoesterey, H. F., Techniques and equipment for the objective measurement of graininess. *Jl. O.S.A.*, **47** (1957), 312.
2 Debot, R., Influence des caracteristiques optiques de l'instrument utilisé à la mesure de la granularite des images photographiques, *Sc.* (2) 57 (1956), 217.
3 Frieser, H., *Messung des Schwankungsspektrums und der mittlerent Schwärzung entwickelter photographischer Schichten.* Agfa, Mitteilungen aus dem Forschungs-laboratorium, Berlin 1958, vol. 2, p. 249.
4 Altman, J. H., The measurement of rms granularity. *Applied optics*, **3** (1964), 35.
5 Frieser, H., Ein Verfahren zur Messung der Körnung photographischer Schichten *Phot. Korr.*, **103** (1967), 133.
6 Selwyn, E. W. H., A theory of graininess. *Phot. Jl.*, **75** (1935), 571; and **82** (1942), 208.

7 Higgins, G. C., and Stultz, K. F., Experimental study of rms granularity as a function of scanning spot size. *Jl. O.S.A.*, **49** (1959), 925.

8 Romer, W., Polish research on graininess and granularity. *Jl. Phot. Sc.*, **11** (1963), 260.

9 Jones, L. A., and Higgins, G. C., Some characteristics of the visual system of importance in the evaluation of graininess and granularity. *Jl. O.S.A.*, **37** (1947), 217.

10 Jones, L. A., and Higgins, G. C., A variable-magnification instrument for measuring graininess. *Jl. O.S.A.*, **41** (1951), 41. Performance characteristics of the variable magnification graininess instrument. *Jl. O.S.A.*, **41** (1951), 64.

11 Hartline, H. K., The nerve messages in the fibers of the visual pathway. *Jl. O.S.A.*, **30** (1940), 239.

12 Granit, R., and Davis, W. A., Comparative studies on the peripheral and central retina. *Am. Jl. Physiol.*, **98** (1931), 644.

13 Van Krefeld, A., Objective measurements of graininess of photographic materials. *Jl. O.S.A.*, **26** (1936), 170.

14 Stultz, K. F., and Zweig, H. J., Relation between graininess and granularity for black-and-white samples with non-uniform granularity spectra. *Jl. O.S.A.*, **49** (1959), 693.

15 Zwick, D., Colour granularity and graininess. *Jl. Phot. Sc.*, **11** (1963), 269.

16 Stultz, K. F., and Koch, D. A., Role of chromaticity difference in color graininess judgements. *Jl. O.S.A.*, **46** (1956), 832.

17 Zwick, D., and Osborne, C., Use of the split frame technique in motion picture investigations. *Jl. S.M.P.T.E.*, **71** (1962), 931.

18 Zwick, D., How color negative film surface characteristics affect picture quality. *Jl. S.M.P.T.E.*, **71** (1962), 15.

19 Rossmann, K., Spatial fluctuations of X-ray quanta and the recording of radiographic mottle. *Am. Jl. of Roentgenology*, **90** (1963), 863.

20 Tregillus, L. W., Image characteristics in Kodak Bimat transfer film processing. I. Grain structure. *Jl. Phot. Sc.*, **15** (1967), 45.

21 Foucault, L., Mémoire sur la construction de télescopes en verre argenté. *Ann. de l'Observatoire Imp. de Paris*, **5** (1859), 197.

22 Sandvik, O., On the measurement of resolving power of photographic materials. *Jl. O.S.A.*, **14** (1927), 169.

23 Carman, P. D., and Charman, W. N., Detection, recognition and resolution in photographic systems. *Jl. O.S.A.*, **54** (1964), 1121.

24 Perrin, F. H., and Altman, J. H., Studies in the resolving power of photographic emulsions. VI. The effect of the type of pattern and the luminance ratio in the test-object. *Jl. O.S.A.*, **43** (1953), 780.

25 Sandvik, O., The independence of the resolving power of a photographic material upon the contrast of the object. *Jl. O.S.A.*, **16** (1928), 244; *Phot. J.*, **68** (1928), 313; *Z. Wiss. Phot.*, **27** (1929), 60.

26 French Standard S 20.003 (December, 1966)

27 Carlu, P., and Ducrocq, J., Méthode améliorée d'évaluation de la qualité photographique des microfilms. *3rd International Conference of Reprography*, London, 1971.

28 Altman, J. H., A simple camera for the measurement of photographic resolving power. *Phot. Sci. Eng.*, **5** (1961), 17.

29 Perrin, F. H., and Altman, J. H., Studies in the resolving power of photographic emulsions. IV. The effect of development time and developer composition. *Jl. O.S.A.*, **42** (1952), 455.

30 Hansson, N., On the resolving power of the photographic image with special regard to the developer. *Arkiv för Astronomi*, **1** (1955), 531.

31 Levy, M., A high resolution exposure determinant for aerial films. *Phot. Sci. Eng.*, **5** (1961), 159.

32 Selwyn, E. W. H., The photographic and visual resolving power of lenses. Part I. Visual resolving power. *Phot. Jl.*, **88B** (1948), 6; Part II. Photographic resolving power. *Phot. Jl.*, **88B** (1948), 46.

33 Perrin, F. H., and Altman, J. H., Photographic sharpness and resolving power. II. The resolving power cameras in the Kodak Research Laboratories. *Jl. O.S.A.*, **41** (1951), 265.

34 Gretener, E., Über die Zusammenhänge zwischen der Häusseren und inneren Exposition in photographischen Schichten. *Z. wiss. Phot.*, **38** (1939), 248.

35 Brock, G. C., Microimage quality. In G. C. Brock, D. I. Harvey, R. J. Kohler and E. P. Myskowski, *Photographic Considerations for Aerospace*. Itek Corporation, Lexington, Mass. U.S.A. 1965, p. 63.

36 Paris, D. P., Influence of image motion on the resolution of a photographic system. *P.S.E.*, **6** (1962), 55.

37 Ross, F. E., *The Physics of the Developed Photographic Image*. New York and Rochester 1924, p. 124.

38 Higgins, G. C., and Jones, L. A., The nature and evaluation of the sharpness of photographic images. *Jl. S.M.P.T.E.*, **58** (1952), 277.

39 Jones, L. A., The contrast of photographic printing paper. *Jl. Franklin Inst.*, **203** (1927), 136.

40 Higgins, G. C., and Wolfe, R. N., The relation of definition to sharpness and resolving power in a photographic system. *Jl. O.S.A.*, **45** (1955), 121.

41 Stultz, K. F., and Zweig, H., Psychometric scaling in the presence of multidimensionality. *Jl. O.S.A.*, **47** (1957), 1053.

42 Zeitler, E., Vergleiche von Messungen des Streulichtes in der photographischen Schicht mit der Theorie. *Phot. Korr.*, **93** (1957), 115.

43 Mie, G., Beiträge zur Optik trüber Medien, speziell kolloïdaler Metallösungen. *Ann. der Physik*, **25** (1908), 377.

44 Theissing, H. H., Macrodistribution of light scattered by dispersions of spherical dielectric particles. *Jl. O.S.A.*, **40** (1950), 232.

45 Sayanagi, K., On the light distribution in the photographic image. *Jl. O.S.A.*, **47** (1957), 566.

46 Lamberts, R. L., Higgins, G. C., and Wolfe, K. N., Measurement and analysis of the distribution of energy in optical images. *Jl. O.S.A.*, **48** (1958), 487.

47 Pinoir, R., Le problème du pouvoir résolvant photographique et la notion de la courbe de contraste. *Sci. & Ind. Phot.*, **15** (1944), 257.

48 Frieser, H., Untersuchungen über die Wiedergabe kleiner Details durch photographische Schichten. *Phot. Korr.*, **92** (1956), 51.

49 Frieser, H., Körnigkeit und Auflösungsvermögen. In *Fortschritte der Photographie II*. Leipzig, 1940, p. 323.

50 Metz, H. J., Die Tiefenabhängigkeit der Belichtung in einer photographischen Schicht. *Thesis Inst. Phot. Munich*, 1964.

51 Pitts, E., The application of radiative transfer to scattering effects in unexposed photographic emulsions. *Proc. Phys. Soc.* (B), **67** (1954), 105.

52 Chandrasekhar, S., *Radiative Transfer*. Clarendon Press, Oxford, 1950.

53 Kourganoff, V., *Basic Methods in Transfer Problems*. Clarendon Press, Oxford, 1952.

54 Metz, H. J., Zur Berchnung der Streulichtverteilung in photographischen Schichten. *Thesis Technische Hochschule, Aachen,* 1968; *Phot. Korr.,* **106** (1970), 37 and 69.

55 Mees, C. E. K., and James, T. H., *The Theory of the Photographic Process.* 3rd edition, Macmillan New York; Collier-Macmillan London, 1966, p. 508.

56 Carlu, P., and Gallois, D., Utilisation de chartes microphotographiques pour l'evaluation simple de films destinés à la reprographie et l'instrumentation. *Nucleus,* **9** (1968), 410; and **10** (1969), 46.

57 Berg, W. F., The photographic emulsion as a three-dimensional recording medium. *Jl. Phot. Sci.,* **16** (1968), 263.

58 Frieser, H., and Kramer, H., Die Abhängigkeit der Modulations—Übertragungs-funktion photographischer Filme von ihren optischen Eigenschaften und dem Aufbau der Emulsionsschicht. *Phot. Korr.,* **104** (1968), 221.

59 Eberhard, G., Ueber die gegenseitige Beeinflussung benachbarter Felder auf einer Bromsilberplatte. *Physik. Zeitschr.,* **13** (1912), 288.

60 Kostinsky, S., Mittheilungen der Nikolai-Hauptsternwarte Pulkowo, I-11 and II-14 (1906).

61 Reference 37, p. 163.

62 Nelson, C. N., *The prediction of densities in fine detail in photographic images.* Communication at the SPSE Convention of May 12, 1966.

63 Yule, J. A. C., See Reference 43 of Chapter 7, p. 513.

64 Riesz, F., and Nagy, B., *Leçons d'analyse fonctionnelle.* (Gauthier-Villars, ed., Paris, 1965, p. 290.

65 Frieser, H., and Pistor, W., Der Wiedergabespalt als Fehlerquelle bei Lichtton-filmen. *Z. techn. Phys.,* **12** (1931), 116.

66 Lamberts, R. L., Relationship between the sine-wave response and the distribution of energy in the optical image of a line. *Jl. O.S.A.,* **48** (1958), 490.

67 Fourier, M., *Théorie analytique de la chaleur.* Paris, 1822.

68 Angot, A., *Compléments de mathématiques.* Paris, 1952, p. 57.

69 Lanczos, C., Harmonic analysis, p. 225. In *Applied Analysis,* Englewood Cliffs, N.J., U.S.A., 1964.

70 Bracewell, R., *The Fourier Transform and its Applications.* New York, 1965, p. 356.

71 Jennison, R. C., *Fourier Transforms and Convolutions for the Experimentalist.* Oxford University Press, 1961, p. 26.

72 Kelly, D. H., Spatial frequency, bandwidth and resolution. *Applied Optics,* **4** (1965), 435.

73 Perrin, F. H., Methods of appraising photographic systems. *Jl. S.M.P.T.E.,* **69** (1960), 151 and 239.

74 Lamberts, R. L., Sine wave response techniques in photographic printing. *Jl. O.S.A.,* **51** (1961), 982.

75 Lamberts, R. L., Adjacency effects in processing. *S.P.S.E. Handbook of photo-engineering.*

76 Simonds, J. L., Analysis of non linear photographic systems. *Phot. Sci. Eng.,* **9** (1965), 294.

77 Lamberts, R. L., Measurement of sine wave response of a photographic emulsion. *Jl. O.S.A.,* **49** (1959), 425.

78 Lamberts, R. L., and Straub, C. M., and Lamberts, R. L., and Garbe, W. F., Equipment for routine evaluation of the modulation transfer function of photo-

graphic emulsions. I—The camera, II—The microdensitometer, III—Evaluating and plotting instrument. *Phot. Sci. Eng.*, **9** (1965), 331, 335 and 340.

79 Hendeberg, L. O., The contrast transfer of periodic structures in a photographic emulsion developed with adjacency effects. *Arkiv för Fysik*, **16** (1960), 457.

80 Wolfe, R. N., and Eisen, F. C., The spatial photographic recording of fine interference phenomena. *Jl. O.S.A.*, **40** (1950), 143.

81 Frieser, H., and Kramer, H., Messung der Modulations übertragungsfunktion photographischer Schichten mit Hilfe einer Interferenz-Apparatur. *Phot. Korr.*, **102** (1966), 69.

82 Langner, G., and Müller, R., The evaluation of the modulation transfer function of photographic materials. *Jl. Phot. Sci.*, **15** (1967), 1.

83 De Belder, M., Jespers, J., and Verbrugghe, R., On the evaluation of the modulation transfer function of photographic materials. *Phot. Sci. Eng.*, **9** (1965), 314.

84 Gendron, R. G., and Goddard, M. C., Characteristic vectors for modulation transfer functions of color films. *Phot. Sci. Eng.*, **10** (1966), 114.

85 Simonds, J. L., Application of characteristic vector analysis to photographic and optical response data. *Jl. O.S.A.*, **53** (1963), 968.

86 Jones, R. A., An automated technique for deriving *MTF*'s from edge traces. *Phot. Sci. Eng.*, **11** (1967), 102.

87 Fellgett, P., Concerning photographic grain, signal-to-noise ratio, and information. *Jl. O.S.A.*, **43** (1953), 271.

88 Zweig, H. J., Autocorrelation and granularity. Part I. Theory. *Jl. O.S.A.*, **43** (1956) 805; Part II. Results on flashed black-and-white emulsions. *Jl. O.S.A.*, **46** (1956), 812; Part III. Spatial frequency response of the scanning system and granularity correlation effect beyond the aperture. *Jl. O.S.A.*, **49** (1959), 238.

89 Doerner, E. C., Wiener spectrum analysis of photographic granularity. *Jl. O.S.A.*, **52** (1962), 669.

90 Rossmann, K., Recording of X-ray quantum fluctuations in radiographs. *Jl. O.S.A.*, **52** (1962), 1162.

91 Rossmann, K., Modulation transfer function of radiographic systems using fluorescent screens. *Jl. O.S.A.*, **52** (1962), 774.

92 Klein, E., and Langner, G., Relations between granularity, graininess, and the Wiener spectrum of the density deviations. *Jl. Phot. Sc.*, **11** (1963), 177.

93 Gaultier du Marache, J., Applications de l'intégrale de Fourier aux images photographiques. *Cahiers de Physique*, **6** (1952), 5, 29

94 Desprez, R., and Pollet, J., Etude de l'image photographique par analyse harmonique optique. *Sci. et Ind. Phot.*, **35** (1964), 113.

95 Simonds, J. L., Kelch, J. R., and Higgins, G. C., Analysis of fine detail reproduction in photographic systems. *Applied Optics*, **3** (1964), 23.

96 Kowaliski, P., Applications pratiques du concept de transfert de modulation en photographie aérienne. *Bull. Soc. Française Photogramm.* XI Congrès International de Photogrammétrie 8-20/7/1968.

97 Kowaliski, P., Computation of the limits of photographic detail resolution. *Jl. Phot. Sci.*, **17** (1969), 20.

98 Kowaliski, P., Praktische Anwendung des Modulationsübertragungskonzepts auf Röntgensysteme. *Röntgen-Blätter*, **22** (1969), 595.

99 Rossmann, K., Lubberts, G., and Cleare, H. M., Measurement of the line spread-function of radiographic systems containing fluorescent screens. *Jl. O.S.A.*, **54** (1964), 187.

100 Rossmann, K., Measurement of the modulation transfer function of radiographic systems containing fluorescent screens. *Phys. Med. Biol.*, **9** (1964), 551.

101 Rossmann, K., and Lubberts, G., Some characteristics of the line spread-function and modulation transfer function of medical radiographic films and screen-film systems. *Radiology*, **86** (1966), 235.

102 Lubberts, G., Random noise produced by X-ray fluorescent screens. *Jl. Opt. Soc. Am.*, **58** (1968), 1475.

103 Lubberts, G., and Rossmann, K., Modulation transfer function associated with geometrical unsharpness in medical radiography. *Phys. Med. Biol.*, **12** (1967), 65.

104 Rossmann, K., A method for measuring one-dimensional spatial frequency spectra of objects in medical radiography. *Proceedings Coll. on diagnostic radiologic instrumentation.* Chicago (Ill.), U.S.A., 1966.

105 Neugebauer, E. J., A describing function for the modulation transfer of xerography. *Applied Optics*, **4** (1965), 453.

106 Kubota, H., and Asakura, T., Optics in Japan: With special reference to the study of transfer function and its application in optical industries. *Applied Optics*, **1** (1962), 284.

107 Tregillus, L. W., Image characteristics in Kodak Bimat transfer film processing. II. Image structure. *Jl. Phot. Sc.*, **15** (1957), 129.

3

Colour Reproduction

An image of a subject or a scene, to be complete, must not only reproduce the luminance distribution and the outlines, but also the colours. The image then contains a much greater amount of information than a monochrome reproduction because it also records in each point the spectral composition of the light reflected from a scene. Colour being on the other hand the characteristic of a visual sensation, the subjective aspect of its reproduction appears to the observer to be of prime importance. It is therefore necessary to relate these two aspects and to define exactly the purposes and requirements of the 'reproduction' of colours.

Still more than tone and detail reproduction colour reproduction is limited by the intrinsic nature of colour to the narrow spectral domain of visible radiation. The study of colour reproduction could thus seem to lack of generality within the very wide frame of the recording of information by the photographic processes. The techniques employed for the reproduction of colour can, however, be extrapolated also to other spectral domains and may thus prove useful in the search of information by the recording of the spectral characteristics of phenomena due to radiation outside the visible domain. This fact allows us to limit the study of colour reproduction to visible radiation without impairing the general validity of the conclusions.

The discussion of the complex problems arising from the requirements of objective and subjective colour reproduction requires a good overall knowledge of the nature of colour, of its measurement as well as of the methods employed for its classification in appropriate systems of coordinates. Taken in its simplest form, the reproduction of colours reduces indeed to the exact restitution of the appearance of the original scene. This does not imply, however, that the spectral distribution of the light reflected by the

reproduction must be identical to that reflected or emitted from the scene; exact restitution in this sense only refers to the identity of appearance.

Recent studies, on the other hand, have shown that this exact correspondence between the original and the image is not really necessary, just as in the case of tone reproduction (see p. 4). The investigation of this last step of colour reproduction must thus rely on the tacit assumption of the validity of the hypothesis of true colour reproduction. Only when the mechanisms involved in this first step are well understood is it possible to study the more complex aspects of subjective observer preferences towards colour reproduction.

3.1 DEFINITIONS

3.1.1 Intrinsic Properties and the Classification of Colours

Even a succinct study of the visual sensation of colour makes its tridimensional character appear: colour has the three attributes: *hue* (described by the adjectives red, green, blue, etc.), *saturation* (the fraction of white content which decreases its coloured aspect), and *brightness* (the degree of darkening in relation to the surround).

By varying each of these parameters continuously it is possible to cover the whole colour domain. The sensation of colour is therefore trivariant, and its classification can be represented in any tridimensional system of coordinates. As it is further possible to match almost all colours in a photometer by mixtures of very saturated red, green and blue coloured lights, chosen as primaries, these can also serve as basic parameters of a system of coordinates.

When all colours are available in the form of samples, they can be arranged in *colour order systems*. These can be constructed in different ways; some are based on additive colour mixture, others on subtractive colour mixture, and a third kind on uniform colour scales.

The rather abstract *systems of colour coordinates* give a generalized picture of the colour domain. They not only allow the correct colorimetric representation of experimental results, but also the definition of quantitative relationships between colours; their usefulness will become apparent in the description of the principle of exact colour reproduction.

3.1.2 The Principle of True Colour Reproduction

Taken literally, the reproduction of the colours of a scene should yield in the image colours identical to those of the original. Only thanks to this severe reasoning the inventors of the classical trichromatic method succeeded in resolving the problem of photographic colour reproduction.

Maxwell's principle, at the origin of all presently employed processes, is based on the principle of reversibility of light rays: any radiation emitted or

reflected by the subject is first segregated by coloured filters into its red, green and blue fractions, each of which serves to yield one of three separation negatives. The corresponding positives, each projected through its respective filter, restitute in principle the original colours on the screen by the super-position of the images in exact register. This laboratory set-up, based on additive synthesis, is now replaced by the customary method of subtractive synthesis, equivalent to it only under certain well defined conditions, not different however in principle.

3.1.3 Reproduction Errors and Corrective Methods

When attempting to reproduce all colours exactly, similar limitations of the luminance scales are encountered as in monochrome reproduction. There are, on the other hand, practical impossibilities which interfere with a rigourous application of Maxwell's principle: as will be shown below, the theory of trichrome colour reproduction requires for the taking material partly negative spectral sensitivities which are obviously not possible; all the dyes of subtractive synthesis show further some unwanted spectral absorptions. These factors forbid satisfaction of the requirements of Maxwell's principle and thus lead to colour reproduction errors. To eliminate these, corrective methods are now generally employed; having reached a high degree of perfection they are integrated in the processes of colour reproduction and allow the obtention of an excellent objective restitution of the original colours.

3.1.4 Objective and Subjective Colour Reproduction

As any final evaluation of a colour image is subjective, it is necessary to know the criterions which allow an observer to judge it. Were he in a position to compare the reproduction to the original scene he could be replaced by measuring devices, and true reproduction according to the principle of reversibility of light rays could then be attempted. As already mentioned, this comparison is however almost never possible, so that the observer must rely on his memory, or even judge the image in absolute value relative to his memory of similar impressions. These rather arbitrary judgments oblige us to introduce the concepts of *memory colours* and of *colours preferred in reproductions*, both now well defined criterions. The former are those colours of uniform patches which evoke the colours typical of subjects frequently encountered, such as complexion, foliage, wood, sky, etc. The latter, colours preferred in reproductions, can be identical or not either to the original colours or to memory colours, but differ in general from both. A good knowledge of these colours allows us to design reproduction processes yielding optimum results.

3.2 THE NATURE OF COLOUR

3.2.1 Characteristics of Colour Perception

3.2.1a *Spectral Properties*

When the light reaching the eye is lacking some of the spectral radiation whose mixture appears white, it gives rise to the sensation of colour. Theoretically this mixture is that of an equi-energetic spectrum; in practice, however, the sensation of 'white' depends on the state of adaptation of the observer and can thus result from less-uniform spectral distributions. Customarily these are then taken as reference and light is judged to be coloured when its spectral composition differs from that of the reference 'white'.

The elimination of some of the radiation emitted by a 'white' light source, for instance through a filter, thus yields coloured light. Similarly, coloured objects, illuminated by white light, appear coloured because they do not reflect all radiations. An object looks green, for instance, not only because it reflects green light, but mainly because it does not reflect some other

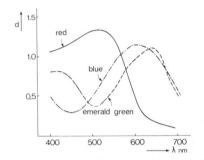

Figure 3.1. Spectral characteristics of vivid colours.

radiations, particularly the red and blue ones. Figures 3.1 and 3.2 show examples of spectral absorptions and reflections of some vivid and of some frequently encountered colours.

Colour having its origin in the non-uniformity of the spectral composition of visible radiation, the coloured aspect, i.e. the deviation from neutrality, increases with the degree of spectral non-uniformity. The most saturated colours attainable in practice, i.e. those of the visible spectrum, result from radiation limited to a very narrow, theoretically monochromatic, spectral band. The saturation of colours due to mixed radiation containing a certain number of neighbouring monochromatic lights increases therefore with the sharpness of the transition between the spectral regions of intense and weak radiation.

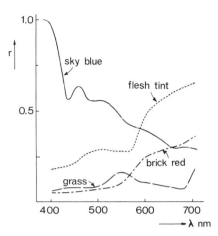

Figure 3.2. Typical spectral characteristics of frequently encountered colours.

This experimental fact of physiological optics allows us to define the spectral characteristics of those coloured surfaces which appear the most saturated and the brightest, called either 'maximum' or 'optimum colours', according to their luminance level.[1,2] While impossible to obtain with dyes or pigments, such hypothetical coloured surfaces would reflect all radiation in a given spectral region and absorb it entirely in the remainder of the visible spectrum. The hue and saturation of the resulting colour would then be determined by the wavelengths of the limits between these two regions[3] (Figure 3.3).

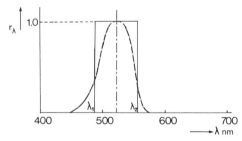

Figure 3.3. Spectral reflectance of a hypothetical 'maximum' colour and of the corresponding real colour.

This effect of the spectral composition of a visible radiation on the appearance of a coloured surface is encountered in practice in the preparation of paints or other dye stuff by mixtures of pigments or dyes. The colour scales resulting from such mixtures, extending first from black to the most saturated

colour (luminosity scale), and then from that colour to white (saturation scale), each contain only one single colour of maximum saturation and brightness. Attempts to increase the saturation by further addition of pigment or dye make the colour darker; lightening them by addition of white pigment or dilution makes them brighter, but decreases their saturation.

3.2.1b *Surface Colours and Coloured Lights*

Taken as the origin of colour sensation, a surface colour does not differ to the physicist from coloured light.[4] Observation of a uniform luminous field limited by a simple geometrical form such as a circle or a square, and entirely separated from its surroundings by a uniform background, does not allow us to make an *a priori* decision about its nature. The colour patch has the appearance of a coloured light when surrounded by a much darker field, and that of an opaque surface illuminated from the front when surrounded by a uniformly white or light grey field, lighter than it. The luminous flux reaching the observers' eyes is the same in both cases but the subjective impression of its nature differs and is essentially determined by the surround.

Minor surface reflections, making a structure appear, also contribute to the appearance of surface colour, less however than the relative brightness of the surround. In daily life coloured lights are further distinguished from surface colours by the arrangement and the shapes of the objects seen, often just by experience without any detailed observation of the physical phenomenon which is at the origin of colour sensation. Only photometric experience therefore allows us to grasp entirely the intrinsic identity of sensations carrying only different names (see also p. 270). While any given radiation, according to the circumstances, can give rise to two different visual perceptions, the coloured aspect of any area always results in a light flux directed towards the eyes of the observer, independently of all the intricacies of its path from the source. This allows us to limit the investigation of the reproduction of colours in the customary manner to that of coloured lights.

3.2.1c *Grassman's Laws and the Trichromatic Fact*

Quite independently of its physical origin the visual sensation of colour, as already mentioned, is trivariant. This fact can be demonstrated by a simple photometric experiment. Illuminating one half of the field by any arbitrarily chosen coloured light C_x—obtained either from white light coloured by the absorption of a filter, or else from a mixture of several monochromatic lights—it is always possible to match this colour by illuminating the other half of the photometric field by a mixture of one single monochromatic light C_λ and an appropriate quantity of white light C_w, according to the equation

$$C_x = C_\lambda + C_w. \tag{3.1}$$

The sum $C_\lambda + C_w$ not only depends on the two luminance values C_λ and C_w, but also on the wavelength λ, i.e. on three parameters. Photometric experience thus demonstrates visual trivariance; its practical consequence can be found in the principle of the corresponding instruments; three commands, levers or knobs are necessary and sufficient to allow in a photometer the visual matching of all colours.

Photometric experiments on mixtures of coloured lights also make other intrinsic properties of colour appear. These properties, synthesized by Grassmann,[5] form together with the trivariance the basis of all colour reproduction. Just as the intrinsic trivarince of colour, Grassmann also described the continuity of all scales resulting from mixtures of coloured lights and further the existence of metameric colours, of identical visual appearance but of different spectral composition. These experimental facts, now known as Grassmann's laws, are:

(i) Three parameters are necessary and sufficient to define the colour of a light.

(ii) All mixtures of coloured lights yield continuous scales.

(iii) The result of an additive mixture of coloured lights only depends on their visual appearance and is independent of the physical origin of their coloured aspect.

Thanks to these two latter properties of colour mixtures, the colorimetric equations employed for the description of colour matching experiments, of the form of equation 3.1, have the same properties as the equations of elementary algebra formulating relationships between arithmetic values (LeGrand[6]). These properties are:

Additivity. A photometric match is not disturbed by the addition of an identical amount of light C to both matched halves A and B of the photometric field.

$$A = B, \qquad \text{therefore } A + C = B + C. \tag{3.2}$$

Multiplicative property. Within the limits of normal daylight vision (photopic vision), multiplication of the luminance values of the two halves of a photometric field by the same factor does not upset their balance

$$A = B, \qquad \text{therefore } kA = kB. \tag{3.3}$$

This type of notation is customary in colorimetry; luminance values are expressed as factors by lower case letters, and the kind of the colours by capital letters (r cd/m^2 of red light R reads rR).

Associative property. A colorimetric match is neither modified by the replacement of the mixture (the sum of several coloured lights) by another

mixture of the same appearance, nor by the addition to both halves of the field of lights identical or of identical aspect.

$A + B = C$ and $A = D + E$, therefore $(D + E) + B = C$, and

$$D + E + B + F = C + F, \text{ etc.} \tag{3.4}$$

Transitivity. Two mixtures of coloured lights, each visually identical to a third mixture, are equivalent.

$$\text{If } A + B = C \text{ and } D + E = C, \quad \text{then } A + B = D + E. \tag{3.5}$$

The visual trivariance of colour expressed by the first of Grassmann's laws has a further consequence which is of fundamental importance to the photographic reproduction of colours. When attempting to reproduce all colours in a colorimeter by mixtures of a minimum number of standard stimuli (lights) of saturated colour, it is also found that three of these coloured lights are necessary and sufficient to match most existing colours in nature. This experimental fact, closely related to the physiological mechanism of colour vision, used first by Young in 1801[7] and then in 1853 by Helmholtz[8] as the theoretical proof of their hypotheses on the mechanism of colour vision, has been called the *trichromatic fact*. Just as the intuitive trivariance, based on the variation of hue, saturation and luminance, and demonstrated by matching a coloured light by a mixture of appropriate amounts of monochromatic and achromatic ('white') radiation, the trichromatic fact confirms the first of Grassmann's laws. Trichromatic mixtures however do not cover the whole colour domain, because they do not allow us to match a small number of highly saturated colours (see p. 220). As will be shown later, this fact is only of secondary importance to the photographic reproduction of colours because it can be compensated for by corrective methods.

Photographic colour reproduction is entirely based on the trichromatic fact. When attempting to demonstrate, as early as 1855, the laws of colour mixture by the then new tool of photography, Maxwell discovered the principle of photographic colour reproduction by the trichromatic method[9] which is still universally employed.

In theory the choice of the three colours which are to serve as primaries is entirely free. In practice, however, the bigger the difference between these three colours, the greater the domain covered. This condition, together with the distribution of the colours over the visible spectrum, determines the choice of those three coloured lights which allow the greatest number of matches. They are:

(i) a highly saturated *red*, of dominant wavelength at one of the extremities of the visible spectrum;

(ii) a highly saturated *blue–violet*, of dominant wavelength at the opposite end of the spectrum; and

(iii) a highly saturated *green* of dominant wavelength approximately half-way between those of the two other primaries.

3.2.2 Elements of Colorimetry

3.2.2a *Calibration of the Visible Spectrum*

The first step in building up a colorimetric system based on the three primary colours red, green and blue is the calibration of the spectrum colours. This calibration is carried out by illuminating one half of the photometric field of the colorimeter, shown in Figure 3.4, successively with all

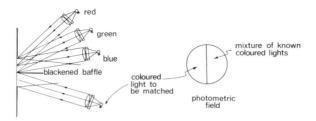

Figure 3.4. Colorimeter (schematic).

monochromatic lights, and by matching each of them by setting the luminances of the primary colours chosen as standards, whose mixture illuminates the other half of the field. These matches, expressed by the equation

$$cC_\lambda = rR + gG + bB, \qquad (3.6)$$

allow us to determine for each monochromatic colour the fractions of unit luminances of the primaries required for its restitution. The—arbitrary— choice of these unit luminances of the primaries, guided only by practical considerations, is such that their additive mixture yields a neutral equal in hue to a previously chosen reference white.

The form of the fractions $\bar{r}(\lambda)$, $\bar{g}(\lambda)$, $\bar{b}(\lambda)$ of the standard coloured lights R, G and B as functions of wavelength can be deduced rather easily, especially in the case of spectral primary lights. The match of any one of such primary colours R_λ, G_λ and B_λ, taken by itself, requires then in the other half of the colorimetric field only this light together with the complete extinction of the other two. This condition determines for each primary the position of three points of the calibration curve: the first point at unit ordinate at the absissa of the chosen primary colour, and the two other points at zero ordinate at the wavelengths of the two other primaries (Figure 3.5). Due to their continuity,

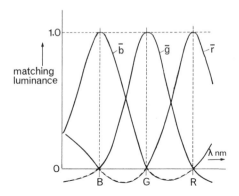

Figure 3.5. Theoretical trichromatic mixture functions.

according to the second of Grassmann's laws, and further to Rolle's theorem the form of the characteristic functions of the fractions $\bar{r}(\lambda)$, $\bar{g}(\lambda)$ and $\bar{b}(\lambda)$, called 'colour mixture curves', are thus known. Each has a maximum at the wavelength of its own primary colour and a negative portion with a minimum between the abscissae of the two other primaries.

This result remains valid for non-spectral primaries, as for instance those obtained with colour filters. By replacing them by a mixture of a monochromatic light and a small amount of white light of identical aspect, the problem is again equivalent to the previous one for spectral primaries, according to Grassmann's third law.

Practical experience of colorimetric matches confirms these hypothetical properties of the mixture curves which show, as mentioned above, for each monochromatic light of a given wavelength the fractions of the three primary lights required to match it. For colours having their spectral maximum near the wavelength of any of the primaries, this nearby primary prevails in the trichromatic mixture, and the corresponding curve passes through a maximum. For colours approximately complementary to the primary, the matching light mixture however is mainly composed of the two other primaries; even total extinction of the first primary does not allow a perfect match. To obtain it, it is therefore necessary to slightly desaturate the colour to be matched by the trichrome mixture, which is possible by adding to it a small amount of the first primary. Only then does a match become possible by a mixture of the two other primary colours. It can be expressed by a colorimetric equation having two terms in each member, such as for instance the equation representing a cyan spectrum colour:

$$cC_\lambda + rR = gG + bB. \tag{3.7}$$

According to the properties of the colorimetric equations resulting from Grassmann's laws and the chosen notation, this equation can be rearranged to yield

$$cC_\lambda = -rR + gG + bB, \qquad (3.8)$$

where the negative sign only serves to describe the above described experimental measure employed for allowing us to make a trichromatic match of a spectrum colour of maximum saturation. The general form of the colorimetric equation is therefore

$$cC_\lambda = \pm rR \pm gG \pm bB. \qquad (3.9)$$

The first systematic determination of colour mixture curves was carried out by Maxwell,[10] who called them 'sensation curves'. Figure 3.6 shows the

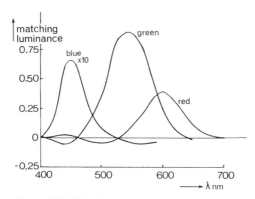

Figure 3.6. Wright's experimental mixture curves.

experimental mixture curves determined by Guild[11] and Wright,[12] which form the basis of the colorimetric system of the Commission Internationale de l'Éclairage. The identity of these results, obtained with entirely different colorimeters as well as different groups of observers, is a splendid demonstration of the third of Grassmann's laws. In Guild's colorimeter the primaries were defined by three filters and mixed by the flicker method, i.e. by their rapid succession in the photometric field through a prism rotating at high speed, while Wright's primaries were stationary monochromatic lights of wavelengths 650, 530 and 460 nm, mixed by optical superposition of the light rays with prisms. The close resemblance of the mixture curves thus obtained for rather wide band primaries (Guild), and for monochromatic primaries (Wright), demonstrates the independence of the appearance of a colour of its physical origin for a normal observer. Guild's and Wright's

mixture curves are also quite similar to those obtained in much older determinations. Figure 3.7 shows their comparison with those determined by König–Dieterici[13] and by Abney,[14] carried out by Richter[15] after transformation of the initial non-coherent figures and their expression in one single system of units.

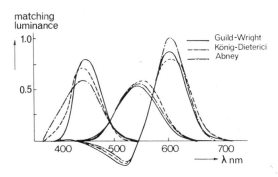

Figure 3.7. Comparison of spectrum calibrations.

3.2.2b *Change of Primaries*

Because of the identity of the visual appearance of the trichromatic mixtures of several different systems of primaries matching any given colour, the equations expressing these matches are also equivalent. They can be related therefore by a simple linear transformation.[16,17]

Let there be a colour of quality C and of luminance c expressed on the one hand in the system of primaries R, G and B, and on the other hand in a system X, Y and Z. In the first of these two systems, the match is written

$$cC = r_c R + g_c G + b_c B. \tag{3.10}$$

Similarly each primary of the other system can be expressed in the R–G–B system by the equations

$$1{\cdot}0X = r_X R + g_X G + b_X B,$$
$$1{\cdot}0Y = r_Y R + g_Y G + b_Y B, \tag{3.11}$$
$$1{\cdot}0Z = r_Z R + g_Z G + b_Z B.$$

Solving this system of equations for R, G and B yields

$$1{\cdot}0R = x_R X + y_R Y + z_R Z,$$
$$1{\cdot}0G = x_G X + y_G Y + z_G Z \tag{3.12}$$
$$1{\cdot}0B = x_B X + y_B Y + z_B Z,$$

and substituting in equation (3.10) this yields, after simplification and rearrangement of the coefficients,

$$cC = (r_c x_R + g_c x_G + b_c x_B)X + (r_c y_R + g_c y_G + b_c y_B)Y$$
$$+ (r_c z_R + g_c z_G + b_c z_B)Z, \text{ or}$$
$$cC = x_c X + y_c Y + z_c Z. \tag{3.13}$$

This transformation allows us to compute colour mixture curves for any system of primaries from a given set of mixture curves obtained by actual matches. The advantage of this operation is to make it possible to determine mixture curves which satisfy predetermined conditions requiring primaries difficult or impossible to materialize. Schrödinger[18] showed that it is thus possible to determine virtual primaries having no relationship with any real coloured light, but mixture curves without any negative sections.

3.2.2c *Standardization of the Observation of Colours*

The colorimetric system of the CIE, Commission Internationale de l'Éclairage, at present employed all over the world for the specification of surface colours as well as of the colour of light sources, is based on this possibility of interchanging primaries.[19]

As shown above, real primaries lead by definition to negative values of the tristimulus values, and thus make numerical computations cumbersome, a factor of primary importance at a time when electronic computers were not yet in use. While choosing as basic elements, because of the well defined experimental conditions of their investigations, the results obtained by Guild and Wright with real primaries, the CIE adopted, according to a linear transformation proposed by Judd,[20] a particular set of primaries X, Y and Z which avoids this drawback. The transformation coefficients employed for their computation were not only chosen to avoid negative values of the mixture functions $\bar{x}(\lambda)$, $\bar{y}(\lambda)$ and $\bar{z}(\lambda)$, but were also adjusted to make the spectrum locus in the chromaticity diagram equidistant from the white locus of an equienergetic spectrum. $\bar{x}(\lambda)$, $\bar{y}(\lambda)$ and $\bar{z}(\lambda)$ are called the 'CIE distribution coefficients'.

The mixture curves $\bar{x}(\lambda)$, $\bar{y}(\lambda)$ and $\bar{z}(\lambda)$ shown in Figure 3.8 therefore define the colorimetric properties of the CIE (1931) standard observer. One of the three primaries, Y, being so chosen that its mixture curve $\bar{y}(\lambda)$ coincides with that of the visibility function V_λ of the standard observer, the relative luminance units L_X, L_Y and L_Z of the three primaries are equal, by definition, to the values $L_X = 0$, $L_Y = 1 \cdot 0$, and $L_Z = 0$.

The practical significance of these conventions, very useful in the applications of colorimetry, is on the one hand to segregate the three parameters of a colour into the two groups of chromaticity and luminance, and on the other

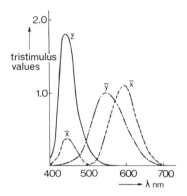

Figure 3.8. Mixture curves defining the 1931 CIE-standard observer.

hand to simplify the numerical specification of colours. The intrinsically coloured fraction of the perception of colour, chromaticity, comprises hue and saturation. The photometric appearance of the colour is defined, on the other hand, by its luminance and depends in the CIE system on the visibility function V_λ. Chromaticity being a function of two parameters only, it can be represented in a plane system of coordinates. Indicating further the numerical value of the colour luminance for each representative point, this system yields a univocal means for the plane representation of colour (see p. 234).

3.2.2d *Constitution of the CIE Colorimetric Reference System*

The elements of the CIE system are:

(i) The tristimulus values X, Y and Z, coefficients of the colorimetric equation defining any given colour.

(ii) The chromaticity coordinates x and y, required for the graphical representation and computed from the tristimulus values.

(iii) Standard illuminants, constituting the achromatic reference stimuli.

(iv) A colorimetric standard observer for the two field angles of 2° and 10°.

Tristimulus values and chromaticity coordinates. The tristimulus values are, by definition, obtained by the convolution of the spectral flux Φ_λ of a colour with the functions of the distribution coefficients

$$X = k \int_\lambda \Phi_\lambda \bar{x}_\lambda \, d\lambda,$$

$$Y = k \int_\lambda \Phi_\lambda \bar{y}_\lambda \, d\lambda, \qquad\qquad (3.14)$$

$$Z = k \int_\lambda \Phi_\lambda \bar{z}_\lambda \, d\lambda,$$

Usually the colour stimulus function Φ_λ is the product of either the spectral transmittance T_λ or the spectral reflectance R_λ and the relative spectral emission S_λ of the standard illuminant employed

$$\Phi_\lambda = T(\lambda)S(\lambda), \quad \text{or} \quad \Phi_\lambda = R(\lambda)S(\lambda). \tag{3.15}$$

In the case of a coloured light taken by itself, Φ_λ is simply equal to its relative spectral emission S_λ, and in the case of a fluorescent material, to the product of the spectral radiance F_λ and the spectral emission of the light

$$\Phi_\lambda = F(\lambda)S(\lambda). \tag{3.16}$$

In practical computations of the tristimulus values the integration (3.14) is approximated by the sums of the products of the ordinates, taken at wavelengths intervals $\Delta\lambda$ of 1, 5 or 10 nm over the whole useful part of the spectrum, i.e. from 300 to 830 nm,

$$X = k \sum_\lambda \Phi_\lambda \bar{x}_\lambda \Delta\lambda,$$
$$Y = k \sum_\lambda \Phi_\lambda \bar{y}_\lambda \Delta\lambda, \tag{3.17}$$
$$Z = k \sum_\lambda \Phi_\lambda \bar{z}_\lambda \Delta\lambda,$$

The constants k are defined by the relationship

$$k = 100 \Big/ \int_\lambda S_\lambda \bar{y}(\lambda)\, d\lambda; \tag{3.18}$$

Y is therefore equal either to the transmittance T of a transparent coloured surface, or to the reflectance R of a reflecting, but opaque surface, expressed as percentages. For a standard illuminant, Y equals 100 because Φ_λ is then identical to S_λ.

The tristimulus values X, Y and Z resulting from these computations are the coefficients of the colorimetric equation

$$(C) = X(X) + Y(Y) + Z(Z). \tag{3.19}$$

According to the notation chosen by the CIE in 1931, these coefficients are in capital letters, just as the reference primaries X, Y and Z of the CIE system, with the purpose of avoiding their confusion with the chromaticity coordinates of the graphical representation, defined by the equations

$$x = \frac{X}{X + Y + Z},$$
$$y = \frac{Y}{X + Y + Z}, \tag{3.20}$$
$$z = \frac{Z}{X + Y + Z},$$

of which only x and y serve in practice, their sum $x + y + z$ being equal to unity.

CIE standard illuminants. For the purpose of the standardization of all practical work as well as of the computations, the CIE defined several standard illuminants, to be employed as reference achromatic stimuli (reference whites) according to each particular purpose. The most important of these standard illuminants are those which reproduce, on the one hand, the average artificial incandescent light sources, and on the other hand, average daylight; this latter being extremely variable, a correlated colour temperature has been defined, representative of the value most frequently encountered. These two fundamental standard illuminants are:

(i) *Standard illuminant A*—Light emitted by an integral radiator of absolute temperature 2854 K. Its relative spectral emission, as a function of absolute temperature, is computed according to Planck's radiation law, by the equation

$$M_{e,\lambda}(\lambda, T) = C_1 \lambda^{-5}(e^{C_2/\lambda T} - 1)^{-1} \text{ watt m}^{-3}, \tag{3.21}$$

where the radiation constants have the numerical values $C_1 = 3.7415 \times 10^{-16}$ watt m^2, $C_2 = 1.4388 \times 10^{-2}$ m K, and $T = 2856$ K.

(ii) *Standard illuminant* D_{6500}—This standard is representative of daylight of a correlated colour temperature of 6500 K. As the present CIE recommendations only define standard illuminants, but not the actual light sources, standard illuminant D_{6500} is defined by a table as a function of its spectral emission.

To allow the use of the numerous published results of previous investigations, the CIE recommendations further temporarily include, besides these two fundamental standard illuminants, two older standard illuminants, which are:

(iii) *Standard illuminant B*—Intended to represent direct sunlight with a correlated colour temperature of 4874 K, it is obtained by filtration of illuminant A by a standardized liquid filter recommended by the CIE.[21]

(iv) *Standard illuminant C*—Representative of daylight with a correlated colour temperature of 6774 K, it is obtained like illuminant B by filtration of standard illuminant A.

(v) *Other standard illuminants*—Certain uses of colorimetry require achromatic standard illuminants different from illuminant D_{6500}. To satisfy this need, the CIE recommends 'daylights' of chromaticities and spectral distributions defined by the following relationships:

(a) Chromaticity: The chromaticity coordinates x_D and y_D must satisfy the equation

$$y_D = -3.0 x_D^2 + 2.87 x_D - 0.275, \tag{3.22}$$

where $0.250 < x_D < 0.380$. The relationship between x_D and the correlated

colour temperature $T_c(K)$ of these daylight illuminants D is defined for correlated colour temperatures from 4000 K to 7000 K by

$$x_D = -4.6070\frac{10^9}{T_c^3} + 2.9678\frac{10^6}{T_c^2} + 0.09911\frac{10^3}{T_c} + 0.244063, \quad (3.23)$$

and for correlated colour temperatures from 7000 K to 25,000 K by

$$x_D = -2.0064\frac{10^9}{T_c^3} + 1.9018\frac{10^6}{T_c^2} + 0.24748\frac{10^3}{T_c} + 0.237040. \quad (3.24)$$

(b) Relative spectral power distribution: The relative spectral power distribution $S(\lambda)$ of daylight D can be computed from equation

$$S(\lambda) = S_0(\lambda) + M_1 S_1(\lambda) + M_2 S_2(\lambda), \quad (3.25)$$

where $S_0(\lambda)$, $S_1(\lambda)$ and $S_2(\lambda)$ are functions of wavelength, and M_1 and M_2 factors whose values are related to the chromaticity coordinates x_D and y_D by

$$M_1 = \frac{-1.3515 - 1.7703x_D + 5.9114y_D}{0.0241 + 0.2562x_D - 0.7341y_D}$$

and

$$M_2 = \frac{0.03 - 31.4424x_D + 30.0717y_D}{0.0241 + 0.2562x_D - 0.7341y_D}. \quad (3.26)$$

To simplify the use of this formulae, the numerical values of x_D, y_D, M_1 and M_2 were computed for correlated colour temperatures from 4000 to 25,000 K and published by the CIE. In the interest of the standardization of colorimetric results, however, the CIE recommends the exclusive use of standard illuminant D_{6500}, except in cases where the need exists for a particular correlated colour temperature. In these exceptional cases the preferred use of the correlated colour temperatures of 5500 K and 7500 K is however recommended. Tables 3.1, 3.2 and 3.3, abridged from the CIE recommendations, are given in the appendix to allow the approximate computation of colorimetric data for wavelength intervals $\Delta\lambda$ of 10 nm. However, precise computations require the use of the complete tables published by the CIE.[22]

CIE standard colorimetric observer. The standard observer is defined, as already mentioned, by the colour mixture curves $\bar{x}(\lambda)$, $\bar{y}(\lambda)$ and $\bar{z}(\lambda)$ of the CIE primaries, determined for a field angle of 2° and recommended in 1931. Experience however shows that this field angle, which corresponds closely to the size of the fovea, does not yield results in agreement with the customary appearance of coloured areas. While still recommending these 1931 distribution coefficients $\bar{x}(\lambda)$, $\bar{y}(\lambda)$ and $\bar{z}(\lambda)$ for field angles from 1° to 4°, the CIE has in 1964 also introduced another set of mixture curves $\bar{x}_{10}(\lambda)$, $\bar{y}_{10}(\lambda)$ and

$\bar{z}_{10}(\lambda)$, corresponding to a field angle of $10°$ which yields a satisfactory compromise. Tables 3.4 and 3.5 give the numerical values of these two series of colorimetric distribution coefficients for intervals of 10 nm.

Computations. In general the computation of tristimulus values and chromaticity coordinates is carried out on electronic computers. As these were not yet available when the colorimetric system of the CIE was established in 1931, two methods were then worked out to facilitate the tedious colorimetric computations, mainly with the purpose of eliminating sources of error.[23] Less indispensible at present, they still merit a mention for eventual use when no computer is available. The first, that of the 'weighted ordinates', is based on the use of tables of the trichromatic distribution coefficients, weighted by the relative spectral power distributions of the standard illuminants according to equation (3.17). The second method, that of the 'selected ordinates', makes use of $\Delta\lambda$ intervals of varying widths, so defined that the products $S_\lambda\bar{x}_\lambda\Delta\lambda$, $S_\lambda\bar{y}_\lambda\Delta\lambda$ and $S_\lambda\bar{z}_\lambda\Delta\lambda$ remain constant. This allows us to reduce the computation of the tristimulus values of a chosen colour to the mere addition of the median ordinates, within these $\Delta\lambda$ intervals, of the spectral distribution T_λ, R_λ or F_λ of this colour. Worked out only for the standard illuminants A, B and C, this method is not recommended any more by the CIE.

3.2.2e *Models of Colorimetric Space*

The intrinsic trivariance of colour sensation compels us to use a three-dimensional space for the geometric representation of the colour domain. Chromaticity of a colour is however only a function of the two parameters hue and saturation so that it is possible to limit such a representation in the well-known way to a plane diagram, easier to use and still sufficient for the solution of a large number of colorimetric problems.

Both models have been used since the beginning of the investigation of colour. Newton[4] chose the plane representation of a circular chromaticity diagram, carrying on its circumference the saturated colours, the reference white in its centre, and all the colours resulting from mixtures of coloured lights in the intermediate area. Figure 3.9 shows this diagram, based on the division of the circumference proportionally to the frequencies of the eight sounds of the musical scale, supposed by Newton to have a progression analogous to that of the spectral colours. Brightness, the third parameter of colour, is introduced in this diagram by ascribing to each point representative of a chromaticity a weight proportional to the brightness of its colour. This allows us to place the points representing colour mixtures in the centres of gravity of the constituting colours. A similar plane diagram has also been employed by Grassmann.[5]

Figure 3.9. Newton's chromaticity diagram.

The first tridimensional colorimetric space is Chevreul's[24], shown in Figure 3.10; hemispherical, it fits over a circular chromaticity diagram resembling Newton's. A straight axis, perpendicular to the plane of this diagram in its centre, carries the lightness scale from white to black on a segment of the length of the diagram's radius, so that all colours are situated within the hemisphere. Chevreul's system is not only remarkable by its constitution, but also because it respects the then still unknown concept of equivalent luminance (see page 91). According to Chevreul, the circular horizontal basis of the hemisphere comprises all 'frank' colours together with their saturation scales on the radii of the circle, starting from the centre and in the quadrants above all colours 'darkened' ('rabattues') with black.

Figure 3.10. Chevreul's colorimetric space.

Each radius carries at the limit of the scales of 'frank' and 'darkened' colour one single colour of highest saturation and brightness, the 'normal tone', situated according to its hue at varying distances from the centre, which is nothing else than the colour of maximum visual efficiency, Chevreul's system

introduces this important concept (see p. 244) and in this way respects also the relative positions of the saturated colours, not only as to their chromaticity, but also as to their brightness.

The modern models of colorimetric space are based on the vectorial representation corresponding to the general form (3.9) of the colorimetric equations. Total obscurity resulting from the absence of light and colour being a unique condition, it is represented by a point which by analogy can be called 'alychne' point which is taken as the origin of a bundle of vectors whose orientation in space defines the chromaticity and whose length determines the luminance of colours. The axiomatic equivalence of colour space and of a tridimensional vectorial space was demonstrated by Schrödinger,[25] as well as the affine structure of this space required to make it invariant to a change of coordinates. The replacement of one set of primary colours by another results, as previously shown, in a linear transformation of the colorimetric equations and therefore leads, in that spatial representation, to a linear transformation of the coordinates, neither modifying the original positions nor the lengths of the vectors. Each endpoint of a vector representing a colour therefore always maintains its position in space. Plane intersections of the vector bundle yield chromaticity diagrams also related to all others by linear transformations. Figure 3.11 shows schematically this vectorial representation.

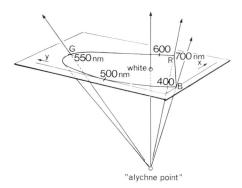

Figure 3.11. Colorimetric vector space.

The arrangements of colour samples called colour-order systems raise the problem of the classification of their elements, and thus also of a representative geometric model. Created either by the manufacturers of dyestuffs or by dyers, painters or printers, and based on the subjective parameters hue, saturation and luminosity, these arrangements are, however, all equiva-

lent to a vectorial representation similar to that of Figure 3.11. While being inscribed in conical or cylindrical coordinate systems, these networks differ from them by their discontinuity, each nodal point representing one single colour which differs from its immediate neighbours by finite values.

According to Wyszecki,[26] these colour-order systems can be grouped in the following three classes:

In the first, based on matches by *additive mixtures* with a colour top, the colour scales are determined from settings of the primary colours on the disk of the top and then matched with paint from appropriate mixtures of pigments. The principal system representing this class is that by Ostwald[27] (Figure 3.12a).

In the second class the colour scales are obtained by *subtractive mixtures*, either by systematic variation of the amounts of the pigments in the mixtures,

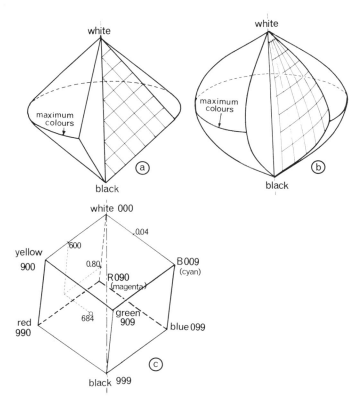

Figure 3.12. Colour order grids: (a) Ostwald system, additive; (b) Plochere system, subtractive; (c) Hickethier system, subtractive halftone screen colours.

or by the use of printed half-tone colour scales. An example of the former is the Plochere system[28] (Figure 3.12b) and of the latter the Hickethier system[29] (Figure 3.12c).

In the third class the colours are arranged according to their visual '*equidistance*', similar to the equidistance of uniform achromatic scales (see p. 46). Statistically determined from numerous measurements carried out by sufficiently large number of observers, these 'equidistant' or 'uniform' scales form the foundation of important and widely used systems such as the Munsell colour-order system[30] and the DIN system (Reference 39 of Chapter 1). Quite generally the uniformity of colour space is one of the most important problems of graphical colorimetric representation (see p. 237).

When adequately oriented, the lattices of the systems corresponding to these three classes show a very pronounced analogy, due to the intrinsic properties of colouring matter as well as of opaque reflecting surfaces (Figure 3.12). Surface colours can indeed never reach the ideal saturation limit of the colours of maximum luminous efficiency (see p. 215), and still less that of monochromatic lights. On the one hand, the spectral absorptions of dyes and pigments are never as selective as those of the hypothetical 'optimal colours', and on the other hand the surface reflection of achromatic light further reduces their saturation. However, extrapolation of the colour system lattices allows us to attribute also to the optimum colours representative points, and thus to construct a volume including all colours, those which can be materialized as well as those which are possible only in theory.

The geometry of this volume has been defined by Luther[2] and Nyberg.[31] In this conical space all coloured lights are represented by vectors. The alychne point, representing the absolute black, is the apex and the directrix curve of the spectral colors is situated in an adequately oriented plane. Luther and Nyberg's colour solid is tangent to this conical surface of the spectral vectors at the proximity of the alychne point, but then converges towards a second apex representing the colour of the most luminous white pigment (Figure 3.13). Each point of the volume represents one colour, the hypothetical oversaturated colours of highest luminosity forming its surface, which therefore carries all points representing the 'optimum colours' and also the 'maximum colours', these latter situated on the curve of contact between the solid outer surface and a vertical tangent cylinder; all less saturated colours are represented by points in the interior of the solid. Its central symmetry around the midpoint of the neutral axis results from the definition of the complementary colours whose additive mixture in equal quantities of adequately defined units must cancel out their colour and yield a neutral; each vertical plane section of the solid therefore contains all colours of two complementary hues.

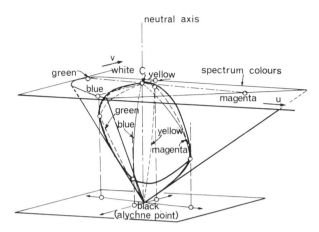

Figure 3.13. Luther–Nyberg's colour solid in colorimetric vector space.

3.2.2f *Chromaticity Diagrams*

Chromaticity diagrams are the only form of graphical representation of the colour domain employed in practice. Being intended to represent the metric relationship between colours, they can have various forms and fit either into rectangular or skew Cartesian coordinate systems, or into polar systems, or even in an equilateral triangle, particularly suitable for the plotting of the relationships between three parameters. According to Newton and Grassmann the points representative of colour mixtures are found in these triangular diagrams by the graphical determination of the centre of gravity of the contributing colours (Figure 3.14).

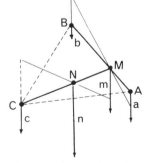

Figure 3.14. Graphical determination of colour mixtures.

Let there be a colour resulting from the mixture of two colours A and B of relative luminances a and b respectively, to be represented in quality and quantity, according to the equation

$$mM = aA + bB.$$

Any point of the straight line AB is made to represent the result of all mixtures of A and B in any proportion; the distances from A and B of the points representing these mixtures are then inversely proportional to the relative luminances a and b of A and B, exactly like those of the centre of gravity of two masses a and b acting at A and B, and they correspond to the colour mixtures, because a tends towards zero when A is decreased until the photometric field remains only illuminated by colour B, and vice versa. The straight line AB containing thus only points corresponding to the mixtures of A and B, the point of any other colour C must lie outside of this straight line. Any such new point determines a plane with the straight line AB. As before the point N of the mixture of the third colour cC with the colour mM resulting from the mixture of aA and bB lies on the straight line CM connecting C and M; in a similar way all other points corresponding to any number of colour mixtures can be found in the same plane.

Applied to the primaries of a colorimetric system, this construction leads to a triangular chromaticity diagram; the equilateral triangle proposed by Maxwell[32] could be thought of as a diagram of constant brightness, the sum of the distances of any point lying in the triangle plane from its sides being constant when these distances are taken positive for all points within the triangle and negative for those outside it. Resulting from the plane intersection of an adequately conceived and oriented vectorial space, the triangle corresponds initially to a brightness level which is defined by the distance of its plane from the origin (Figure 3.11). As all such triangles lying in parallel planes are similar, one only is sufficient to represent all brightness levels, and any change in brightness only corresponds to a change of scale. Brightness, or luminance, requiring a third dimension, is therefore considered not to be shown in the chromaticity diagram, so that *all* luminances of any chromaticity are represented by one single point.

Intersection of the vector bundle by planes of different orientation yields non-equilateral triangles; these can however also be considered as chromaticity diagrams of constant brightness because they are related to the initial diagram, through a linear transformation, by a univocal correspondence between their respective points. Requiring a special coordinate paper the equilateral triangular diagrams are not very practical, so that this possibility of a projective transformation is currently employed for the construction of rectangular diagrams. Placing the real red, green and blue primaries at the apexes of the right-angled triangle, the spectral colours fall outside of it because of the partly negative values of the colour mixture functions of the spectral colours (see p. 220 and Figure 3.5). The diagrams employed by Guild and Wright (Figure 3.15) are typical of this representation. To allow us to plot all real colours inside the triangle and thus the exclusive use of positive coordinates, the unreal primaries X, Y and Z of the 1931 CIE system

(see p. 223) are so situated with respect to the real primaries R, G and B that the triangle XYZ circumscribes the curve of the spectral colours. It is made rectangular at the point Z by a linear transformation of the original RGB triangle, so that a couple x–y of rectangular coordinates corresponds to each chromaticity (Figure 3.16).

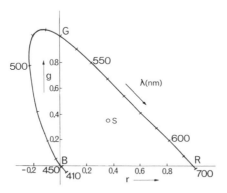

Figure 3.15. Guild's and Wright's r–g diagram.

The *dominant wavelength* and the *excitation purity* of a colour can be determined graphically in the chromaticity diagram. The former is that wavelength of a spectral radiation which when mixed with an appropriate quantity of a chosen reference white matches a given colour, and the excitation purity is defined by the equations

$$p_e = \frac{y - y_w}{y_d - y_w} \quad \text{or} \quad p_e = \frac{x - x_w}{y_d - y_w}, \tag{3.27}$$

where x and y are the chromaticity coordinates of the given colour, x_d and y_d those of the light of the corresponding dominant wavelength, and x_w and y_w those of the reference white (Figure 3.16). To obtain the numerical value of the ratio p_e with the best precision, it is recommended to use that of the two equations in which the numerator has the greater arithmetic value.

The difference between the brightness of a colour and the spectral colour of the corresponding dominant wavelength is not taken into account by this definition of the excitation purity; to respect it the concept of colorimetric purity, defined by the relationship

$$p_e = p_e \frac{y_d}{y}, \tag{3.28}$$

was proposed, but is not used in practice.

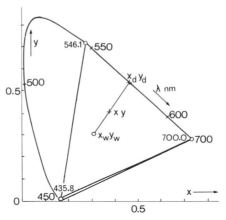

Figure 3.16. 1931 CIE *x–y* diagram.

The chromaticity diagram also allows us to plot the locus of the comple-
mentary of any spectral colour by extending the straight line connecting the
points representative of that colour and the reference white as far as its
second intersection with the spectral locus. To include also non-spectral
chromaticities, this construction has been generalized by MacAdam;[33] the
representative points of all complementary colours lie on the two inter-
sections of the straight lines connecting them and passing through the point
of the reference white, with conic sections of which the 'white' locus is one
of the focal points, and the *x*-axis the corresponding directrix (Figure 3.17).

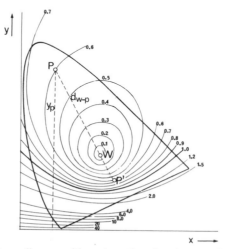

Figure 3.17. CIE *x–y* diagram with conic sections locating complementary colours.

3.2.2g *Uniform Colour Space*

The principal advantage of the geometrical representations of colour space is to allow the graphical evaluation of the relative magnitude of colour differences, a problem which already appears in the oldest models, such as those of Newton and Chevreul, and which remains fundamental in colorimetry.

Certain colour-order systems are based on perceptual 'equidistance' and their spatial models, while resulting from empirical determinations, give a good general idea of the construction of an approximately uniform colour space. The most important of these systems are those already mentioned, the Munsell and the DIN systems.

The Munsell system[30] (see also Reference 40 of Chapter 1). The method employed for the definition of the colours of this system's samples, typical for the experimental determination of a colour-order system of perceptual 'equidistance', shows very well the difficulty of the constitution of a uniform colour lattice. The *basic hues* were chosen by taking among a big number of colour samples those of equal brightness and of reflectance 0·20, including a neutral tint. In a second series of selections only those samples which showed chromatic equidistance relatively to the grey were retained. This set of colours of constant saturation was then employed for the establishment of the final visually equidistant hue scale, which includes only forty colours.

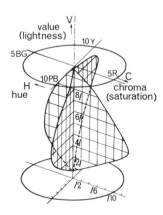

Figure 3.18. Munsell system grid.

Starting from this hue scale the perceptual uniform *saturation scales* were then established by a selection of samples of constant brightness. To cover the colour domain in brightness also, a scale of ten regularly spaced grey samples was finally set up to yield the *brightness scale* of the system (see also p. 47). Repetition, at each brightness level, of series of observations

like those carried out at the beginning for the determination of the hue and saturation scales finally yielded all the remaining colours of the system. These are classified according to the parameters *hue H*, *chroma C* (saturation) and *value V* (lightness), and the lattice of the system is one of cylindrical coordinates (Figure 3.18).

The DIN system[34] (see also Reference 39 of Chapter 1). Of very similar construction, this system is based on the parameters *hue T*, *saturation S* and *'darkness'* (decreasing lightness) *D*. Its equidistant 'basic hue scale' includes twenty-four colours of saturation $S = 6$ and of lightness $D = 1.5$. Provision is made for seven saturation steps of each hue, and the grey scale includes eight steps of decreasing lightness (Dunkelstufe). The lattice representative of the DIN system has the form of an inverted cone of spherical base (Figure 3.19).

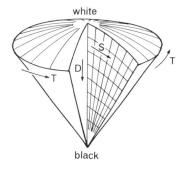

Figure 3.19. DIN system grid.

These materialized 'uniform' spaces, while having been established by great numbers of trials carried out under conditions which should insure their general validity, can of course only be approximations of the intrinsically uniform colour space. In spite of the big efforts in their construction, their uniformity remains only relative as also demonstrated by later checks[35] (see also Reference 40 of Chapter 1). They are besides this discontinuous and do not cover the whole gamut of all colours attainable with light, because the preparation of surface colours highly saturated as well as very bright is not possible. While yielding an explicit image of the colour domain, they are thus not useful for the deduction of the intrinsic properties of its spatial representation.

The investigation of the theory of these properties and of the uniformity of colour space is necessarily based on the definition of the elementary distance between any two colours at the limit of discrimination, whether they differ

in hue, in saturation or in brightness, or else by any combination of these parameters, this elementary distance of line element being the unit measure of universal colour space. Let x, y and z, and $x' = x + dx$, $y' = y + dy$ and $z' = z + dz$ be the chromaticity coordinates of two colour patches which can just be distinguished. According to Helmholtz,[8] supposing Weber–Fechner's psychophysical relationship (References 42 and 28 of Chapter 1) to be valid for all colours, their distance is equal to

$$(ds)^2 = \frac{1}{3}\left[\left(\frac{dx}{x}\right)^2 + \left(\frac{dy}{y}\right)^2 + \left(\frac{dz}{z}\right)^2\right], \qquad (3.29)$$

which generalized by Schödinger[36] yields the line element of colour space in the homogeneous quadratic form

$$(ds)^2 = g_{11}(dx)^2 + g_{22}(dy)^2 + g_{33}(dz)^2 + 2g_{12}\,dx\,dy$$
$$+ 2g_{23}\,dy\,dz + 2g_{31}\,dz\,dx. \qquad (3.30)$$

This form of the line element, confirmed by the experimental work of MacAdam[37] and Brown–MacAdam,[38] makes it invariant to coordinate transformations, but defines a colour space of Riemannian and therefore non-Euclidian geometry. The representation of an n-dimensional Riemannian space in a customary, i.e. Euclidian, coordinate system without any modification of the distances between its elements would require a space of $m = \frac{1}{2}[n(n + 1)]$ dimensions.[39] The representation of the tridimensional colour universe would therefore require a six-dimensional coordinate lattice, which obviously is of no use for a graphical representation.

The g_{ij} coefficients of equation (3.30) are functions of x, y and z, and the line element ds therefore varies with the position in space of the colour initially chosen for the evaluation of the difference of another colour in relation to it. This variability of the elementary distance between colours of just noticeable differences is what characterizes the non-Euclidian nature of colour space. Setting, however, $g_{11} = g_{22} = g_{33} = 1$ and $g_{12} = g_{23} = g_{31} = 0$ results in the line element of an Euclidian space,

$$(ds)^2 = (dx)^2 + (dy)^2 + (dz)^2, \qquad (3.31)$$

which by the choice of an appropriate coordinate system can yield an approximation sufficiently satisfactory for practical use.

Experimental determinations of the differences between neighbouring colours or of the uniformity of the line element, were carried out, besides those already mentioned, by Wright[40,41] and by Stiles.[42] Figure 3.20 shows in the CIE diagram of 1931 the results of these investigations by MacAdam, Wright and Stiles. MacAdam's ellipses show, ten times enlarged, the just noticeable differences between adjacent colours, evaluated as standard

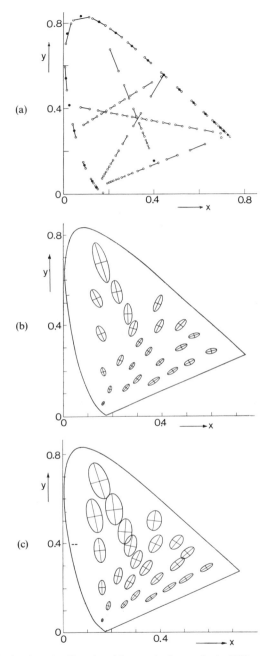

Figure 3.20. Evaluation of uniformity of the metric element in the CIE x–y diagram; (a) Wright's line segments; (b) MacAdam's ellipses ($\times 10$); (c) Stiles' ellipses ($\times 3$).

deviations of the matches. The lengths of Wright's line segments however give those differences between colours which were judged by the observers to be of constant magnitude. Stiles's measurements finally determine the perceptibility of a colour change resulting from the addition of a small amount of one coloured light to another. All three series of measurements demonstrate the great variability of colour differences in the chromaticity diagram, and thus underline the non-uniformity of the CIE 1931 x–y chromaticity diagram.

While the non-Euclidian nature of colour space forbids its true graphical representation, it is possible however to obtain in a Euclidian vectorial space a satisfactory approximation by an appropriate linear transformation of the chromaticity diagram. Such diagrams, as already mentioned, are plane intersections of the bundle of colour vectors (Figure 3.11), and their linear transformations thus represent the intersections of the vector bundle by planes of other orientations. A diagram of maximum uniformity therefore results from the choice of this orientation such as to yield the best compromise.

The linear transformation of a coordinate system x, y into another u, v can be expressed by the equations

$$u = \frac{c_1 x + c_2 y + c_3}{c_7 x + c_8 y + 1},$$
$$v = \frac{c_4 x + c_5 y + c_6}{c_7 x + c_8 y + 1}.$$

(3.32)

The role of the constants c_1 to c_8 has been discussed by MacAdam, as well as the general role of this linear transformation in the construction of a uniform chromaticity diagram,[43] and the geometrical aspects of the problem were studied by Wyszecki.[44] By an appropriate choice of the constants c_1 to c_8, MacAdam proposed the simple linear transformation

$$u = \frac{4x}{-2x + 12y + 3},$$
$$v = \frac{6y}{-2x + 12y + 3},$$

(3.33)

which yields an excellent compromise.[45] The resulting chromaticity diagram is now recommended for all those uses which require a perceptually more uniform spacing than that of the original x–y diagram of 1931. Figure 3.21 shows the CIE u–v chromaticity diagram and its graphical relationship to the

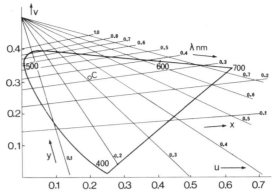

Figure 3.21. 1960 CIE u–v diagram.

x–y diagram. The improvement of the uniformity is demonstrated very strikingly by the transformation of the results of MacAdam's, Wright's and Stiles' investigations (Figure 3.22). To facilitate colorimetric computations, tables have been prepared by the CIE which give the spectral tristimulus values $\bar{u}(\lambda)$, $\bar{v}(\lambda)$, $\bar{w}(\lambda)$ and the corresponding chromaticity coordinates $u(\lambda)$, $v(\lambda)$, $w(\lambda)$ for field angles of 2° and 10° (Tables 3.6 and 3.7).

Besides the u–v chromaticity diagram the CIE recommends further a three-dimensional space with more nearly uniform perceptual differences between colours than those of the original XYZ coordinate system. Based on the u–v diagram, it is called the CIE 1964 uniform colour space and its parameters are U^*, V^* and W^*, defined by the equations

$$W^* = 25Y^{1/3} - 17,\ 1 \leqslant Y \leqslant 100,$$

$$U^* = 13W^*(u - u_0), \tag{3.34}$$

$$V^* = 13W^*(v - v_0),$$

where u and v are computed from equations (3.33) and u_0 and v_0 are the coordinates of the reference white, placed in the origin of the diagram. This space being Euclidian, the CIE recommends also a colour difference formula of the form of equation (3.31). The distance between any one colour (U_1^*, V_1^*, W_1^*) and any other (U_2^*, V_2^*, W_2^*) in this $U^*V^*W^*$ space is thus equal to

$$\Delta E_{\text{CIE}} = [(U_1^* - U_2^*)^2 + (V_1^* - V_2^*)^2 + (W_1^* - W_2^*)^2]^{1/2}. \tag{3.35}$$

It is intended to apply to the comparison of colour differences between objects of identical size and shape, viewed by a photopically adapted observer against a neutral grey surround illuminated by light not too different from average daylight.[46] Field trials of the validity of equation (3.35) show

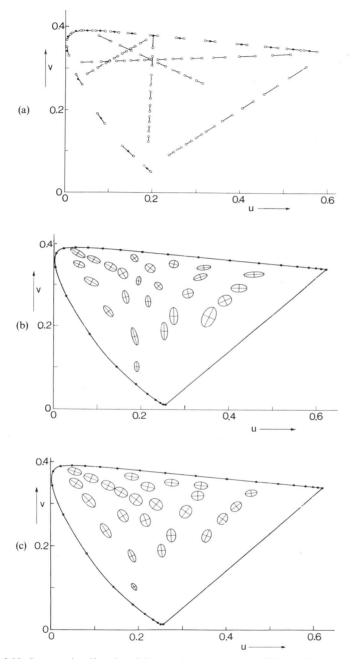

Figure 3.22. Improved uniformity of the metric element in the CIE u–v diagram: (a) Wright's line segments; (b) MacAdam's ellipses ($\times 10$); (c) Stiles' ellipses ($\times 2\cdot 5$).

that it allows us to predict observed colour differences with satisfactory approximation.[47]

3.2.2h *The Brightness of Colours*

The brightness of a colour in relation to its surround defines its colour appearance, and colours also appear lighter or darker according to their hue. The chromaticity for instance, of the light yellow–orange of a marigold yields a brown colour when seen under the same conditions but with considerably less brightness, and we also know, by experience, that a saturated yellow is much brighter than a deep blue–violet. The judgment and the correct graphical representation of the relative brightness of colours is therefore very important for the study and the optimum choice of the conditions of their reproduction.

In the CIE system, owing to its ingenious constitution, the brightness of colours is directly described by their tristimulus value Y. This is due to the choice of the primary Y such that its colour matching function $\bar{y}(x)$ is identical to the spectral sensitivity function V_λ of the CIE 1931 standard colorimetric observer. But the evaluation of the brightness of a colour in relation to its surround implies also its direct comparison, by heterochromatic photometry, to the achromatic scale, i.e. to the neutral reference colour of identical luminance. This aspect of the brightness of colours has been defined by Judd and Wyszecki[48] as the attribute permitting the colour perception to be classified as equivalent to a step of a series of achromatic perceptions ranging from very dim to very bright, and for lightness from black to white. Experience shows that these two kinds of the determination of luminance yield different results, and particularly that the perceived luminance is not related in a simple manner to the physical luminance of a colour. Measurements carried out by several authors with a great number of observers show that the apparent brightness or 'equivalent luminance', determined in relation to the achromatic reference colour, increases with saturation at any given constant luminance level for all colours, with the exception of the yellows.[49–57] This change is due, on the one hand, to the intrinsic nature of the colours whose non-uniformity of spectral composition, the determining factor of their chromaticity (see p. 214), varies considerably with hue, and on the other hand to the spectral sensitivity of human vision. The visual adjustment of the two halves of a photometric field, one of which is illuminated by the coloured light to be measured, and the other by a mixture of red, green and blue lights, implies in fact an observer of normal colour vision. The match is therefore dependent on the spectral sensitivity of the normal observer, which defines the quantitative relationship between the energetic flux and the perceived light (see p. 40). Owing to the subjective nature of photometric matches, however, the definition of spectral sensitivity is different from that

of a photoelectric receiver as employed for the energetic measurement of luminance.[58] The response of the photoelectric cell is given by the equation

$$i_\lambda = s_\lambda e_\lambda, \tag{3.36}$$

where e_λ is the energy of the radiation in watts, i_λ the current generated, and s_λ the sensitivity of the cell for monochromatic light of wavelength λ. The spectral response of the cell as a function of wavelength is proportional to the intensities of the current, generated by the unit energies of each monochromatic radiation. To determine the spectral sensitivity S of human vision it is not possible to use the same method, because the measurement cannot be obtained otherwise than by a photometric match. Illuminating one half of the field by light from a standard source L_1 of known colour and energy, and the other half by a different monochromatic light L_2, the match is obtained by decreasing or increasing the energy of the light to be measured until L_2 looks to the observer equal to L_1. The sensitivity of the eye to these two radiations then is, by definition, in the inverse ratio of their respective energies e_{λ_1} and e_{λ_2},

$$\frac{S_{\lambda_1}}{S_{\lambda_2}} = \frac{e_{\lambda_2}}{e_{\lambda_1}}. \tag{3.37}$$

This basic difference between the respective definitions of the spectral sensitivities of the photoelectric receptor and the standard colorimetric observer also explains, at least in part, the differences between the colorimetric luminance Y and the equivalent luminance L. Figures 3.23, 3.24 and 3.25 show, for the six hues important for the photographic reproduction of colours, red, green, blue, cyan, magenta and yellow, the results of measurements of the equivalent luminance; these graphs are vertical sections of a network of cylindrical coordinates (Figure 3.26), proposed for the representation of the brightness of colours, mainly for the interpretation of their photographic or other reproduction. The constitution of this coordinate system is the following:

(a) The plane horizontal sections are CIE 1960 u–v diagrams of identical size.

(b) The vertical axis passes through the achromatic points and carries the logarithmic luminance scale graduated in cd/m².

(c) The ratios of the scales, determined by heterochromatic photometry, are such that one decimal luminance unit on the vertical axis is equal to one tenth of one u or v unit of the horizontal diagrams.[57]

The importance of the notion of equivalent luminance appears in several applications of colour reproduction, particularly in the printing processes where it is closely related to the 'vivacity' of the printing inks, and in television where the luminance to chromaticity ratio is of great importance.

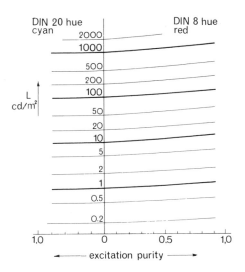

Figure 3.23 Red–cyan.

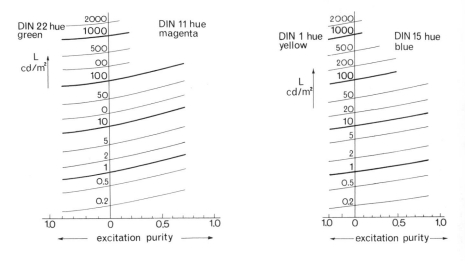

Figure 3.24. Green–magenta. Figure 3.25. Blue–yellow.

Figures 3.23, 24, 25. Equivalent luminances of the six colours important in photographic repro-
duction.

Plate 2

Figure 3.27. Diagrammatic representation of three-colour synthesis. *Reproduction by additive synthesis* (left): Beams of red, green and blue light, projected in a darkened room in variable amounts onto a white screen yield colours ranging from high saturation to white. In additive three-colour photography each of the three beams is modulated by a black-and-white positive transparency. *Reproduction by subtractive synthesis* (right): Dyes and pigments are used to subtract successively fractions of the radiation contained in white light. This yields all colours ranging from high saturation to black. In photography subtractive synthesis results from the superposition of cyan, magenta and yellow positives, each of which modulates the corresponding primary by subtracting from white light an appropriate fraction of its radiation.

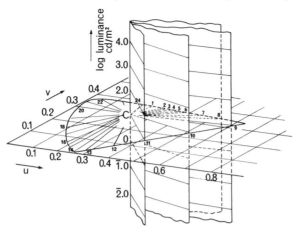

Figure 3.26. Graphic representation of chromaticity and luminance in cylindrical coordinates.

3.3 PRINCIPLES AND MECHANISMS OF COLOUR REPRODUCTION

3.3.1 Theory

3.3.1a *The Axiom of the Exact Reproduction of Colours*

All colour reproduction processes must be based on the axiomatic hypothesis of colorimetrically exact reproduction, the only principle acceptable to the physicist. Accordingly, the result required from the outset, the exact restitution in the image of the chromaticity and the luminance of each elementary area of the original scene, is thus equivalent to a colorimetric match in a photometer. This exact reproduction, even when perfectly materialized, is not necessarily optimum because of the intrinsically subjective nature of the evaluation of its quality by human observers. This latter criterion has however only to be considered in a second step, so that the fundamental mechanism of trichromatic synthesis according to Maxwell's principle, based on that of the reversibility of light rays in optics, remains the basis of all processes. This not only holds when the photographic image is the final purpose of the reproduction, but also when this latter only yields an intermediate which is to serve in a non-photographic process, such as printing or television; the photographic image then however still records the information contained in the original scene, so that the principle of the reproduction remains unchanged in spite of the final transformation of the initial recording.

3.3.1b *Scheme of the Mechanisms*

Subdivided into its elementary steps, the scheme of three-colour reproduction is simple and comprises only two basic operations. The first, the trichromatic analysis of the scene or the original to be reproduced, serves to

determine photographically in each point its tristimulus values. The second, the trichromatic synthesis, yields the colour reproduction through the recomposition of these values. It was in this simple form that Ducos du Hauron[59] invented in the second half of the last century three-colour photography, independently of Maxwell, and used it to make a great number of colour pictures.

Let there be a still life to be reproduced, composed of a red flower with green leaves in a blue vase, and a lemon, placed in front of more or less bright neutral areas (Figure 3.27 [see Plate 2]). The first operation is then the photographic recording of the red, green and blue fractions of the light reflected from the scene, obtained by successive exposures through red, green and blue filters; this analysis of the subject yields three black-and-white negatives called *colour separation negatives*. The first of these, exposed by red light, is dense only in the images of the red flower, of the white background and of the lemon, because these objects reflect red light. It is, on the contrary, transparent in the images of the blue vase, the green leaves and the black strip of the background, because these objects do not reflect the red radiation of the white light which illuminates them. The constitution of the two other separation negatives can be predicted similarly: omitting the background, the second negative is transparent only in the images of the flower and of the vase which absorb green light, but dense in the images of the leaves and of the lemon which reflect it; and the third negative is exposed only in the image of the vase and transparent in the leaves, the flower and the lemon, which do not reflect any blue light. This decomposition of the light reflected from the scene yields for each of its elementary areas the relative quantities of the three primary colours and thus allows us to restitute the original colours in each point of the image by trichromatic synthesis, just as in colorimetry.

This synthesis, which is the second essential operation, can be carried out in the photographic reproduction system in two different ways. In the first the three beams of the red, green and blue primaries are superimposed on a white screen, each being modulated by a black-and-white positive printed from the corresponding negative, with the three separation images in perfect register. Adding up in their respective amounts, the three primary lights thus mix to match the original colours. This synthesis is therefore called additive. The white background, illuminated by the three beams carefully adjusted to yield the reference white of the process, appears white; the lemon, illuminated by the red and green beams, but not by the blue one, is yellow. Only red light reaches the flower, only green light the leaves, and only blue light the vase: the image of these objects therefore not only reproduces their shapes, but also their colours.

Additive synthesis, unwieldy in this elementary form, is now however employed in colour television in a slightly modified form. In all photographic

and printing applications it has been replaced by subtractive synthesis, which, while based on the same principle, is in fact only another working method. Considering white light as a mixture of appropriate quantities of three primary colours allows us to obtain any colour by the subtraction of adequate fractions of these primaries. To act only on the first primary, the red one, a dye is required which absorbs just this radiation, but none of the two other primaries. Similarly the modulation of the second primary requires a dye absorbing only green, but being transparent for red and blue light, and the blue primary requires a yellow dye, absorbing only blue light. All that is then needed is to replace the black-and-white silver images of the three separation positives of additive synthesis by three identical dye images of these three dyes (Figure 3.27 [see Plate 2]). The magenta positive absorbs that fraction of the white light which forms the green primary, and the yellow positive that corresponding to the blue primary, so that only red light remains, for instance in the image of the flower. Similarly only the green light of the second primary is left in the image of the leaves whose red and blue fractions have been absorbed by the first and the third positives, and the image of the vase contains only light of the blue primary, because the first and the second positives absorb all red and green light in that area. The restitution of the colour of the lemon is particularly simple: it results from the absorption of blue light by the yellow dye of the third positive, the two other being transparent here.

In this schematic description the photographic images are considered only in an oversimplified way as yielding 'all or nothing'. In actual three-colour reproduction, advantage is taken of all the subtlety of the continuous density variation of photographic images, negative as well as positive, monochrome or in colour, which allows us to approximate most satisfactorily the chromaticity and also the luminance of the original colours.

3.3.1c *Maxwell's Principle*

The application of the photographic process, according to Maxwell's principle,[9] to colorimetrically true reproduction requires the definition of a relationship between the three primaries whose mixtures restitute the original colours, and the spectral sensitivities of the three separation negatives. As colorimetric matches depend on the mixture functions of the system primaries, a linear relationship is necessary between these and the spectral sensitivities of the colour separation negatives (Ives,[115] Schrödinger,[116] Luther[2]). The process of trichromatic colour reproduction, according to Maxwell's principle, can therefore be reduced to the following steps: (i) the choice of three primary colours; (ii) the determination of the corresponding mixture functions; (iii) the exposure of the separation negatives on layers with spectral sensitivities proportional to the mixture functions of the chosen

reproduction primaries; (iv) the restitution of the original scene either by additive or by subtractive synthesis.

The physical theory of this methodology of photographic colour reproduction was worked out by Hardy and Wurzburg[60] through the application of the principles of colorimetry. The three primary colours A, B and C of the reproduction system are then also the primaries of a colorimetric system of reference. Let there be, to be reproduced, a colour $I = a_I A + b_I B + c_I C$, of spectral reflectance $I(\lambda)$. In the ABC reference system, whose mixture functions are $\bar{a}(\lambda)$, $\bar{b}(\lambda)$ and $\bar{c}(\lambda)$, the tristimulus values a_I, b_I and c_I are given by the equations

$$a_I = \int_{400\,nm}^{700\,nm} I\bar{a}\,d\lambda, \qquad b_I = \int_{400nm}^{700\,nm} I\bar{b}\,d\lambda, \qquad c_I = \int_{400\,nm}^{700\,nm} I\bar{c}\,d\lambda. \quad (3.38)$$

Let further the tristimulus values of the reproduction I' be called a'_I, b'_I and c'_I. According to the above mentioned condition, and to Hardy and Wurzburg, colorimetrically true reproduction requires that the colours of the reproduction be, if not equal, at least proportional to the original colours,

$$a'_I = ka_I, \qquad b'_I = kb_I, \qquad c'_I = kc_I. \quad (3.39)$$

The spectral sensitivities of the three separation negatives being $\bar{s}_A(\lambda)$, $\bar{s}_B(\lambda)$ and $\bar{s}_C(\lambda)$, their three exposures to an area of colour I yield the exposure values

$$E_A = \int_{400nm}^{700\,nm} I\bar{s}_A\,d\lambda, \qquad E_B = \int_{400\,nm}^{700nm} I\bar{s}_B\,d\lambda, \qquad E_C = \int_{400\,nm}^{700nm} I\bar{s}_C\,d\lambda.$$
$$(3.40)$$

Supposing a linear response of the photographic system, the tristimulus values of the reproduction then are

$$a'_I = k_A E_A, \qquad b'_I = k_B E_B, \qquad c'_I = k_C E_C. \quad (3.41)$$

Assembling and substituting into equation (3.39) yields

$$k'_A \int_{400\,nm}^{700\,nm} I\bar{a}\,d\lambda = \int_{400\,nm}^{700\,nm} I\bar{s}_A\,d\lambda,$$

$$k'_B \int_{400\,nm}^{700\,nm} I\bar{b}\,d\lambda = \int_{400\,nm}^{700\,nm} I\bar{s}_B\,d\lambda, \quad (3.42)$$

$$k'_C \int_{400\,nm}^{700\,nm} I\bar{c}\,d\lambda = \int_{400\,nm}^{700\,nm} I\bar{s}_C\,d\lambda.$$

Thus, if all colours $I(\lambda)$ are to be reproduced correctly, in the colorimetric sense, regardless of the form of the function $I(\lambda)$, the necessary condition is

that

$$\bar{s}_A = k'_A \bar{a}, \qquad \bar{s}_B = k'_B \bar{b}, \qquad \bar{s}_C = k'_C \bar{c}. \tag{3.43}$$

Application of colorimetry to the system of trichromatic reproduction thus yields the 'Luther' condition: the spectral sensitivities of the colour separation negatives must be proportional to the mixture function of the reproduction primaries.

3.3.1d The Primaries of Subtractive Synthesis

This description of Maxwell's principle only concerns the mixture of coloured lights, i.e. the additive synthesis in its original form. However, as shown before, the positives of cyan, magenta and yellow colour of subtractive synthesis have images photographically identical to those of the three black-and-white positives of additive synthesis. Admitting thus the equivalence of these two methods of colour reproduction, at least as far as the underlying principle is concerned, it still remains necessary to define the primaries of subtractive synthesis to also allow the application of Maxwell's principle to this method.

As a consequence of the great number of available processes and the great variety of their domains of application, the very numerous dye sets employed in practice for trichromatic subtractive synthesis have widely varying spectral properties. Their purpose being however to yield, by a well defined and unique mechanism, colour reproductions satisfactory for all observers of normal vision, i.e. the great majority, they very much resemble each other. They always include a cyan whose principal spectral absorption band lies in the red domain, a magenta with an important absorption of green radiation, and a yellow absorbing blue and violet light (Figure 3.28).

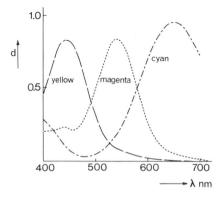

Figure 3.28. Spectral characteristics typical of subtractive three-colour synthesis.

Just as all dye-stuffs, these dyes and pigments also show, outside of their principal absorption, weaker but non-negligible spectral absorptions which impair in practice, as shown by Hardy and Wurzburg, the theoretical identity between the additive and subtractive syntheses.[60]

The method employed by these authors to find the spectral characteristics of subtractive primaries is to choose in an image, obtained by a given process, a patch which, while not perfectly neutral, contains about equal amounts of the three dyes, and then to repeat the reproduction by reducing the quantity of only one of them while maintaining identical all other conditions. Each dye acting mainly on one of the three primaries of the process, the required spectrum of any one of the primaries is therefore found by subtracting the spectral transmittances or reflectances of the corresponding two images.

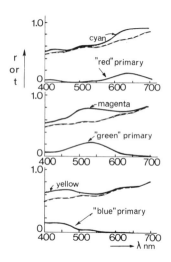

Figure 3.29. Determination of the primaries of a subtractive three-colour reproduction system by subtraction from the spectral reflection curves of the cyan, magenta and yellow images (curves in continuous lines) the ordinates of the curve of a given colour (dotted line).

Figure 3.29 shows the example chosen by Hardy and Wurzburg for the determination of such primaries from a light flesh tint reproduced by a printing process. Describing their result, Hardy and Wurzburg underline that the choice of any other patch of a different colour would have yielded another set of primaries, so that these are not *stable*, as are additive primaries.

For the primaries of a subtractive process to be stable, as required by Maxwell's principle, it is necessary therefore that its three dyes be of maximum visual efficiency, i.e. they should have either total or zero spectral transmit-

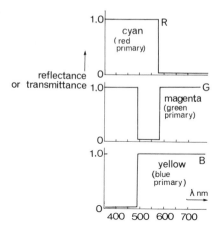

Figure 3.30. Hypothetical subtractive dye set yielding stable primaries.

tances or reflectances. The spectra of such a hypothetical dye set and of the corresponding subtractive primaries, equivalent to a set of additive primaries, as given in Hardy and Wurzburg's example, are shown in Figure 3.30 and the corresponding chromaticities in the 1930 CIE diagram in Figure 3.31. These

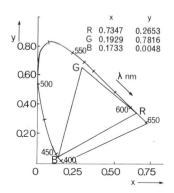

	x	y
R	0.7347	0.2653
G	0.1929	0.7816
B	0.1733	0.0048

Figure 3.31. Chromaticities of the primaries corresponding to the hypothetical dyes of Figure 3.30.

dyes have no secondary absorptions, however, so that other hypothetical subtractive dyes were also proposed to establish a relationship between additive and subtractive primaries which, while not rigourous, would yield a close approximation. MacAdam[61] and Hanson and Brewer[62] have shown that there exists a simple linear relationship between subtractive mixtures of

hypothetical dyes with rectangular spectra and secondary absorptions, i.e. having constant absorption in each spectral region, called block dyes (Figure 3.32), and additive mixtures. The linear relationship between the two processes

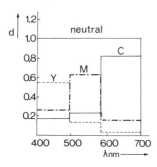

Figure 3.32. Hypothetical dyes with rectangular spectra and secondary absorptions (Block dyes).

then allows us to extend the theoretical treatment of Maxwell's principle also to the subtractive process with hypothetical dyes, but resembling real dyes more than those without secondary absorptions. Their primaries are stable and identical to those of a set of hypothetical dyes of maximum visual efficiency (Figure 3.30).

3.3.2 Practical Problems

3.3.2a *Material Limitations*

The mixture functions of a set of real primaries always contain negative sections (see p. 220), so that, according to Maxwell's principle, the spectral sensitivities of the sensitive layers employed for colour separations, to satisfy Luther's condition, should be negative in the corresponding spectral regions. This theoretical requirement can obviously not be materialized; it is possible, at the limit, to entirely cancel the sensitivity of a photographic layer in a given part of the spectrum, for instance with a filter having total absorption in this region, but it is not possible to impart a negative sensitivity to the layer. The mixture curves corresponding to the primaries in Figures 3.30 and 3.32 however, show important negative fractions (Figure 3.33); their non-observation would introduce important reproduction errors, for hue as well as for saturation. To obtain colorimetric true reproduction it is therefore indispensable to correct the omission of these negative sensitivities, at first for the correct application of the trichromatic reproduction by additive synthesis, and then, by extension, to that by subtractive synthesis.

A second practical limitation arises from the dyes of subtractive synthesis which have neither independent domains of spectral absorption, corresponding to the scheme of Figure 3.30, nor the rectangular spectra of block dyes

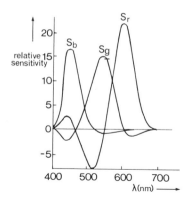

Figure 3.33. Mixture functions corresponding to the primaries of Figure 3.32.

such as those of Figure 3.32. The spectral absorptions of the dyes existing in practice rather resemble those of the curves of Figure 3.28, with important secondary absorptions and more or less wide transitions between domains of high and of low absorption. The presence of secondary absorptions and the lack of sharp-cut spectra creates an interdependence of the dyes' actions on the primaries, not consistent with the theory, and harmful to the true reproduction of colours. They lead to unfavourable modifications either of hue or of saturation or brightness, and also oblige us to use corrective methods.

The response of photographic materials, at last, is not linear as required by Maxwell's principle. Any departure of the sensitometric response $d = f(\log \mathbf{E})$ from linearity necessarily introduces reproduction errors.[60,63] The hue of the colour to be reproduced is thus modified, and shifts in principle towards the primary nearest to the dominant wavelength of the original colour.[64] This effect is negligible however when compared with the reproduction errors resulting from the non-observation of the negative spectral sensitivities and the unwanted absorptions of the subtractive dyes.

3.3.2b *Corrective Methods*

Correction by masking. Supposing the overall sensitometric response of a photographic process to be linear, and restricting it to the straight-line section of the objective tone reproduction function, it is at first necessary to compensate for the lack of negative spectral sensitivities, and then for the secondary absorptions of the dyes employed for the synthesis. The first correction implies a subtraction of exposures, difficult to accomplish; several proposed methods were in fact never employed in practice. The second correction, however, that of the effects of the secondary absorptions of the dyes, can be carried out rather easily with photographic masks. Discovered and applied a

long time before the theory of their intrinsic mechanism was explained, such masks used in various forms allow us at present to obtain almost perfect colour reproduction.

A photographic mask is a copy of a photographic recording, of identical or opposite sign, made to be superimposed on the original in exact register with the purpose of modifying its reproduction characteristics. With a camera negative, therefore, the mask, geometrically identical to the original, is either a negative or a positive of different but appropriate sensitometric characteristics. The first application of masks by Albert[65] demonstrates this basic principle. Having found in printed four-colour reproductions that many colours were darkened by the black printer, an indispensable complement of tricolour-process inks for yielding neutral greys as well as blacks of high density, he eliminated the excess ink in the shadows by superimposing on each of the three separation negatives a low-contrast positive of the black image. By adding density to the three negatives, these marks thus diminished the amounts of the cyan, magenta and yellow inks in the printed positive image, proportionally to the black printer image.

The theory of the correction of colour reproduction by masking can be considered from various angles. Assuming the axiom of colorimetric true reproduction, the problem can first be approached for the exact reproduction of a tricolour image with the same dye-set as that forming the original. According to Yule[66] this type of exact reproduction requires not only a linear sensitometric response, but also the observation of certain additivity and proportionality rules for the dyes and the spectral sensitivities of the three negatives, as well as six masks. If the spectral sensitivities are further proportional to the mixture curves of the primaries, this reproduction scheme also remains valid for other colours than those resulting from mixtures of the three dyes of the system, on condition that their matching by these mixtures is possible. The requirement of six masks for this type of reproduction has been confirmed by MacAdam[63] by another approach, resembling it however in its principle. On the other hand, it is also possible to determine the masks required for the exact reproduction of a restricted number of important object colours, expecting the reproduction of all other colours still to remain sufficiently close. When applying this method, proposed and developed by Marriage,[67] the assumption of proportionality between the spectral sensitivities and the mixture curves of the primaries, in fact never observed in practice, is not required any more, but a set of masks is determined which together with the given set of spectral sensitivities yields optimum reproduction of four principal colours. Marriage chose for these a flesh tint, a foliage green, a perfectly neutral grey and a white; the last two achromatic colours were introduced in the computations to insure the correct reproduction of the grey scale. This second method, entirely different in principle from that

described above, when applied to a numerical example also leads to a set of six masks, very similar to those determined by MacAdam.

The contrasts of the six masks can be computed, further to the assumption of a linear sensitometric response, by a set of three linear equations. According to Brewer, Hanson and Horton[68] these are of the form

$$d_c = \gamma_{cr}(-\log \mathbf{E}_r) + \gamma_{cg}(-\log \mathbf{E}_g) + \gamma_{cb}(-\log \mathbf{E}_b) + k_c,$$

$$d_m = \gamma_{mr}(-\log \mathbf{E}_r) + \gamma_{mg}(-\log \mathbf{E}_g) + \gamma_{mb}(-\log \mathbf{E}_b) + k_m, \qquad (3.44)$$

$$d_y = \gamma_{yr}(-\log \mathbf{E}_r) + \gamma_{yg}(-\log \mathbf{E}_g) + \gamma_{yb}(-\log \mathbf{E}_b) + k_y,$$

where d_c, d_m, and d_y are equivalent neutral densities, \mathbf{E}_r, \mathbf{E}_g and \mathbf{E}_b the exposure values of the three separation negatives, the γ_{ij}s the photographic contrasts of the cyan, magenta and yellow dyes resulting from these exposures, and k_c, k_m and k_y constants which depend on the exposure conditions and serve to balance the three negative sensitivities. *Equivalent neutral density* is a particular type of analytical density useful for the treatment of colour reproduction problems;† for a given dye deposit it is the density of the neutral grey obtained by the addition of those minimum amounts of the two other dyes of the system which reestablish neutrality.‡ Equations (3.44) can be simplified by introducing 'exposure densities' for the expressions in brackets,

$$D_r = -\log \mathbf{E}_r, \qquad D_g = -\log \mathbf{E}_g, \qquad D_b = -\log \mathbf{E}_b, \qquad (3.45)$$

and by normalizing the reference while $L_{\text{white}}(\lambda)$ for the colour separation with layers of spectral sensitivities s_r, s_g, s_b, by the relationship

$$\int_{400\,\text{nm}}^{700\,\text{nm}} L_{\text{white}}(\lambda)s_r(\lambda)\,d\lambda = \int_{400\,\text{nm}}^{700\,\text{nm}} L_{\text{white}}(\lambda)s_g(\lambda)\,d\lambda$$

$$= \int_{400\,\text{nm}}^{700\,\text{nm}} L_{\text{white}}(\lambda)s_b(\lambda)\,d\lambda = 1. \qquad (3.46)$$

With these values the general colour reproduction equations are

$$d_c = \gamma_{cr}D_r + \gamma_{cg}D_g + \gamma_{cb}D_b + k_c,$$

$$d_m = \gamma_{mr}D_r + \gamma_{mg}D_g + \gamma_{mb}D_b + k_m, \qquad (3.47)$$

$$d_y = \gamma_{yr}D_r + \gamma_{yg}D_g + \gamma_{yb}D_b + k_y.$$

† For the definition of analytical density (see Chapter 1, p. 21).
‡ In the general case of a selective absorption of this composed neutral, the equivalent neutral density is also a function of the spectral characteristics of the illuminant employed; this illuminant once chosen, however, the equivalent neutral density depends only on the dyes considered.

In these equations γ_{cr}, γ_{mg} and γ_{yb} are the overall contrasts $\gamma_{neg}\gamma_{pos}$ of the three dye images, and the six other coefficients γ_{ij} characterize the effect of the masks. In the case of a tricolour reproduction obtained by direct separation, i.e. with three separation negatives and the three corresponding positives, the required mask contrasts would be obtained by dividing these coefficients by the respective overall contrasts; the mask printed from the green exposure negative and employed for the correction of the cyan positive should thus have a contrast of γ_{cg}/γ_{cr}. This mask being a positive, to be superimposed on the red-exposure negative, the sign of γ_{cg} in the first of the three equations (3.47) would be negative, because this contribution to the final positive image is negative. As normally the sign of the masks is opposite, just as in this case, to that of the three principal images of a three-colour reproduction, the coefficients γ_{cg}, γ_{cb}, γ_{mr}, γ_{mb}, γ_{yr}, γ_{yg} of the six corrective terms are negative in general.†

The role of masks. Equations (3.47) not only serve to compute the three principal contrasts and those of the three masks, but also allow us to distinguish the contribution of those corrections which compensate for the lack of negative sensitivities from those eliminating the effects of the secondary absorptions of the dyes. Hanson and Brewer[69] investigated this problem by computing first the masks correcting the secondary absorptions of the image dyes, then those which would yield satisfactory reproduction without negative sensitivities, and by comparing finally a set of masks combining both corrections with one computed directly for the optimum reproduction of a certain number of object colours by a method derived from Marriage's method. Hanson and Brewer determined the coefficients of the colour reproduction equations from a greater number of object colours than those of Marriage's computations, and adjusted them by the method of least squares.[68]

For a dye set having spectral absorption characteristics resembling those of Figure 3.28, and nine object colours comprising also a flesh tint, grass green and sky blue, the computation of the masks correcting only the secondary absorptions of the image dyes yields, by application of this method to a numerical example, the equations

$$d_c = 1{\cdot}26D_r - 0{\cdot}38D_g + 0{\cdot}13D_b,$$

$$d_m = -0{\cdot}20D_r + 1{\cdot}32D_g - 0{\cdot}26D_b, \tag{3.48}$$

$$d_y = -0{\cdot}25D_r - 0{\cdot}41D_g + 1{\cdot}73D_b.$$

† The density of an image is conventionally considered as a function of log exposure, and the contrast of a positive image is therefore negative. In the colour reproduction equations the analytical densities d_c, d_m and d_y appear however as functions of the 'exposure densities' of the original, so that the sign of the principal contrasts γ_{cr}, γ_{mg}, γ_{yb} is always positive.

Those masks which compensate for the absence of negative sensitivities are then obtained by the same method of computation. With the same set of object colours and block dyes without secondary absorptions (optimum colours Figure 3.30), and only the positive parts of the spectral sensitivities proportional to the corresponding mixture curves, this yields

$$d_c = 1{\cdot}38D_r - 0{\cdot}26D_g - 0{\cdot}01D_b,$$
$$d_m = -0{\cdot}25D_r + 1{\cdot}41D_g - 0{\cdot}10D_b, \qquad (3.49)$$
$$d_y = -0{\cdot}01D_r - 0{\cdot}06D_g + 1{\cdot}08D_b.$$

Assuming that this last set of equations also applies approximately to dyes with spectral absorptions resembling those of real dyes, such as the block dyes of Figure 3.32, the simultaneous correction of both reproduction errors can be obtained by substituting the values of d_c, d_m and d_y of equation (3.48) for the exposure densities D_r, D_g and D_b in equation (3.49),

$$d_c = 1{\cdot}83D_r - 0{\cdot}87D_g + 0{\cdot}16D_b,$$
$$d_m = -0{\cdot}61D_r + 1{\cdot}92D_g - 0{\cdot}41D_b, \qquad (3.50)$$
$$d_y = -0{\cdot}26D_r - 0{\cdot}62D_g + 1{\cdot}90D_b.$$

Comparison of these coefficients with those obtained directly in a previous investigation of these authors,[68] making use of the same method of least squares but of another set of object colours,

$$d_c = 1{\cdot}83D_r - 0{\cdot}88D_g + 0{\cdot}17D_b,$$
$$d_m = -0{\cdot}51D_r + 1{\cdot}98D_g - 0{\cdot}51D_b, \qquad (3.51)$$
$$d_y = -0{\cdot}30D_r - 0{\cdot}62D_g + 1{\cdot}94D_b,$$

shows that the directly computed masks correct in fact both sources of reproduction errors, the omission of the negative fractions of the spectral sensitivities of the separation negatives and the secondary unwanted absorptions of the subtractive image dyes.

Application of masking to separation negatives. The actual introduction into a colour process of the corrections required by the coefficients of equations (3.50) or (3.51) raises several problems. In the case of a direct separation, or the separation of a transparency into three negatives, as for instance in printing processes, the use of six masks, to be routinely obtained for a great number of reproductions, would be much too involved for the correct observation of the contrast and overall density levels of the masks. The superposition in register of several films would further lead to physical defects such as undesirable border effects, interference patterns or dust spots,

and thus impair the quality gain resulting from the improved reproduction of colours.

A compromise is therefore resorted to by correcting only the most important reproduction errors, customarily with only two masks. As in the printing processes the effects of the secondary absorptions of the printing inks are quite sensible, these being less transparent than the dyes employed in photographic processes, the normally applied corrections compensate only the most important unwanted absorptions, that in the green region by the cyan ink and that in the blue region by the magenta ink.

To avoid an excess of magenta ink in those areas where cyan ink is also important, a light positive mask, printed from the red filter negative and therefore similar to the cyan image, positive but of lower contrast, is employed with the second or green filter negative for the printing of the magenta image. This mask subtracts from the magenta image densities proportionally to those of the cyan image; all colours containing mainly cyan ink are therefore not contaminated by an excess of magenta ink and their reproduction is more satisfactory than if both inks were superimposed without corrections. Similarly, to avoid an unwanted excess of yellow ink in those parts of the image which mainly contain magenta ink, a low-contrast positive mask, printed from the green filter negative, is superimposed on the blue filter negative during the exposure of the yellow positive. This eliminates from the image those amounts of yellow ink which otherwise would contaminate violet and magenta areas in which magenta ink is predominent.

With this scheme the colour reproduction equations are

$$d_c = \gamma_{cr}D_r,$$
$$d_m = \gamma_{mr}D_r + \gamma_{mg}D_g, \qquad (3.52)$$
$$d_y = \qquad\quad \gamma_{yg}D_g + \gamma_{yb}D_b.$$

Applied to the dyes and object colours of the example employed by Brewer, Hanson and Horton,[68] with the additional restriction for the neutrality of the grey scale which requires the sums of the gammas in each equation to be equal to 1, and the exposure conditions so defined as to make the constants $k_i = 0$, the coefficients have the numerical values

$$d_c = 1.00D_r,$$
$$d_m = -0.65D_r + 1.65D_g, \qquad (3.53)$$
$$d_y = - \qquad\quad 0.80D_g + 1.80D_b.$$

The mask printed from the first negative would thus have a contrast of 0·65/1·65, or 0·39, and the second mask a contrast of 0·80/1·80, or 0·44, i.e. contrasts slightly higher than those employed in practice.

Interimage effects and coloured couplers. In the currently employed photographic multilayer materials it is possible, contrary to the case of separation negatives, to apply corrections which satisfy the colour reproduction equations quite well, because they can be incorporated into the processes without the complexity of a material separation of the images. The two principal methods of introduction of masking effects into photographic processes are *interimage effects* (see p. 467) and *coloured couplers* (see p. 464). The first are mainly employed in reversal processes yielding directly positive images intended for viewing or photomechanical reproduction, and the latter in the negative–positive processes of professional motion pictures and amateur photography. Interimage effects however also occur in these processes, and the use of coloured couplers would also be possible in photographic reversal materials, for instance if they were to serve as intermediates in another reproduction chain, as for instance in television.

According to the schematic principle of three-colour reproduction, and without any corrective term, each of the three positive images should only be a function of the corresponding negative, and the reproduction equations would then be of the form

$$d_c = \gamma_{cr} D_r + k_c$$
$$d_m = \gamma_{mg} D_g + k_m, \qquad\qquad (3.54)$$
$$d_y = \gamma_{yb} D_b + k_y.$$

This simple relationship between positives and negatives is however never encountered in multilayer processes, because the exposure and the development of each layer influences more or less the development of the images in the adjacent layers. The amount of dye formed in each layer therefore also depends on the exposure of its neighbouring layers. This interaction between the elementary images, called interimage effects, has been described and investigated by Behrendt,[70] Hanson and Horton,[71] and Thiels[72] (see also p. 467 and Reference 93 of Chapter 7). Thiels underlines the complexity of the origins of interimage effects, as these depend on numerous parameters related to the diffusion of developer reaction products.

The expression of *interimage effects* by colour reproduction equations allows us to evaluate their corrective action. Hanson and Horton[71] employ to this purpose a special sensitometric technique, involving either individual or combined exposure of the layers to an exposure scale; onto the material to be judged for its interimage effects a neutral grey step wedge is exposed with red, green and blue narrow cutting filters, limiting each exposure practically to only one of the three layers. A balanced successive exposure of a test strip to all three filters is thus practically equivalent to an exposure to white light and compared, after development, to the separate exposures

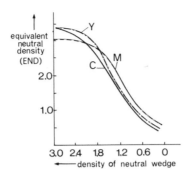

Figure 3.34. Response of a reversal colour film to red, green and blue exposures balanced for yielding a result equivalent to a single 'white'-light exposure.

of the individual layers. In Hanson and Horton's example this method was applied to a reversal film yielding directly colour transparencies (see p. 474). Figure 3.34 shows for this film the result of such successive exposures with three filters, corresponding to a neutral, and Figure 3.35 shows the responses of the separately exposed layers, compared to their responses to the combined exposure taken from Figure 3.34.

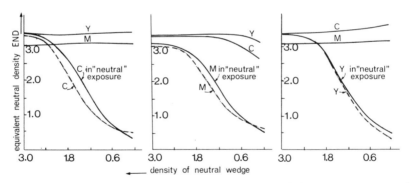

Figure 3.35. Responses of a reversal colour film to red, green and blue exposures compared to the responses to 'neutral' exposures.

The effects of interactions in the reproduction of highly saturated red, green or blue colours can be determined by another method, the stepped exposure of one layer together with a uniform selective exposure of another layer (Figure 3.36). The slopes of the tangents to the sensitometric curves then allow us to compute on the one hand the principal contrasts γ_{cr}, γ_{mg}, γ_{yb}, and on the other hand the coefficients of the corrective terms, and yield for

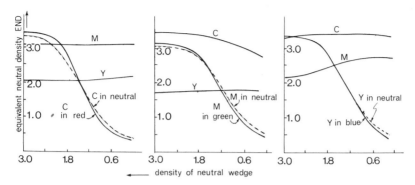

Figure 3.36. Response of a colour reversal film to stepped single layer exposures combined with selective uniform flashing of the other layers, compared to its response to stepped white-light exposures.

Hanson and Horton's example

$$d_c = 1{\cdot}79D_r - 0{\cdot}11D_g - 0{\cdot}31D_b - 0{\cdot}09,$$

$$d_m = -0{\cdot}12D_r + 1{\cdot}63D_g - 0{\cdot}30D_b + 0{\cdot}48, \qquad (3.55)$$

$$d_y = -0{\cdot}05D_r - 0{\cdot}04D_g + 1{\cdot}92D_b - 0{\cdot}44.$$

Comparison of these coefficients to those of equation (3.51) shows that the corrective terms of this very early system, while correct in sign, are in general too small in magnitude, thus making the system undercorrected as a whole. The excellent colour reproduction by more recent processes demonstrates the progress made in handling interimage effects.

The inclusion of corrective terms in photographic processes by the method of *coloured couplers*, described by Hanson and Vittum,[73] is based on another very ingenious principle. The couplers, chemical compounds forming the three image dyes by reaction with the oxidation products of the colour developer (see p. 461), are themselves coloured. Incorporated in the layers and having, prior to colour development, the required spectral absorptions, they loose their own colour during the formation of the image dyes by the colour development reaction. The resulting dye images are therefore composed on the one hand of negatives of the dyes formed and on the other hand of positive masks of residual coupler.

Figure 3.37 demonstrates this principle with spectral absorption curves for a yellow coupler forming upon development a magenta-coloured image dye. Curve a represents the absorption of the coloured coupler, and curve b that of the dye resulting from the completed colour-forming reaction. An intermediate state, corresponding to a lower dye density in the image and

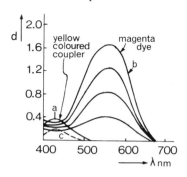

Figure 3.37. Progression of spectral characteristics during dye formation with a coloured coupler.

therefore to a less complete colour forming reaction, yields an absorption curve due in part to the developed dye and in part to the residual coupler, shown by curve c. At 560 nm the principal absorption increases progressively with exposure in the areas containing magenta dye, whereas the secondary absorption at 440 nm remains constant and uniform all over the image, being either due to the dye developed, to the coloured coupler, or to the sum of the partial contributions of both. It does not contribute to the image and is compensated for by an appropriate adjustment of the printing exposure.

3.3.2c *Reproduction Equations for a Negative–Positive Process Including Coloured Couplers*

Hanson[74] showed that the correction by coloured couplers allows us to take into account all corrective terms of the reproduction equations. A negative–positive process, separated into its two fractions, can be described by two such sets of equations, each corresponding to one of the two operations. The equivalent neutral densities of the positive, measured with the three spectral sensitivity distributions of the respective positive layers, are then, as functions of the exposure densities of the negative

$$d_c = \gamma_c^p D_r^n + K_c^p,$$
$$d_m = \gamma_m^p D_g^n + K_m^p, \tag{3.56}$$
$$d_y = \gamma_y^p D_b^n + K_y^p,$$

where γ_c^p, γ_m^p and γ_y^p are the contrasts of the three positive dye images. Expressing the exposure densities D_r^n, D_g^n, D_b^n as functions of the object colour exposure densities, the negative is described by the relationships

$$D_r^n = \gamma_{cr}^n D_r + \gamma_{cg}^n D_g + \gamma_{cb}^n D_b,$$
$$D_g^n = \gamma_{mr}^n D_r + \gamma_{mg}^n D_g + \gamma_{mb}^n D_b, \tag{3.57}$$
$$D_b^n = \gamma_{yr}^n D_r + \gamma_{yg}^n D_g + \gamma_{yb}^n D_b.$$

Substitution of these values in equations (3.56) yields the reproduction equations of the coloured coupler process,

$$d_c = \gamma_c^p(\gamma_{cr}^n D_r + \gamma_{cg}^n D_g + \gamma_{cb}^n D_b) + K_c^p,$$

$$d_m = \gamma_m^p(\gamma_{mr}^n D_r + \gamma_{mg}^n D_g + \gamma_{mb}^n D_b) + K_m^p, \qquad (3.58)$$

$$d_y = \gamma_y^p(\gamma_{yr}^n D_r + \gamma_{yg}^n D_g + \gamma_{yb}^n D_b) + K_y^p,$$

which allow us to compute the spectral absorptions of the initial colours of the couplers. When applied by Hanson to the equations (3.51) of Brewer, Hanson and Horton's example[68], equations (3.58) show the requirement of a red–orange cyan-dye forming coupler, a green magenta-dye forming coupler, and a magenta yellow-dye forming coupler (Figure 3.38).

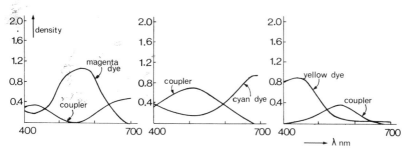

Figure 3.38. Theoretical spectra of couplers defined by equation (3.58).

Numerical values of these corrections were computed by Brown[75] with a set of twelve object colours for an actual negative–positive colour system, based on dyes with much sharper spectral absorptions than those employed in Brewer, Hanson and Horton's computations, and having therefore higher purities (Figure 3.39). These corrective terms, necessarily of lower magnitude

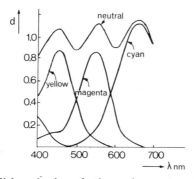

Figure 3.39. High-purity dyes of a three-colour system of reproduction.

than those of equations (3.51), confirm however the corrective requirements and thus the hues of the couplers determined by Hanson. The real corrections of this process, obtained by Brown by the application of the method of least squares to the actual image densities of the twelve object colours, are expressed by the equations

$$d_c = 1 \cdot 078D_r + 0 \cdot 08D_g - 0 \cdot 003D_b,$$

$$d_m = -0 \cdot 507D_r + 1 \cdot 551D_g + 0 \cdot 108D_b,$$

$$d_y = -0 \cdot 625D_r - 0 \cdot 379D_g + 2 \cdot 314D_b. \tag{3.59}$$

Only the corrective terms for D_r in the second and for D_r and D_g in the third equation have the required negative sign as well as the numerical values approximating those theoretically required. The initial colour of the real couplers of Brown's example is in fact not exactly that required by his equations and those determined by Hanson; although cyan-forming colour couplers are in general red–orange in agreement with these equations, magenta-forming couplers are yellow instead of being green, and there are no yellow-forming couplers of magenta colour available (see also p. 464). The resulting corrections, very satisfactory in practice however, resemble those obtained with two masks in direct separation as employed in the graphic arts.

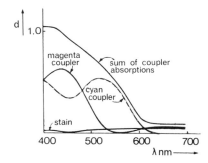

Figure 3.40. Spectral densities of two typical coloured dye-forming couplers.

Figure 3.40 shows the spectral absorption of such typical coloured couplers which form by colour development cyan and magenta dyes, and Figure 3.41 the spectral absorptions of the processed area of a negative film containing these couplers and a colourless yellow-dye forming coupler, exposed to light of neutral 'white' relative to the sensitivity balance of its three layers. The raw film as well as the neutrally exposed and processed area show a strong orange tint, typical of negative films with coloured couplers. The additional absorption of blue and green radiation by such negative film is compensated

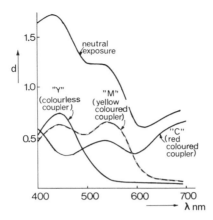

Figure 3.41. Partial and total spectral densities of a processed negative film moderately exposed to 'white' light.

for during printing by the use of a film or paper with sensitivities in the blue and green spectral regions higher than in the red.

3.3.2d *Spectral Sensitivity Distributions of Multilayer Positives and Intermediates*

Maxwell's principle defines the spectral sensitivity distribution of the three negative layers only for the case of a reproduction entirely separated into its trichromatic elements for the printing of the final positives. The equivalence of subtractive and additive synthesis can therefore also be established only on condition that each of the three positives depends exclusively on the corresponding negative (see p. 251). This condition however is fulfilled only by direct colour separation where three black-and-white negatives are exposed to red, green and blue radiation, but can obviously not be satisfied with the current photographic multilayer materials. A negative colour film, while having the three spectral sensitivities required by Maxwell's principle, contains after colour development in its layers cyan, magenta and yellow dye images whose overlapping secondary absorptions impair their perfect separation. To yield that separation with sufficient approximation, the spectral sensitivities of each layer of the print material must therefore be very narrow and carefully placed in the spectrum, so as to coincide with the minima of the secondary absorptions of the dyes to be omitted as well as with the absorption maxima of the dyes which in the negative form the images to be copied. It must be emphasized that this is not one of the problems inherent to the principle of three-colour reproduction, such as the theoretical requirement of negative spectral sensitivities

or the necessity of the absence of secondary absorptions of the image dyes. It is simply a problem of realization: once the separation is obtained according to Maxwell's principle and corrected by introduction in the process by the corrective methods described above, i.e. interimage effects and coloured couplers, nothing more is required than the retransmission from the negative to the positive of the information recorded in each layer, a condition described by equations (3.56) and (3.58).

The same principle remains valid for all other printing or reproduction steps in any number of generations: the spectral sensitivities of the first set of separation negatives must be proportional to the mixture curves of the primaries of the final restitution, but all other films, intermediates as well as positives, must have spectral sensitivities insuring the successive transfer, layer by layer, of the information recorded in the three separation negatives.

In the most frequent case of printed edition, for instance, where the original is a positive transparency on reversal film, the spectral sensitivities of its three layers correspond to Maxwell's principle and the corrections required by the six corrective terms of equation (3.47) are incorporated in the reversal process to yield a reproduction as true as possible with the three dyes of the reversal film. To obtain the printed reproduction of this initial trichromatic recording, the transparency is not considered any more as an original scene, but rather as an intermediate step, and the cyan, magenta and yellow images are reseparated with filters of narrow transmittance bands situated in the spectrum according to the principles described above. Figure 3.42 shows the spectral absorptions of the dyes typical of a reversal film, yielding positive transparencies and employed for the first recording, and the corre-

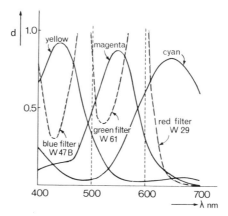

Figure 3.42. Typical absorptions of the dyes of a reversal colour film and spectral characteristics of the corresponding separation filters.

sponding spectral transmittances, of red, green and blue filters yielding maximum separation of the three dye images of the positive transparency, which plays the role of an 'intermediate original'.

The observation of this principle is important in all applications where intermediate steps between the camera exposure film and the final positive are required, as in the case of professional motion pictures; in negative–positive systems the intermediate films yielding interpositives and inter-negatives have narrow spectral sensitivities, just as those of the final positive. Similarly a motion-picture reversal duplicating film, to be printed from a reversal camera original, has three layers with narrow spectral sensitivities and thus differs intrinsically from a reversal taking film.

A similar, but intrinsically different reasoning applies to colour tele-cine where the positive 'original' or its positive print—obtained either by reversal or through several stages of printing from a negative film—is retransmitted by the television chain. For this type of reproduction process, in which suitable masking or electronic transformation can be used, the fundamental requirement is only that the spectral sensitivities of the camera film be proportional to colour mixture curves for any set of primary colours, as for instance those emitted by the phosphors of the television screen, but the spectral sensitivities of all other intermediates, including those of the receiving tubes of the television camera, must be narrow in order to reseparate as perfectly as possible in each operation the three elementary images recorded in the previous step.

3.4 THE SUBJECTIVE ASPECTS OF COLOUR REPRODUCTION

The final step of any process of colour reproduction is the evaluation of the result by an observer, be it an image on an opaque support seen by reflection, a transparency viewed by transmission, or an image projected on a screen. The conditions of observation therefore define one of the intrinsic operations of the reproduction process, just as important as those which serve to prepare the material image. They have a determining influence on the luminance distribution and the spectral composition of the radiation reflected from the image towards the observer, and therefore on his sensations. It is well known on the other hand that the observer is an extremely complicated and variable receptor, so that it is necessary to suggest to him the appearance of the original scene rather than to give him an exact restitution of reality. A perfect knowledge of the influence of the conditions of observation on the subjective judgment of a colour reproduction is therefore indispensable to attain the best results with the processes based at the outset on the principle of colorimetrically true reproduction.

3.4.1 The Effects of the Conditions of Observation

The appearance of an image, or even of a uniform coloured area, depends not only on the level and the colour of its illumination, but also on the surround and the unmodulated diffused radiation which, superimposed on that forming the image, reduces the contrast locally. All these parameters, closely related to each other, influence the quality judgment of the reproduction; they were discussed in detail by Evans.[76]

3.4.1a *The Illuminance Level of an Image in Colour*

The conditions of illumination can be extremely variable according to the type of image. Reflection prints are observed at all luminance levels ranging from mesopic vision almost up to glare level, and the open screen luminance of projection screens can vary from 3 to 300 cd/m². The optimum of reproduction quality occurs however at intermediate levels which can be defined with satisfactory precision by appropriate experiments made with sufficient numbers of observers. Figure 3.43 shows the result of such a determination carried out by Bartleson.[77] According to these results the relative quality of transparencies on reversal film reaches maximum values depending on the sensitivity attributed to the film, which in turn is a function of the illuminance of the projection screen, with an optimum for a maximum open gate luminance between 700 and 1400 cd/m². The transparencies yielding the best quality at these luminance levels of the projection screen are necessarily very dense and thus correspond to about twice the nominal film speed, valid for the normal screen luminance of 135 cd/m². If the individual sensitometric responses of the elementary cyan, magenta and yellow images were linear and exactly superimposed on their whole length, the reciprocity between film speed and screen illumination would be real. This condition, however, is only observed very approximately in practice, so that picture quality can only be optimum with exposure at the nominal film speed and normal screen illuminance.

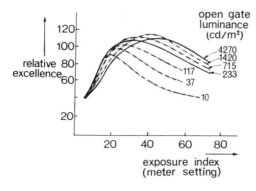

Figure 3.43. Relative excellence of colour transparencies as a function of exposure level and screen illuminance.

In a darkened audience the luminance level of the screen can be comparatively low. The open screen luminance of an average picture theatre is about 60 cd/m², that of an amateur motion-picture screen ranges from 20 to 40 cd/m², and the normal luminance level for the projection of still pictures is 135 cd/m². On the contrary, inspection of unenlarged transparencies on an illuminator in a well lighted room requires a much higher luminance level, up to 1400 cd/m² at the unshielded illuminator surface. Similarly the illuminance for reflection prints, photographic or printed, should range from 1000 to 2000 lux (about 100 to 200 ft cdls).

3.4.1b *The Reference White*

The correlated colour temperature of the illumination employed for evaluation is just as important as the level of image illuminance. The illuminating light must be so chosen as to have the appearance of white, which is a subjective notion of visual perception. A very thorough investigation into the nature of white by Hurvich and Jameson[78] demonstrates that light of almost any colour temperature can give rise to the sensation of white, according to the luminance level, the area perceived, the time of observation, and the degree of observer adaptation. A rather close relationship exists however between the minimum value of luminance, the colour temperature yielding white and the colour of the surround illumination. The lower the colour temperature of the illuminant of the principal field of vision or image area, and the greater the colour temperature difference between this area and the surround, the higher the level required for the illuminance of the principal field to yield white. According to their colour temperature the light sources are in fact more or less efficient in giving rise to the sensation of white. A graphic representation by Bartleson and Witzel[79] (Figure 3.44)

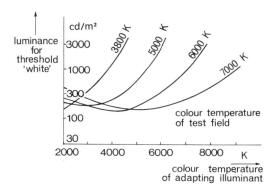

Figure 3.44. Influence on the sensation of 'white' of the colour temperatures of the adapting illuminance and of that of the principal field of vision.

summarizes these results of Hurvich's and Jameson's investigations. It shows the minimum luminance required for the impression of white as a function of the colour temperature of the ambient illumination, for several colour temperatures of the principal field.

The light sources employed in the various fields of use of colour pictures thus have quite variable colour temperatures. As there is in general practically no visible surround in the case of the projection onto a screen, the colour temperature ranges from 3200 K, for the projection of still pictures and amateur films, to about 5400 K in motion-picture theatres. The light sources of transparency illuminators, often used under a high level of general illumination, have in general a colour temperature of about 5000 K, just as those employed for the critical evaluation of reflection prints, photographic or printed. At the usual luminance levels of these illuminators for prints and transparencies the colour temperature of 5000 K yields an excellent compromise, making them appear white under considerably varying ambient conditions, from the very cold daylight illumination of a grey sky to the very warm light of incandescent lamps.

3.4.1c *Ambient Conditions*

The effect of the surround on the appearance of an image seen by reflection at a relatively high level of general illumination can be quite important and is not negligible either for a transparency observed on an illuminator in a well lit room, or in television. The ambient conditions, however, as mentioned before, do not interfere in practice with the judgment of pictures projected onto a screen in a darkened room, except for unwanted diffused light which occasionally may impair the image quality.

The chromaticity changes of uniform colour areas, either through a colour change of the surround or by observer adaptation to ambient conditions, have been investigated by MacAdam,[80] Burnham, Evans and Newhall,[81,82] and MacAdam.[83] They are important and can lead, mainly for coloured areas of relatively low saturation, to chromaticities entirely different from those determined under other conditions of adaptation. MacAdam's comparison of the chromaticities of several colour scales of constant hue, measured either without any adaptation, or with adaptation to tungsten light of 3200 K, shows the degree of this effect (Figure 3.45). The role of adaptation is further emphasized by a supplementary observation made during these colorimetric matches: in each scale the colour represented by the most interior point of the curve, nearest the 'white', shown by a star, itself looks white when compared on the colorimeter to the most saturated colour of that same scale.

The importance of colour changes with adaptation is confirmed by the numerous measurements made by Burnham, Evans and Newhall with a

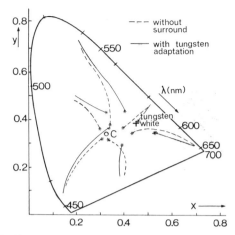

Figure 3.45. Chromaticity shift with adaptation to tungsten illumination.

binocular matching method (see p. 277). In Figure 3.46, which summarizes these results, the arrows show the chromaticity shift of the colorimetric change that must be made in the colour area to retain the same appearance as that prevailing with daylight adaptation (illuminant C) when changing to tungsten light (illuminant A, arrowheads).

The effect of the surround on colour appearance has an important influence on the quality evaluation of colour prints. Observer adaptation then depends

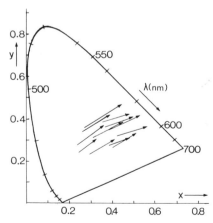

Figure 3.46. Chromaticity shift by a change of observer adaptation from daylight (arrow tails) to incandescent tungsten light (arrow heads).

not only on the colour temperature and the general level of illumination, but also on all objects which happen to be in the field of vision. The problem is still more complicated than in colorimetry, where uniform areas are perceived with a uniform surround, because neither the image which forms the principal field nor its environment which determines the surround are homogeneous. Experience however shows that this lack of homogeneity partly compensates for the effects of adaptation, and that it does not keep observers from concentrating their attention on the image area. Leaving aside all aesthetical considerations, it is known that the image will be judged to be satisfactory as an objective reproduction of the visual appearance of a given scene if it satisfies certain technical criterions such as the neutrality of greys, the quality of the tone scales, and chromatic oppositions.

If an image in colour is to be judged satisfactory by the majority of observers, all image areas reproducing achromatic surfaces of the original scene must be perfectly neutral over the whole scale of luminances; this scale must further be correctly reproduced not only for the greys, but also for all other colours (see p. 91), and finally it is required that a certain balance exists over the image area in the relative distribution of complementary chromaticities. The definition of this last criterion is the most difficult because it depends on the areas as well as on the chromaticity and the luminance of the individual colour patches. The absence of colour bias in a print depends on this criterion of chromatic equilibrium, and an image will therefore appear balanced when the homogeneous mixture of all radiations reflected from its whole area towards the observer's eyes is practically neutral. This condition obviously does not apply to images which represent on their major area highly coloured objects or surfaces.

The evaluation of a colour print is more critical in daylight at a high level of luminance (6500 K and about 1500 lux), than in the comparatively orange tungsten light of incandescent lamps which, by the resulting chromaticity shift, can hide a certain lack of colour balance. An image which appears well balanced in daylight illumination, natural or artificial, will therefore remain so under all circumstances. This fact was confirmed by Bartleson[84] in an investigation on the influence of observer adaptation on the acceptance of photographic prints, carried out by the judgment of colour prints of varying colour balance, with adaptations due either to uniform coloured backgrounds or to environments recalling those of daily life, such as an office or a sitting room. The results of this investigation demonstrate that observers systematically prefer well balanced prints. independent of their adaptation to a strongly coloured surround or to a customary environment illuminated either by daylight or by artificial light.

Adaptation takes no part, as mentioned before, in the quality evaluation of images projected under satisfactory conditions in a non-illuminated room.

There being no standard for the observer to evaluate 'white' other than the general illumination reflected from the screen, he adapts rather fast to the colour temperature of the projector lamp. This adaptation can be disturbed, however, by the presence of other light sources of different colour temperature near the visual field. Not very important under satisfactory conditions of motion-picture or transparency projection, this factor can make itself felt when the projection is poor, for instance at a high level of ambient illumination relative to that of the screen, particularly in television. It has not only an influence on colour balance, but also distorts the luminance scale by the addition of uniform veiling luminance to the modulated light distribution of the image. The effect of this veiling luminance on the quality of projected colour images has been studied by Bartleson for screen luminances of 72, 264 and 1500 cd/m², by systematic variation of the uniform veiling luminance added to the principal projection by a second projector.[85] The observers defined without difficulty a level of 'acceptable veiling luminance' not impairing quality significantly, but above which images rapidly became poor. The luminance level of this limit is higher for slightly overexposed and light images than for dark and contrasty images. This effect of veiling luminance on quality can be represented as a function of the ratio of uniform veiling to open gate screen luminance. An example is shown in Figure 3.47 for four colour transparencies of the same scene, one of which is normally exposed, one underexposed by one stop and two overexposed by one and two stops respectively. Inspection of these curves shows that a ratio of screen to veiling luminance of 100 to 1 must be considered to be a minimum in practice for acceptable colour quality.

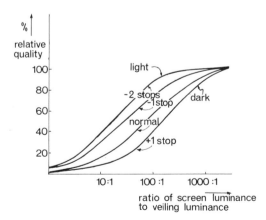

Figure 3.47. Effect of veiling illuminance on the quality of a projected image according to exposure level.

3.4.2 Subjective Colorimetry

3.4.2a *Colour Appearance*

These few practical considerations offer only a glimpse into the very wide domain of the psychological aspects of colour perception, as ramified as all other appreciations of the external world by our senses. While the appearance of a coloured area varies with its size, its luminance and its environment, it can also remain remarkably constant under other circumstances in spite of changes of all geometrical and photometric parameters of observation. Colour appearance being a function of observer adaptation, it entirely depends on these parameters; colorimetric evaluation obtained by matching two adjacent and simultaneously observed fields, on the contrary, is entirely independent of the state of adaptation (see also p. 282). A match, once established, remains valid even after adaptation has changed.[86]

The mechanism of adaptation. Various theories have been proposed for the explanation of those general or local adaptation phenomena which act on colour contrast and therefore also on brightness contrast, brightness being the third attribute of the sensation of colour. The general belief is that adaptation is merely an adjustment, mainly physiological, of visual sensitivity. In the case of trivariant colour vision this adjustment is equivalent to the rebalancing of the three sensitivities according to the level and the quality of the illumination. Von Kries[86] postulated that the predominance in the illumination of one of the primary radiations reduces the sensitivity of that mechanism on which it acts, thus creating an apparent increase of the other mechanisms sensitivities and therefore a balance shift. This is the von Kries's coefficient law which states that the visual sensitivities are inversely proportional to the relative degree of their excitation.

Local adaptation, leading to the phenomena of simultaneous contrast, however depends on more involved mechanisms. According to Jameson and Hurvich[87] excitation in an area adjacent to the principal visual field induces in this latter an opposing physiological response. Brightness contrast, for instance, is thus explained, by attributing the darkening of an initially light field by the introduction of a very bright surround, to the induction by this surround of an opposite physiological response in the neural tissue, initially only excited by the light field, rather than to a lowering of its sensitivity. Similarly for the case of colour contrast, an initially neutral field appears greenish after the introduction of a red surround not by a general lowering of the sensitivity to red, but rather because the physiological red activity resulting from long wavelenth radiation induces an opposite response of green tendency in the neural tissue corresponding to the principal field.

Quantitatively the response R_f not only depends on the principal stimulus S_f in the focal area f, but it is equal to the sum of this primary response and the activity induced by the response R_s in the surround, which is proportional to this response R_s but of contrary sign,

$$R_f = cS_f^n - kR_s. \tag{3.60}$$

Similarly the surround response is

$$R_s = cS_s^n - kR_f. \tag{3.61}$$

With $c = 1$, $n = \frac{1}{3}$,[88] (see also p. 51) and $k = 6$, this relationship satisfactorily expresses numerous results of classical researches on adaptation effects investigating colour appearance under varied conditions of observation.

Haploscopic matches. Colorimetric matches, performed under only one condition of observation, merely allow us to compare two colour stimuli or to evaluate their difference in this condition, but they do not yield any information on the appearance of these stimuli under other conditions of observation. The effects of these conditions on colour appearance, more involved than colorimetry by direct matching, can be evaluated quantitatively by two methods. Colour appearance can be measured either by judgments based on the memory of colours, inherently not very precise, or by interocular or haploscopic matches which involve the comparison of two different visual fields, each including a principal field and a surround, presented simultaneously but separately to each of the eyes of the observer. This technique presupposes the independence of the response of the two eyes, especially of their state of adaptation. While not perfect, this interocular independence is sufficient under the current conditions of the observation of images to justify haploscopic matches. Among the very numerous types of instruments making use of this principle three recent models were employed in studies related to photographic colour reproduction. The first, due to Burnham,[89] corresponds exactly to the definition given above and has two comparison fields perceived separately with each eye (Figure 3.48). The instruments employed by Hunt,[90] and by Burnham, Evans and Newhall,[81]

Figure 3.48. Visual field of Burnham's haploscopic colorimeter.

also make use of binocular fusion, but with two bipartite colorimetric fields respectively black either on the left or on the right side (Figure 3.49), therefore allowing matches almost as precise as in direct colorimetry. To allow the evaluation of appearance of coloured surfaces seen directly with the unaided eye, a third type of instrument has been built by Hunt[91] and also by Bartleson.[92] These instruments have only one comparison field with its surround,

Figure 3.49. Respective appearances of the visual fields of Hunt's haploscopic colorimeter (a) during adaptation periods and (b) during actual matches.

to be observed with one eye, while the other eye perceives directly the surface whose appearance is to be judged. The trichrome additive mixtures are obtained in these instruments by a Burnham filter[93] in conjunction with an integrating prism in Hunt's instrument, and an integrating sphere in Bartleson's instrument.

Figure 3.50. Hunt's haploscopic colorimeter (schematic).

The difference between the results of direct colorimetric matches and of determinations of colour appearance was demonstrated with haploscopic matches by Hunt.[91] When measured with a Hilger colorimeter, the colour changes of surface colours varying widely in hue and saturation, due to the change from high-level daylight illumination (400 ft cdls) to rather low-level

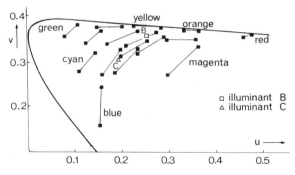

Figure 3.51. Effect on colour appearance of a change from daylight to tungsten light, determined by classical colorimetry (simultaneous matches).

tungsten illumination (2·2 ft cdls) seem to depend on the colour difference of the two illuminants. The chromaticity of a white, for instance, shifts almost exactly from the locus of illuminant *C* to that of illuminant *A* (Figure 3.51). Judged by interocular comparison however, the same change of illumination yields an entirely different result. White shifts only slightly towards orange because adaptation compensates almost entirely the colour change of the illuminant. The low light level of the tungsten illumination in this series of measurements also makes all colours appear less saturated than in full daylight and, besides giving them a slight tendency towards orange (Figure 3.52), makes them look darker relative to their surround.

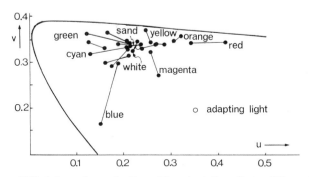

Figure 3.52. Interocular evaluation of the adaptation effects of Figure 3.51.

The results of appearance measurements thus make possible the quantitative treatment of current observations related to colour vision, such as the loss of saturation as well as the relative darkening of all colours with diminishing illumination, as observed every evening during sunset.[90]

Appearance measurements also allow us to evaluate the effects of particular conditions of image presentation. By increasing the illumination of the image area of a reflection print without modifying that of its surround, for instance by projectors equipped with masks, all colours of the additionally illuminated image seem to gain in saturation.[94] This effect on print appearance was determined by Bartleson[92] with a haploscopic colorimeter for an image initially illuminated together with its surround at 6500 ft cdls, and then in the image area only with an additional 4000 ft cdls. This special lighting of a print not only leads to a noticeable and general increase of its relative brightness, but also increases its saturation, and thus gives the print the appearance of a transparency viewed on an illuminator.

This gain in saturation by increased illumination can also be observed at much lower light levels. Comparing the appearance of uniform areas whose luminances varied approximately in the ratio of 1 to 7 (2·9 cd/m² and 21·6 cd/m²), Burnham found the same tendency towards brightness and saturation increase with increasing illumination.[89] Another very important observation of this same investigation, carried out with a simple bipartite field without binocular blending, is a similar increase of the brightness and saturation of all colours at constant illumination with increasing size of the coloured area. Raising the field angle from 2 to 12 degrees yielded under Burnham's experimental conditions a brightness increase from 2·9 to 21·6 cd/m². This result explains, at least in part, the apparent quality gain by enlargement: having to rank for quality two reproductions of the same subject, identical in colour but of different size, the observers invariably attribute the better quality to the larger of the two images.

Constancy of colour appearance. The study of the appearance of colours also concerns their constancy. To the unbiased observer the appearance of objects currently perceived in daily life seems to remain almost unchanged, independent of all variations of the conditions of observation. This apparent constancy can be measured by comparing the appearance of a coloured object or a coloured surface, as seen under a given condition, with its appearance in the absence of that condition; the less the particular condition influences the appearance of the object, the greater the constancy. In the case of a reflection print, for instance, constancy of appearance is a necessity so that the conditions of observation do not modify its aspect, because the print must remain satisfactory in full sunlight as well as in shadow or in artificial light.

Quantitative determination of colour constancy, either under direct illumination or in the shadow, carried out by direct binocular observation,[95,96] confirm the results of haploscopic appearance measurements. Perceived in the shadow, a coloured surface appears to be less saturated

than when fully illuminated and also slightly darker, but such changes of appearance remain unnoticed in most cases of casual observation.

3.4.2b *The Vivacity of Colours*

Another important subjective aspect related to colour reproduction is vivacity.[97,98,99] This essentially practical concept corresponds to the visual appearance of coloured surfaces of maximum saturation and lightness. Indeed attempts to increase the colorimetric purity of a dye mixture above a certain limit by addition of dye or pigment invariably lead to a darkening of the colour which makes the resulting mixture duller and less coloured. Most observers define this limit with satisfactory precision; it is always situated near the junction of the brightness and the saturation scales (see p. 92), at one of the first steps of a very slight desaturation, depending on the hue. While the physical properties of the corresponding radiation are in theory well defined by a spectrum of total or zero radiation, with only two transitions,[3] the impression of vivacity is difficult to define by this rigid criterion. Resulting from a compromise between lightness and saturation, the degree of highest vivacity is physically less well defined because in the proximity of this optimum observers cannot distinguish between a variation of colorimetric purity and one of luminance. Subjectively, then, only one colour of the scale seems to be the most coloured, the most luminous and the most vivid, i.e. that of maximum vivacity. Several formulas have been proposed for the expression of this property by one single figure, but none has proved sufficiently satisfactory in practice to describe the appearance of vivacity. Graphical methods have also been employed for the evaluation of vivacity, mainly in printed reproduction.[100]

Closely related to vivacity are the concepts of 'grey content' and of 'fluorence' of surface colours.[101] When increasing either the luminance or the colorimetric purity of a small area, seen in the centre of a large 'white' field above a maximum level corresponding to the luminance of this surround, the observer has the sensation of a fluorescent colour within a small interval of transition just before the area attains the appearance of a self-luminous object after an additional increase of its luminance. By reducing the luminance of the coloured area, on the contrary, the colour does not initially seem to change until a certain degree of darkening; below this level the observer has the impression of a progressive addition of grey to the initially pure colour until at very low illumination the central area appears black by a decrease of luminance as well as of purity.

3.4.2c *Colour 'valence'*

The subjectivity of colour perception is intrinsically related to its nature. Originating in a radiation, i.e. in a well defined and measurable physical

parameter, it only exists through the presence of an observer able to experience the sensation of perceiving, a subtle and variable psychological phenomenon released by physiological mechanisms.[102] Colour measurement is therefore determined by this visual character of colour: obviously it cannot be carried out otherwise than by having an observer match the aspect of a colour with that of another colour resulting from radiation of known composition. This integral evaluation of colour perception is not defined, however, by the physical characteristics of the radiation creating it: this latter is a function of spectral energy distribution, i.e. of an infinity of values, while colour perception is entirely defined by three parameters only. Trichromatic colorimetry, based on this property of human vision, is thus made possible only through the matching of the aspects of two adjacent areas illuminated by very different radiations, one of which is of non-uniform spectral distribution, and the other for instance the sum of red, green and blue radiations in appropriate quantities.

The fundamental importance of this integral visual appreciation of different radiations is demonstrated also by the persistence of colorimetric matches, discovered by von Kries.[86] The identity of aspect of two areas illuminated by spectrally different radiations persists indeed independently of the state of adaptation of the observer. This property of vision is easy to check: having matched any given colour in a colorimeter by a trichromatic mixture, the observer modifies the adaptation of only one eye by entirely shielding the other eye with the hand. After a short period of adaptation the whole colorimetric field then appears of different colour to each eye, but the match of its two halves remains undisturbed for one eye and the other, independently of their individual state of adaptation.

To allow the attribution of a precise definition to this integral evaluation of colour perception, defined on the one hand by the trichromatic fact and on the other hand by the persistence of colorimetric matches, and also to underline that a precise definition of this visual judgment by that of the primary stimulus, the radiation, is impossible, the German Standards Committee (Deutscher Normenausschuss) includes in the German Standard DIN 5033 the concept of *chromatic 'valence'* (Farbvalenz).[103] According to its definition in this standard, chromatic valence is that measurable magnitude of a radiation, resulting from the mechanism of human vision, which characterises it relative to an equivalent trichromatic additive mixture.

The role of chromatic valence has been described by Richter.[104] Taken as an aspect of visual colorimetric matching it is an individual property of each observer and thus depends on the normality of his vision. Related to the colorimetric system of the CIE, however, chromatic valence becomes a function of the standard observer; depending then only on physical parameters, it could seem to loose its psychophysiological character. Richter

demonstrates that this is not the case,[105] the intrinsic significance of the spectral sensitivity functions given by the CIE distribution coefficients $\bar{x}(\lambda)$, $\bar{y}(\lambda)$, $\bar{z}(\lambda)$ of the standard observer being to translate satisfactorily the visual impressions of real observers into colorimetric results.

3.4.3 Subjective Evaluations

3.4.3a *Colour Memory*

The measurement of colour as well as the principle of its photographic reproduction are based on the visual comparison of two simultaneously perceived areas. The case of direct comparison of the reproduction to the original scene by an observer is however an exception practically never encountered, so that the judgment of a reproduction depends on memory, an entirely psychological concept. Recent studies of colour memory are therefore based on the statistical evaluation of results obtained with a sufficient number of normal observers. Either luminous colour areas or coloured samples seen by reflection are presented to each of the observers during shorter or longer periods and the observers are then requested, after a certain time lapse, to restitute the same colour either by a new setting of the instrument illuminating the area (as for instance a spectrograph) or by the choice of a coloured sample within a given series.

While revealing for most observers an astonishing memory for colours, the results of such colorimetric 'successive matches' are of course more dispersed than those of simultaneous measurements. On the one hand, the differences between observers are quite important in spite of their normality of vision,[106] and there occurs further, according to the hue, a pronounced variation in the difficulty of restitution. Independent of quite varied experimental conditions, the restitution by memory of a yellow can be accomplished by most observers with good precision, while they experience quite some difficulty in restituting greens. Similarly, reproducibility by memory of a blue is satisfactory, but it is not so good with reds.[106] Repetition of the test by the same observers further demonstrates the existence of a pronounced capacity for mnemonic recording: the precision of the restitution increases with the number of experiments, a fact well known for a long time (Rood[107]). The comparative ease of the restitution of yellow and blue colours was also determined by Hellmig,[108] whose results further underline the sensitivity of observer memory for the contamination of a pure yellow by a slight addition of green.

Among the variables which act on colour memory, chromaticness, especially the hue component, seem to be of primary importance. Contrarily, the influence of the time lapse between the presentation of a coloured area to an observer and the restitution of this colour by memory seems to be astonishingly negligible, apparently because of the very rapid but lasting

recording of a rather precise impression. In an investigation by Hamwi and Landis[109] a variation of the time intervals from 15 minutes to 24 and 65 hours did not influence the results significantly, while rather strong effects resulted from the hue or chromaticity of the samples and the individuality of the observers.

The precision of colour memory is also demonstrated by the speed of successive matches. In a series of measurements carried out by Newhall, Burnham and Clark[110] simultaneous colorimetric matches required on the average a time of 59 seconds, but successive matches after observation of the coloured area during five seconds and a waiting interval of another five seconds took on the average only 25 seconds. However, the former yielded necessarily much more precise results than the matches based on memory.

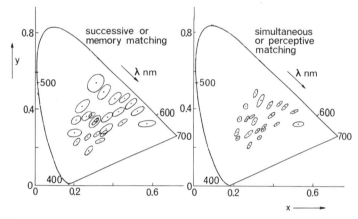

Figure 3.53. Comparison of the relative variability of successive and of simultaneous matches.

Figure 3.53 shows the relative variabilities of either successive or memory matches, or simultaneous or perceptual matches, represented in the CIE chromaticity diagram by the ellipses of 39% probability limits.

While almost of the same hues as the colours to be matched, those retained in memory are systematically of different saturation and brightness. Most observers remember them as being of higher purity and also of increased luminance. This tendency towards purer and brighter colours can have two origins: either there occurs some more adaptation during the memory match than during the shorter viewing of the test colour, and the observer compensates for it by choosing a colour of higher vivacity,† or some progressive

† In simultaneous or perceptual colorimetry, where only the two halves of a photometric field are to be matched, the adaptation of the observer due to the prolonged viewing of the field has no influence on the result, according to the von Kries coefficient law.[86]

memory fading of less dominant aspects of the colour to be matched leads to a strengthening of the memory of the original colour, and thus in memory makes it appear more saturated and brighter than it was in reality. An extended series of matches carried out by Newhall, Burnham and Clark rather confirm the second hypothesis.[110]

3.4.3b *Memory Colours*

Considering colour as an inseparable attribute of objects frequently encountered in daily life, instead of an abstract notion without any form, an additional and non-negligible factor is introduced into the problem of colour memory. So as to distinguish these colours from those of uniform areas when intentionally retained by observers for subsequent matching, it was proposed by Newhall, Burnham and Clark[110] and also by Bartleson[111] to call them 'memory colours'. They are not determined by successive matches but simply by the choice of the colour typical of a given subject out of an arbitrary array of a great number of uniform patches, generally square, of a great variety of colours. While the same tendency towards more vivid colours can be observed as in the experiments on colour memory, there occur however additional hue shifts, some of them rather strong, not encountered in the memory of abstract colours. This simultaneous change in hue and saturation can be quite important, as shown by the result of a series of trials carried out by Bartleson with fifty observers for ten frequently occurring colours, among which were that of flesh tint, of the green of foliage and grass, of blue sky and of sand (Figure 3.54). The memory colours of

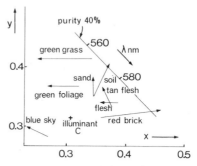

Figure 3.54. Chromaticity differences between memory colours (arrow heads) and the corresponding object colours (arrow tails).

the greens of grass and foliage are not only more saturated, but also more cyan than they really are; the memory colour of the flesh tint, while less saturated than on the average in nature, is also more yellow, and the memory sky-blue is more cyan than true sky and of slightly higher saturation.

The considerable difference between the hues of colours obtained by successive matching and those of memory colours is well demonstrated by the results of another series of measurements by Bartleson,[112] shown in a

horizontal plane of the Munsell lattice (Figure 3.55). The colours restituted by successive matches are almost of the same hues as the original colours, but all memory colours show important and non-systematical hue shifts.

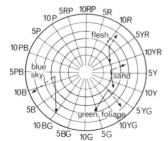

Figure 3.55. Munsell plot of differences between memory colours (heads of full line arrows) and colours obtained by successive matches (heads of dotted arrows), compared to the object colours (arrow tails).

3.4.3c *Colours Preferred in Reproductions*

Being unable to compare a reproduction to the original scene, and relying therefore in the majority of cases on his memory, the user of a photographic reproduction is compelled to judge it in absolute value. How then should colours be reproduced satisfactorily? Is it right to adopt the viewpoint of the physicist, supposing that only colorimetrically true reproduction can solve the problem because it again gives rise to a colour perception identical to that in the original? Or would it be desirable, on the contrary, to reproduce the most frequently encountered colours by matching their memory colours? This is essentially a psychological problem whose solution must obviously be based on the perfect knowledge of the preferences of the great mass of the users; while these preferences can be determined in the laboratory by adequate experiments with small numbers of observers, the validity of such results is further checked by their comparison to the general tendency of acceptance by the public, of representative colour reproduction processes.

There then arises another question, no less delicate than the first one. If the users have a tendency to prefer reproductions which do not conform with reality, which are the colours to which they attribute the greatest importance? The answer obviously not only depends on the type of subjects whose colours are specific, but also on the frequency of their appearance in photographic reproductions, printed illustrations, and motion pictures. Certain colours prove invariably to be repeated in most images: the flesh tint, the green of vegetation, and the blue of the sky. While other subjects of different colours are also quite frequent, such as those of wood or of stone and bricks, or painted or otherwise coloured surfaces, experience shows that the observers are much more tolerant towards the reproduction of most of these colours than towards the first three, flesh tint, vegetation green and sky blue. Flesh tint is particularly one of those colours which seem to constitute a central criterion for the evaluation of image quality.

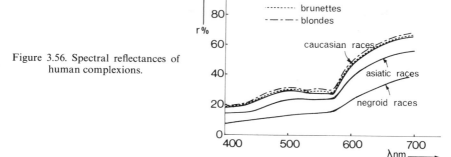

Figure 3.56. Spectral reflectances of human complexions.

The spectral reflectance of human skin was studied by Buck and Froelich[113] and Figure 3.56 shows the average of these determinations for 51 male and 52 female subjects. The resulting spectral characteristic is rather typical, in spite of the well known but frequently overestimated variations of the various types of complexions. In this figure curves representative of the flesh tint of either blondes or brunettes do not differ much from that of the average tint, and other current variations are of similar magnitude. The corresponding memory colour, however, as has been shown, is considerably more yellow and less saturated than this true flesh colour. Which then is the colour preferred by most users of images?

In an investigation on preferred reproduction colours carried out with eleven observers, Bartleson and Bray[114] compared these with the original colours of the subjects and those of the corresponding memory colours. The colours studied were a flesh tint, sky blue and grass green, because of their frequent appearance in the images. From the results of this investigation it can be concluded that the colours of the three typical subjects preferred in photographic reproductions are neither those of the corresponding memory colours nor those of the real subjects. They differ from both according to their original hue.

To make the reproduction of a flesh tint satisfactory to most observers, it must be reproduced much yellower than natural flesh, with the hue of the memory colour, but slightly less saturated. Figure 3.57 (see Plate 3) allows the comparison of this colour with that of natural flesh and the corresponding memory colour. For the green of grass, the preferred colour has the same hue as the general reflectance of a real lawn, but not that of the memory colour which is much more cyan. Just as in the case of the flesh tint, the saturation of the reproduction must however be lower than that of the natural colour. For sky blue, on the contrary, the users prefer a higher saturation than that of reality, but the preferred hue corresponds well to that of a true sky and not to that of the memory colour, which is more cyan (Figure 3.58).

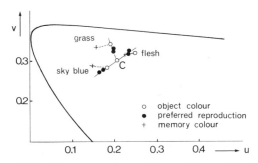

Figure 3.58. Chromaticities of memory colours, object colours and preferred reproduction colours.

Should these results lead us to conclude on the non-validity of Maxwell's principle, based on colorimetric fidelity? Certainly not: the deviations from exact reproduction, necessary to satisfy user preference, while quite visible, are of comparitively small magnitude and do not require the reproduction system initially not to be colorimetrically true. It must on the contrary be designed for yielding literally exact colour reproduction, which then makes it easy to introduce the very slight corrections necessary to reproduce the colours of flesh tint, sky blue and green grass, as well as others, like those which the observers prefer. This is indeed the case for the most widespread photographic and cinematographic processes, as well as for the bulk of illustrated printed edition.

REFERENCES

1 Ostwald, W., *Phys. Zeitschr.*, **17** (1916), 328.
2 Luther, R., Aus dem Gebiete der Farbreizmetrik. *Zeitschr. f. techn. Phys.*, **12** (1927), 540.
3 MacAdam, D. L., The theory of the maximum visual efficiency of colored materials. *Jl. Opt. Soc. Am.*, **25** (1935), 249.
4 Newton, Sir I., *Opticks*, London, 1704, I/2, prop. 6/2 (Dover Edition, New York, 1952).
5 Grassmann, H., Zur Theorie der Farbenmischung. *Poggendorffs Ann. Phys.*, **89** (1853), 69.
6 Le Grand, Y., *Optique Physiologique*, Paris 1948; **2**, 139.
7 Young, Th., *A Course of Lectures on Natural Philosophy and the Mechanical Arts*, London 1845, 344.
8 Helmholtz, H., *Handbuch der physiologischen Optik*, Hamburg and Leipzig, 1866. (*Optique Physiologique*, Edition N. Desroches, Vigneux sur Seine France, 1967).
9 Maxwell, J. C., *Trans. Roy. Soc. Edinburgh*, **21** (1855), 275, and: On the theory of three primary colours. *The scientific papers by James Clerk Maxwell*, **1** (1890), 445.

10 Maxwell, J. C., On the theory of compound colours and the relations of the colours of the spectrum. *Proc. Royal Soc.*, **10** (1860), 404 and 484.
11 Guild, J., The colorimetric properties of the spectrum. *Phil. Trans. Royal Soc. London*, **A230** (1931), 149.
12 Wright, W. D., A redetermination of the trichromatic coefficients of the spectral colours. *Trans. opt. Soc. London*, **30** (1928–29), 141.
13 König, A., and Dieterici, C., Die Grundempfindungen in normalen und anomalen Farbensystemen und ihre Intensitätsverteilung im Spektrum. *Z.f. Psychol.*, **4** (1892), 241.
14 Abney, W. de W., The numerical registration of colours. *Proc. Royal Soc. London*, **49** (1892), 227.
15 Richter, M., *Grundriss der Farbenlehre der Gegenwart*, p. 53, Dresden and Leipzig, 1940.
16 Ives, H. E., The transformation of color mixture equations from one system to another. *Jl. Franklin Inst.*, **180** (1915), 673.
17 Reference 15, p. 19.
18 Schrödinger, E., Grundlinien einer Theorie der Farbenmetrik im Tagessehen. *Ann. Phys.*, **63** (1920), 387, § 9. Irreelle Eichfarben, p. 444.
19 Commission Internationale de l'Éclairage, *Compte rendu de la 8ème Session, Cambridge 1931*. Cambridge University Press, 1932.
20 Judd, D. B., Reduction of data on mixture of color stimuli, Res. Pub. No. 163, *Bur. of Standards Jl.*, Res. **4** (1930), 515.
21 Reference 19 and Davis, R., and Gibson, K. S., Filters for the reproduction of sunlight and daylight and the determination of color temperature. *Misc. Pub. Nl. Bur. Stand. USA*, No. 114, 1931.
22 International Commission on Illumination, *Official Recommendations, Colorimetry*, Paris, 1969.
23 Hardy, A. C., *Handbook of Colorimetry*, pp. 32 and 49, Cambridge, Mass., E.U.A., 1936.
24 Chevreul, E., *De la loi du contraste simultané des couleurs*, Paris, 1839.
25 Reference 18: 5. Die Abbildung auf ein Vektorbüschel, p. 427.
26 Wyszecki, G., *Farbsysteme*, Berlin–Frankfort, 1960.
27 Ostwald, W., *Farbnormen Atlas*, Leipzig, 1925.
28 Plochere, G. and G., *Plochere Color System*, Los Angeles, 1948.
29 Hickethier, A., *Farbenordnung Hickethier*, Hannover, 1952.
30 Munsell Color Co., *Munsell Book of Color*, Baltimore, 1943.
 Newhall, S. M., Nickerson, D., and Judd D. B., Final report of the O.S.A. subcommittee on the spacing of the Munsell Colors. *Jl. Opt. Soc. Am.*, **33** (1943), 385.
31 Nyberg, N., Zum Aufban des Farbenkörpers im Raume aller Licht empfindungen. *Z.f. Phys.*, **52** (1928), 406.
32 Maxwell, J. C., *Roy. Soc. Edinburgh Trans.*, **21** (1855), 275.
33 MacAdam, D. L., Photometric relationships between complementary colors. *Jl. Opt. Soc. Am.*, **28** (1938), 103.
34 German standard DIN 6164, and Richter, M., Untersuchungen zur Aufstellung eines empfindungsgemäss gleichabständigen Farbsystems. *Die Farbe*, **1** (1953), 85.
35 Berger, A., and Brockes, A., Prüfung der Gleichabständigkeit der Beiblätter zur Vornorm DIN 6164. *Die Farbe*, **13** (1964), 167.
36 Reference 18, p. 483.

37 MacAdam, D. L., Visual sensitivities to color differences in daylight. *Jl. Opt. Soc. Am.*, **32** (1942), 247.

38 Brown, W. R. J., and MacAdam, D. L., Visual sensitivities to combined chromaticity and luminance difference. *Jl. Opt. Soc. Am.*, **39** (1949), 809.

39 Silberstein, L., Investigations on the intrinsic properties of the color domain, II. *Jl. Opt. Soc. Am.*, **33** (1943), 1.

40 Wright, W. D., The sensitivity of the eye to small colour differences. *Proc. Phys. Soc. London*, **53** (1941), 93.

41 Wright, W. D., The graphical representation of small colour differences. *Jl. Opt. Soc. Am.*, **33** (1943), 632.

42 Stiles, W. S., A modified Helmholtz line element in brightness color space. *Proc. Phys. Soc. London*, **58** (1946), 41.

43 MacAdam, D. L., Projective transformations of color mixture diagrams. *Jl. Opt. Soc. Am.*, **32** (1942), 2.

44 Wyszecki, G., On projective transformations of the CIE-chromaticity diagrams. *Jl. Opt. Soc. Am.*, **46** (1956), 982.

45 MacAdam, D. L., Projective transformations of ICI color specifications. *Jl. Opt. Soc. Am.*, **27** (1937), 294.

46 Wyszecki, G., Proposal for a new color-difference formula. *Jl. Opt. Soc. Am.*, **53** (1963), 1318.

47 Wyszecki, G., and Wright, H., Field trial of the 1964 CIE color-difference formula *Jl. Opt. Soc. Am.*, **55** (1965), 1166.

48 Judd, D. B., and Wyszecki, G., *Color in Business, Science and Industry*, New York and London, 1967, p. 345.

49 MacAdam, D. L., Loci of constant hue and brightness determined with various surrounding colors. *Jl. Opt. Soc. Am.*, **40** (1950), 589.

50 Breneman, E. J., Dependence of luminance required for constant brightness upon chromaticity and chromatic adaptation. *Jl. Opt. Soc. Am.*, **48** (1958), 228.

51 Tessier, M., and Blottiau, F., Variations des caractéristiques photométriques de l'oeil aux luminances photopiques. *Rev. Opt.*, **30** (1951), 309.

52 Dresler, A., The non-additivity of heterochromatic brightnesses. *Trans. Illum. Eng. Soc.* (London), **18** (1953), 141.

53 Halsey, R. M., A comparison of three methods for color scaling. *Jl. Opt. Soc. Am.*, **44** (1954), 199.

54 Chapanis, A., and Halsey, R. M., Luminance of equally bright colors. *Jl. Opt. Soc. Am.*, **45** (1955), 1.

55 Sanders, C. L., and Wyszecki, G., Correlate for lightness in terms of CIE—tristimulus values: Part I, *Jl. Opt. Soc. Am.*, **47** (1957), 398, 840; Part II, *Jl. Opt. Soc. Am.*, **48** (1958), 389.

56 Kowaliski, P., Etalonnage de l'espace des couleurs en luminosité apparente. *Die Farbe*, **14** (1965), 302.

57 Kowaliski, P., Le problème de la luminance équivalente. *Rev. Opt.*, **46** (1967), 359. Equivalent luminances of colors. *Jl. Opt. Soc. Am.*, **59** (1969), 125.

58 Wright, W. D., *Researches on Normal and Defective Colour Vision*, London, 1946, p. 73.

59 Ducos du Hauron, L., *Les couleurs en photographie: Solution du problème*, Paris, 1869.

60 Hardy, A. C., and Wurzburg, F. L. Jr., The theory of three-color reproduction. *Jl. Opt. Soc. Am.*, **27** (1937), 227.

61 MacAdam, D. L., Physics in color photography. *Jl. Appl. Phys.*, **11** (1940), 46.

62 Hanson, W. T. Jr, and Lyle Brewer, W., Subtractive color photography: the role of masks. *Jl. Opt. Soc. Am.*, **44** (1954), 129.

63 MacAdam, D. L., Subtractive color mixture and color reproduction. *Jl. Opt. Soc. Am.*, **28** (1938), 466.

64 Kowaliski, P., Colour reproduction theory and separation filters. *Jl. Phot. Sc.*, **12** (1964), 76.

65 Albert, E., German patents 101379 (1899) and 116538 (1900).

66 Yule, J. A. C., Theory of subtractive color photography I. The conditions for perfect color rendering. *Jl. Opt. Soc. Am.*, **28** (1938), 419.

67 Marriage, A., Subtractive colour reproduction. *Phot. Jl.*, **88B** (1948), 75.

68 Brewer, W. L., Hanson, W. T. Jr, and Horton, C. A., Subtractive color reproduction. The approximate reproduction of selected colors. *Jl. Opt. Soc. Am.*, **39** (1949), 924.

69 Hanson, W. T. Jr, and Lyle Brewer, W., Subtractive color photography: The role of masks. *Jl. Opt. Soc. Am.*, **44** (1954), 129.

70 Behrendt, W., Vertikaler Eberhard-Effekt und Schwarzschild-Effekt beim Agfacolorfilm. *Z. Naturforschung*, **6a**-(1951), 382.

71 Hanson, W. T. Jr, and Horton, C. A., Subtractive color reproduction: Interimage effects. *Jl. Opt. Soc. Am.*, **42** (1952), 663.

72 Thiels, A., Einige kolorimetrische Folgen der Diffusionsvorgänge bei Farbfilmentwicklung. *Z. wiss. Phot.*, **47** (1952), 106 and 246.

73 Hanson, W. T. Jr, and Vittum, P. W., Colored dye forming couplers in subtractive color photography. *Jl. Phot. Soc. Am.*, **13** (1947), 94.

74 Hanson, W. T. Jr, Color correction with colored couplers. *Jl. Opt. Soc. Am.*, **40** (1950), 171.

75 Brown, W. R. J., Evaluation of the actual color-reproduction equations for a color process. *Jl. Opt. Soc. Am.*, **45** (1955), 539.

76 Evans, R. M., Visual processes and color photography. *Jl. Opt. Soc. Am.*, **33** (1943), 579.

77 Bartleson, C. J., Interrelations among screen luminance, camera exposure, and quality of projected color transparencies. *Phot. Sci. and Eng.*, **9** (1965), 174.

78 Hurvich, L. M., and Jameson, D., A psychophysical study of white; I. and II. Neutral adaptation. *Jl. Opt. Soc. Am.*, **41** (1951), 521; III. Adaptation as variant. *Jl. Opt. Soc. Am.*, **41** (1951), 787.

79 Bartleson, C. J., and Witzel, R. F., Illumination for color transparencies. *Phot. Sci. Eng.*, **11** (1967), 329.

80 MacAdam, D. L., Influence of surround on hue and saturation. *Jl. S.M.P.T.E.*, **57** (1951), 197.

81 Burnham, R. W., Evans, R. M., and Newhall, S. M., Influence on color perception of adaptation to illumination. *Jl. Opt. Soc. Am.*, **42** (1952), 597.

82 Burnham, R. W., Evans, R. M., and Newhall, S. M., Prediction of color appearance with different adaptation illuminants. *Jl. Opt. Soc. Am.*, **47** (1957), 35.

83 MacAdam, D. L., Perception of colors in projected and televised pictures. *Jl. S.M.P.T.E.*, **65** (1956), 455.

84 Bartleson, C. J., Influence of observer adaptation on the acceptance of color prints. *Phot. Sci. Eng.*, **2** (1958), 32.

85 Bartleson, C. J., Factors affecting the quality of projected images: Level of veiling illuminance. *Phot. Sci. Eng.*, **9** (1965), 179.

86 Kries, J. von, Die Gesichtsempfindungen, in W. Nagel, *Handbuch der Physiologie des Menschen*, 1905, pp. 109–282.

87 Jameson, D., and Hurvich, L. M., Theory of brightness and color contrast in human vision. *Vision Research*, **4** (1964), 135.
88 Hurwich, L. M., and Jameson, D., An opponent-process theory of color vision. *Psychol. Rev.*, **64** (1957), 384.
89 Burnham, R. W., Comparative effects of area and luminance on color. *Am. Jl. Psychology*, **65** (1952), 27.
90 Hunt, R. W. G., Light and dark adaptation and the perception of color. *Jl. Opt. Soc. Am.*, **42** (1952), 190.
91 Hunt, R. W. G., Measurement of color appearance. *Jl. Opt. Soc. Am.*, **55** (1965), 1540.
92 Bartleson, C. J., Color appearance measurement. I. A colorimeter for haploscopic color matching. *Phot. Sci. Eng.*, **10** (1966), 104.
93 Burnham, R. W., A colorimeter for research in color perception. *Am. Jl. Psychol.*, **65** (1952), 603.
94 Bartleson, C. J., Reese, W. B., Macbeth, N., and James, J. E., Lighting details of the Kodak Photo-tower, New-York world's fair. *Illum. Engineering*, **59** (1964), 375.
95 Newhall, S. M., Burnham, R. W., and Evans, R. M., Color constancy in shadows. *Jl. Opt. Soc. Am.*, **48** (1958), 976.
96 Newhall, S. M., Burnham, R. W., and Evans, R. M., Influence of shadow quality on color appearance. *Jl. Opt. Soc. Am.*, **40** (1959), 909.
97 Edelmann, E., Méthodes colorimétriques de comparaison des impressions trichomes.
 C.R. des 2èmes Journées Internationales de la Couleur, Toulouse, 1958, p. 61 and *Couleurs* (1958), 28
98 Driancourt, F., Le facteur de vivacité: étude expérimentale de différentes formules. *C.R. des 5èmes Journées Internationales de la Couleur, Paris, 1960*.
99 Driancourt, F., Nouveaux aperçus sur le concept de vivacité d'une couleur. *Bulletin Com. Fr. Cartogr.*, (1963), 185.
100 Preucil, F., How strong to run the color. A simple vivacity factor. *Penrose Annual 1965*, p. 273, London, 1965.
101 Evans, R. M., Fluorescence and gray content of surface colors. *Jl. Opt. Soc. Am.*, **49** (1959), 1049.
102 Bartleson, C. J., Color perception and color television. *Jl. S.M.P.T.E.*, **77** (1968), 1.
103 German standard DIN 5033, Berlin, 1954.
104 Richter, M., Wesen und Bedeutung des Farbalenz Begriffes. *Die Farbe*, **3** (1954), 49.
105 Richter, M., Uber das Verhältnis zwischen Physik und Farbenlehre. *Physik Bl.*, **8** (1952), 2.
106 Collins, M., Some observations on immediate colour memory. *Brit. Jl. Psychol.*, **22** (1932), 344.
107 Rood, O. N., Our memory for colour and luminosity. *Nature*, **21** (1879), 144.
108 Hellmig, E., Versuche über das Farberinnerungsvermögen. *Die Farbe*, **7** (1958), 65.
109 Hamwi, V., and Landis, C., Memory for color. *Jl. Psychol.*, **39** (1955), 183.
110 Newhall, S. M., Burnham, R. W., and Clark, J. R., Comparison of successive with simultaneous color matching. *Jl. Opt. Soc. Am.*, **47** (1957), 43.
111 Bartleson, C. J., Memory colors of familiar objects. *Jl. Opt. Soc. Am.*, **50** (1960), 73.
112 Bartleson, C. J., Color in memory in relation to photographic reproduction. *Phot. Sci. Eng.*, **5** (1961), 327.

113 Buck, G. B., and Froelich, H. C., Color characteristics of human complexions. *Illum. Eng.*, **43** (1948), 27.
114 Bartleson, C. J., and Bray, C. P., On the preferred reproduction of flesh, blue-sky, and green grass colors. *P.S.E. Jl.*, **6** (1962), 19.
115 Ives, F. E., The optics of trichromatic photography. *Photo. Jl.*, **40** (1900), 99.
116 Schrödinger, E., 'Die Photographie in naturlichen Farben mittels Farbraster.' In Muller-Pouillet, *Lehrbuch der Physik*, **2** (1926), Chapter 37, p. 488.

APPENDIX

Numerical Tables for Colorimetric Computations

TABLE 3.1. Relative Spectral Power Distributions of Standard Illuminants A and D_{6500}

λ (nm)	(A) $S(\lambda)$	(D_{65}) $S(\lambda)$	λ (nm)	(A) $S(\lambda)$	(D_{65}) $S(\lambda)$
300	0·93	0·03	600	129·04	90·0
10	1·36	3·3	10	136·35	89·6
20	1·93	20·2	20	143·62	87·7
30	2·66	37·1	30	150·84	83·3
40	3·59	39·9	40	157·98	83·7
350	4·74	44·9	650	165·03	80·0
60	6·14	46·6	60	171·96	80·2
70	7·82	52·1	70	178·77	82·3
80	9·80	50·0	80	185·43	78·3
90	12·09	54·6	90	191·93	69·7
400	14·71	82·8	700	198·26	71·6
10	17·68	91·5	10	204·41	74·3
20	20·99	93·4	20	210·36	61·6
30	24·67	86·7	30	216·12	69·9
40	28·70	104·9	40	221·67	75·1
450	33·09	117·0	750	227·00	63·6
60	37·81	117·8	60	232·12	46·4
70	42·87	114·9	70	237·01	66·8
80	48·24	115·9	80	241·68	63·4
90	53·91	108·8	90	246·12	64·3
500	59·86	109·4	800	250·33	59·5
10	66·06	107·8	10	254·31	52·0
20	72·50	104·8	20	258·07	57·4
30	79·13	107·7	30	261·60	60·3
40	85·95	104·4			
550	92·91	104·0			
60	100·00	100·0			
70	107·18	96·3			
80	114·44	95·8			
90	121·73	88·7			

TABLE 3.2. Components $S_0(\lambda), S_1(\lambda), S_2(\lambda)$, of Daylight used in the Calculation of Relative Spectral Power Distributions of Daylight of Different Correlated Colour Temperatures

λ (mn)	$S_0(\lambda)$	$S_1(\lambda)$	$S_2(\lambda)$	λ (nm)	$S_0(\lambda)$	$S_1(\lambda)$	$S_2(\lambda)$
300	0·04	0·02	0·0	600	90·5	−5·8	3·2
350	61·8	41·6	6·7	650	81·9	−10·7	7·3
400	94·8	43·4	−1·1	700	74·3	−13·3	9·6
450	125·6	35·9	−2·9	750	65·2	−10·2	6·7
500	113·1	16·2	−1·5	800	61·0	−9·7	6·4
550	104·4	1·9	−0·3				

TABLE 3.3. Chromaticity Coordinates x_D, y_D, u_D, v_D and Factors M_1, M_2 used in the Calculation of the Relative Spectral Power Distribution of Daylight of Correlated Colour Temperature T_c in the Range 4000 to 25,000 K

T_c	x_D	y_D	u_D	v_D	M_1	M_2
4000	0·3823	0·3838	0·2236	0·3366	−1·505	2·827
4500	0·3621	0·3709	0·2153	0·3308	−1·286	1·302
5000	0·3457	0·3587	0·2091	0·3254	−1·040	0·367
5500	0·3325	0·3476	0·2044	0·3206	−0·786	−0·195
6000	0·3217	0·3378	0·2007	0·3162	−0·536	−0·519
6500	0·3128	0·3292	0·1978	0·3123	−0·296	−0·688
7000	0·3054	0·3216	0·1955	0·3088	−0·070	−0·757
7500	0·2991	0·3150	0·1935	0·3057	0·144	−0·760
8000	0·2938	0·3092	0·1919	0·3030	0·342	−0·720
8500	0·2892	0·3041	0·1906	0·3006	0·526	−0·652
9000	0·2853	0·2996	0·1894	0·2984	0·697	−0·566
9500	0·2818	0·2956	0·1884	0·2964	0·856	−0·471
10,000	0·2788	0·2920	0·1876	0·2946	1·003	−0·369
12,000	0·2697	0·2808	0·1850	0·2890	1·495	0·045
15,000	0·2614	0·2702	0·1828	0·2835	2·021	0·586
20,000	0·2539	0·2603	0·1809	0·2781	2·571	1·231
25,000	0·2499	0·2548	0·1798	0·2751	2·907	1·655

TABLE 3.4. CIE 1931 Standard Colorimetric Observer. Abridged Set of Spectral Tristimulus Values $\bar{x}(\lambda)$, $\bar{y}(\lambda)$, $\bar{z}(\lambda)$ and Corresponding Chromaticity Coordinates $x(\lambda)$, $y(\lambda)$

λ (nm)	$\bar{x}(\lambda)$	$\bar{y}(\lambda)$	$\bar{z}(\lambda)$	$x(\lambda)$	$y(\lambda)$	λ (nm)	$\bar{x}(\lambda)$	$\bar{y}(\lambda)$	$\bar{z}(\lambda)$	$x(\lambda)$	$y(\lambda)$
380	0·0014	0·0000	0·0065	0·1741	0·0050	430	0·2839	0·0116	1·3856	0·1689	0·0069
390	0·0042	0·0001	0·0201	0·1738	0·0049	440	0·3483	0·0230	1·7471	0·1644	0·0109
400	0·0143	0·0004	0·0679	0·1733	0·0048	450	0·3362	0·0380	1·7721	0·1566	0·0177
410	0·0435	0·0012	0·2074	0·1726	0·0048	460	0·2908	0·0600	1·6692	0·1440	0·0297
420	0·1344	0·0040	0·6456	0·1714	0·0051	470	0·1954	0·0910	1·2876	0·1241	0·0578

Plate 3

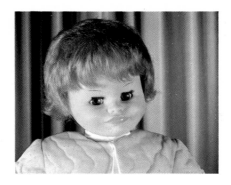

Figure 3.57. Memory colour (top), object colour (centre) and preferred colour in reproduction (bottom) of a flesh tint.

TABLE 3.4. CIE 1931 Standard Colorimetric Observer. Abridged Set of Spectral Tristimulus Values $\bar{x}(\lambda)$, $\bar{y}(\lambda)$, $\bar{z}(\lambda)$ and Corresponding Chromaticity Coordinates $x(\lambda)$, $y(\lambda)$—continued

λ (nm)	$\bar{x}(\lambda)$	$\bar{y}(\lambda)$	$\bar{z}(\lambda)$	$x(\lambda)$	$y(\lambda)$	λ (nm)	$\bar{x}(\lambda)$	$\bar{y}(\lambda)$	$\bar{z}(\lambda)$	$x(\lambda)$	$y(\lambda)$
480	0·0956	0·1390	0·8130	0·0913	0·1327	630	0·6424	0·2650	0·0000	0·7079	0·2920
490	0·0320	0·2080	0·4652	0·0454	0·2950	640	0·4479	0·1750	0·0000	0·7190	0·2809
500	0·0049	0·3230	0·2720	0·0082	0·5384	650	0·2835	0·1070	0·0000	0·7260	0·2740
510	0·0093	0·5030	0·1582	0·0139	0·7502	660	0·1649	0·0610	0·0000	0·7300	0·2700
520	0·0633	0·7100	0·0782	0·0743	0·8338	670	0·0874	0·0320	0·0000	0·7320	0·2680
						680	0·0468	0·0170	0·0000	0·7334	0·2666
530	0·1655	0·8620	0·0422	0·1547	0·8059	690	0·0227	0·0082	0·0000	0·7344	0·2656
540	0·2904	0·9540	0·0203	0·2296	0·7543	700	0·0114	0·0041	0·0000	0·7347	0·2653
550	0·4334	0·9950	0·0087	0·3016	0·6923	710	0·0058	0·0021	0·0000	0·7347	0·2653
560	0·5945	0·9950	0·0039	0·3731	0·6245	720	0·0029	0·0010	0·0000	0·7347	0·2653
570	0·7621	0·9520	0·0021	0·4441	0·5547	730	0·0014	0·0005	0·0000	0·7347	0·2653
						740	0·0007	0·0002	0·0000	0·7347	0·2653
580	0·9163	0·8700	0·0017	0·5125	0·4866	750	0·0003	0·0001	0·0000	0·7347	0·2653
590	1·0263	0·7570	0·0011	0·5752	0·4242	760	0·0002	0·0001	0·0000	0·7347	0·2653
600	1·0622	0·6310	0·0008	0·6270	0·3725	770	0·0001	0·0000	0·0000	0·7347	0·2653
610	1·0026	0·5030	0·0003	0·6658	0·3340	780	0·0000	0·0000	0·0000	0·7347	0·2653
620	0·8544	0·3810	0·0002	0·6915	0·3083						

TABLE 3.5. CIE 1964 Supplementary Standard Colorimetric Observer. Abridged Set of Spectral Tristimulus Values $\bar{x}_{10}(\lambda)$, $\bar{y}_{10}(\lambda)$, $\bar{z}_{10}(\lambda)$ and Corresponding Chromaticity Coordinates $x_{10}(\lambda)$, $y_{10}(\lambda)$

λ (nm)	$\bar{x}_{10}(\lambda)$	$\bar{y}_{10}(\lambda)$	$\bar{z}_{10}(\lambda)$	$x_{10}(\lambda)$	$y_{10}(\lambda)$	λ (nm)	$\bar{x}_{10}(\lambda)$	$\bar{y}_{10}(\lambda)$	$\bar{z}_{10}(\lambda)$	$x_{10}(\lambda)$	$y_{10}(\lambda)$
380	0·0002	0·0000	0·0007	0·1813	0·0197	530	0·2365	0·8752	0·0305	0·2071	0·7663
390	0·0024	0·0003	0·0105	0·1803	0·0194	540	0·3768	0·9620	0·0137	0·2786	0·7113
400	0·0191	0·0020	0·0860	0·1784	0·0187	550	0·5298	0·9918	0·0040	0·3473	0·6501
410	0·0847	0·0088	0·3894	0·1755	0·0181	560	0·7052	0·9973	0·0000	0·4142	0·5858
420	0·2045	0·0214	0·9725	0·1706	0·0179	570	0·8787	0·9556	0·0000	0·4790	0·5210
430	0·3147	0·0387	1·5535	0·1650	0·0203	580	1·0142	0·8689	0·0000	0·5386	0·4614
440	0·3837	0·0621	1·9673	0·1590	0·0257	590	1·1185	0·7774	0·0000	0·5900	0·4100
450	0·3707	0·0895	1·9948	0·1510	0·0364	600	1·1240	0·6583	0·0000	0·6306	0·3694
460	0·3023	0·1282	1·7454	0·1389	0·0589	610	1·0305	0·5280	0·0000	0·6612	0·3388
470	0·1956	0·1852	1·3176	0·1152	0·1090	620	0·8563	0·3981	0·0000	0·6827	0·3173
480	0·0805	0·2536	0·7721	0·0728	0·2292	630	0·6475	0·2835	0·0000	0·6955	0·3045
490	0·0162	0·3391	0·4153	0·0210	0·4401	640	0·4316	0·1798	0·0000	0·7059	0·2941
500	0·0038	0·4608	0·2185	0·0056	0·6745	650	0·2683	0·1076	0·0000	0·7137	0·2863
510	0·0375	0·6067	0·1120	0·0495	0·8023	660	0·1526	0·0603	0·0000	0·7168	0·2832
520	0·1177	0·7618	0·0607	0·1252	0·8102	670	0·0813	0·0318	0·0000	0·7187	0·2813

TABLE 3.5. CIE 1964 Supplementary Standard Colorimetric Observer. Abridged Set of Spectral Tristimulus Values $\bar{x}_{10}(\lambda)$, $\bar{y}_{10}(\lambda)$, $\bar{z}_{10}(\lambda)$ and Corresponding Chromaticity Coordinates $x_{10}(\lambda)$, $y_{10}(\lambda)$—*continued*

λ (nm)	$\bar{x}_{10}(\lambda)$	$\bar{y}_{10}(\lambda)$	$\bar{z}_{10}(\lambda)$	$x_{10}(\lambda)$	$y_{10}(\lambda)$	λ (nm)	$\bar{x}_{10}(\lambda)$	$\bar{y}_{10}(\lambda)$	$\bar{z}_{10}(\lambda)$	$x_{10}(\lambda)$	$y_{10}(\lambda)$
680	0·0409	0·0159	0·0000	0·7198	0·2802	730	0·0010	0·0004	0·0000	0·7195	0·2806
690	0·0199	0·0077	0·0000	0·7202	0·2798	740	0·0005	0·0002	0·0000	0·7189	0·2811
700	0·0096	0·0037	0·0000	0·7204	0·2796	750	0·0003	0·0001	0·0000	0·7183	0·2817
710	0·0046	0·0018	0·0000	0·7202	0·2798	760	0·0001	0·0000	0·0000	0·7176	0·2824
720	0·0022	0·0008	0·0000	0·7199	0·2801	770	0·0001	0·0000	0·0000	0·7169	0·2831
						780	0·0000	0·0000	0·0000	0·7161	0·2839

TABLE 3.6. Spectral Tristimulus Values $\bar{u}(\lambda)$, $\bar{v}(\lambda)$, $\bar{w}(\lambda)$ and Corresponding Chromaticity Coordinates $u(\lambda)$, $v(\lambda)$

λ (nm)	$\bar{u}(\lambda)$	$\bar{v}(\lambda)$	$\bar{w}(\lambda)$	$u(\lambda)$	$v(\lambda)$	λ (nm)	$\bar{u}(\lambda)$	$\bar{v}(\lambda)$	$\bar{w}(\lambda)$	$u(\lambda)$	$v(\lambda)$
380	0·0009	0·0000	0·0026	0·2569	0·0110	580	0·6109	0·8700	0·8477	0·2623	0·3736
390	0·0028	0·0001	0·0081	0·2564	0·0109	590	0·6842	0·7570	0·6229	0·3315	0·3667
400	0·0095	0·0004	0·0274	0·2558	0·0106	600	0·7081	0·6310	0·4158	0·4035	0·3596
410	0·0290	0·0012	0·0838	0·2545	0·0106	610	0·6684	0·5030	0·2534	0·4691	0·3530
420	0·0896	0·0040	0·2616	0·2522	0·0113	620	0·5696	0·3810	0·1444	0·5202	0·3479
430	0·1893	0·0116	0·5682	0·2461	0·0151	630	0·4283	0·2650	0·0763	0·5565	0·3443
440	0·2322	0·0230	0·7339	0·2348	0·0233	640	0·2986	0·1750	0·0386	0·5830	0·3417
450	0·2241	0·0380	0·7750	0·2161	0·0366	650	0·1890	0·1070	0·0187	0·6005	0·3400
460	0·1939	0·0600	0·7792	0·1877	0·0581	660	0·1099	0·0610	0·0090	0·6108	0·3389
470	0·1302	0·0910	0·6826	0·1441	0·1007	670	0·0583	0·0320	0·0043	0·6161	0·3384
480	0·0638	0·1390	0·5672	0·0828	0·1806	680	0·0312	0·0170	0·0021	0·6199	0·3380
490	0·0213	0·2080	0·5286	0·0282	0·2744	690	0·0151	0·0082	0·0010	0·6226	0·3377
500	0·0033	0·3230	0·6180	0·0035	0·3420	700	0·0076	0·0041	0·0005	0·6234	0·3377
510	0·0062	0·5030	0·8289	0·0046	0·3759	710	0·0039	0·0021	0·0002	0·6234	0·3377
520	0·0422	0·7100	1·0725	0·0231	0·3891	720	0·0019	0·0010	0·0001	0·6234	0·3377
530	0·1103	0·8620	1·2313	0·0501	0·3912	730	0·0010	0·0005	0·0001	0·6234	0·3377
540	0·1936	0·9540	1·2959	0·0792	0·3904	740	0·0005	0·0002	0·0000	0·6234	0·3377
550	0·2890	0·9950	1·2801	0·1127	0·3880	750	0·0002	0·0001	0·0000	0·6234	0·3377
560	0·3963	0·9950	1·1972	0·1531	0·3844	760	0·0001	0·0001	0·0000	0·6234	0·3377
570	0·5081	0·9520	1·0480	0·2026	0·3796	770	0·0001	0·0000	0·0000	0·6234	0·3377
						780	0·0000	0·0000	0·0000	0·6234	0·3377

TABLE 3.7. Spectral Tristimulus Values $\bar{u}_{10}(\lambda)$, $\bar{v}_{10}(\lambda)$, $\bar{w}_{10}(\lambda)$ and Corresponding Chromaticity Coordinates $u_{10}(\lambda)$, $v_{10}(\lambda)$

λ (nm)	$\bar{u}_{10}(\lambda)$	$\bar{v}_{10}(\lambda)$	$\bar{w}_{10}(\lambda)$	$u_{10}(\lambda)$	$v_{10}(\lambda)$	λ (nm)	$\bar{u}_{10}(\lambda)$	$\bar{v}_{10}(\lambda)$	$\bar{w}_{10}(\lambda)$	$u_{10}(\lambda)$	$v_{10}(\lambda)$
380	0·0001	0·0000	0·0003	0·2524	0·0411	580	0·6761	0·8689	0·7963	0·2888	0·3711
390	0·0016	0·0003	0·0044	0·2512	0·0404	590	0·7457	0·7774	0·6068	0·3501	0·3650
400	0·0127	0·0020	0·0365	0·2488	0·0391	600	0·7493	0·6583	0·4255	0·4088	0·3591
410	0·0565	0·0088	0·1654	0·2449	0·0380	610	0·6870	0·5280	0·2767	0·4606	0·3539
420	0·1363	0·0214	0·4161	0·2376	0·0373	620	0·5709	0·3981	0·1689	0·5017	0·3498
430	0·2098	0·0387	0·6774	0·2266	0·0418	630	0·4316	0·2835	0·1015	0·5286	0·3471
440	0·2558	0·0621	0·8849	0·2127	0·0516	640	0·2877	0·1798	0·0540	0·5517	0·3448
450	0·2471	0·0895	0·9462	0·1926	0·0697	650	0·1789	0·1076	0·0273	0·5701	0·3430
460	0·2015	0·1282	0·9138	0·1620	0·1031	660	0·1017	0·0603	0·0141	0·5775	0·3423
470	0·1304	0·1852	0·8388	0·1130	0·1604	670	0·0542	0·0318	0·0071	0·5822	0·3418
480	0·0537	0·2536	0·7262	0·0519	0·2454	680	0·0272	0·0159	0·0034	0·5848	0·3415
490	0·0108	0·3391	0·7082	0·0102	0·3205	690	0·0133	0·0077	0·0017	0·5858	0·3414
500	0·0025	0·4608	0·7985	0·0020	0·3652	700	0·0064	0·0037	0·0008	0·5863	0·3414
510	0·0250	0·6067	0·9474	0·0158	0·3842	710	0·0030	0·0018	0·0004	0·5859	0·3414
520	0·0785	0·7618	1·1141	0·0402	0·3898	720	0·0014	0·0008	0·0002	0·5851	0·3415
530	0·1577	0·8752	1·2098	0·0703	0·3903	730	0·0007	0·0004	0·0001	0·5840	0·3416
540	0·2512	0·9620	1·2614	0·1015	0·3887	740	0·0003	0·0002	0·0000	0·5827	0·3417
550	0·3532	0·9918	1·2247	0·1375	0·3859	750	0·0002	0·0001	0·0000	0·5812	0·3419
560	0·4701	0·9973	1·1434	0·1801	0·3820	760	0·0001	0·0000	0·0000	0·5795	0·3421
570	0·5858	0·9556	0·9940	0·2310	0·3769	770	0·0000	0·0000	0·0000	0·5777	0·3422
						780	0·0000	0·0000	0·0000	0·5757	0·3424

4

Information Recording and Transfer

The intrinsic purpose of the combined specific properties of the photographic 'image', discussed in detail in the three previous chapters, is to transfer information in the most general sense of the term. It therefore seems quite natural also to apply to the photographic medium the analytical and synthetic methods primitively created only for the communication of signals, i.e. for telecommunications. Initially applied to photography mainly for the study and evaluation of detail reproduction (see p. 160), these methods yield at present more apparent results, also through the spreading use of electronic computers. On the one hand they favour by their advantageous influence on the development of the photographic techniques an increase of the information content of the 'images' by purely photographic methods, such as the judiciously appropriate design of the sensitive layers and the adaptation of their processing to each particular purpose, or of corrective methods either using masks or development effects. On the other hand digital image processing allows us to extract by television type scanning and computer processing the required pertinent information from a first recording obtained under unfavourable prevailing conditions. The numerous possibilities of these latter methods facilitate the simultaneous application of several types of corrections, as for instance the elimination of unwanted image matter *and* of granularity; the improvement of sharpness *and* of tone reproduction; the straightening of oblique images *and* the suppression of image curvature; and many other eliminations of information degrading effects.

The application of information theory to photographic recording also leads to the analysis of the possibilities and limitations of the photographic process. By the exact evaluation of its efficiency and its limits of sensitivity,

methods can be found for the determination of optimal working conditions at the limits of the possible. Information theory thus extends the already wide domain of the photographic process.

Definitions

The photographic system considered as communication channel. As defined by Hartley[1] and Shannon[2] the purpose of communication is the reproduction at one point of a message selected at another point. A communication system comprises the *source of information,* the *means of transmission,* of *transfer* and of *reception,* and an *element of destination.* Applied to 'images' by the substitution of the time variable by a spatial variable (see also p. 160) the theory of communication leads to the study of the capacity of information detection and storage of the photographic system; it makes it possible to evaluate quantitatively the influence of all unwanted but inevitable parameters such as noise, uniform ambient radiation incidence or undesirable information content, and also the capacity of the system of transmitting even the smallest signals in spite of the presence of the unwanted ones. For the photographic system considered as communication channel the elements corresponding to those of telecommunication are the *original 'scene'* (source), the unit *optical system-sensitive recording layer* (transmitter), the *copying and processing devices* (transfer channel), the *print or final recording* (receiver), and the *human observer* or the *element of exploration or interpretation* (destination).

Information capacity. The information capacity of a photographic layer can be considered as a particular case of that of any radiation detector (Rose[3]). Without background noise, neither in the detector nor in the incident radiation, this capacity would be infinitely large; it depends on the other hand only on the variation of the incident power because a steady flux of power carries no information. For a communication channel, information capacity is measured in bits (binary digits) per second, and for a photographic system in bits per square centimetre. By definition the information capacity of a photographic layer is therefore equal to the maximum number of bits per unit area which the layer is capable of recording in such a way that they can all be 'read' off without any error (Jones[4]). Obviously this information capacity of the photographic image depends on its intrinsic properties: being recorded within two limiting density values, the minimum and the maximum densities, the image shows the behaviour of a peak limited communication channel; and not only its overall response is non-linear—to a regular progression of input signals (exposure) corresponds a non-linear function of output signals (see p. 171)—but its noise as well, the granularity, which is a non-linear function of density.

Quantum efficiency. The capacity of a photosensitive layer for recording information contained in an incident radiation is determined, according to Rose,[3] by the ratio of the number of distinct output elements to the number of photons (quanta) acting as input on the layer; this ratio is called *responsive quantum efficiency* (Jones[5]); it only shows the overall responsive capacity of the layer but gives no information on the size of the smallest signal detectable in the presence of background noise or of radiation without information content. It is most important, however, to obtain knowledge about the minimum amount of energy required to produce a signal just sufficient to be detected. To this purpose first a criterion of the limit of detection is defined by the density difference just superior to the standard deviation of the density fluctuations in a 'uniform' image area, and the capacity of information detection is then determined by the *detective quantum efficiency* (Jones[5]). This is by definition the square of the ratio of the effective or measured signal-to-noise ratio to the signal-to-noise ratio of an ideal detector receiving the same signal input under identical conditions, especially of ambiant radiation.

The limits of sensitivity. Considered within the framework of information transfer, sensitometric speed is only a convenient parameter, but it is limited in its bearing. The true sensitivity of a photographic process is determined by its limiting capacity of recording and transferring information. It therefore depends, just as sensitometric sensitivity, first on the properties of the light-sensitive crystals, i.e. on their absorption capacity of photons or of quanta of invisible radiation, and on the quantum threshold determined by the number of photons which must be absorbed to make a crystal developable; but it also depends on detective quantum efficiency, i.e. on the smallest signal detectable above the quantum fluctuations of the incident radiation and the inherent noise of the system. Considered from this fundamental viewpoint limiting sensitivity is closely related to detail reproduction.

The notion of image quality. The subjective evaluation of image quality involves, in a somewhat arbitrary fashion, all physical properties of the 'image': tone and detail reproduction, sharpness and graininess. Experience shows that the assumptions determining the judgments of quality by the majority of observers are dictated by feelings rather than by rational reasoning. In spite of this not very precise definition, quality has however a direct influence on the information content of an image; its determination by objective evaluation appears therefore to be indispensable. It can be based on various criteria, but it must yield a satisfactory correlation with the subjective evaluation of the quality adequate for specific tasks. The determination of this correlation either relies on statistical evaluations of numerous observer judgments and the comparison of these results with those obtained

by objective methods of measurement (Stultz and Zweig;[6] Biedermann[7]), or
it is determined by the application of statistical decision theory (Roetling,
Trabka and Kinzly[8]). This latter has the advantage of evaluating quantita-
tively, according to the assigned purpose, the *detection* of details in an image,
i.e. the *type of decision* which may be based either on a binary choice or on the
selection of one criterion out of many.

 The detection of image shapes. Besides the sheer detection of the presence
of a signal, it is also necessary to gain on the one hand knowledge about its
information content, and on the other hand to remove all unimportant
information from the first rough recording. The detection of almost in-
distinguishable shapes in an image recorded at the limit of the sensitivity of
the system is related to the visibility of the boundaries of adjacent areas
(Vetter and Pizer[9]). The discontinuity stems from the separate photon impacts
which form a quantum limited image, built up of light points corresponding
to the impacts within a uniform background without information content.
When analysing this quantized recording the observer reestablishes in his
mind an image with continuous transitions. In order to extract from the
image pertinent information, i.e. the shapes of the objects, he scans it visually
in the search of bounded areas and assumes the presence of delimitations by
his perception of just visible luminance differences, perceived by visual
statistical exploration of adjacent image areas. The *extraction of image
shapes* by the removal from a recording of all surplus information content
can be carried out by photographic methods, such as for instance the matched
filter method. A reference standard shape is first chosen, and then all locations
in the rough recording containing it are determined; the cross-correlation
function of the two images is then derived and the presence of the required
shape is considered to occur wherever this function has a maximum. Usually
only peaks exceeding the noise level are considered as significant (Hawkins[10]).

4.1 THE PHOTOGRAPHIC MEDIUM AS
CARRIER OF INFORMATION

 The purpose of information theory is the quantitative determination of the
probability of the presence of a signal in the reproduction (the output),
relative to the dispatched frequency of the message (the input); in other
terms this is the computational comparison of the information content of
the original and the reproduced data. Essentially statistical, the notion of
information applies in electronics to telecommunications and serves in
photography to evaluate the significant 'image' content (see also p. 299).
On the one hand the advantage of the application of information theory to the
photographic system is due to the quantized nature of the message, composed

of impacts of photons or quanta of invisible radiation, and on the other hand to the heterogeneity of the classical sensitive layers which, being at the origin of their granularity, is considered in this context as 'noise'. Analogies with statistical thermodynamics can also be found in this theory.

4.1.1 The Information Capacity of a Photographic System

In the classical photographic system each silver halide crystal, acting as elementary radiation receptor, can only be, after exposure and development, in one of two distinct states: either it is reduced, or it remains unmodified and is then eliminated during fixation.† Considered as binary receptor it is therefore either in a state called 1 or in another state called 0; according to the number x of crystals composing the system there are consequently 2, 4, 8, 16, ..., 2^x information carrying elements (Figure 4.1). The transmitted number of binary digits or bits is therefore an appropriate measure of the information capacity of the 'image' (see above, p. 299). For the computation of this capacity the surface of the image is subdivided into n elementary areas of equal size, each of which capable of reaching one of m distinct and equally

Figure 4.1. Influence of the number of elements on the recording capacity of a binary receptor.

† For other light-sensitive systems it is necessary to apply a similar reasoning, adapted however to each particular case: for a light-sensitive polymer, for instance, the unit element is the either still soluble or the insolubilized polymer molecule.

probable density levels. The 'image' is then defined by a given combination of the m states of the n elementary areas, and the number of possible images is $N = m^n$; the proof of this relationship is obtained by observing that addition of any one new element to the n elements already present multiplies the number of possible images by m, because each new element can add m new distinct states to those existing, $N(n + 1) = mN(n)$. By recurrence this yields effectively $N = m^n$.

Hartley[1] and Shannon[2] defined the corresponding information capacity by the logarithmic relationship

$$H = n \log m. \tag{4.1}$$

The information capacity thus increases with the possible number of 'images'; this number, or any monotonic function of it, can therefore be used as a measure, and the apparently arbitrary choice of the logarithmic function has on the one hand the advantage of corresponding to intuitive evaluations, and on the other hand of simplifying the operations. Simultaneous inspection of two 'images' for instance, which intuitively appear only to double the capacity, yields indeed N^2 possible images, $2H(N) = H(N^2)$; the logarithmic function $H = n \log m$ satisfies this condition and further leads, with logarithms of base 2, directly to the binary units of bits per square centimetre. It is however important to stress again that this simple relationship only corresponds to the case of m equally probable states. For n independent receptors with m nonequally probable states, of probabilities $p_1, p_2, p_3, \ldots, p_i$, the information capacity is

$$H = k \sum_{i=1}^{n} p_i \log p_i, \tag{4.2}$$

where the constant k is determined according to the choice of the unit of measurement. This quantity H, named by Shannon the entropy of the set of probabilities p_i vanishes when the outcome of the transmission of information is entirely certain, i.e. when all p_i but one vanish, and reaches its maximum value when all p_i are identical and therefore equal to $1/n$, which intuitively corresponds to the situation of the highest uncertainty.

Treated according to Fellgett and Linfoot[11] by the application of harmonic analysis (see p. 160), the information capacity of the photographic system can also be expressed in another way. Let us suppose that the frequency of the incident signals, which in the photographic case constitute the exposure $E_0(x, y)$ of the sensitive layer in the x–y plane, is normally distributed in the statistical sense, i.e. that it is Gaussian; as in the chapter on image structure we call the Fourier transform $A^{\#}(v_x, v_y)$ and the modulation transfer function of the sensitive layer $\rho(v_x, v_y)$, and the granularity of the layer is given by its power spectrum $\Phi(v_x, v_y)$ (see pp. 166, 184). As defined by Fellgett and Linfoot

the information capacity then is

$$H = \frac{1}{2} \int_{\bar{N}} \int \log_2 \left[1 + \frac{|\rho(v_x, v_y)|^2 |A^{\#}(v_x, v_y)|^2}{\Phi(v_x, v_y)} \right] dv_x \, dv_y, \tag{4.3}$$

where \bar{N} is the frequency domain in which $\rho(v_x, v_y) \neq 0$, i.e. the transmitted frequency band. The numerator of the fraction is the power spectrum Φ_{image} of the transmitted message, i.e. the density distribution in the image,

$$\Phi_{image}(v_x, v_y) = |\rho(v_x, v_y)|^2 |A^{\#}(v_x, v_y)|^2. \tag{4.4}$$

Substituting this yields

$$H \text{ (in bits/cm}^2) = \frac{1}{2} \int_{\bar{N}} \int \log_2 \left[1 + \frac{\Phi_{image}(v_x, v_y)}{\Phi_{grain}(v_x, v_y)} \right] dv_x \, dv_y. \tag{4.5}$$

Now the expression within parentheses is the ratio of the transmitted signal $(\Phi_{image} + \Phi_{grain})$ to the noise Φ_{grain}, and equation (4.5) therefore describes the functional relationship between the information capacity and the signal-to-noise ratio.

This treatment of information capacity however requires the very strict observation of three conditions: firstly, the frequency distribution of the input signals must be Gaussian, as was assumed above; secondly, all phases of the operation of information transfer must be linear; and the noise level must finally be statistically independent of the signal level. The first condition can be satisfied by the appropriate choice of the input, i.e. the exposure conditions (see also p. 299). The linearity of response, however, is observed by the photographic material only at very low contrast; Fellgett's and Linfoot's equations therefore apply only to this case, even in their application to the general case of optical images. The third condition, finally, is contrary to the behaviour of the photographic layers as their granularity varies in non-linear fashion with density. Equation (4.5) is however useful; yielding the information capacity as a function of the input signal power, i.e. of the exposure level, it makes it possible to determine the maximum level of information capacity and consequently to make an optimal choice of the input, i.e. of the exposure.

As photographic layers are in general isotropic, their information capacity H can advantageously be expressed as a function of one variable only. Shaw[12] showed that the introduction of one line spread function only (see p. 148), yields

$$H = \pi \int_0^{v_0} \log_2 \left[1 + \frac{|\rho(v)|^2 |A^{\#}(v)|^2}{\Phi(v)} \right] v \, dv, \tag{4.6}$$

where $v = \sqrt{(v_x^2 + v_y^2)}$, and the expression within parentheses is again the signal-to-noise ratio.

4.1.2 Detection Capacity

Considered as an information detector the photographic material can be assessed by the energy required for the production of a detectable signal; Zweig, Higgins and MacAdam[13] proposed to consider in this sense as real and detectable any density increase Δd, within an area a, greater than the standard deviation $\sigma_a(d)$ of the statistical density fluctuations due to granularity. The choice of this criterion is a logical consequence of Jones' definition of the perfect detector,[5] supposed to give rise to an observable phenomenon at each photon impact. If M is the number of photons per unit area incident upon the detector from a first radiator, and that due to another source of radiation and hitting the same area of the sensitive layer differs from the first by ΔM, the input signal becomes detectable when the difference ΔM is at least equal to the standard deviation $\sigma(M)$ of the random fluctuation of the incident photons. $\sigma(M)$ being the noise accompanying the message, this difference ΔM^* is called the *noise equivalent signal*.

The detection capacity of a photographic layer is thus determined by taking into account the increase by ΔM^* of the number of incident photons required to increase the density d due to the impacts of M photons by one standard deviation $\sigma_a(d)$. Multiplied by the area a this increase yields the *noise equivalent energy* $a\Delta M^*$, and the inverse value

$$S_{\text{detection}} = \frac{1}{a\Delta M^*} \tag{4.7}$$

is a measure of the *detection sensitivity* of the layer.

This definition makes it possible to demonstrate the close relationship between detection capacity and the ratio of the sensitometric speed to the granularity of a photographic material. The gradient g of its density–exposure relationship $d = f(M)$ plotted against a linear exposure scale (Figure 4.2), $g = \Delta d/\Delta M$, has for the noise equivalent signal the value $g^* = \sigma_a(d)/\Delta M^*$; substitution, and introduction of the Selwyn relationship granularity, $\mathcal{G} = \sigma_a(d)\sqrt{a}$ (see p. 125), yields $S_{\text{detection}} = g^*/\mathcal{G}\sqrt{a}$.[13] Expressing further the gradient g by the sensitometric contrast and speed,

$$g = \frac{dd}{d\mathbf{E}} = \frac{dd}{d \log \mathbf{E}} \frac{d \log \mathbf{E}}{d\mathbf{E}} = k\gamma S, \tag{4.8}$$

this then yields the measure of the detection capacity of the layer (Jones' figure of merit),

$$S_{\text{detection}} \sqrt{a} = k\gamma \frac{S}{\mathcal{G}}. \tag{4.9}$$

This development by Zweig, Higgins and MacAdam[13] shows that the detection capacity depends for each value of γ directly on the *speed–granularity*

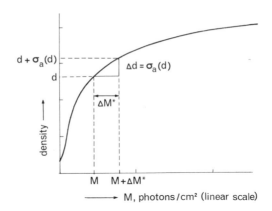

Figure 4.2. Sensitometric response of a photographic layer relative to a linear exposure scale expressed in photons incident per square centimetre.

ratio. This again confirms the importance of this ratio, one of the intrinsic characteristics of the photographic materials; the recent progresses of their speed increase without any quality loss result indeed mainly from its successive improvement (see also in the chapter on detail reproduction, p. 119, etc., the relationships between granularity, resolving power and sharpness).

Equation (4.9) further demonstrates that the capacity of information detection depends to equal extents on the *area a* of the detail to be detected, on the *granularity* \mathscr{G} which determines the value of the standard deviation $\sigma_a(d)$ and consequently that of the minimum density step Δd, and on the *sensitometric contrast* γ which affects both other parameters. Indeed, the greater the density difference between a detail and its surround, the easier it can be distinguished, and the recorded amount of information per unit surface also increases with diminishing detail area a.

The uncertainty of the detection of a detail depends on the one hand on its visibility, i.e. on the luminance difference threshold, and on the other hand on the random fluctuations of density in a uniform area which forbids us from asserting the presence of a signal when the density difference between the detail and the background is smaller than a limiting value which depends on the size of the former. It is therefore necessary first to determine this smallest discernible visible density difference and then the minimum size of a detail still yielding transmission of a signal. The value of the smallest density step which depends on the granularity is expressed, within an elementary cell of area a, by the number k of standard deviations of density; to avoid any influence of their variation with the density level it is advantageous to choose as a unit the average standard deviation $\bar{\sigma}_a(d)$. The number m of steps available for the recording of information within the density scale DS of the

photographic material is then

$$m = \frac{DS}{2k\bar{\sigma}_a} + 1. \tag{4.10}$$

After replacement of $\bar{\sigma}_a$ according to the Selwyn relationship $\mathscr{G} = \bar{\sigma}_a \sqrt{a}$, this yields

$$m = \frac{DS}{2k\mathscr{G}}\sqrt{a} + 1. \tag{4.11}$$

As shown by Altman and Zweig,[14] this expression can be introduced in the Hartley–Shannon relationship (4.1), $H = n \log m$ (see p. 303); n being the number of elementary cells of area a per unit surface, $n = 1/a$, the approximate value of recorded information is then given by the expression

$$H_{\text{approximate}} = \frac{\log_2 a}{2a} + \text{const}; \tag{4.12}$$

the information capacity therefore increases with decreasing area because the logarithm varies more slowly than its argument.

To make information recording possible, at least two luminance levels must at the limit be discernible. The logical conclusion would therefore appear to be that the greatest possible density of information packing per unit surface would result from the reduction of the elementary cell area to the size of one single silver halide crystal, i.e. to the detail in one of only two states of density level, and therefore yielding binary recording. The spread function of the layer (see p. 148) constitutes however a limit to this size reduction because no detail can be reproduced that is smaller than the diameter of the spread function. On the other hand, the size of the area a of the elementary cell can be computed for a given value of k from equation (4.11), with $m = 2$ for the case of binary recording. Altman and Zweig thus obtained values of an area slightly smaller than the corresponding spread function area; this fact should make it possible to still increase the amount of recorded information by using not only two but several density levels.

The maximum recording capacity in bits per square centimetre, determined from this data, is given in Table 4.1 for several films; it is based on density steps of $\pm 10\sigma$, i.e. $k = 10$. If normal distribution of the density readings were assumed, smaller values of k could have been employed according to the permissible error rate, such as for instance $k = 3$ or $k = 5$; but for density readings by image scanning the statistical distribution is unknown and may not necessarily be normal; $k = 10$ therefore appeared to be the most appropriate value.

The comparatively small differences of the maximum recording capacities by either binary or multidensity recording make preferable the former

TABLE 4.1

Film	Binary recording Maximum capacity (cells/cm^2 \times 10^6)	Separation, $\pm 10\sigma$ Available density levels	Maximum capacity (bits/cm^2 \times 10^6)
Kodak fine grain cine positive	0·11	8	0·33
Kodak Royal-X Pan	0·14	2	0·14
Kodak Plus-X Pan	0·21	3	0·33
Kodak Panatomic-X	0·44	3	0·70
Recordak Micro-file Type 5454	0·64	6	1·60
Kodak high resolution Type 649	160	2	160

whenever the maximum number of details per unit area is required, mainly for practical reasons: the greater overall density difference of a binary system increases the certitude of differentiation, and the eventual subsequent reproduction of the initial recording is also easier. The theoretical advantage of the binary recording of minimum size detail was also shown by Levi.[15]

Information transfer by the photographic system can also be considered from the viewpoint of image transmission, and it must then act, through the density scale of the photographic material, on the transfer of several luminance levels. This transfer, which depends on the number of density steps determined by the detail size, was investigated by Langner; Figure 4.3 shows an example of the increase of the number of the discernible density steps m, as a function of varying detail area a as well as of increasing exposure level. The numbers m of steps were determined by Langner with a modified Goldberg crossed wedge test object (Reference 72 of Chapter 1). This carries

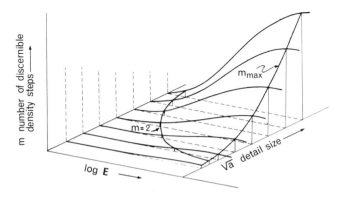

Figure 4.3. Perceived numbers m of density levels depending on exposure and on the area a of the information transmitting elements.

a square matrix of small 'details', represented by round areas of diameters chosen according to the specific problem investigated, with densities gradually increasing from top to bottom, and lying on a step-wedge type background which varies by the same density increments from right to left (Figure 4.4).

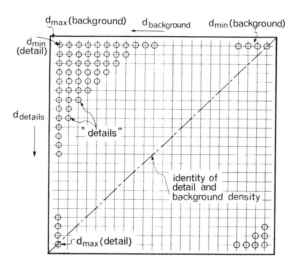

Figure 4.4. Test object for the determination of the number m of discernible density levels.

In one of the two diagonals each detail has thus the density of its background; after exposure on the material to be evaluated and development of the test, the number of steps are determined on the test film above this diagonal in which other 'details' are also identical with the background. This yields for any given detail area a the number m of steps as a function of exposure (Figure 4.5).

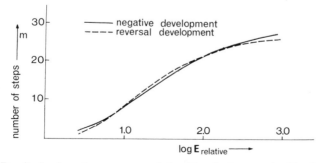

Figure 4.5. Density level number–exposure relationship of a fast negative film for 'detail'-size corresponding to a 24 × 36 mm camera.

4.1.3 Quantum Efficiency

As mentioned before, the yield of a photographic system considered as information carrier depends essentially on the signal-to-noise ratio; this latter therefore constitutes the basis of the definition of a criterion characteristic of the system, the *detective quantum efficiency*.† According to Jones[5] this is the measure of the signal detection efficiency of a real detector in the presence of a continuous flux of ambiant energy, relative to the detection capacity of a perfect detector.

In the classical photographic system the notation of quantum efficiency depends on two parameters: the chance distribution of the photon impacts and the discontinuous structure of the transmitted signals. According to its definition given above, on page 305, and to Jones' detection criterion, the perfect detector transmits a signal when it is at least equal to the standard deviation of the statistical variations of the photon flux; the photon incidence occurs randomly in time according to a Poisson distribution, and a signal of M photons per unit area hitting an area a of the perfect detector is therefore transmitted when it is at least equal to $\sigma(aM)$ or $(aM)^{\frac{1}{2}}$. In a real detector, on the contrary, only a fraction q of the incident photons give rise to observable output events.

The reasons for this difference between the real photographic and the perfect detector were discussed by Zweig.[17] Contrary to the perfect photographic detector, which would only require one single incident photon to make a silver halide crystal developable, the real detector has a lower yield for one or several of the following reasons: (i) the crystals fill the available space only partially and a part of the incident flux is lost; (ii) the crystals do not absorb the total incident flux striking them; (iii) more than one photon is required to make a crystal developable.

The imperfect quantum yield of a photographic layer is in general due to the simultaneous presence of all three of these reasons; the difficulty of distinguishing them by experiment, and the ambiguity of the meaning of the fraction q of use of the incident photons, therefore oblige us to resort to another development.

4.1.3a *Definitions of Quantum Efficiency*

Quantum efficiency is a dimensionless pure ratio; two different forms of this ratio are employed in photography: the first is directly derived from Jones' fundamental definition and gives quantum efficiency in terms of the incident energy and the noise accompanying the input signal, i.e. the number of photons composing the signal, as well as their standard deviation. The

† The origin of this name is historical; introduced by Rose[3] for the description of *quantum yield*, i.e. of the ratio of the number of incident photons to that of the reproduced signals, it has at present the different sense described in this section.

second form on the contrary, while still containing a term characteristic of the signal, is based on the properties of the particular photographic material and especially on the ratio of the sensitometric contrast to the granularity of the material.

For the real detector the noise equivalent energy $a\Delta M^*$ constitutes in the area a the smallest detectable increment (see above, p. 305) of a uniform incidence of M photons per square centimetre;[13] the ratio of this increment to the uniform flux is $a\Delta M^*/aM$, or $\Delta M^*/M$. For the perfect detector the corresponding ratio is $(aM_p)^{\frac{1}{2}}/aM_p$, or $1/(aM_p)^{\frac{1}{2}}$, where M_p is the number of photons per unit surface of the perfect detector yielding the same uncertainty of detection as the real detector investigated. The comparison of these two ratios yields according to Zweig[17] directly an expression for quantum efficiency of the first form, because it gives the number of photons detectable by the real detector relative to that number for the perfect one, i.e.

$$\Delta M^*/M = 1/(aM_p)^{\frac{1}{2}}, \quad \text{or} \tag{4.13}$$

$$\eta^2 = M_p/M = aM/(a\Delta M^*)^2.\dagger \tag{4.14}$$

For the purpose of adaptation of equation (4.14) to the photographic system Zweig replaces the area a by the number N of silver halide crystals within the area of the signal to be transmitted, a fraction of which was made developable by the incidence of λ photons per crystal. The noise equivalent signals for the photographic layer is then $N\Delta\lambda$ and the corresponding signal which could be detected by a hypothetical layer having the properties of a perfect detector is $(N\lambda)^{\frac{1}{2}}$. The increment detectivity η, equal by definition to the ratio of these two detectable increments of the number of incident photons, is

$$\eta = \frac{(N\lambda)^{\frac{1}{2}}}{N\Delta\lambda} = \frac{\lambda^{\frac{1}{2}}}{N^{\frac{1}{2}}\Delta\lambda}, \tag{4.15}$$

and the definition of *detective quantum efficiency* then is

$$DQE = \eta^2 = \lambda/[N(\Delta\lambda)^2]. \tag{4.16}$$

This also is an expression of the first form, taking in account however the nature of the photographic receptor. It is different from the corresponding expression derived by Jones[5] for photographic materials by adaptation of his fundamental equation.

This basic expression describes quantum efficiency, according to its definition, by the ratio of the squares of the signal-to-noise ratios of a perfect

† A similar value, also derived from the notion of equivalence between the smallest detectable signal and the standard deviation of the quantisized random incidence of energy, i.e. the noise, was named by Linfoot 'noise equivalent quantum efficiency'.[18]

and a real detector,

$$DQE = \frac{(\text{signal/noise})^2_{\text{measured}}}{(\text{signal/noise})^2_{\text{maximum}}}. \qquad (4.17)$$

Both of these quotients are output ratios, that of the numerator characteristic of the response of the real detector, and that of the denominator equal to the maximum possible response attributed to the hypothetical perfect detector. Their introduction in the form of their squares is explained by Jones by the need to make equation (4.17) compatible with the definition of quantum yield ('responsive quantum efficiency', see p. 300) whenever simultaneous use of both criterions is required.

The application by Jones of this basic concept of detective quantum efficiency to photographic layers transforms the defining equation (4.17) into an equation of the second form. The noise determining the smallest detectable signal appears in it in the form of the granularity at the density level corresponding to the uniform ambient exposure, and the signal is represented by the energy of photons of appropriate wavelength. After substitution the expression for detective quantum efficiency then is

$$DQE = \varepsilon U_a \frac{g^2}{a\sigma_a^2(d)}, \qquad (4.18)$$

where ε is the energy of a photon, $\varepsilon = 4{\cdot}6180 \times 10^{-12}$ erg at 430 nm, U_a the exposure in ergs incident on the area a, g the gradient of the exposure density relationship, and $\sigma_a(d)$ the standard deviation of the density fluctuations measured with a scanning area a. The application of this equation by Jones to a few films yields the curves of Figure 4.6.†

Comparison of the various aspects of the notion of quantum efficiency demonstrates that its definition can be derived identically by reasonings inherent to statistics, to electronics or to photographic technology (Zweig[19]). Independently of the kind of the derivation it finally always results in the same definition based on the fundamental phenomenon, the ratio of the transmitted signal to the overall noise composed of the random fluctuations of the incident energy as well as of the discontinuous structure of the means of transmission. There is thus no specific need to base this definition on the perfect detector; in a more realistic sense it rather derives from the comparison of the final output signal with the input, and therefore takes the form

$$Q = \frac{(\text{signal/noise})^2_{\text{output}}}{(\text{signal/noise})^2_{\text{input}}}. \qquad (4.19)$$

† These curves are given as an example; they are representative only of the behaviour of the films mentioned at the time the experiments were carried out. However, it must be recognized that the characteristics of products of the same name may vary within manufacturing tolerance at any given time and may change significantly from time to time.

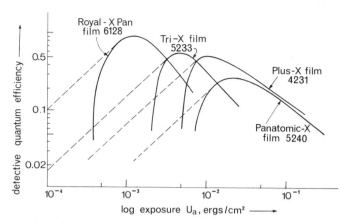

Figure 4.6. Examples of detective quantum efficiencies, according to Jones' definition, of several black-and-white films.

This approach is at the basis of the expression for the quantum efficiency of the photographic system developed by Shaw;[20] it leads to an equation of the second form equivalent to Jones' equation (4.18).

Similarly, as in the relationship of a perfect and a real photographic detector described above, the standard deviation $\sigma(aM)$ or noise of an input signal aM of M photons per unit surface, incident on the area a of a photographic layer according to a Poisson distribution, is equal to $(aM)^{\frac{1}{2}}$. The square of the average input signal-to-noise ratio is therefore

$$\bar{R}^2_{\text{input}} = [aM/(aM)^{\frac{1}{2}}]^2 = aM. \tag{4.20}$$

After low contrast development the result of this exposure \mathbf{E}_a, the image of the signal, has a mean density level \bar{d}_a; its contrast is

$$\gamma = \frac{dd_a}{d \log \mathbf{E}_a}, \tag{4.21}$$

and the relation between exposure and density is therefore

$$dd_a = 0.434 \frac{d\mathbf{E}_a}{\mathbf{E}_a}. \tag{4.22}$$

The standard deviation $\sigma(d_a)$ of the density variations resulting from granularity, measured with a scanning aperture of area a, constitutes the noise of the image of the signal; the output signal-to-noise ratio is therefore

$$\bar{R}^2_{\text{output}} = \left(\frac{\mathbf{E}_a}{d\mathbf{E}_a}\right)^2 = 0.188 \frac{\gamma^2}{\sigma^2(d_a)}. \tag{4.23}$$

Substitution of these two signal-to-noise ratios into equation (4.19) yields the *equivalent quantum efficiency* (expression chosen by Shaw by extension of that given by Linfoot, but otherwise equivalent to that derived by Jones)

$$EQE(\equiv DQE) = \frac{\overline{R}^2_{\text{output}}}{\overline{R}^2_{\text{input}}} = 0.188\frac{\gamma^2}{aM\sigma^2(d_a)}, \qquad (4.24)$$

and by substituting Selwyn granularity $\mathscr{G} = \sigma(d_a)\sqrt{a}$, for the standard deviation of density $\sigma(d_a)$,

$$DQE = 0.188\frac{\gamma^2}{M\mathscr{G}^2}. \qquad (4.25)$$

This macroscopic definition applies only when the granularity \mathscr{G} is determined with a sufficiently large scanning area a, eliminating the microscopic density fluctuations. To make it also valid for very small scanning areas, Shaw generalized it by applying harmonic analysis to his concept of equivalent quantum efficiency; this allowed him to express the information capacity of the photographic detector by its equivalent quantum efficiency and the ratio of the power spectrums of the signal and of the fluctuations of the incident photons.[12]

Equation (4.25), typical of the second form of detective quantum efficiency, makes it possible to discuss its intrinsic sense. The input signal, given by the number M of photons incident per unit area of the detector, corresponds by definition to the smallest detectable energy; appearing in the denominator it can be considered as the equivalent of a photographic speed value. *Detective quantum efficiency therefore yields a characteristic relationship between the three essential parameters of a photographic layer, which are its speed, its contrast and its granularity.* It essentially depends on the ratio of the latter two, the contrast and the granularity, and attains its optimal value at the coincidence of the relatively highest sensitometric gradient with the lowest granularity value.

4.1.3b *Practical Applications*

The notion of detective quantum efficiency can be applied to the determination of optimum working conditions for the photographic recording of very weak signals, as for instance in stellar photography or in spectroscopy.

In limiting cases, when the output signal is almost hidden by noise (Figure 4.7), two methods can be employed to yield the best result of which the photographic system under consideration is capable: either the use of a less sensitive material of low granularity requiring longer exposure than the material of maximum sensitivity, or a weak uniform pre-exposure. The domains of efficiency of these two methods were investigated by Branscomb[21]

Figure 4.7. Faint signal within noisy background.

and by Marchant;[22] whenever it is possible to increase exposure time the first method remains by far the most efficient; uniform pre-exposure however can also serve to improve detail detectability by increased contrast-to-granularity ratio. The following numerical example, given by Marchant, shows the relative advantages of both methods.

The photons due to the radiation of the signal reach the sensitive layer with a frequency of $M_s = 5\cdot3$ photons/μ^2/sec. together with a background noise of $M_b = 5\cdot0$ photons μ^2/sec, and act on an area $a = 5$ mm$^2 = 5 \times 10^6$ μ^2. The signal-to-noise ratio of the input signal is then, according to equation (4.20), with an exposure time of one second,

$$(\text{signal/noise})_{\text{input}} = (M_s/M_b - 1)(aM_bt)^{\frac{1}{2}}$$

$$= (5\cdot3/5 - 1)(5 \times 10^6 \times 5 \times 1)^{\frac{1}{2}} = 300:1.$$

According to equation (4.19)

$$(\text{signal/noise})_{\text{output}} = DQE^{\frac{1}{2}} (\text{signal/noise})_{\text{input}}, \tag{4.26}$$

and by substituting the quantum efficiency figure of Kodak Tri-X film for the energy level of the input signal as determined by Marchant, and the above computed figure of the signal-to-noise ratio of the input, we obtain

$$(\text{signal/noise})_{\text{output}} = 300 \times 0\cdot0141 = 4\cdot26:1,$$

a figure much too low to insure reliable detection. As it is obviously not possible to modify the incident signal, the only alternative remains an appropriate exposure time increase; this yields, as shown by the curves for Tri-X film in Figure 4.8, an increase of the output signal-to-noise ratio by about ten times. If on the other hand the equipment and the actual working conditions allow us to increase the exposure time still more, the use of a slower film can further improve the appearance of the signal (as shown by the dashed curves). Finally, a uniform pre-exposure also still allows us to double the output signal-to-noise ratio.

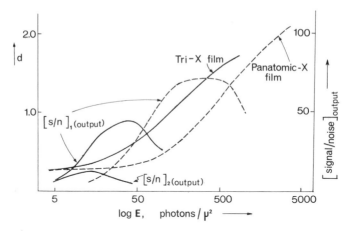

Figure 4.8. Comparison of the sensitometric characteristics and of the output signal-to-noise ratios of Kodak Tri-X film (solid curves) and of Kodak Panatomic-X film (dashed curves).

Application of these results to the detection of faint stellar objects was described by Marchant and Millikan.[23] Their substitution of numerical values in equation (4.26) includes the following elements:

(i) Exposure of a star of magnitude 23·7 on a Kodak spectroscopic Type 103a-0 plate during 30 sec. at the prime focus of a 200-in. telescope.

(ii) Quantum efficiency of this plate for a density level of from 0·6 to 0·9: $DQE = 0.005$.

(iii) An output signal-to-noise ratio of 5:1, just sufficient to still distinguish faint details on the 103a-0 plate.

These conditions yield as input data:

$$(\text{signal/noise})_{\text{input}} = (\text{signal/noise})_{\text{output}}/DQE^{\frac{1}{2}} = 5/0.005^{\frac{1}{2}} = 70:1.$$

To be detectable a star must therefore show a signal-to-noise ratio against the night sky of at least 70:1, independently of its magnitude.

A method for improving detectivity in stellar photography by a reduction of background noise was proposed by Davies.[48] In this system the information from a number of identical negatives is combined by successive partial exposure, in perfect register, through each of them. The effect on graininess is then similar to that in motion-picture projection, and the resulting average noise has much lower amplitude than that contributed by one single negative exposed over the sum of the fractional exposure times. The net result is an increase of the signal-to-noise ratio, increasing detectivity continuously with total exposure, i.e. with the number of negatives.

Another interesting application of quantum detectivity is the evaluation of the advantage of very low-contrast development, applied to the detection of almost indiscernable signals by Shepp and Kammerer.[24] This application of quantum detectivity shows that the important criterion for the comparison of detectivities resulting from various developers is the ratio of the sensitometric contrast to the granularity; called 'relative detectivity', this function of exposure is defined by the relationship

$$D_{\text{relative}} = \gamma/\sigma_a(d) = k\sqrt{DQE}, \tag{4.27}$$

where $\sigma_a(d)$, the standard deviation of the density fluctuations at the density level d, expresses the granularity for a constant scanning area a. Figure 4.9 shows the application of this criterion to the comparison of the low-contrast developer formulated by Shepp and Kammerer with the energetic Kodak D-19 developer. With a sufficiently high exposure level the value of the relative detectivity $\gamma/\sigma_a(d)$ can be up to ten times higher for the low contrast than for D-19 developer.

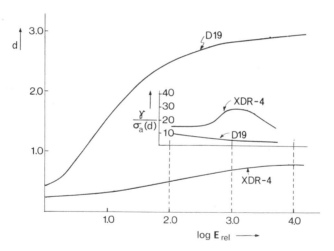

Figure 4.9. Relative sensitometric responses and detectivities obtained with low-contrast developer XDR-4 and with Kodak D-19 developer, respectively.

4.2 THE LIMITS OF SENSITIVITY
OF PHOTOGRAPHIC SYSTEMS

From what precedes it is obvious that the detection capacity of a photographic system is measured by the smallest energy yielding a detectable output signal; to obtain a knowledge of the system's limit of sensitivity it is

therefore necessary to determine on the one hand the minimum number of photons required for making a silver halide crystal developable, and to measure on the other hand the detection sensitivity of the system, equal to the reciprocal of the noise equivalent energy (see p. 305), on which depends the differentiation of the reproduced signal from its noisy surround.

An estimate of the average number of photons required per crystal was obtained by Zweig, Higgins and MacAdam,[13] for the practical case of a high-speed negative film, by expressing its sensitometric characteristic by the image-exposure relationship of the number of crystals developed as a function of the number of photons incident per unit surface (Figure 4.10).

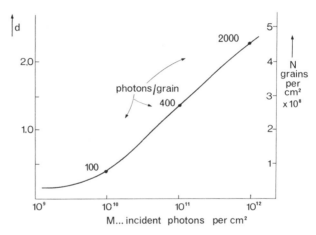

Figure 4.10. Sensitometric response of a photographic layer, expressed in silver halide crystals per square centimetre as a function of the logarithm of photons incident per square centimetre.

The transformation of the customary sensitometric variables was carried out by replacing optical density by substitution according to Silberstein's and Trivelli's approximation,[25] $d = 0.434 \, \alpha N/A$, where α, the projective area of a developed crystal, was taken equal to one μ^2 and the unit surface A equal to one square centimetre, and by expressing the exposure in photons per square centimetre, taking into account the energy $h\nu$ of one photon, with h Planck's constant and ν the frequency of the exposing radiation. This representation of the overall response of a photographic material yields a good approximation of the number of photons required to make one crystal developable: it amounts to about a hundred photons per crystal at the toe of the sensitometric response of the negative film. This rather high figure, due to the absorption of the radiation within the layer, gives a valid average

for the crystals of a thick layer but does not correspond to the limiting sensitivity of the most sensitive ones.

This latter, the quantum sensitivity of the individual crystals, was experimentally determined by Farnell and Chanter[26] and computed from their results by Marriage.[27] According to the emulsion type the sensitivity of the crystals of a given size class can vary by a factor of a hundred, but the crystals

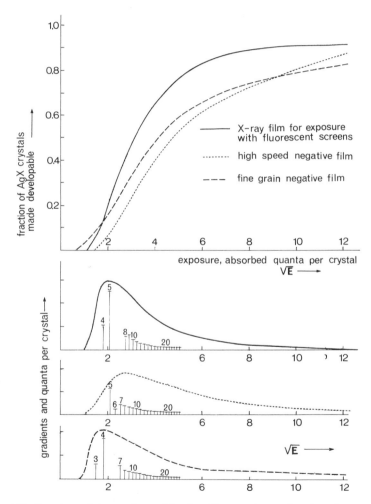

Figure 4.11. Fractions of the numbers of developable crystals as a function of exposure. The curves at the bottom show the gradients, and the tops of the vertical straight lines the average number of quanta per crystal as computed by Marriage.

of the different size classes of one single emulsion show rather uniform sensitivity. On the other hand, sensitivity is spread within large limits and the number of quanta required to make a crystal developable can vary considerably within one size class; while from three to five quanta per crystal are required to make one tenth of the crystals of a given layer developable, ten to twenty-five quanta per crystal are required to act on one half of the crystals of a given size. To develop all of the crystals of a given size class the exposure necessary is from ten to a hundred times greater than that yielding a just perceptible fraction of developed crystals. The statistical analysis of this result by Marriage yields the results shown in Figure 4.11; these results demonstrate that the incidence of *four quanta per crystal* is sufficient to initiate the development of one fifth of the most sensitive crystals of a high-speed emulsion.

The minimum number of four quanta per crystal was also confirmed by the investigation by Frieser and Klein[28] and by Klein[29] of the influence of the limiting sensitivity on the theory of the sensitometric response. The examination of the sensitivity threshold of a highly sensitive photographic layer shows that it should be possible to obtain a further speed gain by improving the absorption of the incident energy, as most sensitive layers only absorb about one half of the radiation which makes them developable. The resulting speed gain would however only be slight: an increase of the quantum sensitivity from four quanta to one quantum only per crystal, impossible to attain in practice, would only yield a speed gain of from four to ten times. Klein's discussion of the possibilities of speed increase further shows that only two approaches could be explored: either an increase of the crystal sizes with the purpose of increasing their absorption (expressed in numbers of photons), or an increase of the overall absorption within the layer for the taking in of a maximum of the incident energy. As also underlined by Klein and by Frieser[30] these two solutions however lead to a loss of image structure and therefore of information content, the first by the inevitably resulting granularity increase, i.e. the higher output noise, and the second by the resulting loss of definition. Neither does an increase of crystal size yield a sensitivity gain proportional to the crystal area exposed to the incident photons; two or more competing latent images then form in the large crystals and lead to inefficient use of the exposing energy. These conclusions on the sensitivity limits of photographic systems were also confirmed by the researches of Volke and Elssner.[31]

The importance of image structure for the evaluation of maximum sensitivity also appears in the definition of a *figure of merit* for photosensitive systems given by Rose.[3] Based on the appreciation of sensitivity according to the system's quantum yield, this figure is proportional to the reciprocal of the total light flux required to produce an image of specified signal-to-noise ratio and resolution in a given exposure time.

Limiting sensitivity is finally closely related to the detection sensitivity given by equation (4.9), $S_{\text{detection}} = 0.434\gamma/\mathcal{G}\sqrt{a\mathbf{E}}$ (see p. 305). Supersensitizing by additional uniform exposures carried out by Guttmann[47] similar to those described by Marchant (see p. 316), show indeed that sensitivity gains obtained by this technique depend on the granularity level resulting from the sensitizing exposure. That this exposure really raises the sensitivity of the system is demonstrated by the example of Figure 4.12.

Figure 4.12. Supersensitizing by additional uniform exposure increases the signal-to-noise ratio: the faint signal is visible above noise (right column) with less image exposure than without a uniform flash (left column).

4.3 THE EVALUATION OF IMAGE QUALITY

In the preceeding sections it was shown that the image in its most elementary form is determined by the noise equivalent signal. Taken in its general aspect, however, it is composed of a very great number of elementary signals of widely dispersed values and the conformity of the reproduction with the 'scene' or the original subject is judged by the property named *image quality*. This is a criterion which can be defined in various ways, ranging from the purely psychological to the purely physical viewpoint; it is necessary, on the other hand, that it corresponds effectively to the specific purpose of the reproduction to which it is to apply.

The difficulty of the determination of a single parameter characteristic of image quality results from the diversity of its aspects; it depends simultaneously on tone reproduction, on granularity, on sharpness and on resolving

power. For the subjective evaluation of quality, only defined by observer preference for one image relative to another, the observers are requested to make a choice according to well-defined criterions, and their answers are then evaluated by statistical methods. In a typical example of an investigation of this kind sharpness and graininess were about equally weighted in the judgments of *picture quality*, but the evaluation of *definition* yielded high correlation with sharpness and only low correlation with graininess (Stultz and Zweig[6]). In another study, evaluation of *image quality* led the observers rather to judge details covering large areas of the prints and therefore related to tone reproduction, while the appreciation of *sharpness* concentrated on very small details, effectively rather significant for resolving power (Biedermann[7]). These two examples demonstrate the rather arbitrary nature of purely subjective evaluations of image quality, even if carried out by a great number of observers and processed statistically.

To avoid this difficulty it has frequently been proposed to express image quality by one single measurable parameter, capable of yielding satisfactory correlation with subjective evaluations. Resolving power is a typical example of such a parameter; in spite of its inadequacy as an exclusive quality criterion it is still frequently employed for the evaluation of reproduction quality (see p. 141). Many other 'figures of merit' were proposed, some based on the modulation transfer functions of the systems employed and others taking into account signal-to-noise ratios or information content.

An expression designed to serve as a quality criterion by the determination of a resolution limit of a sinusoidal object luminance distribution was derived by Selwyn.[32] It involves the sensitometric contrast γ, the modulation transfer function $\rho(v)$ and the granularity \mathcal{G} of the light-sensitive material, and yields, with the magnification so adjusted that the image viewed by the eye always has the same size as the last resolved chart element, the sinusoidal resolution

$$v_R = \frac{\gamma \Delta E_0 \rho(v)}{k \mathcal{G}},\qquad(4.28)$$

where E_0 is the contrast of the periodic sinusoidal object pattern and k a constant. Selwyn's condition for the visibility of the sinusoidal line pattern is therefore

$$\gamma \Delta E_0 \rho(v) = k \mathcal{G} v_R.\qquad(4.29)$$

This is typically an image quality criterion which takes into account the parameters of the image structure of the material considered but however is based on its modulation transfer function.

The *G* quality criterion developed by Biedermann[7] is another example of a unique parameter intended for the overall evaluation of photographic

quality; it was designed for the appreciation of the quality of images frequently encountered in daily life, and is defined by the equation

$$G = c_1 + c_2 \log \int_0^\omega \rho(v)B(v)\,dv, \tag{4.30}$$

where c_1 and c_2 are constants, $\rho(v)$ the overall modulation transfer function of the photographic system, and $B(v)$ an 'evaluation function' (Bewertungs-funktion); this latter, similar to a modulation transfer function, accentuates its effect by a further reduction of the transfer of the high spatial frequencies. Determined by Biedermann for several standard image types from a very large number of judgments made by many observers, the function $B(v)$ and the constants c_1 and c_2 seem to vary appreciably with the type of subject, and especially according to the distribution of the spatial frequencies characterizing the subject and their importance for the final purpose of the image, i.e. with the image spectrum.

The relative merits of several other criterions based on harmonic analysis were analysed by Trott.[33] By analogy with the Strehl ratio of optics—the ratio of the intensity at the Gaussian image point to the intensity in a diffraction limited image—image quality could be evaluated by the normalized area under the curve of the modulation transfer function of the system, or still better by taking into account the quality limitation for the human observer resulting from the presence of noise, by the cross-hatched area of Figure 4.13, comprised between the modulation transfer function and the threshold contrast required for the visual perception of resolution. Other

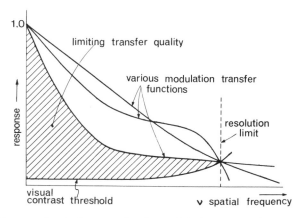

Figure 4.13. The cross-hatched area under the modulation transfer function, limited at the bottom by the contrast threshold of visual resolution perception, is one of the proposed criterions of image-quality perception.

image quality criterions could be Schade's 'equivalent passband',[34] defined by the equation

$$N_e = \int_0^\infty \int_0^\infty |\rho(\omega_x, \omega_y)|^2 \, d\omega_x \, d\omega_y, \tag{4.31}$$

where $\rho(\omega_x, \omega_y)$ is the optical transfer function of the system, or, according to a proposal by Shaw,[35] the relative information capacity, derived from equation (4.6),

$$H = \pi \int_0^{v_0} \log_2 \left(1 + 0.188 \frac{\gamma^2 \rho^2(v) |A^\#(v)|^2}{\Phi(v)} \right) v \, dv \text{ bits/unit surface.} \tag{4.32}$$

The evaluation by Trott of these criterions relative to resolving power classes them as follows:

Resolving power. Defined by a limiting spatial frequency based on visual perception it only corresponds to one single restrictive use of a complex system designed for many uses.

Area under the modulation transfer function. This criterion only yields a summary evaluation corresponding to a mean spatial frequency bandwidth without taking into account the relative transfers of the various frequencies. When the area is limited by the visual threshold contrast boundary, however, it takes into account the effect of granularity on detail perception (Figure 4.13).

Equivalent passband. It weighs the higher spatial frequencies of the transfer function more heavily and therefore constitutes a compromise between resolving power and the area under the modulation transfer function; Biedermann's G criterion shows a similar behaviour and differs from the equivalent passband only by its possibility of adaptation to the various uses of the photographic systems by the appropriate choice of the evaluation function $B(v)$.

Relative information capacity. This criterion takes in account both the quality performance limiting effects of the system's noise and the effects of modulation transfer, by the evaluation of the bandwidths.

This discussion shows that among the parameters available each has specific advantages or drawbacks; any of these quality criterions, however, can simultaneously cover several uses of photographic systems and the judgment of image quality must therefore be obtained by agreement among several appropriate criterions rather than from a single figure.

It is also possible, finally, to consider the determination of image quality by an entirely different approach, based on *statistical decision theory.*

The subjective methods employed as ultimate standard can in fact be freed of their arbitrary nature by better specifying the tasks of the observers. Without assuming that this approach would allow us to account entirely for their complex judgment by a simple linear theory, it can be shown that the application of decision theory leads to criterions of image quality at least as valid as those based on *ad hoc* assumptions (Roetling, Trabka and Kinzly[8]).

For the application of this theory the quality determinations based on more or less arbitrary judgments are replaced by the choice between two concrete and opposed cases. For determining, for instance, whether a periodic line pattern is resolved or not, the observer only decides about the presence of one of two subjects, a sinewave fluctuation of luminance on a uniform background or the background alone. The first corresponds to a state $O_1(x, y) = 1 + C \sin^2 \pi v_R x$, where v_R is the spatial frequency at the resolution limit, and the second to a state $O_2(x, y) = 1$; the differential signal of the two objects of this alternative then is $\Delta(x, y) = C \sin 2\pi v_R x$, with $x < L$ and $y < L$ in order to limit the image to the height and width L of the field of view.

The quality prediction is based on an equation derived from the output signal-to-noise ratio of a linear filter (Harris[36]). Applied to the two-dimensional case this performance criterion P is

$$P = \frac{1}{\Phi(v_x, v_y)} \int_{-\infty}^{\infty} \int_{-\infty}^{\infty} |\rho(v_x, v_y)|^2 |S_\Delta(v_x, v_y)|^2 \, dv_x \, dv_y, \qquad (4.33)$$

where Φ is the noise power spectrum, ρ the modulation transfer function of the system, and S_Δ the spectrum of the difference of the two objects whose choice is to be decided. Substitution into equation (4.33) of this transform,

$$S_\Delta(v_x, v_y) = \gamma L^2 C \left(\frac{\sin \left[(v_x - v_R)\pi L \right]}{(v_x - v_R)\pi L} + \frac{\sin \left[(v_x + v_R)\pi L \right]}{(v_x + v_R)\pi L} \right) \frac{\sin v_y \pi L}{v_y \pi L}, \quad (4.34)$$

and integration after some simplification yields

$$P = \frac{k \gamma^2 L^2 C^2}{\mathscr{G}^2} \rho^2(v_R, 0). \qquad (4.35)$$

Applications to this image quality criterion of the same condition for the sinusoidal pattern frequency as that applied to Selwyn's visibility criterion, equation (4.29), then leads to an expression of the same form, but containing instead of an empirical constant one derived from the decision criterion for the presence or absence of a resolved or unresolved line pattern,

$$\gamma C \rho(v_R) = (P/k)^{\frac{1}{2}} \mathscr{G} v_R. \qquad (4.36)$$

Decision theory thus yields an objective image quality criterion, compatible, however, with the results of intuitive evaluations.

This theory also gives access to a criterion for object detectability; without being able to determine its shape, the observer simply decides, just as in the previous case, whether an object is present in his field of view, or whether this field is uniform. A typical example of this detectability problem is that of one-dimensional objects such as roads or railroads seen from high altitude. In this case the difference spectrum is

$$S_\Delta(v_x, v_y) = \text{const } \delta(v_y),\tag{4.37}$$

where the delta function $\delta(v_y)$ represents a narrow frequency band near $v_y = 0$. According to equation (4.33) the criterion of detectability performance is therefore

$$P_{\text{detectability}} \cong \frac{1}{\Phi(v_x)} \int_{-\infty}^{\infty} |\rho(v_x)|^2 \, dv_x = \frac{2N_e}{\Phi(v_x)},\tag{4.38}$$

i.e. an expression containing Schade's equivalent passband (see above, p. 324) and the noise power spectrum of the system. This confirms the equivalence of the relative importance of sharpness and therefore of acutance, on the one hand, and of graininess on the other hand, for the detection of very small objects.

4.4 THE IMPROVEMENT OF INFORMATION TRANSFER BY IMAGE PROCESSING

In principle an image should have a one-to-one correspondence with the object space which it represents. This exact correspondence is however disturbed, in general, by the presence during recording of one or several degradation mechanisms, and the purpose of the image processing techniques is to correct or to compensate for the resulting information loss. These techniques only form a part of the wide domain of optical data processing and concern in the present context only the case of an image explicitly recorded with the purpose of determining objects present in the field of view: the principal purpose of the processing of an illegible image in view of its restoration is therefore to make it intelligible to the observer. The gain achieved by the processing of a degraded image can be determined by comparing the information which it is possible to extract from it by the human visual system prior to and after its processing.[37]

A degraded image can be described by the convolution integral

$$L_{\text{input}}(x, y) = \int_{-\infty}^{\infty} \int_{-\infty}^{\infty} L(x - \xi, y - \eta)A(\xi, \eta) \, d\xi \, d\eta,\tag{4.39}$$

where L is the luminance distribution of the perfect image, i.e. of that obtained without degradation, as a function of the two coordinates of the image plane, $A(\xi, \eta)$ is the total input point spread function, and L_{input} the effective

luminance distribution in the image.† In the simple case in which the image spectrum is not band-limited and the degradation is of the linear homogeneous type, i.e. one having an invariant point spread function over the whole image area, the purpose of the image processing operation is according to Harris[37] the solution of equation (4.39) for L when L_{input} and A are known. This operation is carried out by the use of the corresponding Fourier transforms,

$$[L_{input}(x, y)]^{\#} = [L(x, y)]^{\#}[A(x, y)]^{\#}, \qquad (4.40)$$

and

$$[L(x, y)]^{\#} = [A(x, y)]^{\#}/[L_{input}(x, y)]^{\#}, \qquad (4.41)$$

and the solution $L(x, y)$ is obtained by taking the inverse transform; in this operation the transform of the input point spread function A is obviously the overall input modulation transfer function ρ_{input}, characteristic of the sum of the initial degrading mechanisms.

Image processing is carried out by appropriate digital manipulation, in a computer, of the optical densities of all elements of the degraded image, determined by scanning either with an appropriately equipped densitometer or with a cathode-ray oscilloscope; the densities of the steps of the corresponding sensitometric scale are also recorded. The computer first forms a positive by taking into account the sensitometric characteristic of the negative, and then carries out the corrective processing. This may consist of a two-dimensional digital filtration compensating for the high-frequency losses which would lead to the degradation of fine detail, or in other modifications of the image spectrum contributing to an improvement of the image. The result of this operation, made visible on the cathode-ray tube screen, yields the processed and improved image. Computer image processing makes it possible to apply to degraded images any appropriate digital sequence; traditionally linear in the non-digital corrections such as those using spatial filtration by stops or masks, image processing therefore enters the field of optimization; it is possible, for instance, as pointed out by Frieden,[38] to chose as criterion for the best correction of an image that the error

$$\varepsilon_j \equiv \langle |\vartheta_j - \bar{\vartheta}_j|^K \rangle \qquad (4.42)$$

be a minimum, where ϑ_j is the unknown spectrum of the perfect image at the frequency ω_j and $\bar{\vartheta}_j$ its optimal restoration; the brackets $\langle \ \rangle$ indicate the average of all possible fluctuations of the physical parameters contributing to the formation of the image, and K is any positive power. Image corrections obtained with equations satisfying these criterions are indeed better than those resulting from linear processing.

† The index 'input' was used by Harris because it is this image which constitutes the input to the processing operation.

A method which allows us to carry out digital corrections in the spatial domain instead of in the frequency domain, abstract to the human visual system, is that developed by MacAdam.[39] This method of *constrained deconvolution*, based on the fundamental identity between the operations of vector convolution and polynomial multiplication, makes it possible to deconvolute noise degraded images of incoherently illuminated objects. Specific chosen image elements are treated like points of a Euclidian n-space, and linear constraints are defined for the convolution relation and the bounds of the recorded luminances and their spread functions. This yields a convex region of possible restorations in n-space which allows the observer to readjust the original constraints for a further improvement of the already processed image information, thus enabling him to introduce at his choice arbitrary limits for important image elements and to make them respected in the restoration step; this makes it possible to introduce statistical data in the corrections whose application is difficult in the frequency domain. MacAdam's method also allows us to solve problems when the spread function is unknown or time variable, important in practice but not easily accessible to the classical methods of spatial filtration.

The principal problem of the corrective methods involving digital processing is due to the great amount of data to handle; in spite of the speed of the electronic computers and in spite of sophisticated programming the requirements of data recording and processing can lead to excessive computer times. According to equation (4.1) a transmission channel must treat from six to seven bits (about 100 distinct density levels) of luminance information for about 80 million elements of an 8×10 in. image, i.e. more than 500 million bits. One of the methods proposed to solve this problem is that of the *source coding of image information* by Bartleson and Witzel.[40] This is the elimination, the distortion or the rearrangement of the initial information with the purpose of the exclusive processing of visually significant information only and the ultimate optimal presentation of the output data. This simplification necessarily leads to some degradation of image quality, but by the judicious choice of the data retained for transmission from a corrected image visual information otherwise inaccessible can be extracted.

The practical results of digital image processing are spectacular; the images of Figures 4.14, 4.15 and 4.16 by Billingsley[41] show some examples of possible image corrections. In Figure 4.14, showing a tumor in an arm, all low frequencies transmitting continuous tone information were eliminated: the processed image therefore only contains the line-pattern of the required information. Figure 4.15 shows the application of a programme of geometric rectification; not only the parallelism of the vertical and horizontal lines of the building is restored but also its proportions, a result which would not have been possible by image correction during exposure such as rising the

Figure 4.14. Improved visibility of the outlines on a medical radiograph by removal of all low frequencies. Furnished through the courtesy of the Jet Propulsion Laboratory, California Institute of Technology.

Figure 4.15. Geometrical correction by digital image processing. Furnished through the courtesy of the Jet Propulsion Laboratory, California Institute of Technology.

Figure 4.16. Improvement of detail visibility by correction of local overexposure. Furnished through the courtesy of the Jet Propulsion Laboratory, California Institute of Technology.

camera front or tilting the lens and the camera back. The partial elimination of the low frequencies finally allows us to compensate for the effect of strong back lighting; Figure 4.16 shows this compensation of a local over-exposure on a lunar photograph of Surveyor III. Similar corrective methods were also employed for the improvement of colour differentiation by Billingsley, Goetz and Lindsley,[42] particularly for increased saturation of the recorded colours.

Digital image processing was applied by Harris[37] to the elimination of degradation due to linear image motion during exposure, and by Mc

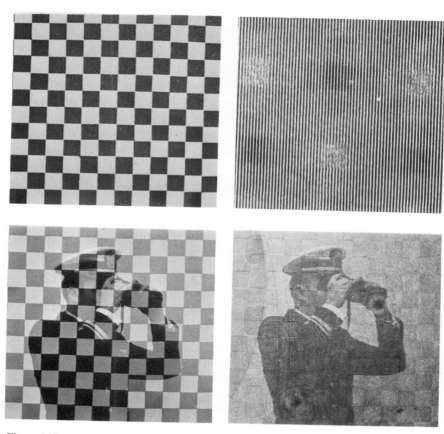

Figure 4.17. *Top left:* Checkerboard noise pattern. *Top right:* Magnified portion of Fresnel side-band hologram of checkerboard pattern. *Bottom left:* Noise pattern superimposed by double exposure on image containing pertinent information. *Bottom right:* Output image showing scene restored by holographic subtraction. (Courtesy K. Bromley, M. A. Monahan, J. F. Bryant, B. J. Thompson, Naval Electronics Laboratory Center, San Diego, California, and Institute of Optics, University of Rochester, Rochester, New York.)

Glamery[49] to the restoration of images degraded by heat generated turbulence of the air between the subject and the image forming lens. In both cases image processing lead in the corrected images to a clear and distinct representation of the initial information, entirely illegible on the original recordings.

Still more impressive results are those obtained by *holographic subtraction*, a purely optical non-digital technique. Image processing, as mentioned before, is one of the techniques of optical data processing and can therefore be carried out, for instance, by complex spatial filtering;[43] this filtration, however, can only be applied when the signal is known, while the noise may be arbitrary. When on the contrary it is desired to detect an arbitrary two-dimensional signal in the presence of stationary noise, holographic subtraction can be applied. This technique, related to the elimination of the conjugated image of a hologram, to the comparison of images by conventional interferometry and to other methods of holographic subtraction, was adapted to the processing of transparencies of superimposed images by Bromley, Monahan, Bryant and Thompson.[44]

In conventional holography with linear recording an arbitrary light wave is first recorded and then made use of for generating an exact reproduction of the initial wave field, in amplitude as well as in relative phase distribution. The method of holographic subtraction employs a filter, capable of canceling the initial wave field, for the determination of the difference of two wave fields identical except for small local amplitude differences; in our case these wave fields are real equiphase images of the light transmitted by two transparencies, an image of a scene and another of a supplementary superimposed information. Figure 4.17 shows this kind of combination and the elements of the corresponding subtraction, with an almost perfect restoration of the photograph containing the pertinent information by the elimination of the superimposed checkerboard noise pattern.

4.5 THE RECOGNITION OF IMAGE SHAPES

The visual extraction of information contained in an image is based on the distribution of luminances which it presents to the observer, and especially on the luminance differences which define the outlines and show the shapes of the scene elements. As mentioned before, the photographic image is however of discontinuous structure. Composed of 'grains', each of which results from impacts of photons or of quanta of invisible radiation, it is a *quantum-limited image*[9] and therefore raises problems for the visibility of the limits and shapes as soon as sufficiently high magnification makes the individual 'grains' or 'dots' which form the image elements visible to the observer (see also Figure 2.1, p. 120). The perception of such quantum-limited images is therefore based on a statistical analysis carried out by the

mechanisms of the visual system which form the image in the eye and interpret it in the brain. By repeated scanning of the supposed limit at right angles the observer inspects adjacent areas of different dot densities per unit surface and then attempts to infer from this inspection the perception of a luminance difference or the presence of the outline of a shape. Various parameters of dot distribution in the image plane could control this operation, such as the number of dots per unit surface, the average distance of each dot from its nearest neighbour, or the distribution of the areas occupied by the dots and the background. Vetter and Pizer[9] showed that the second parameter, the statistical distribution of the distances between the dots of a quantum-limited image, yields the best correlation with the visual evaluation of the boundaries of areas of different optical densities. The human visual system seems indeed to evaluate quantum-limited images rather in function of their texture than by a blurring and fusion of the dots and the judgment of averages of luminance differences.

In many applications, such as in radiography, in photogrammetry or in photo-interpretation, complex shapes in the image must be rapidly recognized and correctly interpreted. The accuracy and efficiency of this operation obliges us to have it performed by skilled operators specialized by long training and experience. The steadily increasing number of these evaluations and their growing difficulty however compel us to also use automatic methods, all the more as the fatigue of attention easily gives rise to errors of judgment. *Automatic pattern recognition* can be carried out either by digital methods with electronic computers or by photographic or optical methods. All these systems are based on the inspection of the raw input data and yield output data identifying and if necessary classifying those recorded in the original image.

The example of a system of pattern recognition using a computer was described by Centner and Hietanen.[45] An electro-optical transducer first converts the image data into electrical impulses; a pre-processing unit then extracts from these data parametric properties adapted to the introduction in a decision logic network, and this latter yields the output data, indicating for instance the presence or the absence of specific objects, a classification of the environment (terrain, classification, etc.), or the presence of geometric shapes or lines (outlines, roads, shorelines, etc.). The training of this system is carried out like that of a human interpreter: by repeated presentation of simple images of given classifications, followed by the necessary corrections, a memory is established which then insures a high yield of correct decisions. The essential elements of the system are the pre-processing unit and the decision logic network. The development of the first is carried out either by parameter evaluation or by that of the degree of parameter interdependence; this latter can go as far as redundancy and then may lead to retaining only

one of the parameters. The decision logic network can be developed either by progressive adaptation or by statistical adjustments. In general the former requires a longer training time, but statistical adjustments can lead to problems of data storage and computer speed.

The photographic techniques for extracting image shapes, based on the use of masks, are part of the optical methods for the determination of the cross-correlation function between an image and a standard reference shape; the theory of this photographic technique was described by Hawkins.[10] A transparency $f(x, y)$, receiving uniform illumination E, is projected through a mask of transmittence $g(x, y)$ and yields in the α–β plane the requested extraction

$$h(\alpha, \beta) = E \int \int f(x, y)g(x + \alpha, y + \beta)\, dx\, dy. \tag{4.43}$$

Figure 4.18 illustrates this scheme for the example of two objects to be extracted from the original image.

Figure 4.18. Optical formation of standard correlation function.

The visibility of a border defining the perception of an object can be expressed by the relationship

$$f(x, y) - f(x + \Delta x, y + \Delta y) > 0, \tag{4.44}$$

i.e. by the condition that

$$|df/dx| + |df/dy| > 0, \tag{4.45}$$

but it is often more advantageous to chose as criterion for an outline the second derivative of the luminance transition,

$$\nabla^2 f = d^2f/dx^2 + d^2f/dy^2 > 0, \tag{4.46}$$

because it always defines the limiting point of luminance transition, independent of its direction.

According to the kind of problem to resolve, various mask functions $g(\alpha, \beta)$ can be employed; when they require negative transmittancies, as for instance when $g(\alpha, \beta)$ is the diffraction function $\sin r/r$, with $r^2 = x^2 + y^2$, the mask may be a combination of a negative and of a positive image and then requires the use of two separate masks (Figure 4.19).

Figure 4.19. Optical-photographic two-stage image processing system. The dashed line shows schematically optical or material transfer of the positive $f(+)$ to the position where it is processed together with $f(-)$ by $g_2(+)$.

Mask designs can have various shapes, ranging from the straight line between adjacent rectangles or circular patterns to the shapes of specific subjects, such as for instance those of particular aircraft or others. Photographic determination of cross-correlation in one single step, as shown schematically in Figure 4.18, is highly sensitive to the angular orientation of the object to be determined relative to the mask, and also to the noise in the limiting zone between the shape to be extracted and its surround. Multistage processing, which consists of a preliminary treatment of important fractions of the image and the combination of the corresponding partial results, is less sensitive to these effects but more complex.

The advantage of automatic pattern-recognition methods is their inherent capacity for the simultaneous determination of the cross-correlation function in two dimensions contrarily to that obtained serially in the time domain on computers. Other advantages of the optical method are that it requires less bandwidth, accepts a lower signal-to-noise ratio, and simplifies computations. For these reasons an optical system with laser illumination was employed by Krulikoski and Kowalski[46] for automatic optical terrain profiling in photogrammetric work, based on the optical determination of

Fourier transforms (see also p. 186) and on holographic recording and spatial filtration techniques described by Van der Lugt.[43] In the specific case of the solution of photogrammetric problems the Fourier transform of one of the stereo photographs is first recorded and then cross-correlated in the Fourier plane with the transform of the second stereo photograph; the correlation signal is obtained by the inverse transform of the product of the two first transforms.

Krulikoski and Kowalski showed further that this optical system, capable of simultaneously processing independent variables and of carrying out two-dimensional computations, can also be applied to multi-channel parallel one-dimensional processing i.e. to the use of one dimension for the selection and identification of a certain number of data in the initial image on the one hand, and of the second dimension for the parallel and simultaneous processing of all these data, on the other hand. An optical processing unit designed by the authors according to this principle automatically computes and traces terrain profiles and carries out other automatic photogrammetric computations.[46]

REFERENCES

1 Hartley, R. V. L., Transmission of information. *Bell System Techn. Jl.*, **7** (1928), 535.

2 Shannon, C. E., A mathematical theory of communication. *Bell System Techn. Jl.*, **27** (1948), 379, 623.

3 Rose, A., A unified approach to the performance of photographic film, television pick-up tubes, and the human eye. *Jl. Soc. Mot. Pict. Eng.*, **47** (1946), 273.

4 Jones, R. C., Information capacity of radiation detectors. *Jl. Opt. Soc. Am.*, **50** (1960), 1166. Information capacity of photographic films. *Jl. Opt. Soc. Am.*, **51** (1961), 1159.

5 Jones, R. C., On the quantum efficiency of photographic negatives. *Phot. Sci. Eng.*, **2** (1958), 57.

6 Stultz, K. F., and Zweig, H. J., Roles of sharpness and graininess in photographic quality and definition. *Jl. Opt. Soc. Am.*, **52** (1962), 45.

7 Biedermann, K., Ermittlung des Zusammenhanges zwischen der subjektiven Güte und den physikalischen Eigenschaften des photographischen Bildes. *Phot. Korr.*, **103** (1967), 5, 25, 41.

8 Roetling, P. G., Trabka, E. A., and Kinzly, R. E., Theoretical prediction of image quality. *Jl. Opt. Soc. Am.*, **58** (1968), 342.

9 Vetter, H. G., and Pizer, S. M., Perception of quantum-limited images. *Photogrammetric Eng.*, **36** (1970), 1179.

10 Hawkins, J. K., Photographic techniques for extracting image shapes. *Phot. Sci. Eng.*, **8** (1964), 329.

11 Fellgett, P. B., and Linfoot, E. H., On the assessment of optical images. *Phil. Trans. Roy. Soc. London*, **A.247** (1955), 369.

12 Shaw, R., Photon fluctuations, equivalent quantum efficiency and the information capacity of photographic images. *Jl. Phot. Sci.*, **11** (1963), 313.

13 Zweig, H. J., Higgins, G. C., and MacAdam, D. L., On the information-detecting capacity of photographic emulsions. *Jl. Opt. Soc. Am.*, **48** (1958), 926.

14 Altman, J. H., and Zweig, H. J., Effect of spread function on the storage of information on photographic emulsions. *Phot. Sci. Eng.*, **7** (1963), 173.
15 Levi, L., On the effect of granularity on dynamic range and information content of photographic recordings. *Jl. Opt. Soc. Am.*, **48** (1958), 9.
16 Langner, G., Zur Messung der Informationskapazität photographischer Schichten. *Phot. Korr.*, **102** (1966), 101.
17 Zweig, H. J., Theoretical considerations on the quantum efficiency of photographic detectors. *Jl. Opt. Soc. Am.*, **51** (1961), 310.
18 Linfoot, E. H., Equivalent quantum efficiency and the information content of photographic images. *Jl. Phot. Sci.*, **9** (1961), 188.
19 Zweig, H. J., Performance criteria for photodetector-concepts in evolution. *Phot. Sci. Eng.*, **8** (1964), 305.
20 Shaw, R., The equivalent quantum efficiency of the photographic process. *Jl. Phot. Sci.*, **11** (1963), 199.
21 Branscomb, L. M., Criteria for pre-exposure of spectroscopic plates. *Jl. Opt. Soc., Am.*, **41** (1951), 255.
22 Marchant, J. C., Exposure criteria for the photographic detection of threshold signals. *Jl. Opt. Soc. Am.*, **54** (1964), 798.
23 Marchant, J. C., and Millikan, A. G., Photographic detection of faint stellar objects. *Jl. Opt. Soc. Am.*, **55** (1965), 907.
24 Shepp, A., and Kammerer, W., Increased detectivity by low gamma processing. *Phot. Sci. Eng.*, **14** (1970), 363.
25 Silberstein, L., and Trivelli, A. P. H., Relations between the sensitometric and the size frequency characteristics of photographic emulsions. *Jl. Opt. Soc. Am.*, **28** (1938), 441.
26 Farnell, G. C., and Chanter, J. B., The quantum sensitivity of photographic emulsion grains. *Jl. Phot. Sci.*, **9** (1961), 73.
27 Marriage, A., How many quanta? *Jl. Phot. Sci.*, **9** (1961), 93.
28 Frieser, H., and Klein E., Contribution to the theory of the characteristic curve. *Phot. Sci. Eng.*, **4** (1960), 264.
29 Klein, E., The theoretical limits of photographic sensitivity. *Jl. Phot. Sci.*, **10** (1962), 26.
30 Frieser, H., Limits and possibilities of the photographic process. *Jl. Phot. Sci.*, **9** (1961), 379.
31 Volke, C., and Elssner, C., Theoretische und praktische Grenze der Lichtempfindlichkeit polydisperser Silberhalogenid-Gelatine-Emulsionen. *Z. Wiss. Phot.*, **64** (1970), 7.
32 Selwyn, E. W. H., Scientist's ways of thinking about definition. *Jl. Phot. Sci.*, **7** (1959), 138.
33 Trott, T., Sine wave testing and its practical implications. *Proceedings Soc. Photo.-Optical Instr. Eng. Geometric Optics*, El Paso, Texas, 1966.
34 Schade, O. H., Image gradation, graininess and sharpness in television and motion-picture systems. Part IV. *Jl. Soc. M.P.T.E.*, **64** (1955), 593.
35 Shaw, R., The application of Fourier techniques and information theory to the assessment of photographic image quality. *Phot. Sci. Eng.*, **6** (1962), 281.
36 Harris, J. L., Resolving power and decision theory. *Jl. Opt. Soc. Am.*, **54** (1964), 606.
37 Harris, J. L., Image evaluation and restoration. *Jl. Opt. Soc. Am.*, **56** (1966), 569.
38 Frieden, B. R., Optimum, nonlinear processing of noisy images. *Jl. Opt. Soc. Am.*, **58** (1968), 1272.

39 MacAdam, D. P., Digital image restoration by constrained deconvolution. *Jl. Opt. Soc. Am.*, **60** (1970), 1617.

40 Bartleson, C. J., and Witzel, R. F., Source coding and image information. *Phot. Sci. Eng.*, **11** (1967), 263.

41 Billingsley, F. C., Applications of digital image processing. *Applied Optics*, **9** (1970), 289.

42 Billingsley, F. C., Goetz, A. F. H., and Lindsley, J. N., Color differentiation by computer image processing. *Phot. Sci. Eng.*, **14** (1970), 28.

43 Van Der Lugt, A., Signal detection by complex spatial filtering. *I.E.E.E. Trans. Inf. Theory*, **IT.10** (1964), 139.

44 Bromley, K., Monahan, M. A., Bryant, J. F., and Thompson, B. J., Holographic subtraction. *Applied Optics*, **10** (1971), 174.

45 Centner, R. M., and Hietanen, E. D., Automatic pattern recognition. *Photogramm. Eng.*, **37** (1971), 177.

46 Krulikoski, S. J. jr., and Kowalski, D. C., Automatic optical profiling. *Photogramm. Eng.*, **37** (1971), 76.

47 Guttmann, A., Background-light sensitization of a fast emulsion. *Phot. Sci. Eng.*, **12** (1968), 146.

48 Davies, E. R., The efficiency of the photographic process. *Jl. Phot. Sci.*, **16** (1968), 217.

49 McGlamery, B. L., Restoration of turbulence-degraded images. *Jl. Opt. Soc. Am.*, **57** (1967), 293.

Part Two

The Mechanisms of the Classical Photographic Process

INTRODUCTION

As customarily considered, the notion of photography is inseparably related to the light sensitivity of the silver halides. While several non-silver processes exist and remain important for industrial applications, such as document copying or the manufacture of printed circuits, and while television and printed edition now occupy a position in manufactured pictorial representation comparative to that held by classical photography, this latter remains unequalled for its exceptional light sensitivity and its flexibility of use. These are obviously the reasons we see it also employed in other processes either as a starting point or as an intermediate link within non-photographic chains. A thorough knowledge of the mechanisms of the silver halide processes is therefore often not only useful but sometimes essential for the correct use of the photographic materials in professional, technical and scientific applications.

The Intrinsic Advantages of the Silver Halide Systems

The precise knowledge of the structure of a photographic silver halide layer and of its transformations during exposure and development reveals, as will be shown, a succession of events by which the formation of the latent image occurs with an exceptional economy of energy. It is this economy which leads to the known very high sensitivity to light and other electromagnetic radiation, the principal characteristic of the silver halide processes.

The judicious use made in these processes of infinitesimal energies results indeed from a highly logical succession of operations. At the start, during the manufacture of the emulsion which is to form the sensitive layer, electron traps are formed within the silver halide crystals by the introduction of

341

impurities into the crystal lattice and by the creation of lattice imperfections. During the subsequent exposure to light, certain electrons acquire through the impact of the photons onto the crystals the energy required to reach the conduction band: they can then move freely within the crystal lattice until their capture precisely on the initially prepared traps. The negative charges thus built up then attract positive silver ions from the crystal lattice and form, by neutralizing them, the minute and invisible silver deposit called latent image. Only elementary particles such as electrons and ions take part in this very small but lasting chemical modification of the crystals; their movements within the lattice, further to its structure, require only a minute amount of energy.

It is at this stage that the amplifying operation can occur, which takes full advantage of this still invisible first recording, by the delivery from outside of the bulk of energy required. To make the latent image visible the exposed photosensitive material is immersed in the developer, a reducing medium which in this context is nothing else than an enormous container of electrons: by facilitating the energy transfer from the developer to the crystals struck by light, the latent image catalyses their reduction and thus discriminates between those exposed and unexposed. This amplification of the effect created with a minute amount of energy by the radiation incident during exposure is then finally not only made use of for directly yielding black-and-white images, but also serves for the obtention of other effects, such as the differential hardening of gelatin or the formation of the dyes required for colour reproduction by trichrome synthesis.

Thanks to the results of numerous researchers the silver halide processes have now not only reached a very high degree of perfection, but also a level of light sensitivity far above that of all other light-sensitive processes. They therefore hold a unique place in photography, responsible for their practically exclusive use.

The Importance of Simple Working Hypotheses

The detailed study of all mechanisms intervening in the application of the various photographic processes shows their rather exceptional complexity. This study, a science in itself, steadily occupies a great number of research workers in highly specialized laboratories; its detailed knowledge is, however, of no use in the current application of the photographic processes, even when employed in quite particular applications. All that is required are simple working hypotheses, descriptive of the essential and well demonstrated aspects of the intrinsic mechanisms. Certain sequences in the following sections will thus appear oversimplified to experts: it is intentionally, however, that the description of the basic phenomena has been limited to their most concrete aspects, the only ones required for the correct use of the photographic materials.

5

Structure of the Photographic Material

Photographic materials are composed of a base and one or several sensitive layers. These latter, playing of course the essential role, must be carried by a transparent or reflecting material, capable of making the whole compound sufficiently strong to maintain all elements of the image or recording in their relative geometrical positions, while still being flexible and elastic enough to comply with their multiple uses.

The film base materials are practically impermeable to water, but the gelatin of the sensitive and other layers is very permeable and swells easily. Paper base, while more permeable than film supports, absorbs much less water than the gelatin layers. The film base being hydrophobic, its surface must be treated to insure satisfactory adherence of the emulsion or backing layers; to obtain this adhesion gelatin molecules are introduced into the base surface during its manufacture. The bulk of the gelatin then fixes solidly to the base.

The heterogeneity of the photographic materials compels us to observe precise working instructions quite generally, and particularly for those specific uses in which the metric properties of the recordings are important, but it makes it possible to incorporate into the design of the materials particularly advantageous properties.

5.1 THE SUPPORTS

According to their proposed use the materials of the supports are either transparent or opaque and reflecting. The first, originally made of glass, are now sheets or webs of flexible and glossy plastic materials of various

343

thicknesses; glass base is only employed for specific uses which require utmost size-holding precision. Reflecting supports are almost always made of paper, and more recently of paper made waterproof by thin layers of surface resin coats.

5.1.1 The Film Supports

The rapid progress of the manufacture of plastics has made several older support types disappear so that there now remain only the two big classes of cellulose esters and polyesters; each of these two types of materials has typical physical properties, more advantageous for certain applications than for others.

5.1.1a *Classes of Supports*

Cellulose esters. After an almost complete predominance since the beginning of the manufacture of photographic film, i.e. the beginning of the century, the cellulose ester bases are at present partly replaced by those made of synthetic polymers. Cellulose triacetate, satisfying however most of the numerous requirements towards a perfect film support (see p. 346), is still very widely employed; some films are still made on mixed ester cellulose bases such as cellulose acetate butyrate.[1]

The cellulose esters result from the reaction of one or several acids with the numerous hydroxyl groups of cellulose. The more complete the esterification, the better the properties of the resulting film support. The cellulose molecule (5.1) carries in fact three hydroxyl functions which must react with

$$
\left[
\begin{array}{c}
\text{structure (5.1)}
\end{array}
\right]
\qquad (5.1)
$$

the acid. In the case of acetic acid theoretical maximum acetylation is of the order of 44·7% but reaches in practice a maximum of only about 44%. The acetobutyrate ester, of better dimensional stability because of its lower absorption of humidity, contains about 29·5% acetyl and 17·5% butyryl.[2]

Polyesters. The relative water permeability of the cellulose esters was at the origin of the researches for a synthetic polymer substitute. This problem found its solution through the rapid development of the plastics industry,

which gave rise to the invention of polymers not only useful for the manu-
facture of synthetic textile fibres but also as film supports.

Polyethylene glycol terephthalate, discovered by Whinfield and Dickson[3]
is a condensation polymer resulting from the esterification of ethylene glycol
by terephthalic acid

$$n(HO-CH_2CH_2OH) + n(HOOC\langle\bigcirc\rangle COOH) \longrightarrow$$

$$\longrightarrow HO-CH_2CH_2O\left[\overset{O}{\underset{\parallel}{C}}\langle\bigcirc\rangle\overset{O}{\underset{\parallel}{C}}-O-CH_2CH_2O\right]_n H + 2nH_2O.$$

(5.2)

In practice it is manufactured by reacting dimethyl terephthalate with
ethylene glycol.[4]

The manufacture of polyethylene glycol terephthalate films, insoluble in
most of the common solvents, is entirely different from that of cellulose
ester film base. This is manufactured by casting a solution, called 'dope',
onto the perfectly polished surface of a big cylinder or onto a wide endless
metal belt running over two rollers, and by evaporating the solvents of the
dope. The terephthalate base, on the contrary, results from the extrusion of
melted material, a method also employed for the manufacture of synthetic
fibres. The thin curtain of base extruded through a slit falls first on a refriger-
ated surface, and the polymer molecules are then oriented in the film plane by
stretching the web in length and in width. These steps together with appro-
priate thermic treatments confer to the terephthalate supports all the
required mechanical and physical properties as well as satisfactory chemical
stability upon keeping; being free from residual solvents these base materials
exhibit very high mechanical resistance.

Polycarbonate, manufactured in Germany since 1957, results from the
reaction of diphenylol propane (bis-phenol A) with phosgene,[5]

$$n(HO-\langle\bigcirc\rangle\overset{CH_3}{\underset{CH_3}{\overset{\mid}{\underset{\mid}{C}}}}-\langle\bigcirc\rangle-OH) + n(Cl-\overset{O}{\underset{\parallel}{C}}-Cl) \longrightarrow$$

diphenylolpropane phosgene

(5.3)

$$\longrightarrow \left[-O-\overset{O}{\underset{\parallel}{C}}-O-\langle\bigcirc\rangle\overset{CH_3}{\underset{CH_3}{\overset{\mid}{\underset{\mid}{C}}}}\langle\bigcirc\rangle\right]_n + 2HCl.$$

polycarbonate

Contrarily to terephthalate, polycarbonate is soluble in methylene chloride and thus makes film base manufacture possible by the classical methods employed for cellulose ester supports.

5.1.1b *The Physical Properties of Film Supports*

The properties required for a photographic film support are impressive: it must not only be photographically inert, but it must also have a number of optical, mechanical, chemical and physicochemical properties. It must be: transparent, without any haze; free from optical defects (absence of inclusions, surface irregularities and inhomogeneities of refractive index); mechanically resistant, also against tear, and have a high value of Young's modulus; sufficiently stiff but still flexible; chemically stable during prolonged keeping; humidity resistant; of high melting point; dimensionally stable (i.e. of low water permeability, of low thermal expansion and free of anisotropy); and, finally, slow burning.

The modern cellulose ester and polyester supports assemble all these properties and are also designed to have in the final complex material of heterogeneous structure, the photographic film, the physical properties required by its use, such as satisfactory flatness before exposure and during all phases of its processing, and high dimensional stability. The physical properties of the cellulose triacetate bases were studied by Calhoun,[2] those of the terephthalate polyethylene glycol supports by Hudson[4] and by Amborski and Flierl,[6] and those of the polycarbonate supports by Streib[7] and Kahl.[8] Some numerical values of the most important properties of cellulose triacetate and polyethylene glycol terephthalate supports are given in Table 5.1. These two types of supports, i.e. cellulose triacetate and polyethylene terephthalate differ mainly in their humidity absorption, but also in their mechanical properties and especially show very different fold, tear and shear resistance.

5.1.1c *Dimensional Stability of Photographic Film*

It is obvious that the dimensions of a photographic film, depending on the simultaneous action of several parameters, vary according to the numerous conditions to which it is successively exposed. The main factors acting on its dimensional changes are the absorption or evaporation of water, the temperature, the effects of photographic processing, and those of prolonged keeping. Certain dimensional variations are reversible, such as elongation or shrinkage due to temperature changes or to uptake or release of humidity, but others lead to lasting size modifications. These permanent variations, most frequently shrinkages, are due for cellulose ester supports to the evaporation of residual solvent and more generally to the plastic flow of the base, further to the stress exerted by the contraction of the drying gelatin layers, to the successive

TABLE 5.1

Physical and optical properties	Cellulose triacetate	Polyethylene glycol terephthalate (Estar)	
Specific gravity	1·28	1·39	
Refractive index	1·48	1·64	
Percent water absorption; 24 hours in 70°F (21°C) water	5·5	0·5	
Swell in the same conditions	0·5–0·6	0·07	

Mechanical properties			Soft steel (for comparison)
Tensile strength at break, lbs/sq in	14,000	25,000	50,000–80,000
Elongation at break, %	35	110	25
Young's modulus, 10^5 lbs/sq in (stiffness)	5·5	6·5	255
M.I.T. folding endurance number	45	10,000	
Tear propagation strength; tear strength, grammes per millimetre of film thickness	50	170–300	

Thermal properties		
Coefficient of thermal expansion, 10^{-5} in/in/°F	3·0	1·0
Softening temperature, °F	300	325

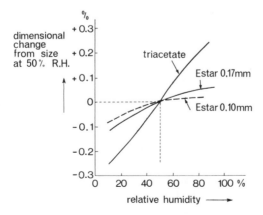

Figure 5.1. Reversible dimensional changes of a photomechanical process film.

release of internal mechanical strains created during base manufacture, and finally to the hysteresis of successive moistening and drying.

Humidity size changes. The size of a film increases by the absorption of humidity and diminishes through its elimination. In humid atmosphere, i.e. at high relative humidity, one therefore observes an elongation while dry atmosphere leads to shrinkage.† Figure 5.1 shows as a typical example size changes of a film employed for screened reproduction in photoengraving. These dimensional changes depend on the nature of the emulsion and backing layers, on their hardening and their relative thicknesses, but of course mainly on the type of film base; they are much smaller for films on polyester base, entirely impermeable, than for films on triacetate support. Between 15 and 50 % R.H. the humidity coefficients of the films of Figure 5.1 for 1 % of R.H. are:

Triacetate support	0·007 %
Estar support‡ 0·004 in.	0·003 %
Estar support‡ 0·007 in.	0·002 %

An important practical rule of thumb resulting from these properties is the following: whenever a specific use of a photographic material requires high dimensional stability, the record should be made use of in the same conditions of relative humidity and temperature as those prevailing during its exposure. The time necessary for the film to reach an equilibrium with the surrounding atmosphere is of the order of half an hour, but for extremely critical uses it might even be useful to attain the humidity and temperature equilibrium in the same sense for the exposure as well as for the subsequent use of the recording. The film size can indeed vary slightly when this state is approached either by increasing or by reducing the humidity contained in the film.

Thermal variations. These are obviously reversible, as mentioned before, and vary considerably with the base materials. Figure 5.2 gives the comparison of the thermal expansion of several materials, such as cellulose triacetate film, two polyester base films, glass, and Invar steel, a highly size-holding alloy employed in various size-measuring devices. Among the photographic films those on polyethylene glycol terephthalate base have the smallest coefficient of expansion, 0·001 % per degree F, equal to about one third of that of films on triacetate base.

Processing size changes. Successive immersions of a film in several aqueous solutions together with rather sharp pH changes, as customary in photographic processing, act on the various constituents of the film. They lead to

† The relative humidity of air (% R.H.) is the fraction of humidity contained in that atmosphere relative to the humidity content at saturation with water vapour at the given temperature.

‡ Polyethylene glycol terephthalate support.

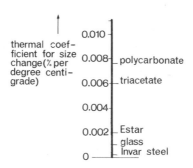

Figure 5.2. Thermal coefficients for size change of photographic films on various base materials compared with those for glass and Invar steel.

permanent dimensional changes, of rather small amplitude for films on polyester base, but non-negligible for those on cellulose ester support which during processing loose the major part of their residual solvent by replacement by the various aqueous solutions and then shrink during drying by the evaporation of the absorbed water.

The heterogeneous structure of photographic film leads to processing size changes by several phenomena. When dry, the gelatin layers are capable of exerting considerable compressive forces on the base, but these are entirely released by the swelling of the layer during its immersion in the processing solutions. According to its Young's modulus and the degree of the initial constraint, the base therefore increases during processing more or less in size, but retracts again in the course of the subsequent drying of the gelatin layers of the developed film, often without attaining again the original dimensions, even when the initial conditions of temperature and relative humidity are exactly restored.[9] For triacetate base films this mechanism adds to those connected to the spontaneous loss of residual solvent and to the slow relaxation upon keeping of tensions introduced during the manufacture of the base. The size holding of films on polyethylene glycol terephthalate base, which is practically impermeable and also does not contain any solvent, is however only influenced by the stresses due to the gelatin layers and the relaxation resulting from their swelling.

The major factors acting on the size variations of all films are the temperature and the relative humidity of the surrounding air before and after processing. But the effects occurring during processing add to these reversible temperature and humidity size changes and may thus lead either to a size increase or to a shrinkage. Table 5.2, established for a film on 0·10 mm polyethylene glycol terephthalate base, gives an example of such modifications of film size.

TABLE 5.2

Atmospheric conditions	1st case	2nd case	3rd case
During exposure	cold and wet (21°C 60% R.H.)	warm and dry (30°C 30% R.H.)	cold and dry (21°C 30% R.H.)
During registration of the processed films	warm and dry (32°C 30% R.H.)	normal (21°C 40% R.H.)	warm and wet (30°C 60% R.H.)
Percent size changes			
Due to processing	−0.02	−0.01	−0.01
Due to the thermal conditions	+0.02	−0.02	+0.02
Due to humidity changes	−0.08	+0.03	+0.08
Net percent size change	−0.08	0.00	+0.09

It is obvious that much higher variations would be encountered with an equivalent film on cellulose triacetate base. In the first case of the table the shrinkage would then be about twice as large (-0.15%) and in the third case it would be almost three times greater ($+0.25\%$).

The advantage of the great dimensional stability of films on polyethylene terephthalate base for use in photogrammetry has also been demonstrated by Harman.[10] When employed under conditions of current use these films show only about one fifth of the differential distortion of topographic mixed cellulose acetate base films and therefore improve the precision of survey work, particularly for convergent oblique aerial views.

The humidity and temperature of the air during drying also act on the dimensional stability of a film; this makes it possible to eliminate practically all processing size variations by an adequate choice of drying temperatures adapted to the humidity of the surrounding air. For films on ethylene glycol terephthalate base, as for instance employed for halftone and line work in photoengraving, these temperatures are given in Table 5.3.

Contrarily to the cellulose triacetate base films, those on polyethylene terephthalate support show a slight size increase at very low relative humidity,

TABLE 5.3

Relative humidity of the surrounding air, %	Optimum dryer temperature range for the elimination of processing size variations of films on polyethylene glycol terephthalate base, °F
30	70–75
40	75–85
50	90–100
60	105–110

i.e. by overdrying, and shrink slightly when dried at average relative humidity (Figure 5.3). This phenomenon is reversible and therefore also allows us to correct slight dimensional variations by repeated appropriate wetting and drying cycles.

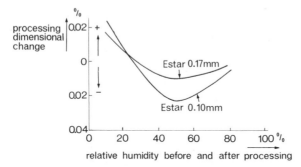

Figure 5.3. Processing dimensional changes of films on polyterephthalate base.

Aging shrinkage. One of the properties of cellulose triacetate base films to be taken in account, mainly when they are employed for professional motion-picture work, is their shrinkage during long periods of storage. This undesirable size change makes itself felt when an old negative is to be reprinted, and it can act on image steadiness on the screen as well as on photographic quality. To avoid it the base for negative motion-picture film is so manufactured that it shows only very low shrinkage upon keeping, and the perforation pitch of motion-picture negative film is slightly shorter, by 0·2%, than that of the corresponding positive films.[11] The processed negatives shrink mainly during the first year of keeping and then remain stable from the third year on.[12] The total shrinkage resulting from processing and keeping varies for these films between 0·12 and 0·24% of the initial dimension of the raw film (Figure 5.4).

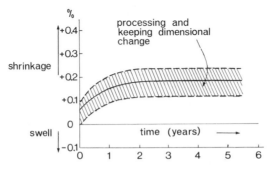

Figure 5.4. Aging shrinkage of a negative motion-picture film on triacetate base.

Films on polyterephthalate base practically do not show any keeping size change. After very long storage at low relative humidity they may exhibit slight shrinkage, but this remains negligible for most practical applications.

5.1.2 Glass as Support for Sensitive Layers

Glass, one of the oldest photographic base materials, while having been entirely replaced for all current uses by plastic base materials, is still employed in specialized techniques which on the one hand require exceptional physical properties, but which leave on the other hand its higher weight and its fragility acceptable. Thanks to its dimensional stability, never equalled by any other base material, it is employed in applications where the photographic recording serves for precision measurements, such as in optical instruments, in astronomy, in topography, in telemetry and in the manufacture of gauges, but also when the minute size and the complexity of the devices to be manufactured cannot be obtained other than by photographic reduction, such as in micro-electronics or in chemical micromilling.

Glass undergoes no size change, either by variations of the surrounding humidity or by storage over very long periods, and it has further an exceptionally low thermal-expansion coefficient. Varying only by 4.5×10^{-6} inch/inch/°F, less than half of a thousandth of one percent per degree F, it is approximately three times as stable as aluminium, twice as stable as bronze and even more stable than hardened steel. Photographic layers, adhering entirely to the glass base, therefore do not show any other size variation than that due to this negligible thermal expansion of the glass.

5.1.3 Paper Bases

Unlike plastic and glass base materials paper has a heterogeneous structure, and therefore requires in most cases an additional baryta layer between the base proper and the light-sensitive layers. More fragile and more sensitive to humidity than the other photographic base materials, the paper bases are also frequently protected by thin layers of impervious resin coats which facilitate rapid drying after processing.

5.1.3a *The Structure of Paper Base*

Compounded of cellulose fibres held together by sizing, just as all other papers, the photographic paper base stands out among most of the others by the chemical purity of its constituents, by its physical properties in the dry as well as the wet state, by its flatness, its tear resistance and the absence of yellowing after processing and keeping. To insure the purity required for the exclusion of any action of the base either on the raw emulsion or on the latent or the developed image, the cellulose fibres are made from wood pulp, most frequently from resinaceous trees (silver fir) and also from leafy trees

(aspen), and the sizing is by colophane and gelatin, with satisfactory mechanical resistance in the wet state obtained by treatment with melamine formaldehyde.[13]

The baryta underlayer contains baryum sulphate of various grain dimensions in a gelatin matrix. According to the size of the grains which are submicroscopic, visible only in the electron microscope at × 10,000 magnification, and to the thickness of the layer and its calendering, the prints are glossy or matt.[14,15] The main purpose of the baryta layer is perfect whiteness in the highlights of the prints; it therefore contains a small amount of blue dye which neutralizes its very slight yellow tint (see below, next section).

5.1.3b *Physical Properties*

In spite of its strong sizing, unvarnished photographic paper swells very easily upon wetting. The water content of a raw support without a baryta coat is at 70°F approximately proportional to the relative humidity of the surrounding air; it is equal to 2·5% at 20% R.H., 4% at 40% R.H., 6% at 60% R.H. and 9% at 80% R.H. Up to the relative humidity of 60% the paper mainly swells only in thickness, because of the swelling of the cellulose fibres, but the entirely watersoaked paper, due to the relaxation of the sizing forces, shows an expansion which varies between 0·1 and 0·5%, and which is greater across the paper web than in the direction of its length. This anisotropy of humidity expansion is rather pronounced and further increases for photographic papers when the drying of the prints introduces additional stresses, such as in the dryers of continuous processing machines or on drum glazers.

Dry photographic paper is mechanically quite resistant. A paper of 200 grams/sq. metre resists in the sense of its length to a traction of 8 to 10 kg per centimetre of width and shows an elongation of 1·5% at break; across the web the corresponding values are 5 to 6 kg/cm and an elongation of 3 to 4%.

The optical properties of paper result from its non-homogeneous structure. The air caught in the interstices of the cellulose fibres, of lower refractive index than that of the fibres, gives rise to diffusion and reflection of the incident light and thus yields the opacity and whiteness of the paper. The origin of the whiteness of the baryta coat is similar: the barium sulphate crystals are just as transparent as the gelatin vehicle in which they are imbedded, but the refractive indexes of these two components of the layer are very different.

The reflection of visible radiation by paper without a baryta coat is nonuniform; the paper is therefore slightly yellow. The hue of the baryta layer having a very similar tint, it is necessary to introduce a fluorescent compound which increases the reflectance in the blue spectral domain and therefore compensates for this natural tint even better than a blue dye (Figure 5.5).

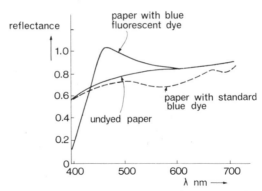

Figure 5.5. Effect of the incorporation of dyes and fluorescent compounds on the spectral reflectance of paper base.

5.1.3c *Physico-chemical Properties*

The interaction between an unvarnished paper base and the sensitive layer depends on the constitution of the paper: the exchange of solutions is partly due to capillarity, mainly during the coating of the layers, and partly to diffusion, either during the processing operations in aqueous media or during keeping at high relative humidity.[16] An appropriate adjustment of the composition of the paper and of the emulsion layers compensates for these effects and insures the required uniformity of large image areas such as cloudless sky or a uniform background, but the penetration in depth between the fibres of the paper of compounds contained in the processing solutions, mainly those of fixers, compels us to resort to long and efficient washing of the prints on unvarnished paper.

5.2 THE ELEMENTS OF THE SENSITIVE LAYERS

The essential elements of the classical photographic layers are the silver halides whose light sensitivity makes photography possible. The other important components of these layers are the gelatin which acts as vehicle, the sensitizing dyes which widen the spectral domain of the sensitivity of the silver halides, and the couplers and other dye-formers, compounds yielding the dyes of photographic colour reproduction.†

5.2.1 The Silver Halide

The silver halides normally employed in photographic layers are mixed, iodobromides‡ in all products of high sensitivity, and chlorobromides in

† Customarily the whole sensitive complex including its vehicle is called 'emulsion' in the photographic literature in spite of the quite different general use of this term.

‡ The major component of a mixed silver halide appears, by convention, at the end of the name of the compound.

other products, such as papers and numerous other films whose processing speed and image structure qualities are more important than high light sensitivity.

5.2.1a *Crystal Structure*

Inspection of the silver halide crystals of photographic emulsions under a microscope shows their shape to be in general triangular or hexagonal, but crystallographic study reveals that they belong as to their crystal structure to the face-centred cubic form (Figure 5.6) which is that of pure silver chloride

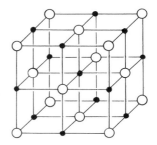

Figure 5.6. Structure of silver chloride or silver bromide
crystals.

or bromide crystals. Wilsey[17] has further shown that silver halides mixed in any proportions (obtained in his experiments by cooling the mixtures from the melts) crystallize in this form in solid solutions; this also applies to the silver iodobromides in spite of the two different forms of crystallization of silver iodide, which are tetrahedral either of zincblende or of wurtzite structure; it is probable however that these tetrahedral forms both also appear locally in the crystals of iodobromide emulsions, Berry[18] having shown their presence in monocrystals.

The forming of the silver halide microcrystals in photographic emulsions is strongly influenced by the presence of gelatin. Investigation of the fundamental mechanisms of silver halide precipitation in these specific conditions by Berry and Skillman[19] shows that it can be separated in four basic processes, which are nucleation, growth, Ostwald ripening and recrystallization. The experimental technique of adding slowly and simultaneously during fifteen minutes 30 cm^3 of 2·0 N solutions of silver nitrate and potassium bromide to 100 cm^3 of 3% gelatin solution at 50°C, and its modifications either by introduction of other addenda or by temperature changes, etc., allow us to study each of these principal phases.

Berry and Skillman found from these experiments that *nucleation* is homogeneous, i.e. that it is independent of the presence of impurities not taking part in the precipitation. Their observations of *crystal growth* in experimental conditions excluding ripening, further demonstrated the

simultaneous growth of all crystals as well as its independance of screw dislocations (see p. 360) which are in general the characteristic origin of most crystalline growths. Silver halide microscrystal growth therefore seems to depend only on the rate at which new material is supplied for precipitation.

Ostwald ripening, which makes the large crystals grow at the expense of the small ones, includes the dissolution of these latter, the diffusion of the dissolved species, and their deposition onto the large crystals. In the case of silver halide microcrystals the ripening kinetics depend on the dissolution rate of the small crystals, but are entirely independent of the rate of diffusion of the dissolved species.[20] It can finally happen that the energy required for the formation of solid solutions in mixed crystals is less than that of Ostwald ripening. Then *recrystallization* occurs in the opposite sense, i.e. reduction of size of the large crystals may be observed.

The lattice parameters were investigated by Chateau, Moncet and Pouradier.[21] For mixed silver halide crystals containing a small amount only of one of the two components, they are proportional to the concentration of the smaller one and defined by the following relationships, valid at 77°F:

$$a = 5.5502 + 0.002246 \text{ [Br] for silver bromochloride, and}$$

$$a = 5.7748 + 0.00368 \text{ [I] for silver iodobromide,} \tag{5.4}$$

where a is the distance between two similar elements of the lattice and [Br] and [I] the concentrations as percentages.

The triangular and hexagonal crystal shapes visible in the microscope are due to the polarity of the medium of precipitation during the preparation of the emulsion. The adsorption on the diagonal planes of the cubic lattice of ions not taking part in the crystal formation blocks the crystal growth beyond these planes and therefore makes them extend laterally by the fixation of further ions on the cubic faces (Figure 5.7). Another factor influencing the exterior shapes of the crystals is the solvent action of the

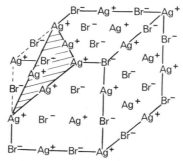

Figure 5.7. Octahedral and cubic faces of the face-centered cubic silver halide lattice.

medium during and after precipitation. An excess of bromide ions, for instance, promotes the formation of the soluble complexes $AgBr_2^-$ and $Ag(NH_3)_2^+$. This leads to an additional crystal growth by physical ripening and coalescence of the smaller crystals. The silver halide crystals of a photographic emulsion therefore show many imperfections and surface defects which act on the photographic speed of the layer (see p. 359).

A recent determination of the sizes and shapes, and also of the rates of growth, of silver halide microcrystals of structure similar to that of the crystals contained in photographic emulsions was carried out by Berry and Skillman.[22] With stochiometrically equal amounts of silver nitrate and potassium bromide the method of precipitation described above,[19] p. 355, yields cubic crystals with (200) surfaces; addition of a small amount of ammonia produces, by its solvent action through ripening, cubes of larger size, and also leads to the formation of numerous aggregates of singly and doubly twinned cubes. A slight excess of potassium bromide, added to the ammonia solution, yields on the contrary, by the polarization of the medium, octahedral or triangular crystals bounded by (111) surfaces. In both cases, with cubic as well as with octahedral crystals, uniform growth is observed for all crystals by progressive addition of new layers to their surfaces.

5.2.1b Crystal Sizes

The size of the silver halide crystals as well as their position in the layer are the geometrical parameters of its light sensitivity, because the probability of a photon hit onto a crystal depends on the projected area presented to the incident radiation. Size and position however act less on sensitivity than the chemical and physical parameters such as the composition and the structure of the crystals, inclusions of impurities, or lattice defects.

The position of the crystals, most of which are triangular or hexagonal flat tablets, defines the total projective area available. In the liquid emulsion their distribution is still entirely arbitrary, but during emulsion coating onto the base, and further by the rather strong contraction of the layer during drying, they are predominantly oriented parallel to the base. Silberstein[23] and Meyer[24] have shown that in a dry photographic layer about 90 % of these flat tablets are inclined by from 0° to 45° with respect to the film plane.

Many investigations have been devoted to the determination of crystal size distribution.[25,26] The analysis of such results is often made graphically by plotting the observed frequency of each crystal size as a function of the crystal diameter (Figure 5.8, curve A), but also by representing the total projective area of the crystals (Figure 5.8, curve B). Table 5.4 gives examples of such diameters and projective areas of crystals present in current emulsions, and also shows the corresponding numbers of grains per cubic centimetre of emulsion.[27]

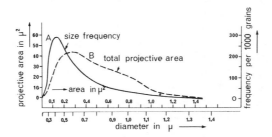

Figure 5.8. Typical size–frequency distribution of the grains of a photographic layer.

TABLE 5.4

Light-sensitive material	Diameter† (μ)	Projective area (μ^2)	Number of grains per cubic centimetre of emulsion $N \times 10^9$
High resolution film	0·048	0·00188	—
Black-and-white motion-picture positive film	0·30	0·07	577.5
Black-and-white amateur negative film	1·09	0·93	22·61
Medical X-ray film	1·71	2·30	6·32

These figures allow us to appreciate the very great number of crystals and also their extremely small size. These orders of magnitude also fix the size limits within which the various phenomena intervening during latent image formation, as well as during development, take place.

The crystal size distribution has an influence on the exposure latitude of the light-sensitive layers. An emulsion containing a great variety of crystal sizes has lower photographic contrast (see p. 32) than one whose crystals are all of about similar size. The relative sensitivities of the various size classes of the first emulsion cover a rather wide scale and the layer therefore yields correct results even with exposures varying within wide limits. The uniform sensitivity of the crystals of the second emulsion, on the contrary, makes them all developable above a given amount of exposure; any exposure smaller than this limit has therefore no effect on the layer, but once the limit is crossed the appearance of latent images is triggered in all of the crystals; in the limiting case there does not then remain any exposure latitude.

† The forms of the crystals are varied and irregular so that the term 'diameter' can only correspond to an approximate dimension. Various methods, some of which are rather elaborate, have been developed for the determination of a satisfactory relationship between the 'diameter' concept and actual crystal size.

5.2.1c *Impurities and Structural Imperfections*

The sensitivity of the silver halides to light and to other radiation is not only due to their intrinsic constitution but also depends on inclusions of foreign ions and structural defects. The former—traditionally called 'impurities'—just as the latter create stresses in the interior and at the surface of the crystals and thus serve to form those efficient electron or other charge carrier traps which are required for latent image formation (see p. 386). Other chemical species adsorbed to the crystals on the contrary reduce their sensitivity and also restrain their spontaneous development, protecting them against fog.

Among the ions foreign to the silver halides but also present in the crystals, which not only have the strongest but also the best known action on photographic sensitivity, are the sulphur ions. Sheppard showed that they most frequently have their origin in compounds contained in the gelatin such as allyldiethylthiourea,[28,29] and their action on photographic sensitivity was demonstrated by Sheppard, Trivelli and Wightman.[30] In modern photographic emulsions the proportion of inclusions of sulphur ions is adjusted with high precision.

Other impurities which increase sensitivity are inclusions of silver atoms resulting from the presence of reducing agents during precipitation. Sensitization by such deposits of metallic silver differs from that by sulphur ions by its much greater chemical reactivity; the treatment with a mild oxidizing agent such as a ferricyanide eliminates the sensitization obtained by reduction without acting on that due to the sulphur ions.[31] Sulphide deposits are only encountered at the outer crystal surface, whereas the silver inclusions are distributed throughout the entire volume of the crystals, including the surface.

A third type of sensitization by the inclusion of impurities in the crystals is that by gold.[32] It is obtained during precipitation, from aureous complexes

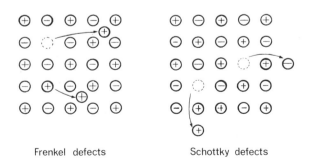

Frenkel defects Schottky defects

Figure 5.9. Structural crystal defects.

such as aureous thiocyanide, by the formation of additional gold sensitivity specks at the crystal surface.[33]

The structural defects of the crystals are of various dimensions. At the atomic level they either result from the absence of an ion pair (Schottky defect[34]), or from that of silver ions (Frenkel defect[35]), much more frequent at room temperature than the former (Figure 5.9). At the scale of the crystal however the dislocations extend over great numbers of lattice cells; they may begin within the crystal and then extend as far as its outer surface (Figure 5.10),

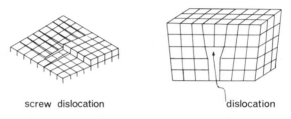

screw dislocation dislocation

Figure 5.10. Dislocations in cubic crystals.

but they can also result from defective surface layer formation (Figure 5.11). The influence of these structural defects on charge-carrier motion has been demonstrated by Haynes and Shockley: electrons capable of moving freely across the crystal under the influence of an exterior electric field are captured on the defects and form metallic silver by the attraction of silver ions, mostly interstitial ones.[36]

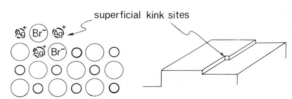

Figure 5.11. Charge distribution in a kink site on the crystal surface.

The origins of crystal defects and their distribution were studied by Berry and Skillman by X-ray diffraction;[22] point defects, line defects and two-dimensional crystal imperfections were distinguished. The *point defects* depend on the impurity content during precipitation; most impurities have however only a negligible effect on the subsequent trapping of electrons or positive holes, except sulphur ions (see also p. 398). *Line defects* are mostly found on the crystal edges. In pure silver bromide crystals there are no line

defects nor screw dislocations, but the presence of a small percentage of iodide ions, customary in negative emulsions, leads to the formation of numerous line defects and distorted crystals with rough surfaces. *Two-dimensional imperfections* resulting from successive addition of new layers to the crystal surface during precipitation and ripening have a strong influence on the crystal's surface properties; these affect the subsequent behaviour of the crystals more than their bulk properties.

The silver halide crystals of the photosensitive materials are protected against spontaneous development, i.e. against fog, by the adsorption of either halogen or organic ions capable of reacting with silver ions to form compounds or complexes of very low solubility. The halogen ions are always in excess in customary emulsions designed for being developed: bromide ions in iodobromide and chlorobromide emulsions, and chloride ions in silver chloride emulsions; in most emulsions smaller quantities of iodide ions are also adsorbed to the crystals.

Among the organic development inhibitors (see also p. 435), many are mercaptans whose —SH groups facilitate the reaction with the silver ions of the halide crystals. Such compounds, the thioanilides, form according to Sheppard and Hudson complexes with silver ions, mainly at the interface between the sulphur sensitizing specks and the halogen ions of the crystals.[37] In an investigation on the adsorption of organic compounds to silver halides Birr has further shown that a definite correlation exists between the low solubility of the complexes formed and their protective action against fog.[38] Some of the frequently employed compounds are the nitrobenzimidazoles, the nitroindazoles and the triazoles, and among the mercaptans the tetrazoles and the aminopyrimidines.

5.2.1d *Electric Conductivity*

An electric current, which is the result of the displacement of charge carriers, travels through a crystal either by ionic conductivity or by the movement of electrons.

In an isolated atom, as for instance in a gas, each electron while 'gravitating' around the nucleus has a well defined level of energy.

In a crystal, on the contrary, the energy levels of the electrons are strongly influenced by the neighbouring ions which form the crystal lattice.[39,40,41] Instead of being exactly defined each level is subdivided into a great number of closely spaced energy values creating an almost continuous band. The schematic representation of Figure 5.12 illustrates these situations for an isolated atom, for a conducting crystal such as that of a metal, and for an insulator. The potential energy of the electrons increases with their distance from the nucleus, but simultaneously the attractive force also grows rapidly as a function of this distance. Only the electrons acquiring an energy level

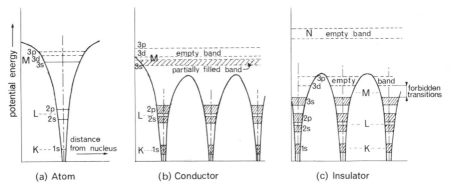

Figure 5.12. Energy levels in an atom (a) and in crystals of conductors (b) and of insulators (c).

above that of the summits of the limiting curves in the graphs are therefore capable of leaving their nuclei and moving freely across the crystal, whereas those of inferior energy levels remain fixed to their nuclei. This schematic representation therefore led to the spaces near the nuclei being called potential wells.

In the example of a conducting crystal (Figure 5.12b) two electronic energy bands lie above the summits of the potential wells; one of them is only partially occupied while the other is empty. Other electrons can therefore reach these levels and conduct current across the crystal. In the case of an insulator, however, the last entirely occupied levels lie well below the summits of the potential wells and a wide gap still separates them from the next free energy band (Figure 5.12c). Only by the addition of a considerable amount of energy from outside can the valence electrons, situated in the last occupied level, reach the conducting band and move through the crystal.

In a silver halide crystal, for instance in silver bromide, the valence electrons belong to the lower energy bands of the halide, i.e. to the bromide ion; an upper zone corresponding to the silver ion is empty and its energy level is much too high for the electrons to attain it by simple thermal agitation. The particular constitution of the silver halides however is such that the photons striking the crystal during the exposure to light can provide the required energy and leave the valence electrons to pass into the conduction band.

Ionic conductivity. This intrinsic property of the silver halide crystals makes it possible to distinguish their conductivity under the influence of actinic radiation from that in the dark. At normal temperature the conductivity of non-illuminated crystals is very low because it only results from ionic motion related to thermal agitation due to the movement of ionic crystal

lattice defects, such as interstitial or lacking silver ions.[42] The mobility of such charge carriers obeys the relationship

$$\mu = C\, e^{U/kT}, \tag{5.5}$$

where U is the lattice energy of the crystal, k Boltzmann's constant ($k = 1 \cdot 38 \times 10^{-16}$ ergs/degree centigrade), and T the absolute temperature. The logarithm of the conductivity σ (this latter being proportional to the product of the ionic mobility and the concentration n of the charge carriers taking part in the conduction of the current), should therefore be inversely proportional to the temperature. According to Lehfeldt's results[43] this dependence is indeed observed at high temperatures where the ionic defects of the lattice are very numerous. At lower temperatures however the inclusions in the crystals of foreign ions predominate over the then rather small number of mobile silver ions. The straight-line characteristic of this relationship therefore shows a rather sharp inflection, situated according to the degree of purity of the crystal (Figure 5.13). At room temperature the ionic mobility is still low and the specific resistivity of the silver halides therefore of the order of 10^{-8} ohm cm.

Figure 5.13. Influence of the temperature on the ionic conductivity of a silver bromide crystal.

Photoconductivity. By illumination with light or any other actinic radiation the conductivity grows rapidly, but it results in this case from the mobility of electrons. According to Lehfeldts measurements[44] the intensity of the photo-current at constant irradiation first increases rapidly as a function of the applied electric field and then rather quickly reaches a limiting value (Figure 5.14). As the current depends on the charge of the electron, which is constant,

Figure 5.14. Dependence of the photocurrent in a silver bromide crystal on the applied voltage.

as well as on the distance it has travelled, this saturation obviously shows that all excited electrons travelled over the whole distance up to the positive electrode applied to the crystal. The lower values of the photocurrent, situated in the inferior part of the curve, therefore apparently correspond to those electrons which were trapped on crystal impurities.[45] This is an important factor in latent image formation (see p. 386).

5.2.1e *Optical Absorption*

The photochemical action of a radiation, according to the Grotthus–Draper law, results from its absorption. The intrinsic sensitivity to light of the silver halides is therefore closely related to their spectral absorption. Figure 5.15 shows the absorption curves of pure silver chloride and silver bromide crystals,[46] whose separation by about 80 nm corresponds to the difference of their spectral sensitivities (see p. 370). The limits of the spectral absorption by mixed crystals of silver chlorobromide and of silver iodo-

Figure 5.15. Spectral absorption of silver chloride and silver bromide.

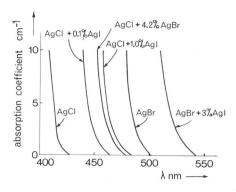

Figure 5.16. Spectral absorptions of various mixed silver halide crystals.

bromide are shown in Figure 5.16, compared to those of pure AgCl and AgBr crystals.[47]

5.2.2 Gelatin

Several properties of gelatin make it an excellent binder for the classical photographic layers. During the precipitation of the silver halide crystals it exerts an efficient action as a protective colloid which inhibits the formation of large crystals and keeps the precipitate from coalescing. Spread on the plane surface of a base material it forms uniform and transparent layers whose refractive index in the dry state almost does not differ from those of plastics and glass. Swelling easily in water and being permeable to aqueous processing solutions it makes possible development and other processing operations such as bleaching, fixing and washing, and constitutes again, after the completion of processing and drying, an excellent and stable binder for the reduced silver or the dyes which form the photographic image.

5.2.2a *Chemical and Photochemical Properties*

Gelatin is a protein composed of amino-acids whose basic functional group has the general formula

$$-\overset{\displaystyle R}{\underset{\displaystyle R'}{N}}-\overset{\displaystyle H}{\underset{}{C}}-\overset{\displaystyle O}{\underset{}{C}}- . \qquad (5.6)$$

By interconnections of their amine and carboxyl groups these amino-acids form polypeptide chains of various lengths, of the schematic structure

$$H_2N-\!\!\!\!\!\underset{NH_2}{\overset{COOH}{|}}\!\!\!\!\!\underset{}{\overset{NH_2\ COOH}{|\quad\ |}}\!\!\!\!\!\underset{NH_2}{\overset{NH_2}{|}}\!\!\!\!\!-COOH \qquad (5.7)$$

This simplified representation of the molecule, useful for the discussion of the properties common to the many different species of gelatin,[48] must only be considered as a general scheme, as more than twenty different amino-acids are known as elements of the polypeptide chains. The word 'gelatin' describes in fact a rather large number of substances among which the most currently used are prepared by various processes from the bones as well as from the hide of cattle and pigs. Gelatins can be distinguished from other proteins by their high glycocol content (about one third of the amino-acid residues), that of proline and of hydroxyproline (another third of the amino-acid residues), and by a very low content of, or even the absence of, cystine and of tryptophane.

According to the pH the lateral and terminal amino and carboxyl groups are partially or totally polarized, between the two limiting states

$$COOH \quad NH_3^+ \quad NH_3^+ \quad COOH \quad NH_3 \qquad\qquad COO^- \quad NH_2 \quad NH_2 \quad COO^- \quad NH_2 \tag{5.8}$$

in acid medium. in alkaline medium.

The increase of the number of ionized acid groups with increasing pH is shown by curve A of Figure 5.17, which resembles that of the neutralization of a mixture of two acids of pK 3·4 and 5·0 respectively;[49] curve B represents the ionization of the alkaline groups as a function of pH. The intersection of

Figure 5.17. pH dependence of the distribution of the acid and basic functions of a gelatin molecule.

the two curves, representative of equilibrium between the ionized acid and alkaline groups, corresponds to the pH of the isoelectric point, a fundamental parameter responsible for many properties of the various kinds of gelatin; the isoelectric points of lime-processed gelatins range from pH 4·8 to 5·1, and those of gelatins processed in acid medium are in the neighbourhood of pH 9·0.

Abribat, Pouradier and Venet[50] gave a description of the action of pH changes on the behaviour of polypeptide chains. Equilibrium between the ionized acid and basic groups at the isoelectric point results in strong intramolecular attractions which make the gelatin molecules curl up, but at other pH values they remain stretched (Figure 5.18). This clustering or

in acid medium at pH of in alkaline medium
 isoelectric point

Figure 5.18. pH effect on gelatin molecule configuration.

stretching out influences the physical and mechanical properties of the gelatin and therefore leads to considerable variations of the viscosity of gelatin solutions, which reaches at the isoelectric point a very pronounced minimum (Figure 5.19).

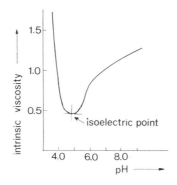

Figure 5.19. Effect of pH on the viscosity of gelatin solutions.

5.2.2b *The Hardening of Gelatin*

Gelatin pellets swollen in water and dissolved by heating to about 35°C form a colloidal solution, a sol, which gelifies on cooling and forms a gel. In the absence of hardening agents this process is entirely reversible and the jelly as well as thin dried gelatin films and coatings obtained from the colloidal solution remain fragile and are easily torn or scratched. Introduction of hardeners in the gelatin solution not only insolubilizes the gel even at high temperatures, but considerably reinforces the mechanical resistance of dry as well as wet gelatin layers. This is indispensible not only for the customary

handling of negatives and prints but mainly for photographic processing which requires a succession of alternative immersions into either highly alkaline or acid solutions. In most cases the light-sensitive layers are therefore hardened during manufacture, but very often this hardening is further increased during the processing of the films and papers by the use of either hardening developers or hardening fixers.

Inorganic as well as organic compounds harden gelatin. Among the former, which react in general with the carboxyl groups of the gelatin through their divalent metallic ions, the most often encountered are alums and chromium salts. Among the very numerous organic hardeners the most frequently employed are the aldehydes.

The mechanisms of gelatin hardening are complex, but a simplified schematic approach can yield working hypotheses useful in the application of the classical photographic processes. Hardening always results from the formation of crosslinks between the reactive groups of the gelatin molecules;[50] according to the pH, and therefore to the degree of stretching or clustering of the molecules, either intramolecular crosslinks are formed at the isoelectric point or intermolecular crosslinks at other pH values (Figure 5.20). Hardening by inorganic salts yields crosslinks connecting the ionized carboxyl groups; as shown by Venet and Pouradier[51] these crosslinks have, upon hardening by chromium salts, in a rather wide pH domain the structure

$$
\left|\text{-----} COO - Cr \overset{\displaystyle OH}{\underset{\displaystyle HO}{-}} SO_4 - Cr - OOC \text{-----}\right| . \tag{5.9}
$$

The higher the number of ionized carboxyl groups in the polypeptide chains, the more general the reaction and the more perfect the hardening. A sufficiently low pH is therefore the first requirement for the obtention of satisfactory inorganic hardening; hardening efficiency however is limited by other factors. When occurring in a too strongly acid hardening solution the reaction is slow and incomplete and at too high pH the rate of diffusion of the inorganic ions through the gelatin layer is insufficient. Figure 5.21 shows the pH range of satisfactory increase of the melting point, taken as a hardening criterion, when the hardener, as is frequent in hardening fixers, is potassium alum, $K\ Al\ (SO_4)_2.12\ H_2O$. In this case the limits of efficient hardening are pH 4·3 and 5·4, but for hardening with chromium salts they are lower and the pH must be maintained between 2·5 and 3·25.

Hardening with aldehydes, on the contrary, occurs by the formation of crosslinks between the amino groups of the gelatin and is schematically

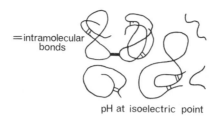

=intramolecular bonds

pH at isoelectric point

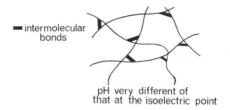

▬ intermolecular bonds

pH very different of
that at the isoelectric point

Figure 5.20. Intramolecular bond formation in the neighbourhood of the isoelectric point, and generation of intermolecular bonds at other pH levels.

represented by the reaction

$$R-NH_2 \atop R-NH_2 + HCHO \longrightarrow {R-NH \atop R-NH}\!\!\diagdown\!\!\diagup\!\!CH_2 + H_2O . \qquad (5.10)$$

This reaction is favoured by high pH values, greater than 8·5, because formaldehyde, like most aldehydes, reacts with the non-ionized NH_2^- groups of lysine and hydrolysine.[52] Dialdehydes such as glyoxal, glutaraldehyde and succinaldehyde react in similar fashion with gelatin, but they form more complete crosslinks which for the two last compounds are thought of as

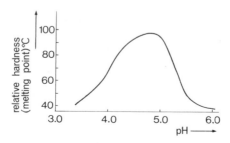

Figure 5.21. Melting point pH dependence of a gelatin sol.

having structures of the form

$$\text{(5.11)}$$

The presence of a hardening compound in a processing solution which has been correctly buffered in the corresponding pH range (see p. 481) increases the mechanical resistance of the layers; their hardening however is complete only after drying, which makes possible the formation of numerous additional crosslinks and therefore the building up of a solid tridimensional lattice.

5.2.3 Sensitizing Dyes

The natural sensitivity of the silver halides covers only a small part of the visible spectrum. Photographic silver chloride layers, while showing some sensitivity at the violet end of the spectrum, are mainly sensitive to ultraviolet radiation, and the sensitivity of silver bromide layers is limited to the blue and ultraviolet domains. Silver bromide crystals containing a small fraction of iodide exhibit a very slight sensitivity to red light, but this is negligible when compared to that to blue and ultraviolet radiation.

Satisfactory tone and colour reproduction is however possible only, as was shown before, when the spectral sensitivity extends over the whole visible spectrum. This extension of the sensitivity is obtained through dyes which when adsorbed to the silver halide crystals are capable of transferring to these the adsorbed energy of the incident radiation required for latent image formation.

5.2.3a *Structure of the Sensitizing Dyes*

A coloured compound absorbs light because its molecules can remain relatively stable in at least two energy states, one of which is the ground state, of lower energy, and the other the excited state, resulting from the absorption of a photon. The currently employed sensitizing dyes have structures fulfilling this condition.

General configuration of the sensitizing dyes. A sensitizing-dye molecule has as typical characteristic a conjugated chain composed of an odd number of carbon atoms linked by alternating single and double bonds and carrying at both of its ends atoms permitting the reversal of the order of bonds according to the formula

$$X-\overset{|}{C}=(\overset{|}{C}-\overset{|}{C})_n=Y \quad\longleftrightarrow\quad X=\overset{|}{C}-(\overset{|}{C}=\overset{|}{C})_n-Y \qquad\text{(5.12)}$$

The two atoms which are most liable to these bonding changes are nitrogen and oxygen; three main classes of sensitizing dyes can therefore be distinguished.

The first, typified by the presence of two terminal nitrogen ions, each of which is at one end of the conjugated chain, is that of the *amidinium ion system*,

$$\ce{>N-C=(C-C)_n=N< \quad <-> \quad >N=C-(C=C)_n-N<} \tag{5.13}$$

In the second class both terminal ions of the conjugated chain are oxygen ions; this is the *carboxyl ion system*,

$$\ce{O=C-(C=C)_n-O \quad <-> \quad O-C=(C-C)_n=O} \tag{5.14}$$

There remains the third class which includes nitrogen as well as oxygen atoms; this is that of the *amidic system*,

$$\ce{>N-C=(C-C)_n=O \quad <-> \quad >N=C-(C=C)_n-O} \tag{5.15}$$

In none of these three systems are the molecules entirely in one or the other of the two extreme states. Through resonance they reach an equilibrium, called a 'resonance hybrid', which is the stable ground state of the molecule; its characteristic is the simultaneous predominance of the two extreme structures. However, the absorption of radiation excites the molecule and makes it tend towards an intermediate state in which there is much less difference between the terminal structures than in the ground state, and where the excess charge carriers are rather localized within the conjugated chain.

The position of the principal spectral absorption band of such dyes in solution depends before all on the configuration of their terminal structures, but it is also influenced to a large extent by the length of the conjugated chain. A typical example of such a shift of the absorption maximum is that of the thiacyanines of the general formula

$$\left[\ce{C=CH-(CH=CH)_n-C} \right] I^- . \tag{5.16}$$

In alcoholic solution the absorption of these dyes shifts with an increase of the number n of the vinylene groups $\ce{-(C=C)}$ or $\ce{=(C-C)}$ successively from ultraviolet towards infrared (Figure 5.22). With $n = 0$ the colour of this dye is a pale yellow and it sensitizes a silver chloride emulsion in the blue region

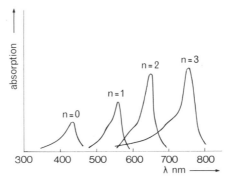

Figure 5.22. Influence of the number of vinylene elements in a dye molecule on its absorption maximum.

of the visible spectrum. With $n = 1$ the dye is magenta and sensitizes in the green, with $n = 2$ it is blue and sensitizes in the red, and for $n = 3$ the emulsion is sensitized in the infrared between 700 and 800 nm.[53]

Classes of sensitizing dyes. The number of sensitizing dyes is considerable; according to their structure the following main classes can be distinguished:

Cyanines.[54] These form one of the most important groups of sensitizing dyes. Belonging to the amidinium ion system they are in general symmetrical and carry their characteristic nitrogen ions in heterocycles such as those of the example of Figure 5.22. The cyanines are ionized and their colour depends, as mentioned above, on the nature of the cation and on the length of the conjugated chain, which in turn depends on the structure of the nucleus.

Some cyanines are asymmetric and carry dissimilar terminal nuclei; they differ from the symmetrical cyanines by the very great difference of the energy levels of their extreme states. Other asymmetric dyes of the amidinium ion system also belong to the cyanines, such as the hemicyanines of the general formula

$$
\left[\underset{\underset{C_2H_5}{|}}{\overset{S}{\underset{N^+}{\bigcirc}}} \mathrm{C\text{-}(CH\text{=}CH)}_n \; \mathrm{-N} \overset{R_1}{\underset{R_2}{<}} \right] \mathrm{I}^-,
\tag{5.17}
$$

or the styryl dyes whose most typical example is pinaflavol,

$$
\left[\underset{\underset{C_2H_5}{|}}{\overset{}{\underset{N^+}{\bigcirc}}} \mathrm{CH\text{=}CH} \text{-}\bigcirc\text{-} \mathrm{N} \overset{CH_3}{\underset{CH_3}{<}} \right] \mathrm{I}^-.
\tag{5.18}
$$

Other cyanines contain three heterocycles, such as the neocyanine,

$$\tag{5.19}$$

Dyes of the carboxyl ion system. This class comprises mainly phthalein derivates, at one time before the general use of the cyanines an important class of sensitizers, and the oxonols. The best known example of the first group is erythrosin, a classical dye sensitizing in the green and employed over several decades in orthochromatic emulsions,

$$\tag{5.20}$$

Merocyanines.[55] These relatively recent sensitizing dyes belonging to the amidic system mainly differ from the cyanines by not being ionized and therefore remaining undissociated. The resonance through the conjugated chain occurs here between an uncharged molecule and a dipolar structure.

$$\tag{5.21}$$

Steric configuration of sensitizing dyes. The conventional notation of the formulas of organic compounds shows neither the relative sizes of the constituents of a molecule nor their mutual distances. Representation of the molecular structure by observing the actual size relationships of the elements however makes steric hindrances appear which, particularly in the case of sensitizing dyes, forbid planar configurations, indispensable for the spectral sensitization of silver halide emulsions.[56] An example of two isomers of different structure demonstrates clearly this difference of steric configuration

for two cyanines of which the first (5.22a), sensitizes satisfactorily whereas the other (5.22b), has no spectral action. Progressive substitution of the various

$$\text{(5.22a)}$$

$$\text{(5.22b)}$$

motives therefore yields quite generally continuous progressions of configuration from planar and uncrowded molecules to dyes of tight and distorted non-planar molecular structure.[57]

5.2.3b *Mechanisms of Spectral Sensitization*

The conditions necessary for satisfactory spectral sensitization of a silver halide crystal are: strong adsorption of the sensitizing dye to the crystal; spectral absorption in the desired domain of sensitization by the dye adsorbed to the silver halide; exclusive use for latent image formation of the energy adsorbed by the dye.

Adsorption of the dyes to the silver halides. The attractive forces responsible for the adsorption of the sensitizing dyes to the silver halide crystals are varied and depend on the structure of the dyes. The adsorption of the cyanines, strongly polarized, is mainly due to ionic attraction between the positively charged dye ions and the negative halide ions in excess on the crystal surface.[58] At low concentration of the dye, however, when its planar molecules are lying parallel to the crystal surface, the attraction can also be due to Van der Waals forces.[59] By progressive increase of the dye concentration, mutual attractions by Van der Waals forces also appear between the dye molecules and these then form aggregates in parallel planes, adsorbed edge-on to the silver halide crystals like pages of a book (Figure 5.23). This rather sharp change in the adsorption of the dyes makes an additional narrow band of spectral absorption appear, the J-band discussed in detail hereafter, on page 376.

The adsorption of the dyes can be followed by the study of the absorption isotherms, which show the dependence of the amount of the dye adsorbed either per unit surface or per unit weight of the adsorbant, in our case the silver halide, on the concentration of the dye solution at equilibrium.[59] Figure 5.24 shows these isotherms for several dyes: curve a is that of a dye adsorbed essentially by ionic forces without any discontinuity up to complete

Figure 5.23. Schematic representation of sensitizing dye adsorption to silver halide crystals.

coverage of the crystal surface; curve b is typical of a dye showing a discontinuity of absorption with the appearance of a J-band; and curve c is that of a dye of non-planar structure due to steric hindrance, less readily adsorbed than others with plane molecules. Adsorption to the silver halide crystals of non-ionized dyes, such as for instance merocyanines, mainly occurs by attractions through Van der Waals forces.

Spectral absorption of the sensitizing dyes. The spectral absorption of dyes in solution depends, as mentioned before, on the terminal motives of the molecules and on the length of the unsaturated chain. The absorption of the adsorbed dye, however, differs in general from that in solution, and particularly the presence of adsorbed dye aggregates gives rise to additional absorption bands of greater wavelength than that of the principal absorption, called J-bands.[60,61]

Describing the absorption of dyes in solution, Carroll and West[62] distinguish the following spectral absorptions: in aqueous or alcoholic

Figure 5.24. Adsorption isotherms of sensitizing dyes.

Figure 5.25. Concentration dependence of the absorption spectra of sensitizing dye solutions.

solution the principal absorption M (Figure 5.25) results from isolated dye molecules and obeys Beer's law. With increasing concentration this principal absorption decreases and there appears in a shorter wavelength range an additional spectral absorption band D resulting from the dimerisation of the dye molecules. By further increase of the concentration the D-band gains in width and finally yields an absorption spectrum of shape H due to the formation of multimolecular aggregates. Still higher dye concentration finally gives rise to the appearance of J-bands by the formation of dye molecule aggregates in parallel planes, which adsorb edge-on to the silver halide crystals. The fundamental mechanisms of the formation of dye aggregates adsorbed to the silver halide crystals of an emulsion and of their spectral absorption were studied by Bird, Norland, Rosenoff and Bryant-Michaud.[63] Their experimental results and theoretical considerations confirm the adsorption of the dye aggregates formed by elements of one molecule per unit cell in a deck-of-cards structure, with distances between the molecular planes of the order of the graphitic spacing, i.e. of 3·37 A. This condition leaves in the absorption spectrum only the J-band, according to the angle of adsorption of the dye molecules to the crystal surface with absorption tails of varying lengths, extending either towards the short or the long wavelengths regions.

By their adsorption to the crystals the principal absorption of the dye shifts at very low concentration against that in solution by 20 to 30 nm towards the longer wavelengths without any marked change of shape of the absorption spectrum;[64] this first shift is due only to the high refractive index of the silver halides. With increasing dye concentration, however, inter-molecular interaction brings about an additional shift of 10 nm towards the

longer wavelengths and yields a modified molecular absorption band called the B-band.

The close correspondence between the spectral absorption of a dye in the adsorbed state and the resulting spectral sensitization has been shown by several authors.[65]

The mechanism of energy transfer. Investigation of the infrared spectra of the adsorbed dyes shows them to be independent of the halide ions of the crystals; the interactions between the sensitizing dyes and the silver halide crystals therefore must occur through the silver ions. Boyer, Malingrey and Preteseille further demonstrated formation of coordination compounds between the π-electrons of the adsorbed dyes and the silver halides.[66]

The absorption of the energy of an incident radiation by the sensitizing dye adsorbed to the silver halide crystal leads to the appearance within the crystal of free electrons like those released in an unsensitized crystal by radiation of shorter wavelength (see p. 386). The sensitizing dye therefore not only extends the spectral domain of the crystal's photoconductivity towards the longer wavelengths, of energy lower than that of radiation corresponding to the intrinsic absorption of the crystal, but it also extends its domain of spectral sensitivity.[67] This extension of the light sensitivity of the silver halides by dyes is efficient for the formation of internal as well as of external latent images (see p. 394).

The differences between the mechanisms of latent image formation in either dye-sensitized or not dye-sensitized crystals were studied by West and Gilman.[68] Experiments with very short exposures of crystals submitted to an electric field, by the technique of Haynes and Shockley (see Reference 10 of Chapter 6), while confirming the formation of free electrons in the dye-sensitized silver halide, show that the positive holes formed in the crystal are trapped on its surface, contrarily to their penetration into its interior when not dye-sensitized. This demonstrates the fundamental difference between the primary result of the exposure of dye-sensitized or unsensitized crystals: the lower energy required for the trapping of a positive hole only at the surface of the dye-sensitized crystal compensates for the lack of energy of the long wavelength quantum relative to that of blue or ultraviolet quanta which act on not dye-sensitized crystals.

The transfer to the crystal of the energy absorbed by the dye can occur in two ways: either an electron is transferred directly from the dye molecule to the crystal, or an energy transfer from the excited dye molecule gives rise within the crystal to the ejection of an electron into the conduction band. In the first case the temporary formation of a free radical of the dye would be followed by the recovery of an electron from a halogen ion; this would regenerate the dye which therefore could continue its sensitizing action.

In the second case, however, according to Mott,[69] the energy level of the excited dye molecule is too low for a direct energy transfer onto the crystal elsewhere than on privileged sites such as structural defects on its surface (see p. 360). The energy levels and the transfers corresponding to these two cases are schematically represented in Figure 5.26.[70] The first mechanism requires for the sensitizing dye in the excited state a certain energy level not necessary in the second case. In spite of numerous researches yielding results in favour of either one or the other of these two mechanisms, no definite proof has yet been found for the precise form of energy transfer from the dye to the crystal.

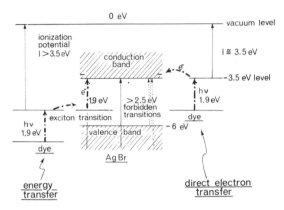

Figure 5.26. Energy levels for silver bromide and sensitizing dyes acting by energy transfer (at left) or by electron transfer (at right).

When the dye is adsorbed edge-on according to Figure 5.23, it might occur that the excited state also transfers from one dye molecule to the neighbouring one; this state, called propagation of excitons,[71] exists when the electronic excitation of a molecule travels through the aggregate from molecule to molecule in a period shorter than that of molecular oscillation. The resulting dissipation of energy reduces the probability of its transfer to the crystal; the resulting spectral sensitization would then only be weak. The additional introduction of either coloured or uncoloured compounds without any own sensitizing power however gives rise in this case to considerable spectral sensitization. The molecules of such compounds, called supersensitizers, seem to be inserted into the pile of sensitizing dye molecules and contribute to the energy transfer onto the silver halide crystal by damping the oscillating field which otherwise would build up within the aggregate of sensitizing dye.[67]

To act this way the supersensitizing molecule should, according to Rosenoff, Norland, Ames, Walworth and Bird,[72] be in an excited state in which it could accept an energy transfer from the sensitizing dye aggregate, thus preventing the dissipation of energy and its resulting loss for latent image formation. West and Gilman[68] ascribe the effect of the supersensitizers either to their action as exciton traps or as exciton trap formers (see above), impeding the propagation of excitons across the pile of dye molecules, or to a quite different chemical effect related to the preferential trapping of positive holes formed in the surface of the dye-sensitized crystals (see above, p. 377).

5.2.4 Couplers and Other Dye Formers

The various layers of films for colour photography contain still another class of principal components, the couplers or other colour-forming compounds which during development form the elementary dye images of three-colour reproduction. These dyes result in the majority of cases from a condensation reaction between the mostly colourless couplers and the developers of the class of the p-amino-N, N-dialkylanilines; in the diffusion-transfer colour processes the images are formed by dye-developers; the mechanisms of these latter reactions are closely related to the development process and therefore described below, on page 457.

The fundamental condition for the satisfactory working of a multi-layer colour film is the complete absence of diffusion of the couplers or dyes from one layer to another. To this purpose the coupler molecules contain groups which immobilize them in the gelatin, and also solubilizing functions which make them compatible with the aqueous medium of the preparation of the emulsion.

Two methods of coupler immobilization are in current use: in the first, due to Fischer,[73] the coupler molecule carries a long aliphatic chain which makes the compound hydrophobic and thus keeps it from diffusing through the gelatin. In the second, due to Jelley and Vittum,[74] the couplers are dissolved in an appropriate organic solvent and the solution then mechanically dispersed in the gelatin in the form of minute droplets. The two methods are schematically represented in the following example of a magenta dye-forming coupler:

$$(5.23)$$

Fischer type coupler

$$(5.24)$$

Jelley and Vittum type coupler.

In the diffusion transfer process the immobilization of the developer dyes only occurs during development, by fixation of the developing function on the gelatin through its reaction with the quinonic form of the oxidized dye-developer.[75]

REFERENCES

1 Calhoun, J. M., Technology of new film bases. *Perspective*, **2** (1960), 250.
2 Calhoun, J. M., The physical properties and dimensional stability of safety aerographic film. *Photogramm. Eng.*, **13** (1947), 163.
3 Whinfield, J. R., Chemistry of 'Terylene'. *Nature*, **158** (1946), 930.
4 Hudson, R. A., Production, properties and applications of the new British polyethylene terephthalate film. *British Plastics*, **26** (1953), 6.
5 Schnell, H., Polycarbonate, eine Gruppe neuartiger thermoplastischer Kunststoffe. *Angew. Chemie*, **68** (1956), 633.
6 Amborski, L. E., and Flierl, D. W., Physical properties of polyethylene terephthalate films. *Ind. and Eng. Chem.*, **45** (1953), 2290.
7 Streib, H. W., Recent experience with polycarbonates. *British Plastics*, **33** (1960), 406.
8 Kahl, R., Quatre années d'expérience avec le polycarbonate. *Ind. Mod. des plastiques et élastomères*, **16** (1964).
9 Calhoun, J. M., and Leister, D. A., Effect of gelatin layers on the dimensional stability of photographic film. *P.S.E. Jl.*, **3** (1959), 8.
10 Harman, W. E. Jr., Recent developments in aerial films. *Photogram. Eng.*, **26** (1960), 151.
11 Fordyce, C. R., Calhoun, J. M., and Moyer, E. E., Shrinkage behavior of motion picture film. *Jl. Soc. M.P.T.E.*, **64** (1955), 62.
12 Adelstein, P. Z., and Calhoun, J. M., Interpretation of dimensional changes in cellulose ester base motion picture films. *Jl. Soc. M.P.T.E.*, **69** (1960), 157.
13 Seve, R., Propos sur la fabrication du papier support photographique. *Papier, Carton et Cellulose*, **6** (1957), 76.
14 Moisand, Ch., Notions théoriques et pratiques sur la fabrication des papiers, plaques et films photographiques. *Papeterie*, **74** (1952), 138.
15 Russell, R. E., Barium sulfate. In *Paper Coating Pigments*. Tappi Monograph Series, no. 30, New-York.
16 Wenzl, H. F. J., Paper as a photographic emulsion support. *Proceedings of the R.P.S. Centenary Conference, London 1953*. (edited by the R.P.S., London, 1955).
17 Wilsey, R. B., X-ray analysis of some mixed crystals of the silver halides. *Jl. Franklin Inst.*, **200** (1925), 739.

18 Berry, C. R., Structure of thin films of silver and silver iodide on silver bromide substrates. *Acta cryst.*, **2** (1949), 393.
19 Berry, C. R., and Skillman, D. C., Fundamental mechanisms in silver halide precepitation. *Jl. Phot. Sc.*, **16** (1968), 137.
20 Berry, C. R., and Skillman, D. C., Surface structure and reaction rates of AgBr-microcrystals. *Phot. Sc. Eng.*, **13** (1969), 69.
21 Chateau, H., Moncet, M. C., and Pouradier, J., Contribution à l'étude des cristaux mixtes de bromo-iodure d'argent. I. Variation de la maille en fonction de la teneur en iodure. In *Wissenschaftliche Photographie, Minutes Cologne Conference 1956*. Darmstadt, 1958, p. 16.
22 Berry, C. R., and Skillman, D. C., Zero-, one- and two-dimensional defects in microcrystals of silver bromide. In *Crystal Growth*, supplement of the *Jl. of Phys. and Chem. of Solids*, (1967), 807.
23 Silberstein, L., The orientation of the grains in a dried photographic emulsion. *Jl. Opt. Soc. Am.*, **5** (1921) 171 and 363.
24 Meyer, H. H., Ueber die Faserstruktur des Bromsilbers in den Schichten photographischer Trockenplatten. *Ann. Phys.*, **86** (1928), 325.
25 Toy, F. C., The sensitivity of silver halide crystals which are geometrically identical. *Phot. Jl.*, **61** (1921) 417.
26 Wightman, E. P., Trivelli, A. P. H., and Sheppard, S. E., The distribution of sensitivity and size of grain in photographic emulsions. *Jl. Franklin Inst.*, **194** (1922), 485.
27 Mees, C. E. K., and James, T. H., *The Theory of the Photographic Process.* Macmillan, New York; Collier-Macmillan, London, 1966, p. 39.
28 Sheppard, S. E., Photographic gelatin. *Phot. Jl.*, **65** (1925), 380.
29 Sheppard, S. E., and Hudson, J. H., Determination of labile sulphur in gelatin and proteins. *Ind. Eng. Chem.*, **2** (1930), 73.
30 Sheppard, S. E., Trivelli, A. P. H., and Wightman, E. P., The production of sensitizing specks on silver halide grains. *Phot. Jl.*, **67** (1927), 281.
31 Lowe, W. G., Jones, J. E., and Roberts, H. E., Some chemical factors on emulsion sensitivity. *Sci. Ind. Phot.*, (2) **22** (1951), 170.
32 Koslowsky, R., Gold in photographischen Emulsionen. *Z. wiss. Phot.*, **46** (1951), 65.
33 James, T. H., The site of reaction in direct photographic development. *Jl. Coll. Sci.*, **3** (1948), 447.
34 Wagner, C., and Schottky, W., Theorie der geordneten Mischphasen. *Z. anorg. Chemie*, **110** (1926), 196.
35 Frenkel, J., Uber die Wärmebewegung in festen und flüssigen Körpern. *Z. f. Physik*, **35** (1926), 652.
36 Haynes, J. R., and Shockley, W., The mobility of electrons in silver chloride. *Phys. Rev.*, **82** (1951), 935.
37 Sheppard, S. E., and Hudson, H., The halogen acceptor theory of sensitivity and the thioanilides. *Phot. Jl.*, **67** (1927), 359.
38 Birr, E. J., Beitrage zum Mechanismus der Stabilisierung photographischer Emulsionen. *Z. wiss. Phot.*, **47** (1952), 72; **48** (1953), 103; (1) **49** (1954), 261; **50** (1955), 107 and 124.
39 Mott, N. F., and Gurney, R. W., *Electronic Processes in Ionic Crystals.* Oxford University Press, 1948.
40 Seitz, F., *Modern Theory of Solids*, New York, 1949.
41 Kittel, C., *Introduction to Solid State Physics*, New York, 1953.

42 Tubandt, C., and Eggert, S., Ueber Elektrizitätsleitung in festen kristallisierten Verbindungen. *Z. anorg. Chem.*, **110** (1920), 196.
43 Lehfeldt, W., Ueber die electrische Leitfähigkeit von Einkristallen. *Z. Phys.*, **85** (1933), 717.
44 Lehfeldt, W., Zur Elektronenleitung in Silber- und Thalliumhalogenidkristallen. *Nachr. Ges. Wiss. Göttingen. Math. Phys. Kl.*, **1** (1935), 171.
45 Hecht, K., Zum Mechanismus des lichtelektrischen Primärstromes in isolierenden Kristallen. *Z. Phys.*, **77** (1932), 235.
46 Moser, F., and Urbach, F., Optical absorption of pure silver halides. *Phys. Rev.*, **102** (1956), 1519.
47 Moser, F., and Van Heyningen, R. S., Optical and electronic properties of silver halide crystals. In C. E. K. Mees and T. H. James, *The Theory of the Photographic Process*, 3rd edn., Macmillan, New York; Collier-Macmillan London, 1966, p. 19.
48 Pouradier, J., Structure de la gélatine. *Chimie et Industrie*, **74** (1955), 1175.
49 Kenchington, A. W., and Ward, A. G., Titration curve of gelatin. *Biochem. Jl.*, **58** (1954) 202.
50 Abribat, M., Pouradier, J., and Venet, A. M., Etude viscosimétrique de la structure moléculaire de la gélatine en solution. *Jl. Polymer. Sc.*, **4** (1949), 523.
51 Venet, A. M., and Pouradier, J., Tannage de la gélatine par l'alun de chrome. II. Fixation du chrome sur la gélatine, *Bull. Soc. Chim de France*, (1955), 1336.
52 Pouradier, J., and Venet, A. M., Formation de ponts intermoléculaires lors du tannage de la gélatine. *Proc. Conference of the British Gelatine and Glue Research Association, Cambridge 1957*, Pergamon Press, London, p. 236.
53 Brooker, L. G. S., Absorption and resonance in dyes. *Revue Mod. Phys.*, **14** (1942), 275.
54 Hamer, F. M., *The Chemistry of Heterocyclic Compounds*; vol. 18: The cyanine dyes and related compounds. Interscience Publishers, New York, 1948.
55 Kendall, J. D., British patents 428 222 and 428 360 (1935); Brooker, L. G. S., U.S. patent 2 089 729 (1937) and British patent 449 527 (1936).
56 Sheppard, S. E., Lambert, R. H., and Walker, R. D., Optical sensitizing of silver halides by dyes, III. *Jl. Chem. Phys.*, **9** (1941), 96.
57 Brooker, L. G. S., White, F. L., Hezeltine, D. W., Keyes, C. H., Dent, S. G. Jr., and Van Lare, E. J., Spatial configuration, light absorption and sensitizing effect of cyanine dyes. *Jl. Phot. Sci.*, **1** (1953), 173.
58 James, T. H., and Vanselow, W., Cooperative and competitive adsorption in the photographic process. *Jl. Phys. Chem.*, **58** (1954), 894.
59 West, W., Carroll, B. H., and Whitcomb, D. H., The adsorption of dyes to microcrystals of silver halide. *Ann. N.Y. Acad. Sci.*, **58** (1954), 893.
60 Jelley, E. E., Spectral absorption and fluorescence of dyes in the molecular state. *Nature*, **138** (1936), 1009.
61 Scheibe, G., Ueber die Veränderlichkeit des Absorptionsspektrums einiger Sensibilisierungsfarbstoffe und deren Ursache. *Z. Angew. Chem.*, **49** (1936), 563.
62 Carroll, B. H., and West, W., Optical sensitization of photographic emulsions. In *Fundamental Mechanisms of Photographic Sensitivity*. (Proc. Bristol Symposium 1950) Edited by J. W. Mitchell, London 1951, p. 162.
63 Bird, G. R., Norland, K. S., Rosenoff, A. E., and Bryant-Michaud, H., Spectra and structure of sensitizing dye aggregates. *Phot. Sci. Eng.*, **12** (1968), 196.
64 West, W., and Geddes, A. L., The effects of solvents and of solid substrates on the visible molecular absorption spectrum of cyanine dyes. *Jl. Phys. Chem.*, **68** (1964), 837.

65 Spence, J., and Carroll, B. H., Desensitization by sensitizing dyes. *Jl. Phys. Colloid. Chem.*, **52** (1948), 1090.
66 Boyer, S., Malingrey, B., and Preteseille, M. C., Etude par spectrophotométrie infrarouge de l'interaction des colorants sensibilisateurs avec les halogénures d'argent. *Sci. et Ind. Phot.*, (**2**) **34** (1965), 217.
67 West, W., and Carroll, B. H., Photoconductivity in photographic systems, II. *Jl. Chem. Phys.*, **15** (1947), 539.
68 West, W., and Gilman, P. B., Recent observations on spectral sensitization and supersensitization. *Phot. Sci., Eng.*, **13** (1969), 221. West, W., Some recent methods of investigation of spectral sensitivity. *Proc. Intern. Symposium on Spectral Sensitization. Bressanone 1967.* London, 1970, p. 105.
69 Mott, N. F., Notes on latent image theory. *Phot. Jl.*, **88B** (1948), 119.
70 West, W., The energy problem in spectral sensitization. In W. F. Berg, *Photographic Science, Zurich Symposium 1961.* Focal Press ed. London, New York, 1963, p. 71.
71 Franck, J., and Teller, E., Migration and photochemical action of excitation energy in crystals. *Jl. Chem. Phys.*, **6** (1938), 861.
72 Rosenoff, A. E., Norland, K. S., Ames, A. E., Walworth, V. K., and Bird, G. R., The resolved spectra of small cyanine dye aggregates and a mechanism of supersensitization. *Phot. Sci. Eng.*, **12** (1968), 185.
73 Fischer, R., German patent 253 335 (1912), and Fischer, R., Siegrist, H., German patent 257 160 (1914).
74 Jelley, E. E., and Vittum, P. W., U.S. patent 2 322 027 (1943).
75 Rogers, H. G., U.S. patent 2 983 606 (first demand on 9.3.1954) French patent 1 168 292, (22.12.1956).

6

The Latent Image

During exposure to light or to other actinic radiation the silver halide crystals undergo a permanent modification which makes them differ from those left unexposed. This structural change increases the probability of their reduction to metallic silver by the developer solution and makes it proceed at a much higher rate than without exposure.

Invisible even at the highest magnification of the electron microscope, and indiscernible otherwise than by development, this modification has been named the latent image.

6.1 ACTION AND NATURE OF THE LATENT IMAGE

In spite of its extremely small size the latent image has been studied by many workers. Its nature and its action in the photographic processes are therefore rather well known in most of their ramifications.

6.1.1 Chemical Nature of the Latent Image

Observation in the microscope of the direct photolysis of silver halide crystals under the effect of intense irradiation on the one hand, and of the initiation of development of considerably less exposed crystals, on the other hand, reveals a close analogy between these two processes. Formation of the photolytic deposit as well as of developed silver starts at distinct points on the crystal surface and spreads from these across the whole volume of the crystal by the continuation either of exposure or of development.

6.1.1a *Print Out*

Study by X-ray diffraction of a photolytic deposit shows it to be composed of silver,[1,2,3] and the measurements of its absorption spectrum by Hilsch

and Pohl[4] demonstrates this deposit to be colloidal silver. With exposures sufficiently strong to yield deposits of a size accessible to analysis and on condition to eliminate the liberated halogen by an appropriate acceptor, the weight of the photolytic silver is proportional to the number of absorbed quanta.[5] By extending, in the graph representing this relationship, the straight-line characteristic it is found to pass through the origin. This extrapolation apparently shows that a normal photographic exposure, much less than that which forms a photolytic deposit of silver, still yields silver.

6.1.1b *Constitution of the Latent Image*

Some other experimental analogies also allow us to suppose that the latent image consists of silver. Various compounds, for instance, which oxidize metallic silver can be employed to make the result of an exposure disappear; treatment of an exposed film with solutions of chromic acid, of potassium persulphate or with others containing free halogen destroys latent images.

The latent image can also be employed as a nucleus for the precipitation of silver. After complete dissolution of the silver halide of an exposed photographic layer the imagewise exposure can still be made visible by the deposit of silver from a reducing solution containing silver ions (physical development, see p. 418). The same kind of silver precipitate can also be deposited on silver nuclei on glass resulting from condensation in vacuum.

All this evidence is of course only based on analogies, but other proof can be given for the nature of the latent image. Further to very precise measurements of extremely low optical densities, Nail, Moser and Urbach[6] demonstrated the continuity of the transition between print out and the

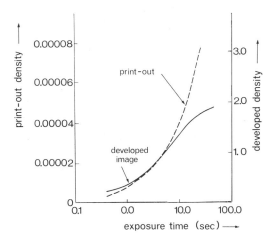

Figure 6.1. Comparison of density scales obtained by either print out or by development.

corresponding developed densities resulting from considerably less exposure (Figure 6.1). The extrapolation of the linear relationship between the absorbed energy and the amount of photolytic silver formed thus seems justified.

The formation of silver in photographic layers by direct exposure to X-rays has also been demonstrated by the neutron-activation technique by Tellez-Plasencia.[7] Here again the energy of exposure is greater than that normally employed in light exposure, but this result may also be extrapolated to this case.

6.1.2 The Mechanism of Latent Image Formation

The formation of photolytic silver as well as that of a latent image are closely related to the mobility of charge carriers within the crystals, and to the presence of impurities and structural imperfections. A basic mechanism proposed by Gurney and Mott in 1938 constitutes the foundation of the theory of latent image formation. Extended by several additional hypotheses, mainly those of Mitchell, required to solve several difficulties of the classical theory, it now allows a very satisfactory explanation of all intervening phenomena.

6.1.2a *The Gurney and Mott Principle*

Further to the results of their investigations on the electronic processes in ionic crystals, Gurney and Mott consider the formation of the latent image to occur in two distinct steps: the first, electronic, is related to the photo-conductivity of the silver halide crystals; the second, ionic, consists in progressive migration through the crystal of interstitial silver ions.[8] According to this hypothesis the energy supplied to the crystal by a photon first ejects an electron from the last orbit of the bromide ion into the conductivity band,

$$Br^- + h\nu \longrightarrow Br + \text{electron}, \tag{6.1}$$

setting it free to move across the crystal. Trapped on an impurity or a structural imperfection it then attracts an interstitial silver ion,

$$\text{electron} + Ag^+ \longrightarrow Ag, \tag{6.2}$$

and thus initiates the formation of a latent image which then further grows by repetition of the same cycle.

This clear separation by the Gurney and Mott hypothesis of the two processes, electronic and ionic, enabled Webb and Evans to devise an experimental check of the principle, based on the effect of temperature on ionic mobility.[9] Making use of a technique of intermittent exposures at liquid–air temperature, these experiments definitely demonstrate the separate existence of the two effects. A sample of film exposed at $-186°C$

during a given time yields, after warming up and development, much lower densities than a check exposed at +20°C (Figure 6.2a). Division of the exposure into two, four or eight fractions without any warming up of the samples between the fractional exposures leaves the result unchanged. However, heating the sample strips to room temperature during the interruptions yields densities which increase with the number of interruptions, thus demonstrating the existence of ionic migration (Figure 6.2b, c and d). The electronic mobility, independent of temperature, indeed remains

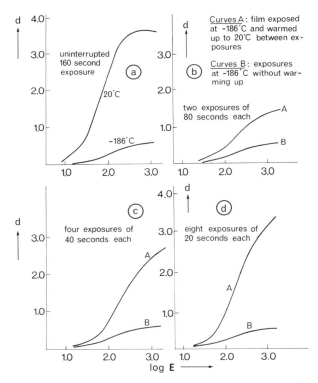

Figure 6.2. A check of the Gurney–Mott hypothesis by interrupted exposures at low temperature.

unchanged even at liquid-air temperature and the primary process, that of the ejection of an electron, occurs in both cases. The ionic mobility however is operative only at much higher temperatures: the partial latent images formed during the periods of reheating become definitive and add up to each other: the densities obtained after eight reheating cycles are practically equivalent to those resulting from an uninterrupted exposure at 20°C.

Other checks of the Gurney and Mott principle are based on the application of pulsed electric fields to silver halide crystals during their exposure. In the original experimental set-up by Haynes and Shockley an electrically insulated silver chloride crystal is placed between the electrodes of a condenser (Figure 6.3) with a semitransparent but conducting aperture in the negatively

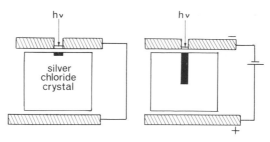

Figure 6.3. Action of a pulsed electric field applied to a silver chloride crystal during exposure.

charged plate.[10] Without an electric field the photolytic silver resulting from exposure to intense ultraviolet radiation forms in the immediate neighbourhood of the window: an electric field applied to the crystal however repels the photoelectrons from the negative electrode and shifts the print-out silver towards the interior of the crystal; this displacement conclusively demonstrates that the formation of photolytic silver occurs where the photoelectrons were trapped. Application of short impulses of electric potential, immediately followed by very short light flashes, as well as electrical insulation of the crystal, are indispensable in these experiments to avoid decomposition of the crystal by electrolysis. A similar technique applied under the microscope to crystals of photographic emulsions first by Webb[11] and later by Hamilton, Hamm and Brady[12] yields spectacular results (Figure 6.4). Without the electric field the photolytic silver deposits are randomly distributed all over the crystal, but by application of a pulsed field they form in the proximity of the crystal edges nearest to the positive electrodes.

6.1.2b *Complements to the Classical Theory*

The now classical Gurney and Mott hypothesis yields *a priori* a satisfactory explanation of the formation of photolytic silver by exposure, and by extension of that of a latent image, and therefore elucidates the sometimes quite involved behaviour of photographic layers; it leaves however several points unexplained, such as the action of the halogen released by the formation of the silver deposit, and the presence in the exposed crystals of positive holes competing with the also positive interstitial silver ions, and also the exact nature of the electron traps.

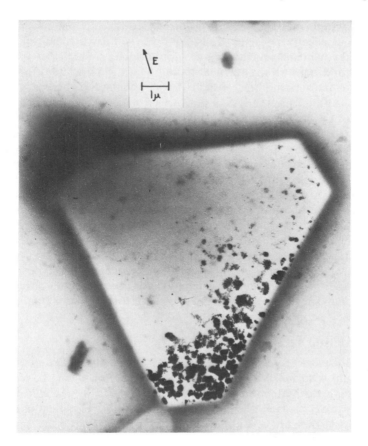

Figure 6.4. Formation of photolytic silver near the positive electrode under the influence of an electric field.

The Gurney and Mott hypothesis is based indeed on that formulated by Sheppard during his discovery of the origin of chemical sensitization (see References 28, 29 and 30 of Chapter 5), which attributes a role of electron traps to the sulphur ion inclusions in the silver halide crystals. To describe the exact nature of the mechanism of the capture of photoelectrons on these traps however requires additional explanation. According to Mitchell's investigations[13] and to those of Matejec,[14] the sulphur nuclei apparently first attract silver ions, i.e. positive charges capable of neutralizing photo-electrons and forming stable subimage specks by their loose contact with the silver sulphide. As it is possible however to form a latent image even after having eliminated the sulphur nuclei with bromine, it still remains possible

that other impurities such as crystal imperfections and also silver or gold form just as effective electron traps, acting by similar mechanisms to that proposed by Mitchell or Matejec for sulphur nuclei.

The second point of the classical theory which requires additional interpretation is the action of the 'positive holes', unbalanced charges within the crystals resulting from the loss of photoelectrons. Formed of a halide atom surrounded by positive silver ions, such 'positive holes' are capable of moving in small steps across the crystal only by the transfer of electrons without any actual ionic motion. The 'positive hole' might thus seem to be capable of entering in competition with an interstitial silver ion for the neutralization of a trapped photoelectron; if its activity were comparable with that of a silver ion the 'positive hole' could entirely inhibit latent image formation and thus altogether cancel the effect of an exposure. To solve this problem Mitchell[15,16] proposes a mechanism which reverses in some manner the initial Gurney and Mott principle. In this latter the first step is electronic and related to the ejection and capture of a photoelectron, whereas Mitchell proposes to let this step be preceded by an ionic movement: according to his hypothesis the interstitial silver ions are first attracted by crystal imperfections or impurities and form in this way true traps for the photoelectrons. Experimental evidence by Matejec[14] supports this theory.

6.1.3 Catalytic Action of the Latent Image

The principal feature of the modification of the silver halide crystals by an exposure is to make them developable; the action of the latent image, by favouring the reduction of the exposed crystals by the developer, is essentially catalytic and therefore influences the development kinetics.[17] By modifying the surface state of the exposed crystals in a few points the latent image initiates the transfer of electrons from the developer solution to the silver halide.

The mechanisms of this catalytic action was the subject of many investigations, and various hypotheses were formulated on its intrinsic nature; a recent hypothesis, taking into account the present knowledge on the actions of the species active in the initiation of development, is that by Trautweiler.[18]

The bulk of the *unexposed crystal* is characterized by its electronic configuration, i.e. by the absence of electrons in its conductivity band, of positive holes in its valence band (see p. 363), and by a given concentration of structural defects. The external surface of the crystal differs from the bulk by a potential difference and another distribution of the ionic defects; the lowest of its energy levels are filled with electrons whereas the higher lying ones are empty. Among these, the Fermi level is by definition that in which one half of the energy states are filled and the other half is empty. The developer, on the other hand, has its own Fermi level; when the crystal is brought in contact

with the developer solution these two levels balance by an exchange of electrons and by ionic movements; the resulting equilibrium is characterized by the compensation of the concentration gradients at the developer–crystal interface by stationary potential gradients. No rapid reduction of the crystal is then possible.

In the *exposed crystal*, on the contrary, the latent image creates in distinct points a particular surface state whose energy level, just less than the Fermi level of the developer, is empty. On bringing the exposed crystal in contact with the developer, an electron fills this level and is then balanced by the attraction of any of the positive charge carriers of the crystal, especially by an interstitial silver ion. The isolated silver atom formed in this way is however thermally unstable at the customary ambient temperatures (see p. 396); formation of a stable latent image therefore requires the succession of several fixations of photoelectrons followed by attractions of silver ions. Trautweiler has given a very explicit graphical representation of this process (Figure 6.5).

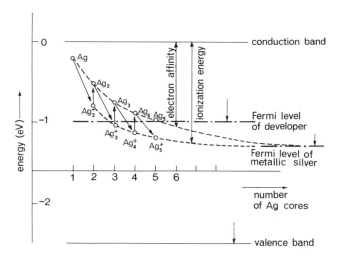

Figure 6.5. Energy levels during the reduction of a silver halide crystal.

According to his hypothesis the first silver atom formed by the exposure, Ag, easily fixes a silver ion with a high liaison energy and yields Ag_2^+, in turn neutralized by a new photoelectron; the two combined silver atoms Ag_2 then attract another silver ion and form Ag_3^+ which allows an increase of the latent image centre by the next photoelectron to three silver atoms; these again attract another silver ion and the process continues until the complete reduction of the crystal. Comparison of the energy levels of these aggregates

of silver atoms and ions with the Fermi level of the developer then makes it possible to determine the limit between the initial reduction of the crystal due to the exposure, and the subsequent continuation of the reduction by the developer.

Bayer and Hamilton[19] assume that this progression of alternate attractions of electrons and silver ions depends on the probabilities of growth and decay of the latent image, the first related to the electronic affinity (probability of electron trapping), and the second to the ionization energy (loss of a silver atom). The ratio of these two energy levels to the Fermi level of the developer determines the action of the latent image on the development of the crystal. As long as the ionization potential remains above the Fermi level, the silver atoms of the latent image centre can be oxidized; as soon as it descends below, the centre is stable. Similarly, as long as the electronic affinity remains above the Fermi level the trapping of an electron is highly improbable, but as soon as it decreases below it the centre traps an electron of the developer and the reduction then continues at a steadily increasing rate.

6.1.4 Spectral Sensitivity and the Latent Image

Exposure of a non dye-sensitized silver halide crystal to blue, violet, or ultraviolet radiation liberates, as mentioned before, an electron in a first step of latent image formation. In a crystal dye-sensitized to radiation of longer wavelengths, the analogous liberation of an electron by an appropriate exposure can be demonstrated by the same method as that employed for an unsensitized crystal, i.e. Haynes' and Shockley's technique of pulsed electric fields and exposure flashes described above, on page 388. Macrocrystals, overcoated with a monolayer of sensitizing dye by immersion into the dye solution, exhibit a displacement of the internal latent image or of the photolytic silver deposit identical to that observed in unsensitized crystals.[20] This experiment seems to confirm that latent image formation in a sensitized crystal does not differ from that in an unsensitized one irradiated in the spectral domain of its natural sensitivity. Experiments by West and Gilman (Reference 68 of Chapter 5) demonstrate that the primary result of an exposure is however different in these two cases. In an unsensitized crystal the incident radiation liberates electrons and positive holes which move across the crystal, but in the sensitized crystal only the free electrons are of the same kind, while the holes are trapped at the outside surface of the crystal. This intrinsic difference between the two mechanisms allows us to interpret the energy difference of the minimum number of quanta required to start latent image formation; it is equal to the energy necessary for the trapping of a hole and compensates for the lack of energy of the quantum of long wavelength relative to that acting on an unsensitized crystal.

The efficiency of spectral sensitization depends on the temperature of exposure. At very low temperatures, below minus 70°C, the silver halide is always less sensitive in the spectrally sensitized domain than in that of its inherent sensitivity.[21,22] This difference is attributed to the presence of a potential barrier which the liberated electron is to cross in a dye-sensitized crystal.[23] The energy level E of the dye in the excited state is sufficiently high for an electron to reach the conductivity band (Figure 6.6), but the electron must then still cross the potential barrier; made possible by the small mass of the electron this passage occurs by a tunnel effect.

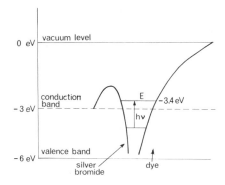

Figure 6.6. Potential barrier in a dye-sensitized silver halide crystal.

6.1.5 Latent Images Resulting from Ionizing Radiation

In many uses of the photographic materials the latent image is not obtained by exposure to radiation of the energy level of visible-light photons, but it results from the impact of particles of much higher energy, such as nuclear particles, high-energy electrons, or secondary electrons resulting from X- or gamma-photon hits. The initial steps of the formation of the latent image are in these cases very different from those due to visible light. The visible-light photon, of relatively low energy, is absorbed in the silver halide crystals by the creation of photoelectrons according to the mechanisms described in the preceding sections. The high-energy particle however penetrates solid matter much more easily and its energy is only absorbed successively along its path by various mechanisms, of which ionization is predominant in latent image formation. By the ejection of valence electrons this ionization in general makes pairs of negatively and positively charged ions appear; in the silver halide crystals these pairs are composed of conductivity electrons and positive holes. The former, after having been trapped, neutralize silver ions and form nuclei of latent image specks.

In the majority of cases the effect of a penetrating radiation, like X- or gamma-rays, is not the direct result of the radiation but it is accomplished by the secondary electrons which it produces. These latter can attain considerable speeds, particularly when the energy of the incident particles is much greater than that required for the ejection of the valence electrons. Latent image formation by penetrating radiation is therefore in many respects similar to that by very short and intense flashes of visible light, and the latent images are consequently of very small size and highly dispersed across the entire volume of the crystals. The relative sizes and the degree of dispersion of the latent images resulting from the various kinds of such radiations have been determined from electron micrographs by Hoerlin and Hamm.[24] These records confirm that latent images due to alpha and X-rays are much smaller and more dispersed than those resulting from exposure to visible light.

6.2 PROPERTIES OF THE LATENT IMAGE

Certain properties of the latent image, such as its distribution throughout the crystal or its keeping with time, have important practical consequences. The knowledge of *the topology of the latent image* which determines the ease of access of the active species of the developer, particularly in the early stages of development, makes it possible to explain satisfactorily the many complex phenomena occurring in photographic layers and by this means to resolve many difficult problems. *The keeping properties of the latent image*, on which the final result of a photographic recording depends until the beginning of development, is just as important.

6.2.1 Topology of the Latent Image

6.2.1a *External and Internal Latent Images*

Observation in the microscope of the print out of macrocrystals of silver halide shows the deposits of photolytic silver to form not only at the surface but throughout the whole volume of the crystals; a similar dispersity of the photolytic silver can also be observed in crystals of photographic emulsion when their size is sufficient for such observations.[25]

The demonstration that the latent image is similarly distributed dates back to the end of the last century; it was carried out in 1894 for the first time by Kogelmann who showed that exposed photographic layers could still be developed after dissolution of a thin surface layer of the silver halide crystals.[26] As the surface latent image was also eliminated from the crystals by the preliminary solvent treatment there could remain no doubt that development resulted from latent images initially hidden within the crystals. The main purpose of further researches of this kind was the determination of

latent image distribution under various experimental conditions; by succes-
sive dissolution either of the latent image silver fixed at the crystal surface
or of the silver halide covering and therefore hiding internal latent images,
Kempf[27] was able to show the presence of latent images within the entire
volume of the crystals. Berg,[28] Stevens[29] and West and Saunders[30] evaluated
the depth of internal latent images by similar techniques. The distribution of
the latent image within the crystals does not however follow a general rule
because it depends on several parameters, among which the most important
are the relative length and the energy level of the exposure and the processing
conditions (see below, p. 442). In particular it is difficult to distinguish
between the solvent action of the developer which uncovers internal latent
images and the formation during development of cracks in the crystals which
open passages for the developer ions into the interior of the crystals.

The sharing of the latent images between the crystal surface and the
interior of the crystals is in general independent of the spectral distribution
of the exposing radiation.[31]

6.2.1b *Determination of the Topology of the Latent Image*

Resulting from exposure as well as from development, the final photo-
graphic recording obviously depends to a big extent on the latent image
distribution within the crystal which determines the interaction between
these two parameters. The investigation of the behaviour of photographic
layers, and particularly of the origins of the so-called photographic effects
(see below, p. 406), therefore requires the determination of the contribution
of either external or of internal latent images to the development of the
crystals.

The usual method employed for the differentiation between these two
types of images is that devised by Berg, Marriage and Stevens.[31] It is based
on the use of developers showing either no solvent action whatsoever, or
being solvent for silver halides. The former only develop crystals carrying
surface latent images, but the solvent developers, by eliminating through
progressive dissolution of the crystals the halide which hides and protects
the internal latent images, are capable of developing those crystals which
while having been exposed do not carry surface latent images. Having of
course access to the internal latent images also, the solvent developers reduce
all exposed crystals to silver independently of the disposition of their latent
images. Before starting development it is therefore necessary to limit their
action only to those crystals which carry internal latent images, by eliminating
all surface latent images by an oxidizing treatment; in the presence of halide
ions such oxidization eliminates them entirely by rehalogenation. According
to another technique proposed by Stevens[33] all crystals carrying external
latent images are first developed in a non-solvent developer and the silver

formed eliminated by bleaching (see p. 483). Only the crystals carrying internal latent images are therefore reduced in the subsequent solvent development.

Among the special non-solvent developers which only act on crystals forming surface latent images, the most frequently employed are those developed by Berg, Marriage and Stevens,[31] and by Stevens,[29] which are free of sulphite and contain as developing agents either catechol or para-hydroxyphenylglycine, and those designed by James, Vanselow and Quirk[32] based either on elon-ascorbic acid or phenidone-ascorbic acid combinations also altogether without any sulphite (see also p. 468).

For the elimination of surface latent images many oxidizing agents can be employed, such as ferricyanides, bichromates, halogens, etc. While acting similarly on the surface latent images they differ considerably in their action on the internal latent images.

Two distinct techniques are known for the development of crystals with internal latent images: in the first, based on the progressive dissolution of the silver halide, developers of normal composition, to which the necessary amount of silver halide solvent has been added, are employed. Customarily the solvents are thiosulphates or thiocyanates; some 'internal' developers also contain sulphite. The addition of silver halide solvents to the developer has the advantage of allowing the use of a single basic formula for the development of the crystals with external latent images when employed without a solvent, as well as after addition of the solvent for the development of crystals with internal latent images; the developers containing ascorbic acid are particularly useful for this technique.[32]

The second method of development of crystals with exclusively internal latent images is based on the formation of deep cracks giving access to the crystal interior by ions able to crack up the crystals, such as for instance iodide ions present in the developer in sufficiently high concentration.[29]

To lead to valid conclusions the results of investigations on latent image distribution are expressed in mass of developed silver per unit surface rather than in optical density. Indeed the presence of the silver halide solvents in the internal developers gives rise to the physical development of a non-negligible fraction of the total mass of reduced silver and thus act on the covering power.[34] Qualitative evaluations based on measurements of optical density are however valid and also yield useful information.

6.2.2 Latent Image Keeping

The lapse of time which in practice separates the exposure from the development of a photographic layer can be extremely variable. Satisfactory keeping of the latent image within this time interval is indispensable for making the final result correspond to the imagewise exposure. In the case of

exposure by radiation of low energy or by very short intermittent light flashes it might happen, on the other hand, that the latent image does not attain a sizeable dimension during its formation so that it redisintegrates in the course of the exposure. The concept of 'minimum size' of the latent image has therefore a great practical importance.

6.2.2a *The Size of the Latent Image*

A single silver atom formed in a photographic layer by the absorption of a photon according to the Gurney and Mott principle does not give rise to a stable latent image. At the customary ambient temperatures thermal agitation leads to the ejection of an electron from the freshly formed silver atom and the result of the exposure is lost. Katz[35] and Webb[36] attempted to determine the time of survival of an isolated silver atom by very low energy exposures and also by short successive flashes. For the emulsion he used Webb found as critical period of existence of a single silver atom a time of eight seconds, but other experimental evidence seems to show that an electron migrates during this time lapse many times from one silver ion to another before being definitively lost.

Webb's experiments demonstrate however that a latent image formed by two silver atoms is stable. An initial requirement for stabilizing the first silver atom appears to be its fixation onto an impurity in the crystal lattice, and it further appears to be necessary for the trapped electron to have lost an amount of energy too great for being again ejected only by thermal agitation. This makes attraction of a second interstitial ion possible and therefore the formation of a second silver atom. Successive repetition of this process builds up an increasingly stable latent image and even photolytic silver i.e. a print-out image, by prolonged and excessive exposure.

The smallest size of a latent image which makes a crystal developable is quite variable; indeed it depends on so many factors that it is impossible to determine a 'critical' size above which one single additional silver atom would lead to development. According to Mitchell[37] there appears to exist in the behaviour of a silver halide crystal a discontinuity which results from the assembly of three silver atoms capable of forming with one interstitial silver ion a positively charged tetrahedral configuration. Other authors propose for a latent image to be efficient a minimum of four, six or even more silver atoms. It is certain however that the bigger the latent image, the better the keeping in time of the crystal's ability to develop.

6.2.2b *Latent Image Keeping in Practice*

The modification of a silver halide crystal by an exposure sufficiently large to catalyse its reduction by the developer, while of atomic size, is astonishingly stable. According to the widely varying conditions of use of the

photographic materials, development may follow the exposure immediately or only after a certain lapse of time. Of a duration of only a few seconds for an oscillograph trace recording or for a document copy, where rapid access to the result is of primary importance, this interval may more often be quite long and even last several months, as for instance for amateur films left in the camera between two periods of vacation. All modern photographic materials are designed for keeping constant the result of an exposure in spite of the great variability of the time interval between exposure and development; very unfavourable keeping conditions after the exposure, such as high temperature or humidity, can make some or all of a latent image fade.

In particular conditions which make the latent image steadily disappear again during the actual exposure, its atomic dimension has also an influence on the final result. Lasting in the majority of cases only a small fraction of a second, the exposure can however also be very long when the illuminance of the subject is very low, such as in astronomy, where exposures of an hour or more are frequent to allow the recording of very small stars of low luminance, but it can on the contrary also be restricted to short flashes lasting only a few microseconds; in still other cases it can be necessary to use an intermittent succession of exposure of very short duration. All these exposure conditions, specific of particular but not very frequent uses of the photographic materials, influence latent image formation and therefore yield results which sometimes may not seem to correspond to the recorded amount of radiation, either because the rate of incidence of the photons is too sluggish, or because they are not numerous enough to form the latent image faster than it disintegrates by thermal agitation. It may also happen that too many photons arrive simultaneously to be able to take part efficiently in the modification of a silver halide crystal. The knowledge of the mechanism of latent image formation allows in each case the correct interpretation of these effects.

Keeping of latent images due to ionizing radiation depends on its energy level and also on the conditions of storage. Of very small size and highly dispersed across the crystal volume, these latent images undergo during long keeping, particularly in relatively humid environment and at high temperature, a redistribution which makes the internal images grow at the expense of the superficial ones. Their satisfactory keeping therefore depends on the initial ratio of these two types of latent image, and consequently on the energy of the X, gamma or other radiation; the latent image formed by low energy X-rays, for instance, is more stable than that due to the gamma rays of Cobalt 60.

6.3 INTEGRATION FAILURES AND PHOTOGRAPHIC EFFECTS

The effects resulting from defective formation of the latent image or of its unsatisfactory keeping have not only been the subject of many investigations,

but they have also played an important historic role in the researches on the intrinsic nature of the latent image. Less important in current practical applications of modern photographic materials than of those in use at the beginning of the century—reciprocity failure excepted—they still remain of practical as well as of theoretical interest; their discussion makes it possible to test on the one hand the various hypotheses on latent image formation, and on the other hand gives insight into the practical behaviour of the silver halide sensitive layers.

6.3.1 Reciprocity Effects

The primary photochemical phenomena obey Bunsen–Roscoe's law which states that the mass of a compound formed by a photochemical reaction, i.e. one exclusively due to the effect of a radiation, only depends on the total energy absorbed, but not on the rate of this absorption.[38] The effect of the photochemical reaction is therefore proportional to the product of the active incident flux by the time of its action. Each of these two parameters being inversely proportional to the other, Bunsen–Roscoe's law is also called 'reciprocity law'.

6.3.1a *The Non-observation of Reciprocity and its Origins*

The complexity of the mechanisms underlying the formation of a developed photographic image obviously excludes the observation of such a simple law. It can apply strictly only to the formation of a photoelectron; the loss of this latter due to the lack of efficient traps, or to the missed attraction of a silver ion by a liberated and trapped but not sufficiently stable electron, would be sufficient to invalidate it. The formation of the final image by development, not necessarily triggered by every available latent image, constitutes a still more important element for the non-observation of the reciprocity law. Quite generally, the evaluation of a photographic result is finally based on its optical density and not on the mass of the silver deposit; the failure proper of the reciprocity law is therefore still hidden partly by the level of the covering power of the silver deposit which forms the developed image.

When exposing a photographic layer to variable illuminances E and times t, while keeping constant the product of these two parameters, optimum efficiency of the exposure is attained only within rather narrow limits of the illuminance. Above and below this level the total energy required to yield a given density—all other conditions remaining unchanged—is greater than its optimum value. This behaviour of a developed photographic layer is customarily represented in a graph which shows for a number of chosen densities the relationship between the total incident energy and the intensity of the active flux (Figure 6.7). Constant illuminance (or flux) appears in this diagram as vertical straight lines, and constant exposure times as straight lines of slope $+1$. The curves representing the total energy necessary for

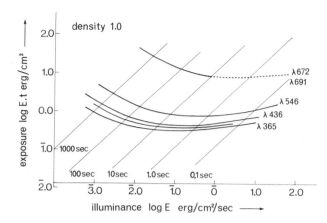

Figure 6.7. Typical reciprocity behaviour of a photographic layer.

yielding any given density have approximately the form of the catenary function, and therefore not only show the domain of optimum illuminance level, but also demonstrate that more energy is required for a given density at lower as well as at higher illuminance levels. Two different effects can therefore be observed, one at high, the other at low illuminance.

At high illuminance the rate of photon incidence is too great and many liberated electrons cannot find free traps to fix themselves at the crystal surface. Some migrate into the interior of the crystal and others are lost outside it or taken up again into the crystal lattice. The silver ions, which in a second step would normally form the latent image by neutralizing the photoelectrons, migrate too slowly to join them immediately after their ejection by the incident radiation. The resulting energy loss compels us to apply a greater total exposure than at optimum illuminance level. This defect is closely related to the great dispersity of the latent images formed by high-energy radiation (see above p. 393).

At the other end of the scale, at low incident flux, reciprocity failure has another origin. In this case the rate of energy incidence is low and the ejection of photoelectrons less frequent, so that enough time would be available for the silver ions to combine with the free electrons to start building up a latent image. The number of silver atoms formed is however not sufficient to give it the required stability (see p. 396); most of the latent image specks redisintegrate under the effect of thermal agitation before having had the time to be sufficiently reinforced. This results again in an energy loss and more exposure is also required than at the optimum illuminance level.

These two hypotheses on the mechanism of the non-observation of reciprocity are based on a number of experimental results, among which the

most important are those due to exposure at very low temperatures. Such experiments carried out by Webb and Evans[9] demonstrate the strong temperature dependence of reciprocity; Figure 6.8 summarizes these results.

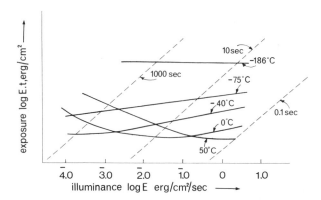

Figure 6.8. Dependence of reciprocity failure on the temperature prevailing during exposure.

At very high illuminance the efficiency of the exposure decreases steadily with temperature according to the mechanism described above. At low illuminance, however, the total exposure required for the obtention of a given density diminishes first with decreasing exposure temperature and then rises again. At some rather low temperature an equilibrium is established between the sluggishness of the ionic migration and the thermal disintegration of the latent image; the efficiency is then at its optimum. Exposure at still lower temperatures makes the ionic movement slow down still farther and again increases the loss of efficiency.

At liquid-air temperature, at $-186°C$, reciprocity is perfectly observed, on condition however of an exposure much greater than at room temperature. At this low temperature there occurs no more ionic migration and the latent image can only form during the period of warming up prior to development, by a small number of solidly trapped photoelectrons. However as in this case ionic immobility during the exposure is the predominant factor, the energy level of the incident flux remains without influence.

Within the customary spectral limits of visible light photography, and in the near ultraviolet, reciprocity failure is independent of the wavelength of the exposing radiation (Figure 6.7).

The essential differences between the latent images due either to a very high or a very low illuminance of exposure are their distribution within the crystals and the degree of their dispersion. At low illuminance, when

the slow incidence of the photons leaves the silver ions time enough to join the photoelectrons, the latent images are mostly superficial and of rather large size, but each crystal only contains a few silver specks. At high level of illuminance, on the contrary, when the high rate of photon incidence makes numerous photoelectrons migrate into the interior of the crystals, a great number of internal latent images of small size form besides those at the surface. According to Baker[39] this dispersity is due to the predominance of the probability of latent image nucleation, i.e. formation of two silver atom aggregates, over that of their growth: the rapid incidence of a great number of photons gives rise to the formation of many latent image specks but these remain small in size. Bayer and Hamilton[19] showed by computation that the inefficiency of latent image speck growth must necessarily lead to the non-observation of reciprocity at high exposure levels.

6.3.1b *The Observation of Reciprocity with Exposures of Very Short Duration or to Ionizing Radiation*

No reciprocity effect can occur when the exposure time is shorter than the minimum time required to neutralize a trapped photoelectron by an interstitial silver ion. Only a small number of photoelectrons strongly fixed onto crystal imperfections or impurities contribute in this case to latent image formation, while all others are lost, and the final yield is as low as with exposures at very low temperatures. Berg demonstrated the occurrence of this situation for exposure times shorter than 10^{-5} seconds independently of the type of crystal or the density level.[40] For still shorter exposures the reciprocity curve therefore shows an inflection towards the horizontal (Figure 6.9).

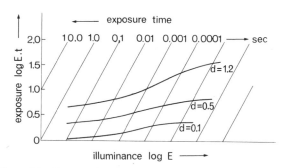

Figure 6.9. Absence of reciprocity failure at very short exposures.

For the same reason reciprocity is perfectly observed for exposure to X-rays. Here the secondary electrons resulting from the ionizing radiation cross the silver halide crystal in still shorter times, of the order of 10^{-12} seconds or less, and the exposure falls entirely within the horizontal part of

the reciprocity curves. As it is further known that each X-ray quantum of average or low energy makes only one single crystal developable,[41,42,43] the effect of exposure to ionizing radiation is entirely independent of the total actual exposure time.[44] This property is particularly important in dosimetry were the radiation recorded during quite variable times can be of various nature and intensity.

The absence of reciprocity effects also leads to the complete absence of intermittency effects for X-ray and gamma exposures (see below, p. 404).

6.3.1c *The Practical Incidence of Reciprocity Failure*

It is obvious that photographic materials are designed for highest efficiency under the customary and most frequent conditions of their use. Specific working requirements may however oblige us to choose sometimes either extremely short exposures at very high illuminance levels, or on the contrary, when the illuminance is low, to expose for long times. In both cases the reciprocity effects make themselves felt either by underexposure or by a contrast change, or by both. They must be compensated for either by an appropriate change of the lens stop setting, in the case of a camera exposure, or else by an adjustment of development time. A typical table for such compensation of reciprocity effects for negative black-and-white films would indicate the corrections as shown in Table 6.1, in which the numerical values are only given as an example.

TABLE 6.1

Exposure time (seconds)	Change of the time of development	Change of lens stop
0·001	—	plus $\frac{1}{2}$ stop
0·01	—	—
0·1	shorter by 10%	plus $\frac{1}{2}$ stop
1·0	shorter by 25%	plus $\frac{2}{3}$ stop
10·0	shorter by 30%	plus $1\frac{2}{3}$ stops
100·0	shorter by 35%	plus $2\frac{2}{3}$ stops

In colour films a non-negligible variation of colour balance adds further to these effects, because of the specific reciprocity response of each of the sensitive layers contributing to three-colour reproduction. As contrast adjustments are obviously not possible in this case (see p. 457) the standard processing cycle is maintained, but the exposure correction is further completed by filtration for colour balance correction; this latter is indispensable for colour reversal film which yields positive images directly (see p. 474), and

the reciprocity failure compensation table has then the following form (Table 6.2), the numerical values being again only given as an example.

TABLE 6.2

Exposure time (seconds)	Change of lens stop	Filtration
0·001	—	—
0·01	—	—
0·1	open by $\frac{1}{2}$ stop	CC05R† compensating filter
1·0	open by $\frac{2}{3}$ stop	CC10R† compensating filter
10·0	open by $1\frac{1}{3}$ stops	CC20R† compensating filter
100·0	open by 2 stops	CC25R† compensating filter

† Designation of a red colour compensating filter of density 0·05, 0·10, etc.

6.3.2 Intermittent Exposures

Exposure to an illuminance E for a total time t, divided into n partial exposures of times t/n, yields in general after development not the same density as a continuous exposure of identical total energy $E.t$. The imperfect integration by the photographic layer of the divided exposure is known as intermittency effect: Webb showed that it is closely related to reciprocity failure which depends, as discussed before, on the rate of photon incidence.[45]

At low illuminance levels the exposure consists intrinsically only of separate photon impacts on each crystal, rather distant in time. Its periodic interruption increases the probability of thermal disintegration of the freshly formed silver atoms prior to their reinforcement or the building up of a stable latent image, and therefore still further reduces the already limited action of the low-level exposure. At high illuminance levels, on the contrary, when the photons incident during continuous exposure would be too numerous to make all simultaneously liberated photoelectrons contribute to latent image formation, the intermittency of the exposure leaves the interstitial silver ions the time required to neutralize the available electrons, and consequently increases the efficiency of the exposure. The importance of these two effects, opposite according to the illuminance level, obviously depends on the frequency of the exposure interruptions.

Indeed the efficiency of an intermittent exposure varies only within limited frequency domains. At very low frequencies the interruptions of the exposure have no effect and either a continuous or an interrupted exposure of identical duration yield the same result. However, with increasing frequency the result finally approaches that of a continuous exposure to an illuminance equal to the mean of that of the interrupted exposures. This level

is attained from a critical frequency f_c on and then remains constant for all higher frequencies.

The continuous exposure appears indeed to be equivalent to an intermittent one when quantized photon incidence is taken into account. Each crystal is only periodically hit by a photon, even during exposure to high illuminance, and from the critical frequency on both kinds of exposures, continuous and intermittent, become equal. Applying to this statistical phenomenon by analogy the same reasoning as that employed for the computation of the paths of molecular motion in a gas, Webb[45] was able to show that this critical frequency is equal to the product of the projective area of the crystal and the mean of the partial exposure illuminance,

$$f_c = a\,\bar{E}. \tag{6.3}$$

According to the type of emulsion the critical frequency lies in general between 100 and 1000 cycles per second. Intermittency being directly related to reciprocity failure, the influence of the frequency of interruptions evidently depends, like this former, on the illuminance level. It is therefore represented in a graph which shows the relationship between these two parameters, exposure interruption frequency and illuminance (Figure 6.10).

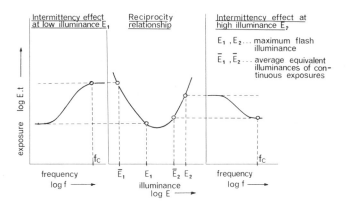

Figure 6.10. Influence of the exposure luminance level and of the frequency of exposure interruption on the intermittency effect.

In practice the intermittency effect is encountered mainly when the exposures consist of successions of short flashes or individual electrical discharges, as for instance those of oscilloscope screens of a scanning frequency near the critical frequency, or in phototypesetting where the exposure of each letter results from several flashes of only a few microseconds duration. These exposures, adequate in one single flash for letters of small size, are

however not sufficient for big lettering or titles which require a succession of two, three or more flash exposures including those necessary to compensate the energy loss due to the intermittency effect.

6.3.3 The Clayden Effect and Other Desensitizations

Formation of a great number of finely dispersed latent image specks resulting from the simultaneous incidence of a great number of photons during a short flash of high intensity gives rise also to another effect: a first exposure of this kind apparently desensitizes the layer towards another of lower illuminance and longer duration. Observed for the first time by Clayden in 1889 during an investigation on atmospheric discharges,[46] this effect can also be due to an X-ray exposure or a mechanical stress acting on the photographic layer.

The great number of internal silver specks of small size resulting either from the first exposure to a very strong and highly penetrating radiation or to a deformation of the crystals, constitute electron traps of greater efficiency than the natural traps on the crystal surface.[47,48] During the second exposure the photoelectrons fix themselves only on these former and therefore do not contribute to the formation of surface latent images, necessary to make the crystals developable in the customary low-solvent developers. Processing in a solvent developer, capable of also reducing crystals carrying only internal latent images, makes the Clayden effect disappear.

Desensitization by mechanical pressure applied to the sensitive layer or by slight bending of the sensitive silver halide crystals, resulting from accidental folding of a film prior to its exposure, also leads to predominant formation of internal latent images.[49] This effect appears to be frequently related to the migration into the interior of the crystals of sulphur ions which, prior to the deformation, formed surface sensitivity specks.

6.3.4 The Villard Effect

The photographic result of an X-ray exposure can be eliminated by a uniform flash of visible light of low luminance.[50] This effect can also be observed when the first exposure to X-rays is replaced by a short, high-intensity flash of visible light.[51] The origin of the Villard effect is different from that of the Clayden effect: bathing the layer in a halogen acceptor solution prior to development considerably reduces the first or even eliminates it, whereas this treatment intensifies the Clayden effect. The Villard effect is therefore considered to be related to the mechanism of solarization described hereafter: the first exposure of high energy, strongly penetrating, forms a great number of latent image specks at the surface as well as in the interior of the crystals, but the second exposure rehalogenizes the surface specks by an excess of liberated halogen. Occurrence of either the Villard or the Clayden

effect therefore depends mainly on the constitution of the crystals, i.e. on the specific nature of the layer.

In certain particular cases the first exposure to X-rays can even sensitize the layer towards the second uniform exposure; this is the Becquerel effect.[52]

6.3.5 Solarization

Above a certain level, lower however than that required for the formation of print-out silver, less density results after development than by an exposure yielding maximum density at the upper end of the sensitometric scale.[53] Not all emulsions show this behaviour to the same extent and especially modern film emulsions never give rise to solarization under their normal conditions of use.

Solarization has its origin in the rehalogenation of the surface latent image by excessive exposure. During the formation of photoelectrons by any exposure a corresponding number of halogen atoms is also produced; however, if the exposure is continued after obtention of an optimum number of latent image centres, which with standard processing would yield the highest density attainable with a given material, the surplus of halogen exceeds the capacity of acceptation by the surrounding gelatin. This excess of free halogen reacts with the initially formed surface latent image silver and reduces the yield of the exposure.[54]

6.3.6 The Herschel Effect

A latent image formed in a photographic layer without any sensitivity to red light can be eliminated by an additional exposure to radiation of much greater wavelength, generally to light of red or orange colour. Discovered by Herschel in 1840,[55] this effect is essentially due to the ejection of electrons from the latent image specks formed by the first exposure and followed by the migration of the resulting silver ions until their reintegration into the crystal lattice.[8] A similar effect can also be obtained with the photolytic silver formed in silver halide macrocrystals by strong exposure to ultraviolet radiation, i.e. with F-centres. Strongly absorbing at the long wavelength end of the visible spectrum, and also in the infrared, the F-centre deposits can be erased by exposures within these spectral domains.[4]

Just as the other photographic effects, the Herschel effect has given rise to a great number of researches and several kinds of 'Herschel effects' are therefore known: according to the experimental conditions it may occur that the latent image due to the first exposure is either eliminated altogether or only modified in its distribution across the crystal. The Herschel effect can indeed be observed only with very small and relatively unstable latent images and progressively disappears with increasing latent image stability. Intensification by gold or mercury, for instance by an after-treatment such as

latensification, eliminates it altogether.[56] The exposure level of the long wavelength radiation capable of yielding a Herschel effect is considerably greater than that sufficient for the first exposure which forms the latent image. According to Webb and Evans the energy required is about one million times greater.[9]

The Herschel effect has an important practical application in films designed for the obtention of direct positive images. Fogged by the manufacturer for yielding maximum density without any additional exposure, their initial fog is imagewise eliminated by exposure to yellow or orange light. Those areas which by this exposure would have been made entirely transparent can then be employed again to form a negative image by further exposure to blue or ultraviolet light. This new image can in turn again be blotted out partially or entirely by a further exposure to long-wavelength radiation, and this alternance of positive and negative images can be carried on as far as desired.

6.3.7 Other Effects

Examination of the origin of the well known integration failures shows that many other exposure successions can readily be imagined for the creation of the most varied new effects, as well as the introduction between the exposures of chemical treatment either by oxidizing or reducing solutions. A certain number of effects were thus discovered within the framework of the researches on the nature of the latent image. Besides those described above in detail the most important are:

Desensitization by exposure to low-intensity radiation. This effect, currently called L.I.D. (Low intensity desensitization) is the opposite of the Villard effect. A modulated exposure to low-energy radiation preceding a second very short exposure of high energy, or to X-rays, yields under certain conditions a direct positive image. The initial internal latent images, of rather big size and few in number, apparently attract during the second exposure the surface latent image specks of the first exposure into the interior of the crystals; they further prevent the formation of external latent images by the second exposure.[57]

The Debot effect. A layer with crystals of almost exclusive internal sensitivity is fogged and any trace of surface latent image altogether eliminated by an oxidizing treatment. A modulated exposure to red light or to infrared radiation of wavelengths up to 1200 nm then yields a positive image; it results from a Herschel effect which redistributes at the crystal surface the internal fog silver intitially formed.[58]

The Albert effect. After a first uniform exposure yielding internal as well as surface latent images, and erasing of these latter by an oxidizing treatment,

a second modulated exposure forms directly a positive image, due again to competition between the internal latent images of the first exposure and those built up during the second one.[59]

The Sabattier effect. Uniform exposure after partial development of a normal photographic image superimposes onto it after the completion of development a reversed image and thus leads to various pictorial effects. This partial reversal, discovered by Sabattier in 1860 and erroneously called 'solarization' in the literature on pictorial and artistic photography, can be obtained either by rinsing the material after the interruption of development or without this rinse. In the latter case the developer reaction products (see p. 156) create transparent border lines between the areas darkened by the first and by the second exposure.[60]

These effects, as well as others omitted here, are very frequently described in the general photographic literature; a rather complete list of the pertinent references on this subject can be found in the treatise on Photographic Theory by Mees and James.[61]

REFERENCES

1 Koch, P. P., and Vogler, H., Ueber die Ausscheidung von Silber aus Silberhalogeniden durch intensive Belichtung. *Ann. Phys.*, (4) **77** (1925), 495.
2 Berry, C. R., and Griffith, R. L., Structure and growth mechanism of photolytic silver in silver bromide. *Acta Cryst.*, **3** (1950), 219.
3 Trillat, J. J., Microscopie électronique. *C.R. Acad. Sci.*, **236** (1953), 60.
4 Hilsch, R., and Pohl, R. W., Zur Photochemie der Alkali-und Silberhalogenidkristalle. *Z. Physik*, **64** (1930) 606.
5 Meidinger, W., Untersuchungen über Masse und Verteilung des photolytisch gebildeten Silbers in Bromsilber—Gelatine Emulsionen VI. *Z. Physik.*, **44** (1943), 1.
6 Nail, N. R., Moser, F., and Urbach, F., An incremental photometer and optical measurements in the photographic latent image range. *Jl. Opt. Soc. Am.*, **46** (1956), 218.
7 Tellez-Plasencia, H., Emploi des radio-isotopes pour l'analyse de l'argent primaire ou développé dans les émulsions photographiques. III. Mesure de l'argent photolytique de l'image latente. *Sci. Ind. Phot.*, (2) **30** (1959), 385. Sur les quantités d'argent photolytique libéré à la surface et dans la masse des microcristaux de bromure d'argent. *Sci. Ind. Phot.*, (2) **31** (1960), 465.
8 Gurney, R. W., and Mott, N. F., The theory of the photolysis of silver bromide and the photographic latent image. *Proc. Roy. Soc. London*, Ser. A. **164** (1938), 151.
9 Webb, J. H., and Evans, C. H., An experimental study of latent image formation by means of interrupted and Herschel exposures at low temperature. *Jl. Opt. Soc. Am.*, **28** (1938), 249.
10 Haynes, J. R., and Shockley, W., The trapping of electrons in silver chloride. *Minutes of the Conference on the strength of solids*, *Univ. Bristol, 1947*, The Physical Society, London, 1948, p. 151.

11 Webb, J. H., Ultrashort light and voltage pulses applied to silver halide crystals by turbine-driven mirror and spark-gap switch. *Jl. Appl. Phys.*, **26** (1955), 1309.

12 Hamilton, J. F., Hamm, F. A., and Brady, L. E., Motion of electrons and holes in photographic emulsion grains. *Jl. Appl. Phys.*, **27** (1956) 874.

13 Mitchell, J. W., Photographic sensitivity. *Rept. Progr. Phys.*, **20** (1957), 433.

14 Matejec, R., Zur elektrischen Störleitung in Halogensilber-Einkristallen. *Naturwissenschaften*, **43** (1956), 533.

15 Mitchell, J. W., and Mott, N. F., The nature and formation of the photographic latent image. *Phil. Mag.*, **(8) 2** (1957), 1149.

16 Mitchell, J. W., Photographic sensitivity. *Jl. Phot. Science*, **6** (1958), 57. The nature and formation of the photographic latent image. *Jl. Phot. Science*, **9** (1961), 328.

17 James, T. H., Catalytic phenomena related to photographic development. In *Advances in Catalysis*, vol. **2**, p. 105, Academic Press, New York, 1950.

18 Trautweiler, F., Implications of a quantum model of the latent image. *Phot. Sci. Eng.*, **12** (1968), 138.

19 Bayer, B. E., and Hamilton, J. F., Computer investigation of a latent image model. *Jl. Opt. Soc. Am.*, **35** (1965), 439.

20 West, W., and Saunders, V. I., Photographic and dye-desorption studies in thin crystals of silver bromide. *Wissenschaftliche Photographie (Conference Cologne 1956)*. Dr. O. Helwich, ed., Darmstadt, 1958, p. 48.

21 West, W., Temperature dependence of spectral sensitization by dye series of regularly increasing chain length and the mechanism of spectral sensitization. *Phot. Sci. Eng.*, **6** (1962), 92.

22 Frieser, H., Graf, A., and Eschrich, D., Untersuchungen über die Temperaturabhangigkeit der spektralen Sensibilisierung, der Ubersensibilisierung und Desensibilisierung photographischer Schichten. *Z. f. Elektrochemie*, **65** (1961), 870.

23 Dörr, F., and Scheibe, G., Modellbetrachtungen zum Mechanismus der spektralen Sensibilisierung. *Z. Wiss. Phot.*, **55** (1961), 133.

24 Hoerlin, H., and Hamm, F. A., Electron microscopical studies of the latent image obtained by exposures to alpha particles, X-rays, and light. *Jl. Appl. Phys.*, **24** (1953), 1514.

25 Meidinger, W., Untersuchungen über Masse und Verteilung des photolytisch gebildeten Silbers in Bromsilber Gelatine Emulsionen verschiedener Korngrösse. *Physik. Z.*, **38** (1937), 564, 737 and 905.

26 Kogelmann, F., *Die Isolierung der Substanz des latenten photographischen Bildes*. Thesis, Graz 1894.

27 Kempf, A., Zur Topographie des latenten photographischen Bildes. *Z. Wiss. Phot.*, **36** (1937), 235.

28 Berg, W. F., Latent image formation and Herschel effect. *Phot. Jl.*, **87B** (1947), 112.

29 Stevens, G. W. W., The depth of internal latent image. *Jl. Phot. Sci.*, **1** (1953), 122.

30 West, W., and Saunders, V. I., Experimental studies of the mode of action of sensitizing impurities in thin crystals of silver bromide. *Phot. Sci. Eng.*, **3** (1959), 258.

31 Berg, W. F., Marriage, A., and Stevens, G. W. W., Latent image distribution. *Jl. Opt. Soc. Am.*, **31** (1941), 385.

32 James, T. H., Vanselow, W., and Quirk, R. F., Developer for use in determining the distribution of the latent photographic image. *PSA-Jl. (Phot. Sci. Tech.)*, **19B** (1953), 170.

33 Stevens, G. W. W., Exclusively internal latent image. *Jl. Phot. Sci.*, **9** (1961), 322.

34 James, T. H., and Vanselow, W., Influence of the development mechanism on the color and morphology of developed silver. *Phot. Sci. Eng.*, **1** (1958), 104.

35 Katz, E., On the photographic reciprocity law failure and related effects. *Jl. Chem. Phys.*, **17** (1949), 1132.

36 Webb, J. H., Low intensity reciprocity law failure in photographic exposure. I. Energy depth of electron traps in latent image formation *Jl. Opt. Soc. Am.*, **40** (1950), 3. II. Multiple quantum hits in a critical time period. *ibid.*, **40** (1950), 197.

37 Mitchell, J. W., Photographic sensitivity. *Sci. Ind. Phot.*, **(2) 28** (1957), 493.

38 Bunsen, R. W., and Roscoe, H. E., Photochemische Untersuchungen der Physik und Chemie. *Pogg. Ann. Physik. Chem.*, **(2) 117** (1862), 529.

39 Baker, E. A., A quantitative theory of the photographic action. *Jl. Phot. Sc.*, **4** (1956), 101.

40 Berg, W. F., Reciprocity failure of photographic materials at short exposure times. *Proc. Royal Soc. London*, Ser. A. **174** (1940), 559.

41 Eggert, J., and Noddack, W., Über die Quantenausbeute bei der Wirking von Röntgenstrahlen auf Silberbromid. *Z. Physik.*, **43** (1927) 222.

42 Eggert, J., Die Empfindlichkeit photographischer Emulsionen für Röntgenstrahlen in Abhängigkeit von der Korngrösse. *Z. Elektrochem.*, **36** (1930), 750.

43 Silberstein, L., and Trivelli, A. P. H., The quantum theory of X-ray exposures on photographic emulsions. *Phil. Mag.*, **(7) 9** (1930), 787.

44 Corney, G. M., X-ray and gamma ray exposures. In C. E. K. Mees and T. H. James, *The Theory of the Photographic Processes*, 3rd edition, Macmillan, New York; Collier-Macmillan, London, 1966, p. 188.

45 Webb, J. H., The relationship between reciprocity law failure and the intermittency effect in photographic exposure. *Jl. Opt. Soc. Am.* **23** (1933) 157.

46 Clayden, A. W., Note on some photographs of lightning and of 'black' electric sparks. *Proc. Phys. Soc. London*, **10** (1889), 180. J. M. Eder, Eine neue Lichtwirkung. *Jahrb. Phot. Repr. Techn.*, **14** (1900), 532.

47 Lüppo-Cramer, H., Zur Kenntnis der Albert'schen Bildumkehrung. *Phot. Korr.*, **72** (1936) 17.

48 Arens, H., Zur Deutung der photographischen Umkehrungserscheinungen. *Z. Phys. Chem.*, **114** (1925), 337.

49 Kowaliski, P., Experiments on the effects of film kinking. *Jl. Phot. Sc.*, **14** (1966), 282. Quelques expériences sur les effets de la pliure d'un film. *Sci. Ind. Phot.*, **(2) 36** (1965), 109.

50 Villard, P., Les rayons-X et la photographie. *Bull. Soc. Encour. Ind. Nat.*, **4** (1899), 1518.

51 Arens, H., and Eggert, J., Die Schwärzungsfläche des Villardeffektes. *Z. wiss. Phot.*, **30** (1931), 121.

52 Becquerel, E., Recherches sur les rayonnements chimiques qui accompagnent la lumière solaire, et la lumière électrique. *C.R. Acad. Sci.*, **12** (1841), 101.

53 Lüppo-Cramer, H., *Photographische Probleme*. Halle a.S. 1907.

54 Webb, J. H., and Evans, C. H., Experiments to test the rebromination theory of photographic solarisation. *Jl. Opt. Soc. Am.*, **30** (1940), 445.

55 Herschel, J. F. W., On the chemical action of the rays of the solar spectrum on preparations of silver and other substances both metallic and non-metallic and on some photographic processes. *Phil. Trans. Roy. Soc. (London)*, **131** (1840), 1.

56 Fortmiller, L., James, T. H., Quirk, R. F., and Vanselow, W., The combined effect of infrared radiation and intensification upon the photographic latent image. *Jl. Opt. Soc. Am.*, **40** (1950), 487.

57 Maurer, R. E., and Yule, J. A. C., A photographic low intensity desensitization effect. *Jl. Opt. Soc. Am.*, **42** (1952), 402.

58 Debot, R., L'effet Herschel sur l'image photographique partiellement détruite par l'acide chromique. *Bull. Soc. Roy. Sci. Liège*, **10** (1941), 675.

59 Albert, E., Ueber das latente Bild. *Arch. Wiss. Phot.*, **1** (1899), 285.

60 Sabattier, M., Positifs directs sur collodion. *Bull. Soc. Française de Phot.*, **6** (1860), 306.

61 Mees, C. E. K., and James, T. H., *The theory of the Photographic Process*, 3rd Edition, Macmillan, New York; Collier-Macmillan, London, 1966, p. 147 and 164.

7

Photographic Processing

After exposure of the photographic layer to an appropriate and modulated radiation, the image, only latent up to this point, must be developed by bringing the sensitive material—film, plate or paper—into contact with a developer. This liquid treatment, as well as others like fixation, bleaching and washing, is indispensable in the classical process for obtaining a photographic record. In a few instances some of these working steps are assembled into one single operation with the purpose either of gaining a very quick access to the result or else of simplifying the process, and sometimes the liquid nature of photographic processing is concealed by the use of only the absolutely necessary amount of water. The fundamental mechanisms of these processes, designed to suit practical requirements, do not however differ from those of the classical process.

In most applications of photography processing remains for the user, besides the choice of the exposure conditions, the most important parameter influencing the result. The practical usefulness of an extensive knowledge of the intrinsic mechanisms of photographic processing is thus obvious.

7.1 THE CHEMISTRY OF
BLACK-AND-WHITE DEVELOPMENT

The purpose of development is to reduce the exposed crystals entirely to metallic silver in as short a time as possible, without modifying the unexposed ones. It is essentially based on the selective transfer of energy from the developer solution to the crystal carrying a latent image. While the physical parameters, by acting also on the exchanges within the layers, have a certain influence on development rate, the mechanisms acting on the reaction kinetics are essentially chemical.

413

The kind of development where the silver of the developed image is directly taken from the exposed crystals is called *chemical or direct development* to distinguish it from another kind of formation of the photographic image, that of the precipitation of silver from silver ions in solution. This second method, called *physical development* (see further, p. 418) is almost never employed in practice by itself, but however contributes nearly always to the final result by the solvent action of most developers for silver halides.

7.1.1 Direct Development

7.1.1a *Electrochemical Mechanism*

The reduction to silver during development occurs through the transfer of electrons from the developing-agent ions to the exposed crystals. It is a reaction between two oxidation–reduction systems, that of the reduced and the oxidized developer, D_{ox}/D_{red}, and of the silver halide and the silver, Ag^+/Ag, according to the equation

$$Ag^+ + D_{red} \rightarrow Ag + D_{ox}, \tag{7.1}$$

i.e. a reaction resulting from the oxidation $D_{red} \rightarrow D_{ox} + e^-$ and the reduction $Ag^+ + e^- \rightarrow Ag$. Development, i.e. an equilibrium shift in the direction of the arrow in equation (7.1), is only possible when the oxidation–reduction potential of the system D_{ox}/D_{red} is more negative than that of the system Ag^+/Ag; to make development possible the potential difference between the two systems must be greater than 50 millivolts.[1] The effect of the latent image on this interaction between the exposed crystals and the redox system of the developer was interpreted by Trautweiler (Reference 18 of Chapter 6) as resulting from the equilibrium of their respective Fermi levels (see p. 390).

The thermodynamic equilibrium of these two oxidation–reduction systems can be evaluated by comparison of their potentials determined by the Nernst equation

$$E_{redox} = E_0 + \frac{RT}{nf} \ln \frac{[Ox]}{[Red]}, \tag{7.2}$$

where E_0 is the standard potential of the system corresponding to a concentration of one gramme-ion per litre, R the gas constant, T the absolute temperature, n the valence of the reaction and f one faraday, or 96,500 coulombs. Applied to the Ag^+/Ag system of the crystal, this equation is

$$E_{Ag} = E_{0Ag} + \frac{RT}{f} \ln \frac{[Ag^+]}{[Ag]}, \tag{7.3}$$

and for the system D_{ox}/D_{red} of a developer, for instance one capable of yielding two electrons according to the reactions $DH_2 \rightleftarrows D + 2H^+ + 2e$

and $Ag^+ + e^- \rightleftarrows Ag$,

$$E_{dev} = E_{0\,dev} + \frac{RT}{2f} \ln \frac{[D][H^+]^2}{[DH_2]}, \qquad (7.4)$$

and the potential difference is

$$E = E_{dev} - E_{Ag}. \qquad (7.5)$$

The potential difference of the two systems determines whether the reduction of the silver halide by a given developer is possible, but it does not give any information on the rate of the reaction or on the differentiation by the developer of exposed and unexposed crystals. These fundamental characteristics of the system depend on several other parameters, among which the most important are the nature and the constitution of the crystals, the charge barrier surrounding them and the nature of the latent image determined by the exposure conditions.

7.1.1b Kinetic Aspects

Two fundamental steps can be distinguished during the progress of photographic development: the very first appearance of optical density after the layer has been brought into contact with the developer, and the end of the development step after a processing time arbitrarily chosen to fit a predetermined aim. The first period could serve to define the kinetics of the initiation of development, but a more typical value is obtained by adding to it that part of the development time during which the rate of density growth still increases. This total starting time is called the *induction period*, and the remainder up to the end of the development the *continuation period*.

Charge barrier and induction period. Induction periods are determined graphically from the development time–density plots[2] by measuring the absissae at the end of the concave part of the curves (Figure 7.1). The duration

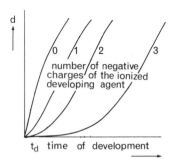

Figure 7.1. Estimation of the induction period by the rate of density increase of the silver deposit during the initial stages of development.

of the induction periods depends on the number of formal negative charges on the developer ions and increases with their number. James[3] and Abribat[4] explain this relationship between the negative charge of the developer ion and the induction period by the amount of kinetic energy required to cross the charge barrier which surrounds the silver halide crystals (see p. 356). This barrier consisting of negative bromide ions adsorbed to the crystal surface exerts a repulsive force whose magnitude increases with the number of charges of the developer ion. Amine developing agents carrying no negative charges do not give rise to any induction period.

This effect of the charge barrier is demonstrated either by the increase of the induction period resulting from the addition of bromide ion to the developer, or by its reduction through the addition of quaternary salts.[3,4,5,6] The former, either adsorbed at crystal imperfections or partially covering the surface latent images where the reduction of the silver halide could be initiated, contribute to keep the developer ions from approaching the crystal and thus increase the induction period while the latter, by neutralizing the negative charge at the crystal surface, facilitate this approach and accelerate the initiation of the reduction. Other compounds, such as dyes adsorbed to the crystal surface, may also affect the induction period, either in a similar or a different manner to quaternary salts.

An entirely different parameter which influences the induction period, and therefore also the overall kinetics, is the degree of solvent action of the developer towards the silver halides. The successive dissolution of the crystal surface layers uncovers latent image specks initially hidden in the interior and thus makes the crystals developable. The time required for this surface dissolution evidently adds to the period of initiation of the reduction of the silver halide.

The catalytic action of the latent image. The latent image considerably accelerates the double oxidation–reduction reaction of equation (7.1) by acting as a catalyser of development. The direct transfer of electrons to the crystal requires a much greater energy than that necessary for a two-step transfer over the electrode formed by the couple (latent image silver)–(silver halide of the crystal). The potential of this electrode, slightly higher than that of the oxidation–reduction reaction of development,[8] allows the transfer to the crystal of an electron liberated by the oxidation of the developer ion,

$$D_{red} \rightarrow D_{ox} + e^-, \tag{7.6}$$

and thus the reduction of a silver ion

$$Ag^+ + e^- \rightarrow Ag^0. \tag{7.7}$$

By this mechanism the silver speck of the latent image continues to grow and makes the reduction of the whole crystal steadily progress. Not only the

catalyser but also the reaction product being silver, the reaction is autocatalytic. According to the mechanism proposed by Trautweiler (reference 8 of Chapter 6; see also p. 390) this reduction of the silver halide crystal by the developer is nothing else but the continuation of latent image growth, initiated during exposure, but carried on during development by the equalization of the Fermi levels of the silver halide crystals and that of the developer redox system.

The electrode theory formulated by Gurney and Mott (see reference 8 of Chapter 6) yields a satisfactory interpretation of most of the observed phenomena and particularly of the dependence of the rate of development $d[Ag]/dt$ on the concentration of the developing agent and hydroxyl-ion concentrations of the developer,

$$d[Ag]/dt = k[D]^a[OH^-]^b, \qquad (0 \leqslant a, b \leqslant 1), \qquad (7.8)$$

and further of the influence on the rate of development of the anion of the various silver halides or of bromide-ion concentration,[9] but it does not sufficiently explain some other facts such as superadditivity (see p. 430) or the action on development kinetics of certain dyes such as the thiacarbocyanines. The theory has therefore been complemented by Jaenicke[10] who distinguishes two steps in the initiation of development.

During the first, in which the silver nucleus of the latent image has not yet reached a size sufficient for it to act as an electrode, the kinetics depend only on the semi-conducting properties of the crystal. As this latter has a much lower conductivity than the developer the potential drop between the crystal and the solution occurs at the internal limit of the solid and liquid phases, i.e. within the crystal. The latent image deforms this potential barrier and thus acts as a trap for the silver ions (Figure 7.2). Being adsorbed they make possible the transfer of electrons from the developer solution onto the crystal where they reach the distorted conductivity band and initiate the growth of the silver speck.

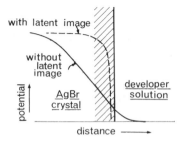

Figure 7.2. Distortion by the latent image of the potential barrier between the solid phase of the silver halide crystal and the liquid phase of the developer.

It is only in a second step, when the nucleus has reached a sufficient size, that it can operate effectively as an electrode. Consequently an equilibrium of adsorbed developer establishes at the crystal surface and the development kinetics then depend only on the rate of the electron transfer and therefore on the rate of oxidation of the developing agent.

7.1.2 Physical Development

In an image resulting from physical development the silver does not originate from the reduction of silver ions of the crystals in the sensitive layer but it is taken from the reducing solution which contains, besides its normal constituents, soluble silver salts. The latent image, while acting in a quite different manner than in direct development, also accelerates this deposition of silver.

The silver halides of the crystals, not contributing directly to the formation of the image, may be eliminated before as well as after the physical development step provided the latent image is undamaged. Two different types of physical development can thus be distinguished: *post-fixation physical development* on the one hand, and that making use of the dissolution of the silver halides by the developer, called *solution-physical development*, on the other. As most of the currently employed developers have some solvent action for silver halides, this kind of physical development almost always occurs simultaneously with direct development. Because of its often quite significant contribution to the final result it is therefore the only kind of practical importance. The morphology of the silver deposit due to solution-physical development is indeed very different from that obtained by direct development; the former, very compact, has a much lower covering power than the latter (see p. 422).

7.1.2a *Mechanism and Kinetics*

The catalytic action of the latent image results in physical development from the production by the silver nucleus of a voltaic couple[8] which facilitates the two step electron transfer,

$$developer \xrightarrow{e^-} latent\ image \xrightarrow{e^-} Ag^+.$$

partial anodic reaction	partial cathodic reaction

Matejec and Meyer[11,12] investigated this electrochemical model by decomposing it into its two phases, anodic and cathodic. In a medium containing only silver ions, but no oxidation–reduction system, an electro-

chemical potential, exclusively determined by the silver-ion concentration, establishes around the silver nucleus of the latent image, which thus remains in balance with the surrounding silver ions; to initiate a current of these ions towards the nucleus a more negative potential than that of the Ag^+/Ag equilibrium is required; this current would constitute the partial cathodic reaction. The presence, however, of an electron donor redox system, i.e. of a developer, by starting a current of electrons towards the nucleus accordingly would give rise to the partial anodic reaction. In a physical developer which contains simultaneously the redox system and the silver ions in solution an equilibrium potential is established around the latent image electrode by the balance of the anodic and cathodic currents.

The decomposition of the development reaction into its two steps according to this electrode mechanism yields a very precise differentiation between direct and physical development: the partial anodic reaction can take place only in solution, but the cathodic reaction is possible in the liquid, as well as in the solid phase of the crystal: in the first case the development is physical, but in the second case it is direct.

During physical development the silver nucleus is entirely surrounded by the solution and the anodic as well as the cathodic deposition occur over its entire surface (Figure 7.3). In direct development, however, where the

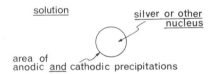

Figure 7.3. Silver precipitation by physical development occurs only on the exterior surface of the latent image speck.

anodic precipitation takes place at the exterior surface of the nucleus, the cathodic reaction, i.e. the deposition of silver, only occurs on the silver–silver halide interface (Figure 7.4). The kinetics of physical development are therefore determined by the area of the silver surface in contact with the solution, and its rate is proportional to this area; this latter has however no influence on the rate of direct development.

Another factor which influences the kinetics of solution-physical development in customary developers is the rate of dissolution of the silver halide. As the solvent action of most developers employed in practice is not very pronounced, this dissolution is the slowest step and therefore determines the overall rate of the contribution by solution-physical development.[13]

With certain developing agents as for instance with Metol, the alkalinity of the developer has only little influence on the rate of physical development,

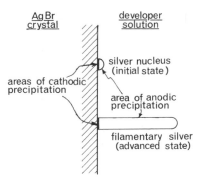

Figure 7.4. In direct development the surfaces of the anodic and cathodic precipitations are clearly separated.

but the pH of such a developer considerably influences the rate of direct development. At low pH therefore the physical development predominates, but at high pH the major part of the image is built up by direct development.

7.1.3 The Morphology of the Developed Silver and the Optical Properties of the Deposit

The absorption of visible light per unit mass of deposited silver determines in black-and-white the efficiency of the photographic operation. The structure of the silver deposit, which is the absorbing element of the photographic recording, is therefore one of its essential parameters; it varies within rather large limits and depends on the processing conditions, mainly on those of development. The area shaded by the developed silver of one silver halide crystal can thus either correspond to its original projective area, or it can be entirely different. Observations by Loveland[14] with an optical microscope showed that the first case occurs when a photographic layer containing only pure silver bromide crystals is developed in a non-solvent developer, i.e. only by the action of direct development, but that development of the same layer in a Metol-hydroquinone developer of customary composition, including the normal concentration of sulphite, not only does not yield silver deposits pseudomorphic with the original crystals, but that it also leads to long silver outgrowths.

At higher magnification, i.e. in the electron microscope, the structure of the silver deposit resulting from exclusively direct development proves to be filamentary (Figure 7.5) and rather resembles an entangled and ramified mass of branches. This filamentary growth yielding silver filaments 200 Å thick was attributed by Berry[16a] to the limited surface diffusion of silver atoms along the freshly formed surface. Silver deposits resulting only from physical development are on the contrary compact and almost spherical

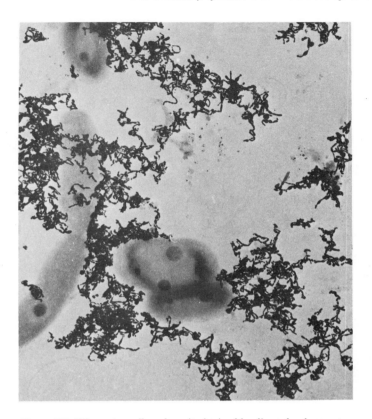

Figure 7.5. Filamentary silver deposit obtained by direct development.

(Figure 7.6). Under the practical conditions of development the filaments are thin and entangled as long as the developer remains only slightly solvent for silver halides, i.e. while direct development is predominant, but they diminish in length and grow thicker simultaneously with the increase of the participation of physical development.[15]

The formation of filaments may be attributed to a mechanism of crystallization[16b] rather than to an extrusion which would result from the cathodic precipitation of silver at the silver–silver halide interface as shown in Figure 7.4. However, the filaments normally obtained have a non-regular and not very stable structure, different from that which would result from crystallization only. This irregular structure as well as the adsorption of substances impairing crystalline growth seem to be at the origin of the strong light absorption and the black appearance of the developed silver deposit.[17,18]

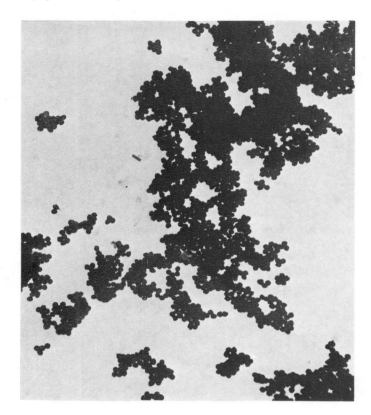

Figure 7.6. Formation of compact particles by physical development.

7.1.3a *Covering Power*

The absorption of light by a developed photographic layer depends on the number n of reduced crystals per unit surface and the average projective area \bar{a}_{dev} of the silver deposits. According to Nutting[19] and to Eggert, Arens and Heissenberg[20] the optical density is therefore defined by the relationship

$$d = \frac{1}{2 \cdot 3} n \bar{a}_{\mathrm{dev}}. \tag{7.9}$$

The mass m of the silver deposit per unit surface being on the other hand

$$m = n \bar{v}_{\mathrm{dev}} \rho_{\mathrm{Ag}}, \tag{7.10}$$

where \bar{v}_{dev} is the effective average volume of silver developed per crystal, and ρ_{Ag} its density in grammes per cubic centimetre. The greater the optical

density obtained with a given mass of silver per unit surface, the greater the yield of the photographic operation; the *covering power* is therefore defined by the ratio

$$\frac{d}{m} = \frac{\bar{a}_{dev}}{2 \cdot 3 \bar{v}_{dev} \rho_{Ag}} d/(\text{grammes Ag per dm}^2), \tag{7.11}$$

and the photometric equivalent by the reciprocal value m/d.

Quantitative determinations of covering power demonstrate the efficiency of the classical photographic process. According to a determination by Eggert, Arens and Heissenberg[20] the density of the spongy silver of a photographic image is $\rho_{Ag} = 2 \cdot 6$ grammes per cubic centimetre, much smaller than that of the compact metal which is 10·5 grammes per cubic centimetre. Owing to this great dispersity of the silver deposits, a quite small mass can yield high optical density. In a region of maximum optical density about 0·0003 grammes of silver per square centimetre are sufficient, for instance in the layers of a motion-picture positive film, to yield a density considerably higher than 3·0. In images obtained by diffusion-transfer processing the yield is still higher: according to Weyde[21] an optical density of 1·0 can be obtained by this process by a deposit of only three milligrammes of silver per square decimetre, much smaller than that of 10 milligrammes per square decimetre required to yield the same density in a normally developed fine-grain layer.

Covering power is considerably influenced by the hardening of the gelatin and by the drying conditions. Pinoir[22] attributes the density variations resulting from relative humidity and temperature changes of the air during drying (see p. 494) to a compression and a rearrangement of the silver particles by rotation. Blake and Meerkamper[23] show that the result of the contraction of the gelatin remains reversible during the initial stage of drying, i.e. during the period of constant evaporation rate (see p. 495), but that it becomes irreversible in the subsequent stages of drying by a lasting contraction of the spongy silver clumps. During the first stage the effect of the rotation of the filamentary tablets prevails over that of their compression and the covering power increases, while the density loss by the predominance of the effect of the compression diminishes it during the second stage of drying, that of falling-rate evaporation.

7.1.3b *The Colour of the Silver Deposit*

Under certain circumstances the hue of monochromatic photographic images, while being perfectly neutral in most cases, can shift towards a brownish orange or violet, or less frequently be slightly bluish. James and Vanselow[24] showed that the absorption of blue light by the silver deposit can be increased by favouring the solution-physical development which results

from the solvent action of the customary developers. For the sensitive material investigated this selective absorption remains weak after development in a non-solvent developer (Figure 7.7, curve a), but increases considerably when this initial development is complemented by one in a developer containing a silver halide solvent in which solution-physical development predominates (Figure 7.7, curves b, c, and d).

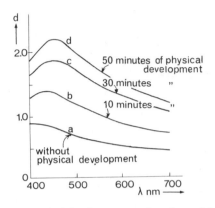

Figure 7.7. Effect of physical development on the colour of the silver deposit.

This hue shift has its origin in several phenomena, among which are the effect of particle size on spectral absorption, the morphology of the silver deposit, and the adsorption of the gelatin onto the silver surface. Particle size plays an important role only as long as the particles remain practically spherical; Klein and Metz[25] gave the experimental demonstration of this validity of Mie's theory (Reference 41 of Chapter 2) by comparing in appropriately developed photographic layers the spectral absorptions of silver particles of diameters ranging from 20 to 180 nm with those computed according to this theory. The similar spectral absorption curves of Figure 7.8(a) and 7.8(b) show the very satisfactory correspondence between the theory and the experimental results for the type of layers investigated. Nearly spherical particles, to which Mie's theory applies, are in practice rather scarce, so that the morphology of the silver deposit plays an important part. It was studied by electron microscopy by Koerber,[26] who distinguishes layers with silver halide crystals of diameters smaller than 100 nm from those with crystals larger than this limit.

The former yield compact silver particles so small that the silver deposit is of brown and sometimes even greenish colour, while layers with larger crystals yield images either neutral or tinted according to the morphology of the deposit, which depends on the anion of the silver halide and on the kind of

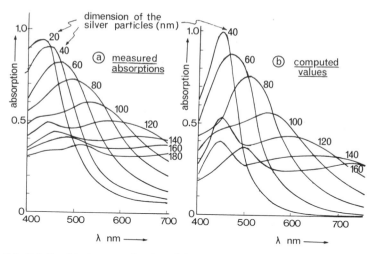

Figure 7.8. Relationship between the size of the silver particles and the colour of the silver deposit.

development. A normally developed silver chlorobromide layer thus yields a rather dark brown image and the silver deposit is definitely of filamentary structure; strongly hardened, however, the same layer yields grains much more compact and the image is neutral; a neutral hue is also favoured by addition to the developer of organic compounds, mainly mercaptans, forming with silver complexes of low solubility. Other investigations with the electron microscope confirm these results; very fine and ramified silver deposits lead to warm image tones, while more compact and larger grains yield neutral deposits.[27]

The effect of mercaptans on silver grain structure was demonstrated by Klein and Weyde.[28] The brownish appearance of photographic images dried at high temperature, due to the resulting modification of the silver grains, can indeed be avoided by the introduction of a small quantity of phenyl mercaptotetrazole in any one of the processing solutions. This addenda not only modifies the morphology of the silver grains, but it also acts on their surface structure and thus on the adsorption of the gelatin. Cassiers[29] showed that the image hue of diffusion transfer images largely depends on this phenomenon. In these images the silver particles are extremely small and the size differences of the grains due to the addition of tetrazoles, shown by the electron microscope, are not sufficient to explain their effect on image hue; the neutrality of these images seems rather to result from a modification of the silver surface, closely related to non-regular crystal structure (see also 421).

7.1.4 The Developer Solution

All developers contain the four main constituents: developing agents; preservative compounds; pH-buffers, generally alkaline compounds; soluble halides and other anti-foggants.

The specific role of each of these constituents is determined by their mutual interaction.

7.1.4a *Developing Agents*

Classification. Numerous developing agents are in general listed and described in the literature, but only a few of these are currently used in practice: Elon(para-methyl-aminophenol), Phenidone (1-phenyl-3-pyrazolidone) and hydroquinone in black-and-white development, alone or in various combinations; some N-alkyl-paraphenylenediamines, acting as colour developing agents; and less frequently some particular kinds yielding either hardening development or other less customary results.

para-methyl-amino-
phenol (Elon, Génol,
Metol)

1-phenyl-3-
pyrazolidone
(phenidone)

hydroquinone

(7.a)

N-alkyl-paramino-aniline
(colour forming)

pyrogallic acid
(hardening)

In most cases these compounds comply with Kendall's rule[30] which is an extension of the rules established for aromatic developers by A. and L. Lumière[31] and by Andresen.[32] According to Kendall the developing activity of an organic compound is related to the presence of the structure a-$(C{=}C)_n$-b, characterized by the double bond between the two central carbon atoms, and where n is zero or a positive integer and a and b are either hydroxyle, amine or substituted amine groups. Customarily this rule is

illustrated by the three isomeric forms of dihydroxybenzene,

$$(7.b)$$

n = 1 non-developing n = 2
catechol, resorcinol, hydroquinone.

Pelz[33] generalized Kendall's rule by giving it the form $\alpha\text{-}(\text{-}A{=}B\text{-})_n\text{-}\alpha'$, with α and α' NR_1R_2 or OH, n zero or an integer, A a carbon atom $-\overset{|}{C}{=}$, and B either also $-\overset{|}{C}{=}$ or $-N{=}$. This generalization makes it possible to include phenidone in the class of the developing agents; it is most probably active in its enolic form (II),

$$(7.c)$$

(I) (II)

Inspection shows that these rules also apply to other common developing agents and to some well-known reducers which are occasionally also employed in developers:

$$(7.d)$$

paramino- parahydroxy- iso-ascorbic
phenol, phenylglycine, acid.

Ionization and dissociation. The essential role of the developing agents is to provide the electrons required for the reduction of the exposed silver halide crystals; their ionization or dissociation therefore strongly influences the development kinetics. The ionization of the developing agents carrying hydroxyl groups depends on the hydrogen-ion concentration, i.e. on the

pH of the developer solution. For Elon, for instance, this relationship is expressed by the equation

$$\frac{[CH_3NHC_6H_4O^-].[H^+]}{[CH_3NHC_6H_4OH]} = K, \tag{7.12}$$

where the dissociation constant K depends on the temperature; at 20°C it is equal to 4×10^{-11}. Transfer of the hydrogen-ion concentration term to the right member of equation (7.12),

$$\frac{[CH_3NHC_6H_4O^-]}{[CH_3NHC_6H_4OH]} = \frac{K}{[H^+]}, \tag{7.13}$$

shows it to be inversely proportional to the concentration of the ionized developer species, the only active one. In acid solution, at low pH or high hydrogen-ion concentration, the developer-ion concentration is therefore low. The level necessary for development can only be reached in alkaline medium, which makes obvious the practical importance of the maintenance of the adequate nominal pH value of the developer.

The ionization of developers with two hydroxyl groups, such as hydroquinone or ascorbic acid, occurs in two steps,

$$DH_2 \rightleftarrows DH^- + H^+, \qquad K_1 = \frac{[DH^-][H^+]}{[DH_2]}, \tag{7.14}$$

and

$$DH^- \rightleftarrows D^= + H^+, \qquad K_2 = \frac{[D^=][H^+]}{[DH^-]}. \tag{7.15}$$

For hydroquinone K_1 is equal to $1 \cdot 2 \times 10^{-10}$ and K_2 to $3 \cdot 7 \times 10^{-12}$ at 20°C.[34] The reaction important for the developer's activity is that of the second ionization, the divalent ion being the active species. Substitution of equations (7.14) and (7.15) demonstrates the still greater importance of the practical observation of the adequate pH value,

$$\frac{[D^=]}{[DH_2]} = \frac{[K_1K_2]}{[H^+]^2}. \tag{7.16}$$

here the concentration of the active developer ion is inversely proportional to the square of the hydrogen-ion concentration.

Developing agents with amino groups, mainly employed in colour developers, are in general entirely dissociated in these highly alkaline solutions. Their reactions are described below (p. 459), in the section on colour development.

Reactions with silver ions. The number of silver ions which take part in the development reaction depends—just as the dissociation of the developing agents—on the number of these latter's reactive groups. The reduction of one silver ion by hydroquinone which carries two negative charges therefore takes place in two steps. In the first appears the resonance stabilized semi-quinone

$$+ \; \text{Ag}^+ \; \rightleftharpoons \qquad + \; \text{Ag} \; , \qquad\qquad (7.17)$$

and in the second the quinone. This latter is, however, not stable at the customary high pH levels of the developers and therefore reacts instantaneously with the sulphite of the developer to form hydroquinone mono- and disulphonates (see below, p. 432).

Developing agents without hydroxyl groups, of the type $-NH_2 \rightleftharpoons -NH^- + H^+$, are only weakly ionized but entirely dissociated at the high pH of the colour developers. Just as in the case of dihydroxybenzenes, the reaction occurs in two steps; the first results in a semiquinone, also resonance stabilized,

$$+ \; \text{Ag}^+ \; \rightleftharpoons \qquad + \; \text{Ag} \; , \qquad\qquad (7.18)$$

and the second in the formation of the corresponding protonated quinone-diimine

$$\text{Ag} + \qquad + \; \text{Ag}^+ \; \rightleftharpoons \qquad + \; 2\text{Ag} \; . \qquad\qquad (7.19)\dagger$$

Just as the oxidation of hydroquinone that of a p-N-alkylphenylene-diamine reduces two silver ions to silver. In black-and-white development, where the silver image is the final result, this equivalence has no economic

† Generally the quinonediimine is shown as in equation (7.48) with loss of an H^+ ion.

significance; in colour development, however, where the image is formed of dyes and where the silver is eliminated in the later stages of the process, the problem of silver economy is important. The equivalence between the number of dye molecules formed and the number of silver ions used up, also depending on the type of couplers employed, then plays a practical role.

Superadditivity. It is common practice to include in the formulas of black-and-white developers not only one but two developing agents, such as the Elon-hydroquinone couple or that of Phenidone and hydroquinone. Developers containing such combinations of developing agents of rather different constitution have advantageous properties; they are more active than those containing only one of the two developing agents, and also less liable to exhaustion.

The increase of development rate by the simultaneous action of the two developing agents results from the phenomenon of superadditivity. Oxidation–reduction reactions of two or more redox systems which take place in a heterogeneous system at the phase limit can indeed be either superadditive, additive or subadditive (Figure 7.9). In the case of photographic development, two developing agents are said to be superadditive when the development rate of a developer containing both is greater than the sum of the rates of developer solutions otherwise identical but containing only one of each of the developing agents.

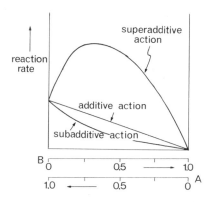

Figure 7.9. Superadditive, additive, and subadditive reactions of two systems A and B.

At first sight it might appear that two rather obvious mechanisms are responsible for superadditivity. The first would favour the adsorption at the silver halide crystal surface of the more active compound of the couple, i.e. of hydroquinone, by helping it to cross the charge barrier[35,36] (see also

p. 415). The access to the crystal of the divalent hydroquinone ion carrying two negative charges would, for instance, be prepared by the Elon ion which carries only one negative charge at the customary pH level of the black-and-white developers. The second mechanism favouring superadditivity would be the continuous regeneration of the reduced form of the less active but monovalent developing agents by the hydroquinone–quinone system, capable not only of reducing the silver halide but the oxidized form of Elon or Phenidone as well.[37]

Closer investigation of superadditivity shows however that these theories constitute only an initial working hypothesis and do not give full insight into the phenomena observed. It could be possible, for instance, that development would be inhibited by the oxidation product adsorbed to the silver halide surface of the first developing agent, Elon or Phenidone, but that its reduction in the adsorbed state by the second developing agent, i.e. by hydroquinone, would on the contrary activate development, especially if that reduction leads to the formation of a more reactive intermediate such as a semiquinone.[38] Lee and James[39] confirmed the superadditive action of such reaction intermediates; they succeeded in obtaining superadditive effects also for solution-physical development, thus eliminating the hypothesis of the mechanisms related to a reduction of the surface charge by the adsorption of the first developing agent. Another demonstration of the superadditive action of the positively charged semiquinone was given by Willems and Van Veelen.[40] p-phenylenediamines and substituted diamino-anilines act on the development rate of hydroquinone by constituting an intermediate for the electron transfer from the solution to the crystal by their semiquinones, stabilized by resonance and adsorbed to the crystal.

The phenomenon of superadditivity is quite general and can also be observed with developing agents having no negative charges, such as the p-phenylenediamine derivatives employed in colour development. Quaternary salts such as lauryl-pyridinium bromide or α-picolinium-β-phenylethyl bromide indeed considerably accelerate development by substituted p-phenylenediamines; the development being inhibited by the iodide liberated from the crystals by the development reaction, it appears that this inhibition is eliminated by the superadditive effect of the quaternary salts.[41]

Superadditive effects may finally also result from the catalytic acceleration of oxidation–reduction reactions: superadditivity is not only observed in development but can also be shown to occur in bleaching (see p. 483), the reaction by which the metallic silver is oxidized to form salts.[42] In both cases the reactivity of the catalysts is inferior to that of the principal reagents: in development the catalyst is a weaker reducing agent than the principal developer, and in bleaching it is less oxidizing than the principal oxidant (Figure 7.10). When the principal reagent meets an insurmountable phase

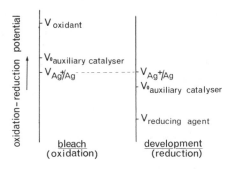

Figure 7.10. Action of auxiliary catalysts on oxidation–reduction potentials.

barrier the catalysts, either reduced or oxidized within the mass of the homogeneous liquid phase, can initiate the transfer of electrons across this barrier; the catalyst of the oxidation–reduction reaction thus eliminates the bottle-neck at the phase boundary.

7.1.4b *The Action of Sulphite*

All practical developers contain sulphite, which has several important functions.

Protection of the development reaction. When developing agents are dissolved in a solution which contains all customary components of a developer except sulphite, they are rapidly autoxidized or they react readily with the oxygen in the air. The first role of sulphite is to inhibit the formation of developer oxidation products not only for maintaining the reducing capacity of the developer but also to limit the influence of the oxidation products on development kinetics. In developers of customary composition the semi-quinones resulting from the oxidation of hydroquinone accelerate development in a rather erratic manner; on the other hand the oxidation products of substituted p-phenylenediamines slow down development.[43,44] In alkaline solution, i.e. at the rather high pH values of the developer, sulphite reacts with the oxidized developing agents and forms monosulphonates which produce practically no effect on development. For hydroquinone this reaction is, in the presence of oxygen from the air,

$$\text{(structure: benzene ring with OH top, OH bottom)} + O_2 + 2\,SO_3^= \longrightarrow \text{(structure: benzene ring with OH top, } SO_3^- \text{ side, OH bottom)} + SO_4^= + OH^- \qquad (7.20)$$

This reaction of the oxidation product of hydroquinone with the sulphite ion also inhibits the formation of polymerized oxidation products which, being orange or brown, would stain the gelatin.

This reaction of the oxidized developing agents with sulphite gives very efficient protection, particularly against aerial oxidation. Since the quinones catalyse the oxidation of the developing agents, the inhibition of their formation by sulphite eliminates the catalyst and makes the oxidation so slow that it seems to have been stopped.

Solvent action. Besides protecting against developer oxidation, sulphite also acts in an entirely different manner. It has a solvent effect on silver halides which modifies the development kinetics and determines in the classical developers the relative importance of solution-physical development.

At the customary bromide-ion concentrations of developers, sulphite increases the rate of solution of the silver halides by the formation of the soluble complex $Ag(SO_3)_2^=$; by uncovering the interior of the crystals it initiates the development of those which carry a latent image below their surface. This increase of efficiency can however occur only with sufficiently energetic developers because it depends on the ratio between the development and the dissolution rates of the silver halide. When development proceeds at high speed a slight solvent action increases its rate further, but when strong solvent action is combined with rather slow development its rate is still more decreased by the dissolution of the silver halide crystals prior to their direct development and the resulting predominance of physical development.

By these mechanisms sulphite affects image structure and particularly granularity. The moderate solvent action of sulphite which favours solution-physical development, just as that of thiocyanate, is therefore made use of in fine-grain developers. When not excessive it consequently diminishes the non-uniform absorption of light in what should be areas of uniform density. Too high a solvent action, however, such as that which would result from the addition of too much thiosulphate, would favour the formation of silver clumps and thus not only increase granularity but it might also lead to processing mottle.

High-contrasting developers. In particular applications, when extremely high contrast is required to yield perfectly sharp boundaries of small dense areas on a transparent background, the catalytic action of the semiquinones of the hydroquinone developing agents can be used. This technique is applied to halftone reproduction in the printing processes, where the form and slope of the tone scale (see p. 46) depend on the precise observation of the required dimensions of the microscopic halftone tint dots. It is then necessary to keep the distance of diffusion and action of the developer oxidation products

within a very narrow boundary around each light-struck crystal in order to limit the acceleration of development only to those crystals which lie in its immediate neighbourhood. This restriction of the radius of action of the semiquinones is made possible by maintaining in the developer a constant but rather low sulphite-ion concentration, obtained from a sulphite reserve consisting of its combination with formaldehyde in the form called formalde-hyde-bisulphite addition product. The dissociation equilibrium of this addition product determines the required concentration level of sulphite ions. Yule[43] showed that this is a true local development acceleration effect leading to the rapid development of all crystals lying within the light diffusion fringe at the boundary separating the screen dots and the transparent background, independently of their size, their exposure and the degree of their developability. Further emphasized by the use of appropriate types of silver halide crystals in the layers, this catalytic action of the semiquinones is generally employed in halftone reproduction.

7.1.4c *Alkali*

All customary developers are alkaline and contain compounds capable of maintaining a constant level of alkalinity over rather extended periods of time during the actual use of the developer as well as during the waiting periods. This constancy is indispensable because the electrochemical equilibrium of the reduced and oxidized forms of the developing agents depends on the hydrogen-ion concentration, i.e. on pH (see equation (7.4) on page 415), which also determines the degree of dissociation of the developing agents with hydroxyl groups, active only in their dissociated form (equations (7.13) to (7.16), p. 414, etc.).

For developing agents with substituted or unsubstituted amino groups, high pH is also very important, but it is acting by a very different mechanism. When dissolved in the developer these developing agents are not dissociated, but their oxidation products reduce the development rate; these semi-quinones and quinone-diimines are however pH dependent and unstable in highly alkaline solutions, so that prevention of their formation through the maintenance of a high pH level insures the required development rate.[44]

Finally, a constant and appropriate pH value is indispensable for a still more fundamental reason. The oxidation of the developing agent by the development reaction continuously liberates H^+ ions which, if allowed to accumulate in the developer, would progressively slow down development and finally stop it altogether. Developers must therefore be adequately buffered.

Buffering action, as is well known, results from the simultaneous presence in a solution of two compounds, one of which combines with hydrogen ions and the other of which yields them by its dissociation. The classical example is a mixture of a weak acid HA with an excess of its anion A^-, introduced into

the solution in the form of its entirely dissociated salt. This results in an equilibrium between the unionized acid HA and the H^+ ions and the A^- ions into which it dissociates; this equilibrium is expressed by the equation

$$\frac{[H^+][A^-]}{[HA]} = k, \tag{7.21}$$

where k is a temperature-dependent constant. As soon as H^+ ions appear in the solution they react immediately with A^- forming HA because k must remain constant. Similarly, an excess of hydroxyl ions would immediately be compensated for by the corresponding dissociation of HA. This equilibrium constancy is obviously not absolute, but its variability in a correctly buffered solution is sufficiently small to be disregarded.

The alkaline compounds employed in practice to insure this buffering action are sodium and potassium carbonate, sodium meta and tetraborate, and trisodium phosphate.

7.1.4d *The Action of Anti-foggants*

Obviously the purpose of development is the reduction only of the light-struck crystals, without any action on those which remained unexposed. All unexposed photographic layers, however, contain crystals which are spontaneously developable, and all developers also reduce, after a certain time, those which should remain unaltered. The resulting unwanted silver deposit is called fog; it can be avoided by the addition to the developer of compounds which inhibit the spontaneous reduction of the unexposed silver halide.

Two types of fog can be distinguished according to their origin: the *intrinsic fog of a sensitive layer* due to the presence of crystals carrying at their surface development nuclei such as sulphur-ion inclusions or traces of metallic silver or gold, and *development fog* resulting from too high developer activity which, by reduction of the silver halides in some vulnerable crystal sites, leads first to the formation of development nuclei similar to latent image specks and then by their catalytic action to the normal reduction of the silver halide. It is therefore very difficult, or even impossible, to distinguish in an exposed layer after its development the density of the silver deposit resulting from exposure from that forming fog density. This latter can result from direct development as well as from solution-physical development of silver ions originating from the development of the image.

The best known means for avoiding fog formation is the addition to the developer of a small quantity of sodium or potassium bromide. These act on the intrinsic fog of the layer as well as on development fog. Other currently employed anti-foggants are organic compounds able to form with silver ions,

just as bromide ions, compounds or complexes of low solubility; the most frequently employed among these organic anti-foggants are nitrobenzimidazole and benzotriazole as well as mercapto compounds, particularly active by their —SH groups. Many developers also contain a low concentration of iodide ions.

The action of the bromide ion on intrinsic emulsion fog results from its preferential adsorption at the silver sulphide–silver halide interface as compared to that at the silver–silver halide interfaces of the latent images. Any surface sulphur inclusions in excess, which might promote fog, are thus covered by a layer of bromide ions carrying a negative charge and repelling the negative developer ions, while the latent image whose catalytic action is desirable remains accessible to the developing agents. The protection of the crystals against intrinsic fog by organic anti-foggants is due to a similar mechanism; Sheppard and Hudson showed for instance that the anti-foggant action of thioanilides also results from this type of preferential adsorption onto the silver sulphide–silver halide interfaces.[45]

Bromide ions also act on development fog which in their absence would form by the direct reduction of the silver halides without the catalysing action of a latent image. Important local variations of the surface charge of the crystals on flaws, dislocations or other structural defects, by leading to the adsorption of the ionized developing agents would indeed favour this spontaneous reduction. A layer of bromide ions strongly adsorbed in these locations protects the crystals and avoids development fog.[46]

Bromide ions also inhibit another type of development fog. At high pH localized hydrolysis of silver bromide yields easily reducible silver oxide.[47] The excess bromide ions prevent this hydrolysis and thus eliminate this origin of fog.

Organic anti-foggants mainly act on the fog which would result from solution-physical development on the various nuclei dispersed in the gelatin. By reacting with the silver ions temporarily solubilized through the development reaction, they prevent the precipitation of silver on these nuclei. Bromide and iodide yield a similar result by acting on physical development, but they rather slow down the dissolution of the silver halide of the crystals.

7.1.4e *Other Compounds*

But for the simplest developers employed for the manual processing of black-and-white films and papers, all developers of the various photographic materials contain additional components which have no direct action on the development reactions proper. Most developers contain sequestering agents for calcium and other metal ions to avoid the formation of processing scums. The physical conditions of mechanized processing also require the introduction of addenda into the developers which impart to the swollen layers

sufficient mechanical resistance during the whole duration of processing to make the recordings withstand the various mechanical stresses as well as the often quite high solution temperatures. Without this protection even an intrinsically perfect image would be diminished in its utility by its un-satisfactory physical quality.

Besides the continuous replenishment of the active developer components required for the maintenance of the chemical levels in the seasoned solutions of large industrial processing machines, still other addenda are necessary in the developers; these developers for instance also contain fungicides to avoid contamination of the large solution volumes continuously recirculated through the machine tanks and the storage and replenishment circuits.

Sequestering agents. The scums which may form in big developer volumes can have various origins. Most frequently they are due to cationic impurities, mainly calcium ions, introduced either from water of too high hardness or by lime-processed gelatins of the photographic layers, i.e., gelatins prepared by treatment with calcium hydroxide.[48] The calcium salt formation is inhibited by complexing these cations with inorganic or organic sequestering agents. Among the former the most frequently employed are the polyphos-phates such as sodium hexametaphosphate $(NaPO_3)_6$ (Calgon[49]) or sodium tetraphosphate $Na_6P_4O_{13}$ (Quadrafos). Henn and Crabtree showed that this latter dissociates in alkaline solutions slower than Calgon and therefore maintains its protective properties for a longer time.[48] Among the organic sequestering agents employed are various salts of ethylendiamine tetra-acetic acid or its 1,3-diamino-2-propanol derivate.[50] Henn[51] investigated the relationship between the structure of the compounds forming complexes with the cations and their capacity to protect developers against scum formation. The sequestering agents form chelate rings between primary carboxy-, nitroso-, or nitro- groups and secondary oxy-, hydroxy-, amino-or olefinic- groups; the greater the number of chelate rings around one single cation the more efficient the sequestering action.

Hardeners and swell inhibitors. The mechanical resistance of the layers during development is increased by the hardening of the gelatin and also by salt effects which keep it from swelling excessively, in general by the addition of sodium sulphate to the developer; the resulting contraction of the layers however reduces the rate of diffusion of the active species towards the exposed crystals as well as of the reaction products which should be eliminated, and thus diminishes the development rate (see p. 477).

The addition of hardening agents to the developers is necessarily limited to compounds which react with the amino groups of the gelatin (see p. 369), the only active hardeners at the high pH values of the developers; only alde-hydes can therefore be employed in practice, and as formaldehyde reacts with

sulphite ions and therefore modifies the kinetics as well as the mechanism of development, especially with hydroquinone, dialdehydes are often employed (see p. 433 and p. 369).

To avoid all undesirable effects of hardeners on development, and to keep their action constant, they are also often employed in the form of prehardeners in industrial processing, i.e. in separate solutions. These are buffered to the optimum pH value of the hardening reaction and often contain bromide to avoid the fog which could result from their action on the unexposed silver halide crystals. Prehardening is used mainly for the processing of colour films and papers (see also p. 486).

7.1.5 The Relative Concentrations of the Developer Components

The composition of a developer and the relative concentrations of its components are determinant for the result because the practical behaviour of a photographic system is obviously defined not only by the structure of the layers and by the exposure, i.e. the latent image, but the physical properties of the record come into existence only after development has been carried out and therefore depend as much on the developer as on the photographic material itself and on the exposure conditions.

Most developer formulas are specific of a given group of products of typical characteristics. Prepared chemicals for making up developers are more and more frequently employed also for industrial processing. They not only insure satisfactory photographic results but are also designed for the particular requirements of each process and for the protection of the layers, fragile in their swollen state during the prolonged immersions in succession of either alkaline or acid solutions, against the sometimes considerable stresses which they must withstand. The aim is therefore to maintain the concentration of each component within narrow limits; certain industrial processes, especially those for professional motion pictures, are therefore controlled by periodic chemical analyses (see p. 506).

7.1.5a *Developing agents*

In developers which contain two or more developing agents, high concentration of the most active member accelerates development and yields high densities and contrast even with short development times, comparatively low temperatures and moderate agitation. Elon-hydroquinone or phenidone-hydroquinone developers for instance, containing only a small amount of the first of the two developing agents present for the rapid initiation of the development reaction, but a comparatively high concentration of hydroquinone, yield high contrasts and densities. Typical examples are Kodak developers D-11 and D-19 as well as some X-ray developers. Similar concentrations in weight of Elon and hydroquinone, on the contrary, yield

slower acting developers employed for the reproducible production of rather low contrasts as required for the development of negative films, such as for instance in Kodak developer DK-50. Kodak developer D-76, widely employed for the development of negative motion-picture films, also falls in this class, the analytical concentration of its starting formula being 2 and 5 grammes respectively of Elon and hydroquinone per litre.[52]

The relationship between the concentration of the developing agent and the development rate was investigated by James,[53] James and Vanselow[54] and by Levenson.[55] As derived for developers of simple composition this relationship determines whether the development rate depends only on the adsorption of the developing agent to the silver halide crystals or also on its diffusion through gelatin, and on the other components taking part in the reactions. In a quite general manner the development rate is proportional to a fractional power of the concentration of the developing agent D.

$$v = k[D]^n, \tag{7.22}$$

where v is the reaction rate, n a number less than or equal to 1 and k a constant. Relative to the electrochemical reactions at the crystal surface the diffusion phenomena appear therefore to be very important, as n could become equal to unity only if the development rate were exclusively dependent on the adsorption of the ionized developing agent.

The effect of aerial oxidation on the analytical levels of Elon and hydroquinone in developers was studied by Mutter.[56] Protected from the surrounding air by a floating lid, the solution still contains after ten days keeping the total amount of Elon and about 84% of the initial concentration of hydroquinone. In contact with air, however, the loss of hydroquinone is much greater and its concentration diminishes to well below one half of its

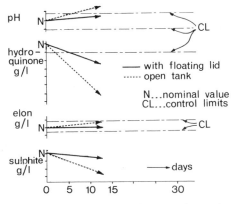

Figure 7.11. Improved keeping of a developer by protection against aerial oxidation.

nominal value (Figure 7.11). The results of this investigation also clearly confirm the regeneration of Elon by hydroquinone (see p. 430).

7.1.5b *Sulphite and the Alkaline Compounds*

As sulphite principally serves to protect the developing agents against oxidation, the customary concentrations of sulphite are quite sufficient in general to insure satisfactory keeping of the developers and in consequence constant sensitometric results. Black-and-white developers are therefore in general not very sensitive to some variation of sulphite concentration, unlike colour developers (see p. 461). It is obvious on the other hand that some special developers, such as those which yield maximum contrast by the presence of the sulphite-formaldehyde complex (see p. 338), are an exception and remain very sensitive to the concentration level of sulphite.

The solvent action of the sulphite ion on the silver halides depends at equilibrium on its concentration, but the rate of dissolution reaches a maximum at about 0·6 moles of sulphite per litre and is strongly influenced by the presence of bromide ion in the developer.[57] Figure 7.12 illustrates this effect for silver iodobromide crystals. Developers containing a rather large amount of sulphite and yielding sensitometric results as well as an image structure depending to a great deal on solution physical development can therefore also be quite sensitive to variations of sulphite concentration.

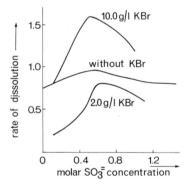

Figure 7.12. Influence of bromide-ion content on the solvent action of sulphite ions.

The effects of the concentrations of the alkaline compounds depend on the constitution of the developer and on the kind of pH buffer employed. What is mainly required is a constant local pH level within the sensitive layer during the whole duration of development; Abribat, Pouradier and David[58] showed that at fixed pH value the contrast as well as the speed of any given layer increases with the buffering capacity of the developer. Checks of the

buffering power of a developer are carried out in practice by simple titrations of total alkalinity which, together with precise measurements of the pH values, yield satisfactory indications of the correct composition of a developer.

Sulphite concentration and pH have a combined effect on the stability of hydroquinone.[56] The protection improves with the quantity of sulphite in the developer, but diminishes with increasing pH.

7.1.5c Halide Ions and Anti-foggants

The most currently employed anti-foggant is the bromide ion because it inhibits, when employed at the customary concentrations, fog formation in silver bromide and iodobromide layers more than the development of those crystals which carry a latent image. The action of bromide is in general greater in areas of low exposure, i.e. in those of low density after development, than in areas strongly exposed and of high density. Bromide-ion concentration therefore considerably influences the sensitometric response of a developer; increasing continuously through the development reactions it constitutes one of the most important chemical parameters of photographic development. The increase of bromide-ion concentration during development not only acts on tone reproduction by cutting the toe portion of the sensitometric characteristic and by increasing the contrast, but also on speed response and, by adjacency effects, on image structure. In large-scale industrial processing, but also in current machine processing, the satisfactory constancy of bromide-ion concentration is therefore insured by constant replenishment of the developer with a precisely defined amount of replenishing solution containing only the required amounts of the developing agents, of sulphite and the alkaline compounds, but void of bromide.

Customarily, the effect of an increase of bromide-ion concentration on the sensitometric characteristic is graphically shown in simplified form by the

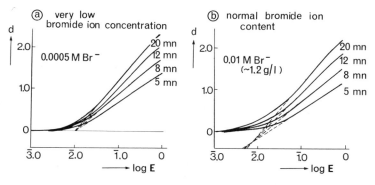

Figure 7.13. Effect of bromide ion on the progression of development rate.

lowering of the point of convergence of the tangents to the linear sections of the sensitometric curves (Figure 7.13). This schematic representation shows the general tendency of the modification of the sensitometric characteristics, but it varies widely in scope according to the nature of the layer and the developer.

The anti-foggant action of the other halide ions, chloride and iodide, differs from that of bromide ion because the solubilities of silver chloride and silver iodide are very different from that of silver bromide. Its solubility product is indeed only about one thousandth of that of silver chloride, and that of silver iodide is still almost ten thousand times smaller. At 20°C, for instance, the values of the three solubility products are respectively

$$AgCl: \quad 1{\cdot}14 \times 10^{-10},$$
$$AgBr: \quad 2{\cdot}70 \times 10^{-13},$$
$$AgI: \quad 3{\cdot}89 \times 10^{-17}.$$

The chloride ion can therefore be efficient as an anti-foggant only with pure silver chloride layers, and the action of the iodide ion necessarily differs considerably from that of the bromide ion. At low concentration the iodide ion is a very effective anti-foggant, but its concentration varies considerably during the lifetime of the developer according to the kind of sensitive layers processed; when reduced, silver iodobromide crystals release iodide and increase its concentration within the developer; it consequently precipitates on unexposed crystals covering them with a thin layer of silver iodide, much less soluble than the original silver bromide surface. According to the initial composition of the developer and to the type and the total surface of sensitive material processed per unit volume of solution, which determines its seasoning, the iodide concentration can therefore either diminish and the anti-foggant action disappear, or it can on the contrary increase and thus give rise to a quite different effect by initiating the development of crystals with internal latent images, made developable by the formation of crevices (see p. 396).

The organic anti-foggants, present in developers at very low concentrations, have a strong action on fog so that the maintenance of their nominal level is of paramount importance for keeping constant the sensitometric characteristics of a given film-process combination. As they form with silver salts and complexes of very low solubility they can be rapidly exhausted by the development of a given amount of sensitive material; their constant replenishment in industrial processing is therefore just as important as the maintenance of the bromide-ion level below an acceptable upper limit. During solution storage the organic anti-foggants show in general very satisfactory stability.[56]

7.1.6 Activators and Monobaths

To satisfy particular requirements encountered in practice it is also possible not to introduce all components of a developer in the solution but to incorporate the developing agent in the sensitive layer and then to carry out the development simply in an alkaline solution called activator. Supplementary components such as silver halide complexants can, on the contrary, be added to the developer for carrying out fixation simultaneously with development; these latter solutions are called 'monobaths'. These variants of the classical development process, while based on the same fundamental mechanisms, have their own peculiar characteristics and therefore yield in certain circumstances quite different results.

7.1.6a *Activators*

In the literature proposals can be found for developers having two successive solutions, the first intended only to imbibe the sensitive layer with the developing agent but the second, containing all other components and especially those which determine the alkalinity of the solution, serving to carry out the development proper.[59,60] This rather old grown principle never found any practical application in its original form but is now widely used in a slightly different form, still based on the same idea: the developing agent being incorporated into the sensitive layer during its manufacture, the development can be reduced, as mentioned above, to a short immersion in an alkaline solution called 'activator'; this process is generally combined with the use of a 'stabilizer', solution which makes it possible to omit fixation as well as the final wash (see p. 481).

This process, called 'stabilization processing', is mainly employed for silver chloride or silver chlorobromide photographic papers; it makes possible their development in a few seconds, as for instance for news work, for the recording of oscillograph traces, for hard copy from microfilm negatives and for phototypesetting. It offers over the classical process a very marked speed advantage which results from the presence of the developing agent within the layer in immediate contact with the exposed crystals. The diffusion of the alkaline activator solution into the layer is very rapid so that the resulting development rate depends only on the electrochemical kinetics of the particular silver halide process combination.

A great advantage of the activation development of photographic layers with incorporated developing agents, besides its speed, is the great stability of the processing solution which, at first, does not contain any compound sensitive to aerial oxidation. After prolonged use the developing agents released from the processed sensitive materials contaminate the activator solution, but they reduce the development rate only slightly by slowly lowering its alkalinity (see p. 482).

7.1.6b *Monobaths*

The incorporation in the developer of a silver halide complexant, such as for instance thiosulphate, makes it possible to carry out development and fixation in one single operation. However, the simultaneity of the dissolution of the silver halides and of their development influences considerably the reduction of the exposed crystals and thus yields, in addition to direct development, an important participation of solution-physical development.

Monobaths containing thiosulphate ion. Satisfactory development by a monobath requires easily developable crystals and a very active developer capable of initiating instantaneously their direct development. The resulting image silver yields nuclei for the precipitation of the silver dissolved by the complexant and originating from non-exposed as well as from exposed crystals. Barnes showed that the final image obtained in a monobath containing sodium thiosulphate, built up at the beginning by direct development and then intensified by physical development, contains from two to four times more silver at any given density level than an image obtained in a conventional developer void of any complexant.[61] The satisfactory interpretation of the sensitometric results of a monobath containing thiosulphate ions is therefore made difficult by the simultaneous presence of silver of high covering power deposited by direct development, and of that resulting from solution-physical development, which only contributes little to the optical density of the record. Introduction of one gramme of thiosulphate per litre into the developer investigated by Barnes, for instance, increases the mass of the developed silver as well as the density, but addition of 32 grammes of

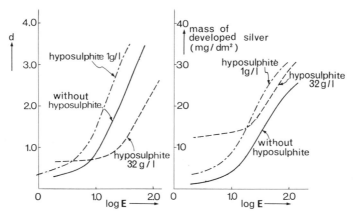

Figure 7.14. Comparison of the density and the silver weight of the silver deposit obtained with a monobath containing varying concentrations of thiosulphate.

thiosulphate per litre, while considerably increasing the mass of silver, yields lower densities than those obtained by normal development, except in the fog region (Figure 7.14). The initiation of development by the exclusive reduction of the exposed crystals, i.e. by direct development, seems therefore according to Barnes to be the prerequisite of a satisfactory monobath because the sensitometric results are determined predominantly by this development prior to the beginning of the dissolution of the silver and the physical development which it initiates. The order of these reactions depends on the electro-chemical equilibrium at the crystal surface and on the concentration gradients of the surrounding solution, on the complexing ion, the complex formed and the halide ion, whether released by the reduction of the crystals by direct development or by the formation of the soluble complex.[62] It could thus appear that monobaths containing thiosulphate are very sensitive to agitation; this is not the case, however, because the acceleration of development due to increased agitation is compensated for by the faster dissolution of the silver halide: processing in monobaths containing thiosulphate ions is less sensitive to agitation effects than conventional development without any complexant.[63]

Organic complexing agents. The use of organic complexants instead of the thiosulphate ion yields monobaths showing a very different behaviour. Some of these complexants, mainly the mercaptans, while dissolving the silver halides rather rapidly, form very stable complexes and therefore do not give rise to physical development. Haist, King and Bassage, when comparing the properties of monobath processes with thiosulphate and with mercaptans, showed that after a very rapid start in both types of solutions development carried out in the presence of a mercapto-compound suddenly stops for the formation of silver as well as for the increase in density, while the deposition of silver continues in thiosulphate monobaths, even after full clarification, however without modifying the already attained density level.[64]

The stability of the complexes formed with compounds of mercapto-acetic acid, cysteine hydrochloride or 2-diethylaminoethanethiol hydrochloride avoids on the one hand the formation of silver sludges—the major practical drawback of monobath processing—and on the other hand makes possible the design of monobath formulas with very low salt contents, indispensable for very rapid processing at high temperatures. The antioxidant properties of the mercaptans further allow us to markedly reduce the sulphite content.

The self-limiting character. A characteristic property of all monobaths is the existence of an upper limit of density as well as of contrast which, once reached after a processing time determined by the solution temperature, cannot be exceeded by continued processing. This self limiting, inherent to

the principle of simultaneous development and fixation, can in particular instances be very advantageous because it allows us to leave the sensitive material with no control in the processing solution, and without the requirement to stop processing at a given time (see also p. 487).

The self-limiting character of monobath processing has been employed for deriving a mathematical expression of its kinetics. Calling t_f the processing time for maximum contrast and density, and γ_f the corresponding contrast, Swing and Barry[65] found satisfactory correspondence between their results and the relationship

$$\gamma = \gamma_f \cdot [1 - e^{-\beta(t/[t_f - t])^\alpha}], \qquad (7.23)$$

where β is a constant descriptive of processing rate, α another constant, t the given processing time shorter than t_f, and γ the corresponding contrast.

Practical applications of monobath processing. The practical properties of monobath processing were studied by Levy.[66] It appears that the parameter most influencing the sensitometric results of energetic hydroquinone-Phenidone monobaths containing thiosulphate is the temperature, because of its differential action on either development or fixation kinetics. The temperature variation of fixation rate being of smaller amplitude than that of development rate, lowering of the solution temperature rapidly reduces density and contrast, but high-temperature processing yields in the same solution a strong increase of density and contrast, but also leads to rather high fog.

Practical applications of monobaths for specific purposes have been reported by several authors, mainly for rapid processes. Processing immediately following oscillograph trace recording, synchronized with the speed of the just exposed fim web, is for instance made possible by a monobath in which a special recording film can be processed in 30 seconds at 100°F.[67] Similarly a viscous monobath makes possible the processing of negative motion-picture film within two minutes, delivering the entirely dry negative.[68] Besides speed of access one of the greatest advantages of these processes is the excellent image structure resulting from the very pronounced adjacency effects, i.e. very good sharpness and high resolving power with granularity identical to that obtained in the classical process.

7.2 THE PHYSICAL PARAMETERS OF DEVELOPMENT

While essentially resulting from chemical reactions, the results of photographic processing, and especially those of development, depend to a great extent on the physical conditions of the processing operation. At any given

instant the kinetics of development are materially conditioned, besides their electro-chemical aspects, by the material presence or absence of the active or inhibiting species, and the kinetics therefore depend on their rates of diffusion across the layers as much as on the development reactions proper. The two fundamental physical parameters of development are thus the *agitation*, on which depend the concentrations at the solution-sensitive layer interface and therefore the diffusion gradients, and the *temperature* which acts in several ways on the rates of the exchanges and the reactions.

7.2.1 Diffusion Phenomena

7.2.1a Diffusion of the Developer in a Photographic Layer

Bringing the sensitive layer in contact with the developer solution sets off a complex process of liquid diffusion through the layers and of development reactions. The penetration of the aqueous solution into the dry gelatin makes it swell and thus changes during the initial stages of the process its thickness and its coherence as well as its geometry, while the reduction of the exposed crystals, by continuously modifying the local concentrations of the developer components and their reaction products, acts directly on their diffusion rates. After a comparatively short time—from a few seconds to one minute— which depends on the temperature and on the type of gelatin and its hardening, the layer has practically swollen to its maximum and attains its upper limit of permeability. In the absence of agitation a thin laminar film of solution, rich in reaction products and exhausted of active components, rapidly forms at the surface of the swollen sensitive layer. This film of liquid, of composition similar to that of the solution within the layer, not only prevents the ex- changes by diffusion but also prevents correct and uniform development by its excess of halide ions, its deficiency of developing agents and its low pH. To keep this barrier from forming, the exhausted solution must be replaced constantly by fresh developer at the surface of the sensitive layer. According to the type of agitation employed this ideal circumstance can however be only partially realized in practice (see below, p. 452).

The relative influence of either diffusion or electrochemical reaction rate on the development kinetics of each particular system depends on numerous parameters, but particularly on the temperature and the alkalinity of the developer. When the development reaction is inherently slow, as for instance in a low pH developer, the rate of diffusion has no influence. With an energetic high pH developer, on the contrary, which reacts instantaneously with the exposed silver halide crystals, the development kinetics depend only on the rate of diffusion.[54]

This reciprocity of development reaction and diffusion rate was investi- gated experimentally by Eggers[69] who coated photographic layers on the plane membrane of a glass electrode with the purpose of following the pH

changes during development at the bottom of the layer simultaneously with infrared density measurements; Figure 7.15 shows one of his results. In an energetic developer a strong pH drop can be observed initially as a result of the rapid exhaustion of the buffer at the bottom of the layer; the nominal pH value is reached again during the later stages of development by diffusion of the alkaline compounds (curve A). In an amidol-sulphite developer, however, slow and of low energy, i.e. indifferent to diffusion rate, the pH at the bottom of the layer shows much less variability (curve B).

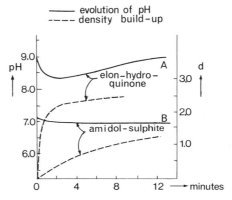

Figure 7.15. Reciprocal effects of development reaction and developer diffusion demonstrated by pH measurements at the bottom of the layer.

The rates of diffusion of the various developer components through the photographic layer are defined by their *diffusion coefficients* (see below). Among the methods employed for their determination are those based on the first appearance of a silver deposit and those employing radioactive molecules. The practical application of the results of such investigations is in general difficult, either because the experimental conditions differ too much from those of photographic processing[70] or else because the diffusion phenomena cannot be distinguished from the initial swelling of the layer. The surface of the sensitive material must either be brought into contact with the developer while still dry, whereupon it swells simultaneously with the beginning of the diffusion, or it must first be soaked with water or an alkaline or other solution which then acts on the diffusion rate. The results obtained by Reckziegel demonstrate this situation[71]: in an unswollen photographic layer the first darkening after its immersion in the developer—designed so as to show null-induction period—did not appear earlier than after 42 seconds, but an identical film sample soaked with water started to darken after 27 seconds when developed under the same conditions, and soaked with

potassium carbonate solution it started darkening after only 7 seconds. According to the method of investigation and the experimental conditions any developer component may thus seem to diffuse either faster or slower than another one: some authors attribute faster diffusion rates to the developing agents and slow diffusion to the hydroxyl or carbonate ions, while others give the opposite order.[72]

7.2.1b *Theoretical Aspects*

Intrinsically, diffusion is the transfer of matter within a given medium resulting from random molecular motion; while occurring in all directions this motion displaces matter from points of high concentration towards regions where its concentration is low. In analogy with the conduction of heat the diffusion in a homogeneous medium can be expressed for the general case by the equation

$$\frac{\partial C}{\partial t} = D\left(\frac{\partial^2 C}{\partial x^2} + \frac{\partial^2 C}{\partial y^2} + \frac{\partial^2 D}{\partial z^2}\right), \tag{7.24}$$

where C is the concentration, t the time and D the diffusion coefficient.[73] This general solution can be applied to particular problems, such as those of development, fixation or drying of photographic materials, by appropriate adaptation. The short derivation given below shows the application of the general diffusion equation to the specific case of the penetration of a developer solution in a photographic layer.

Neglecting laterial diffusion during the penetration of a developer in the layer, this yields for the unidimensional case of only one concentration gradient in the x-direction

$$\frac{\partial C}{\partial t} = D\frac{\partial^2 C}{\partial x^2}. \tag{7.25}$$

In the non-homogeneous medium of the photographic layer, the diffusion coefficient is variable and equation (7.25) becomes

$$\frac{\partial C}{\partial t} = \frac{\partial}{\partial x}\left(D\frac{\partial C}{\partial x}\right). \tag{7.26}$$

If the developer contains gelatin hardeners, D also varies with time, $D = f(t)$, and the introduction of a new time scale T such that $dT = f(t)\,dt$ yields

$$\frac{\partial C}{\partial T} = \frac{\partial^2 C}{\partial x^2}. \tag{7.27}$$

This equation can be solved by the method of separation of variables (Crank[74]); this method was applied to the photographic system by Lederer.[75] It consists of the introduction of the functions X of x and T of t, necessary to

define the relationship $C = X(x)T(t)$. By substitution this yields

$$X\frac{dT}{dt} = DT\frac{d^2X}{dx^2},$$

or

$$\frac{1}{T}\frac{dT}{dt} = \frac{D}{X}\frac{d^2X}{dx^2}.$$ (7.28)

Each member of (7.28) then depends on one variable only and can be set equal to the same constant, chosen for the sake of convenience as $-\lambda^2 D$, so as to yield the two ordinary differential equations

$$\frac{1}{T}\frac{dT}{dt} = -\lambda^2 D,$$ (7.29)

and

$$\frac{1}{X}\frac{d^2X}{dx^2} = -\lambda^2,$$ (7.30)

of which solutions are respectively

$$T = e^{-\lambda^2 Dt},$$ (7.31)

and

$$X = A \sin \lambda x + B \cos \lambda x.$$ (7.32)

The solution of (7.25) is then of the form

$$C = (A \sin \lambda x + B \cos \lambda x) e^{-\lambda^2 Dt},$$ (7.33)

where A and B are integration constants. Since equation (7.25) is linear, the general solution is obtained by summing the solutions of the form (7.33), which yields

$$C = \sum_{m=1}^{\infty} (A_m \sin \lambda_m x + B_m \cos \lambda_m x) e^{-\lambda_m^2 Dt},$$ (7.34)

where A_m, B_m and λ_m can be determined for each particular problem from the initial and the border conditions.

For a plane layer of great extension and low thickness $2l$, such as a photographic layer immersed in a relatively small volume of steadily agitated solution, the initial conditions are

$$C = 0, \qquad -l < x < l, \qquad t = 0.$$ (7.35)

Taking into account that the total quantity of the compound contained in the solution and having diffused into the layer, such as for instance the

developing agent, remains constant, and supposing the agitation sufficient to make the concentration in the layer only a function of time, the conditions at the limits $x = \pm l$ are

$$a\frac{\partial C}{\partial t} = \mp D\frac{\partial C}{\partial x}, \qquad x = \pm l, \qquad t > 0. \tag{7.36}$$

For these conditions one of the solutions of the diffusion equation is given by Crank.[74] By using the Laplace transform, which allows us to eliminate the time variable, and calling M_t the amount of compound contained in the layer at time t, and M_∞ the corresponding amount at total equilibrium, i.e. after infinite time, this solution is

$$\frac{M_t}{M_\infty} = 1 - \sum_{n=1}^{\infty}\frac{\cdot\, 2\alpha(1 + \alpha)}{1 + \alpha + \alpha^2 q_n^2}e^{-Dq_n^2.t/l^2}, \tag{7.37}$$

where the q_n's are non-zero positive roots of

$$\text{tg } q_n = -\alpha q_n, \tag{7.38}$$

and $\alpha = a/l$ the ratio of the volumes of the swollen layer and of the surrounding solution.

To take into account the effect on diffusion of the development reaction it is necessary to add to the diffusion equation an additional term. The rate of the electrochemical reaction at the crystal surface being in most practical cases greater than that of the diffusion, it might at first approximation be admitted that the concentration S of the compound having already reacted is proportional to that of the diffusing compound C,

$$S = RC, \tag{7.39}$$

and the diffusion equation then becomes, with D constant,

$$\frac{\partial C}{\partial t} = D\frac{\partial^2 C}{\partial x^2} - \frac{\partial S}{\partial t}, \tag{7.40}$$

or

$$\frac{\partial C}{\partial t} = \frac{D}{R + 1}\frac{\partial^2 C}{\partial x^2}, \tag{7.41}$$

i.e. it remains in its initial form, but the diffusion coefficient becomes $D/(R + 1)$. The progressive disappearance of the diffusing compound, in our case the developing agent, therefore progressively diminishes the rate of diffusion.

The real conditions of diffusion during photographic development are however much more involved. Depending on the exposure of the layer which causes the extent of the development reaction to vary locally, the diffusion

gradients differ from one point to another; due to the simultaneous presence of several active developer compounds of various diffusion rates, they are besides this in constant evolution. The swelling or hardening of the gelatin which occurs during development also steadily modifies the diffusion coefficients. Instead of attempting a quantitative evaluation of the influence of diffusion on development kinetics, the problem is in practice resolved empirically by the elimination of the stagnant liquid layer in contact with the sensitive surface, through agitation of the developer, for the purpose of favouring as high concentration gradients as possible.

7.2.2 Methods of Agitation and their Effects

From the most straightforward experimental evidence it is obvious that development non-uniformity in a uniformly exposed area cannot be avoided without adequate agitation of the developer. The slight constant rocking of the traditional tray of the photographers during development is one of the best known examples.

In the industrial processes, whether manual or mechanized, obviously more energetic methods of agitation must be employed. Among the numerous techniques which could be used for the creation of convection currents at the surface of the sensitive materials being processed, only a few methods of agitation have stood the test of time, either because of their efficiency or of the simplicity of their principle and use. They can be grouped in the following classes.

Manual tank processing. The sensitive layer is periodically brought in contact with unexhausted developer, for instance every 15, 30 or 60 seconds, either by draining the films or papers and by immersing them again into the solution, or by energetic nitrogen bursts set off at the bottom of the tank.

Manual processing on a drum. By applying the emulsion side of the sensitive material against a smooth or only slightly embossed circumference of a rotating horizontal cylindrical drum which dips into the developer solution, a thin layer of developer is continuously laminated between the cylinder and the surface of the sensitive material and creates a turbulent motion of the solution.

Machine processing. In the continuous processing of long webs of film or paper a non-negligible fraction of developer agitation results from the motion of the sensitive material through the solution; this agitation is often assisted by submerged jets which direct recirculated developer onto the layer to be developed. In machines which transport webs or sheets of sensitive material through the solutions by a succession of rollers, the so-called roller transport machines, the major part of the agitation is due to the elimination

of the exhausted solution adhering to the surface of the processed material by the transport rollers; their action is often further emphasized by counter-rotating agitation rollers.

When the elimination of the stagnant layer is not obtained by mechanical squeegeeing off, the efficiency of agitation increases with the degree of turbulent flow of the solution in contact with the sensitive material. The creation of turbulent flow in a laminar current depends to some extent on the geometry of the channel, i.e. on its form and the dimensions of its profile, but it depends essentially on the speed and pressure of the liquid. In a tube of circular cross-section, for instance, the speed profile across the tube has the shape of a parabola at low and medium speeds, but beyond a certain limiting speed it becomes almost rectangular together with the appearance of turbulent flow (Figure 7.16). This limit corresponds to a rather well defined value

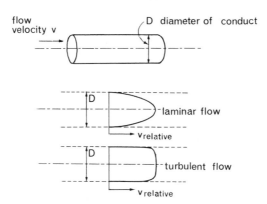

Figure 7.16. Variation of linear flow velocity distribution with overall flow speed.

of Reynolds' number

$$R_e = \frac{Dv\rho}{\mu},$$
(7.42)

D being the diameter of the circular tube, v the speed of the liquid, ρ its density and μ its viscosity. Reynolds' number, expressed in homogeneous units, is without dimension and the limit between laminar and turbulent flow lies for a tube of circular section approximately at $R_e = 2300$; for channels of rectangular cross-section this figure varies according to the shape of the rectangle. While appropriate laminar flow can yield satisfactory agitation, turbulent flow is more efficient because the liquid provides its own agitation by forming a great number of vortices. Katz[76] and Katz and Esthimer[77] showed that the thickness of the stagnant layer of reaction products adhering to the sensitive layer is inversely proportional to $R_e^{0.8}$ and

directly proportional to the diameter of the cross-section available, and
confirmed these results by experiment. In an experimental set-up allowing
speeds from 20 to 160 metres per second and Reynolds' numbers from 50,000
to 500,000 it thus proved possible to double the development rate of an aerial
film relative to that obtainable from manual processing with moderate
agitation.[77]

The principles of agitation by either laminar or turbulent flow are ex-
tensively applied in the design of industrial processing equipment. In con-
tinuous processors the gap widths between the tank walls and the paths of the
sensitive material define the cross-sections and thus the linear speed of flow
of the solutions, and the positioning of the recirculation inlets and outlets,
especially of submerged jets, contributes efficiently to the constant renewal
of the solution in contact with the processed surface. Agitation in the roller
transport machines is very efficient through the combination of several
principles of agitation: the movement of the sensitive material across the
solution, the replacement at each roller of the reaction products by fresh
solution, and finally the microturbulent agitation by the counter-rotating
rollers.

7.2.3 The Part of the Temperature

Like the kinetics of all chemical reactions, that of development obviously
depends on temperature. The acceleration of the overall kinetics with rising
temperature varies roughly with the type of developer, and to a certain extent
also with the kind of processed layer. In the customary development tem-
perature range, from 18°C to 24°C, the temperature coefficient—i.e. the
factor of development rate increase for a temperature rise of 10°C—is of the
order of 3·0 for most of the currently employed black-and-white developers;
it diminishes slightly with dilution, but attains values of up to 4·0 for low-
energy developers. The following specific values of some Kodak developers
are an example (Table 7.1).

TABLE 7.1

Kodak developer		Temperature coefficient (for a 10°C increase)
D-11 (Elon-hydroquinone, high contrast)	undiluted	3·2
	diluted 1:1	2·8
DK-50 (Elon-hydroquinone, medium contrast)	undiluted	2·8
	diluted 1:1	2·5
D-19, D-61a, D-72, D-76, DK-20, DK-60a, HC-110, Dektol, Versatol, Polydol, Microdol	undiluted or diluted	3·0 to 3·2
D-23 (Elon-sulphite)		3·6
D-25 (Elon-sulphite-bisulphite)		3·9

To facilitate in practice the correct choice of the development time for any given temperature, quantitative information is usually published for each developer in the form of graphs.[78] These allow one to determine, for any sensitive material–developer combination which yields a satisfactory result at a chosen temperature and development time, the appropriate development time at another temperature (Figure 7.17). From this graphical

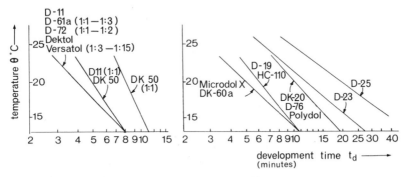

Figure 7.17. Time temperature development charts.

representation it appears that there exists a linear relationship between the temperature θ and the logarithm of the development time t_d,

$$\log t_d = c_1 - c_2\theta. \tag{7.43}$$

This relationship is also valid in the low-temperature range, e.g. at 15°C, and even for processing at sub-zero temperatures made possible only by the addition to the developer of ethylene glycol as an antifreeze agent.[79]

This relationship can also be written

$$t_d = k_1 e^{-k_2\theta}; \tag{7.44}$$

the exponential decrease of the development time with rising temperature obviously allows one to considerably accelerate processing only by the choice of high temperature—which of course must remain compatible with the physical resistance of the processed layer and other practical requirements—but it also compels one to maintain the nominal temperature of development within narrow limits to insure satisfactory results.

The three parameters on which the overall kinetics depend, the *electrochemical reaction rate*, the *solubility of the silver halide*, and the *diffusion*, each have their proper kinetics.[80] According to James, the first, the electrochemical reaction rate, rather closely obeys Arrhenius' law, adapted to photographic development by the introduction of a factor $f(c)$ for the observation of the concentrations of the active species of the developer, and of a

second factor $p(t)$ introducing the area of the reacting surfaces which varies with development time,

$$v_d = kf(c)p(t) e^{-E/RT} \tag{7.45}$$

where k is a constant, E the activation energy, R the gas constant and T the absolute temperature.[9] The rate of diffusion, inversely proportional to the square of the gelatin layer thickness, increases according to Reckziegel[71] linearly with the temperature between 5 and 25°C.

Temperature acts in several ways on the development reactions. The ionization of the developing agents increases with temperature; a rise in temperature therefore leads to an increase of the concentration of the active species with development agents which are active in the ionized state, such as those with hydroxyl groups. The ionization being also pH-dependent, it is the more complete the higher the pH; a temperature increase has therefore less effect on a well buffered high pH developer than on others of low pH, such as for instance D-25 developer (see p. 454).

Another important factor which depends on the temperature is the contribution of solution-physical development. The solubility of the silver halides, which increases in the order chloride, bromide, iodide, also increases slightly with temperature; a rise in temperature therefore favours solution-physical development, and this is more sensitive in general to temperature changes than is direct development. The increase of solubility with temperature also leads to higher fog when development at high temperature is carried to the same contrast and the same speed as that at low temperature.[81] Finally, the action of temperature on development kinetics also depends on exposure; it is more apparent in the low exposure range, where a slight density increase of the positive modifies the appearance of an image more than in the shoulder of its sensitometric characteristic.

The practical necessity of fastest access to the recorded information gives rise to a constant increase of all recommended processing temperatures; while temperatures of the order of 18 to 20°C were traditional for most black-and-white developers, they now reach up to 40°C or still higher levels for rapid access processing. In consequence very close adherence to the recommended development temperatures is more and more important as well as the precise observation of the nominal, sometimes very short development time, and also the sensitometric or analytical control of the processing solutions (see p. 502).

7.3 PROCESSES BASED ON THE USE OF DEVELOPING AGENT OXIDATION PRODUCTS

In normal black-and-white development the oxidation products of the developing agents are obviously undesirable. One exception is the use of oxidized developing agents for tanning gelatin which serves various purposes.

It is possible also to take further advantage of the oxidized forms of the developing agents: modern colour photography is entirely based on this principle.†

7.3.1 Colour Development

The oxidation products of a number of organic developing agents are dyes which colour gelatin. The idea to make use of these for photographic three-colour reproduction is due to Homolka[82] who employed indoxyl and thioindoxyl as developers to form blue and red images.

This direct process, called primary colour development, cannot however be employed in practice because of its contradictory requirements towards the developing agents. To insure adequate development kinetics these agents should readily diffuse through the gelatin of the sensitive layers; the dyes formed should on the other hand obviously find themselves solidly anchored in their respective layers to avoid any intermixing of the images. The diffusion rates, however, of the developer as well as of the dye, its oxidation product, are necessarily of similar magnitude because their respective molecules are of almost equal size. High diffusion rate is therefore *a priori* incompatible with the immediate *in situ* fixation of the just formed dye; if the developer molecules diffuse easily through all layers the reproduced colours are contaminated; if on the contrary the dye molecules are large enough to avoid the unwanted diffusion the penetration of the developer into the layers is sluggish and development efficiency remains low. The image quality resulting from primary colour development would therefore be unsatisfactory.

This difficulty can be avoided by separating development and dye formation. This method, invented by Fischer and Siegrist,[83] is called secondary colour development, or simply colour development.

7.3.1a *The Mechanism of Colour Development*

Colour development takes place in three steps: development, coupling to form a leuco dye, and dye formation by the oxidation of the leuco dye. The separation of the functions of development and dye formation results from the use of colour developers which when oxidized yield one part of the dye molecule, and of couplers which are compounds able to yield the other part of the dye molecule.[84] The three successive steps of colour development can schematically be represented by the following reactions:

colour developer (generally a substituted p-phenylenediamine) + n Ag$^+$ (silver ions of the exposed silver halide) \rightarrow n Ag + *oxidized colour developer*;

oxidized colour developer + coupler \rightarrow *leuco dye*;

leuco dye + oxidant \rightarrow *dye*.

† This remark not only applies to classical colour forming development but also to the modern transfer processes (see p. 472).

Most leuco dyes are oxidized during the development step, presumably by oxidized developer. Some leuco dyes are more persistent and are oxidized later, during removal of the silver image.

All that remains then to be done after the formation of the monochrome images in their respective layers is to eliminate the silver due to the development of the silver halide. This operation, in general carried out by rebromination and fixation (see p. 483), makes use of an oxidizing solution which also acts on the persistent leuco dyes and transform them to dyes.

Colour developers and couplers. The properties required for a *colour developing agent* can only be found in a restricted number of compounds. All colour developing agents employed in practice are therefore derivatives of p-phenylenediamine, more precisely of 4-amino-N-dialkylanilines of the general formula

$$(7.e)$$

Among the great number of compounds falling in this class only a few are in current use. Typical examples are para-amino-diethylaniline hydrochloride, (CD1) and 2-amino-5-diethyl-amino-toluene hydrochloride (CD2)[86]:

$$(7.f)$$

To reduce the allergenic properties of these compounds Weissberger proposed the introduction either on the benzene ring or in the alkyl groups of the amine hydrophilic substituents such as —OH, —SO₃R or —CO₂R.[85,86] A developer of this type is 4-amino-N-ethyl-N(β-methane-sulphonamido-ethyl)-metatoluidine sesquisulphate monohydrate (CD-3), of formula

$$(7.g)$$

The currently employed *couplers* belong to three classes:

(i) the class of couplers with *reactive methylene groups*, carrying a $-CH_2-$ group activated by electron accepting functions such as

$$-\underset{\underset{O}{\|}}{C}-R,\; -\underset{\underset{O}{\|}}{C}-NH-R \;\; \text{and} \;\; C\equiv N,$$

the open chain methylene couplers most frequently yielding yellow dyes;

(ii) the class of *cyclic methylene couplers*, mostly pyrazolones yielding magenta dyes, of the general formula

$$
\begin{array}{c}
R'-C-CH_2 \\
\quad\;\;\| \quad | \\
\quad\; N \quad C=O \\
\quad\;\; \diagdown N \diagup \\
\qquad\quad | \\
\qquad\quad R
\end{array}
\;\; ; \tag{7.h}
$$

and

(iii) the class of *methine couplers* comprising phenols and naphthols yielding cyan dyes.

The oxidation of the developer. The oxidation of the di-substituted para-phenylene diamines employed as colour developers occurs in two steps.[87,88] First a semiquinone ion forms by the departure of one electron,

colour developer semiquinone ion (7.46)

and then two semiquinone radicals react to form a quinone-diimine ion and to regenerate a developer molecule

semiquinone quinone-diimine developer
ion ion, stabilized molecule
 by resonance

Tong and Glesman[89] showed that the concentration of the semiquinone is however negligible at the customary high pH levels and that the principal reaction leads to the total oxidation,

$$(7.48)$$

The importance of the quinone-diimine as reactive species of the coupling reaction was also confirmed by Eggers and Frieser.[90]

Besides the principal coupling reaction several less desirable side reactions also take place. When the incorporated coupler (see p. 462) is used up in the vicinity of a site of development, the quinone-diimine might react with the hydroxyl ion in a deamination reaction which yields quinone-monoimine,

$$(7.49)$$

By diffusing into areas where there had been no exposure, the quinone-monoimine then cross oxidizes colour developer, and the resulting quinone-di-

$$(7.50)$$

imine reacts with coupler to form undesired dye fog. The deamination reaction of quinone-diimine is however much slower than that of image forming coupling and this kind of dye fog formation therefore only occurs near areas where the whole available incorporated coupler has been used up locally for image formation.

Other side reactions of quinone-diimine or semiquinone are sulphonation, also relatively slow and therefore favoured by local lack of coupler, just as deamination; and the formation of symmetrical azo compounds by the reaction of two oxidized developer molecules.

The coupling reaction. By its reaction with the coupler ion the quinone diimine yields the leuco dye; this reaction is favoured by the high pH of the colour developers at which the couplers are strongly ionized, thus forming the reactive species of the copulation. In the case of an open chain methylene coupler, these reactions are

$$\underset{Y}{\overset{X}{\diagdown}}CH_2 + OH^- \;\rightleftharpoons\; \underset{Y}{\overset{X}{\diagdown}}\overset{\textstyle H}{\underset{\textstyle }{C}}:^{\ominus} + H_2O \text{ , and} \qquad (7.51)$$

$$\underset{Y}{\overset{X}{\diagdown}}\overset{\textstyle H}{\underset{\textstyle }{C}}:^{\ominus} + \overset{H}{\underset{}{:N}} = \!\!\left\langle \begin{array}{c} \\ \end{array} \right\rangle \!\! = NR_2^+ \;\longrightarrow\; \underset{Y}{\overset{X}{\diagdown}}\overset{\textstyle H}{\underset{\textstyle }{C}} - \overset{H}{\underset{..}{N}} \!\!\left\langle \begin{array}{c} \\ \end{array} \right\rangle \!\! NR_2 \; . \qquad (7.52)$$

$$\quad\text{coupler} \qquad\qquad \text{quinone-} \qquad\qquad\quad \text{leuco dye}$$
$$\quad\text{anion} \qquad\qquad\quad\; \text{diimine}$$

The leuco dye must then be made to react with an oxidant to yield the dye; most frequently this oxidation occurs in the colour developer by the reaction of the leuco dye with an additional amount of quinone-diimine. Two of its ions being required, two further silver ions are necessary to form the dye:

$$\underset{Y}{\overset{X}{\diagdown}}\overset{\textstyle H}{\underset{\textstyle }{C}} - \overset{H}{\underset{..}{N}} \!\!\left\langle \begin{array}{c} \\ \end{array} \right\rangle \!\! NR_2 + 2\,Ag^+ \;\longrightarrow\; \underset{Y}{\overset{X}{\diagdown}}C = N \!\!\left\langle \begin{array}{c} \\ \end{array} \right\rangle \!\! NR_2 + 2\,Ag + 2H^+. \qquad (7.53)$$

The overall colour forming reaction is thus based on the exchange of four electrons, i.e. four silver ions must be reduced to yield one dye molecule, two of them for the oxidation of one molecule of developing agent and the two others for the oxidation of the leuco dye.

Two-equivalent 'elimination coupling'. Inspection of the structures of the classical couplers, either those with open chain or cyclic methylene groups as reactive functions or those which react by one of the elements of a benzene or a naphthalene ring, shows that the coupling position is always occupied by a hydrogen atom. It is possible, however, to replace it by substituting in this position sulpho-, carboxyl, or alkoxy-groups without modifying the resulting dye molecule.[92] The formation of the dye then only requires one single quinone-diimine molecule and therefore only two silver atoms, and this type of coupler is thus more efficient than non-substituted couplers which require four silver atoms.[86] This type of reaction, which yields the dye molecule by the elimination of the substituting group,[93] can be schematically

represented as

$$(7.54)$$

$$(7.55)$$

The Z^- groups liberated by the coupling reaction are chosen to be without any photographic action when optimum dye yield is required; it is possible, however, to use the presence of such groups for the improvement of image structure and colour reproduction quality (see below, p. 466).

7.3.1b *Methods of Introduction of the Couplers*

Among the three species which contribute to the formation of dye images by colour development, i.e., the silver halide, the colour forming developing agent and the coupler, the first is necessarily located in the photosensitive layer and the second normally contained in the developer. The couplers, however, can either be incorporated in the layers or dissolved in the colour developers. Incorporated couplers must be fixed solidly in the gelatin to avoid their diffusion, especially during development, and thus prevent any unwanted dye mixtures or spreading of lines or other image details.

Fixation of the couplers within the layers. As shown in the description of the components of the sensitive layers, p. 379, two methods are known for the fixation of the couplers to the gelatin of the photographic layers: the original method proposed by Fischer,[94] and that of the Kodacolour couplers due to Jelley and Vittum.[95] As stated above, the mechanisms of these methods are:

(i) In the first the coupler molecule is made hydrophobic by the attachment of a long aliphatic chain; this keeps it from diffusing through the water-soaked gelatin, for instance during processing. However, to make possible the introduction of the couplers into the layers during their preparation, the Fischer couplers also contain solubilizing groups.

(ii) In the second method of coupler introduction, that of the Kodacolor system, the couplers, made heavier by the attachment of butyl chains, are dissolved in water-immiscible organic solvents. These organic solutions are

then vigorously mixed with the gelatin already containing the silver halide so that they form microscopic droplets.

Examples of these two methods of coupler introduction are given in Chapters 5, p. 379.

Couplers dissolved in the colour developers. This method for introducing the couplers, known by the Kodachrome process invented by Mannes and Godowsky,[96] avoids altogether the problems related to the introduction of the couplers in the sensitive layers, but requires dyes which while forming fix themselves in the layers. The couplers, each dissolved in the respective three-colour developers (see below), easily penetrate the layers immediately after the immersion of the sensitive material. Several mechanisms then contribute to the fixation of the dyes formed by the development and coupling reactions: first the lowering of their solubility by the loss of the acidic functions of the phenolic or methylene groups, and further the size increase of their molecules through the combination of the oxidized developer with the coupler ion. According to Weissberger[97] other factors for the immobilization of the dyes are the appearance of dipolar attractions and of Van der Waals forces between the dye molecules, creating molecular aggregates, and also between the dye molecules and the gelatin.

The practical application of the introduction of couplers in aqueous processing solutions is possible only with reversal materials, yielding after exposure and processing direct positives (see below, p. 473). The successive steps of this type of process are: after imagewise exposure of the film (Figure 7.18 [see Plate 4]) the three separation negatives, each in its respective layer, are first developed together in a single black-and-white developer. A uniform exposure to red light, fogging all residual silver halide only of the red sensitive bottom layer, then makes it possible to develop the positive complement of this layer in a colour developer containing the dissolved coupler yielding cyan dye. Similarly, by exposure to blue light, just sufficient to expose the complementary silver halide in the top layer, but entirely stopped by the yellow filter layer which separates the top layer from the layers beneath, the yellow image can be developed in a second colour developer which contains the yellow coupler in solution. Only the third positive image of the three-colour reproduction then remains to be developed. To this purpose the layer is fogged with white light, or by a chemical, and subsequently developed to form the magenta positive. After elimination of the developed negative silver as well as the positive silver by rebromination and fixation, only the three monochrome positives remain in their respective layers and reproduce the original (see also p. 247).

Comparison of the various methods of coupler introduction. The method chosen for introducing the couplers has of course no effect on the physical

result of the three-colour reproduction, but it slightly differentiates the various processes in practice. Incorporation of the couplers in the layers not only allows one to carry out colour development of negative as well as of reversal materials, but also simplifies the processing: each coupler being fixed in its respective layer, one single developer can simultaneously form the three monochrome images of three-colour synthesis. When, on the contrary, the couplers are dissolved in three separate colour developers, each preceeded by an adequately filtered reversal exposure of narrow tolerance, the process is not only restricted to reversal but the greater number of operations also makes it more involved. Requiring in consequence considerable processing control, it is useful only when applied to industrial large-scale processes and therefore only serves for reversal amateur films, movies as well as still transparencies. Films and papers with the couplers incorporated in the layers, on the other hand, can either be processed industrially on a large scale, or else in small tanks by hand. In the first case they are mainly employed in the negative–positive processes of professional motion-picture film and in amateur photography to yield paper prints; manual small-scale processing on the contrary is rather restricted to professional and commercial photography, for reversal as well as for negative–positive materials.

7.3.1c *The Chemistry of Coloured Couplers*

The correction by masking, required because of the omission of the negative sensitivities in the separation negatives as of the unwanted absorptions of the dyes of three-colour synthesis, can be incorporated into negative films by the system of coloured couplers (see p. 263). As mentioned before, these couplers, incorporated into the layers, have the hue appropriate to form a positive mask during colour development. By losing their proper hue in the areas where the dyes of the negative images are formed by the coupling reaction they yield on the one hand the cyan, magenta and yellow negatives, and on the other hand the positive masks in their own initial colours.

The hue of the coloured couplers results from the attachment of an azo dye group in the reactive position of the coupler; during the coupling reaction with the oxidized developing agent this azo group is separated from the coupler which thus looses its initial hue by forming one of the three dyes of three-colour synthesis. The following example illustrates this type of reaction for the case of a yellow coupler yielding a magenta dye (Reference 73 of Chapter 3):

$$\longrightarrow \ C_6H_5-CO-NH-C-C \overset{N=N-\langle\rangle}{\underset{\underset{N}{\overset{||}{N}} \quad \overset{|}{\underset{}{C=O}}}{\diagdown}} \overset{H}{\underset{N}{\diagdown}}\langle\rangle N(CH_3)_2 \qquad \xrightarrow{-e, -H}$$

$$(7.56)$$

$$\longrightarrow \ C_6H_5-CO-NH-\underset{\underset{N}{\overset{||}{N}} \quad \overset{|}{\underset{}{C=O}}}{C}-C=N\langle\rangle N(CH_3)_2 \ + \ N\equiv\overset{+}{N}\langle\rangle$$

dye diazonium
 ion

Formation of the quinonediimine requires two silver ions, and the loss of one electron and one hydrogen atom the reduction of two further Ag^+, making reaction (7.56) at this stage 4-equivalent. However, the diazonium cation reacts with developer, extracting two electrons, so that 2-equivalency is retained.

$$N\equiv\overset{+}{N}\langle\rangle \ + \ H_2N\langle\rangle N(CH_3)_2 \ \longrightarrow$$

diazonium developer
 ion

$$(7.57)$$

$$\longrightarrow \ H\overset{+}{N}\langle\rangle N(CH_3)_2 \ + \ \langle\rangle \ + \ N_2$$

quinone-
diimine

A colourless coupler, not carrying the azo group, such as (7.i) would yield an identical dye to the colourless coupler, that shown in the last line of reactions (7.56).

$$C_6H_5-CO-NH-\underset{\underset{N}{\overset{||}{N}} \quad \overset{|}{\underset{}{C=O}}}{C}-CH_2$$

$$(7.i)$$

7.3.1d *DIR-Couplers*

Masking correction by coloured couplers can be applied only in negative–positive processes and those reversal materials which are designed to serve as intermediates in photographic or non-photographic reproduction chains (see p. 267). Indispensable also in the photographic reversal processes which yield positives directly on the imagewise exposed material, these corrections of colour reproduction can now be applied to these processes also through interimage effects obtained with couplers releasing development inhibitors and called DIR or development inhibitor releasing couplers.[93] These couplers make it further possible to influence the image structure and therefore to improve both the granularity and the sharpness of colour images.

Mechanism. Standard couplers, as mentioned above, carry hydrogen ions in their reactive positions, and coloured couplers azo dye groups (see p. 459 and p. 464); liberation of these fragments during dye formation by coupling has no effect on the development reaction proper. Grafting onto the reactive positions of groups which act on the development process, however, not only allows one to create interimage effects, and thus to introduce corrections by masking without the presence of corrective dye images which cannot be made use of in reversal processes, but also makes it possible to improve detail reproduction.[98,99] Some typical examples of such couplers, releasing during elimination coupling (see p. 461) either development inhibitors (couplers a and b), or fragments undergoing subsequent reactions yielding such inhibitors (coupler c), are the following:

(a) cyan coupler releasing benzotriazole

(7.j)

(b) yellow coupler releasing a mercaptotetrazole

(7.k)

| coupler | oxidized developer | indoaniline dye | benzotriazole precursor |

(c) cyan coupler releasing a benzotriazole precursor

The DIR-couplers have the additional advantage, like many couplers substituted in the reactive position, of requiring only two equivalents of silver per dye molecule formed,[86] as opposed to the classical couplers carrying only hydrogen atoms in the coupling position. The DIR-couplers thus add the advantage of silver halide economy to the usefulness of the compounds released by coupling-off.

Effects of the released development inhibitors. The fragments released from the DIR couplers during coupling are organic anti-foggants, i.e. inhibitors of the development reaction.[100] They can be used to yield interimage or adjacency effects (see p. 156), either in the layer in which they are released (intralayer effects), or in one or several neighbouring layers in a multilayer material (interlayer effects).

The intralayer effects act on image structure by reducing the granularity of the colour images and by a sharpness improvement. The dye image clouds cover indeed areas much larger than those of the silver halide crystals being at their origin, and their optical density, while restricted to a limited region of the visible spectrum, is however much greater than that of the corresponding silver deposit and therefore leads to high graininess. Reduction of the dye cloud diameters by the development inhibitor, together with an increase in the number of the small developed silver halide crystals, considerably diminishes graininess. Similarly, the fog restraining fragments released by the coupling reaction create adjacency effects and thus act advantageously on the sharpness and the reproduction of fine detail (see p. 159).

Also diffusing into the neighbouring layers, the released inhibitor fragments act there in a quite different manner by interlayer effects. Their concentration is practically proportional to the density of the image from which they are released—with the exception of a slight lateral diffusion, also yielding useful effects—and in consequence restrict the development in the

layer they attain proportionally to the image in their own layer. This, however, is precisely the mechanism of correction by masking (see p. 255); the interlayer effects thus not only yield excellent colour reproduction, but also yield the additional advantage of a slightly unsharp mask with its beneficial effects on image structure.[93]

7.3.2 Tanning Development

7.3.2a *Mechanism*

The quinonic forms which result from the oxidation of developing agents with two or more hydroxyl groups react with gelatin by setting up cross links between its molecules as in the following example;

$$
\left.\begin{array}{c} R-NH_2 \\ R-NH_2 \end{array}\right\} + \text{(benzoquinone)} \longrightarrow \text{(hardened quinone)} \tag{7.59}
$$

gelatin oxidized developing agent hardened gelatin

To make this kind of tanning development possible, yielding not only an image but also a gelatin relief insoluble in warm water and reproducing the exposure pattern, it is not desirable to remove the developer oxidation product by an unwanted reaction such as by the reaction with the sulphite ion; tanning developers therefore do not contain any sulphite. As the oxidation of the developing agents is autocatalytic, however, they must be protected so as to retain their potential of reduction. Either reducing agents other than sulphite must be employed, such as ascorbic acid, or the developer must be prepared in slightly acid solution and the alkaline accelerator then introduced only immediately prior to development. This latter technique can only be applied in manual tray processing because the developer solutions remain active only during a very short lapse of time, just sufficient to allow the development to reach completion.

The developing agents employed in practice for tanning development are mainly dihydroxybenzenes;[101] among these oxidized catechol reacts the most rapidly with gelatin so that hardening takes place *in situ* and the gelatin reliefs correspond exactly to the exposure pattern. After its oxidation pyrogallol reacts slower with gelatin and therefore spreads cross linking and hardening by its diffusion very slightly out of the neighbourhood of the exposed crystals; this diffusion is still more pronounced with hydroquinone.

7.3.2b *Sensitometry of Tanning Development*

The physical mechanism of the formation of hardened gelatin images is entirely different from that normally applied for the obtention of silver images, especially in those processes which require gelatin reliefs whose thicknesses are to be proportional to the image densities, such as in dye transfer processes where the gelatin relief serves after imbibition with a soluble dye to its transfer into a receiving layer of uniform thickness. To form the gelatin relief the differential penetration into the layer of the exposing radiation is emphasised by incorporating into it a compound absorbing in the spectral region of its sensitivity; in the case of a blue-sensitive layer the absorber would thus be a yellow dye. The exposing radiation then forms the latent image in relief in the depth of the layer according to the intensity of its flux; the inherent sensitometric contrast of the layer further being made very high, a very sharp border forms between the developable and the non-developable strata of the layer in accordance with the exposure (Figure 7.19).

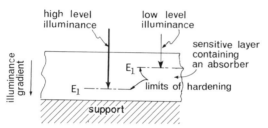

Figure 7.19. Differential depth penetration due to the presence in the layer of an absorbant of the exposing radiation.

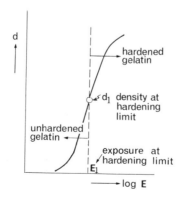

Figure 7.20. Relationship between exposure and tanning development.

Figure 7.20 shows the sensitometric characteristics of a layer designed for this type of hardened relief formation; below a certain exposure limit the amount of oxidized developer is not sufficient to make the gelatin insoluble in warm water, but above this limit it yields the required raising of the melting point and therefore satisfactory hardening.

By the appropriate choice of the developing agent and the developer formula it is thus possible to prepare a relief with thicknesses practically proportional to the logarithms of the exposures. To make it adhere to the base after washing off with warm water, the layer must be exposed through the base (Figure 7.21).

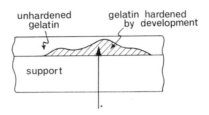

Figure 7.21. Formation of the gelatin relief against the film base.

7.3.2c *Applications*

Processing by tanning development and washing out of the soluble gelatin in the non-exposed areas has a few practical advantages. Requiring neither fixation nor washing, it is rapid and simple; the hardened gelatin relief is very thin, much thinner in general than the unexposed and unprocessed sensitive layer. The contraints of the base due to the image forming relief are therefore negligible when compared to those from ordinary photographic layers, and thus favour the size-holding properties and also the flatness of the film or paper after drying. Such a process can therefore be useful for films for engineering drawing reproduction. In other more specific forms it has found application in colour reproduction processes and for office copying.

Dye transfer processes. In these processes, still in use in colour reproduction,[101] the gelatin reliefs only serve to transfer at each point of the image the just required amounts of the image-forming dyes. The three reliefs, after exposure through the corresponding colour separation negatives, and tanning development and wash off, are each imbibed in aqueous solutions of the appropriate dyes of three-colour synthesis (see p. 249). This inhibition, carried out in acid medium, temporarily immobilizes the dyes in high and uniform concentration in the hardened gelatin relief; the amount of dye fixed in each point of the relief is then proportional to its thickness, i.e. to the optical density of each of the cyan, magenta and yellow images.

Plate 4

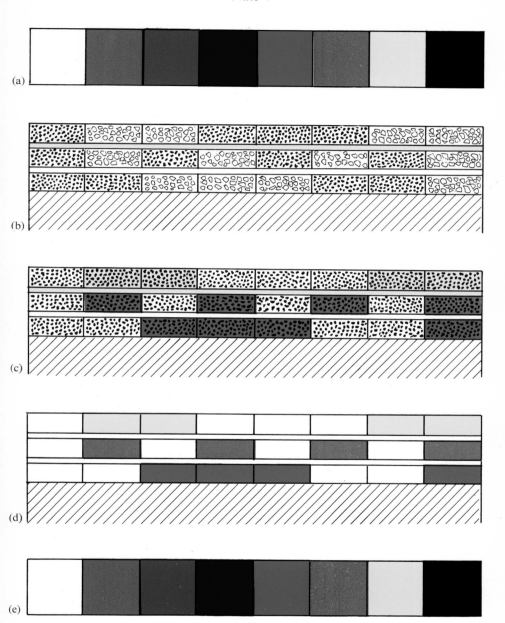

Figure 7.18. Diagram of reversal colour development with couplers dissolved in the colour developers. (a) Original. (b) Film exposed and developed in black-and-white, carrying the three separation negatives and the whole residual halide. (c) Selective exposures of each layer followed by colour development yield the cyan, magenta and yellow dye positives in three separate steps. (d) After elimination of the developed silver there remain only the three monochrome positives of three-colour synthesis. (e) Reproduction.

The final images are formed in the mordanted gelatin layer of uniform thickness of a receiving material, film or paper, by the successive transfer of the three dye images in exact register. Immediately after being brought into contact with this layer, which is soaked with a slightly alkaline buffer solution, the temporary fixation of the dyes ceases by the sudden pH rise; this makes the dyes diffuse into the receiving layer where they are then firmly fixed by their instantaneous reaction with the mordant. This latter accelerates their transfer by constantly maintaining the diffusion gradient at its maximum value until the complete exhaustion of the dye contained in the gelatin relief.

Image formation by physical transfer. The hardening of the gelatin of the exposed areas of a photographic silver halide layer can also be made use of in a very different manner for the physical transfer of the unhardened gelatin onto a receiving base.[102,103] This technique is applied to office document copying with a particular kind of exposure called 'reflex exposure' (Figure 7.22); the exposing radiation, after having crossed the photosensitive material, is reflected only by the light areas of the document but not by the type matter or the figures. By reaching the sensitive layer for a second time after having been reflected, the luminous flux is almost doubled and becomes sufficient to make the image developable.

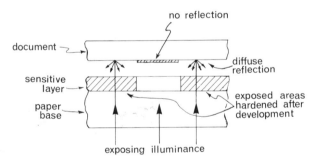

Figure 7.22. Principle of reflex exposure.

To simplify processing, the sensitive layer of the matrix also contains the tanning developing agent; this allows us to carry out the development and the hardening of the exposed areas by only immersing the matrix into an alkaline solution (see also p. 443). By pressing the matrix into contact with a receiving base it is then possible to form the final image by the transfer of a part or the whole of the unhardened layer (Figure 7.23). Those parts of the layer which are to be transferred for the formation of the positive print, fogged by the ambient light, are developed by the continuation of the development until the transfer. As only a part of the unhardened gelatin is

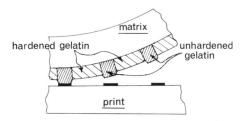

Figure 7.23. Application of tanning development in a document-copying process: a small fraction of the gelatin of the unhardened areas is transferred at each contact onto a sheet of receiving paper.

transferred at each contact, several copies can be obtained from one single matrix.

Transfer of dye developers. This is the technique intrinsic in the instant processing of full colour images within the camera.[104,105] As in the other transfer processes based on tanning development, two elements are made use of: a negative camera film and a receiving sheet.

For each of the three elementary images of colour reproduction the negative film carries two layers: a sensitive layer of customary composition, sensitized in the appropriate spectral region, and a second layer containing the dye developer, a compound having the constitution of a developer as well as that of a dye, such as those of the following examples:

$$(7.1)$$

Dye developers of (a) cyan, (b) magenta, and (c) yellow hue.

After its exposure the negative film is brought in contact with the mordanted layer of the receiving sheet while an alkaline viscous solution is spread between the two surfaces. The dye developers, by developing the negatives, are oxidized to their quinonic form and fix themselves onto the gelatin; in the non-exposed areas, on the contrary, they freely diffuse until

reaching the mordanted receiving layer where they are immobilized just as in the customary dye transfer processes (see above, p. 470). Formed by the complement or the dye negatives fixed in the layers of the exposed camera taking film, the three transfer images yield on the receiving sheet directly the full colour positive image (Figure 7.24). To insure its satisfactory

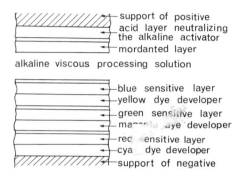

Figure 7.24. Diagram of reversal by transfer of dye developers.

keeping, the receiving paper carries adjacent to the mordanted layer an acid-containing layer able to neutralize the residual excess of viscous alkaline processing solution. The water formed in this neutralizing reaction contributes to the rediffusion of the exhausted processing solution into the negative; as this latter is discarded after its separation from the final image, the positive remains stable.

7.4 REVERSAL PROCESSES

7.4.1 Classical Reversal

It is often desirable to obtain directly a positive image on the material having been exposed, without the intervention of an intermediate negative which serves no useful purpose when one single image is all that is required. In black-and-white photography the sensitive material is therefore developed to a negative after its exposure and the remaining complement of light-sensitive material in the layer then employed to form directly the positive by a uniform exposure, and a second development; in colour photography an identical technique is applied to materials with couplers incorporated into the layers (see p. 462); in the materials without couplers, however, the formation of the positive image is carried out separately for each of the three layers by developing them in the corresponding colour developers containing the couplers in solution.

7.4.1a *Order of the Operations*

Black-and-white reversal processing. After exposure the negative silver is developed in an energetic developer and then dissolved in an oxidizing solution which forms a sufficiently soluble silver salt, generally silver sulphate. This solution, currently called a 'bleach', normally contains potassium permanganate as oxidant; by its reduction through the contact with the gelatin an unwanted residue of manganese dioxide forms in the layer. This must be eliminated; it is dissolved in a solution of sodium or potassium bisulphite, called 'clarification'. The residual complement of silver halide, having the configuration of the positive corresponding to the exposure, is then uniformly fogged and developed to yield the final recording. Like the normal processing of negatives, reversal development is in general followed by fixation and washing.

Colour reversal with incorporated couplers. The development of the silver separation negatives is carried out simultaneously in the three layers as in black-and-white, in an energetic developer. After having been stopped by immersion in an acid solution, this development is immediately followed by a reversal exposure to strong white light, and then by colour development which forms the monochrome images of three-colour synthesis. The major part of the silver having then been developed in the three layers, it must be eliminated, which is done by rehalogenation in an oxidizing solution ('bleach'), and dissolution in a fixer.

Colour reversal with couplers dissolved in the colour developers. Here also the development of the three negatives remains unchanged as compared to black-and-white, but the reversal exposures, each according to the spectral sensitivity of one of the three layers, are carried out separately as well as the colour developments which follow them (see p. 463). The elimination of the negative as well as of the positive silver is again obtained by rehalogenation and fixation.

7.4.1b *Mechanisms Specific to Reversal Processing*

Reversal processing, in black-and-white as well as in colour, is based on several rather specific mechanisms.

Sensitometric difference between the initial imagewise and the uniform reversal exposures. Whereas the negative image is the result of a modulated, i.e. a variable, exposure of a layer of uniform silver halide concentration, the positive reversal image results from the uniform exposure of a layer of imagewise variable silver halide concentration and sensitivity.[106] After development of the negative the residual silver halide varies not only in its amount according to the initial exposure, but also in its sensitivity and the dimensions

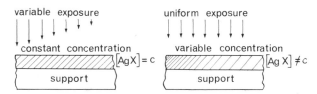

variable exposure uniform exposure

constant concentration variable concentration

$[AgX] = c$ $[Ag\,X] \neq c$

support support

Figure 7.25. The intrinsic difference between the initial modulated exposure and the uniform reversal exposure.

of its crystals (Figure 7.25). In an area of intense negative exposure only a few of the smallest crystals of low sensitivity remain unmodified after the first development; the residual sensitivity of this area is therefore very low. In an only slightly exposed area, on the contrary, only a small number of the most sensitive crystals are affected; after the first development the layer therefore still contains almost the total amount of the original silver halide and practically retains its initial sensitivity. The sensitometric characteristics of these two areas are therefore very different, the first being that of a layer of low sensitivity and small coating weight (Figure 7.26, curve b), but the second that of a fast negative layer (Figure 7.26, curve a). This difference in speed and sensitometric response, while varying only gradually between these two extremes, strongly influences the result of the reversal exposure which must therefore be chosen at a well defined level.

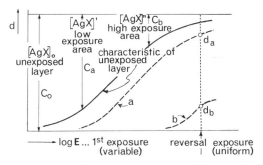

Figure 7.26. Sensitometric characteristics of the unexposed layer and of areas slightly or strongly exposed, after negative development.

Role of the solvent action of the first developer. Among the great mass of silver halide crystals of a photographic layer, a certain number always only form internal latent images and therefore remain undeveloped even after an exposure sufficient to yield the maximum density; in ordinary negative processing they disappear by being fixed out. In a reversal process, however,

these 'dead' crystals are unwanted, because they easily become developable after their passage through the bleach and clarification solutions and the intermediate washes, and then give rise to high fog during the second development after the reversal exposure. To avoid this reversal fog it is not enough to choose a first developer of high energy, but it must also contain a silver halide solvent so as to develop those crystals which carry internal latent images.

When containing a silver halide solvent however, the first developer also gives rise to a high level of solution-physical development of the unexposed silver halide onto the negative silver, which reduces the mass of silver available to form the positive image during the second development.[107] For this reason the solvent action is limited to a level just sufficient to avoid fog; the solvents normally employed are the thiocyanate and sulphite ions.

Resensitization of the black-and-white layers in the clearing bath. The oxidant required for the formation of soluble silver salts in the bleach following the first developer, the permanganate or bichromate ion, also eliminates the sensitivity specks at the surface of the still unexposed silver halide crystals and thus makes them almost unsensitive to light. To avoid the excessive reversal exposure which would then be required, it is therefore necessary to resensitize these residual crystals which are to form the positive image in the second developer. This resensitization is obtained from the clearing bath by a not very well defined mechanism: the bisulphite ion seems to contribute not only to a sulphur deposit sufficient to again form nuclei of external sensitivity, but also to the dissolution of a very shallow surface layer of the crystals and the resulting uncovering of pre-existing internal nuclei at low depth. The film or paper thus recovers during clarification a sensitivity sufficient for the reversal exposure.

Obviously this resensitization would also act on the 'dead' crystals carrying internal latent images if these were not developed in the first developer, and it would thus create high fog during the second development. This is another reason for the requirement of a solvent first developer.

7.4.2 Reversal by Diffusion Transfer

Instead of forming the positive in the very layer exposed in the camera, such as in classical reversal, it is also possible to constitute it in a receiving layer on a separate support. This process, called diffusion transfer, serves to yield instant pictures developed within the camera, for document copying, and in aerial and spatial photography for the development without immersions into processing solutions.

In the diffusion-transfer process the sensitive layer, after its exposure, is soaked with a monobath and then immediately pressed in contact with a

receiving material whose layer contains nuclei for physical development.[108,109,110,111] The silver of the negative image is thus reduced by direct development and remains immobilized in the exposed sensitive layer, whereas the residual silver halide, made soluble by the complexant of the monobath, diffuses into the receiving layer where the positive image forms by physical development. After the separation of both layers a positive results directly without the necessity of eliminating the negative image; it is even possible to use the negative in the customary way after fixation and washing. This possibility is not employed with camera processing and for document copying, but often serves in aerial photography. In this application the diffusion-transfer process is mainly used to avoid the use of processing solutions at high altitude or in outer space; the receiving film, carrying a layer which contains precipitation nuclei, is soaked beforehand with a monobath and thus kept until exposure and processing are required. These can then be carried out by simple common up-winding of both webs, the light-sensitive film and the soaked receiving material.[112]

The particular mechanism of the diffusion-transfer process requires very easily developable light-sensitive crystals and a very energetic developer without any induction period, capable of reducing the exposed silver halide before its dissolution by the complexant. A very precise balance is necessary between the rates of the development of the negative, the solubilization of the residual silver halide and the diffusion of the complex formed.

According to the balance of these rates the distribution of the silver precipitated by physical development either onto the already developed negative silver or onto the nuclei of the receiving layer can vary considerably.[61] The type of complexant used in the monobath formula and the kind of nuclei in the receiving layer also influence the characteristics of the positive image.

7.5 COMPLEMENTARY PROCESSING STEPS

The photographic process essentially depends on the mechanism of latent image formation and on the use of the latent image for the amplification, by development, of the recorded signals. These operations, while being the most important, are not sufficient to yield the final and stable images or recordings; it is still necessary to complete them by various processes, in general called secondary, like those of bleaching, fixing, washing and drying. Other secondary processing steps often required are prehardening, the elimination of backing layers prior to development, and the stabilization of the image dyes with the purpose of insuring the satisfactory keeping of colour images by improving their resistance against various radiations, humidity and heat. These processing steps, while being only complementary to the formation proper of the images or recordings, are just as necessary as the development

and often have a capital importance for the physical quality of the final result.

7.5.1 Elimination of the Residual Constituents after Image Formation

After development the layers still contain various residual components not contributing to image formation, such as silver halides in black-and-white, or silver developed during colour development and residual couplers in colour, which must be eliminated, or at least neutralized, without any modification of the recording just created.

To eliminate the residual silver halides they are transformed into soluble salts or complexes; subsequent washing in water then eliminates the solubilizing compounds or complexants in excess; sometimes it is also sufficient, as for the acceleration of the processing of photographic papers, to transform the silver halides into silver compounds not sensitive to light and also sufficiently stable against humidity and heat to satisfy practical requirements. The first method, called *fixation*, yields images of the highest stability during prolonged keeping; experience acquired until now proves that correctly fixed and washed records remain unaltered over one hundred years or more. The second method, called *stabilization*, yields, in spite of its apparent precariousness, prints sufficiently stable for various purposes, such as for instance photographic news shots.

In colour reproduction the elimination of the silver accessorily formed during colour development is obtained by its rehalogenation in an oxidizing solution followed by the classical dissolution of the resulting silver halide by fixation. The dye images are then definitely stabilized by blocking the reactive functions of the residual couplers.

7.5.1a *Fixation*

Mechanism. Compared with the complexity of the mechanism of development, that of fixation is relatively simple: all that is required is to displace the equilibrium between the two ionic species of the photosensitive silver halide to solubilize it. At the customary temperatures of the photographic processes the solubility product $[Ag^+][X^-] = k$ of the silver halides is so low that they can be considered to be insoluble (see p. 442). Fixation therefore requires a silver complexant capable of forming very stable complexes, thus disrupting the balance between the silver and the halide ions. With a complexant called A these complexes have the general formula $AgA_2^{(2n-1)-}$ and their dissociation constant is defined by the relationship

$$\frac{[Ag^+][A^{n-}]^2}{[AgA_2^{(2n-1)-}]} = k'.\dagger \tag{7.60}$$

† Some authors use the reciprocal of the dissociation constant and call it the stability constant; data are thus often reported also by this constant, and also as $-\log k'$. One of the values in the table would thus be, for example, $-\log k'$ for $Ag(S_2O_3)^-$ = 8·85.

To make a complexant efficient as a solubilizing agent the value of k' must be chosen as small as possible.[113] Table 7.2 lists values of k' at 25°C for some silver ion complexant ions such as sulphite, ammonia, thiocyanate, thiosulphate and cyanide ions.[114]

TABLE 7.2

Complexing agent	Complex ion	Dissociation constant k'
SO_3^{2-}	$Ag\,SO_3^-$	2.5×10^{-6}
	$Ag\,(SO_3)_2^{3-}$	2.1×10^{-9}
	$Ag\,(SO_3)_3^{5-}$	1.2×10^{-9}
NH_3	$Ag\,(NH_3)_2^+$	6.2×10^{-8}
SCN^-	$Ag\,(SCN)_2^-$	6.5×10^{-9}
	$Ag\,(SCN)_3^{2-}$	5.0×10^{-10}
	$Ag\,(SCN)_4^{3-}$	10.0×10^{-10}
$S_2O_3^{2-}$	$Ag\,(S_2O_3)^-$	1.4×10^{-9} (20°C)
	$Ag\,(S_2O_3)_2^{3-}$	3.5×10^{-14}
	$Ag\,(S_2O_3)_3^{5-}$	5.4×10^{-15}
CN^-	$Ag\,(CN)_2^-$	8.0×10^{-22} (18°C)
	$Ag\,(CN)_3^{2-}$	1.6×10^{-22}
	$Ag\,(CN)_4^{3-}$	2.1×10^{-22}

The formation of the second of the silver thiosulphate complexes, for instance, by the reaction of silver bromide with sodium thiosulphate, takes place according to the following equation:

$$AgBr + 2Na_2S_2O_3 \rightleftarrows Na_3[Ag(S_2O_3)_2] + NaBr. \qquad (7.61)$$

Inspection of the dissociation constants also makes apparent the reason underlying the exclusive use of thiosulphate as a fixer; cyanide would be still more efficient, but its extreme toxicity forbids its use.

Obviously the essential factor of the usefulness of a complexant as fixer remains the solubility product of the silver halide to be dissolved: the fixation of silver chloride and silver bromide by thiosulphate is very efficient, but silver iodide, whose solubility product is of the order of 10^{-16}, is much less soluble in a thiosulphate solution and thus diminishes the rate of fixation of negative layers containing in their silver bromoiodide crystals a non-negligible fraction of iodide ion.

On the other hand, the fixer must not dissolve any image silver. In practice this condition is fulfilled by thiosulphate fixing solutions, especially during the comparatively short duration of the immersion of the sensitive layers in these baths. If the fixer were allowed to act on a developed layer for a considerably longer time, as for instance of the order of several hours, the most fragile parts of the silver deposit would be dissolved; these are the parts of the image composed of the most finely divided silver particles. In acid fixers

this dissolution is favoured by the presence of the bisulphite ion, which facilitates the formation of silver oxide and consequently the solubilization of the image silver.

Kinetic aspects. Fixation being considered as an accessory step, the tendency is in general to complete it in the shortest possible time; the kinetics of the dissolution of the residual silver halide is therefore of rather great importance. For any given complexant it depends on the nature of the cation, and quite generally on the rate of diffusion and therefore on agitation and temperature. Another principal parameter acting on the rate of fixation is the concentration of the thiosulphate ion.

The kinetics of the fixation of any given sensitive layer are investigated by the determination of the time required to clear it, called clearing time. Due to its proper nature this determination is not very precise, and the results reported in the literature[115] (as well as others), generally rather remote, were in most cases carried out without any prior development. Being only approximate they allow us to estimate the orders of magnitude of the influence of the various parameters. The time required to attain complete fixation, on the other hand, is considered in practice to be twice that of clarification. With the clarification just completed there still remains in the layer a certain concentration of the initially formed monovalent complex $Ag(S_2O_3)^-$, so that the elimination of the residual salts during the subsequent wash is in risk of remaining incomplete.

The two cations of the thiosulphate salts exclusively employed in practice are the sodium and the ammonium ions. Ammonium thiosulphate fixes silver bromoiodide negative layers approximately twice as fast as sodium thiosulphate. Battaglia and Honnick[116] determined by chronopotentiometric measurements the diffusion coefficients of the thiosulphates and found their dependence on the alkaline ion in the order $NH_4^+ > K^+ > Na^+ > Li^+$; from this cationic progression and the effect of pH on diffusion, it may be deduced that the influence of the alkaline ions on diffusion rate is related to their action on the swelling of gelatin, but it may also be related to the size of the cation with its associated solvent shell.

The current use of sodium thiosulphate is related to its satisfactory keeping in the crystallized state, but the use of ammonium hypo, highly deliquescent, is justified by the increased fixation rate and also by the rapidly spreading use of chemicals in concentrated solutions.

The rate of fixation depends essentially on the efficiency of the exchanges between the fresh solution and that having reacted, retained in the layer. Obviously the same problems of diffusion are encountered here as in development; to facilitate the exchanges it is therefore also necessary to steadily eliminate by agitation the laminary film of exhausted solution

accumulating at the surface of the sensitive layer (see p. 447). Maintenance by agitation of a diffusion coefficient of satisfactory magnitude is also favoured by high solution temperatures; these not only facilitate the exchanges by accelerating them, but also by the resulting additional swelling of the gelatin. On the other hand, further to the successive passages in solutions of low and high pH, the layers then run the risk of loosing too much of their mechanical resistance and thus being damaged (see p. 367). The recommended processes, even those of high nominal temperature, are therefore in general designed to avoid these problems as well as that of reticulation—the formation of a surface of interlaced wrinkles—occurring through the rapid transfer of a film from a warm into a cold solution or vice versa.

The thiosulphate concentration of fixers acts on fixation rate by accelerating it rather fast up to about 300 grammes of crystallized salt per litre. Considering as speed of fixation the inverse of the clarification time, Jaenicke[117] found proportionality between this rate and the thiosulphate concentration between 0·025 and 1·08 moles per litre.

The fixing solution. Besides its principal component, the complexant, the fixers also contain buffers, stabilizers and very often hardeners. Their pH must indeed be maintained at a comparatively low level, from about 3·0 to 6·0 according to its formula, but not below pH 3·0 to avoid decomposition of the thiosulphate ion and the resulting precipitation of sulphur according to the reaction

$$S_2O_3^= + H^+ \rightleftarrows HSO_3^- + S. \tag{7.62}$$

Addition of sodium bisulphite to the fixer shifts the equilibrium towards the left side, and thus stabilizes the solution; besides sodium bisulphite and potassium metabisulphite other buffering compounds currently employed are organic acids, such as boric acid, acetic acid and others. The bisulphite ion is also frequently obtained directly in the fixer solution by the reaction of the sulphite in an acid medium.

The acidity of the fixing solution is required not only to completely prevent all physical development which would result from the simultaneous presence of both the residual developer and the complexant which solubilizes the silver halides, but also to insure satisfactory hardening of the gelatin in hardening fixers. The hardening compounds most frequently employed in fixers are chromium and potassium alums, whose useful pH ranges for gelatin hardening are respectively from 2·5 to 3·0 and from 4·3 to 5·4, with optimum levels of about 3·0 and 4·8 (see also p. 368).

7.5.1b Stabilization

Mechanism and kinetics. The chemistry of stabilization, based on the transformation of the residual silver halide into complexes insensitive to

light and comparatively stable to heat and humidity, is fundamentally the same as that of fixation. It is more involved, however, because the silver complexes as well as the stabilizing compounds, liable to undergo further reactions, are retained in the photographic layer. The stability of the resulting complexes is consequently still more important than in fixation, where both the complexes and the complexants are eliminated altogether by washing.

As the essential purpose of stabilization is the acceleration of the processing operation, its kinetics which depend on similar factors as that of fixation remain, together with the stability of the prints, one of its essential criterions. A gain in stabilization rate can be obtained either by choosing a temperature as high as possible, but still compatible with the structure of the layer to be processed, and also by vigorous agitation. When stabilization is applied to a sensitive material without incorporated developing agents, processed in a developer instead of in an activator (see p. 443), the requirement of rapid access to the result compels one to allow the retention of only a minimum of developer in the layer; stabilization can indeed be initiated only after elimination of the developer by the stabilizing solution. This is the reason for the use, particularly for rapid paper processing, of surface application of the solutions by rollers instead of immersion processing.

Stabilization rate also depends on the nature of the sensitive layer: photographic layers with very small crystals are stabilized much faster than those with large crystals, and the sensitive layers of papers are stabilized faster than those of most films. The thickness of the layers as well as the nature of the silver halide also plays its part: the stabilization of thin layers and of crystals with low iodide content proceeds faster than that of thick layers and of crystals with comparatively high iodide content.

Complexants of stabilization. Many properties must be assembled in a stabilization complexant; these were enumerated by Russel, Yackel and Bruce.[118] An ideal complexant should be soluble in an acid, alkaline or neutral solution and it should neither generate noxious odours, nor be toxic, corrosive or deliquescent. It should react rapidly and completely with all silver salts contained in the photographic layers and form colourless, highly stable complexes resistant to heat as well as to light and humidity. Finally, it should not soften the gelatin nor bleach the developed silver.

The stabilizing agents can be classed into two groups: those forming with silver ions stable but soluble complexes, and those yielding insoluble complexes. The first group includes the thiosulphates, the thiocyanates and thiourea and its derivatives. Among the thiosulphates those of sodium and potassium form complexes more stable than those of ammonium thiosulphate. Stabilization by ammonium thiocyanate yields prints of high light stability but has the drawback, just as stabilization by thiourea, of conferring

to the images only low resistance to humidity and to heat;[119] the slight softening action of the thiocyanates towards gelatin further leads to prints tacky when leaving the processor.

Stabilizers yielding unsoluble complexes are in general organic sulphur compounds carrying a mercapto group, of the general formula R-SH. Among these compounds Haist and King[120] proposed the use, especially in alkaline solution as for instance in monobaths, of monothioglycerol, of thioglycol, of β-mercapto ethylamine and of 2-thiobarbituric acid. While yielding opaque precipitates these complexants are useful because they form with silver ion complexes of high stability, even in the absence of the complexant, making possible an additional improvement of the stabilization of prints by the partial elimination of the residual unwanted compounds by a short rinse.[64]

Practical aspects. Shortened processing by stabilization finds many applications in classical, professional and commercial photography, as well as in technical uses such as oscillograph trace recording. When photography only serves as a tool in non-photographic operations, the time lapse between the recording of a phenomenon and the availability of the print can be of utmost importance. By eliminating this delay, stabilization processing facilitates the access to the information while still yielding the full advantages inherent to the photographic process. By its very short access time, stabilization processing is very well suited for news photography.

Stabilization is in general employed in complete systems composed of the sensitive material, the development solution (activator or developer), that of stabilization, and the processing equipment insuring the exact observation of the physical parameters such as time, temperature and agitation. Of limited dimensions, these small processing machines fit easily into recorders or other apparatus.

7.5.1c Bleaching

The elimination of accessory silver images. The elimination of the residual halides by fixing is sufficient only in black-and-white to bring the process of photographic recording to completion; in colour reproduction it is also necessary to eliminate the silver formed during colour development, an indispensable accessory for the creation of the dye images, but undesirable after their completion. This elimination is initiated by the rehalogenation of the silver with oxidizing solutions, traditionally called bleaches.[121]

In the negative or positive colour materials only that silver which corresponds to the dye images must be bleached, and the final elimination is then obtained by fixation occurring simultaneously with that of the unused residual silver halide. In the reversal materials bleaching also serves to

eliminate the negative image silver developed without the colour forming reaction, so that the bleach transforms the total amount of silver in each layer—that forming the black and white negatives and that of the colour positives—into a halide or other silver salt subsequently dissolved in the fixing bath (see p. 474). The bleaches of most colour processes thus only form non-soluble salts, later dissolved by complexants together with the residual silver halide. In black-and-white reversal, on the contrary, where the negative image is to be eliminated immediately after having been formed, this must be obtained without any action on the remaining silver halide which subsequently serves to form the positive image; the bleaching solutions must then necessarily be of another type and yield soluble silver salts.

Bleaching chemistry. The first phase of bleaching, the oxidation of the silver, results, as the reduction of the silver ions by development, from a balance shift between two oxidation–reduction systems. In a second step the presence of an appropriate anion then makes it react with the silver ions to form either a soluble or non-soluble salt. This is nothing else than the classical reaction of the reducers for black-and-white negatives,[124] not employed any more as such in photography.

Among the many oxidants which could be employed for bleaching, only a small number have all desirable properties. That mainly employed in the black-and-white reversal processes is the permanganate ion, and that in almost exclusive use in the colour processes the ferricyanide ion; less frequently the bichromate ion is employed in both cases. An oxiding agent satisfactory for bleaching must indeed satisfy several requirements; it must not only have the appropriate oxidation–reduction potential, but the bleaching reaction must also be rapid, and the oxidation of the leuco dyes must occur without any undesirable action on the dyes, neither of the oxidizing reaction nor of the pH of the bleach. The solution must further be reasonably stable and the action of the residual effluents must have no noxious action on vegetal or animal life.

The salts customarily formed are silver sulphite in black-and-white reversal, where a soluble salt is required, and halides in colour processing, most frequently silver bromide; bichromate bleaches yield silver chromate.

The formation in black-and-white reversal of neutral silver sulphate takes place according to the ionic reaction

$$(MnO_4)^- + 5Ag + 8H^+ \rightarrow 5Ag^+ + Mn^{++} + 4H_2O, \qquad (7.63)$$

and the corresponding overall reaction is

$$10Ag + 2KMnO_4 + 8H_2SO_4 \rightarrow K_2SO_4 + 2MnSO_4$$
$$+ 5Ag_2SO_4 + 8H_2O. \qquad (7.64)$$

The formation of silver bromide in the colour processes occurs by the oxidation of the developed silver by ferricyanide,

$$[Fe(CN)_6]^{3-} + Ag \rightleftarrows [Fe(CN)_6]^{4-} + Ag^+, \qquad (7.65)$$

followed by the precipitation of silver bromide resulting from the presence of a soluble bromide,

$$Ag^+ + Br^- \rightarrow AgBr. \qquad (7.66)$$

The two corresponding reactions are also found in the bichromate bleaches; as applied in black-and-white reversal the first still yields the soluble silver sulphate,[122]

$$(Cr_2O_7)^{2-} + 6Ag + 14H^+ \rightarrow 6Ag^+ + 2Cr^{3+} + 7H_2O, \qquad (7.67)$$

or $$K_2Cr_2O_7 + 6Ag + 7H_2SO_4 \rightarrow 3Ag_2SO_4 + K_2SO_4$$
$$+ Cr_2(SO_4)_3 + 7H_2O, \qquad (7.68)$$

and the second yields silver chromate;

$$(Cr_2O_7)^{2-} + H_2O \rightarrow 2(CrO_4)^{2-} + 2H^+. \qquad (7.69)$$

As the chromium salts also harden gelatin, the bleaching by the chromate ion can lead to exaggeration and therefore unwanted adjacency effects. These effects were demonstrated by Bello and Zwick.[123]

Combined bleaching and fixing. To reduce the rather important number of separate processing steps of the colour processes, bleaching and fixing are often combined into one single operation. The application of the reactions for direct solubilization, such as those of equations (7.64) and (7.68), is however not compatible with the adequate keeping of the dye images formed during colour development.

It might *a priori* seem to be possible to combine bleaching and fixing by the ferricyanide–thiosulphate combination of Farmer's reducer,[124] but it is well known that this solution is very unstable. This difficulty is avoided by the use of ferric ion with another complexant, the ethylene diamine tetraacetic acid.[125] In this bleach–fixer, employed in the Agfacolor processes, the oxidation of the developed silver and the solubilization by the thiosulphate occur simultaneously:

$$Ag + Na[Fe^{3+}Y] + nNa_2S_2O_3 \rightarrow Na_2[Fe^{2-}Y]$$
$$+ Na_{2n-1}[Ag(S_2O_3)_n]. \qquad (7.70)$$

The oxidation potential of the ferric complex of ethylene diamine tetracetic acid (Y) is however much lower than that of the ferricyanide ion and the time required for the solubilization of the silver is therefore just as long as the sum of separate bleaching and fixing times. Several addenda for the acceleration

of this reaction have been proposed, and especially the addition of the thio-ether derivatives of polyethylene oxides.[126]

7.5.2 Other Complementary Processing Steps

7.5.2a *Elimination of Backing Layers*

Many continuous large-scale processes also include a pre-hardening solution with the purpose of insuring adequate resistance to the layers of the films and papers during their passage at high temperature through alterna-tively alkaline and acid processing solutions (see p. 367). When the films carry an eliminable protective or antihalation backing layer containing black pigment, the solutions often also serve to eliminate it as well. The binders of these antihalation layers are either cellulose esters of dicarboxylic acids or polyvinylic resins, insoluble in water but soluble in alkaline medium.[127] Containing in general aldehydes as hardeners, the pre-hardening solutions are buffered at about pH 10·0 an alkalinity level appropriate also for making the vehicle of the antihalation backing layers soluble.

7.5.2b *Stabilization of Dye Images*

Processed colour films and papers contain in the layers, besides the dye images, residual couplers which upon keeping either decompose and form coloured reaction products or react with the dyes and bleach them. The elimination of the residual couplers, in analogy with that of the residual silver halide, is however not possible; therefore the dye images are stabilized by blocking the reactive functions of the couplers to make them inoffensive. It is obtained by a short immersion in a diluted formaldehyde solution; the formaldehyde reacts with many couplers but mainly with those of the pyrazolone class.[128] This stabilization is effective only after complete elimination of all residual thiosulphate by washing (see below, p. 491); dye stability is further improved by a short rinse in a buffer solution which fixes the pH of the layers prior to their drying.[129]

7.5.2c *Protection of Silver Images by Gold*

In spite of the remarkable permanence of adequately fixed and washed silver recordings, it is sometimes necessary to insure a still safer level of total stability by an additional protective processing step. This is particularly the case with microfiles, which must remain unchanged upon keeping during several decades while often exposed to the various impurities of the polluted air of modern industrial areas, such as hydrogen sulphide and sulphur dioxide, or ozone and other peroxides capable of attacking the finely dis-persed silver of the recordings and thus leading, by the formation of micro-scopic spots, to a loss of archival information content.[130] To protect archival

microfiles against these deteriorations the films are treated by solutions in which the whole surface of the silver microdeposits is overcoated by a thin gold layer. In this protective processing, proposed for the protection of photographic records by Crabtree, Eaton and Muehler,[131] the gold, introduced by its thiourea complexes, replaces the silver by the reaction

$$Au^+ + Ag^0 \rightarrow Au^0 + Ag^+. \tag{7.71}$$

According to Henn and Mack[132] this protection is excellent even for images containing traces of silver sulphide or iodide; the thicker the gold layer covering the silver filaments, the more efficient the protection. As the surface of the silver filaments is currently estimated to represent 5 or 6% of the silver atoms of the deposit, and as a microfile film normally contains 7 milligrammes of silver per square decimetre, less than half a milligramme of gold per square decimetre would be sufficient; the protection is however far better when the immersion is continued until this amount of gold is doubled.

7.5.3 Rinsing and Washing

At several instances during processing, and particularly at its completion prior to drying, all soluble compounds must be eliminated from the layers. This is the purpose of the rinses and washes which are apparently only minor, but in fact very important, steps of photographic processing. Not only the final wash of black-and-white photography, abundantly discussed in the literature, plays a fundamental role for the satisfactory keeping of the recording, but all intermediate eliminations of the reaction products are also fundamental because they insure the succession of the processing steps without any unwanted interferences. The effect of each of the processing steps on the subsequent elimination of residual compounds depends on the solubility of these residues and on the ease of their desorption; each of the rinses, squeegeeing steps and washes is therefore just as specific as all other processing steps and must be adequately adapted to the processing cycle.

7.5.3a The Purposes of the Washes

Rinses and stop baths. In black-and-white photography, where processing comprises only the two principal steps of development and fixation, the interactions between the two solutions are avoided by a short intermediate rinse which eliminates the major part of the residual developer and its reaction products still retained in the layer. Otherwise the simultaneous presence of thiosulphate and developer would, by the reducing action of the developer, lead to the precipitation of silver sulphide and to the formation of dichroic fog, especially on paper prints. In most processes the simple rinse is therefore advantageously replaced by an acid stop bath (an aqueous 3% solution of

acetic acid) which has the additional advantage of stopping development suddenly and thus avoiding a progressive pH increase of the fixer, impairing the hardening action of the fixers and giving rise to calcium sludges in the solutions and deposits on the films. In many processing machines, on the contrary, the elimination of the developer is often limited to a simple rinsing jet followed by an efficient squeegeeing device which forces the excess of developer back into its tank; this arrangement is satisfactory especially when the acid fixer is adequately buffered.

In the colour processes, which are more involved, the purpose of the apparently obvious intermediate washes varies considerably in its details according to the exact nature of each process. In the reversal processes, for instance, a short passage through an acid stop bath after the first developer (see p. 474) is not sufficient to eliminate the residual non-colour-forming developing agents, such as elon or hydroquinone, from the layers. If retained they act as competing developers in the highly alkaline medium of the colour developer and upset the process; a very thorough wash after the acid stop bath is therefore necessary. Similarly the complete elimination of all residual colour developing agent prior to the introduction of the sensitive material into the bleach bath is indispensable in all colour processes to avoid the formation of a red-orange fog due to the dye formed by the oxidation of the developing agent. After bleaching, a thorough intermediate rinse is also necessary to avoid the introduction of the oxidizer, and especially of ferricyanide, into the fixer.

The final wash of black-and-white processing. After development of the silver image and the dissolution of the residual silver halide in the fixer, the photographic material still contains a non-negligible amount of thiosulphate as well as a smaller, but also unwanted, amount of silver thiosulphate complexes. Complete elimination of these residues by washing is paramount for the satisfactory keeping of the images and recordings; thiosulphate ions, even when present only in small amounts after insufficient washing would gradually react with the finely divided image silver and transform it into brown or yellowish silver sulphide; the silver thiosulphate complexes would also stain the surface of the sensitive material by their decomposition upon prolonged keeping, especially at high temperature and humidity.

Thiosulphate and the silver complexes are on the one hand retained in the photographic layers, but on the other hand also in the base and in the baryta layer of the photographic papers. In films and plates whose base materials are impermeable, an efficient wash can eliminate the totality of all unwanted residues, but it is very difficult, and sometimes almost impossible, to desorb the last traces of thiosulphate and of the silver thiosulphate complexes from the paper supports and the baryta layers. The adsorption of thiosulphate to

paper was investigated by Crabtree, Eaton and Muehler;[131] the amount of thiosulphate retained by the base of an experimental paper material carrying all elements of a photographic paper except the silver halide, increased approximately in proportion with the time of immersion into a solution of 400 grammes of sodium thiosulphate per litre; washing experiments showed, on the other hand, that considerably more thiosulphate was retained by a photographic paper on double-weight base than by one on single-weight base (Figure 7.27). In both heavy and light papers the thiosulphate elimination by washing practically comes to a stop after a rather rapid decrease of the thiosulphate concentration, at about 1.0 mg/dm^2 for double-weight paper and about 0.5 mg/dm^2 for single-weight paper (as anhydrous $Na_2S_2O_3$), independently of the subsequent washing time. The washing of paper prints which are to be kept in archival files over very long periods must therefore necessarily be carried out with great care and must be of longer duration than that of films and plates (see below, p. 493). This problem is much simplified with papers of recent manufacture whose base is made waterproof by protective resin coats; their washing is therefore equivalent to that of a film.

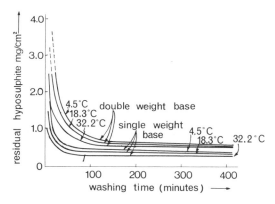

Figure 7.27. Effect of paper support thickness on hypo-retention.

The elimination of the residual thiosulphate depends on the kind and the degree of hardening and especially on the hardening agent in the fixer. The adsorption, and particularly the fixation of the thiosulphate ion on the gelatin, is stronger with a hardening fixer containing potassium alum than in one containing chromium alum.[131] The aluminium ion apparently mordants the thiosulphate onto the gelatin more than the chromium ion so that the thiosulphate concentration diminishes much faster in a wash succeeding fixation with hardening by chromium alum than by potassium alum (Figure 7.28).

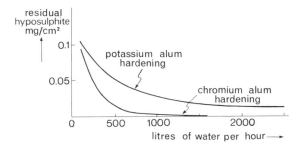

Figure 7.28. Differential fixation of hyposulphite ion onto the gelatin according to the hardener cation. (Time of washing ten minutes.)

To make the final washes as efficient as possible, and also to accelerate them, various methods can be employed, based either on the optimal solubilization of the silver thiosulphate complexes or on the desorption of the thiosulphate retained by the various components of the photographic materials.

Silver complexes of low solubility result from low thiosulphate concentration combined with a relatively high silver-ion content in the fixer; they are therefore mainly formed in exhausted fixing solutions. To keep them from forming, two separate successive fixing solutions are frequently employed together with a very efficient rinse between them, the first of these fixer solutions having already been in use for some time, while the second is a fresh solution of high thiosulphate concentration and a very low silver ion content.[133] This method is particularly useful for the manual processing of paper prints.

An acceleration of the desorption of thiosulphate can be obtained from the presence of various salts in the wash water, and by extension of this method by 'thiosulphate eliminators'. It is well known indeed that thiosulphate elimination is much faster with sea-water washes than with those in soft water; followed by a short rinse in this latter, required to avoid any subsequent action of the residual chloride on the image silver, it can be carried out in a time much shorter and with a volume of water much smaller than the customary washing with ordinary water.[134] In the technique of washing acceleration by 'hypo eliminators' this accelerated desorption is made use of by the action of oxidants in alkaline medium; among the various proposed formulas, that based on the combination of hydrogen peroxide and ammonium hydroxide has been shown to be particularly efficient.[131,135] Thiosulphate is transformed by this treatment into highly soluble sulphates,

$$Na_2S_2O_3 + 4H_2O_2 + 2NH_4OH \rightarrow Na_2SO_4 + (NH_4)_2SO_4 + 5H_2O.$$

(7.72)

Hypo eliminators are often useful to increase the efficiency of the washing of paper prints for archival files; their use has also been proposed with motion-picture theatre prints.[136]

The action of salts on thiosulphate elimination and on that of silver was studied by Henn, King and Crabtree,[137] and also by Levenson who showed how salts can have an effect not only at high concentrations, such as in hypo eliminators, but also at the rather low concentrations of the salts customarily encountered in waters of current use. Among these the bicarbonates have the greatest influence on the thiosulphate eliminating capacity of a wash water.[138]

Permissible levels of residual thiosulphate content. When important docu-ments such as radiographs or archival microfiles are to be kept over long periods of time it is necessary to limit the thiosulphate and silver complex content in the films to a minimum to insure their satisfactory conservation. Due to the great importance of this problem it has been extensively investi-gated, especially with respect to international standardization made in-increasingly necessary by the steady spreading of the use of photographic archival files.

Various methods can be employed to determine precisely the level of residual thiosulphate content in processed photographic materials. A USA-Standard[139] recommends the application of the Crabtree–Ross test,[140] based on the turbidity due to the precipitate which results from the presence of thiosulphate in a solution of mercuric chloride. Another method, proposed by Crabtree, Eaton and Muehler[141] and further investigated by Pouradier and Chateau[142] and by Pouradier and Mailliet,[143] based on the trans-formation of the residual thiosulphate into silver sulphide, takes into account the tetrathionate formed by its decomposition; it is particularly useful with black-and-white photographic papers. The application to colour films and papers of methods based on these principles—those of the Silver Ion Demand (SID) and of the Chemical Densitometric Index (CD)—was described by Larson, Hubbell and West[144] (see also below, p. 392). These methods, developed for routine application, are insensitive to the delay after processing, contrary to the original Crabtree–Ross method which neglects the trithionates and tetrathionates resulting from the decomposition of the residual thio-sulphate. An improved analytical method based on borohydride reduction of thiosulphate to sulphide and the formation of methylene blue was proposed by Warburton and Przybylowicz.[145] This latter method also takes into account the titration of the compounds due to the decomposition of the thiosulphate.

The permissible amount of residual thiosulphate depends on the nature of the layer and especially on the grain sizes of the silver deposit. USA-Standard PHI.28-1957, revised in 1968,[146,147] specifies an upper limit of 0.1 mg/dm^2

of anhydrous thiosulphate per layer of black-and-white fine-grain films for printing and duplicating, including those for microfilming. For negative films with coarser grain, and for X-ray films, the corresponding limit is $0.3 \, mg/dm^2$; these limiting values are related to unit areas of film because the influence of the thickness of the layers can be neglected. A preliminary draft of a recommendation by the International Standards Organization (ISO) also proposes the first figure of $0.1 \, mg/dm^2$ for microfiles.[148]

In the current use of photographic recordings not intended for prolonged keeping, the requirements for thiosulphate elimination can be less stringent; recommendations can be found in the literature which admit amounts up to ten times those recommended for archival keeping.

The absence of silver complexes harmful to satisfactory conservation depends, as mentioned before, on the correct composition of the fixer and on its state, and on the efficiency of the fixation. The ISO draft therefore recommends, also for films for archival microfiles, an unexhausted fixer not containing more than 0.5% of silver relative to its content of crystallized sodium thiosulphate $Na_2S_2O_3.5H_2O$, or not more than 0.8% relative to the anhydrous ammonium thiosulphate level.

Washing and stability of colour images. Correct elimination of the reaction products and also of thiosulphate is of the highest importance for the stability of dye images; the final wash of colour processing has therefore an importance equivalent to that in black-and-white. The two parameters acting on the keeping of colour pictures are the final pH of the layers and the residual thiosulphate content. Horowitz and Weller[149] determined as maximal permissible content in a motion-picture colour positive film $0.3 \, mg/dm^2$ of anhydrous thiosulphate, and also that a pH below 4.2 impaired the yellow-dye stability of that film while a pH above 6.0 had the equivalent effect on the cyan-dye image. Independently of the blocking of the residual couplers by formaldehyde to avoid their action on the dyes (see above, p. 486), the final wash of the colour film and paper processes is therefore kept within narrow control limits with the same care as in black-and-white, and in many colour processes the pH of the layers is stabilized immediately prior to drying, by a passage through an appropriate buffer solution without any further rinse.[129]

7.5.3b *Mechanisms and Parameters of Washing*

The exponential nature of washing. Just as the penetration of the developer into the photographic layers and the evacuation of its reaction products towards the bulk of the developing solution, and also as the other processing steps exclusively based on exchanges between fresh and partly exhausted solutions, washing depends on diffusion and therefore on agitation (see p.

446). This diffusion is therefore also described by a relationship of the form of equation (7.26), and the concentrations of the soluble compounds are in principle exponentially reduced during washing. This simple relationship only holds, however, when the soluble compounds are not adsorbed or otherwise fixed, for instance mordanted, onto the various components of the layers. As shown in previous sections, for instance, the elimination of thiosulphate follows an exponential decrease of its concentration only in the early stages of washing (Figure 7.29), but the full elimination of the last remainders, especially from paper prints, is still slower than if it was exponential because of the intervention of other mechanisms than straightforward desorption, (see above, p. 488).

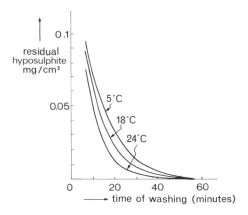

Figure 7.29. Acceleration of thiosulphate elimination by increase of wash-water temperature.

To carry out washing with as little water as possible, all means favouring the exchanges are applied, such as counter-current water circulation, turbulent agitation, submerged or unsubmerged jets, etc. In manual processing most efficient washing results from several entire replacements of the whole content of the wash tank with manual agitation of the films and papers, just as in the other processing steps, between these water changes.

Effects of other physical parameters. The efficiency of washing also depends on the temperature of the water, on its hardness and on its pH. A temperature increase also facilitates the exchanges by favouring the swelling of the gelatin; too high wash water temperatures can not however be employed in general and must be restricted to materials sufficiently hardened for high-temperature processing.

The hardness of the water has no effect on the exchanges, but high hardness can lead to calcium precipitates on the surface of the records, especially without acid stop baths or with insufficiently buffered fixers.

The alkalinity and the pH of the water acts in various ways, particularly when the fixer contains an alum as hardener (see above, p. 368). Even without hardening, thiosulphate elimination accelerates with a pH increase of the wash water.[133] The usefulness of wash waters is not determined, however, by their pH level proper, but rather by the way the particular hydrogen-ion concentration is buffered and kept unchanged by the salt content. To be satisfactory for washing a wash water should quite generally contain as little impurities as possible. For photographic processing solutions, and particularly for the wash waters, maximum permissible impurity contents were determined by West[150] and are given in Table 7.3 for the large-scale industrial processing of black-and-white and colour materials.

TABLE 7.3

Practical limits of impurity contents in wash waters	Maximum permissible impurity content in p.p.m. (millionths in weight)
Dissolved solids	250·0
Silica	20·0
Copper, iron, manganese (each)	0·1
Chlorine (as free hydrochlorous acid)	2·0
Chloride:	
in black-and-white reversal processes	25·0
in colour processes	100·0
Bicarbonate	150·0
Sulphate	200·0
Sulphide	0·1
Discolouration and solid matter in suspension	total absence by appearance
Other characteristics:	
pH	7·0 to 8·5
hardness as $CaCO_3$	40 (preferable) to 150

7.5.4 Drying

After completion of the humid part of processing it is still necessary to evaporate the water retained in the permeable layers of the photographic materials. This apparently simple drying operation is an essential element of the final quality of the recordings, and requires for its correct and efficient execution in the shortest possible time at least as much attention as the other processing steps.

7.5.4a *The Mechanism of Drying*

The diffusion and evaporation of the residual water. After the elimination of the superficially adhering liquid by squeegeeing off, the films and papers still contain humidity which must also be eliminated. During the drying operation that follows, the moisture content of the photographic material is progressively reduced until an equilibrium is reached between its residual humidity and the relative humidity of the ambient air; Figure 7.30 shows a typical set of such equilibria. Drying takes place in two steps.

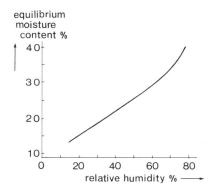

Figure 7.30. Moisture equilibrium after drying.

During the first step the surface of the processed material always remains wet because the diffusion of humidity across the gelatin is adequate to maintain this initial state; drying rate then only depends on the movement of the air and on the thermodynamic conditions of the process of evaporation. This is the *constant-rate drying period*, during which the drying rate is approximately proportional to the difference between the dry and wet bulb temperatures of the drying air.

As soon as the residual humidity decreases to a level called the *critical water content*, the rate of diffusion of water towards the surface reaches a limit below which the humidity of the deeper permeable strata is too low to maintain the surface wet. Evaporation rate then diminishes rapidly and the decrease of residual humidity depends exponentially on time only; this is the *falling-rate drying period*. Examples of this sharp change of drying rate were given by Boyd for several films for aerial photography.[151] Figure 7.31 shows how the two distinct periods of drying can always be observed, independently of the type of drying, the kind of film or the processing conditions.

Parameters and kinetics of drying. The evaporation of water is a mass transfer out of the solid medium of the film and paper into the gaseous

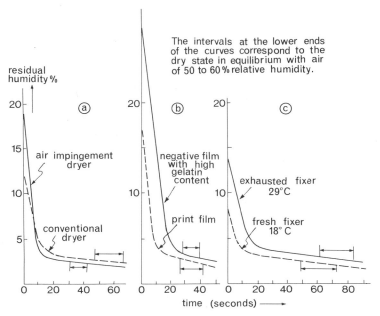

Figure 7.31. Typical drying characteristics showing the sharp transition between the constant-rate and the falling-rate periods of water evaporation. Under customary drying conditions this general characteristic is independent (a) of the type of dryer, (b) of the type of film, (c) of the type of process.

environment of the ambient air. It depends on the driving forces and on the contact area of the two phases, but also on the elements opposing resistance to the transfer. Requiring a considerable amount of energy, drying also involves heat transfer by the film or paper surface, subject to the same laws of diffusion as that of matter.[152]

The forces giving rise to humidity transfer result from a difference of pressure, that between the vapour pressure of the drying air and that of air saturated with water vapour of the same temperature; similarly, heat transfer is due to a temperature difference. Both transfers are held back by the stagnant air layer which builds up between the surface of the material and the mass of air in motion, in equilibrium on one side and the other with each of these media (Figure 7.32). The principal parameters on which drying efficiency depends are therefore the relative humidity of the air, the temperature at the surface of the film or paper, and the agitation of the drying air flow acting on the thickness of the stagnant air layer.

The relative humidity of air is the ratio of the mass of water it contains to that of air saturated with water vapour at the same temperature; this ratio

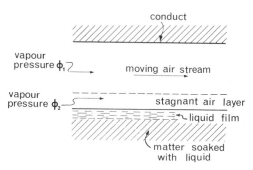

Figure 7.32. Geometry of the drying circuit.

is also equal to that of the vapour pressure of the particular air to the vapour pressure of saturated air. The relative humidity of the air employed for drying therefore determines the driving force on the water molecules contained in the film or the paper, i.e. the force compelling them to leave, in the form of water vapour, the solid domain of the permeable layers of the photographic materials for the gaseous phase of the drying air stream. The lower the relative humidity of the drying air the higher the efficiency and rate of drying.

The advantage of the use of very dry and even of dehydrated air was underlined by Fisher.[153] Dry air not only favours evaporation but avoids overheating of the surface of the materials to be dried. The air's capacity of humidity absorption, i.e. of the mass of water contained at saturation in one unit of volume, rapidly increases with temperature. Creation of the driving force required to initiate and to maintain rapid evaporation therefore compels one to raise the temperature considerably to obtain a sufficiently large difference between the dry and wet bulb temperatures, especially with air of rather high relative humidity, as for instance 50 to 80% R.H. During the constant-rate drying period, when the temperature of the still wet surface of the photographic material is equal to the corresponding wet bulb temperature, the layers could then easily be damaged by fusion or reticulation. However, if drying is carried out with very dry air the temperature at the film or paper surface not only does not rise, but it can even decrease by the loss of heat due to the evaporation.

The temperature of the drying air, by acting on its capacity of humidity absorption and therefore on its vapour pressure gradient, is of primary importance and determines the drying kinetics by defining the evaporation rate as a function of the relative humidity of the air. Temperature, however, not only has an effect on drying rate but also acts considerably on the physical quality of the result. Towards the end of the constant-rate drying period, when the surface ceases to remain wet and the rate of evaporation

decreases, additional heat is absorbed much slower than initially; the resulting temperature rise leads to uncontrolled hardening of the gelatin and modifies the structure as well as the surface aspect of the processed material.

The importance of the *agitation of the air* for the elimination of the stagnant layer which opposes a resistance to both the mass and the heat transfer was emphasized by Katz.[152] Applying the general solution of the molecular diffusion of two gas streams to the evaporation of water through the stagnant layer, he determined by Kaye's, Kennan's and McAdams' method[154] for the rate of evaporation v_E the relationship

$$v_E = A \frac{\delta(\Phi_2 - \Phi_1)}{\text{const. } BR} \left[\frac{1}{1 - \Phi_m} \right], \tag{7.73}$$

where A is the area perpendicular to the direction of humidity and heat transfer, δ the molecular diffusibility of water vapour in air, B the thickness of the stagnant layer, R the gas constant, Φ_1 the partial water vapour pressure of the drying air, Φ_2 that of saturation at the wet surface of the layer to be dried, and Φ_m their logarithmic mean $(\Phi_2 - \Phi_1)/\ln(\Phi_2/\Phi_1)$. The evaporation rate is thus proportional to the area of contact A and to the vapour pressure gradient, but above all inversely proportional to the thickness B of the stagnant layer. As every means tending to reduce it, or even to eliminate this layer altogether, would accelerate evaporation, Katz suggested the use of highly agitated air flow and in particular the creation of high turbulence at the surface to be dried by an air jet impinging at right angles to it (Figure 7.33). Amplified by the multiplication of such jets, this principle led to the application to photographic processing of impingement drying as proposed by Miller.[155]

air intake

film

Figure 7.33. Elimination of the stagnant layer by air impingement.

7.5.4b *Techniques of Drying*

Drying by air impingement. In this drying method, applied in most industrial processing machines, air is blown from numerous small orifices at right angles against the surface of the material to be dried; the air adhering to the surface

and liable to form the undesired stagnant layer is thus constantly driven away. Besides this advantage, impingement drying also makes possible the convenient transfer, by convection, of the heat required for evaporation.

The heat necessary for drying can indeed be transmitted by radiation, by conduction, or by convection. Heating by radiation, for instance by infrared, has the disadvantage of heating the processed materials selectively, according to their optical density, especially in black-and-white where the silver deposit strongly absorbs in the corresponding spectral domain; it also leads to overheating of the base material not cooled like the gelatin layers by the evaporation of humidity, so that the film or paper base risks warping and so impairing the planeity of the negatives or prints. Heating by contact, while apparently straightforward in principle, requires an excellent contact between the sensitive material and the heating surface, difficult to obtain continuously with films, but easy with unvarnished papers and therefore widely applied for the ferrotyping of prints (see below, p. 500).

For the drying of films and of papers with varnished base, the most advantageous method is heating by convection. The warm air blown at right angles onto the surface to be dried has not only the required capacity of water-vapour absorption, but also distributes the heat required for evaporation very evenly over the entire wet surface without excessively heating the base. Another advantage of this kind of heating is the relative insensitivity of the drying operation against even rather important fluctuations of the relative humidity of the air taken in. Figures given by Miller[155] comparing the drying times with very dry (20% R.H.) and very humid (90% R.H.) air, at several temperatures, demonstrate this independence of the humidity content of the drying air (Table 7.4).

TABLE 7.4

Temperature of drying air °C	Percent increase of drying time by a change from 20% to 90% R.H. of the supply air in impingement drying
21	87%
52	30%
65	20%
94	9%

This comparison underlines the usefulness of as high temperatures as compatible with the physical properties of the processed material. High drying temperature also allows one to influence the appearance of the dry surface, not only important for films where microreticulation of the surface

could have unfavourable effects on image structure, but also for papers on resin coated base. To obtain on these papers prints with a glossy and brilliant surface resembling that obtained with unvarnished paper base by glazing, drying is carried out at the highest permissible temperature; this reduces the constant-rate drying period to a minimum and the surface becomes glossy by the combined effect of fusion and hardening.

Drying efficiency by air impingement depends on the speed of the air and on the size and form of the jet openings. No gain results from speeds above limits depending on the air temperature; at 52°C this limit is approximately 20 metres per second. The most advantageous form, rectangular or circular, of the blower orifices, as well as their optimal sizes, were studied by Daane and Han,[156] and a typical example of the orifices of a dryer for aerial films was given by Boyd.[151] In this dryer the perforated faces of the opposing blower plates are separated by about 5 centimetres and blow air simultaneously onto the face and the back of the film running between them. The blower panels carry rows of holes about 3 millimetres in diameter and 20 millimetres apart in the direction of film travel.

Glazing of prints. To give the paper prints a mirror-like glossy surface they are dried by glazing or ferrotyping, i.e. by applying their still-wet image side against a polished and heated, mostly chromium-plated metal plate. The transfer of the heat of evaporation occurs in this case only by the contact of the gelatin of the top layer with the heated metal, and the water evaporates through the vapour permeable paper base without any forced replacement of the surrounding air. Glazing is thus based on the complete omission of the constant rate drying period and only comprises the second phase of drying, that of falling rate.

Resulting from the moulding of the gelatin against the polished metal surface, glazing is based on the balance between partial melting of the top layer and hardening of its gelatin. Too much prehardening keeps the prints from fitting exactly to the polished surface and yields irregular ferrotyping, but too little hardening makes the prints stick to the metal. This unwanted adherence does not result from a chemical reaction between the metal, generally chromium, and the acid groups of the gelatin, but rather from its degradation by the contact, in the wet and swollen state, with the hot metal.

Efficient crosslinking of the amino groups of the gelatin by formaldehyde (see p. 396), by avoiding this degradation reduces the tendency of sticking. It can be entirely avoided by the introduction of a surface active compound in the top layer of the paper, such as monodiethylaminoethyldodecenyl succinate together with natural beeswax.[157] Another means against the sticking of prints is the introduction, during their being brought in contact with the polished glazing surface, of a highly diluted solution of a fatty acid.

Glazing can also be carried out by applying the processed and dried paper under strong pressure against the polished surface of a chromium-plated cylinder. When not overdried by its passage in the customary air dryers the paper still contains from 7 to 10 % of humidity relative to its dry weight, and can be applied by a counter roller at a pressure of about 27 kilogrammes per centimetre against the polished cylinder heated to about 110°C.

Other methods of drying. Drying being a technique widely employed in many other domains, the application of methods non-customary in photography can also be taken in consideration. Fisher[153] proposes drying with air overdried by industrial dehydrators of a production capacity of about 300 m³ of low relative humidity air per horse power. Ryman and Overturf[158] evaluated in a detailed investigation of the entire question of photographic drying the possibilities of various new technologies such as those of infrared, high frequency, diathermic and di-electric heating, and also of their effects on photographic ultra-rapid drying. A new method proposed as a result of this investigation is the drying with evanescent high-frequency electric fields whose rapid polarity changes accelerate the evaporation of the water at the surface of the film, supported during this drying operation by an air cushion (Figure 7.34).

Figure 7.34. Drying by an evanescent electric high-frequency field.

7.6 MAINTENANCE AND CONTROL OF PROCESSING

The investigation of the intrinsic mechanisms of photographic processing, while being fundamental for the design and the most efficient use of the processes, only yields limited information on their practical behaviour. The solutions undergo changes upon keeping and by the processing reactions;

to insure constant results they must be renewed by the continuous or periodic replacement of a fraction of their volume with replenishment solutions containing the depleted compounds in adequate amounts to maintain the balance of the nominal concentrations of their basic formula. The physical parameters of the processors must also be kept within close limits; otherwise their fluctuations, adding to those of the chemical constitution of the solutions, would arbitrarily alter the photographic results. The small accidental variations of each of these elements either amplify each other or compensate and cancel out by their change combinations; the application of statistical methods is therefore indispensable.

7.6.1 Systematic Solution Maintenance

7.6.1a *Evolution of the Solutions*

After the dissolution of their components the processing solutions change slowly, even when protected against the oxidizing action of air, and tend towards an equilibrium which is only very seldom that of their optimum. This change is especially important in developers whose principal components, the developing agents, are subject to aerial oxidation (see p. 433). In consequence the basic formulas are designed to cope with such changes, and include elements liable to insure continuous activity of the principal components, such as the sulphite ion which in the developers protects the developing agents from being oxidized and in the fixers the sulphur from precipitating, or auxiliary active components such as the complementary developing agents of superadditive combinations (see p. 430) etc.

The principal changes occurring in the solutions are however those due to the processing reactions and also to their contamination by other solutions carried over from one tank into the next by the photographic material. The processing reactions not only exhaust the principal components but also lead to the accumulation of reaction products acting on them, such as for instance the halide ions in the developers. Solution replenishment, designed to maintain processing activity constant, therefore consists on the one hand of the replacement of the used up amounts of the active compounds, and on the other hand of the evacuation of the excess of undesirable products.

7.6.1b *Methods of Replenishment*

The most classical method of replenishment results from an obvious requirement: the material to be processed, immersed in the dry state in the developer, carries out liquid when leaving it again and constantly reduces its volume; replenishment is then materially indispensable to maintain the level constant, be it only for insuring complete immersion of the sensitive materials. Considered from the viewpoint of the solution's chemical composition, however, this replenishment is not sufficient. The replacement

of the small volume carried over per unit surface of processed material allows one at the limit to add to the solution fresh products in amounts corresponding to those used up, on condition that they are sufficiently soluble, but it cannot serve the removal of the reaction products formed in greater quantities than those contained in the solutions carried over by the film or the paper. Solution replenishment is therefore carried out, especially in large-scale industrial processing, by the constant elimination by overflow—apart from the liquid carried out by the processed material—of a fraction of the volume corresponding to the elimination of the reaction products, and by its replacement by a replenishing solution which only contains the used up compounds. This method, originally developed in the motion-picture laboratories, is in general based on adjustments made by trial and error and with the consideration of the solution volumes, the characteristics of the processing machines and their recirculation, the nature of the material to be processed and finally also the average density level of the recordings, on which depend the amounts of the compounds taking part in the reactions.

The determination of replenishment by computation, proposed by Evans,[159] was developed for a black-and-white three-solution system by Henn and Herzberger,[160,161] and further generalized for its application also to colour processing by Goldwasser.[162] As the modifications which the solutions undergo during processing and replenishment are specific to each particular process, these computations only allow one to determine the composition of the replenishment solution and of the volume to be replaced in the particular case considered. Their usefulness is therefore rather limited to the preliminary development of very specific processes, later followed by fine adjustments by empirical methods. Henn's and Herzberger's method, however, has proven useful in various applications such as for instance the evaluation of the accumulation of halide ions in developers or of silver ions in fixers, and it allows, just as Goldwasser's more general computations, a more economic determination of replenishment than that by simple trial and error. For the particular case of discontinued batch processing in deep tanks, replenishment computations were determined by Carlu.[163]

After extended use of the solutions, i.e. after a great number of processing cycles and replenishments, the concentrations of the various components of each solution reach an equilibrium which is adjusted, either by computation or empirically, to obtain optimum photographic results. These concentrations approach at the limit, after supposedly infinite use, those of solutions modified by the reactions of the process considered, called 'seasoned solutions'. It is therefore more advantageous to start from solutions compounded according to replenishment formulas and to add to them only once, just prior to their being put in use, complementary amounts of compounds summarily called 'starters' and designed to compensate, during the start up of the

process, for the differences between the final equilibrium and that of the replenishment solutions. By this means these latter are transformed into artificially seasoned ones. This avoids the preparation, prior to each start of a process, of solutions of 'nominal' composition different from the replenishment solutions available in large amounts in the storage tanks.

Processing with solutions kept constant by replenishment represents the best possible practical compromise, especially on an industrial scale. For certain specific processes however, only carried out by intermittence for limited amounts of photographic materials, it is possible to adjust the formulas more exactly to the desired photographic results by applying the method of 'one time solution use'. In this method the amounts of solutions brought in contact with the sensitive material to be processed exactly correspond to its area; entirely exhausted by the process, the solutions can be discarded when it is completed. The advantages of this method—perfect reproducibility, optimum adaptation to the required photographic properties, and economy—were underlined by Mouchel,[164] who cited various examples such as drum processing or that by application of viscous solutions (see p. 452 and p. 446). A practical compromise between these processes of 'total overflow' and the classical replenished processing is that of 'economic one time processing' in which only the entirely exhausted fraction of the processing solutions is discarded. It is possible indeed, by working with very reduced amounts of solutions and by replenishing at counter current, to make only that fraction of the solution volume overflow which corresponds exactly to the exhausting by the processed area. This is the method employed in most roller transport processing machines, for instance for the processing of medical X-ray film (see p. 452).

7.6.2 Processing Control

7.6.2a *Statistical Aspects*

The great number of parameters involved in photographic processes has as consequence a considerable influence on their chance fluctuation. The effects of these small accidental variations are either intensified when they act in the same sense, or they diminish when they are mutually compensated. An efficient control of photographic processing is therefore only possible by the application of statistical methods; these make it possible to check whether a change of the photographic properties is due only to chance or whether it results on the contrary from an effective processing change; in the first case, the processing conditions are kept unchanged, while it is necessary to adjust them in the second case to obtain the desired result.

The purely aleatory nature of the small variations of the numerous parameters, chemical as well as physical, leads us to consider their distribution as normal, i.e. Gaussian; it is therefore characterized by its symmetry

around the mean value and by the close grouping of the observed values of each parameter near its mean. The precision and the reproducibility of the process are defined by the width of its distribution, given by its standard deviation σ.

As is well known, both the standard deviation σ and the mean \bar{x} of a normally distributed variable x can be determined exactly only from an infinite number of measurements; a satisfactory estimate can however be obtained from a sufficiently great but still reasonably finite number of values. A valid approximation to the distribution of the processing parameters is thus determined from the standard deviations recorded during an appropriate period with close processing control, for instance during one month. The probability limits of the chance variations are then known: in 68% of the processes the variations are comprised within the plus and minus 1σ limits, in 95% they fall between $+1\sigma$ and $+2\sigma$ and between -1σ and -2σ, in 99% they are within the 2σ to 3σ limits, and so on. The experience of photographic processing shows that the $\pm 2\sigma$ limits, characteristic of satisfactory parameter levels, determine the domain of their unavoidable but inoffensive fluctuations; as long as these limits are not attained the process can be considered to be under control.

Thanks to this knowledge which, it must be stressed, is based on experience, rational processing control is made possible. It is carried out with the help of graphs which show the variation of each surveyed parameter at regular time intervals (Figure 7.35), at a scale which makes it possible to evaluate them

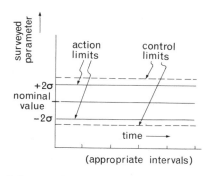

Figure 7.35. Schematic lay-out of a process control diagram for one single parameter.

relative to the $\pm 2\sigma$ limits. The process remains satisfactory as long as the plot of the measured values of the parameter surveyed remains within these limits, also called 'action limits' because no action is required before they are crossed; frequently the adopted rule is even not to intervene before a second control value plots on that limit. Other limits, imperative, must

therefore be defined whose crossing compels the immediate discontinuation of the process. Slightly wider than two standard deviations they are called 'control limits' (Figure 7.35, broken lines).

7.6.2b *The Chemical Parameters*

When the processing formulas are known, and when their volume is sufficient to justify the expense of analytical control, statistical methods can be applied to the principal components. In a typical black-and-white developer, for instance, this control concerns the concentrations of elon, hydroquinone, the sulphite ion, the bromide and iodide ions, those of organic anti-foggants, and the total alkalinity and the pH; in a colour developer it applies to the colour developing agent, to the sulphite and halide ions, and also to total alkalinity and pH. Similarly the control of a fixer is carried out for the thiosulphate and sulphite contents and for the total acidity and the pH, and that of other processing solutions also for their principal components. These few examples are only intended to give a general idea of the types of parameters controlled, each control being obviously adapted to its specific kind of solution.

The analytical solution control has a double purpose: it allows us on the one hand to check the keeping changes of the solutions showing poor keeping behaviour, and it serves on the other hand during processing to survey the replenishment by periodic checks of the individual concentration of each component.

The *keeping of photographic processing solutions* and the principal origins of their variations were described by Mutter:[56] their composition not only changes by aerial oxidation but also by the evaporation of water and of other solvents, by the hydrolysis, the polymerization and other reactions of the dissolved compounds, by the absorption of carbon dioxide, which lowers the pH, and finally also by accidental contaminations.

The *modifications of the solutions during processing*, mainly due to the reactions between the exposed sensitive materials and the solution components, but also to carry-over by the processed material, remain within the $\pm 2\sigma$ limits as long as replenishment compensates for the consumption of the active compounds and eliminates the reaction products; control values appearing outside of these limits indicate unsatisfactory replenishment. The exact knowledge of the lack or excess of each parameter makes it possible to correct the replenishment rates and by this means to insure constantly correct and reproducible photographic results.

The industrial and economic importance of large-scale photographic processing has led to the development of many analytical methods, particularly for the most frequently employed developing agents such as elon and hydroquinone. The progressive evolution of these methods, described in a

complete and chronological literature review by Creyf and Roosens,[165] is a good example of the general perfection and efficiency as well as of the precision of the analytical methods specific to processing control.

According to the relative concentrations of the components, each particular method is adapted to a specific processing solution. Even succinct mention of the very numerous published methods, such as for instance those developed for use in the motion-picture laboratories[166,167,168,169] is therefore not possible. The basic principles of the methods most frequently employed are the following:

Elon and hydroquinone. Two analytical methods are employed, chemical titration and spectrophotometry. In the first the two developing agents are first extracted by ethyl acetate and the elon then separated with a strongly acid aqueous solution; both solutions are then titrated by ceric sulphate and the small amounts of Elon retained in the ethyl acetate phase, and of hydroquinone remaining in the aqueous phase, is taken into account by corrective coefficients. The spectrophotometric method is based on the absorption difference of Elon and hydroquinone at 270 and 290 nm. After their extraction by ethyl acetate the absorption differences are determined at these two wavelengths for the developer and the residual solution from which Elon and hydroquinone have been extracted. As each of these differences depends on both absorptions the result is readily obtained by the solution of two linear equations with two unknowns.

Colour developers. After extraction by an organic solvent in alkaline medium, of the developing agent from the developer solution, its concentration can be determined either by one spectrophotometric measurement at the absorption maximum, or by cerimetric titration.

Halide ions. These are determined in the classical way by potentiometric titration with silver nitrate. The methods vary in detail according to the relative concentrations of chloride, bromide and iodide.

Organic anti-foggants. After extraction by an organic solvent in acid medium, possible with most of the currently employed anti-foggants, their titration is carried out either by potentiometry with silver nitrate or by spectrophotometry; in this second method the silver salt of the anti-foggant is first precipitated with silver nitrate and then dissolved by addition of ammonia. The measurement of the ultraviolet absorption of the ammonium salt of the anti-foggant then yields the result of the titration.

Sulphite and thiosulphate. In the developers, as well as in the fixers, sulphite is determined by iodometry, by addition of an excess of iodide and its titration by a standard thiosulphate solution; in developers this method

yields the concentration of the sulphite ion, but in fixers the sum of sulphite and thiosulphate ions is obtained. To determine thiosulphate separately, the sulphite and bisulphite ions must first be complexed by formaldehyde; the difference of the two results then yields the concentration of either sulphite or bisulphite.

pH, and total alkalinity or acidity. As mentioned before, a correct level of hydrogen-ion concentration is essential for the reactions of photographic processing. Constant pH control is therefore carried out with great precision, with appropriate glass electrodes as indicator electrodes relative to a calomel reference electrode. Special precautions must be observed for developers because of their high pH values and high sodium-ion concentration, especially in colour developers. The special alkaline glass electrodes are constantly kept in potassium borate solutions, the linearity of their response is standardized with solutions buffered in the pH region of the actual pH domain of their current use, and the solution temperature is carefully checked and kept constant. The single pH measurement, even when correct and precise, is however not sufficient for satisfactory processing control; to discover abnormal concentrations, for instance of organic or mineral components in developers, the total alkalinity must also be determined by titration with a 0·1 N sulphuric acid solution. Similarly total acidity is determined in the fixers by titration with a 0·1 N solution of sodium hydroxyde.

7.6.2c *Physical Parameters*

The maintenance of these parameters only requires simple inspection of a few instruments for periodic checks of the satisfactory functioning of automatic or semi-automatic control devices. It mainly concerns temperature control, especially that of the developers, and further the control of the replenishment rates of all solutions and of the regularity of the film or paper transport speed; these controls depend closely on the type of machine or installation and are applied, just as the other controls, by observing the statistical limits of plus or minus two standard deviations.

7.6.2d *Sensitometric Control*

The essential purpose of processing control and maintenance remains obviously the constancy of the photographic results; the most efficient control is therefore based on these rather than on the parameters on which they depend. Every processing control system therefore includes the systematic observation of the sensitometric parameters.

These controls are in general limited to densitometry; the periodicity and the frequency of the measurements indeed compels one to apply the simplest control methods, and experience shows that the measurement of the


[7.6] Maintenance and Control of Processing 509



densities of a few steps on control strips exposed under very precise sensito-metric conditions and processed in the process to be controlled responds the best to this requirement. The density values systematically controlled are in general those slightly above fog level, medium densities corresponding to frequently encountered levels in the images or recordings, and high densities near the possible maxima of the process. For these densities—measured in integral densities for colour—$\pm 2\sigma$ limits are again established, just as for the other parameters, and the regularity of the process is then controlled from these densitometric measurements by action either on the physical process variables or on the replenishment rates, according to the requirements.

This control method yields more information on the processing parameters than might appear at first sight. A variation of development time, for instance, can yield sensitometric results very different from the change of a replenishment rate. A difference of this kind is demonstrated by the curves of Figures 7.36 and 7.37 corresponding to the development of a colour paper.[170] In this case the control is based on red, green and blue integral density measurements of six steps, three of which are in the mid-density range and the others at the maximum density of the cyan, magenta and yellow dyes of the process. The differences between the high and medium densities then yield for each of the three colours an indication for the evaluation of the contrast, and the

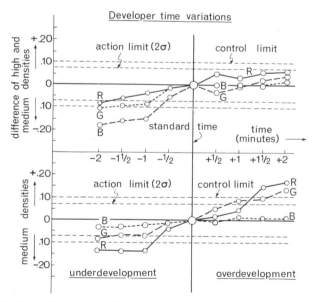

Figure 7.36. Sensitometric control of development time variations. Corrective actions can be decided without analytical control.

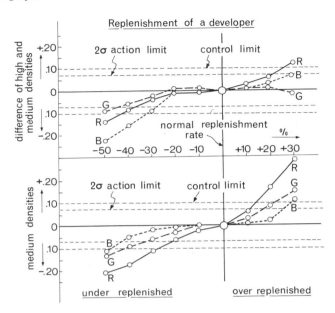

Figure 7.37. Sensitometric control of developer replenishment.

medium densities for that of the sensitivity of the corresponding layers. Under-development, represented by the values plotted on the left of Figure 7.36, leads to a lowering of magenta contrast, but the corresponding sensitivity loss makes itself felt only in the cyan layer. Under-replenishment, on the contrary, acts the least on magenta contrast and the most on yellow contrast, which diminishes considerably, while the sensitivity drop is again that of the cyan layer (Figure 7.37). This example demonstrates the extension of the possibilities of interpretation of the results of simple densitometric control, reduced to the measurement of six density values, and consequently more economical than any other more involved method.

Sensitometric processing control therefore allows one to maintain the processes constant and thus to insure correct results while only requiring a minimum of equipment and of manpower. Applied in common with the use of prepared chemicals it is the simplest method of satisfactory processing maintenance; the expensive and important means of an analytical laboratory is indeed only justified in large-scale industrial laboratories such as those of the professional motion-picture industry. The simple sensitometric control with eventual corrections only of the physical parameters and replenishment rates, on the contrary, allows an efficient control satisfactory for most small and medium-size processing units.

The solution of the processing problem, often considered as an undesirable but also inevitable drawback of the photographic process, therefore consists of the use of compact machines such as for instance those making use of roller transport, fed with replenishment solutions obtained from prepared chemicals, and controlled by sensitometry with the observation of plus or minus two sigma limits. By extension this method obviously also applies to more important processing units such as those of professional photofinishing and others.

REFERENCES

1 Reinders, W., and Beukers, M. C. F., The physical development of the latent image. *Trans. Faraday Soc.*, **34** (1938), 912.

2 James, T. H., The charge effect in relation to the kinetics of photographic development. I. The general effect. *Jl. Franklin Inst.*, **240** (1945), 15.

3 James, T. H., Mechanism of development. I. The general effect of oxidation products on the development process and the nature of the induction period. *Jl. Phys. Chem.*, **43** (1939), 701.

4 Abribat, M., A contribution to the theory of development. *Phot. Jl.*, **92B** (1952), 25.

5 Lottermoser, A., and Steudel, R., Über den Einfluss oberflächenaktiver Anionen und Kationen auf Halogensilbersole und photographische Emulsionen. *Kolloid-Z.*, **82** (1938), 319.

6 Willems, J. F., Photographic development by hydroquinone compounds with positively charged groups. *Phot. Sci. Eng.*, **4** (1960), 101.

7 James, T. H., and Vanselow, W., Co-operative and competitive adsorption in the photographic process. *Jl. Phys. Chem.*, **58** (1954), 894.

8 Jaenicke, W., Krüger, A., and Hauffe, K., Modellversuche zum photographischen Entwicklungsprozess. *Z. Phys. Chem.*, **197** (1951), 161.

9 James, T. H., Catalytic phenomena related to photographic development. *Advanced Catalysis*, **2** (1950), 105.

10 Jaenicke, W., The mechanism of photographic development. *Phot. Sci. Eng.*, **6** (1962), 185.

11 Matejec, R., and Meyer, R., Elektrodentheorie der photographischen Entwicklung. *Z. wiss. Phot.*, **57** (1963), 18.

12 Matejec, R., and Meyer, R., Contribution on the mechanism of photographic development. *Phot. Sci. Eng.*, **7** (1963), 265.

13 James, T. H., and Vanselow, W., The role of silver halide solvents in practical development. *Phot. Eng.*, **7** (1956), 90.

14 Loveland, R. P., quoted in C. E. K. Mees, *The Theory of the Photographic Process*, 1st edition, Macmillan, New York, 1942, p. 463.

15 Klein, E., Physical shape of developed silver. Contribution to the explanation of the mechanism of photographic development. *Z. Elektrochemie*, **62** (1958), 505.

16 (a) Berry, C. R., A growth mechanism for filamentary silver. *Phot. Sci. Eng.*, **13** (1969), 65. (b) James, T. H., Photographic development as a catalyzed, heterogeneous reaction. *Jl. Chem. Phys.*, **11** (1943), 338.

17 Loening, E. E., and Farnell, G. C., The photographic behavior of the silica–silver ion system. *Phot. Jl.*, **92B** (1952), 187.

18 Eggenschwiller, H., and Jaenicke, W., The catalytic action of photographically developed silver for the reduction of silver complexes. *Z. Elektrochemie*, **64** (1960), 391.

19 Nutting, P. G., On the absorption of light in heterogeneous media. *Phil. Mag.*, **26** (1913), 423.

20 Arens, H., Eggert, J., and Heissenberg, E., Zusammenhang zwischen Schwärzung, Silbermenge, Deckkraft, Kornzahl und Korndimension entwickelter photographischer Schichten. *Z. wiss. Phot.*, **28** (1931), 356.

21 Weyde, E., Grösse und Form des entwickelten Silberkornes und seine Beziehungen zu bildwichtigen Eigenschaften. *Photographic Science (Symposium: Zürich 1961)*, W. F. Berg, ed., Focal Press, London and New York, 1963, p. 197.

22 Pinoir, R., Influence de la gélatine sur le pouvoir couvrant de l'argent réduit. *Sci. Ind. Phot.*, **(2) 14** (1943), 242.

23 Blake, R. K., and Meerkamper, B., Developed image structure. *Jl. Phot. Sci.*, **9** (1961), 14.

24 James, T. H., and Vanselow, W., The influence of the development mechanism on the color and morphology of developed silver. *Phot. Sci. Eng.*, **1** (1958), 104.

25 Klein, E., and Metz, H. J., Die Farbe kolloidaler Silbersole in Gelatine. *Mitt. Forschungslab. Agfa, volume III*. Springer ed., Berlin-Göttingen-Heidelberg, 1961, p. 335.

26 Koerber, W., Über den Zusammenhang zwischen Morphologie und Farbe des entwickelten Silbers in photographischen Schichten. *Wissenschaftliche Photographie, Conference Cologne 1961*. Helwich, ed. Darmstadt and Vienna, p. 535.

27 Johann, I., and Klein, E., Elektronenmikroskopische Untersuchungen an photographischen Schichten. *Phot. Korr.*, **91** (1955), 179 and 199.

28 Klein, E., and Weyde, E., Farbumschlag von entwickelten photographischen Schichten bei Heisstrocknung. *Mitt. Forschungslab. Agfa, volume II*. Springer ed., Berlin-Göttingen-Heidelberg, 1958, p. 117.

29 Cassiers, P. M., Der Farbton des Bildsilbers im Silbersalzdiffusionsverfahren. *Wissenschaftliche Photographie, Conference Cologne 1961*. Helwich, ed. Darmstadt and Vienna, p. 285.

30 Kendall, J. D., La chimie des sensibilisateurs, désensibilisateurs et développateurs organiques pour les halosels d'argent. *Xe Congrès intern. phot. sci. et appl. Paris 1935*. Rev. d'Opt., ed. Paris, 1936, p. 227.

31 Lumiere, A., and Lumiere, L., Sur les réducteurs de la série aromatique susceptibles de développer l'image latente photographique. *Bull. Soc. Française Phot.*, **(2) 7** (1891), 310.

32 Andresen, M., Über para-Amidophenol als Entwickler. *Phot. Mitt.*, **28** (1891), 124 and 286.

33 Pelz, W., Zum Chemismus der chromogenen Entwicklung in der Farbenphotographie. *Angew. Chemie*, **66** (1954), 231.

34 Baxendale, J. H., and Hardy, H. R., Ionization constants of some hydroquinones. *Trans. Faraday Soc.*, **49** (1953), 1140.

35 Reinders, W., and Beukers, M. C. F., Metol-hydroquinone developers. *Phot. Jl.*, **74 (N.S.58)** (1934), 78.

36 James, T. H., The nonadditive properties of Elon-hydroquinone developers. *Jl. Phot. Soc. Am.*, **9** (1943), 62.

37 Levenson, G. I. P., The Elon-hydroquinone developer. *Phot. Jl.*, **88B** (1948), 102; **89B** (1949), 2, 13. Further notes on super-additive developers. *Phot. Jl.*, **92B** (1952), 109.

38 James, T. H., Mechanism of superadditivity in photographic development. *P.S.A.-Jl.* (*Phot. Sci. Tech.*), **19B** (1953), 156.

39 Lee, W. E., and James, T. H., Superadditivity in photographic development by substituted hydroquinones used with 1-phenyl-3-pyrazolidone. *Phot. Sci. Eng.*, **6** (1962), 32.

40 Willems, J. F., and Van Veelen, G. F., The superadditivity with hydroquinone of photographic developing agents forming positively charged semiquinones. I. The p-phenylenediamines. *Phot. Sci. Eng.*, **6** (1962), 39.

41 Neuberger, D., and Roberts, H. C., Effect of quaternary salts in p-phenylene-diamine developers. *Phot. Sci. Eng.*, **12** (1968), 121.

42 Günther, E., and Matejec, R., Redoxkatalyse als Ursache für photographische Superadditivitätseffekte. *Phot. Korr.*, 104 (1968), 205.

43 Yule, J. A. C., Formaldehyde-hydroquinone developers and infectious development. *Jl. Franklin Inst.*, **239** (1945), 221.

44 James, T. H., Silver-image development by derivatives of p-phenylenediamine. I. General characteristics. *P.S.A.-Jl.* (*Phot. Sci. Tech.*), **16B** (1950), 83.

45 Sheppard, S. E., and Hudson, H., The halogen acceptor theory of sensitivity and the thioanilides. *Phot. Jl.*, **67** (**N.S.51**) (1927), 359.

46 James, T. H., The mechanism of normal fog formation in hydroquinone developers. *Jl. Franklin Inst.*, **234** (1942), 371.

47 Lüppo-Cramer, H., Hydrolyse des Bromsilbers. *Phot. Korr.*, **73** (1937), 49.

48 Henn, R. W., and Crabtree, J. I., Calcium scums and sludges in photography. *Jl. S.M.P.T.E.*, **43** (1944), 426.

49 Le 'Calcivore Lumière', *Rev. Franç. phot. ciném.*, **18** (1937), 76; *Brit. Jl. Phot.*, **84** (1937), 184.

50 Henn, R. W., and Piper, D. E., U.S.A. patent 2 656 273 of Oct. 20, 1953.

51 Henn, R. W., The calcium-sequestering properties of organic compounds in photographic developers. *Phot. Sci. Eng.*, **3** (1959), 140.

52 *Processing chemicals and formulas for black-and-white photography.* Kodak Publication no. J.-1, 1970. 6th ed.

53 James, T. H., Mechanism of photographic development. II. Development by hydroquinone. *Jl. Phys. Chem.*, **44** (1940), 42.

54 James, T. H., and Vanselow, W., The kinetics of development by 1-phenyl-3-pyrazolidone. *Phot. Sci. Tech.*, (**2**) **1** (1954), 77.

55 Levenson, G. I. P., The Elon-hydroquinone developer. IV. Development by Elon and by hydroquinone. *Jl. Phot. Sci.*, **1** (1953), 117.

56 Mutter, P. J., Chemical stability of photographic processing solutions. *Phot. Sci. Eng.*, **8** (1954), 49.

57 Lee, W. L., in C. E. K. Mees and T. H. James: *The Theory of the Photographic Process*, 3rd ed., Macmillan, New York; Collier-Macmillan, London, 1966, p. 368.

58 Abribat, M., Pouradier, J., and David, J., Influence du potentiel d'oxydoréduction et du pH du révélateur sur l'allure du développement. *Sci. Ind. Phot.*, (**2**) **20** (1949), 21.

59 Crabtree, J. L., Parker, H., and Russel, H. D., Some properties of two-bath developers for motion picture film. *Jl. S.M.P.T.E.*, **21** (1933), 21.

60 Staude, H., Ein vergessenes Entwicklungsverfahren. *Z. wiss. Phot.*, **34** (1935), 72.

61 Barnes, J. C., Mechanism of development in monobaths containing thiosulfate ion. *Phot. Sci. Eng.*, **5** (1961), 204.

62 Eggenschwiller, H., and Jaenicke, W., Über die Kinetik der Fixierentwicklung. *Phot. Korr.*, **95** (1959), 149.
63 Kazen, D. R., and Wolnick, M. F., Agitation effects. *Phot. Sci. Eng.*, **6** (1962), 241.
64 Haist, G. M., King, J. R., and Bassage, L. H., Organic silver-complexing agents for photographic monobaths. *Phot. Sci. Eng.*, **5** (1961), 198.
65 Swing, R. E., and Barry, S. A., An approach to monobath kinetics. *Phot. Sci. Eng.*, **4** (1960), 173.
66 Levy, M., Combined development and fixation of photographic images with monobaths. *Phot. Sci. Eng.*, **2** (1958), 136.
67 Barnes, J. C., Moretti, W. J., and Bushmann, D. G., A new film–monobath combination for oscillography. *S.P.I.E. Jl.*, **5** (1967), 95.
68 Barnes, J. C., Bahler, W. H., and Johnston, G. J., Rapid processing of a panchromatic negative film by the application of a viscous monobath. *Jl. S.M.P.T.E.*, **74** (1965), 242.
69 Eggers, J., Measurement of the changes in pH in photographic coatings during development. *Phot. Sci. Eng.*, **4** (1960), 284.
70 Luvalle, J. E., Dunnington, F. M., and Margnetti, C., The diffusion of hydroquinone and strontium ion in gelatin. *Phot. Eng.*, **6** (1955), 42.
71 Reckziegel, E., Die Diffusion photographischer Bäder in Mehrschichtenfilmen. *Mitteilungen Forschungslab. Agfa,. Volume 1.* Springer ed., Berlin-Göttingen-Heidelberg, 1955, p. 239.
72 Blyumberg, I. B., and Davydkin, I. M., quoted in C. E. K. Mees and T. H. James. *The Theory of the Photographic Process*, Macmillan, New York; Collier-Macmillan London, 1966, p. 355; and E. Reckziegel, reference 71.
73 Fick, A., Ueber Diffusion. *Ann. Phys.*, **170** (1855), 59.
74 Crank, J., *The Mathematics of Diffusion*, Oxford University Press, 1967, p. 4, 15, 52, 121.
75 Lederer, E. L., Anwendung der Fourier-Funktionen auf die Diffusion. *Koll. Zeitschr.*, **46** (1932), 169.
76 Katz, L., Controlled processing of film using turbulent flow phenomena. *Phot. Eng.*, **2** (1951), 89.
77 Katz, L., and Esthimer, W. F., Further experiments in high-speed processing using turbulent fluids. *Jl. S.M.P.T.E.*, **60** (1953), 105.
78 Reference 52, p. 24.
79 Henn, R. W., and Crabtree, J. I., Photographic processing at low and subzero temperatures. *Jl. Phot. Soc. Am.*, **12** (1946), 445.
80 James, T. H., Dependence of the rate of development of surface latent image on the temperature of the developer. *Phot. Sci. Techn.*, (2) **2** (1955), 81.
81 Fortmiller, L. J., Exley, N. A., Ives, C. E., and James, T. H., Factors involved in the rapid development of motion picture positive film and their dependence on temperature. *Phot. Eng.*, **7** (1956), 171.
82 Homolka, B., Experiments on the development of the latent image with indoxyl compounds. *Brit. Jl. Phot.*, **54** (1907) 216.
83 Fischer, R., and Siegrist, H., Über die Bildung von Farbstoffen durch Oxydation mittels belichteten Halogensilbers. *Phot. Korr.*, **51** (1914), 18.
84 Vittum, P. W., and Weissberger, A., The chemistry of dye-forming development. *Jl. Phot. Sci.*, **2** (1954), 81.
85 Weissberger, A., U.S.A. patent 2 193 015 (1940).
86 Bent, R. L., Dessloch, J. C., Duennebier, F. C., Fassett, D. W., Glass, D. B., James, T. H., Julian, D. B., Ruby, W. R., Snell, J. M., Sterner, J. H., Thirtle,

J. R., Vittum, P. W., and Weissberger, A., Chemical constitution, electrochemical, photographic and allergenic properties of p-amino-N-dialkylanilines. *Jl. Am. Chem. Soc.*, **73** (1951), 3100.

87 Vittum, P. W., and Weissberger, A., Recent advances in the chemistry of dye forming development. *Jl. Phot. Sci.*, **6** (1958), 157.

88 Tong, L. K. J., and Glesmann, M. C., Semiquionone formation of partially oxydized p-phenylenediamines. *Phot. Sci. Eng.*, **8** (1964), 319.

89 Tong, L. K. J., and Glesmann, M. C., Mechanism of dye formation in color photography. III. Oxidative condensation with p-phenylenediamine in aqueous alkaline solutions. IV. Oxidative condensation in acidic aqueous solutions. *Jl. Am. Chem. Soc.*, **79** (1957), 583.

90 Eggers, J., and Frieser, H., Der Ablauf der Farbkupplungsreaktion von p-Aminodimethyl aniline. *Z. Elektrochem.*, **60** (1956), 372.

91 Tong, L. K. J., Kinetics of deamination of oxidized N,N-disubstituted p-phenylenediamines. *Jl. Phys. Chem.*, **58** (1954), 1090.

92 Vittum, P. W., and Brown, G. H., Indoaniline dyes. III. Coupling of para-substituted phenols with oxidized p-aminodimethylaniline. *Jl. Am. Chem. Soc.*, **71** (1949), 2287.

93 Barr, A., Thirtle, J. R., and Vittum, P. W., Development-inhibitor-releasing (DIR) couplers in color photography. *Phot. Sci. Eng.*, **13** (1969), 74.

94 Groves, W. W., British patent 481.501 of March 7, 1938.

95 Jelley, E. E., and Vittum, P. W., U.S. Patent 2 322 027 of June 15, 1943.

96 Mannes, L. D., and Godowsky, L., U.S. Patent 1 954 452 of March 19, 1930.

97 Weissberger, A., Principle and chemistry of color development, in C. E. K. Mees and T. H. James, *The Theory of the Photographic Process*, 3rd edn, Macmillan, New York; Collier-Macmillan, London, 1966, p. 393.

98 Whitmore, K. E., Staud, C. J., Barr, C. R., and Williams, J., U.S. Patent 3 148 062 of September 8, 1964.

99 Barr, C. R., Williams, J., and Whitmore, K. E., U.S. Patent 3 227 554 of January 4, 1966.

100 Newmiller, R. J., and Pontius R. B., The absorption of development restrainers to silver and their effects on physical development. *Phot. Sci. Eng.*, **5** (1961), 283.

101 Tull, A. G., Tanning development and its application to dye transfer images. *Jl. Phot. Sci.*, **11** (1963), 1. This abstract contains an extensive list of references on dye transfer processes.

102 Yutzy, H. C., and Yackel, E. C., U.S. Patent 2 596 756 of May 13, 1952.

103 Bylemans, J., Image transfer processes, in *Progress in Photography 1955–1958*, D. A. Spencer (ed.), Focal Press, London, 1958, p. 30.

104 Rogers, H. G., U.S. Patent 2 983 606 of May 9, 1961.

105 Dery, D. A., Polacolor. *Phot. Jl.*, **104** (1964), 161.

106 Leiber, F., Sensitometrische Untersuchungen zum Umkehrverfahren. *Kino-technik*, **14** (1932), 116.

107 Klein, E., The influence of silver halide solvents in the developer on the characteristic curve in negative and reversal development. *Jl. Phot. Sci.*, **8** (1960), 178.

108 Rott, A., Un nouveau principe de l'inversion: L'inversion transfert par diffusion. *Sci. Ind. Phot.*, **(2) 13** (1942), 151.

109 Land, E. H., A new one-step photographic process. *Jl. Opt. Soc. Am.*, **37** (1947), 61.

110 Weyde, E., Über die Silberausscheidung durch Keime beim Silbersalzdiffusionsverfahren (Agfa-Copyrapidprozess). *Z. Naturforschung*, **6a** (1951), 381.

111 Weyde, E., Über die Wiedergabe von Details in den nach dem Silbersalz-Diffusionsverfahren hergestellten Positiven. *Phot. Korr.*, **88** (1952), 203.
112 Tarkington, R. G., A new Kodak processing method for the aerospace age. *Soc. Phot. Opt. Inst. Eng. Jl.*, **1** (1963), 226.
113 James, T. H., and Higgins, G. C., Fixing and washing, in *Fundamentals of Photographic Theory*, Morgan & Morgan, New York, 1960, p. 155.
114 Chateau, H., Pouradier, J., and Berry, C. R., Structure and thermodynamic properties of silver halides, in C. E. K. Mees and T. H. James, *The Theory of the Photographic Process*, 3rd edn, Macmillan, New York and London, 1966, p. 8 and 9.
115 Sheppard, S. E., and Mees C. E. K., *Investigations on the Theory of the Photographic Process*, Longmans, Green and Co., London, 1907, p. 70.
116 Battaglia, C. J., and Honnick, W. D., Diffusion of thiosulfate, ferro-, and ferricyanide ions through gelatin: alkali metal ion effects. *Phot. Sci. Eng.*, **11** (1967), 336.
117 Jaenicke, W., Zur Kinetik des photographischen Fixiervorganges. (Kinetik der Auflösung von Silberhalogeniden unter Komplexbildung III.) *Z. physik. Chemie*, **195** (1950), 88.
118 Russell, H. D., Yackel, E. C., and Bruce, J. S., Stabilisation processing of films and papers. *P.S.A.-Jl. (Phot. Sci. Tech.)*, **16B** (1950), 59.
119 Russell, H. D., Procedures and equipment for the rapid processing of photographic materials. *Phot. Eng.*, **2** (1951), 136.
120 Haist, G. M., and King, J. R., U.S. Patent 2 875 048 of February 24, 1959.
121 Mees, C. E. K., *The Theory of the Photographic Process*, 2nd edn 1954, Macmillan, New York, p. 738. This summary also contains an extensive list of references on reducers.
122 Zuidema, J. W., The sulfuric acid–potassium bichromate bleach in the black-and-white reversal process. *Jl. S.M.P.T.E.*, **72** (1963), 485.
123 Bello, H. J., and Zwick, D. M., An edge effect in color caused by the distortion of the developed image when a hardening bleach is used. *Phot. Sci. Eng.*, **3** (1959), 221.
124 Farmer, E. H., A convenient reducing agent. *Yearbook Phot.*, 1884, 59.
125 Heilmann, M., Über das Agfacolor-Bleichfixierbad. *Mitt. Forschungslab. Agfa*, Vol. *I.* Springer, ed. Berlin-Göttingen-Heidelberg, 1955, p. 256.
126 Heilmann, M., von Brachel, H., and Holtschmidt, H., German Patent D.A.S. 1 146 363 of March, 28, 1963.
127 Simmons, N. L., *Produits photosensibles comportant une couche anti-halo.* French Patent 945 157 of April 27, 1949.
128 Gale, R. O., and Williams, A. L., Factors affecting color film dye stability. *Jl. S.M.P.T.E.*, **72** (1963), 804.
129 *Eastman Kodak motion picture films for professional use.* Kodak Publication H-1, 1966, p. 43.
130 Henn, R. W., and Wiest, D. G., Microscopic spots in processed microfilm: their nature and prevention. *Phot. Sci. Eng.*, **7** (1963) 253.
131 Crabtree, J. I., Eaton, G. T., and Muehler, L. E., The elimination of hypo from photographic images. *P.S.A.-Jl.*, **6** (1940), 6.
132 Henn, R. W., and Mack, B. D., A gold protective treatment for microfilm. *Phot. Sci. Eng.*, **9** (1965), 378.
133 Crabtree, J. I., Eaton, G. T., and Muehler, L. E., The removal of hypo and silver salts from photographic materials as affected by the composition of the processing solutions. *Jl. S.M.P.T.E.*, **41** (1943), 9.

134 Eaton, G. T., and Crabtree, J. I., Washing photographic films and prints in sea water. *Jl. S.M.P.T.E.*, **40** (1943), 380.

135 Crabtree, J. I., How to save water in photographic processing. *P.S.A.-Jl.*, **16** (1950), 70.

136 Crabtree, J. I., and Henn, R. W., Increasing the washing rate of motion picture film with salt solutions. *Jl. S.M.P.T.E.*, **65** (1956), 378.

137 Henn, R. W., King, N. H., and Crabtree, J. I., The effect of salt baths on hypo and silver elimination. *Phot. Engineering*, **7** (1956), 153.

138 Levenson, G. I. P., The washing powers of water. *Jl. Phot. Sci.*, **15** (1967), 215.

139 U.S.A.—standard PH4.8-1958. *American standard method for determining the thiosulfate content of processed black-and-white photographic film and plates.*

140 Crabtree, J. I., and Ross, J. F., A method of testing for the presence of sodium thiosulfate in motion picture films. *Jl. S.M.P.T.E.*, **14** (1930), 419.

141 Crabtree, J. I., Eaton, G. T., and Muehler, L. E., A review of hypotesting methods. *Jl. S.M.P.T.E.*, **42** (1944), 35.

142 Pouradier, J., and Chateau, H., Dosage du sulfure et de l'hyposulfite restant après traitement dans les films et papiers photographiques. *Photo-Revue*, (1962), 165.

143 Pouradier, J., and Mailliet, A. M., Remarques sur le dosage de l'hyposulfite résiduel dans les papiers photographiques. *Sci. Ind. Phot.*, **(2) 35** (1964), 193.

144 Larson, G. W., Hubbell, D. C., and West, L. E., Application of two analytical test methods to predict processed image stability. *Jl. S.M.P.T.E.*, **71** (1962), 495.

145 Warburton, C. D., and Przybylowicz, E. P., A new test method for the measurement of residual thiosulfate in processed film based on borohydride reduction to sulfide and methylene blue formation. *Phot. Sci. Eng.*, **10** (1966), 86.

146 U.S.A.-standard PH1.28-1957. *American standard specifications for photographic films for permanent records.*

147 Adelstein, P. Z., Proposed U.S.A. standard for archival film on cellulose ester base. *Jl. S.M.P.T.E.*, **77** (1968), 819.

148 Preliminary proposal for recommendation ISO/42/WG.5/1. *Traitement et conservation des microcopies gélatino-argentiques sur film, destinées à l'archivage.*

149 Horowitz, P., and Weller, W. R., Some considerations of Eastman color print film dye stability. *Jl. S.M.P.T.E.*, **67** (1958), 401.

150 West, L. E., Water quality criteria. *Phot. Sci. Eng.*, **9** (1965), 398.

151 Boyd, J. W., Rapid-drying characteristics of several films for aerial photography. *P.S.E.*, **4** (1960), 354.

152 Katz, L., Ultrarapid drying of motion picture film by means of turbulent air. *Jl. S.M.P.T.E.*, **56** (1951), 264.

153 Fisher, O., An appraisal of drying systems. *Photographic Eng.*, **4** (1953), 226.

154 Kaye, J., Kennan, J., and McAdams, W., Measurements of friction coefficients for supersonic flow of air in a pipe. *M.I.T. Technical Report*, no. 6418, June 1, 1949.

155 Miller, F. D., Rapid drying of normally processed black-and-white motion picture films. *Jl. S.M.P.T.E.*, **60** (1953), 85.

156 Daane, R. A., and Han, S. T., An analysis of air impingement drying. *Tappi*, **44** (1961), 73.

157 Sottysiak, J., *Physical properties of photographic papers.* U.S. Patent of February 7, 1961, No. 2 970 907.

158 Ryman, J. G., and Overturf, W. K., A review of the drying of silver halide photographic film. *Jl. S.M.P.T.E.*, **78** (1969), 3.

159 Evans, R. M., Maintenance of a developer by continuous replenishment. *Jl. S.M.P.T.E.*, **31** (1938), 273.
160 Henn, R. W., and Herzberger, M., Equations for calculating the condition of photographic solutions in continuous systems. *P.S.A.-Jl.*, **13** (1947), 494.
161 Henn, R. W., Calculation of the condition of used processing solutions. *P.S.E.*, **9** (1965), 154.
162 Goldwasser, S. R., A mathematical approach to replenishment techniques. *Jl. S.M.P.T.E.*, **62** (1954), 11.
163 Carlu, P., Replenishment of solutions in batch processing. *Jl. Phot. Sci.*, **12** (1964), 61.
164 Mouchel, P., Photographic processing with one-time use of solutions. *Jl. Phot. Sci.*, **14** (1966), 209.
165 Creyf, S., and Roosens, L., Die chemische Analyse photographischer Verarbeitungsbäder. *Phot. Korr.*, **100** (8) (1964), 130, and **107** (1971), 5.
166 *Chemical control procedure for black-and-white film processing.* Eastman Kodak Co, Motion Picture Film Department, Rochester, N.Y. (1966).
167 *Production of motion pictures in color using Eastman Color Films.* Appendix D, Analytical reagents and methods for use in processing control. Revised edn., 1966. Eastman Kodak Co, Motion Picture Film Department, Rochester, N.Y.
168 *Manual for processing of Ektachrome Commercial Film. Analytical reagents and procedures.* Eastman Kodak Co, Motion Picture Film Department, Rochester, N.Y., (1967).
169 *Manual for processing of Eastman (or Kodak) Ektachrome ER film and Ektachrome Reversal Print Film.* Analytical procedures. Eastman Kodak Co, Motion Picture Film Department, Rochester, N.Y. (1968).
170 *Monitoring for processing Kodak Ektacolor Paper with Ektaprint C chemicals.* Eastman Kodak Co, Professional, Commercial and Industrial Markets Division, Rochester, N.Y. (1969).

Author Index

Subject Index